Against Voluptuous Bodies

Cultural Memory
in
the
Present

Mieke Bal and Hent de Vries, Editors

Against Voluptuous Bodies

LATE MODERNISM
and the
MEANING OF PAINTING

J.M. Bernstein

STANFORD UNIVERSITY PRESS
STANFORD, CALIFORNIA
2006

Stanford University Press
Stanford, California

© 2006 by the Board of Trustees of the
Leland Stanford Junior University.
All rights reserved.

No part of this book may be reproduced or transmitted in any form
or by any means, electronic or mechanical, including photocopying
and recording, or in any information storage or retrieval system
without the prior written permission of Stanford University Press.

Printed in the United States of America
on acid-free, archival-quality paper

Library of Congress Cataloging-in-Publication Data

Bernstein, J. M.
 Against voluptuous bodies : late modernism and the meaning of painting /
J. M. Bernstein.
 p. cm.
 Includes bibliographical references and index.
 ISBN 0-8047-4894-2 (cloth : alk. paper)—
ISBN 0-8047-4895-0 (pbk. : alk. paper)
 1. Modernism (Art) 2. Painting, Modern—20th century.
3. Painting—Philosophy. 4. Adorno, Theodor W., 1903–1969—
Aesthetics. I. Title.
ND196.M64B47 2005
759.06—dc22 2005012303

Original Printing 2005
Last figure below indicates year of this printing:
15 14 13 12 11 10 09 08 07 06

Typeset by James P. Brommer in 11/13.5 Garamond

To Gregg
For the Friendship, the Art, the Philosophy

Contents

List of Figures xi

Acknowledgments xiii

Introduction: (Late) Modernism 1

1 Wax, Brick, and Bread—Apotheoses of Matter and Meaning in Seventeenth-Century Philosophy and Painting: Descartes and Pieter de Hooch 19

2 Judging Life: Kant, Clement Greenberg, and Chaim Soutine 46

3 Modernism as Philosophy: Stanley Cavell, Anthony Caro, and Chantal Akerman 78

4 Aporia of the Sensible—Art, Objecthood, and Anthropomorphism: Michael Fried, Frank Stella, and Minimalism 117

5 The Death of Sensuous Particulars: T. J. Clark and Abstract Expressionism 144

6 Social Signs, Natural Bodies: T. J. Clark and Jackson Pollock 165

7 Readymades, Monochromes, Etc.: Nominalism and the Paradox of Modernism (Thierry de Duve and Marcel Duchamp) 194

8 Freedom from Nature? Reflections on the End(s) of Art:
 Arthur Danto, Yves-Alain Bois, and Robert Ryman 223

9 The Horror of Nonidentity: Cindy Sherman's
 Tragic Modernism 253

 Notes 327

 Index 385

List of Figures

1	Pieter de Hooch, *Courtyard in a German House*	31
2	Jan Vermeer, *The Milkmaid*	41
3	Chaim Soutine, *Self-Portrait*	69
4	Chaim Soutine, *View of Céret*	71
5	Chaim Soutine, *Carcass of Beef*	76
6	Anthony Caro, *Prairie*	103
7	Donald Judd, *Untitled*	129
8	Frank Stella, *Die Fahne Hoch!*	137
9	Barnett Newman, *Onement I*	145
10	Camille Pissarro, *Two Young Peasant Women*	168
11	Jackson Pollock, *The Wooden Horse (Number 10)*	184
12	Joseph Cornell, *Toward the "Blue Peninsula" (for Emily Dickinson)*	216
13	Louise Bourgeois, *Cell 1*	217
14	Robert Ryman, *Untitled*	243
15	Cindy Sherman, *Untitled Film Still, #40*	272
16	Cindy Sherman, *Untitled, #132*	285
17	Cindy Sherman, *Untitled, #153*	300
18	Cindy Sherman, *Untitled #190*	303
19	Cindy Sherman, *Untitled, #250*	315
20	Cindy Sherman, *Untitled, #316*	322

Acknowledgments

In stretching my claims of competence from philosophy to art history and criticism I have needed and benefited from the advice and help of friends, colleagues, students, and also the kindness of some strangers. I am sure this is not everyone, but I vividly remember and am grateful for the help I received from the following: Karl Ameriks, Judy Butler, Howard Caygill, Tim Clark, Rebecca Comay, Alice Crary, Alex Düttmann, Rick Eldridge, Jim Elkins, Ståle Finke, Rodolphe Gasché, Tom Huhn, Maggie Iversen, Ellen Levy, Michael Newman, Peter Osborne, Graça Peixoto, Max Pensky, Bob Pippin, and Kaja Silverman. Wonderful students at the University of Essex, Vanderbilt University, and the New School for Social Research always pressed me to make Adorno's ideas clearer, and made me think harder about artworks and how best to talk about them.

Jeanette Christensen, on a memorable evening in Oslo, shared her art with me and changed my ideas about the possibilities of contemporary art, of what is modern and what postmodern.

My brief three years in Nashville, Tennessee, would have been on any account ones to be grateful for, but the fact that while there I had the fortune to have Gregg Horowitz as first a colleague and then a dear friend made that sojourn an irreplaceable event in my life. Gregg was, at the very least, the perfect interlocutor for the ideas that are central to this book. On matters both philosophical and art critical he seemed to know, even before I did, what I wanted to say and pushed me to say it better and more fully. His and Ellen Levy's encouragement, their passion for modernism, and their friendship are things without which this book would not have come to be. Because my debts to Gregg for this book are so immense, the very least I can offer in return is to dedicate the book to him.

Toward the end of the process of putting this book together two Grad-

uate Faculty students gave timely support: Micah Daily did all the hard graft on arranging for the artworks that are reproduced here, and Micah Murphy provided invaluable help in proofreading and indexing.

Earlier versions of almost all the chapters of this work appeared, in whole or in part, as articles in journals and collections. I note here where the articles first appeared and express my gratitude to the editors and publishers for permission to reprint the following: "Cavell and Modernism," in Richard Eldridge, ed., *Stanley Cavell* (Cambridge: Cambridge University Press, 2003); "Wax, Brick, and Bread: Apotheoses of Matter and Meaning in Seventeenth-Century Philosophy and Painting," in Dana Arnold and Margaret Iversen, eds., *Art and Thought* (Oxford: Blackwell, 2003); "The Horror of Non-Identity: Cindy Sherman's Modernism," in Peter Osborne, ed., *From an Aesthetic Point of View: Philosophy, Art, and the Senses* (London: Serpent's Tail Press, 2000); "Judging Life: From Beauty to Experience, from Kant to Chaim Soutine," *Constellations* 7, no. 2 (June 2000); "Aporia of the Sensible: Art, Objecthood and Anthropomorphism," in Barry Sandywell and Ian Heywood, eds., *Mapping/Explorations of the Hermeneutics of Vision* (London: Routledge, 1999); "The Death of Sensuous Particulars: Adorno and Abstract Expressionism," *Radical Philosophy* 76 (March 1996): 7–18; "Social Signs and Natural Bodies: On T. J. Clark's *Farewell to an Idea: Episodes from a History of Modernism*," *Radical Philosophy* 104 (Nov./Dec. 2000).

Against Voluptuous Bodies

Introduction: (Late) Modernism

> There is no system without its residue.
> —Theodor W. Adorno, "Notes on Kafka"

> . . . to produce what is blind, expression, by way of reflection, that is, through form; not to rationalize the blind but produce it aesthetically, "To make things of which we do not know what they are."
> —Theodor W. Adorno, *Aesthetic Theory*

In this work I offer a philosophical defense of modernism, of modernism as a philosophical claim, of modernism as art's insistence that it has a philosophical claim that is both intrinsic to it and separate from it—hence a defense of modernist aesthetics as a cornerstone of a modernist philosophy in relation to a (here) painterly modernism that is its condition of possibility. This is also an accounting of the fate of modernism: its waning and remaining, its perpetual lateness. Modernist painting, as a stand-in for modernist art generally, as it will emerge in these pages, will have a not unfamiliar look; yet that look will be inflected in a distinctive direction, a direction that has not yet had its due, not in painting, not in the debates around and about modern painting. Crudely and quickly told, the standard story of modernist painting runs thus: At a certain moment in the nineteenth century, by virtue of its dawning awareness of its irrevocable autonomy, painting began to consider the source of its claim to rational attention, hence its rational authority, as lying within the specific character of its practice, entailing the necessity of making the elements of the practice palpable components of works. Initially, in a series of remarkable transformations, the representational content of paintings came to be marked, shadowed, or

resisted by being displayed through or embodied in features unique to the practice of painting: the brush stroke, the properties of the pigment, the flat surface, the shape of the support, the specific properties of color and line. This process of foregrounding and incorporating the components of painterly practice into works took on a distinctive profile in the early years of the past century. In Picasso's cubism representational content is at first sustained, while flatness is asserted through a fragmentation of the object and its decomposition into facets that alternately invoke other facets, implying volume and depth, or simply lie flat on the picture plane (*Girl with a Mandolin*, 1910). In time the facets all flatten onto the picture plane, becoming almost gridlike (*Portrait of Ambroise Vollard*, 1910), till the moment in which representational content is wholly submerged, lost or nearly so, in the grid from which it has been (de-)composed (*Man with Mandolin*, 1911). (It is sometimes argued about this moment that Picasso's beginning to stencil the names of the absent object onto his paintings is meant to signify that, in any act of representing, the object is absent from the act, which is evident in language but had been suppressed by painting.) Conversely, at about the same time, in Kandinsky's abstract paintings representational content is (almost) forgone while the (immaterial) forms of painterly pictorialism—above all deeply saturated areas of brightly contrasting colors, but also shape, composition, and the relations between these forms—take on a hermetically expressive life of their own. One can think of cubism's representation without pictorialism, and of abstraction's heightened pictorialism without representation, as extremes or limit cases or ideal types that were employed in differing combinations and emphases throughout the first half of the century; finally, abstract expressionism dispensed with both representation and pictorialism. With abstract expressionism, the underlying and dynamic project that seems to have begun with Manet and Cézanne comes almost to an abrupt halt, nearly bottoms out, all but ends. What is this history about? Of what significance its (apparent) end?

Let me concede that no single telling of this history will ever be sufficient unto itself since there truly were competing projects and hopes, moments of achievement and promise that closed in on themselves, branchings out and diversions not to be ignored. Nonetheless, the emphatic character of the ending of it all seems to entail that *something* (all but) ended, and it is that *something* whose shape and fate need articulation. Since the shape of the history and the meaning of its end are what these chapters seek to provide, I

will here baldly state my governing idea: Modernism is modern art's self-consciousness of itself as an autonomous practice. Art's autonomy, however, is not the achievement of art's securing for itself a space free from the interference of social or political utility, but a consequence and so an expression of the fragmentation and reification of modern life. Autonomy is not, in the first instance, a reflective categorial accomplishment, but art's expulsion and exclusion from everyday life and the (rationalized and reified) normative ideals, moral and cognitive, governing it. Once expelled and aware of that expulsion, art *then* is forced to interrogate what is left to it, the meaning of its now isolated practice, and, simultaneously, the significance of its excision; in all, painting sought to uncover the possibilities of continuing, of its being able to authorize itself (or to fail to do so), and thus to remain a form of conviction and connection to the world in the absence of what had previously been supposed to be the source of its conviction and connection—representational content and evaluative ideals. Art would not have been ostracized from everyday life if what remained to it was not incommensurable with what the everyday itself had been forced to surrender and/or repudiate. The fact of autonomous art is thus already the beginning of an account of the meaning of modernity.

From the outset, modern autonomous art operates as a critique of modernity because its very existence derives from the ever-expanding rationalization of the dominant practices governing everyday life to the point at which those practices no longer emphatically depend on individuals' sensuously bound, embodied encounter with the world for their operation and reproduction. What hibernates, what lives on in an afterlife in the modern arts, is our sensory *experience* of the world, and of the world as composed of objects, things, whose integral character is apprehensible only through sensory encounter, where sensory encounter is not the simple filling out of an antecedent structure, but formative. Conversely then, what has been excised from the everyday is the *orientational significance of sensory encounter, sensory experience as constitutive of conviction and connection to the world of things.* The emptying of sensory encounter of orientational significance is our mortification.[1] Artworks expound our mortification by evincing it, elaborating a subjectivity that is no longer subject or substance. In modern painting it is predominantly our visual experience of the world, our capacity for irreducibly visual encounter with things demanding visual/perceptual reckoning, that lingers, afterimages without originals.

Since, obviously, we all have sensory experiences all the time, the notion of "sensory experience" is too indeterminate to encapsulate what the arts attempt to salvage; experience in modernity is systematically equivocal.[2] The notion of experience that has become authoritative—the one contested by modernism—derives from Kant, or more precisely, achieves its most acute elaboration and legitimation in Kant's epistemology. In what follows I employ Kant's conception of experience in its literal, epistemological sense and metaphorically, as a figure for the structural divisions within modern social life.[3] In a well-known passage from the *Critique of Pure Reason*, Kant states, "Thoughts without content are empty, intuitions without concepts are blind" (A 51 = B 75). Intuitions are singular representations that refer immediately to an object. Empirical intuitions are conveyed through sensory affection. Intuition, and hence the act of intuiting, stands for the immediate, sensory, embodied, object-dependent element in knowing. Conversely, concepts are products of the spontaneity of the human mind; they are general representations, representations of what several different objects have in common. Concepts thus enable us to comprehend objects through the recognition of the features and properties that they share with other objects. Knowledge—empirical experience—occurs when intuitions are subsumed under concepts. In a nutshell, that is Kant's account of knowledge and experience. Its depth depends on comprehending concept and intuition not as two distinct and separate elements that are contingently brought into harmony or cooperation with each other in empirical knowledge, but as intrinsically indeterminate aspects of conceptual experience that reciprocally determine each other, are incomplete on their own, and thus realize *their own* rationality potential only in those acts where mutual determination takes place. Said another way, Kant's account means to be more than harmonizing; it requires us to conceive of each component of cognitive experience, concept and intuition, as the *fulfillment* of the opposing component. Concept, so-called, and intuition are both *aspects* of the whole empirical concept, the concept as such; if we conceive of the concept as the minimal unit of cognition, then the so-called concept, concept without intuition, and intuition together are the components of rational encounter. (It matters to the history of all this that one aspect of the concept as such has been identified as "the concept," with the moment of intuition thus figured as lying outside conceptuality, so outside reason and cognition.) Kant's classificatory conception of the concept-intuition relation is structured around four du-

alisms, which, were the theory to deliver what it promises, would be fully reconciled with one another: concepts stand to intuitions, first, as *form* stands to *matter*, as what orders or structures in relation to what is ordered; second, as the *general* (or universal) stands to the *particular*; third, as the products of *spontaneity* or intellectual activity stand opposed to the products of *receptivity*; and finally, by implication, as what belongs to the domain of the *intelligible* stands opposed to what belongs to the domain of the *sensible*.[4] In Kant these really are dualisms, broken and incommensurable aspects of a whole of experience; hence it is in the very duality of these elements that we can discover what is excluded from authoritative acknowledgment that ruins experience as such.

Even this minimal analysis of Kant's account of judging raises a puzzle, one that speaks both to a technical problem in Kant's theory and to the fading of emphatic experience from social life, since what it reveals is a lack of equality in the two moments. Without equality there cannot be mutual determination ("reciprocal subordination" as Friedrich Schiller puts it), and without mutual determination the very idea of the concept collapses, or at least becomes something so equivocal that the difference between the two possibilities, concepts with and without intuitions, all but fails to be a difference in kind (conceptualization without encounter is not a kind of encounter); without the possibility of a full concept, encounter lapses; if a subject cannot encounter an object, then there are neither subjects nor objects—it will come to that. The technical puzzle is simply this: according to Kant, intuitions can only cognitively matter to us by *first* being subsumed under concepts—that is, by being brought within the framework of our spontaneously produced conceptual scheme. We can only be aware of a particular *after* it has been subsumed under the appropriate concept. This thought is necessitated precisely by the claim that intuitions without concepts are blind. However, this is not as straightforward as it may appear. The raw data for conceptualization are provided, again, by sensory awareness. But if awareness requires conceptual articulation, if awareness of something *as* a unified thing with distinct properties occurs through the unifying and organizing functioning of concepts, then how can sensory awareness on its own be *awareness* at all? If the point of concepts is to articulate the sensory given, how can the sensory given *guide* or trigger conceptuality? If *only* concepts provide discriminating awareness, how can intuitions be discriminable? If conceptuality gives *to* intuitions their cognitive

significance, then what significance can intuitions have apart from concepts? But if intuitions have no cognitive significance apart from concepts, then what do concepts re-mark and discriminate? Kant seems to have given to intuition the role of providing for sensory encounter with individual objects, but in handing over all capacity for recognition to conceptuality and discursivity he deprived sensory awareness of the means of doing so. The result is a form of epistemological ventriloquism, the puppet intuitions saying only and exactly what the master concepts say, which is to acknowledge that the intuitions say nothing, have no voice of their own. (I take conceptual ventriloquism to be the deep source of the illusions that sensory matter is expressed in a concept rather than being its dummy. Puppetry is the direct converse illusion to illicit animism.) Intuitions, formally, are but dead (sensory) matter given *all* the meaning they can possess by what is essentially extrinsic to them. If concept and intuition are elements of the concept as such, then the Kantian concept is on its own terms broken, deformed, and alienated from itself, and we, as a consequence, are broken, deformed, and alienated from ourselves.

We do not need to track this puzzle into the labyrinths of Kant's epistemology to appreciate its significance.[5] Although Kant's tale aims at being one of cooperation between the faculties of sense and thought, by making the senses utterly and irredeemably passive, and handing over all activity to the pure spontaneity of the mind, he fragments the subject into two. When I said that in modernity individual, embodied experience is increasingly and systematically vanquished, and with it the individual objects that are the internal correlates of such experience (the integrity and orientational significance of individual experience and the dignity of singular objects waning in direct proportion to each other), and so the subject that would have such experiences, I had in mind the way in which, in accordance with Kantian epistemology, sensory experience becomes a mere shadow cast by (abstract) conceptuality. In metaphorical terms, but terms that I argue are not merely metaphorical, Kantian conceptuality's increasing independence from its sensory bearer is enacted, cognitively, in the mathematical explanations of modern natural science, and practically in the rationalizations of the practices and institutions that legislate the shape and meaning of modern social life.[6] The former entails the domination and hegemony of scientific reason; the latter yields life without emphatic experience, without those kinds of experiences that can transform everyday life and provide ori-

entation within it, hence without those experiences through which subjects attain their very subjective standing, their standing in relation to a world.

Whither then intuition, our immediate, singular representations of things through the senses? Significant sensory experience (and the unique objects and events that are its intentional substance) has been dispatched, delegitimated, left without any authority in the reproduction of the social world; but a fundamental element of our self-understanding of ourselves *as (autonomous) individuals* presupposes a self-image of ourselves as centers of agency and experience. Whither this element of our self-image? Whither that portion of intuition that would or could determine the abstract concept? The conceit upon which my argument turns is that *the arts have become the bearers of our now delegitimated capacity for significant sensory encounter: emphatic experience*—and it is because the arts do (or did) fulfill this role that, apparently beyond any reasonable accounting, seemingly beyond our reflective capacity to account for this fact, the arts matter and possess authority. The arts are just now the defused authority of emphatic experience. Only through emphatic experience could we be "in touch" with what is other to the products of the spontaneity of the mind, hence *others* in themselves rather than their being mere mirrors reflecting what has been imposed upon them by the mind's spontaneous, general forms, hence truly sensible others. The arts provide, so to speak, the sensory experience of particulars writ large, writ as a complex and overdetermined social practice with its own distinctive history. More precisely, the institutional practice of *producing, exhibiting,* and *interpreting* works of a modernist kind is the bearer of the rationality potential of the repressed intuitive moment of the concept, repressed nature within and without. Hence what the arts configure, offer a reminder or promise of (in effigy), is the rationality potential of intuitions and intuiting—say, again, the arts are brute material inscriptions of an evacuated subjectivity. The task of the arts is to rescue from cognitive and rational oblivion our embodied experience and the standing of unique, particular things as the proper objects of such experience, albeit only in the form of a reminder or a promise.

Because art is the systematic bearer of such capacities and such objects, then it suffers, in part, from the same pressures that forced sensory experience and particularity into hibernation in the first place: delegitimation and progressive emptying. The project of modernist painting ends not because it realized painting's true essence, but because it was *hounded* into empti-

ness by dint of its emphatic isolation from practical life; this is not to deny that modern art involves a quest—on this account, an anti-skeptical quest played out *through* the specific forms that give painting its distinctive capacities for producing irreducibly unique particulars that (normatively) demand to be responded to in their own right and on their own terms, the terms they themselves set: intuitions demanding a complex, discriminating, judgmental response that is incapable of being discursively grasped. But the hounding of art is there from the beginning;[7] it is what forces art to become autonomous. In being autonomous, the claim of art is already vanquished, already constituted by being, in fact, de jure expelled from empirical experience, and in being expelled carrying its social illegitimacy with it. Modern art is always too *late*. Late modernism, in theory and artistic practice, modernism after its demise, is just the perpetuation of the *claim* of modernism after the *dynamic* history that revealed that claim and made it salient has ended; but again, since the claim of modernism emerges as what has been disclaimed, repudiated, and delegitimated generally, then lateness is inscribed in modernism's emergence. From the outset, the works of modernism are fugitives; or better, what they provide is fugitive experience, exemplars of emphatic experience in the midst of a world in which experience has been reduced to a Kantian shadow experience: experience of irreducibly unique material objects versus the kind of experience that occurs when individuals are submerged, and thus merely shadows thrown by the concepts articulating them. Rationalized modernity destroys emphatic experience, *Erfahrung*, leaving in its stead only a dull, anesthetized remnant, *Erlebnis*.[8]

Because art is the systematic bearer of the claim of intuitions and intuiting, and these are components of the concept as such, then it raises a philosophical claim in a manner that is irreducible to philosophical practice because philosophical practice is and remains on the (abstract, broken) conceptual side of the division between concept and intuition. Because art's claim matters to cognition and rationality as a whole, then it matters to philosophy. Modernist philosophy is the kind of philosophy that depends on art, emphatically (just as in the bad Kantian story concepts were *supposed* to depend on intuitions), which is to say, it is the kind of philosophy whose task is to acknowledge the irreducible moment of sensibility *within* the concept, which is not the sensible as such (that is the reduction of sensibility that the abstract concept carries out) but the insensible within the sensible that is not another (abstract) concept but its now repudiated con-

dition of possibility. Such art, in its turn, needs philosophy in order to reveal how its claim matters to cognition and rationality generally (how it is suppressed conceptuality writ large), how it stands as a repudiated moment of spirit. When the different aspects of this story are composed they yield an account of the rational authority of individual experience, the dignity of particular, indigent things, and the materiality of the social sign, the riveting together of the social sign with its material bearers, which are, must be, more than mere bearers. All this is given through the modernist experience of the absence of experience, that is, the production, exhibition, and interpretation of modernist works.

But again, and this matters, since art is the source of the authority of this claiming, and modern art constituted by a hounding that imposed this task upon it, then art's capacity to fulfill its imposed task is contingent and fragile, subject to indefinite harassment and eventual defeat. Its mortality and perpetual lateness belong to the *substance* of modernist painting. But to explicate the contours of modernism as exemplifying a form of claiming and meaning in relation to what hounds it equally entails that modernism cannot be reduced or confined to a particular style or look or school or canon of works. To say that modernism is always late is equivalent to saying that it always involves painting in the absence of painting—that is what makes modernism always late. Modern painting proceeds as the absence of painting because all modern painting (or sculpture, or music, et al.) secures its appearing fullness upon its existential emptiness: it is without actual content, its claim to fullness made possible by its being without empirical significance, its being semblance. One might consider this the mood of sadness, the melancholy that hangs over even the most resplendent works. All painting's power derives from its being without empirical purpose, its existential emptiness, that it can secure nothing, achieve nothing, be nothing. It is because the achievement of painting is only ever the absence of painting that modern painting at every moment is threatened by philosophical disenfranchisement. If every actual painting is a necessary failure, if every painting is abject with respect to the desire it configures (to be worldly and empirically mean), and that is the only form of success available, then it can appear as if every painting fails the idea of painting, thus making the idea of painting the transcendent measure of actual painting. This gets exactly wrong the source and meaning of painting's failure: it makes actual paintings fail with respect to a transcendent Idea, call it the

philosophical idea of painting, rather than failure being a consequence of achieving the idea of painting, painting in the absence of painting—failure the form of success now available to painting.

Said differently, painting in the absence of painting is painting in the absence of painting representing the world, aligning us with it. But if painting occurs in the absence of painting—because what matters about painting is not representational but categorial, an inscription of and a way of bearing the burden of the absence of experience, the default of sensuous particulars, the excision of bodily happiness—then modernist painting need not and indeed is not, always and everywhere, literally, *painting*. Modernism continues, its painting in the absence of painting continues in works that standardly have been interpreted as postmodernist. Such labeling, modernism/postmodernism, lets style and chronology determine meaning too quickly (as if, say, after Warhol, after April 1964, after the *Brillo Boxes*, a modernist claim could not, in principle, arise with any hope of vindication, authenticity, or authority).[9] So one further inflection of the idea of late modernism is that there are works now, the pictures of Cindy Sherman, Louise Bourgeois's *Cells*, that are as emphatically modernist as any of the canonical works that have rightly been found fundamental for eliciting its meaning and standing.[10]

There is one final nuance to the claim that modernism is perpetually late. One side of the claim of modernist art is that it proffers the defused and repudiated claim of sensuous particularity, and hence sensuous nature in relation to a rational freedom that arises *through* its separation from nature. But this entails that the force of the claim of sensuous nature is in part constituted through its clinging or lingering on as the murdered antagonist of rational freedom. Normatively, what the rational concept is dependent on is not the undiluted authority of sensuous particularity itself, but the *continuation of the slaughter of its authority* as the plenipotentiary of the authority of living nature. Hence the other side of modernist art's lateness will be its being *too late*; that is, the force of its claim will not be a claim to autonomous authority, as if living nature itself could (once more) provide the orientations necessary and sufficient for our leading purposeful lives, as if art could itself truly resurrect or reanimate the authority of living nature; rather, it is the irremediable loss of that claim that *is* its continuing claim, the claim of art against reason. Art cannot restore or reanimate the authority of dead nature, but it can, does, press the claims of the dead against the

living as the permanent condition for the living fending off cultural death. At its highest reach, art turns cultural melancholy into form.

Such, in the broadest possible terms, is the story I want to tell. It is not, of course, my story, but the account of the meaning of high modernism that T. W. Adorno worked out in numerous writings, most notably *Aesthetic Theory*. That Adorno, who wrote irreplaceable accounts of musical and literary modernism, did not attempt to provide an account of painterly modernism is intriguing, especially since the issues that I contend are focal to it—namely, the standing of perceptual experience as orientational, as providing conviction and connection to world, and the role of art mediums as stand-ins for the lost authority of nature—are most forcefully and radically raised in modernist painting. Modernist painting is the crux of the claim of modernism, of modernism as the philosophical self-consciousness of modernity, of modernism as philosophy. That as yet there has been no explicit Adornoian account of modernist painting means that what is without question the most systematic defense of the meaning of modernism has been absent from the ferocious and important debates around modernist art over the past half-century. For reasons I shall come to momentarily, the need for the saliences and emphases of Adorno's modernism turn out to be not only timely, but also a matter of urgency to contemporary art theory and practice.

My argument operates on three distinct levels of accounting: philosophical, historical, and critical. Although Adorno's aesthetics and philosophical modernism orient the argument of each chapter, I barely mention Adorno before Chapter 5, and when he does enter the discussion it is in the context of another theorist of modernism (Chapters 5, 7, and 8), or as the relevant background for the reading of modernist works (Chapter 9). The most robust philosophical elaborations of modernist aesthetics hence occur through the words of others: Kant and Stanley Cavell. With some perversity, the Kant chapter brings into play the materialist commitments of modernism, its binding of itself to the medium as the stand-in or plenipotentiary for nature, while the Cavell chapter attempts to make good the rationality potential exemplified by aesthetic experience and judgment. It is more than helpful for my purposes that the contours of modernist thought emerge from different locales and in terms remote from Adorno's own, even if those other perspectives take on the emphases they do through my allegiance to

Adorno's thought, since that shows that the depth of those contours is not dependent on the idiosyncratic features of Adorno's philosophy.

My explicitly historical story begins in Chapter 1 with the divorce between philosophy and painting, concept and intuition, in the seventeenth century in a speculative contrast between Descartes's dissolution of the sensible world into a mathematical one and Pieter de Hooch's reconfiguration of Dutch realism (which is here construed as a forerunner of modernism in its attempt to forge a perceptual world irreducible to ideas about it). In the following chapter, Kant's aesthetic theory is offered as the conflicted model of the link between aesthetics and nature; a conflict that is then traced—as my critical narrative kicks in—in the modernist aesthetics of Clement Greenberg, Cavell (Chapter 3), Michael Fried's Greenbergian formalism (Chapter 4) and T. J. Clark's Greenbergian radicalism (Chapters 5 and 6). The goal of these chapters is to inflect the model of Greenberg's aesthetic modernism, which has served as the paradigm defense of painterly modernism in the Anglo-American world, in an Adornoian direction. So Chaim Soutine's adherence to paint-stuff performs a standing rebuke to Greenberg's self-loathing formalism, while the history of modernity hounding modernism from without, which is so painful in Soutine, reveals that the categorial abyss separating the modernist art Fried prizes cannot be realistically distinguished from the theatrical, minimalist art he despises; T. J. Clark's political diagnosis of the limits of modernism, even if correct, is too bound to the fantasy of a different kind of art for a different kind of social world to capture the epistemological achievements and rationality potential of modernism: its materialism, its defense of contingency, its abiding with the fragmentary. The next three chapters track the post-Greenberg, edgy, and ambivalent modern/postmodern contesting of modernism in the critical theories of, first, Thierry de Duve, and then Arthur Danto, Yves-Alain Bois, and by implication, in the art of Cindy Sherman.[11] De Duve's nominalism, finally, can make nothing of either the dynamic history of modernism or its binding itself to the demands of the medium, while Bois's defense of the arbitrariness of sign in the understanding of modernism makes his defense of Robert Ryman as "the last modernist" almost contradictory—again the submergence of the demands of the medium, which are everywhere in Ryman, are left unnecessarily and unintelligibly exposed. In my opening chapter I contend that realism is not primarily a matter of making likenesses of the world but a complex matter of

the *fitness* of the wholly human powers of art in relation to a particular, wholly human, and secular social world. The lack of fit that makes modernism necessary thus relates to the failure of the world to be fully habitable by beings like ourselves. Modernism as the forsaking of realism is hence the record of the sorrow of the world, its lack of human worldliness. Only this explains why modernism must be an art of failure, a painting in the absence of painting.

The weaving together of the philosophical, historical, and critical strands of the claim of Adorno's philosophical modernism should, ideally, enable its reception in the already well-formed debate about painterly modernism; equally, and perhaps even more important, it should enable a reception that is not narrowly tied to the development of Critical Theory, and hence exposes it to the interests of a wider and very different audience. Such, at least, was the task I set for myself from the moment the idea for this book first emerged.

Of course, the philosophical and critical portions of my argument would have little weight if they did not directly say something about modernist painting itself. Not being an art historian or a critic by training, I am ill-equipped to compose my own history of modernist painting. But the model of my first encounter with T. J. Clark, an encounter I extended in "Social Signs and Natural Bodies: On T. J. Clark's *Farewell to an Idea: Episodes from a History of Modernism*," has proved efficacious. Rather than directly providing a reading of modernist painting, I forward the analysis and meaning of Adorno's modernism indirectly by engaging with those accounts of modernism that have proved to be the most challenging and telling in recent debates. Apart from the two essays on Clark, there are the essays on Fried, de Duve, Danto, and Bois.[12] Although Greenberg crops up in a variety of places, my most direct encounter with his thought occurs in "Judging Life," where I take issue with his interpretation of Chaim Soutine. My essay on Cindy Sherman's photographs should have managed an encounter with the writings of Rosalind Krauss and Hal Foster, but Sherman proved so demanding on her own that working out my differences with Krauss and Forster fell away. Indeed my encounter with Sherman was long, drawn out, and distinctive, since making sense of her works forced upon me a radical rethinking of my understanding of Adorno. In ways I have yet to fully digest, her pictures demanded that a family of concepts I had previously ignored or marginalized—life, death, death-in-life, decay,

organism, animality, animism, and suffering, which in turn led to further thoughts about art and melancholy—became central. What these notions help give precision to is the notion of the invisible within the visible that is not itself reducible to the concept, but needful of it—as well as, and more demandingly, the uncanny liveliness of works that are, finally, composed of dead matter, and hence the intolerableness of their rebuke: they screen us from the mortification that their urgency (their sublimity, if you wish) exposes. The mark of that transformation is evident in "Judging Life," "Readymades, Monochromes, Etc.," and "Freedom from Nature?"[13] I have always interpreted Svetlana Alpers's *The Art of Describing: Dutch Art in the Seventeenth Century* as a defense of modernist painting avant la lettre, explicating how modern art could secure for itself autonomy from the Italian model with its hierarchical structure in which ideal (read: concept) orders descriptive content (read: intuition). "Wax, Brick, and Bread" attempts to inflect Alpers's account more explicitly in that modernist direction under the impact of the paintings of Pieter de Hooch. My limning of "Cavell's Modernism," in which the sculptures of Anthony Caro play a pivotal role, forms a bridge between Kantian aesthetics, of which Cavell proffers a distinctly modernist reading, and Fried's thought, which is deeply informed by Cavell's take on Wittgenstein and ordinary-language philosophy as well as Greenberg's formalism.

Hence, although I offer nothing like a deep art-historical accounting, in each chapter I do attempt to engage with the relevant works, to offer recountings of them that bear directly on the conceptual issues at stake, and hence to sustain a fully internal relation between our experience and understanding of works and the theories that attempt to explicate the nature and meaning of their claiming. My difference in approach from traditional art theory and criticism is basic: what requires explanation is not, primarily, the meaning of works, but their capacity for *claiming*, for demanding or requiring acknowledgment and assent, and so, by extension, that they are objects we care about, and possess, in ways that remain almost unintelligible, a form of authority. I presume that works of art and aesthetic experience are puzzling, even insufferable, since, at a material level, they hardly seem worthy of the attention invested in them. In this respect, each essay in this work is haunted by a skeptical anxiety, an inner voice contending that painted expanses of canvas cannot conceivably deserve our involvement and engagement. In this respect, it is the voice of the skeptic and philistine

in each of us that is the real object of my analysis. In this setting, interpretation matters only to the degree to which it aids in explaining the normative force of works, that they do lodge a claim that requires heeding.

Routinely, the retrospective accounting for the normative force of a work or body of works diverges from the intentions and ambitions of their makers. That this is a routine occurrence in modernism is to be understood as a consequence of the fact that the setting for the enterprise as a whole, painting's salvaging of sensory significance in the context of its hounded autonomy, did not and does not uniformly and insistently impose itself on the *immediate* conditions of artistic production, exhibition, and interpretation. Autonomy and the kind of dynamic history it precipitated entailed that the immediate conditions determining art practices inevitably were contemporary practices, accomplishments, claims, and events. It became the task of the critic, the task that Greenberg's criticism exemplifies, to connect the indirect pressure of the general setting (rationalized modernity) to particular works and artists. Ignoring the weight and significance of the general setting in relation to the internal development of the practice with its immediate demands is the core of my criticism of Fried; conversely, I contend that T. J. Clark's method of analysis attempts to transform the indirect pressures of rationalization into immediate sociopolitical pressures (the valences of class) that can have readable consequences on painterly practice. The historical pressures of modernity, its hounding, are too remote, too insignificant in Fried's modernism, and too close, too intimate in Clark's—or so I argue. So some central works of de Hooch, Soutine, Caro, Ryman, and Jackson Pollock, along with Sherman, are given extended treatment, while there are a variety of lesser engagements with Jan Vermeer, Frank Stella, Louise Bourgeois, Joseph Cornell, Willem de Kooning, and others.

Doubtless the most exorbitant line of argument in this text relates to the notion of artistic mediums as stand-ins or plenipotentiaries for nature as a source or condition of meaning (intuition is, in part, the epistemological name for material nature); and it is just this notion of medium that is hounded out of aesthetics and eventually art by the reigning concept of the concept, the concept cut loose from its moorings in materiality and sensible experience, the abstract concept whose appearances include the increasing dominance of technological reason and rationality. In writing not included here, I have elaborated the emergence of this claim in eighteenth-

century aesthetic theory; in the writings of Gotthold Lessing, Schiller, and Friedrich Schlegel is adumbrated the whole trajectory of art from modernism to postmodernism, with each moment in that development scored by the hounding of art that I contend is a central feature of modern art.[14] By locating that hounding in the ur-history of modern and postmodern aesthetic theory, I intend to underline modernism's perpetual lateness, how painting in the absence of painting was urged on autonomous art even before Manet.

Equally, just how urgent and contemporary is this conception of artistic mediums was brought home to me when I read an essay by Michael Newman on the work of Tacita Dean. Newman begins by elegantly limning the notion of medium as it stretches from traditional to contemporary art.

The mediums of art are concretions of time. Such concretion takes a different form in each medium and in each work. Paintings and sculptures delay, condense and spread out time in their own way. So do photographs, films, and videos. Each medium and each work posits a distinct relation between past, present and future. The photograph re-presents the past as present in the trace of its absence. Film presents a record of the past's passing which is recreated in the present. Video acts as a real-time flowing correlate of the past as present.[15]

Newman goes on to sketch some of the dialectic between media (as technologies) and mediums (as complex apparatuses enabling particular artistic possibilities), how transformations in the former engender the possibility of transformations in the latter; and how even here Benjamin's notion that the "redemptive possibility of a technological form is glimpsed at the moment of its obsolescence" operates.[16] This whole account, however, is put in place in order to set up the darker question that he thinks the work of Tacita Dean confronts. The question that requires attention is not, or is no longer, how to distinguish one medium from another or how to explicate the different uses of a medium that is provided by a particular state of technological development, but rather "*whether a medium as such is even possible* in the context of the technological transformation—specifically the digitalization of media as a whole.*"*[17] Newman then offers a long passage from the opening pages of Friedrich Kettler's *Gramophone, Film, Typewriter* that argues that the "general digitalization of channels and information erases the differences among individual media" since those differences, voice and text, sound and image, are reduced to surface effects of the digital codes, the numbers, encoding them.[18] Digitalization does for media what the Carte-

sian reduction of the piece of wax did for nature in general: it reduces material form into abstract numbers. Once this occurs, then in principle any medium can be translated into any other. The idea of a total media link on a digital base will hence "erase the very concept of medium." Digitalization thus represents the apotheosis of concepts without intuitions.

This is not the place to either evaluate Kettler's and Newman's claims about digitalization or interrogate how Tacita Dean's works raise and engage this issue, what the chances are for artistic resistance. It is enough that a prima facie claim for the existence of this collapse in this form should suddenly loom so compulsively on the artistic horizon.[19] I am broaching the issue of digitalization and the looming erasure of the very idea of artistic mediums here in order to bring into focus how what appears to be the most pressing question confronting contemporary art, the very possibility of the continuing existence of art in a form continuous with its past, whether art still exists and has a right to exist, in order to cast an appropriate spotlight on the art and aesthetics of the recent past. If I am right about eighteenth-century aesthetics and about the suppressed meaning of modernism, the question of autonomous art has been from the outset the question of mediums, and the fate of the claim of art bound up with the possibility of their being artistic mediums at all. But this is just to say that our capacity for recognizing and analyzing the present danger is dependent on our understanding of modern aesthetics and artistic modernism. Fugitively, too late, always too late, modernist art flagged the danger, flagged that its obsession with pigment and color, line and shape, flatness and the delimitation of flatness, were conditions of possibility for sensuous encounter in a world without experience. But neither modernism itself nor modern aesthetics has always been clear about this; on the contrary, even within modernist art and aesthetics the forces of disintegration have been continuously active. This is what Adorno knew; maybe it is everything and all he knew, which at certain moments and for certain audiences appeared wildly too little, too narrow, too panicky and obsessed. Our present makes Adorno's maddening bias suddenly appear prescient, a correct envisioning of the stakes and meaning of modernism. The consequent wager I offer is that because modernism was always late, then perhaps yet there is a possibility.

Although designed as a broadly continuous and developing argument, as harbinger of a theory of modernism and polemic about its recent fate, the separate chapters of this book originally appeared, often in different,

and briefer, form than they appear here, as separate essays intended for different audiences. For the sake of texture and readability, and because each chapter attempts to mount a distinct argument, it seemed wise to leave each chapter in something like its original essay (or lecture) format. This means there is some repetition of key ideas, which I hope will be found productive for comprehension rather than an irritant.[20]

1

Wax, Brick, and Bread—Apotheoses of Matter and Meaning in Seventeenth-Century Philosophy and Painting: Descartes and Pieter de Hooch

I suppose it is correct to say that the Enlightenment was a motley, a variety of overlapping, diverging, crisscrossing trends. Historians are good at gathering and replaying such complexities. Philosophers, on the other hand, are, for all their abstruseness, simplifiers. And what I want to offer in this chapter is a wild simplification, a way of thinking about the meaning of the Enlightenment through the consideration of two images: a piece of wax and some bricks, a brick wall really. My thought is this: each of these two images, wax and brick, embodies and thereby provides or projects an account of the meaning of enlightenment; hence each image pictures a utopian moment that can be thought of as constitutive of the very idea of enlightenment; but, and here is the rub, these two images stand in radical opposition to each other. Hence what we are given through the two images, wax and brick, are two enlightenments, the one we have actually had, enjoyed, and suffered, and another enlightenment that has been lost almost from the moment of its appearance, that indeed has never been more than a painted image. Since precision is not part of this story, it is nice to know that each image is precisely datable: the piece of wax is from 1641, and the brick wall from 1658.

Wax

Most of you will have already guessed the provenance of my piece of wax: those great paragraphs that conclude the Second of Descartes's *Meditations*

on First Philosophy. I still find this one of the strangest, most disturbing, and most breathtaking moments in all of Western thought. Let me remind you how this story goes. At this juncture in his account Descartes has already shown how even the most radical doubt—say, that some evil demon is trying to deceive me at every turn—can be terminated by the knowledge, the certainty, given through the *cogito ergo sum*. I can never doubt that I exist since the very act of doubting presupposes that I exist. In the midst of doubting I necessarily affirm my existence and so myself. Knowing that I exist in this way, Descartes argues, I also know that I am a thinking thing. That too is indubitable. Nonetheless, Descartes worries that he is tempted by the common-sense thought that "corporeal things," physical objects, are more clearly known than one's own mind (153).[1] In order to test this idea he suggests we consider "the commonest matters, those which we believe to be the most distinctly comprehended, to wit, the bodies which we touch and see; not indeed bodies in general, for these general ideas are usually a little more confused, but let us consider one body in particular. Let us take, for example, this piece of wax: it is fresh from the honeycomb so it retains the taste of honey, the smell of the flowers from which it was gathered; its color, shape and size are manifest. It is hard and cold to the touch, gives out a sound when rapped with my knuckle" (154). Now, Descartes says, I will put the piece of wax by the fire: it loses the remains of its flavor, the fragrance evaporates, the color changes, the shape is lost, the size increases, it becomes fluid and hot, it can hardly be handled, it no longer gives out a sound if you rap it. Is this the *same* piece of wax? Of course it must be: no other piece of wax or anything else has come to replace it. Yet its look, feel, taste, smell, and sound have all either changed utterly or even disappeared. Every sensible feature of the piece of wax—"the sweetness of the honey, . . . the agreeable scent of flowers, that particular whiteness"—has altered. How can it be the same? "Abstracting from all that does not truly belong to the piece of wax, let us see what remains. Certainly nothing remains excepting a certain extended thing which is flexible and movable" (154). Having rid the piece of wax of all its sensible features, or rather delegitimated those features of their authority as constitutive of the identity of the piece of wax and hence delegitimated sensory awareness of its authority as being capable of grasping the object, Descartes inquires into what we might mean by thinking of the wax as flexible and movable—ideas that may be capturable by the imagination. But not only cannot the

piece of wax be known through the senses; it also cannot be imagined, since flexibility involves an "infinitude of changes," which is to say more changes than I could ever imagine: "I should not conceive clearly according to truth what wax is, if I did not think that even this piece that we are considering is capable of receiving more variations in extension than I have ever imagined" (155). With this in place, Descartes can now move to his conclusion: "We must then grant that I could not even understand through the imagination what this piece of wax is, and that it is my mind alone which perceives it."

Let me say immediately that some of the great power and magic of this passage actually stems from a misreading of it, and that it is the misreading and the actual argument together that have made the image of the piece of wax almost an emblem of enlightened thought. The misreading is quite natural since it tracks the apparent disappearance of the sensible piece of wax after its ordeal by fire. It is as if the actual fire and the fire of the mind had, together, truly purged the wax of all it sensory properties, such that the piece of wax known by the senses could disappear altogether in order to be replaced by its purely intellectual counterpart. Thus the only properties essential to the piece of wax are that it is something that fills space and can take on an infinite number of shapes. But this is just to say that what belongs to the wax essentially are just those features of it that are quantifiable, and hence those properties that make the only true knowing of the piece of wax the knowledge given of it by mathematical physics. For Descartes, true knowledge of the wax is given not by the senses or imagination but by mental perception alone. Before our eyes, so to speak, the sensuous piece of wax, with its delirium of taste and aroma and feel and look, has disappeared and been replaced by an "object" whose true nature is to be expressed in a series of equations and formulas.

In fact, this is not quite what Descartes is arguing; it is only in the *Fifth Meditation*, if anywhere, that he argues for the essence of matter being extension and hence for the ideal of a science of nature based on geometry. The argument of the *Second Meditation* is more modest. It starts from the belief that our *conception* of wax is derived from the senses—that is, we conceive of wax as something the senses reveal as hard, white, and sweetly scented, etc. When all those sensible features change, it follows that our conception of the piece of wax cannot have rested on them since we are still conceiving the same piece of wax. Indeed, it is part of our ordinary

conception of the piece of wax that it can change in an infinite number of ways and yet remain the same piece of wax. It might even change so radically that it would stop being a piece of wax. But this is just to say that our ordinary conception of the piece of wax goes beyond information provided by the senses or the imagination. *My everyday conception* of the piece of wax draws on, and is a work of, the understanding rather than the senses. Hence the common-sense belief that the material bodies we touch and see are better known than our own minds is false: what we know of bodies belongs strictly to the mind itself, apart from the senses and imagination.[2] Of course, Descartes could not conclude that the mind is better known than bodies without fully anticipating the argument that the essence of material objects is solely their mathematical properties, something that Descartes states with his usual vividness: "But when I distinguish the wax from its external forms, and when, just as if I had unclothed it, I consider it quite naked, it is certain that although some error may still be found in my judgment, I can nevertheless not perceive it thus without a human mind" (156). The image of the material world as merely clothed in sensory images, and that when unclothed quite naked, revealing a perfect intellectual form without sensory residue, is still startling. It is hard not to think of the fire that burns away the sensory as the fire of the intellect, and that fire of course as the purifying fire of enlightenment itself.

That course of argument in Descartes covers just six paragraphs; but in those six paragraphs the visible world of things known through the senses disappears and we are left with the refinements of mathematical knowing—the things themselves becoming somehow insensible. The truth of the visible world is the invisible world of insensible particles described wholly in mathematical terms. There are endless variations on this frightening and exhilarating moment in Descartes, from Galileo to Eddington's two tables. But there is something exemplary about the piece of wax: having the familiar world of the senses first liquefy and then disappear into mathematical knowing is a fable for the fate of things in the modern world, and by extension a fable of modernity itself with which we have yet to get on level terms. The account of the piece of wax can have this power, because, by continuing the abstractive process and achievement of methodical doubt, it leads to a radical undermining of the authority of the senses, not merely in terms of their overall accuracy or veridicality or sufficiency, but as properly cognitive mediums with objects corresponding to them. Delegitimating sensory

knowledge takes with it the sensible world. It is not too much of a stretch to see the abstraction from particularity and sensory givenness as the abstractive device of modern forms of social reproduction: the subsuming of the use values of particular goods beneath the exchange value of monetary worth, or the domination of intersubjective practices by norms of instrumental reason that yield the rationalization or bureaucratization of our dominant institutions. Somehow the advance of the modern world, its enlightenment, is the advance of the process of abstraction and the domination of the qualitative by the quantitative. This of course is both a utopia and a nightmare.

What makes Descartes's dissolution of the sensible world even more disturbing is that in the very next decade the attempt was made to offer to the material world of the senses an authenticity, and so an authority, beyond anything previously achieved. It was an attempt to transform the material world from a forever surpassed vehicle for spiritual—ultimately, "other" worldly—activity and meaning into the perfected corollary of being ourselves wholly embodied, sensuous, and finite beings. In putting the matter this way I am suggesting that what happened in the following decade, in 1658, was the emergence, however briefly, of a "naturalism" or even "materialism" different from the naturalism or materialism we associate with the scientific revolution of the seventeenth century and its triumphal procession into the present.

Brick

My candidate for the author of an enlightenment "other" than the Cartesian one is the Dutch artist Pieter de Hooch.[3] In 1658 in Delft, de Hooch began painting canvases of ordinary life, which gave to the visible, tangible experiences of everydayness a solidity, dignity, authority, and self-sufficiency that has found no equal. Whatever else is occurring in these canvases—which is to say, however else we might read and interpret these pictures—the dominant experience they render is of a material world suddenly "there" with a density and solidity not in themselves imaginable, and by extension, a vindication of a wholly secular world that requires nothing outside itself for its completion. To put the same thought another way, I want to see these paintings as themselves a form of claiming, a way of rendering the sensible world of everyday experience such that it can be seen *as* self-

sufficient and complete, hence fully worthy of our investment in it. What de Hooch offers is everydayness raised to the level of the monumental, a sublime everydayness that in being sublime in this way images a life for finite creatures that does not call up any contrasting—infinite, otherworldly, heroic—values. Arguing this case is a complex matter since it involves, first, urging these paintings as forms of claiming that are considerable in their way every bit as much as a philosophical argument is considerable in its; second, transforming, or at least deepening, the standard reception of de Hooch; and hence, third, distinguishing de Hooch's accomplishment from that of Vermeer. That Vermeer is the greater painter I will not dispute; but the similarity of their paintings in the period between 1658 and 1660 may lead one to consider de Hooch simply the lesser artist rather than, as I shall suggest, falling upon for a short period of time a unique vision, one that simply disappears almost as soon as de Hooch moves from Delft to Amsterdam sometime in 1660. But I am getting ahead of myself.

Although suggesting that Pieter de Hooch rather than, say, Locke or Hume or even Rousseau provides the most profound challenge to the Cartesian version of enlightenment (the version that reaches its fulfillment in the thought of Kant) is, I confess, wild, it has a precise echo in debates inside art history. And these art-historical debates are not idle ones for the purposes of my argument because they concern the kind of intelligibility that Dutch art of the seventeenth century might possess. Attuning ourselves to these issues takes some effort because, I suspect, for most of us no art seems more readily accessible and self-evident in its claims than the realism of the Dutch school. Yet neither traditionally nor even now is the meaning of realism, its point and purpose, or its claims clear or uncontested. On the contrary. The easiest place to begin is the famous critique of the art of the Netherlands that Francisco de Hollanda attributes to none other than Michelangelo:

Flemish painting . . . will . . . please the devout better than any painting of Italy. It will appeal to women and nuns and to certain noblemen who have no sense of true harmony. In Flanders they paint with a view to external exactness or such things as may cheer you and of which you cannot speak ill, as for example saints and prophets. They paint stuffs and masonry, the green grass of the fields, the shadow of the trees, and rivers and bridges, which they call landscapes, with many figures on this side and many figures on that. And all this, though it pleases some persons, is done without reason or art, without symmetry or proportion, without skillful choice or boldness, and finally, without substance or vigour.[4]

Let this passage stand in for the broad Italian critique of Dutch realism. This critique has both a hermeneutical aspect and a connected if distinct normative, aesthetic aspect. The hermeneutical issue is there on the surface: what could be the meaning of an art that seems content to merely describe what it sees, that gives itself over to a world presumed to exist prior to and independently of its rendering in paint? What is the point of realism? Can realism have a point, or is it not, despite its technical accomplishment, pointless and empty, a mere collecting of particulars as if the heaping up of these by itself could be meaningful? The connected aesthetic challenge, lodged most fiercely by E. H. Gombrich, follows on directly: We can understand the nonclassical ideals of Dutch art *only* from within the frame of the "objective core of the classical ideal."[5] In accordance with Gombrich's view, there is only one core Italian aesthetic norm for modern European art in which the claims of *order* on the one hand, and *fidelity to nature* on the other, are competing axes of orientation that must be somehow reconciled. The ideal solution to the demands of the competing axes is the "classic solution," and it is that which the great art of the Italian Renaissance represents.[6] What is thus denied by Gombrich is that there could be a nonclassical aesthetic, at least for us. For Gombrich, fidelity to nature is only ever *intelligible* as an axis in relation to the competing claims of nonmaterial order. The competing axes constitute the possibility of painting, and the "classic solution," which is thus "a technical rather than a psychological achievement," represents all that painting, in principle, could hope for itself; the classic solution might be repeated, but cannot be improved upon: "Deviation on the one side would threaten the correctness of design, on the other the feeling of order."[7]

One bold response to this critical charge is to deny that Dutch realism flouts the norms and expectations of the classical model. Rather, the argument goes, Dutch paintings were intended to delight and instruct, with the descriptive delight being the lure through which the predominantly moral instruction was to occur, the moral instruction occurring through disguised symbolism.[8] The making out of this claim would inevitably be complex since it would have to traverse the full range of realist art: landscape, still life, portraiture, domestic scenes, and the rest. Nonetheless, one thread of this view bears directly on de Hooch. Nearly a third of all de Hooch's works are of domestic scenes containing women and children without husbands and fathers. While there were some anticipations of this before de Hooch,

in particular by Gerard Dou, there can be no doubt that he exploited and developed it in a unique manner. At one level this subject matter may be thought unsurprising, since in the seventeenth century we witness the first blossoming of the nuclear family as the primary social unit. This blossoming included both the raising up of the significance of marriage and the acknowledgment or invention of childhood as an autonomous stage possessing its own needs and joys. Simultaneous with the emergence of the nuclear family there appeared a deluge of heavily illustrated domestic conduct books, the most famous of which was *Houwelyck* (1625) by Jacob Cats; it is claimed that by mid-century there were over 50,000 copies of this book in circulation, and that every middle-class Dutch home would have its copy of Father Cats's book of manners propped up next to the family bible. If one is tempted to try and squeeze Dutch realism into the pattern of Italian narrative art, then the parallel phenomenon of Cats's book of conduct and the sudden emergence of paintings of domestic scenes becomes irresistible. We find Peter Sutton, the foremost commentator on de Hooch, staking himself to this iconological interpretation of the paintings, contending that the "representation of order and cleanliness is one source of the special beauty of de Hooch's paintings."[9] Exactly how the representation of bourgeois order and cleanliness is a source of beauty is, to me, deeply puzzling; what intelligibility the thought has derives from the force of its opposite proposition, namely, that we are not initially or unproblematically attracted to scenes of filth and disorder. Worse for Sutton, if we look closely, dirt and disorder are not a priori excluded from de Hooch's world.

Without question the most influential book on Dutch art opposing the twin furies of Italian hermeneutics and aesthetics is Svetlana Alpers's *The Art of Describing: Dutch Art in the Seventeenth Century*; this work is clearly intended as a response to Gombrich, who was Alpers's teacher.[10] Although, as will become evident, my claims for de Hooch's Delft paintings stand slightly apart from Alpers's, it would not be wrong to say that my reading of de Hooch is a part of the attempt to construe Dutch art as an autonomous development with protocols not reducible to those of the south. Very quickly and baldly, Alpers attempts to demonstrate that Dutch art belongs to a wider set of cultural assumptions that are simply incommensurable with those of the Italian south. Alpers pointedly offers a passage of Panofsky's on Jan van Eyck that becomes, I think, the driving force of her reconstruction:

Jan van Eyck's eye operates as a microscope and as a telescope at the same time . . . so that the beholder is compelled to oscillate between a position reasonably far from the picture and many positions very close to it. . . . However, such perfection had to be bought at a price. Neither microscope nor telescope is a good instrument with which to observe human emotion . . . the emphasis is on quiet existence rather than action. . . . Measured by ordinary standards the world of the mature Jan van Eyck is static.[11]

Alpers urges that the "ordinary standards" invoked here are none other than the expectations of narrative action created by Italian art. Once the presumptions of those standards are put aside, then the analogy between painting on the one hand, and microscopes and telescopes on the other, becomes not only apt, but also a kind of hermeneutical key to the project of much Dutch painting. Painting is a craft that means to interrogate the world in a manner analogous to how a microscope can be used to investigate the world. "[N]orthern images," Alpers states, "do not disguise meaning or hide it beneath the surface but rather show that meaning by its very nature is lodged in what the eye can take in—however descriptive that might be."[12] In order to make her case, Alpers proceeds circumstantially, by placing Dutch art within the wider frame of a Dutch culture in which there were whole ranges of images, including those seen through microscopes and telescopes, whose purport could be understood as purely descriptive. On this account, picturing becomes a way or mode of seeing rather than a visualization of it; picturing might be thought of as a kind of "attentive viewing" whose aim is to reveal the individual case in its individuality rather than its belonging within or exemplifying some higher ideal.[13] If this sounds familiar, almost English, it should, because part of the cultural setting for realist painting is Dutch Baconianism, which, with its extraordinary trust in the attentive eye, sought to remove illusions, idols, through the effort of careful and sustained observation. Only within a Baconian context with its privileging of identity (individuality) over resemblance (ideality), Alpers claims, can we make sense of why the Dutch pictorial tradition gave so much weight to portraiture.

Although the embedding of realism within Baconianism is just one element of Alpers's account, it is the governing element. The problem with the analogy is that it is not clear how much of a favor to art it is. Here is Alpers becoming nervous over the status of her analogical creation:

The Baconian program suggests that the artist's own craft . . . was itself considered at the time to constitute a significant form of acquiring knowledge. The distinc-

tion between the two forms of knowledge parallels the distinction between the two modes of seventeenth-century scientific thought.... As I suggested at the conclusion of my introductory discussion ... the nonmathematical, observational bias of the Baconian project, with its lack of ancient precedent, corresponds to the model of Dutch art; the mathematical, less empirical, and ancient bias of the classical sciences fits Italian art. The comparison between a science based on observation and one based on mathematics, like the comparison between the art of the north and that of the south, has not been treated as a comparison of equals. A sense of the inferiority of observation and experiment has persisted.[14]

Alpers's intention is to dignify Dutch realism by making it a legitimate branch of Baconian empirical inquiry. But this becomes something of a poisoned chalice if, as Alpers herself begins to suspect, Baconian science has itself become for us a delegitimated form of acquiring knowledge. Once the mathematical sciences underlined their reliance on experiment, verification, and careful observation *within* their overall practice, the primitive observational orientation of the Baconians could drop away as so much dross. Observation does not make for science. If science is used as the guiding thread, then Descartes and by inference Italian art win. But if that is the case, then in a way we are back at the beginning trying to make sense of images too detailed and static for narrative purposes, pictures full of many small things that emphasize their surface color and texture rather than their place in legible space, images often unframed with no clearly situated position for the viewer and yet, despite all these divergences from the Italian norm, somehow strangely compelling. What might explain the power of compulsion here if it is neither hidden symbolism nor Baconian empirical observation? The problem with Alpers's analogy and assimilation is, I suggest, that it goes in the wrong direction. Rather than claim that Dutch art is an unrecognized form or an extension of observational science, we might try the thesis that Dutch art, painting, is a mode of viewing (encountering and responding to) reality that is *not* further translatable into science, hence that it is art or painting that is a *model* for knowing that expresses, if anything does, what was meant (desired and hoped for) by "observation." Realist painting must be seen as legitimating the hope of Baconian science, rather than Baconian science being the grounds for legitimating Dutch painting. Hence it is not a matter of waiting for the philosophers and historians of science to render a verdict on Baconianism; instead we might vindicate Dutch realist painting as, in certain moments, an achievement of "obser-

vation," as offering another telling of the world as a wholly secular, finite, material place. In putting the matter this way I raise the stakes enormously, since I am claiming that a necessary condition for finding in Dutch art an alternative to Italian aesthetics is that it be able to issue at the same time a challenge to the claims of Cartesian enlightenment. And this is necessary because, as things stand, Cartesian enlightenment, the ideal of rendering the material world transparent through its reduction to number, possesses a hegemony over the normative ideals open to us, what we can and cannot affirm or know.

I am not, at least here, likely to be able to convince you that painting can bear the kind of weight I am attributing to it, of being a material practice of meaning-giving that is not only or merely an enclosed, autonomous practice but a defused or displaced mode of rendering or encountering the world. Although putting the challenge this way, reminding ourselves of how deeply *puzzling* the actuality of painting is, both the evident consistencies of a practice of material inscription and the continuing enigma of the aboutness of that practice, should underline that there is an unsettled score between art and science that recent debates about postmodernism have led us to simply forget. Postmodernism is the concession that art lost the argument. For the purposes at hand, however, it is enough if we acknowledge the overlap or convergence of the norms of Italian art with their insistence on transcendent ideals of order, and so meaning, on the one hand, and the ideals of Cartesian enlightenment on the other, with its purging of sensory encounter of any authority and its insistence on the privilege of the ideal, mathematical object over its empirical—material and sensory—counterpart. Once that is granted, then clearing a space for Dutch realism as something other than a mere deviation from the Italian model entails, at least, the existence of a potential rival to the Cartesian enlightenment. Hence, whatever my disagreements, I agree with Alpers about the stakes of Dutch realism and the currents it swims in; seventeenth-century Dutch realism is —ironically given its utter celebration of the bourgeois form of life—the leading edge of the critique of rationalized modernity.

Nothing prepares us for 1658. Certainly nothing in de Hooch's own painting.[15] Before 1658, de Hooch produced mostly in the genre of guardroom painting, paintings of soldiers bivouacked in stables and inns, chatting, drinking, playing cards. For the most part these are dimly lit scenes that use a muted palette of browns and oranges, in which space is defined

by the anecdotal relation of the figures; what lies behind them is merely backdrop, not itself spatial. It is hard to think of the paintings of 1658 as coming from the same artist. What is striking in them is a convergence between technical achievement and the emergence of new content. This overlap is not, of course, consistent, but itself a moment within a more uneven development. In several of the canvases of 1658 de Hooch continues to use the genre of the "merry" or "elegant" company, only these have now moved from stables and inns to apparently bourgeois interiors and courtyards. Some of de Hooch's technical innovation is palpable in *Card Players*, in which the anecdotal action of four figures gathered around a table is overwhelmed by the movement of space and light: the space, initially defined by continuously receding black-and-white square floor tiles, extends out through an open doorway into a courtyard and then beyond into a dark passageway; in opposition to this receding space, light *floods forward* toward us through the doorway and the ceiling-high window framing the players. It is as if the movement of recession and the glare of the sunlight, especially on the door (turning its wood-brown to near white) and on the tiles in the doorway (accented by the consequent darkness of the back wall), had become themes in their own right, almost displacing the now backlit and hence depersonalized figures—they have become things of shadow and light.[16] Even with the evident action—the drinking, smoking, and smiling, the concentration of the female card player—there is about this image something indeed static; might we say "still and quiet"? The stilling of the scene, its de-narrativization, is a work of space and light. And what are we to make of the moving of this scene into what can only be a middle-class interior? If the card playing, the drinking and smoking, and the litter on the floor hint at deviance, the bathing of the scene in sunlight, its quietness, and its whitewashed and tiled setting purify it, giving to the pleasures it pictures an innocence impossible in the earlier guardroom versions.[17] As will become evident directly, the alternation of inside and outside space, and the employment of multiple light sources, are significant de Hoochian signatures.

The second grand innovation in the de Hoochian moment concerns subject matter: we are suddenly offered scene after scene of women and children in either a domestic interior or a courtyard. In order to appreciate this moment, it is important to place it historically. As Elizabeth Alice Honig has convincingly argued, the role of women in Dutch painting

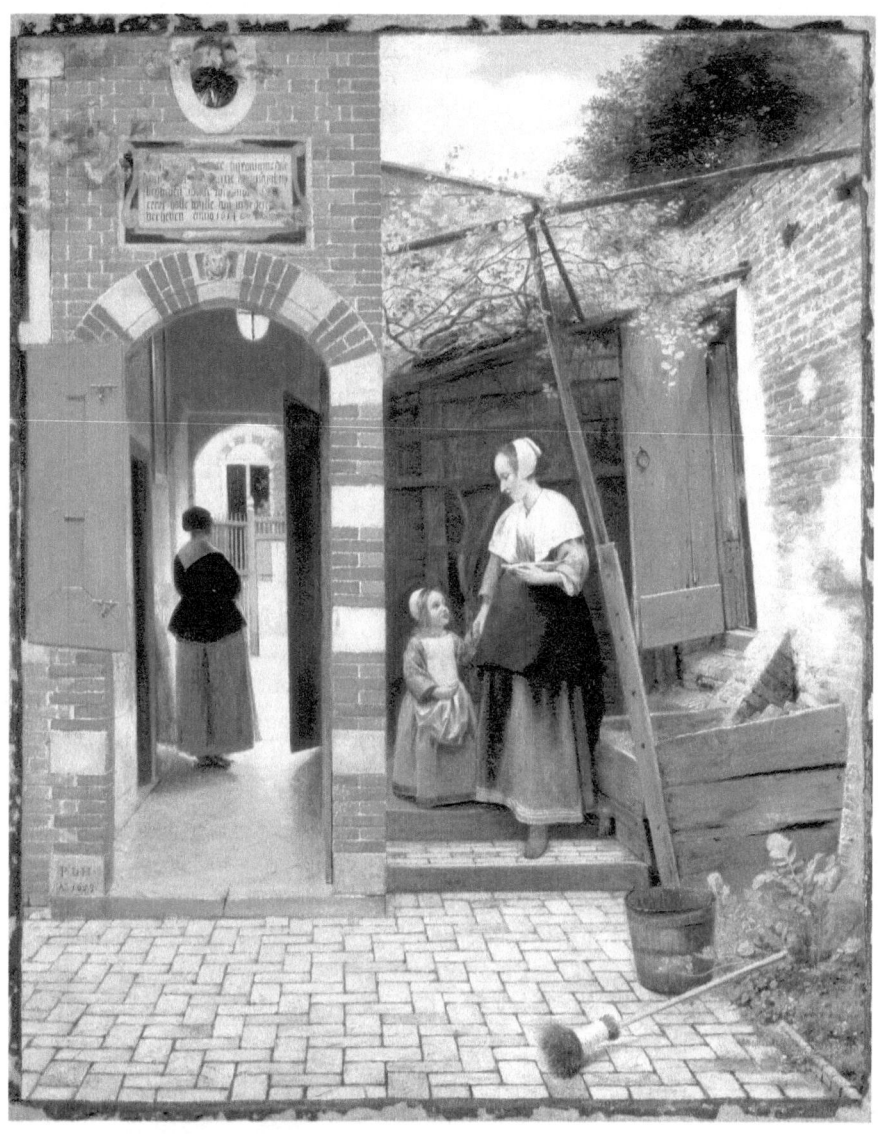

1 Pieter de Hooch, (1629–1681). *Courtyard in a German House.* National Gallery, London, Great Britain. Photo credit: Alinari / Art Resource, NY.

needs to be keyed to the Dutch art market.[18] Dutch art was for the most part not a public art, but an art intended to decorate the walls of the wealthy and the middle classes. But the interiors to be decorated were increasingly defined by women as *their* space, one ideally distinct from the rapacious world of capital and manufacture outside. Thus it seems correct to say that Dutch painting was an art "made to be viewed within a sphere increasingly defined as 'feminine.' The anticipated beholder of this art must have been female at least as often as male, and the very act of beholding was a private, domestic one."[19] But if this is right, then two consequences immediately follow. First, it makes sense to think that women were actively involved in deciding which works were to hang on the family walls; and thus, second, it makes sense to begin thinking of these paintings as works not simply to be seen by women, but to *appeal* to women, to their ideals, gazes, tastes.[20] Honig's trenchant claim here is thus that the combination of the social placement of art in the home with the consequent role of women as audience for and purchaser of art enables something like a *female gaze* to emerge from its space of otherness (goddess or whore), from its formation by the male gaze into something in its own right.

This is thematic in de Hooch. In *A Woman with a Baby in Her Lap, and a Small Child* we are offered an image of great naturalness and intimacy: the mother quietly telling the sleeping infant on her lap about his(?) sister who, mimetically repeating the mother's embrace, is holding the family dog, which she is intending to show to her sibling. The "action" of the painting is meant to create a small, closed, feminine universe: the woman is pointing to her daughter while gazing at her baby, with the daughter too fixing her look on the infant. The surround of this universe: the whitewashed walls of the room with a small room behind it whose windows let in a light that, although bright, is indefinitely softened as it slips through curtains and along walls, becoming finally diffused as it descends into the embrace of the room below; the light too embraces. I am almost tempted to say that de Hooch makes the falling light and surrounding room objective correlatives of the holding and embrace enacted by mother and daughter: protecting their vulnerable, animal (which is to say finite and natural) others—baby and dog. Still, we know from the glare on the door (again nearly whitened) that the sun outside is bright, so bright that it bleaches to the point of near unrecognizability a portrait hanging on the wall of the small room; the portrait must be of the father of the house. The enclosing

space is generated by the exclusion of the male gaze; blinded by sunlight, he knows nothing of the world he naively believes he oversees.

To my eye the idea of a secular madonna, the closed world of women, children, and animals, is overreached and strained in a painting like *A Woman Nursing an Infant with a Child and a Dog*; while failing, the painting underlines the relative autonomy of the domestic universe that I am claiming is being constructed by de Hooch at this moment. By contrast, consider the relaxed and lovely *The Bedroom*, in which the movement is radically continuous from private to public, or better, from private interior to city and nature: it goes from the bedroom, where the mother stands before the recessed bed at the right of the picture, through the room to the doorway with the playing child holding the door handle, then out into an entrance hall or public room, and then out into the yard and beyond. The connection between inside and outside is felt to be porous, casual, immediate. In this case the use of the dual sources of light (through a door at the back and a window on the left of the painting)—with the breathtaking reflection of the sunlit window on the back left wall—perfectly complements the thematic opening or fulfilling of the private interior in the wider world beyond.

These paintings are certainly celebrations of domesticity. Yet I think it would be brutal and misguided to assimilate these paintings to any conceivable idea of modeling domestic conduct. It is not that such thoughts are impossible with respect to de Hooch—it is difficult not to consider *A Mother and Child with Its Head in Her Lap* as somehow connected to the virtue of cleanliness; instead, such readings miss everything that makes the painting compelling. Surely the image of the mother picking lice from her child's head, if that is what she is doing, says more about a kind of *intimacy* between mother and child, their absorbed activity so complete that while they "belong" in the space they inhabit, they and the space exclude any attempt to frame or employ that enclosure. To use their intimacy for the sake of warnings or prescriptions would, aesthetically, be a violation. But this is to suggest that "domesticity" is a charged and ambiguous concept in this setting.

We might consider de Hooch's courtyard paintings the perfect synthesis of his formal and substantial innovations. *Two Women and a Child in a Courtyard* must be an early go at this genre since space here is still flattened toward the picture plane and de Hooch's palette reminiscent of his guard-

room paintings. Nonetheless, what is striking is how this domestic activity (one woman washes linen in a wooden tub, her daughter watching; another woman draws water from a well) is framed by a cityscape, so that what occurs in the yard belongs intrinsically to the life of the city, or better *is* the city's life. Something even more emphatic is the finer *A Woman and Child in a Bleaching Ground*, which has a meticulously described crumbling brick wall "framing" the scene from the left.

In *Figures Drinking in a Courtyard*, on the right of the picture, in a recessed corner of the courtyard, we see two seated men and a woman standing next to them with a glass of wine in her hand. In the center of the painting, on the raised floor of the entrance to a passageway leading directly to the street, sits a young girl with a white puppy on her lap. I take de Hooch to be attempting here to merge the domestic theme (we are to assume that the child and dog belong to the woman) with the merry company genre. While there is something stilted and posed about this painting, it nonetheless appears to underline the connection between sociality and domesticity as joint emblems of nothing other than a self-sufficient secular world.

Ironically, that same courtyard reappears in what I consider to be de Hooch's finest painting, *A Courtyard in Delft with a Woman and Child* (Figure 1)—where in the recess, which is distinctly shabbier than in the previous painting, mother and daughter stand holding hands, gazing fixedly at one another. In this painting the courtyard really is a quiet, protective, and nurturing interior that has been moved outside. (One should notice that in de Hooch's Holland it is always summer.) Here, rather than glimpsing the exterior through a window or doorway, we see an exterior that is an interior, and then an interior passageway that leads into both the interior of the home (with the doorway on the left of the passageway) and out into the street; at the end of the passageway a woman with her back to us is looking ambiguously into the open street and the interior of the house across the way. The ambiguity or continuity between inside and outside is echoed in the makeshift character of a trellis supporting the vine from whose shadow mother and daughter are emerging. De Hooch's signature inside/outside movement is itself thematic since the interlocking character of interior and exterior, the composing of interior space through aerated sunlight is the self-sufficiency of these scenes, their sense of being complete, wanting in nothing. But for me, what gives this painting its bounded intensity is the

brickwork around the arch above the entrance of the passageway and, above all, in the wall on the right: the brick and mortar are precisely rendered, each patch of wall in a slightly different state of decay. Has anyone ever been as enamored of masonry as de Hooch? It is the fineness of those brick walls that gives to the scene its materiality, its earthiness, its firmness of place.

De Hooch's bricks are themselves correlatives of the thematic inside/outside structure. We see a range of brickwork: the brickwork around the archway is elegant and decorative, yet also clearly utilitarian; above is the brickwork of the house, solid and in good repair. Neither decorative elegance nor good repair can be ascribed to the right-hand wall: the bricks themselves are worn, the mortar crumbly, and toward the bottom serious lime leaching has occurred. If the bricks offer everything possible in the way of culture in aesthetic and utilitarian terms, they are nonetheless material stuff, bits of nature that have been worked up, *fired* to hardness, to create a wholly human and humane habitat, which, for all that, belong (as the crumbling and lime-leaching denote) intrinsically to finite nature.

This is an extraordinary and, as we shall see, fragile moment. De Hooch generates a conception of order, and thereby an aesthetic, that can provide an alternative to the Italian model. For the Italian model, and the classical solution, although "composition" and "fidelity to nature" represent different axes, the fidelity-to-nature axis has no independent or autonomous authority. Rather, and Gombrich is unabashed at this, fidelity to nature is merely the vehicle for presenting or representing rational order. Because rational order, classical norms, are ideals, then while there can be a competition about which ideals are most worthy of our allegiance, painting nonetheless lives off the "objective core of the classical ideal": "For all critics of the past both Beauty and Truth were acknowledged values. What Caravaggio was accused of . . . was to have sacrificed Beauty to Truth, while the academic tradition was attacked for sacrificing Truth to Beauty. The true accusation in both cases was perhaps that both sacrificed more of the rival value than was absolutely necessary to do justice to their supreme norm."[21] In making realist painting an analogue of a lens, telescope or microscope, Alpers plays into Gombrich's hands rather than resisting him. Resistance would require locating some specificity in *painting* itself that enables it to provide a different conception of order and ordering.

De Hooch can paint the world because the world depicted is the constant

crossing of nature as matter and order, and culture as matter and order. De Hooch's painterly materialism continually works to dissolve any permanent boundary between nature and culture, between subjective lives and the material conditions of those lives, without ever denying the difference between them. In this respect his formal innovations—aerated light opening up an emphatically spatial world in which what is interior and what is exterior alternate;[22] and thematic creations—the constellation of woman, child, animal, and domestic interior or courtyard as simultaneously private interiors and naturalized cityscapes—parallel and repeat one another. But the interlocking of formal innovation and thematic creation is precisely what yields a novel grammar that is painting's own. The constant reversibility, continuity, or exchange between nature and culture, or matter and form if you wish, entails *that order and its absence are everywhere*; hence there is no holding nature or disorder or matter or woman at bay, fending them off, transcending them, excluding them. On the contrary, natural order, say feminine procreativity or nature as perpetual summer, and disorder, nature as decay and death, are mirrored in the material order and decay of the human artifice. Hence the orderliness of de Hoochian realism can be paratactic, the accumulation of many small things, each with its own weight and gravity in relation to those contiguous with it, rather than hypotactic (order from the vantage point of the ideal), and that order can itself be *expressive*.[23] This, by the way, shows what is most profoundly wrong with Alpers's strategic assimilation of painting to observations, lenses, and mapping: it can make no sense of the intense expressive power of what is supposed to be likeness.

Dutch realism, if measured from the standpoint of de Hooch, is a *relishing* of the world, savoring and delighting in it without consuming it. It can do so because for a precious moment human ordering could consider itself both a *working on* nature, the production of the artifice of home and city, and simultaneously *part of* a wider nature. Although in *Two Women in a Courtyard* de Hooch beats this idea to death, once we catch on to the schema of his realist materialism, there can be no doubt about what we are perceiving. The woman sitting with her back to us spinning is forming nature into something useful, while her maid, moving from sunlight into shade as she carries water from the well to the house, is absorbed in the cyclic labor of protecting the human habitat from natural erosion; hence she polices the boundary between nature and culture, which as the recessive

movement from courtyard to backing homes to church (Nieuwe Kerk) to sky implies, are nonetheless continuous. This continuity and discontinuity are, again, thematic in the lime-leached brickwork on the right. (It is worth mentioning here that de Hooch's father was a bricklayer.)

There is always a puzzle about realist paintings, a puzzle that makes them opaque in a peculiar way—namely, how their opacity becomes difficult to detect against the grain of their obviousness, their simple accomplishment of likeness. And certainly the dominant strategy in unlocking realist paintings is to demonstrate that they operate in accordance with codes that we have become oblivious to, and that can then be revealed through a hermeneutical act of decoding. But decoding in that way, I have argued, covers over rather than reveals the source of the opacity. Alpers's refusal to be coerced by this hermeneutical rationalism remains, for me, exemplary. In saying this I do not mean to assert the converse, that de Hooch found an intransigence in the very idea of realist painting in the way that, say, Courbet did that would henceforth make realist painting impossible.[24] Such an assertion would deprive de Hooch of a naiveté that I want for him, his impossible hope for realism. Instead, I would point to a convergence between a certain practice of painting and the form of life painted that would make realism suddenly, which is to say against the odds and improbably, both possible and appropriate. And for this convergence to be possible, I am arguing, the kind of immanent transcendence that we think belongs to painting, its embrace of its medium as a way of celebrating the world, requires a comprehension of the world as immanently transcendent, as a satisfying, wholly secular place. *Realism, materialist realism, is thus not a question of likeness, achieved or failed, but of a fitness between the powers that are painting's own and the world represented.* In making this argument turn on a question of *fitness* or amenability between the powers of painting and the world painted, the structure of my claim is formally akin to how Kant demonstrates the possibility of aesthetic reflective judgments of taste in general—that is, as a matter of the fitness between our subjective powers of judging and nature.[25] This form of argumentation is appropriate since it turns on locating the powers of painting (the handling of perspective, the use of color, the deployment of light and shadow) as wholly human ones geared to a world that is wholly human—human, above all, in the manner in which human society and its habitation of a natural world are interwoven in, for example, the deflated allegorical relation between bricks and painting.[26] In

this light, I am tempted to say that my argument amounts to a transcendental induction of the possibility of realism—induction rather than deduction because the possibility is historical rather than a priori. History and contingency become the locale of opacity; and that fate of realism, its possibilities and impossibilities, becomes broadly historical.

For realism to be *possible*, which again is not a matter of painterly technique but of how that technique is employed, the world, suddenly and improbably, has to be *found* satisfying, *discovered* to be a wholly human one. Perhaps this finding is operative in a whole range of Dutch realist paintings. It may have been; I do not know, although that thought would help Alpers's line of argument.[27] What distinguishes de Hooch in this regard is that his finding the world so disposed is historically specific: it is just *this* world, and explicit in his painting. It is his theme and not something that can be taken for granted: he figures the fitness between painting and world. To have simply taken for granted the fitness would have made his realism, well, photographic and not painterly. De Hooch's naiveté is thus to be located in his finding and discovering, and his making that discovery explicit (as revealed by the way in which the massive change in painterly practice works in a one-to-one relation with the change in subject matter); only so can it be that this world is not shadowed by an ideal of immanence, a will to immanence, an idealization of ordinariness.[28]

Bread

In his courtyard paintings de Hooch provides us, more radically, emphatically, and perspicuously than anywhere else, with the syntax and semantics for a materialist realism, the elements that compose the claim of Dutch realism. Nonetheless this is an extremely fragile moment, in part because of the way de Hooch finds the world, his embrace of it. How fragile (or rare) becomes clear if we compare de Hooch's work with two rival paintings by Vermeer, also from around 1658, and clearly intended to be continuous in inspiration with de Hooch. The most obvious comparison is with Vermeer's *The Little Street* (or: *A Street in Delft*). Although this painting includes what would appear to be so many signature de Hoochian elements —the finely described brickwork; the porousness between inside and outside, private and public, culture and nature; the connecting of domestic life, the life of women and children, with a wider cityscape; as well as a

similar palette—it is a different kind of picture. Although even less framed and hence more a glimpsed reality than de Hooch's, Vermeer's glimpsing is done from a *distance*. In this instance, that distance changes everything. Given the unframed character of the image, the distancing gives the whole something of the feel of a snapshot.[29] Even if that thought is resisted, the distance from which the scene is observed is not just spatial; spatial distance here becomes a figuring of temporal distance. With the figures diminished and their actions frozen in time, the whole has the feel of an emphatically past moment, of something thus lost in the past, something that belongs in the realm of memory, "fixed in an artifice of eternity."[30] The use of spatial distance to figure temporal distance, which is part of the genius of this picture, is a way of idealizing the moment, of giving it the weight of ideality. This is a different thing entirely from a de Hoochian finding.

If there is any painting of Vermeer's that might be thought to compete with de Hooch in its materialist realism, which is to say, in its capacity to embody an image of a self-sufficient secular world (as found rather than idealized), it would be *The Milkmaid* (or: *A Maidservant Pouring Milk*) (Figure 2). And indeed there is something almost hallucinatory in the intensity and realism of Vermeer's basket, bread, pitcher, and milk. Equally there is a contrast between the freshness of milk and bread and the deterioration of the wall beneath the window or the disrepair of the wall at the back. And the sun blessing the lot. Nonetheless, there is little doubt that the sensuousness of Vermeer is of a different order than de Hooch's. At the very least one would have to say that bread, basket, pitcher, bowl, and cloth are *too* real, hyper-real, with the bread possessing the richness of a precious gem.[31] It is as if these objects have, through the intensity of their presence, become symbols. Symbols of what? Perhaps symbols of themselves, perhaps symbols of painting, but symbols nonetheless. But then this is a highly composed and structured work, every inch of it thematically worked. Here is Edward Snow commenting on the relation between the milkmaid herself and her environment:

The terms of that world comment on her presence. Note the elaborately contrasted images of things open and closed (the brass and the wicker basket, the pitcher and the standing jug, the whole and the broken loaf), full and empty (the basket on the table and those fastened to the wall, the blue overskirt and the cloth hanging from the table, the dense bread and the cavernous jug); and of interior disclosed and concealed (the lifted overskirt and the covered table, the pitcher and

the standing jug again, different aspects of the footwarmer), unknown (the standing jug) and known on trust (the table under the tablecloth, the emptiness of the hanging baskets). These counterpointed objects are like facets of a meditation on both the woman's presence and the "worldness" of the world.[32]

Even if this passage is slightly overwrought, its overwroughtness is at one with its object. Above all Snow points to how the contrasts in Vermeer differ from those in de Hooch. I would put the matter this way: in place of a reversible interior/exterior as the governing structure, Vermeer has disclosed and concealed; and what is concealed, unknown, mysterious in Vermeer is, above all else, woman. Vermeer women are women seen by men, women who possess a depth of inwardness that is the inwardness, the unknownness of their sexuality. What I have called the overwroughtness of Vermeer's painting is just the sense that, whatever he paints, he paints his desire by painting its object as the perfected object of desire. Let me concede that this thematic and Vermeer's unbelievable touch together produced paintings that are consistently riveting in a manner de Hooch cannot touch. But equally, Vermeer's power comes at a certain cost, at least from a de Hoochian perspective, since for Vermeer the object is always the object of desire, so what we receive is as much fantasy as reality. In brief, Vermeer still paints within the ambit of the male gaze, picturing woman as (mysteriously) other, while de Hooch's realism involves finding the terms for an autonomous female gaze which, understood aright, is the look of a wholly secular modernity.[33] In this context, the construction and circulation of the female effectively desublimates the object: it is no longer the transient stand-in for an ultimate and forever lost object of desire.

In order to get at the stakes of what I think is the huge difference between Vermeer's bread and de Hooch's brick, it will help to take a short detour. In her account of Hans Holbein's "The Body of the Dead Christ in the Tomb," Julia Kristeva contends that Holbein's minimalist technique is a metaphor not for desire, which is a bond, but for *severance*, "[w]hich is the truth of human psychic life, a severance that is represented by death in the imagination and that melancholia conveys as symptom."[34] Christianity, despite itself, thinks severance: the death of Jesus is, in actuality, the death of God, and so the end to the thought of transcendence and immortality. Or that, rather, is the experience that the death of Jesus comes to for Holbein, and that is the task of his painting to convey: the painting *is* the inference, and his "minimalist" technique the painterly means for

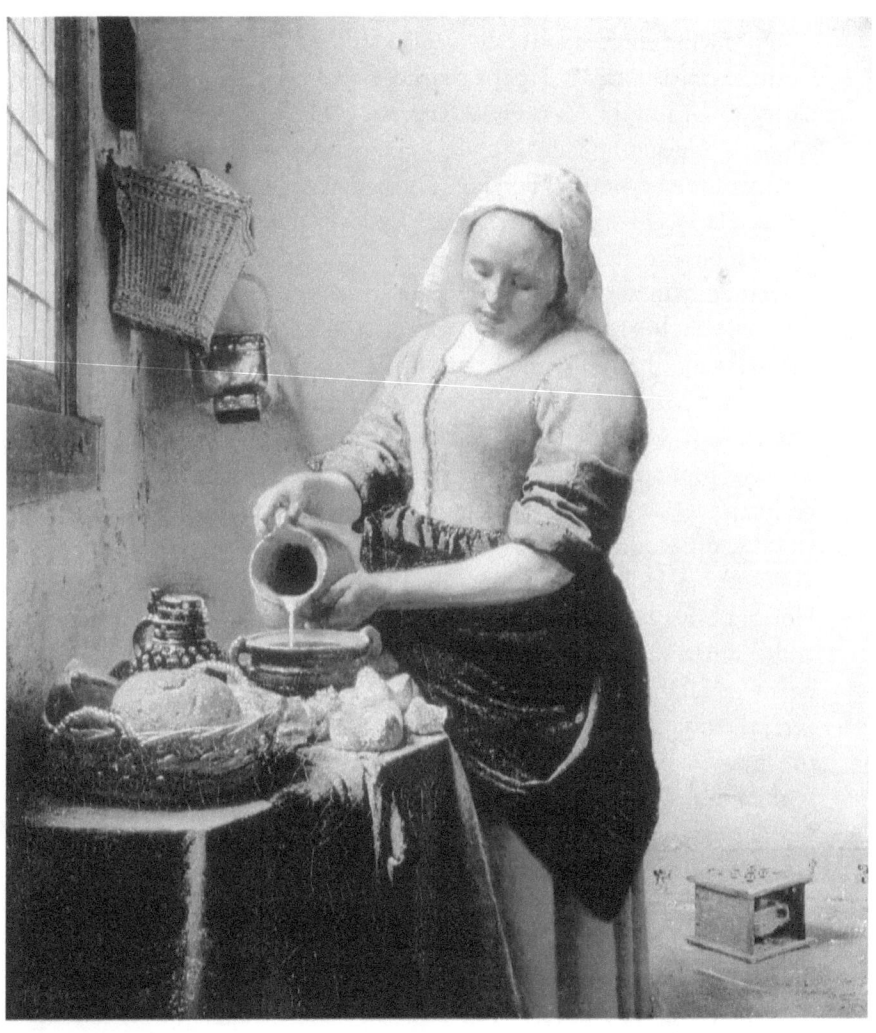

2 Jan Vermeer (1632–1675), *The Milkmaid*, 1658–1660. Rijksmuseum, Amsterdam, The Netherlands. Photo credit: Erich Lessing / Art Resource, NY.

making that inference (together with, of course, the painting's intense horizontality, its severing of the dead body from even the thought of transcendence by its claustrophobic encasement in the tomb).

Minimalism here stands out against both the emerging mannerism and Gothic extravagance; it departs sharply from the eroticization of the dead Christ in Grunwald's *Isenheim Altarpiece*, for example, and from "the Italian path of negating pain and glorifying the arrogance of the flesh or the beauty of the beyond."[35] Severance is the new hard thought demanded of the secular imagination: finding space for loss and finitude. Holbein's painterly response to this new demand, his minimalism, is the provision of a quiet dignity in the face of loss by painting the slightest shift, transforming the melancholy of the revelation into mourning, or perhaps only the idea of mourning; the shift is slight, infinitesimal: the picture's awful, disturbing beauty. Minimalism anticipates Dutch realism.

Of course, both de Hooch and Vermeer are well beyond Holbein's melancholic pronouncement; for them the loss of Christian transcendence is no longer felt as a loss. For them transcendence has already become this-worldly, the world's beauty. Nonetheless, de Hooch's realism can be seen as inheriting Holbein's minimalism in a way that Vermeer's cannot. De Hooch's brick walls entwine severance and bonding, material transience with human making and perdurance, even joy, while Vermeer's bread is nearly sacral, however secular, an eroticization of the everyday that substitutes the mystery of (sexual) desire (however metonymic its operation) for the mystery of redemption. Could I say that de Hooch's brick walls represent the indefinite *work* of mourning, the endless work, repair, and maintenance required by a material world laced with transience and loss? Should we say that the opacity of de Hooch's realism is his resistance to the attempt to render the world transparent, hence a resistance to the idea that the world could be purely present? Is not what is figured in the density of de Hooch's brick walls a requirement for *acknowledging* that the human habitat belongs to nature?[36] And isn't that acknowledgment, the call for it, just the recognition that the limit of human powers, the material world as such, is a condition for that habitat's possibility? And conversely, doesn't Vermeer's bread offer an insistent promise of happiness, even *jouissance*? Because, again, if nature in de Hooch is both transience (severance) and fecundity (bonding), then he can restore to painting a framing background without that background insinuating other-worldly transcendence (as it

would have if it had appeared in Holbein's painting). Brickwork, which perhaps is just an allegorical presentation of painting itself (de Hooch is his father's son), is the crossing of domains that makes that secular everyday possible, an immanent utopia even.

The End of Realism

Although I think there are overwhelming reasons to believe that while de Hooch knew that in 1658 he had discovered something (since it is only then that he begins occasionally to date his paintings), there are equally good reasons to believe that he mistook the nature of his own achievement, namely the paintings he produced shortly afterward in Amsterdam. This is obvious from just the quickest of looks at a typical Amsterdam painting: *Portrait of a Family Making Music*. This is certainly a celebration of the family, their music-making the symbol of their harmony together, but the opulence and richness of setting and clothing drive out any thought that what we are witnessing is either everyday or ordinary. This is a celebration of bourgeois wealth, full stop.[37]

In experiencing de Hooch's best paintings one's eyes are continually diverted from the human protagonists and their actions to the setting, natural and man-made. Have brick walls, wooden doors, baskets and linens, windows and floors, brooms and buckets ever seemed less indigent than in de Hooch's Delft paintings? Have human artifacts—houses, alleyways, sheds, patios—ever seemed so self-contained and world-making, composing so complete a human world, as in de Hooch's scenes of Delft life? De Hooch, I am suggesting, gave us for the first and perhaps only time a wholly sensible world of touch and sight that was sufficient in itself, a world of things that was fit for sensory encounter and that thus affirmed in us our sensuous nature. This discovered self-sufficiency of the world is, at the same time, the sufficiency of the practice of painting to the world. In "at the same time" is located the possibility of realism, art's secular autonomy.

If Descartes's account of the piece of wax is a fable of modernity, then de Hooch's brick walls can uncomfortably be felt as *simultaneously* the most concrete and the most utopian rendering of a wholly secular everydayness because what is lustrous and self-sufficient in that image now seems impossible.[38] In comparison with de Hooch's brick walls we will find in the mountains of Cézanne or the chairs of Van Gogh a *longing* for concreteness

and visibility, a desire for things whose truth can be gathered through unaided seeing. With the brick wall before our eyes, the immediacies of a Pollock or a de Kooning can be felt as the wounded abstractions they are, perhaps as encapsulations of the moment when the material object has been "liquefied" by the fire of modernity before disappearing into the vacuum of mathematics or the indifference of exchange value. But if we cannot render the world of everydayness with the solidity that de Hooch gave it, then that world, no matter how simple, sensible, and material it is, is still a world lost, hence a utopia of the ordinary rather than its fact. That de Hooch's immanence now appears transcendent or ideal is what makes the paintings' realism so difficult to comprehend.

One might think that the paratactic orderings of Dutch realism anticipate modernism—a thought not far from my mind when I began thinking about it and pondering Alpers's critique of the Italian model (which surely is intended as a sotto voce legitimation of the ambitions of modernist painting). But this is not what I am claiming here. On the contrary, I am suggesting that what is exemplary in de Hooch is that he uncovers the possibility of modern art's autonomy before that autonomy became a withdrawal into painting. The fineness and rarity of the moment de Hooch represents is that, although it is *through painting* that the secular everyday is revealed, and hence that there is a privilege to painting at this moment because it is uniquely well placed to gather the wedding of meaning and matter, social sign and natural order, that wedding is performed without a sense of the abstractions that are already beginning to make that marriage appear as only ideal, a thing of painting alone—say, the work of dissolution that Descartes has already performed on his piece of wax. Because de Hooch in 1658 does not feel the stress of the abstractions that are already occurring, he can *present* the ordinary, the material and transient, without feeling the need to make a claim for it, to idealize the claim. If we compare this moment with what happens in the work of the painter who I think most appreciates the Dutch model, namely Chardin, it is evident that Chardin needs to inflect his scenes with an almost Vermeerian radiance in order for the *claim* of the everyday to become manifest. Contemplate, for example, *Saying Grace* (*Le Bénédicité*) (1739) or, shifting to the mode that most emphatically attempts to recall the importance of the material base of life, what is always overlooked but emphatically there, *Kitchen Still Life* (1735).[39] With Chardin the object has already become a symbol—a symbol

of ordinariness, of the claim of the egalitarian world of the everyday to be sure, but still a symbol, thus speaking (as the symbol always does) of an absence: absence from the things of the world of just the quiet dignity and worth that his painting provides them.

The contrast of Descartes's piece of wax with de Hooch's brick wall is for me the image of unreconciled modernity. The most profound challenge to the unity and unifying work of culture is the separation, diremption, gap, or abyss separating the sensible world we aspire to live in every day, the world of things known through sight and sounds and touch and feel, from the exactitudes of scientific explanation. Of course this gap between the visible and the invisible, the sensible and the insensible, what is observable and what theoretical, between art and science, is not one gap but a variety of gaps and separations as well as connections. Nonetheless, there can be no doubt that the fable of the piece of wax has been the dominant trajectory of modern experience, with de Hooch's courtyards becoming more and more a fiction, a desire, a Vermeerian longing. Yet what object could be more material and sensible, more everyday and ordinary, more a simple thing of the world than a stretch of brick wall? How could this simple thing have become so remote? More precisely, how could the authority of the material world of the senses, the brick and bread of everyday life, have become so evanescent?

2

Judging Life: From Beauty to Experience, from Kant to Chaim Soutine

It must seem an insult to commitments to justice and a travesty of the feelings that support such commitments (compassion for the sufferings of others, or righteous anger at those who calculate the worth of human lives as if it were a simple matter of profit and loss) that the intelligibility and validity of those commitments and feelings could be thought to hang on or be found in just "this" painting or "this" urgent brush stroke of red. The disproportion between these two, the unjust ruination of human lives on the one hand and the velleities of some cultural artifacts on the other, is so immense that to consider the latter as a, or the, voice of the former, perhaps even the condition in which the latter has voice, appears outrageous (to mind and sensibility), even blasphemous. Because the disproportion at issue here is actual, hence the sense of insult and travesty actual (and so apparently always possibly justified), the need to make sense of the intimate connection between concern for the worth of human lives that are systematically denied worth, the validity of a passion for justice and happiness, and the refinements of high cultural artifacts is constant. Or rather, since the kind of ethical investment in high cultural artifacts that has been, from Lukács to the present, the extravagant claim of "materialist" aesthetics must transgress against the more direct deliverances of ethical reason and experience, then the logical violence of that claim will need to be vindicated.

In this chapter I offer an analytic genealogy of aesthetic and artistic materialism that attempts to explain, first from within Kant, just how the aes-

thetic and the problem of human embodiment became entwined, and then how that entwining, in a *continuation* of the Kantian gesture, became the underlying and dynamic element of modernist painting. In making out the latter claim I shall instance the paintings of Chaim Soutine. Although saying something about Kant and modernist painting in such short compass must leave both accounts in deficit, the connection is central to what I want to say. The interconnection of problems in the *Critique of Judgment* is the most direct way of establishing how the formation of the modern aesthetic was simultaneously the formation of a refuge for an experience of *living* nature, that Kant's logical problems with nature as mechanism and nature as life categorially adumbrate the societal problem of reification, say; and hence why the sort of sensuousness and sensuous particularity that is an issue for modernist painting is, no matter how unknown to itself, a site for an unacknowledged problem of life and embodiment. Making out this set of connections is, to be sure, to inflect the meaning of "materialism," to say why at a certain moment only a *vulgar materialism* of the body could do justice to the justice denied it; or, what is nearly the same, how the unfolding claims of and for modernist art become intelligible only when a literalism in the understanding of societal reification is adopted. That such a literalism is called for is, of course, what makes the art and the understanding of it desperately uncomfortable, and hence subject to endless denial.

In making out this argument one cannot rely solely on the evidence of (philosophical) reflection: the distortions of reason that privilege the mechanical understanding and with it a certain conception of discursivity equally deflect, repress, or simply circumscribe the claims of aesthetic phenomena. Desublimating the aesthetic, so to speak, is a matter of registering *its* claims appropriately, seeing how and why the claims *for* sensuous experience can and must be made *sensuously*; or, what is the same, how the theoretical claims for artistic materialism must be made through the very material items that theory had hoped to vindicate.

The problem of aesthetics, as it emerged and took form in the eighteenth century, was never really about the questions "What is beauty?" or "What is art?," however important those questions remain. Rather the problem of aesthetics was almost immediately the problem of sensuous meaningfulness, the kind of nondiscursive meaning that material things have, material meaning—and hence about meaning or cognition or reason or experi-

ence that escapes or eludes propositional meaning (assertion) and determinate judgment. Clearly this problem arose by virtue of the disenchantment of nature and the mechanization of the material world: the ideal reduction of a piece of wax to an algebraic equation. But that is equally to say that the mechanization of nature quickly turned into the "mechanization" of reason and intellect. The two together—mechanized nature and rationalized reason—raised deep and immediate problems about the meaning and intelligibility of organic phenomena, about life, hence about human embodiment, not to speak of nature as a whole.

Aesthetic judgment and taste became the refuge for the meaningfulness of the natural world, material meaning, beyond rationalized discursive meaning. Ignoring the question of how or why this occurred, nonetheless, nowhere is the whole interconnected bundle of issues at stake here more pointed, fraught, and anticipatory of its finale than in Kant's *Critique of Judgment*.[1] Throughout, the third *Critique* is concerned with what I call the "amenability problem"—that is, the problem of the fitness, suitability, or as Kant names it, purposiveness of nature for human ends, theoretical and practical. Amenability necessarily goes beyond the resources of mechanical understanding; to think the amenability of nature, we require the resources of not determinate but reflective judgment. And in Kant's thought, there is a formal connection between the amenability problem and the problem of judging life: judging life too requires the resources of reflective judgment. Reflective judgment, one might say, provides the rhetorical supplement or surplus to transcendental logic that lets life live and nature be whole. Yet without question, the apotheosis, the fullest articulation and expression of the powers of reflective judgment is to be found in aesthetic reflective judgment.

In sections 1–4 I argue that Kant's mishandling of the judging of life, our ability to recognize something as living, is almost made good in his handling of *aesthetic* reflective judgment—almost but not quite. Equally, the amenability problem in its most demanding form, as Kant half implies, cannot be solved philosophically. If it is solved or resolved anywhere, it will be in *actual* aesthetic reflective judgments of natural beauty. But the actuality of judgments of natural beauty is itself intensely problematic; natural beauty must finally give way to art beauty. And that eventuality changes everything: it will take us directly to the claims of artistic modernism (section 5). Perhaps, to rush to my conclusion, in his pictures of carcasses that

bleed with painted life, the paint itself taking on a "fatty carnality," and landscapes of Céret in which the fabulous distortions to houses, trees, and hills are extended to the point at which the whole becomes "a mass of tumbling paint, like chicken-guts,"[2] Soutine performs a *transcendental induction* of the conditions of human meaningfulness that accomplishes, completes or realizes, what the *Critique of Judgment* could only point toward —namely, answering the life problem and the amenability problem at once (section 6). In part this is because those two problems are for us not just formally connected but materially identical. To claim that Soutine's work performs a transcendental induction that resolves the problems posed in the third *Critique* is to claim him, his art, and by extension modernist art generally, for epistemology. But just such a claim is going to be necessary if the extravagances I noted in my opening paragraph are to be answered. In section 7 I summarily pace out the notion of artistic mediums that is presupposed in my reading of Soutine.

I. The Need for Reflective Judgment

Works of art might be seen to make a peculiarly compelling claim if they could be seen as answering a *problem* thrown up by scientific knowing and moral experience. The problem is the one systematically addressed in Kant's *Critique of Judgment*; this problem (or crisis, as it appeared to Kant's successors) has two sides.

On the one hand, the crisis concerns the dematerialization of nature, the reduction of circumambient nature to a mechanical system whose lineaments are provided by the immaterial forms of mathematical physics. The paradigmatic allegory of the disappearance of sensuous nature and its replacement by an immaterial, mechanical system is given in Descartes's dissolving of the sensuously resplendent piece of wax into properties (extension and malleability) graspable by the mind's eye alone in the second *Meditation*. One way of expressing this dematerialization would be to say that it involves a delegitimation of the authority of nature, a delegitimation of nature as being authoritative, in favor of the authority of abstract, scientific reason. So it concerns the disenchantment of nature, nature being dispossessed of voice or meaning, and all meaning being given *to* nature by mathematical reason, or, to state the same in the challenging tones of Kant's Copernican turn: objects must now be conceived as conforming to our

knowledge and concepts, where the concepts constituting objective experience are just those that depict nature as a mechanical system.[3]

Saying that the crisis concerns reason's displacement of nature as a source of meaning may sound perplexing because we typically do think that nature is disenchanted and meaningless: there is no voice to hear or meanings to be deciphered. But this response is too quick since the primary natural object at stake must be the human body. Arguably (the argument I want to urge that works of art are), nature speaks or means in our bodies, as in those of our nearest animal relations, in the issuing of *pains, pleasures, desires, feelings, needs*.[4] These might be thought to compose a minimalist language of nature, one that comes to naught with the mathematization of nature and the hegemony of a certain (methodologically governed and reductionist) scientific rationality—say, the rationality of the understanding and reason in Kant's critiques of pure and practical reason. Thus when it is said that reason delegitimates the authority of nature, this means at least that these promptings of the body come to lack *normative* authority (can no longer operate as *reasons*), and so cannot be thought to raise claims or demands that should (or should not) be heeded. Such items become nothing other than causal facts no different in kind from those of dead nature—the snapping of a twig underfoot on a cold wintry morning.

But the full weight of the crisis of the object is given through its corollary, the crisis of the subject. This too can be thought of as a dematerialization, as the self losing its substantiality, its worldliness. If nature comes to be figured as a mechanical system, then the self must become divorced from the natural world as such. The "I think" loses its placement as substance, becoming the active locus of the categorial forms that must be capable of accompanying all our thoughts as a condition of their being thoughts (with objects) at all, and is nothing beyond this functional accomplishment. The "I think" is exhausted in its role as the unifying pivot of cognitive synthesis.

Analogously in the moral domain, the self comes to be identified with its subjective willings or intendings and the rules that provide coherence for willing. The self cannot be identified with its actions themselves (or the states of affairs precipitated by them) because as *worldly* events they stand outside the ambit of immaterial subjectivity. Only what is within our power and control can belong to subjectivity; but actions involve transformations of the material environment, hence are worldly items, and thus must be

viewed as belonging to the nexus of causally determined items. Only what belongs within the circuit of thought and reflection can be subject; that is what willing becomes in this new dispensation. The freedom of the subject is not a substantial property that might be an object of awareness, but rather becomes what we must practically believe about ourselves if we are to be able to understand our having any normative commitments whatsoever.

Because the physical world is causally constituted, then nothing *in* the world can count as a product of freedom, and hence nothing can irreducibly count as present as a consequence of free action or be irreducibly interpreted as meaningful because it is the product of an intentional doing. The world, however much as it appears to be marked or stamped by freedom, must be properly understood in terms that make no essential reference to having an origin in free action. There is, we might say, an utter lack of fit between how we must regard physical reality (as a closed and immaterial causal system) and how we must regard ourselves (as free and self-determining immaterial subjects).[5]

Kant's settlement, of course, is simply to give to each—world and self—a separate domain, with a (transcendental) logic proper to itself. In making each transcendental logic irreducible to the other, and giving each a distinct domain for its proper employment, Kant had hoped to settle the dispute, preventing any further incursions from scientific rationality into self-determining subjectivity. Crisis and settlement are one, since the world remaining has become forever impervious to significance, and the self is ensconced in a disembodied house of reason, as a princess might be imprisoned in her tower: all the world is there outside the window, but is forever unreachable.

Stating the crisis in this way can sound terribly underwhelming. After all, as a consequence of this crisis we do not stop feeling pains and pleasures and taking them seriously (although how and when we take them seriously changes); nor do we desist from acting in the world or from evaluating the actions of others (blaming and punishing them, for example). The dematerialization of nature does not mean that nature literally disappears; on the contrary, there is a crisis because sensuous nature does not disappear regardless of how analytically and ideologically delegitimated and dematerialized it is. Hence the force of the crisis is indirect: it is the crisis in the *authority* of wholly secular moral norms and ideals (their capacity to be motivating and effective in practice); the crisis in freedom

through which the French Revolution collapses into the Terror; the crisis in what the author(s) of "The Oldest System Programme" identify as the reduction of the state to something "mechanical"—or stretching the eighteenth century story into our story, the way in which the progress of reason (of science and technology and capital and state formation and bureaucracy) has revealed itself as also a history of barbarism. These are the empirical crises whose underlying cause can be said to be the disenchantment of nature, its dematerialization and delegitimation, and the corresponding emptying of the self, the de-worlding if you will, of self-consciousness and freedom.

Kant's own awareness of the crisis of the abyss separating moral reason and freedom (the worldless self) from mechanical nature (the dematerialized, meaningless world), the awareness that makes for the multi-leveled, anxious argumentation of the *Critique of Judgment*, emerges obliquely, as if an afterthought, in the form of the quandaries about, first, how nature as a whole enables scientific reason to discover concepts and laws (the amenability problem), a worry then about how a spontaneous reason must nonetheless be *dependent* on nature, and second, how within such a mechanized system there can be room for living things. Kant became anxious about how science could be intelligible without nature's cooperation, its purposiveness for reason, and how living things could be intelligible independent of some conception of natural purposiveness. Underlying these anxieties is nothing other than a dawning recognition that in giving to freedom and nature incommensurable logics, in that perfect settlement, human life in the world suddenly becomes unintelligible.

Nature's amenability first appears explicitly as a problem in the *Critique of Pure Reason* where Kant notes, "If among the appearances which offer themselves to us there were such a great diversity . . . in content . . . that even the most acute human understanding could not discover the least similarity through the comparison of them . . . , then the logical law of genera would simply not hold; and there would not even be any concept of genus or indeed any general concept, indeed any understanding, which has to do solely with such concepts."[6] In accordance with the requirements and results of the first *Critique*, for an item to be a part of nature is for it to be, in principle, subsumable under some mechanical law of nature, for it is only by virtue of such subsumability that objects and events are connectable with other items and events in the natural world; and what is not in

principle connectable cannot belong to a whole of experience. The actual subsuming of objects and events under concepts and laws is the work of determinant judgment.

For determinant judgment, explanation is just mechanical explanation, and, as Kant extravagantly puts it, it operates as if "wishing perhaps to have everything reduced to a mechanical kind of explanation" (*FI*, 218).[7] This works well for "earths, stones, minerals" and the like which as "mere aggregates . . . are suitable for a classification of things under empirical laws in a system of nature, even though they do not individually manifest the form of a system." When nature's products are aggregates, then nature operates mechanically as "mere nature" (*FI*, 217). But mere mechanistic nature does not exhaust the natural world.

There are other types of items in the natural world—Kant notes "various shapes of flowers, or the inner structure of plants and animals" (ibid.)—that appear to consciousness as incapable of being explained by natural laws alone. As Christel Fricke correctly states the thesis: "The interaction of the parts of such a system cannot be explained mechanically because the completeness of the parts, the essential characteristic of a system, cannot be explained by means of their mechanical relations without having recourse to the representation of the whole system."[8] The aggregates that make up mere nature have surfaces, but no boundaries; they can be divided or aggregated without those divisions or aggregations affecting their intrinsic natures. For all intents and purposes, a broken off part of a stone is simply a stone.[9] Not so with living beings; a broken off part of plant or animal is not a plant (although it could become one) or animal (catgut doesn't sing "meow"). Parts of organic things are only intelligible from the perspective of the whole of which they are (functional or purposive) parts.

Because living beings must "be both *organized* [from the perspective of the whole] and *self-organizing* [from the perspective of the interplay of its parts]" (*CJ*, §65, 373–74), they can be comprehended as possible neither in accordance with pure mechanical principles nor as artifacts. But, according to Kant, those two modes of comprehension exhaust the possibilities of objectively cognizing living beings by a *discursive* intellect, that is, an intellect in which the "analytically universal" (*CJ*, §77, 407) or abstract concept precedes and so determines the meaning of the sensible intuitions brought under it. About this Kant is emphatic: for a discursive intelligence like our own, the self-organized character of living nature "has nothing analogous to

any causality known to us" (*CJ*, §65, 375). In a profound sense, living nature is opaque and inscrutable. In order to cognize living beings then, we *must* judge them as purposive since their complexity of form exceeds the grasp of mechanical explanation, while acknowledging that there is something *inexplicable* in the principle of purposiveness employed. It is the combination of how we *must* regard living beings and the ultimate opacity of the principle of teleological judgment that makes it "reflective," subjective albeit not merely subjective.

In the case of living beings, reflective judgment, by employing a principle of judgment that is both necessary and yet inscrutable, compensates (literally? metaphorically?) for the under-determination of the intelligibility of empirical phenomena by the transcendental constitution of nature. But from this angle of vision, the problem of heterogeneity and the need for unity in the *Critique of Pure Reason* is exactly the same: from the perspective of the constitution of nature in general there exists a problem of under-determination. The heterogeneity of natural phenomena might be so complete that "it would be impossible to regard them as possessing shared empirical properties";[10] which is to say that it is compatible with the transcendental constitution of nature as a whole that we be unable to form even one empirical concept of an object. And again it is reflective judgment that steps into the breach in making the "subjectively necessary transcendental presupposition that nature does not have this disturbing boundless heterogeneity . . . but rather, through the affinity of its particular laws under more general ones it takes on the quality of experience as an empirical system" (*FI*, 209). Reflective judgment (transcendentally) must ascribe to nature an amenability to the needs of human cognition whose satisfaction is, from our perspective, contingent and so, again, opaque and inscrutable. In operating in this manner, reflective judgment must be conceived as underwriting and supplying the surplus of intelligibility that we require of nature and that nature appears to offer to us but which is impossible to account for, make intelligible, on the basis of discursive thinking alone.

Reflective judgment is, so to speak, the point of contact between discursive and nondiscursive cognition, where our form of cognition and another cognition, another order of meaning or intelligibility—for Kant: God's—meet, touch, and fly apart. Without further ado, I will presume that Kant's strategy of referring the excess of form, meaning, and intelligibility

of living beings and nature to a divine intellect explains nothing, and that the reference to God's intellect is simply the site of the problem of nondiscursive cognition.

II. Stones, Flies, and Corpses

To concede that from the perspective of our discursive understanding the organized and self-organizing character of living beings is under-determined is equivalent to agreeing that living beings have a surplus or excess of form beyond what discursive thinking can accommodate. But this sensuous excess is more troubling for Kant's system than he allows. The employment of teleological judgment permits us to begin the work of reflectively *explaining* living beings. But this use of teleological explanation in one important sense comes too late: before we can embark on the business of explaining living nature, we must first recognize the object before us *as* a living being. What *calls* for teleological explanation, what makes it required, is the surplus of form that, if not exactly immediately, at least emphatically and categorically distinguishes our experience of the living from our experience of mere things, mere nature. Reflective judgment's turn to teleological explanation must be a second reflection, a consequence of encountering something as living in a manner that imposes a demand on consciousness to be accounted for differently.

Kant's pointing to the "inner structure" of organic phenomena already points to a context of explanation beyond and parasitic upon some earlier encounter. For comparison, and for an opening onto that earlier encounter, consider the following passage from Wittgenstein:

Look at a stone and imagine it having sensations.—One says to oneself: How could one so much as get the idea of ascribing a *sensation* to a *thing*. One might as well ascribe it to a number!—And now look at a wriggling fly and at once these difficulties vanish and pain seems able to get a foothold here, where before everything was, so to speak, too smooth for it.

And so, too, a corpse seems inaccessible to pain.—Our attitude to what is alive and to what is dead, is not the same. All our reactions are different.[11]

Atypically, Wittgenstein is here suggesting that there is something basic and categorial in our apprehensions of mere things, dead things and living ones, and that in making these discriminations we are not blindly sub-

suming these different kinds of objects under different (categorial) concepts, but that our apprehensions are somehow *responses* to the objects, guided and governed by their forms of appearing—too smooth, wriggling, inaccessible to pain.[12] It is as if the smoothness or motionlessness of the stone, the wriggling of the fly, and the inaccessibility to pain or further hurt in the corpse were themselves not external properties of the objects concerned—not, that is, mere empirical predicates picking out mere properties capturable in a normal predicative judgment or assertion ("the fly is wriggling"), but, at least here, features of them experienced subjectively as experientially marking these objects off from one another, providing us with utterly different and incompatible orientations toward them: "*All* our reactions are different" in the different cases. If all our reactions are different, then the sense or weight or force of predicates across kinds will not be the same: the "smoothness," say, of the stone is like and then again wholly unlike the "smoothness" of the skin of a baby's bum. I am arguing, then, that the large and repressed issue at stake in Kant, that in our apprehensions and self-presentations of these different kinds of things—mineral, organic, living, dead—we are originally, as it were, involved in categorically distinct and irreducible *orientations* toward the world, orientations that somehow, so far inexplicably, live off and depend on the objects they are themselves oriented towards.[13] Should we not be minded to say here that, in apprehending the wriggling fly as living, discursive and nondiscursive cognition touch? For Wittgenstein the experience in which discursive and nondiscursive meet is acknowledged as belonging to the "grammar" of our language, where the grammatical is another name for what is materially a priori. And while this is fine as far as it goes, it does not go far enough, for what we want to understand is not that there are "grammatical" or "material a priori" truths, but that in the relevant cognitions there is an alignment or relating of the nondiscursive—an apprehension or a feeling or an experience—to the discursive. Kant's account of aesthetic reflective judgment is, despite itself, a conception of judgment appropriate to this task.

III. Aesthetic Reflective Judgment: Nondiscursive Knowing

The *stakes* of aesthetic reflective judgment are the same as the stakes of the principle of reflective judgment that secure the systematicity of nature—

namely, the amenability of nature for cognition in general. Above I noted that the problem of specification concerned not only high-level systematicity but, equally, our anticipation that even ordinary objects and events could be conceptualized and subsumed. Does discovering that an empirical manifold can be subsumed under an empirical concept count as "success" or "advance"? That we *can* subsume different manifolds under one concept demonstrates that nature is not wildly heterogeneous, completely chaotic. But does it demonstrate that *nature* contains only finite kinds, that there are repeating types *in* nature, or only that nature can be molded into types, seen as if possessing some orderliness in its self-specification? Why shouldn't we believe that the orderliness we find *in* nature is something we wholly *impose on* nature, that we only get out of nature what we have already put into it?

The question of the amenability of nature to cognition in general thus comes to this: unless we can, however reflectively, come to believe that our successes in cognizing nature generally are not flat impositions onto nature of the kinds of forms we need anthropomorphically, then the very idea of cognition, of truth, will collapse into an arbitrary criterion of pragmatic success: whatever works is true. And, perhaps bizarrely, it is in aesthetic reflective judgments, judgments of beauty, that Kant perceives evidence for *the* purposiveness of nature for cognition, and hence reflective evidence for the belief that it is indeed nature's own unities that are the objects of empirical judgments and not simply unities that our will to truth or need for self-preservation have put there. From this angle, his criteria for aesthetic reflective judgment make perfect sense. First, *disinterestedness* is required in order to bracket all the different sorts of interest, transcendental or empirical, that might be taken to lead us to impose order and meaning onto the world. While the stance of disinterestedness aims to detach the objects of aesthetic judgment from our fundamental purposes, this disinterestedness would be abrogated if our judgments were nonetheless empirical. Hence Kant's second criterion: we must judge only the *form* of the object in aesthetic judgments. To disregard the empirical content of objects is another corrective to and way of bracketing interest, of securing the disinterestedness of such judgments, and thus another aspect of attempting to ensure that what is found in aesthetic reflective judgments is not something we have had reason to put there. For Kant, disinterested reflecting on the form of objects constitutes what it is to interrogate the purposiveness of nature for cognition in general since the *abstraction* from and *negation* of the

sources of interest, and hence from the ways in which objects can "satisfy" us, guarantees that nothing else could be at stake. Yet, despite the fact that we are only judging the fitness or suitability of the object for cognition in general by seeing if in disinterested reflection there is a harmony between its apprehension and presentation (*Darstellung, FI*, §VII, 220–21),[14] nonetheless, criterion three, the judgment must be *universally communicable*— that is, about something that is not merely subjective, personal to me, but demanded of everyone. The intersubjective communicability of aesthetic judgments, their form of universality, reveals that the nondiscursive experience undergone in aesthetic judging, and hence the feeling of pleasure aroused, is not personal and private.

Of course, this way of putting the point states the argument back to front: Kant begins with judgments of taste and seeks to demonstrate that the pleasure we feel in such judgments is something demanded of everyone. How can we make sense of the fact that in glimpsing the budding rose or delicate filigree of the spider's web we make judgments of the form "This is beautiful," judgments that although a function of subjective experience nonetheless claim universality for themselves? Given the setting and stakes, the amenability problem, Kant's response is unsurprising: the self-exposure to the object that is a consequence of disinterestedness and formality uncovers what is the subjective prelude to each act of subsumption, each determinate judging—the buried history of encounter upon which conceptual determination rests. Thus Kant claims that in judgments of taste we must regard the feeling of pleasure as "attaching neither to the sensation in an empirical presentation of the object, nor to the concept of that object, but consequently as attaching to . . . nothing but the reflection and its form, the reflection by which judgment endeavors to advance from empirical intuitions to concepts as such" (*FI*, §XII, 249). For Kant the pleasure we feel in the wholly indeterminate coordinating of imagination and understanding is best explained by the fact that what is given is purposive for our cognitive powers, utterly amenable to them despite the fact that we are asking or requiring and looking for nothing determinate in what is given to consciousness. By asking for nothing determinate, by bracketing our governing interests in the world, we get back everything: the purposiveness of nature for cognition in general.

It is important for the way I am construing Kant that aesthetic reflective judgments are, let us say, quasi-cognitive in character. Although in making

aesthetic judgments we are not interrogating the manifold in search of some determinate something, we are nonetheless interrogating it, surveying it, attempting to make sense of it, however indeterminately. To have the capacity for aesthetic reflective judging is to have the ability to appreciate the kind of unity and complexity of an intuitive manifold as an indeterminate whole that could be, would be, or is ideally suited for being cognized, having meaning. What one senses through aesthetic reflective judgments is the *determinability*, which is to say, the proto-meaningfulness, of nature in general. It is thus no accident that Kant should construe nature's beautiful forms as akin to the "cipher (*Chiffreschrift*—secret code) through which nature speaks to us figuratively" (*CJ*, §43, 301). Thus to say that aesthetic judgments reveal the purposiveness of nature is equivalent to saying that in them we become sensitive to and aware of nature's language, its suitability for and anticipation of the kind of meaningfulness we attribute to it when we make determinate judgments and assertions. In aesthetic judgments we are (to shift the sense of Kant's language) determinately attuned to an indeterminate but determinable meaning, and hence complexly aware of a potential for meaningfulness that is not a (sheer) consequence of our doing. I can think of no more apt way of expressing what happens on such occasions than to say that in making aesthetic judgments we nondiscursively cognize what is there, and that in such nondiscursive cognitions we are aware of a meaningfulness without meaning—a lawfulness without law in Kant's jargon. In such episodes we become aware of a potential for determinate meaning that we have not imposed but found, discovered, and that it is just and only this potential for meaningfulness, this meaningfulness without meaning, that demonstrates that our meaningfulness, determinate cognizing, is not an imposition, not a creation, not a sheer imputation to nature, but a continuous work of determining the indeterminately meaningful, and that this is what grounds or founds, in conjunction with the transcendental conditions of experience, the enterprise of human knowing in a world not of our own making.

But surely, one wants now to say, this nondiscursive cognizing is exactly what we have been searching for in order to make sense of our discriminating judgment between the stone and the fly: in those cases the "smoothness" of the stone and the "wriggling" of the fly are being judged, almost, "aesthetically" in Kant's sense. In judging the fly as living, "is living" has something like the force of "is beautiful" in that it is not a simple deter-

mining or classifying of the manifold, but a judgment that attunes us to that perceptual manifold generally; it is presupposed in all our reactions to things like that, it orients the kind of meaningfulness our application of predicates to that kind of object has. Wriggling, I want to say, is something like the *form* of the fly, a bit of nature's cipher that we decode as "is living." Of course such a judgment is not merely aesthetic—any more than it is merely metaphorical or rhetorical—since there is a kind of determining moment; in recognizing the wriggling fly as living, we are *emphatically* attuned to a domain of being: the very possibility that life lives, hence cognitively turning from the world of dead nature to the world of living nature. In such cases the only or best expression of knowledge is a transformation of attitude; failure in such cases will equally be manifest not in a missing bit of information but through a kind of blindness to a whole domain of experience. Either way, Kant's fierce division between reflective and determinate judgment must become blurred, discursive and nondiscursive cognition touching.[15]

IV. Mechanism's Wish, or Where Have All the Flies Gone?

Yet there are problems with Kant's argument. In making judgments of natural beauties, are we really disclosing the purposiveness of nature for cognition, and thus finding a general fitness of the natural world for human purposes? Are we convinced by his argument that the meaningfulness we discover in the world is something we have not imposed upon it? What these questions point to is a significant modesty in Kant's deduction of taste that reverberates back into and eventually undermines what might appear to be his solution to the amenability problem. What Kant actually provides in the deduction of taste is not a vindication of the amenability of nature to human cognition, but an interpretation of the significance that judgments of natural beauty could have, *were there any valid ones*. That is, the most that the deduction of taste can be construed as showing is how judgments of taste could be valid, what is presupposed by the claim that there are valid ones, and what the consequence of that validity is, or how it can be interpreted. But what this means is that the resolution to the reflective question of the purposiveness of nature, right down to the question of the applicability of concepts to experience, is provided not philosophically,

not in the deduction of taste, but aesthetically, in valid aesthetic reflective judgments. Stating the thesis exorbitantly, the transcendental demonstration of the amenability of nature for cognition happens, if at all, "empirically," in actual judgments of taste. Hence, concrete and particular judgments must be regarded as themselves possessing or bearing transcendental significance—as possessing a grounding orientational and reflective significance. This is Kant's own axial turn toward the object.

Thus even if one finds the general pattern of argumentation in the *Critique of Judgment* compelling, evaluating it cannot be detached from the evaluation of aesthetic culture, that is, from our sociologically informed judgment of what the possibilities for and constraints on aesthetic judging are.

And now hard questions arise. Do we have reason to believe that there are now valid aesthetic judgments of natural beauties? Does bracketing our cognitive interests and attending only to forms put us in touch with *nature*? Has any of us ever seen, "seen" in Kant's demanding sense, a rose that is not utterly and completely saturated with the mythic roses of romantic love or with sacrificial religion or botanical idealization or, indeed, with some clichéd idea of beauty? Is not every rose, vista, birdsong we encounter already packaged as, potentially, a "beauty," something to be swooned over and gaped at? Does not the very idea of a vista, for example, insinuate a landscape, thus the process through which subjects have extricated themselves from their natural environment and packaged it as an item for aesthetic perception?[16] If every occasion of natural beauty strikes us, with some embarrassment, as a cliché, as a bit of social engineering, as if Walt Disney had already been there and set the whole thing up, how can we say anything about nature's role in the generation of human meaning?[17] Has not the wish of mechanism, the claimed hegemony of discursive thinking, come true: that everything we behold, however bracketed and "aesthetic" our beholding, is explicable in mechanistic terms, whether the mechanism is natural science or capital or the culture industry or some broader process of social rationalization? And must not all that (quite apart from our presumption that there could not be a socially unmediated contact with nature, however disinterested, or our post-Freudian hunch that appreciating beauty is connected to sublimated sexual desire) hollow out and undermine the trumpeted transcendental significance of aesthetic reflective judgments?

If my hectoring questions about the sheer existence of aesthetic judgments of natural beauty ring true, then what they suggest is that Kant's two

thematics—the amenability of nature for cognition and the surplus of form in living things—have become for us utterly fused: the contingency-of-fit question has lapsed because everything we encounter has always already been subsumed, classified, labeled; and the form the experience of that prepackaging of the world takes for us is that everything has already been ordered and quantified, measured and weighed (scientifically or culturally); so the cultural anxiety that our meaning-giving works in a void, moving nothing but itself, comes out as or is equivalent to the worry that life does not live. Nature, within and without, is dead nature: either a vista prepared by the local tourist board or a decimated woodland packed with tract housing. All our flies have been turned to stone. Discursivity has triumphed.

V. Modernism: Negativity and Experience

Although it is not a claim I can defend here, the entire history of modernism can be constructed or reconstructed as an engagement, intentional and unintentional, well aimed or confused, with this worry over the fate of aesthetic reflective judgments, over whether and how they, and the works of art that have become the medium of their maintenance, can sustain their transcendental significance. What modernist art intuitively realized is that no stance-taking on our part, no attempt to judge disinterestedly and formally, is going to be sufficient to drive out the doubt that what we are finding in objects is only the conventional order and meaningfulness we have already placed there. Artistic modernism is the process of *producing* manifolds of sense that are lawful—intelligible—without there being any law or concept capable of subsuming them; it accomplishes this productive task through a process of reiterated *abstractions* from and *negations* of known forms of meaningfulness, known conceptualities of every kind. Abstraction and negation therefore *produce* disinterestedness, or at least an analogue of disinterestedness, by actively doing the work of bracketing and thereby removing known meaning (perceptual schemata and hermeneutical grids) from the field of judgment. As judgers, we thus become able to assure ourselves that the intuitive manifold is free of determinate sense by *experiencing* the moment of abstraction and negation itself, experiencing the destruction and loss of determinate sense, and thus having no concepts or laws available to make intelligible what we are beholding.[18] Subsumption must be impossible; its impossibility *forces* us into a stance of reflective en-

gagement. But if subsumption must be impossible in order to provide reflective evidence for the absence of known (empirical) meaning, then every modernist work, as a condition of its authenticity, must challenge our interests in subsumption to the core, which is to say, right down to our ability to be sure, confident, that what we are beholding is a work of art at all. Modernism's reiterated negation of traditional conceptions of art (right up to the "tradition" in force yesterday) is not some failure or willfulness on its part, but a necessary condition of its having an aesthetic claim. The necessity for an active and systematic negation of determinate meaning, the *practice* of artistic modernism, as a condition for aesthetic meaning is thus an explanation of both why art became the repository of the problematic of our relation to the natural world, why the question "Is it beautiful?" became the question "Is it art?," and why thus the problem of aesthetics shifted from the question of "What is beauty?" to "What is art?"

Reflectively attempting to challenge and hold in abeyance the hegemony of mechanism by securing or locating our dependence on living nature for meaningfulness—the very task of the *Critique of Judgment*—has fallen to modernist art since it alone has attempted to sustain a field of *sensuous* meaning in excess of determinate, discursive meaning, to force eye and ear to take on their corporeal embeddedness as a condition for their intellectual doings.

VI. Soutine's Hemorrhage[19]

"Consciousness does justice to the experience
of nature only when, like impressionist art,
it incorporates nature's wounds."

—T. W. Adorno

In an essay written in 1951, Clement Greenberg offered as good a one-sentence interpretation of Soutine's achievement as I have read: "Soutine's vision of the heights of painting saw Old Master pathos and naturalism lending themselves to the directness of 'pure' painting."[20] Soutine, Greenberg avers, is attempting to combine the painterliness of artistic modernism in which, increasingly, the matter of painting is what happens on the surface of the canvas (and not beyond or through what is depicted on it), with the representational ambitions and thematic concerns of pre-impressionist art.[21] Stated so baldly, it can indeed sound as if Soutine was

attempting to square the circle, to carry on the tradition not just formally, as a matter of achievement, but substantially, while nonetheless employing means whose raison d'être was, at least, to transform the subject matter of painting, and maximally were conceived of as negating traditional assumptions, hollowing them out and discarding them as things worn out and unusable—our conviction and connection with the world having become something no longer available through perspective, and by implication, in time, representation generally. And that is precisely how Greenberg did see Soutine. No sooner has he uttered his pithy summation than in the next two sentences he elaborates the implied ludicrousness of the vision: "Only an outsider and newcomer could have thought this possible. His attempt to wrest from paint matter itself what other artists got from *relations* was, as far as Western tradition was concerned, utterly exotic and largely futile."

One does not have to listen hard to hear in Greenberg's rejection both a disgust for the Jew newly arrived from the shtetl who carries its abysmal, hungry, and so base and noncosmopolitan history with him; and, as a continuation of this distancing (and self-distancing), his affirmation of Mediterranean decorativeness, and the drama that shockingly such decorativeness can enact,[22] as alone what befits a commitment to modernism. Any reference to or invocation of the pathos of things is necessarily a retreat from the purity of painterliness, and hence for Greenberg an essentially "literary" incursion that has no place in *painting*. Yet, even conceding these biases, and however over-determined Greenberg's rejection of Soutine might be—his identification with Soutine as an outsider defensively generating his anxious acts of repudiation and distancing—it does nothing to obviate the precision of his characterization of Soutine's achievement and hence the implied paradox, if not outright contradiction, he discovers.

However briefly here, I want to suggest not only that Soutine's best work can be redeemed from Greenberg's slander, but more radically that we should take Soutine's oeuvre to be exemplary for the comprehension of painterly modernism, its pivot, his presumptively naïve and idiosyncratic attempt to connect the ambitions of pure painting with traditional naturalism saying something about the stakes and meaning of modernism that is excised from, repressed in, the Greenberg account. Again, what Greenberg objects to is Soutine's attempt to wrest from "paint matter" what other artists got from relations; and surely he is right: for Soutine pure painting is not only concerned with relations created by line or color but is also borne

essentially by the matter of painting itself: oil-paint-on-canvas. Paint-stuff is not for Soutine an invisible or neutral or indifferent medium through which optical forms emerge; it is a precise material stuff whose optical—relational—properties are, or become in Soutine's handling, *visibly* non-detachable from its tactile properties. And this must be central to pure painting if that painting means to make of painting something that fully acknowledges its conditions of possibility—flatness or two-dimensionality in Greenberg's telling. Soutine operates as if the gelatinous stuff that is the material medium of the painted image were as essential to it, and essential in an analogous way, as, say, the fact that my lover's lips are flesh is essential to them. (Imagine the moment of the kiss, the touch of lips to lips, and suddenly the lips touching yours are not flesh but wood or steel or dust: dead matter. Matter matters to mattering.) If painting must acknowledge its medium as essential to what it can be, then it matters to painting that this stuff as applied with a brush or palette knife can visibly hold this or that shape, that applied "just so" it visibly carries the history of its application, that the thickness of it informs the image produced, that the density of application of the stuff and the "density" of the image produced are distinct yet internally related, that in responding to a painting we must be responding to the painter's handling and use of paint-stuff, and so, finally, that painting is a manipulation of paint matter. None of this is exactly new with Soutine, the exchange between brush stroke and image already urgent in Manet, Cézanne, and above all, Van Gogh—it may even be considered if not the first then perhaps the primary way in which *painterliness* and hence modernism emerges. But these acknowledgments are ambiguous because they do contribute to the flattening of the picture plane, dis-illusioning perspectival space; even drawing attention to the brush stroke for its own sake can be conceived as aiding that end. But surely there is more to the revelation of brush stroke and paint-stuff than that in Van Gogh, an extra inflection of the materiality of the paint that both underscores and works *against* the optical revelations?[23] Assume that it is essential to what transpires in Pollock and de Kooning that their canvases require an acknowledgment of the materiality of paint, its being paint matter; still what is such an acknowledgment *of*? And given what paint matter is, how could it conceivably speak to or address nature (living or dead)?

How do paintings carry conviction and connection to experience? Through making emphatic that what we had before us was a *painted im-*

age, impressionism revealed that it was not through sheer likeness to the world. Do not the accomplishments of early modernism demonstrate that line and color on their own provide the anthropologically sufficient means by which humans can construct nonarbitrary conventions of visual meaningfulness? Perhaps it is just this neutral anthropology in Greenberg's account that enables him to treat painting as a relatively autonomous cultural practice that articulates the *seen world*. For him, no matter how deracinated and impoverished the actual visual world has become—the reduction of things to commodities and nature to raw material—modernist painting holds out a hope of something more by revealing the intrinsic possibilities of perceptual meaning. I am tempted to say that for him modernist painting performs an *epoché* or bracketing of actual seeing in order to reconstitute its essential optical possibilities (the unfolding of modernism is thus the equivalent of an ongoing eidetic variation). But, and this is all I need to say here in the way of criticism of Greenberg,[24] this thesis abstracts line (as boundary, border, limit) and color from colored *things*, and by extension discounts the sensuous particularity of things, and hence their thingliness, as what needs to be salvaged. But this abstraction does indeed capture modernism's most insistent temptation, and by extension the critical limit of Greenberg's comprehension of modernism (the interpretive realization of that temptation): to consider the deliverances of painting an encapsulation or articulation or exploration, while always a revealing and a (re-)securing, of *visual culture*—where "culture" stands in opposition to nature, or better is a defense against it.[25] The abysmal "paint matter" of Soutine's finest works announces the repression of nature and thereby its return. But it is *repressed* nature that returns in Soutine, that part of nature that has been unabsorbed by or proven resistant to cultural forming, the misbegotten and out-of-place.

What Soutine discovers or uncovers as the secret of paint-on-canvas is its derivation from and affinity with embodiment and nature: the painted image is a configuration of meaning that arises solely through the configuration of matter, meaning arising as essentially *this material/natural stuff* configured. The mystery of painting that Soutine reveals is not that meaning can arise from line and color alone (both of which are all too human), but that what arises in that way is matter through and through, the germ or ooze in the ghost. If paint-on-canvas is sublimed, sublimated embodiment, and if now painting has *only* paint-on-canvas with which to forge a

meaning for itself and so be meaningful, a source of conviction and connectedness to the world, then, if these paintings work and are authentic (not kitsch or rhetorical or melodramatic or naive), it is the *semblance* of life, the life of the gelatinous stuff, that *appears* vital, quivering and alive, and through which I (we) discover my (our) mortification—that in repressing base nature we have denied ourselves as part of it so that what survives us and remains alive, or at least is necessary for there to be lives, is ironically what we have found lowest (what Greenberg cannot bear about Soutine or himself).[26] If these works are bearers of conviction, then what is left of nature to be affirmed is only its ruination as what cannot be—artistically or aesthetically—forged or faked or sentimentalized. But the role and stand-in for base nature in painting is paint matter; hence painting that fully acknowledges paint matter acknowledges painting (and so culture) as an inflection of nature, fully of it and only meaningful thereby. Soutine takes painting to the limit of intelligibility, to the very place at which meaningfulness must collapse if culture (and so meaning) is the great and autonomous and wholly human enterprise we believe it to be and ruins it; all the pathos of the human emerges from the wholly inhuman: gelatinous stuff configured.

The most direct way into this telling of Soutine's accomplishment is to attempt to tease out the inner connection among the three apparently traditional genres in which he worked: landscape (above all those of Céret), figure painting, and still life (emphatically those of dead cattle, fish, and fowl). The consideration of each genre is here offered as a step in an inductive sequence; each consideration requiring an acknowledgment, and each acknowledgment satisfied by a transformation in attitude or standing in relation to these paintings and their intentional objects. But, in fact, the induction is Soutine's, the considerations, tracking the connection among the genres, are a way of eliciting what his inductive argument was. In broad terms, his transcendental induction might be said to be for the sake of reinstituting the claim of "is living" as a material a priori necessary for the possibility of meaningfulness generally, of making good at least some of what Kant hoped could be retrieved in valid judgments of natural beauty. Soutine's method, so to speak, is to demonstrate an affinity or inner connection between the ruination of the represented object and its representing, so that the form of his painting, its formal insistences, just are its content; this is how pure painting and naturalism are intertwined in Soutine.

I have placed Greenberg's critique at the head of my account because it is appropriate to consider each inductive transformation as being accomplished through the overcoming of a resistance to the experiences in question.

It makes sense to begin with the figure paintings since those works lend themselves most easily to being considered "expressionist" in the conventional sense of the word. Elie Faure, Soutine's finest critic, comments: "An embryonic organism of Soutine—human face, clothing, landscape, still life—gives off a profound heat, which makes even the brightest flames of chromatic decorations look pale in comparison."[27] Ignore the slap at Matisse. Why designate human face or clothing as "an embryonic organism"? Assume Faure is making a recommendation about Soutine's grammar: the minimal representational unit of a Soutine painting should be considered as like an emergent (almost) living thing, hence not the thing it is or represents (a face or a bit of clothing). Since a pictured face is not a face, then even *qua* representation it must not be what it represents and is in its representing something else. Hence rather than thinking of there being an *oscillation* between paint and representation, the brush stroke that can also be seen as a flower, Soutine's distortions—the grotesquely large ears, the fervid red uniforms that seem to be choking or swallowing their inhabitants, mouths that appear to be moving across the faces of the persons whose mouths they are, or, in the *Self-Portrait* (1918) (Figure 3), "his impossibly red lips pushed forward toward the picture plane"[28]—have the effect of generating a new minimal level of visual meaning that even at the level of representation holds together, fuses, or makes visibly *simultaneous* the representation, the lips, and their being just, only, emphatically paint matter (see Figure 3). Achieving this fusion requires both a lowering and a lifting: nothing must "mean" by virtue of what it is (what it represents), but solely by virtue of its being painting. So there can be no privileged objects; faces and uniforms mean equally, are each embryonic organisms. But every embryonic organism is nothing but paint matter configured.

It is natural to say of Soutine's figures that they express the pain and suffering of their subjects. But while pain is the ambience of a Soutine, it is rarely its subject matter; his figures have none of the melodrama of *The Scream* or a Francis Bacon.[29] Rather it is because the ambience of these paintings is pain and suffering that grammatically the minimal unit of meaning becomes the embryonic organism. Distortion, an explicit form of negation, is not something Soutine does to a representational image; rather

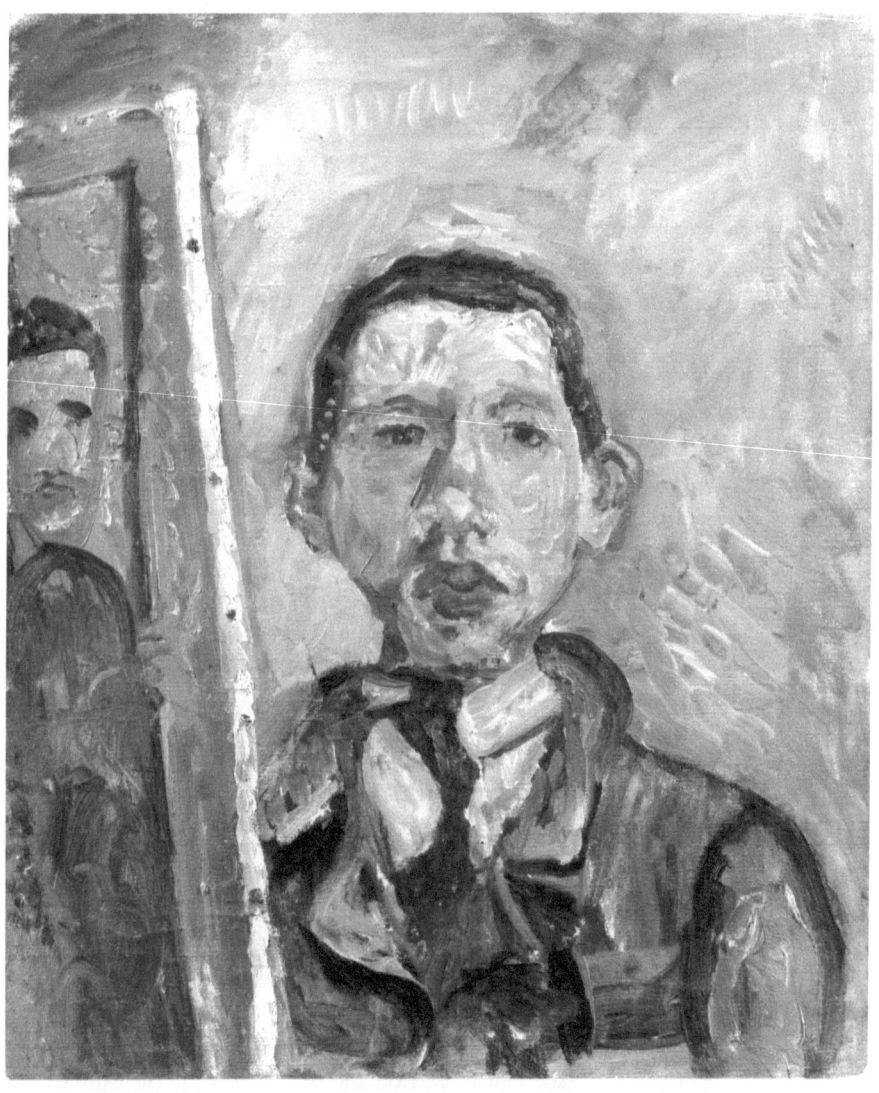

3 Chaim Soutine, 1893–1943, *Self-Portrait*. Oil on canvas; 21 ½ x 18 in (frame 31 ¾ x 28 in); 54.6 x 45.7 cm (frame 80.7 x 71.1 cm). The Henry and Rose Pearlman Foundation, Inc. Photo credit: Bruce M. White. L.1988.62.23.

distortion records the *fate* of an image, the damage history has done to it, to the point at which it sloughs off anything that might be held against it—against its honesty or integrity or authenticity—as a paint image. Distortion as painterly effort is intended as a self-overcoming of that effort so that the force of the image is not derived from its construction, but from the impossibility of construction, the excess of the image beyond what has been put into it. Distortion records the erosion or decay of the image to the point at which it is about to dissolve utterly back into pure paint matter, pure inorganic stuff. That the image holds, that we are still inclined to perceive the painting as a landscape, albeit like no landscape that anyone has ever seen or imagined, appears as if an intrinsic property of paint matter, *as a potentiality of it* rather than an arbitrary convention, an affinity between paint matter configured and its object. But still, and uneasily, it is paint matter that is meaning; each nexus of brush strokes is a paint image, like a twitch, cringe, or writhing. Here is Greenberg's account and indictment of the Céret landscapes:

The landscapes of this period, with their canted and skewed *Jugendstil* hills and houses, and their dark green, dark brown, tan-yellow cast, have force and originality, but do not stay in place the way pictures should. They do not "sit" decoratively. Their paint and handling can be savored, but not their unity, and without this we miss the final exhilaration which is the most precious thing in art's gift.[30]

The "heatedness," or writhing, of these paintings indeed does not let them sit decoratively. For Greenberg their failure of closure means, finally, that they are not "altogether retinal," and hence not altogether painting. The opposite of unity is not heterogeneity, though, as one would suppose, but "agitation" and lack of "quietness."[31] For Greenberg these images are not dead enough; they lack "reassuring unity," indeed attack it. The Céret landscapes insist on their furious record of decay as alone what can or should gain our assent: to assent to a fuller image would be to deny what history had already done to image and object; to assent to less would be to pretend that the threat was not mortal (see Figure 4). Soutine transforms the pleasure of the beautiful into our humiliation (a gasp of horror) before its disappearing.[32] But its disappearing—modernism's subliming of the tradition of the harmoniously beautiful—is a withering, decaying, writhing. So Soutine's paintings insist that there cannot be a "withering," "decaying," "degeneration," "collapse," "decomposition," "destruction," and on, of the tradition

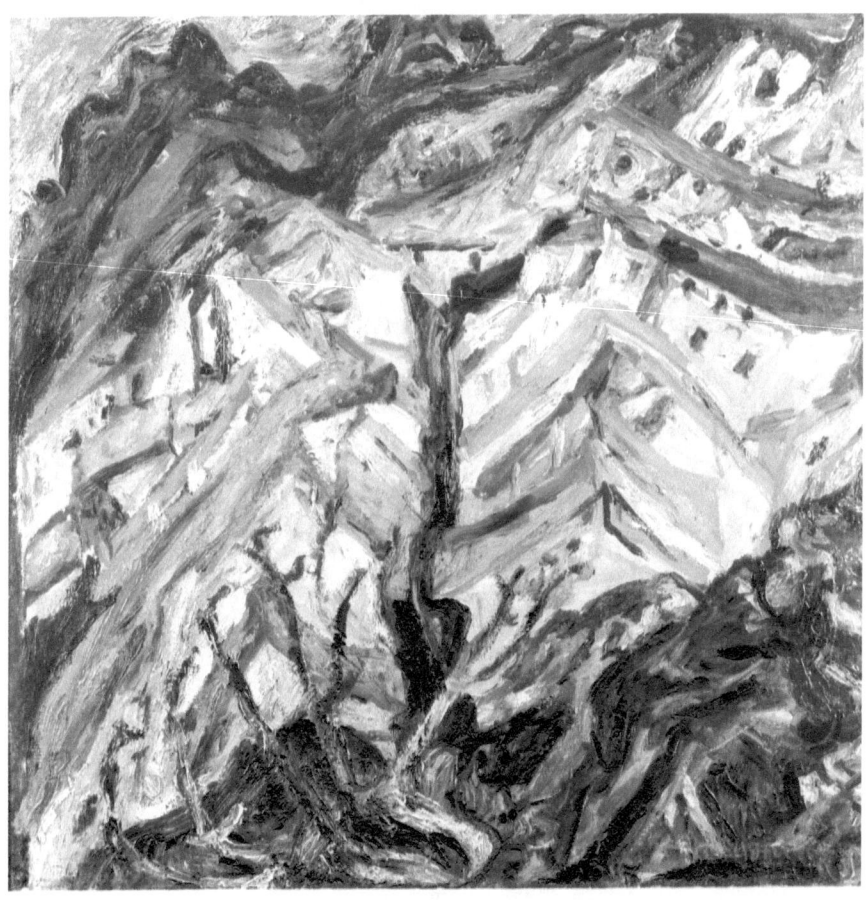

4 Chaim Soutine (Russian, 1894–1943). *View of Céret*, C. 1922. Oil on canvas. 29-1/8 x 29-1/2 in. © The Baltimore Museum of Art: Gift of Mabel Garrison Siemonn BMA 1960.57.

of meaning (beauty and harmony), in which those terms are merely metaphorically related to life and death, living and dying.[33] Put the thought this way: a part of the aesthetic *force* of harmony, Greenberg's notion of "reassuring unity," is that it replicates at the level of the painted image the kind of part/whole integrity that belongs to the organism—the living thing, above all the human body, as exemplary for part/whole relations in general.

Another part of the force of harmony or unity is, doubtless, that which belongs to the unification achieved through a point of view that emerges with perspective; and, almost certainly, as modern painting matured, this latter force of unification drove out of consideration organismic bodily associations. For Soutine, it is part of the problem that formal unity has aesthetically overtaken organic unity, and that the set of associations belonging to life and organism and body no longer belong to painting's inner life. He means to refashion the connection between organic and formal unity precisely through making the negation of the latter reverberate onto the former. "Heatedness" is not a sign of aesthetic failure for Soutine, but belongs to the grammar of painting. But isn't that incipient literalism equivalent to saying that the "embryonic organism," within painting and without, is the minimal unity of meaningfulness? What Greenberg then cannot bear about these paintings, and defends himself against at every moment, is their semblance of life: in seeing them he is, rightfully, mortified (experiencing the mortification that has already occurred), and rushes to treat his mortification as Soutine's aesthetic failure.

In further resistance against these works one might nonetheless complain about the landscapes that the decomposition of the images into paint cells—as if the whole of trees, houses, hills, and roads in being both radically skewed and thrown violently toward the picture plane become simply the dismembered parts of an unknown dying animal—is schlock decay, nothing but, via distortion, manner, mannerist, the production of a "decay effect."[34] Whatever one's hesitancy about the landscapes, it must halt before the testimony of the still lifes—as even Greenberg does before the 1925 *The Beef*. It is as if in painting his dead cow, horse, and ox carcasses, corpses of turkey, rabbit, and skate, the decomposition of the represented object offered no resistance to the painterly practice of decomposing, abstracting, flattening, and rendering into paint matter its image; that is, it is as if the *negations* that constitute the practice of modernist painting were just the process of decay of the organic into the inorganic in paint. In fi-

nally coming to the still lifes, Soutine found a subject matter in which his painterly violence to the image—anticipating in large and small much of what was to follow—was the form of fidelity required to the object, and by extension to the tradition. The integrity of the embryonic/decomposing organism, the paint-image carcass, say, is the condition of painterly meaning, of painting being a form of conviction and connection to the world. The capture of decomposing flesh, all that is left of nature, *is* the decomposing image. Hence what here places us in relation to nature is not likeness but the violence of decomposition operating on painting and object alike, in which the joining between them lies finally and by historical necessity in the synecdochical relation of paint matter (and its potentiality for imaging) to organic/inorganic matter. Or rather that synecdoche, and hence the acknowledgment of rotting nature as now *all* that survives of meaning (as the medium of human conviction and connection to the world) and as thus the "vital" necessary condition of meaning, is the truth-content of Soutine's work. The semblance of a wriggling fly, so to speak.

Greenberg's account of Soutine is instructive because its acute accuracy and degree of antipathy makes sense not as a misinterpretation but as a potent form of defense and resistance. And something is there to be resisted: in opposition to the belief that the material world is bracketed in pure painting (giving back to culture its authority), a Soutine canvas operates as a materialist reduction of meaning; all authentic meaning must acknowledge its material conditions of possibility, an acknowledgment that occurs through the *impossibility* of these paintings attaining pure or undiluted visual meaning. The ruin of "reassuring unity" in the decomposition of image into paint matter is how these works both mean and fail to mean; their exquisite moment of failure is their precise kind of meaning. What then gives the materialist reduction of meaning its force is the history that makes it, makes the acknowledgment of the decomposing organism as the surviving remnant from the rationalization of experience, the condition of the works' attaining authenticity or integrity. If I were to attempt to write a history of artistic modernism that followed Soutine, letting him be its pivot, its guiding thought would be: *modernist works of art mean the way a body in pain means.*[35] I understand abstract expressionism in Pollock, de Kooning, Still, Rothko, and the rest to be an austere continuation of this thought (via Arshile Gorky perhaps),[36] coming to self-consciousness (again) in the late-modernist works of Cindy Sherman and Gerhardt Richter. As mid-point in

this Soutine-inspired story, perhaps we should look again at de Kooning's woman paintings, their ghastly vitality like a Medusa's head turning all who perceive them into stone.

VII. Mediums as Reason Materialized

To reprise my premise: Nature dematerialized and human subjectivity deprived of worldly substantiality in their interaction and reenforcement of one another form the two struts supporting the various rationality crises of modernity to which it is proposed that artworks and the reason they exemplify might somehow be a response. If artworks are going to be a response to this crisis, to project or insinuate or promise or exemplify a resolution, then they must suspend the dematerialization of nature and the delegitimation of its voice, on the one hand, and reveal the possibility of human meaningfulness being materially saturated and so embodied on the other.

The hypothesis that has begun to emerge through the material stresses of Soutine's painting, in the inner affinity between paint-stuff (pigment) and the materiality of the object represented, is that the core of art's rationality potential relates to the role and status of artistic mediums. By mediums I will henceforth mean, minimally, the material conditions of a practice as they appear to an artistic community of producers at a given time; so, the medium of an artistic practice is the disposition of the material conditions of that practice at a given time, and thus materials are the conditions of possibility for making works. The medium(s) of sculpture at a given time would include not just the raw materials thought acceptable for sculpting (wood, marble, etc.), but what *kinds* of things are required to make stuff like that into works, what things minimally can or must be done to that stuff in order to transform it into a work, hence what potential for making works is perceived as lying in those materials as projected onto them in the practices through which they are shaped.

Working in a medium is working with a material that is conceived of as having a potential for sense-making in a manner that is material-specific. In art the medium is not a neutral vehicle for the expression of an otherwise immaterial meaning, but rather the very condition for sense-making. *The specificity of (modern) art-meanings is that their mediums are not regarded as contingent with respect to the meanings communicated*; if that were so, if the medium were there merely as an instrument, a means, for con-

veying a meaning (an end) indifferent to it, then the work of art would disappear once the meaning it conveyed was grasped. But this is precisely what we think is not true for the sense-making that occurs in works of art. Art-meanings, the kind of meanings artworks have, are nondetachable from the medium through which they are embodied and communicated: the too vibrant redness of the paint is the ghastliness of death itself in the Albright-Knox *Carcass of Beef* (Figure 5).

Artistic sense-making, then, is making sense in a medium. So mediums are the potential for sense-making. But since mediums are at least certain types of materials (as conditions of possibility for sense-making), then mediums are those materials, hence matter conceived of as a potential for sense-making. Since art is a kind of sense-making that is medium dependent, and mediums are aspects of nature conceived of as potentials for sense-making, then art, its reason, is minimally the reason of nature as a potential for sense-making at a certain time. If artworks make a claim at a particular time, then at that time nature is experienced as possessing a material-specific potential for sense-making. Hence the experience of a work as making a claim at a time is to experience the dematerialization and delegitimation of nature as suspended. Or rather, that is how we come to understand and experience uniquely modern, autonomous works of art; and, in time, it is the claim that self-consciously modernist works make for themselves. The idea of an artistic medium is perhaps the last idea of material nature as possessing potentialities for meaning, or, more accurately, as Soutine surveys, as remnants of sense-making, as materials about to lose their potential for sense-making, as the decay of material meaning, as the material a priori of sense collapsing, as the dissolving, fragmenting, folding in on itself of reason materialized in things.

Working from the other side: in modern works of art, freedom, the human capacity for autonomous sense-making, *appears*; that is, artworks are *unique objects* that as unique sources of normatively compelling claims are experienced as products of freedom, as creations; their uniqueness and irreducibility are understood and experienced as the material mark of an autonomous subjectivity. In autonomous works of art, human autonomy appears; the autonomy of the former figures the autonomy of the latter. Beauty, Schiller will tell us, is freedom in appearance. But the material bearer of appearing freedom cannot be neutral or indifferent, a mere occasion through which a meaning indifferent to its material substratum is

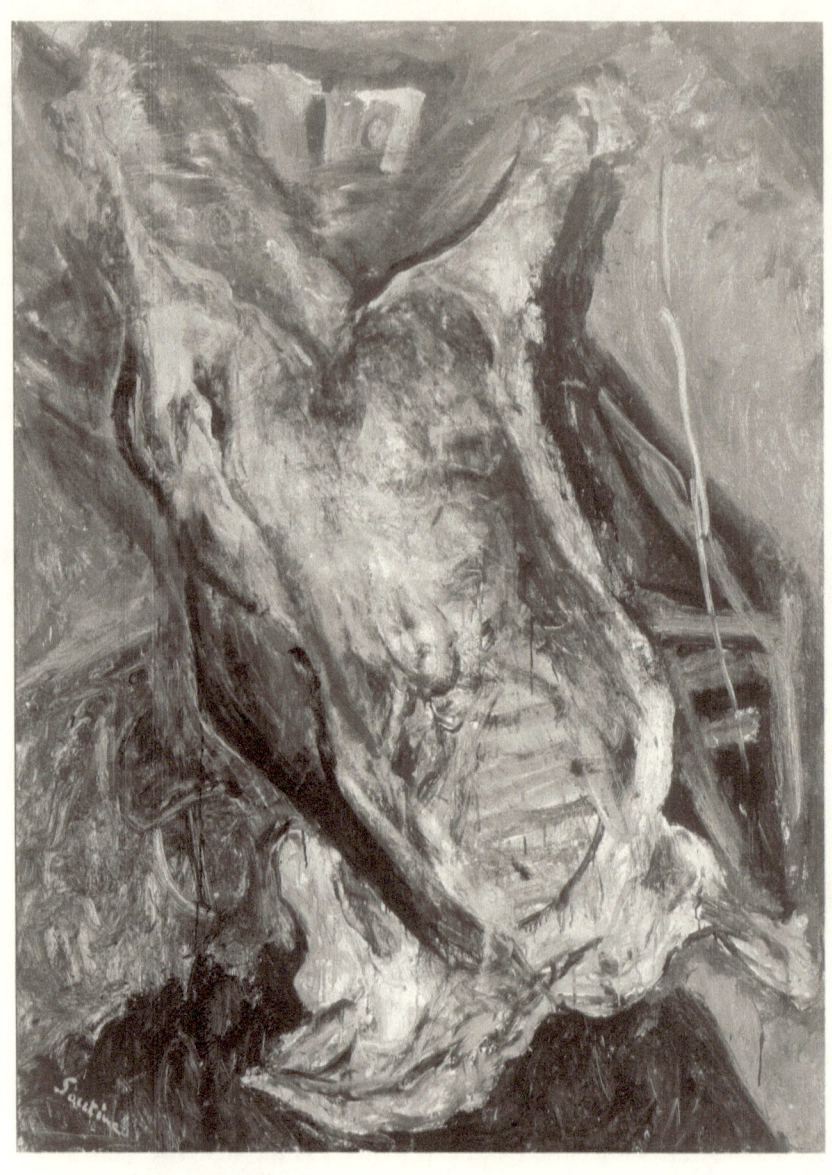

5 Chaim Soutine, *Carcass of Beef*, ca. 1925, oil on canvas, unframed: 55 ¼ x 42 ⅜ in (140.33 x 107.63 cm), Albright-Knox Art Gallery, Buffalo, New York, Room of Contemporary Art Fund, 1939.

transmitted. If meaning is indifferent to its material bearer, then freedom is not so much *appearing* as merely being transmitted. For freedom to appear, it must be *embodied*; but if truly embodied, then there must be an exchange between matter and meaning, a way in which "that" matter enables "that" meaning to be the meaning it is. So for freedom to appear, nature must be truly amenable to human sense-making, implying, again, the idea that a medium reveals nature as a potential for sense-making.

In modern autonomous works of art, nature in the form of an artistic medium appears as meaningful (for example, the compellingness of modernist paintings derives solely from paint-on-canvas and not from conventional codes or representational illusions or culinary delight), and human sense-making is absorptively present in what is nonetheless simply a useless (purposive but without a purpose) material object. Artworks suspend, displace, sublate, sidestep, ignore, and contest scientific, instrumental, formal reason and formal (immaterial) moral rationality. Because formal reason really is constitutive of empirical rationality, then what contests it is nothing empirical. So what makes artworks *only* appearances, semblances, is that they abrogate the conditions that make empirical experience, cognitive and moral, possible. What makes such appearances substantive in their own right is that they reveal, however we construe the status of this revelation, through the compellingness or demandingness of the works, a rationality potential excised from the (normative and/or transcendental) repertoire of modern self-consciousness.

3

Modernism as Philosophy: Stanley Cavell, Anthony Caro, and Chantal Akerman

In his criticism, the philosopher Stanley Cavell has always proclaimed an intimacy, at times amounting to a virtual identity, between the *logic* of aesthetic claiming (the logic appropriate to our claims, evaluative and interpretive, about works of art and, by extension, the logic of those works, their claiming) and the *logic* peculiar to ordinary language philosophy ("what we say when" and "what we mean when we say it"). Cavell also states that artistic modernism "only makes explicit and bare what has always been true of art" (MD, 189),[1] entailing that now what we think of aesthetics, and so of art, is bound to artistic modernism. Holding on to the first identification of aesthetic claiming and philosophy, this would associate or identify the logical form of modern philosophy—its forms of writing, argument, claiming—as forged paradigmatically in Wittgenstein's late writings, with the logical form of modernist works of art, with their modes of claiming and authenticity. Analogously, at the close of *The Claim of Reason*, Cavell mourns Othello and Desdemona, finding in their fate something that philosophy must be capable of—call it acknowledgment—but that, ever since Plato banned the poets from his ideal republic, philosophy has banned from its precincts. So much is implied both by the analysis itself and by Cavell's statement that "tragedy is the story and study of acknowledgment, of what goes before it and after it—i.e., that the form of tragedy is the public form of the life of skepticism with respect to other minds" (*CR*, 478). In light of his demonstration of the entanglement between the philosophical problem of skepticism and the role of acknowledgment,[2] Cavell wonders whether

there is space in philosophy for Othello and Desdemona, their fate: "But can philosophy accept them back at the hands of poetry? . . . Perhaps it could if it could itself become literature. But can philosophy become literature and still know itself?" (*CR,* 496). Whether this is meant as a specification of the earlier claims or as an addition is, even in context, difficult to say. At any rate, I presume that these claims of virtual identity betwixt philosophical and aesthetic forms of claiming, betwixt the position of modern philosophy and artistic modernism, and betwixt philosophy and literature, at least at the level of logical form (whatever that means here), are deeply puzzling if not immediately repugnant.

Let me flesh out the puzzle a little, letting the repugnance take care of itself. In making his claims of association or overlap or logical homology or analogy or virtual identity (which is it? is there a difference to be drawn here?) betwixt the logic of philosophical and aesthetic claiming, philosophy and artistic modernism, philosophy and literature, Cavell must be regarding art or literature transcendentally; that is, he must be thinking that art of a certain kind reveals, at least, some necessary conditions for the possibility of there being objective significance, or meaning, at all.[3] Hence the import of art or literature is not given directly by its practice (or the canon that catalogues it), but by what is revealed through it or exemplified by it.

So, in a first step, Cavell must believe that there is an unrecognized or misinterpreted and suppressed transcendental claim lodged by some artworks that, at least heretofore, has arisen only in relation to them, or has been more perspicuous (surveyable, intense) in them than elsewhere. Some artworks represent a privileged locale or a possibility for the intensification or exhibition or dramatization of a certain kind of claiming that is, when seen aright, necessary for the possibility of objective meaningfulness *überhaupt.* But if there is going to be any necessity in philosophy associating itself with art, a second step, then the relevant artworks must be raising more than just any old necessary condition for the possibility of objective meaningfulness (that there be meaning and mattering generally). Rather, it must be one that is explicitly and self-consciously embodied in philosophy, if philosophy is going to be objectively meaningful; the condition can be satisfied only if self-consciously satisfied. It is not enough that philosophy be able to point to the transcendental condition of meaningfulness that art exemplifies; the worth of its own claiming must depend on it too exemplifying that transcendental condition.

A final twist, then, becomes: If philosophy must exemplify the same

transcendental condition that it reveals artworks to exemplify, what becomes of the difference between philosophy and art (literature)? In pointing to the transcendental significance of certain works of art and coming to recognize the generality of the demand that that notion of transcendental significance implies, is there any space left for philosophy beyond flagging its own emptiness and ceding all to art? (Think of this as philosophy's long good-bye.) Or, if philosophy did manage the trick, did manage to exemplify the condition of meaningfulness it shows to be transcendental, would the product still be recognizable as philosophy? Does this matter? Why? What is the difference between the two final possibilities?

I take it that these questions begin to flesh out the open question with which Cavell concludes *The Claim of Reason*—that that and my questions are open because philosophy has not yet attained to the condition that would satisfy the demands on it or completed its long good-bye or become utterly irrelevant. To the extent to which Cavell has meant his writing to satisfy those demands, its sense and worth remain unsettled and the debate over it, exemplary or empty, unresolved. I take the claims identifying philosophy with aesthetic claiming or literature to be repugnant when heard as courting emptiness, as evacuating precisely the space that philosophy aims to fill. In a more restrained mode, one will find Cavell's claim repugnant just in case he fails in distinguishing philosophy from art. Cavell's general answer to this dilemma is to demand that his philosophizing be responsive to the history of philosophy, and that it be in dialogue with analytic philosophy (contemporary Anglo-American philosophy as dominantly practiced) in ways that are relevant to the latter, hence in ways that analytic philosophy might, ideally, be brought to recognize. These are not demands that any modernist painter or novelist or poet need feel. That Cavell's kind of philosophy should *recognizably* remain in relation to the tradition and practice from which it departs makes the conditions for success internal and external: recognition is necessary. It is this issue of recognition, internal and external, that Cavell also had in mind in his closing question.[4]

While he was composing Part IV of *The Claim of Reason*, Cavell increasingly came to associate the bundle of claims concerning the relation between philosophy and aesthetics/modernism/literature as having its natural home in Romanticism, literary and philosophical.[5] In its critique of scientism, industrialism, and mass culture, Romanticism anticipates modernism; modernism, in turn, extends Romanticism's project for cultural re-

newal via the renewal or transfiguration of meaning; and it might prove enlightening to compare modernist practices formally with those of German Romanticism, in particular their use of the fragment to exhibit the reflexive awareness of human finitude and its liabilities (fragments as exemplifying the finitude of thought).

All this is to say that there are deep and unexplored affinities between Romanticism and high modernism, that the latter can appear as the severe and self-consciously mortal continuation of the former.[6] Nonetheless, since Cavell's relation to Romanticism is a topic in its own right, I will restrict my observations to those texts most pertinent for unlocking the conceptual puzzle of broadening and reforming philosophy as aesthetic in its claiming, modernist in its condition, almost literary in its particularity, intimacy, and need for self-dramatization. There is an appropriateness in so doing, since, arguably, the specificity of Cavell's philosophical oeuvre is its demand that philosophy too attain to the modernist condition (having done so already in the writings of Wittgenstein), that it recognize that only a modernist philosophy can be an authentic one here and now. Everything else—the Romanticism, the business about American philosophy, and so the role of Emerson and Thoreau in his oeuvre, the particulars of his Shakespeare or movie criticism—is all either an inflection of or secondary to or a separate country from the claim for a modernist philosophy.

Cavell's aim, sometimes explicitly, more recently only implicitly, has been to bring philosophy within the precincts of modernism, and routinely his own works' mode of claiming is only intelligible if interpreted in modernist terms.[7] I will begin with a précis of "Aesthetic Problems of Modern Philosophy"—the title gives away the content—and go on to elaborate Cavell's account of modernism in "Music Discomposed," "A Matter of Meaning It," and *The World Viewed*, Chapters 14–19, before turning to the question of how his philosophy is meant to exemplify what it characterizes as modernism.

Aesthetics: Logics of Material Meaning

Let me caricature the philosophy that Cavell means to transform (it does not much matter whether this characterization is accurate or a straw man, since the opposing burden, what philosophy must become, remains the same). Philosophy is to be an underlaborer to the natural sciences, in the

triple sense that it should underwrite (by reforming our everyday understanding of the world accordingly) the naturalist and materialist vision of the world that, above all, mathematical physics projects; that it should secure the methodological procedures of natural science as the sole rational procedures for securing knowledge of the world; and that it should in its own practices, therefore, to the degree to which this is appropriate and possible, embody the very methodologies of natural science that it secures. In response to this last charge, modern philosophy, formally, should conceive of its activities as those of problem-solving; the problems to be solved and methods of solving them should be impersonal, value-free, and hence formally universalist; solutions therefore should be a consequence of logically valid arguments that ideally can be expressed in perfectly deductive form. One can consider this philosophical ideal type as the ghost in the machine of modern philosophical culture, philosophy's self-imposed superego. It is this ideal type that has repressed aesthetic problems.

Aesthetics should not be regarded as essentially about the nature of art, about talk about artworks, or about an arty and empty way of seeing ordinary things (aesthetic perception); nor is it a logic of the beautiful, whatever the beautiful is. It has been understood in all of these ways. Each of these ways of characterizing aesthetics seems to me a good reason for ignoring it (unless one happens to hang out in art galleries, libraries, or musical gatherings, or spend time squinting at sunsets). This is why I began by expressing the *stakes* of aesthetics, modernism, and art/literature in transcendental terms, that is, in terms of the necessary conditions for cognition, meaning, reason.

As a first approximation, let us say that, often unknown to itself (albeit not in Kant or Nietzsche) and in league with the modern drive to distinguish meaning and cognition from psychology, to undo the psychologizing of logic and knowledge, aesthetics has been a mode of depsychologizing psychology (AP, 91, 93), indeed the great attempt to do so before Freud. So aesthetics has been a mode of revealing how the apparently merely subjective aspects of knowing or meaning (say sensing and feeling) are not merely so (not merely psychological), but somehow ingredients *in* objective knowing and public meaning that cannot be fully left behind. The familiar distinction between appearance and reality as one between first- and third-person perspectives—how things stand (look, feel, seem) to me versus how they are for everyone (including me)—makes psychological life

the opposite of logical life and hence its enemy, what must be overcome or suppressed if logical life is to be achieved; this duality must be overcome if objectivity is going to be possible at all. So aesthetics concerns, speaking crudely and indiscriminately, the sensible conditions of knowing and meaning, which is to say, sensuous or material meaning: the sensuous element of perceptual claims, and the perceptual element of objective cognitions; the subjective but not private conditions for objective knowing, what can be known only in sensing (MD, 191) or only known in or by feeling (MD, 192). Or, say, aesthetics explores the discursive expression of the logic of experience, the necessities of experience for meaning, which the making and judging of artworks reveal (because they crystallize them). At a metaphysical level, aesthetics so understood entails not only that every universal must be instantiated in some particular (the Aristotelian claim), but also that the particular logically precedes the universal because universals come to be (the Hegelian claim); aesthetics further entails that no universal can be valid unless self-consciously asserted, reflexively embodied and proclaimed (the Kantian/Heideggerian claim).[8]

These are the transcendental claims that aesthetic claiming raises or presupposes or makes perspicuous. Insofar as modern philosophy takes for granted the protocols of its ideal type, then they have been repressed; and because they are repressed, they are the source of the aesthetic problems of modern philosophy—aesthetics as the problem for modern philosophy. The fact of aesthetics, if seen aright, makes the orientation of modern philosophy as specified by its ideal-type formulation perverse, and because perverse, irrational.[9]

Following the lessons of Kant's *Critique of Judgment*, Cavell approaches these problems sideways on, namely, through an exposition of the peculiar logic possessed by evaluative judgments concerning works of art. Kant says that judgments of taste of the form "This is beautiful" are reflective assertions of the pleasure one takes in particular objects or states of affairs that, without the mediation of concepts, without being subsumed under a concept—say the concept *beauty*—lay claim to intersubjective validity. Reflective judgments of taste, Kant contends, "demand" or "exact" agreement from everyone, and everyone "ought" to give the object in question approval and pronounce it beautiful (e.g., *CJ*, §7, 213; §19, 237). However, since there is no fact of the matter (seeing something as beautiful is not like seeing it as red), and there is no universal principle (seeing something as

beautiful is not demanded the way that respecting others is demanded by the moral law), then the aesthetic "ought" is neither an ideal prediction of what others will say nor a statement of fact to which they must assent on pain of not being one of us at all, nor a moral obligation deriving from antecedent principle. Cavell elaborates the oddness of such judgments in terms of patterns of conflict and argument.

When I judge the gravy too thick and gooey, and you find it just right, hearty and rich, there is no reason to think that our different judgments, reflecting simply what we like or prefer, should not be decisive: what is pleasant is what we find pleasant.[10] When gravy is at stake, pleasure and its tasty cohort remain subjective and psychological. In reflective judgments of taste, matters are different. I say that I found his playing beautiful. You respond aghast, arguing with me that "there was no line, no structure, no idea what the music was about. He's simply an impressive colorist" (AP, 91). How might I respond? I could respond in kind, pointing to aspects of the playing that I took to express sensitivity to line and structure; or I could complain that what you call colorist playing I think of as romantic sweep. As I shall document directly, substantive argument—and not mere rhetorical jostling—is possible. Or I could say, "Well, I liked it," but in so doing I would be backing off from my original claim—the assertion of the playing as beautiful, which reflectively raises or lifts my pleasure in the playing to one appropriate to or deserved by the object and so demanded of everyone—and retreating to personal taste, as if the playing were so much gravy.

We have a sense of the significance of reflective judgments of taste just in case we do hear in the "Well, I liked it" a retreat, just in case, that is, the issuing of the statement of mere preference is heard as a way of withdrawing engagement with either the object or you, and so a collapsing into subjectivity: walking away.[11] There are costs to such a retreat. If it is a typical response by me, it may mean my being discounted by you in all matters musical. But that may be tolerable to me and to you. It may be a little thing, which is to say that retreat in such matters to mere preference or liking is not impossible, not something obviously unbearable, and that it is not obviously so is part of what is logically announced in the demand's being oughtish without the full force of a moral imperative, factual without the full force of an empirical predication. (In a different mood, my continuous retreat to preference may make things intolerable between us—which is also in need

of explaining since whatever is "intolerable" here had better be quite other than our wishing to go to different restaurants on Saturday night.)

Here then is the curious pivot of such judgments: they claim objectivity, they aim to speak with a "universal voice," for everyone, and thus demand that others see things in the same way. Yet there is no matter of fact or reason (no concept or principle that my judgment comes under) that grounds any such judgment and thus empirically or logically necessitates that others make the same judgment. Because there are no ultimate grounds for judgment, retreat is possible; because retreat is possible, the judgments themselves may appear somehow systematically vulnerable, and because vulnerable, not really objective (rational and cognitive) but merely psychological. It is not an accidental feature of aesthetic judgments that they have been misrecognized as being merely psychological in character: their form of universality, in its inability to prove itself, makes them vulnerable to this form of dismissal. Conversely, Cavell wants to assert that the import of such judgments is proportional to their vulnerability: it is because such claims are universal but incapable of proof that they have the relevance they do. How might that be?

Aesthetic arguments are possible. I can give reasons for my claims, offer evidence, provide analogies from like cases, construct a narrative linking the work under consideration to what preceded it, and so try to make its features more intelligible. These structures of support are not mere auxiliaries to aesthetic judgments: part of what constitutes them is that they are subject to distinct patterns of support, refutation, affirmation, and dismissal; without these, without the relevant body of criticism, interpretation, and history, aesthetic discourse and judgment would be impossible (unrecognizable). The rub here is that apparently valid trains of argument do not entail or compel the conclusion: this is beautiful. It is this detachment that can make the judgment itself look, at best, logically disconnected from what supports it, and at worst, merely psychological, as if all the arguing were just trying to get the other to feel a certain way. Which is half right: I do want the other to have a certain sensed/sensory/feeling *response* to the object, but that response will matter only if it is, fully and properly, a response to the *object*, a response called down by appropriate sensitivity and/or cognitive alertness to what is there—which is what all argument, interpretation, and criticism are about.

Let's say that in logic (in empirical inquiry), the goal is for me to sur-

mount my subjective response to what is there in order that there be no gap between valid argument and agreement in conclusion; and learning the logic of empirical inquiry, being inducted into it, internalizing it, is just the way one learns to discount subjective response, letting pattern (of argument and support) and agreement (conclusion) become perfectly aligned. In matters aesthetic, the ambition is otherwise: "The problem of the critic, as of the artist, is not to discount his subjectivity, but to include it; not to overcome it in agreement, but to master it in exemplary ways. Then his work outlasts the fashions and arguments of a particular age. That is the beauty of it" (AP, 94). The reason there is a dislocation between patterns of support and convergence in a conclusion upon which all can agree in aesthetic matters is that the structure of empirical features constituting the object judged—its being composed of just these sounds, in this order—is *also, at the same time*, a structure or order or logic of feeling that demands or calls for a certain (sensuous) response in the hearer. So works of art, in the mastering and including of subjectivity in their construction of an empirical whole, align or mean to align how things are and how they strike one, how we feel in knowing them and know in feeling them. Because feeling here is neither simply nor immediately causally triggered, like the taste of gravy, nor mediated by a concept, like the empirical features of the object, but a feature of the object that—normatively? meaningfully?—calls for a response of a certain kind, then there is the gap, the gap between pattern and agreement, the gap that permits the retreat into mere preference. It is this gap that makes the demand that something arise from me, while presuming an intersubjective validity as thoroughgoing as the one attending a simple empirical judgment of a matter of fact, that nonetheless can fall into an abyss ("the risk of isolation," AP, 89) without that fact obviously impugning the rationality or moral standing of either me or the other. The marker for the gap in aesthetic argument is the moment the critic stops arguing, stops offering discursive support for her claim, and offers *her testimony* as the last ingredient: "Don't you see, don't you hear, don't you dig. . . . Because if you do not see *something*, without explanation, then there is nothing further to discuss" (AP, 93).

Here Cavell explicitly aligns the situations of the artist and the critic: both must master and include their subjectivity, and their doing so amounts to producing an exemplary object (work of art, piece of criticism). Criticism, as the communication of one's experience of the work of art, "is itself

a form of art; the burden of describing it is like the burden of producing it" (MD, 193). Criticism is thus a mechanism for crossing the gap between argument and agreement (without filling it in or obviating it). As Mulhall nicely states the thesis: "What bridges the gap between the imputation of agreement and its realization . . . is the controlled deployment of subjectivity. . . . The good critic . . . by speaking for herself as honestly and accurately as she can . . . discover[s] that she can speak for others."[12]

As I shall suggest later, there is very little in what Cavell wants from criticism or philosophy, or for that matter from ethical action conceived of in his Emersonian perfectionist terms, that is not captured by the idea of mastering and including subjective response through making it exemplary. One could, I suspect, recover a good deal of what is most structurally challenging in Cavell's thought through the logic of exemplarity.

Thus far I have attempted no more than to make perspicuous the status of reflective aesthetic judgments as Kant and Cavell conceive them, underlining the peculiar gap between support and agreement that makes the demand for agreement, the claim that one is speaking for everyone and so with a universal voice, both plausible, even unavoidable, and presumptuous. Such a demand is an inflation of one's own response into the necessary condition in which a feeling response to an object must be manifest if it is to have a meaningful objectivity. This means that there must *also* be a solidarity, *as if* we could not speak coherently about the world unless and until we were attuned to how it felt, to what kind of human import or significance it had. It is this side of aesthetic universality—our agreement about meaningfulness, or the conditions of meaningfulness—that is focused, rehearsed, worked through, and dispensed in the making and reception of artworks that can make a retreat into mere preference intolerable; we cannot speak to one another because we cannot trust one another to respond appropriately. Art and criticism solicit a convergence between fact and significance; the precise calibration of the depth, scope, and complexity of that "as if" is what the effort of Cavell's philosophy is about.

What We Say When

It is no wonder that, having limned the logic of aesthetic reflective judgment, Cavell goes on to urge that, with a slight shift of accent, Kant's notion of a universal voice is what we hear recorded in the philosopher's claim

about "what we say when," although the philosopher's claim depends on "severer agreement" than is borne by the aesthetic analogue (AP, 94). Let me risk an example. The traditional philosopher, glancing over his shoulder at the achievement of Newtonian physics and its successors, will claim that everything in this world and the next must be subject to causal explanation under universal law, including human action. But this infringes on the presumed freedom that distinguishes the mere movements of things from human action proper, and thereby on the possibility of human action being a domain in which moral predicates might have a grip, since they all presume that one is responsible for what one does and that there is no responsibility without freedom. So the terrible debate between freedom and determinism begins.

The ordinary-language philosopher sees the very raising of the problem as a work of alienation, of imposing a demand for absoluteness upon a concept (AP, 77): actions must be either free or determined. So the ordinary-language philosopher is going to remind the traditional philosopher of the contexts in which the notions of freedom and determinism, actions as voluntary or involuntary, have their purchase. I am standing by the tap, pouring myself a drink of water. You come in and ask if I am doing so freely. How curious, how bizarre a question. Would I, without further ado, know how to begin to answer it? I might say, nervously, "I was thirsty." Would that help you? You might think that shows the action was determined (by my thirst). But that is a view I find curious: although I was having the drink because I was thirsty, I might not have bothered relieving my thirst, I need not have, or I might have slaked it otherwise, with a beer. You might now press me as to whether I really could have done otherwise. I insist I could have. You insist that I could have only if I had then wanted to, otherwise not. I feel hemmed in, as if I can only prove to you I am free by proving I was so in the past—that I could have done otherwise—knowing that any such proof will be interpreted by you as showing I could not have done differently given the desire I acted upon. And what should I do now? Scream?

We can see where this dialectic is going: everywhere (the whole debate over freedom and determinism) and nowhere. But that is because your original demand was untoward. If there was nothing particularly fishy about my pouring myself a drink of water (say because you just saw me finish a beer), why would you ask whether I was doing so freely?[13] You think there is question, but from where does that question come? When an ac-

tion is asserted to be free, isn't it because that action *in that context* might be impugned: Did you really mean that insult? to trip him up? to leave the children behind? To assert that one acted freely in these cases might be required because they are so untoward (we hope he wasn't acting freely). Without contextual specification, requiring that an action be classified as free or determined, voluntary or involuntary, intentional or unintentional, places a demand on the general intelligibility of action to which only action*s* can respond. As if we could know what action itself is apart from the different actions we take; as if actions might be meaningful or meaningless in general apart from the specific ways they acquire or have meaning, and the manifold ways in which they can be found meaningless (empty, pointless, without progeny, without benefit or utility, without hope, mad, alcohol-induced, hormone driven, etc.).

The ordinary-language philosopher claims that "we say" an action is free (or determined) only in contexts in which, for whatever reasons, a concrete and particular question about that action in that context arises over whether there is something fishy about it. Outside of such contexts, the concepts *free* and *determined* lose their meaning. My evidence for this, however, is not head counting or a matter of empirically checking whether people really do say that then (meaning what? most of the time? would 51 percent of the time be enough?). Instead, my evidence comes from checking or testing my own intuitions on the matter, which here are exemplified by the narrative of my water-pouring. If I can convince you that there is something untoward in the very demand to classify my action, then we are on our way to dissolving the debate over freedom and determinism—which does not lessen our caring about freedom, but preserves it by placing it where it belongs. As in the aesthetic case, there is a gap: I cannot prove the untowardness of your requesting a determination of my water-pouring, however bizarre, forced, groundless, or pointless; hence I cannot prove, demonstrate from agreed empirical premises to a logical valid conclusion, that contexts saturate meaning with respect to freedom and determinism; nor can I prove that there is not some general metaphysical, cosmic issue that gets raised by Newtonian science. I can only hope to show you how we satisfy ourselves in particular contexts over this question ("there was a gun to my head when I said it"; "I was pushed"), and thus hope to show you that without such a context nothing will seem to answer the question. And without the hope of getting an answer, maybe you will find yourself able to stop asking the question.

"Severer agreement" than in the case of aesthetic judgments is demanded here because we are not talking only about our response to one object, but about how the community as a whole will regulate its use of a fundamental concept; this means that there is less room for retreat to personal preference without coming to find one another unintelligible. If you and others ignore my universal voice in this case, and carry on your metaphysical debate, and thence decide that all action must be determined, then, well, I dread the consequences, and dread this community. Maybe I must walk away. But to where? Where does Nora go at the close of *The Doll's House*?

In the Austin (Strawson and Arendt) dissolution of the determinism debate, the analogies with aesthetic judgment are vivid; but there is also, at least here, the appearance of a troubling disanalogy. What gives weight to the aesthetic cases is that the gap caused by the fit between empirical structure and its being a structure of sense (a mastered and projected or objectified subjectivity) calls for a particular subjective response. In the case of freedom, I must judge that the question about water-pouring without anything fishy is not really intelligible, that despite the grammatical impression of a well-formed sentence, we have no way of using the concept *free* without a particular background of fishiness and thus potential "unfreedom." But in this case it is the regularities of usage that displace the convergence of empirical structure and the logic of sense in the aesthetic case. And this seems illegitimate since it is not clear why *we* should not invent a new context for using the concepts of freedom and determinism—namely, a general metaphysical one; after all, there is the fact of Newtonian physics and its claim to universality. Does not that create a new context of usage? If meaning is use, then why cannot we manage more extensive and original uses? Is not the claim of ordinary-language philosophy, its so-called universal voice, just the reifying of old practice and the damning of new usages?

To answer this question the ordinary-language philosopher needs to deny that the source of the normative force that his universal voice aims to express is in any way disanalogous from the aesthetic case; *he too is tapping a joining of empirical structure and affective significance that itself demands a particular kind of cognitive and feeling response.* What the ordinary-language philosopher presupposes is that the experience of fishiness that calls into play the explaining of an action as free or determined is one of the fundamental ways in which we register how actions matter; so the mattering of action, its significance, is registered in the feeling of fishiness that thence

gets responded to appropriately (with excuses, justifications, explanations, exculpations, confessions, affirmations, etc.). So the claim about "what we say" *is* a tracking of a complex and yet general jointure of empirical structure and affective significance; and without that jointure there is no question to be asked about actions. Affective significance is not only a matter of how one feels, but also a matter of feeling as evaluating, of things being objects of care, concern, worthy of attention, having claims, claiming us.

In discounting the question of how actions *strike* us, the traditional philosopher supposes that the metaphysical/cosmic question of freedom and determinism is a value-neutral question. And the ordinary-language philosopher urges that, at least as yet, we have no utterly context-free, value-neutral conception of human actions to which the predicates *free* or *determined* might apply; on the contrary, calling some actions free and others determined (so barely actions) are just ways of registering the significance of actions; they are part of the evaluation of actions. None of this is meant to deny that concepts can be extended and new usages developed; it is to claim that the traditional philosopher has not done so in the case of freedom and determinism because he has failed to notice how those terms get their significance in the first place. And the traditional philosopher will *never* be able to register that significance until it is agreed that claims for significance can be sustained only with patterns of argument and agreement that are aesthetic.

Modernism

Usages embody the same kind of jointure or convergence of empirical structure and affective significance that artworks do, and they do so because they are a record of our responses to such jointures—of why we say what we do when we do. The ordinary-language philosopher can be a sounding board, so to speak, manifesting the entwinement of how things are and how they mean, as that entwinement is registered in those usages in which our commitments are most staked, which can be just about any word at any time. This can be misinterpreted as a comforting picture, one that imagines the philosopher as the voice of traditional wisdom in a traditional society.[14] Nothing could be easier than knowing what "we think" in a society in which there is no space for dissent, disagreement, collapse. There, what "we think" is all there is to think, and it is the task of parents,

elders, priests, the transmitters and voices of traditional authority, to police those who would use words out of place. The comforting picture does not imagine the philosopher at all because, in a homogeneous traditional society, one presumes that the role of the philosopher is unnecessary. "What we say when" and "what we mean when we say what we do" can be philosophical matters only when there is no traditional authority establishing "what we say when" and hence only when there is a crisis of authority.

What the analogy between philosophical and aesthetic claiming does not establish are the conditions in which that analogy might come into force, how a culture might need a philosophy like "that." And Cavell's answer is: a culture will need a philosophy that models itself on the claiming of works of art and the claims appropriate to them at the very moment in which artworks themselves must self-consciously claim that capacity for themselves. Call this the moment of modernism.

Modernism is what happens to art under conditions of modernity—after the gods have died off or slinked away or been murdered, thus after traditional authority has withered, and thus after the traditional forms of art have been found to be somehow merely conventional in their authority, have stopped being forms through which we might "depict our conviction and connectedness with the world" (*WV*, 117); we have discovered that the task of making sense of our standing in the world is somehow wholly up to us. Modernism is the moment in which we no longer have clear criteria for what constitutes a new work of art: neither tradition nor pure reason can determine what a poem or a painting or a sculpture or a musical composition is. But if these things are not known a priori, before we attend to or produce a work, then we also do not know what art is. And not knowing what art is means that the very domain of the aesthetic is not known or knowable in anticipation of all possible works. The death of god or the collapse of traditional authority or the disappearance of the a priori all amount to the claim that there are no universals that can ground our doings. But if there are none, this is because there never have been any. Modernism is thus not the denial of tradition, but a way of taking up its claims for it.

A modernist work of art is one that can claim validity or authenticity for itself if and only if its claim is transcendentally valid, that is, if *its* claim to validity is at the same time the lodging and sanctioning of a claim about what art is. Modernist works risk the very idea of being an artwork in order to establish, make possible again, what art is.

The task of the modernist artist, as of the contemporary critic, is to find what it is his art finally depends upon; it doesn't matter that we haven't a priori criteria for defining a painting, what matters is that we realize that the criteria are something we must discover, discover in the continuity of painting itself. But my point now is that to discover this we need to discover what objects we *accept* as paintings, and why we so accept them. And to "accept something as a painting" is to "accept something as a work of art," i.e., as something carrying the intentions and consequences of art: the nature of the acceptance is altogether crucial. (MM, 219)

Let us say that a modernist work must forge for itself its standing as a work of art by explicitly dispensing with what we thought were the conventions constituting the possibility of that art and somehow carrying on (MD, 201). In carrying on, in somehow managing to be a work of sculpture, say, in excess of everything that we thought constituted the possibility of sculpture, it lays bare what sculpture is (and so what art is). So, for example, Cavell says of the sculpture of Anthony Caro:

I had—I take it everyone had—thought . . . that a piece of sculpture was something *worked* (carved, chipped, polished, etc.); but Caro uses steel rods and beams and sheets which he does not work . . . but rather, one could say, *places*. I had thought that a piece of sculpture had the coherence of a natural object, that it was . . . spatially closed or spatially continuous . . . ; but a Caro may be open and discontinuous, one of its parts not an outgrowth from another, not even joined or connected with another so much as it is juxtaposed to it, or an inflection from it. I had thought a piece of sculpture stood on a base (or crouched in a pediment, etc.) and rose, but a Caro rests on the raw ground and some do not so much rise as spread or reach or open. . . . Caro paints his pieces . . . the experience I recall is perhaps hit off by saying that Caro is not using colored beams, rods, and sheets, but beams and rods and sheets of color. It is almost as though the color helps dematerialize its supporting object. . . . [They seem therefore] neither light nor heavy, resistant to the concept of weight altogether—as they are resistant to the concept of size. . . . They are no longer *things*. (MM, 216–17)

One quick way of underlining Cavell's concluding thesis might be this: it is natural to think of sculptures as things in space or things that occupy a spatial region. But at least some of Caro's works (*Bennington, Deep Body Blue,* and *Prairie,* for example) seem to construct or create space, to spatialize by providing orientation or spatial schema that one must take up in order to perceive the work at all. It is as if the work creates the spatial conditions in which it is thence perceived, so that it is both a form of intuition

and what is intuited.[15] The sculpture establishes itself *as* a piece of sculpture, and so a work of art, by defeating the perception of it as a mere thing in space, by its disenfranchisement of given space, and by the spatializing that its rods, beams, and sheets of metal accomplish.

It is important to consider a specific case, since only in its light will we be able to track what sort of burden the modernist work is taking up. Cavell poses Caro's sculpture as between two extremes: it departs from all the obvious and traditional terms that have constituted what it is for a thing to be a piece of sculpture—"I had thought. . . . " (Cavell does not even mention that sculpture was not just carved or chipped or molded but that the goal of the carving, etc., was a mimesis of a natural object, often human); nonetheless, despite those departures, despite the fact that Caro employs things that we cannot help seeing as what they in fact are (namely, steel rods, beams, sheets), what appears is not a thing (in the way that a steel rod, beam, or sheet is a thing). Although it will taking some fleshing out, Cavell's thought here is this: because the work departs from everything we had thought constituted the possibility of something being a piece of sculpture, then we know that its being a piece of sculpture, if it convinces us that it is, does not rest on *mere* convention, *mere* say-so, *mere* agreement. On the other hand, although the object flirts with, dares, risks, exposes itself to being a mere object, a thing among things (rods, beams, and sheets of steel), it defeats thinghood; it somehow appears as "more." Hence it is something beyond what nature could provide, a mere thing, beyond utility or functionality or artifactuality (artworks, although intentional objects, made, are "without purpose"), and beyond what might be the case merely because we *decide* it *is* the case. (Modernism opposes, to the last inch, any idea that what counts as an artwork is what is dubbed an artwork or licensed by experts or museum practice as an artwork, or, in accordance with a regime of discursive practice, can be asserted as an artwork.)

The rising of the modernist work of art is, we might say, the rising up of human significance in general, as if with *this* thing meaning or the possibility of meaning itself comes into the world. This is what I mean by saying that artworks raise transcendental claims: in saying "here is sculpture" the work also says "here is art," and in saying that, it says too, "here is meaning, significance." "A work of art does not express some particular intention (as statements do), nor achieve particular goals (in the way technological skill and moral action do), but, one may say, celebrates the fact that

men can intend their lives at all . . . , and that their actions are coherent and effective at all in the scene of indifferent nature and determined society" (MD, 199). In defeating thinghood, for example, the modernist work defeats skepticism, or at least the way in which the skeptical orientation manifests itself in art. Crucial to that defeat is our "acceptance" or acknowledgment of the modernist work.

It is noteworthy that modernist works acknowledge and expose their material conditions of possibility: that paintings are made of pigment on canvas, literature of words, music of sounds, and so forth. I think of this invocation and laying bare of the material basis of art as, in part, disenchanting the artwork, of making the work of art a secular thing; but also, in part, as an insistence that human meaningfulness belongs to the natural world and has a material basis. Modernist works make all meaning embodied meaning, the meaning of embodied creatures. Nonetheless, it is, Cavell avers, wrong to conceive of the material basis of an art as its medium; to do so is to suppose that the material conditions of meaningfulness are themselves fully given, a priori facts; or better, to presume the material basis of art as given is to presume a fully dualist ontology, with human meaning and intention on one side and raw matter on the other: the old, crude, form-matter story. Nothing can be counted as the medium of an art independently of the art; so

> wood or stone would not be a medium of sculpture *in the absence of the art of sculpture*. . . . The idea of a medium is not simply that of a physical material, but of a material-in-certain-characteristic-applications. . . . [So] there certainly are things to be called various media of music, namely the various ways in which various sources of sound . . . have characteristically been applied: the media are, for example, plain song, work song, the march, the fugue, the aria, dance forms, sonata form. It is the existence or discovery of such strains of convention that have made possible musical expression. (MM, 221)

This sharpens what the ambition of a modernist art must be: "One might say that the task is no longer to produce another instance of art but a new medium within it" (WV, 103), where it is understood that the "medium is to be discovered, or invented out of itself" (MM, 221).

In *The World Viewed*, Cavell contends that in creating a new medium the modernist artist is creating a new "automatism." By automatism Cavell means both broad genres and forms and "those local events or *topoi* around which a genre precipitates itself" (WV, 104). Automatism is another term

for "convention" and its component parts (its lexical units and syntactical resources); automatism is meant to reveal some of the depth or power of convention, to yield the intuition that the conventional can be deep, necessary, all there is in the sense-making that a work of art (and so a human life) is. Cavell suggests three impulses behind his coinage: (1) A medium is an automatism in the sense that, once discovered, it generates new instances; automatisms thus falsify both nominalism and realism about universals. (2) The notion of automatism is meant to capture our experience of the work of art as "happening of itself"; as I hear it, automatism is Cavell's term for Kant's idea that works of art appear as if "natural" and thereby not there, again as a matter of mere will or decision (*WV*, 115). Traditional art gives to its practitioners the automatisms their art is based on; the modernist artist "has to explore the fact of automatism itself, as if investigating what it is at any time that has provided a given work of art with the power of its art as such" (*WV*, 107). (3) The notion of automatism is meant to record the idea that when I make a work—if the work works, is authentic—it is freed from me; automatism points to the work's autonomy.

A further noteworthy aspect of Cavell's analysis, and the payoff from the account of medium and automatism, is that modernist works, because of their departure from tradition and their need to engender a new medium, new automatisms, occur in a context in which necessarily there is a danger of fraudulence. A traditional artist could fail to adequately apply or extend the automatisms bequeathed to her; she could produce bad art, and perhaps even art so bad it barely deserved to be called art. And the modernist artist can fail: I think I can see what Morris Louis was up to, the kind of medium he meant to establish, in his veils, but they strike me as just an opportunity for displaying his gifts as a colorist, and so by his own high standards, standards revealed by the best of his later unfurleds, fail. Fraudulence is not failure but the producing of an art look (sound, appearance, shape) without producing, finally, a work. Fraudulent works avail themselves of the look of an artwork while disavowing the responsibilities of art. Because there really is an art look, and indeed a look that is not remote from authentic art, the separation of authentic from fraudulent is not merely difficult: it is the very critical effort necessary for distinguishing the possibility of art meaning from its utter, if deferred or suppressed, repudiation.

In "Music Discomposed," Cavell systematically attacks the idea of "totally organized" music as sponsored by, among others, Ernst Krenek, show-

ing how composition, chance, and improvisation are transformed almost into their opposites by Krenek's theory (and, by implication, practice, although it is only the theory that is explicitly critiqued). For example, in art, chance relates not to ceding control and letting materials make their own music, so to speak (MD, 194) (which is at least one aspect of the postmodernist view of chance), but to creating one's dangers and taking one's chances; hence for the modernist chance will relate, via composition, to tensions, problems, shocks, surprise, and the response to or resolution of those in fulfillment, release, vision: "The *way* one escapes or succeeds is, in art, as important as the success itself; indeed, the way constitutes the success." (MD, 199). So even if the modernist artist wants to give to objective chance (the only notion of chance that the postmodernist recognizes) a larger role than it had in traditional art, still such chances must finally relate to the composition (the intention of the artist) as a whole.

In painting, where the matter is vivid, Pollock showed how each chance event provided the opportunity to compose a work beyond all imagining (beyond all planning). So Pollock showed how one might, under the most extreme conditions of uncertainty, chance, nonetheless take full or absolute responsibility for one's doings, how in the midst of pours, tube-squeezed ropes, splatters, flecks, and spills one might still compose a *work* that was emphatically and unavoidably one's own. In opposition to the ideology of total composition, Cavell asserts that the first fact of works of art "is that they are meant, meant to be understood" (MM, 227–28).

A more fully elaborated critical analysis of artistic fraudulence is provided by Michael Fried in "Art and Objecthood" and the essays surrounding it. In those essays the mode of fraudulence Fried means to detect, which is not wholly unlike the fraudulence of "total composition," is the repudiation of composed works (paintings or sculpture), which are necessarily the bearers of human intentions, for works that approach or mean to be or have the look of mere things among other things—but for the fact that they are artworks. Artistic "minimalism," or "literalism" as Fried calls it, involves the use of obdurate materials in simple geometric shapes either by themselves or in structures that themselves appear geometric, that have the feel of being the consequence of a formal procedure, algorithm, or mathematical design. Ideally, such works should give no sign of the human hand (arm or wrist), the whole conceivably produced by a machine, or at least a team of workers following precise instructions, like builders following a blueprint. The prime

example of such minimalist art would be Tony Smith's *Die*: a six-foot black-painted steel cube. Such works appear as artworks, have an art look, because they are *theatrical*; that is, they include the beholder in their possibility of effect, relieving themselves (the artist) thereby of responsibility for meaningfulness. On Fried's analysis, theater is the form of fraudulence common to our situation, and its defeat requires the defeat of the reduction of the work to thinghood—the very achievement of Caro's sculpture. I note that the kind of arguments used to defend minimalism's (and total composition's) eschewal of modernist art can be seen as systematic variations on the protocols of the analytic ideal-type philosophy in its repudiation of subjectivity.[16] Which is chilling—for art and philosophy.

Modernism and Acknowledgment

Aesthetic judgments and the claims of the ordinary-language philosopher speak with a universal voice that is nonetheless incapable of proof (empirical or logical) because they concern the jointure of orders of fact with orders of feeling, call it an expressive empirical order. Such an order must be seen (heard, experienced) and felt *like this*. Artworks are objects designed precisely for the purpose of generating such responses; the ways in which empirical objects (things, persons, typical states of affairs and events) systematically embed an expressive empirical order is recorded in "what we say when." Modernity yields a state of affairs where the expressive empirical order is hounded by three different and identifiable factors: by the collapse of traditional authority, the growing belief that meaning is a matter of mere convention (because all convention is a matter of agreement, because the meaning of the sign is constituted by nothing other than a system of differences, because nominalism is true, etc.); by the emergence of modern reductive naturalism ("indifferent nature") and its rational corollary—the belief that the only rational authority is that which accords with the logical or formal or procedural or mathematical conception of reason modeled by the natural sciences; and by "determined society," say, the consequences for social existence implied by the first two houndings. Cavell routinely expresses this last with Emerson's phrase "every word they say chagrins us"—because every word they say has stopped being an effective jointure of fact and meaning, the world is no longer an expressive empirical order.

Modernism takes up the burden of this situation in art—or better, art

is the *necessary* site of this problem—because art traditionally was the cultural space in which we collectively rehearsed the experience of society as an expressive empirical order in its force and fragility. So the condition in which the expressive empirical order is hounded generates the *aesthetic problems of modern society*, of which the aesthetic problems of modern philosophy are but the reflective articulation. It is because the problem of modern society can be designated as an aesthetic one that art practices become a site of transcendental reflection; that is, art, which used to rehearse (and so reproduce and reaffirm) society's expressive empirical order, must, in the teeth of the triple hounding of that order, show that such an order is possible. That is why modernism has the developmental dialectic it does: under the triple hounding, any achievement of art, the establishing of a new medium, new automatisms, and so the very idea of a (new) expressive empirical order, becomes or threatens to become a part of the dead past of convention. What keeps past art alive, including past modernist art, is only present art in its escape from skeptical collapse. But this is to say, and it is this that Cavell's remarks on fraudulence were meant to show, that modernist art is the kind of art that, even for itself, is shadowed by skeptical doubt. Because skepticism is the reflective (that is, philosophical) comprehension of the meaning of the triple hounding,[17] any modern critical discourse, any modern philosophy that might hope to respond to the predicament of modernity must be framed by the problem of skepticism.

Hence Cavell's recurring claim that, for us, philosophical problems have the form: we have lost our way. And it is for this reason that Cavell refuses to think of art or philosophy in directly political terms: "To speak now of modernism as the activity of an avant-garde is as empty as it is in thinking about modern politics or war, and as comforting: it implies a conflict between a coherent culture and a declared and massed enemy; when in fact the case is more like an effort, along blocked paths and hysterical turnings, to hang on to a thread that leads from a lost center to a world lost" (*WV*, 110).[18] The *stakes* of art are not less than those of politics or war once the easy assumption of a coherent culture on one side and a massed enemy on the other is dropped; for now, at least, the stakes are the possibility of there being a (meaningful) world, the worldhood of the world.

I have been moving slowly over this terrain in the hope of adequately preparing and motivating the final two steps in Cavell's account of modernism, the ones that will come most fully to inform his modernist philos-

ophizing: (1) it is the particular and distinct demand of modernist art that it take the form of *acknowledgment* (acceptance), and that so doing is nondetachable from, say, (2) my voicing my acknowledgment, so from regarding work and criticism as exemplary individual performances. This entails that philosophy must become a performance of the philosopher if it is going to state what is necessary. Said another way: only from the perspective of modernism can the role of acknowledgment for knowledge be articulated fully and so become central; but if the role of acknowledgment in knowledge is the pivot of Cavell's philosophy, then his philosophy can effect itself only as a modernist transformation of the practice of philosophy—which is what I promised to show.

Modernist works of art are exemplary joinings of fact and meaning. Being bereft of traditional backing, such works can appear as nearly the same as a fraudulent impostor. For Cavell, this entails that for modern art the experiences of fraudulence and trust are essential; hence a full answer to the question "What is art?" will, in part, "be an answer which explains why it is we treat certain objects, or how we can treat certain objects, in ways normally reserved for treating persons" (MD, 189). While at first blush this might sound exorbitant, it is the natural extension of the position being outlined. It arises because modernist works are sites of transcendental claiming: they are material formations of mastered subjectivity that claim that human activity *can* be meaningful, that we *can* intend our lives, that even in the midst of indifferent nature and determined society meaning and action are *possible*. Because the particular claim of any modernist work is at the same time the claim that "so here is art (again)," and thus "here I am; here is meaning, value (again),"[19] then its approach to us or claim upon us is not unlike the approach or claim of another person. This thought gains purchase once we concede that the best and unavoidable terms of criticism for such works are precisely the ones we use for discussing persons: "We approach such objects not merely because they are interesting in themselves, but because they are felt as made by someone—and so we use such categories as intention, personal style, feeling, dishonesty, authority, inventiveness, profundity, meretriciousness, etc., in speaking of them" (MD, 198).

What is thus appalling and terrifying and nihilistic about total composition and minimalist art is that they would, if they could, and they mean to, do away with such a vocabulary; they aim to put works of art beyond

the forms of critical response for meaningful acts. Instead, such fraudulent art practices instrumentalize art-making and aesthetics: either a procedure produces an interesting effect or it does not, and the artist is now the one who makes it more probable that an interesting event or series of events will occur, using "these" pre-given and simple mechanisms. If this oversimplifies the practices in question, and it does, it does not oversimplify the stakes of those practices, what they portend.

Every modernist work raises the issue of fraudulence and trust, which is to say that every modernist work of art raises an equivalent of the problem of other minds: what is it for a material display to be a display of human meaning, that is, the display of a person? In order to see what is involved in answering this question, we need to return to the way in which modernist works pose *themselves* as responses to it. I think that the way Cavell runs his account of this, in the "Excursus: Some Modernist Painting" chapter of *The World Viewed*, is unconvincing; this is one place where Michael Fried's critical program leads him in a wrong direction, not over the question of acknowledgment itself in modernist works, but over their way of expressing and demanding it, what Fried calls "presentness."[20] Let's begin, however, with the issue of acknowledgment itself.

Acknowledgment emerges as an informing gesture of modernist works because each must declare itself for its medium as a whole, and each can only accomplish this by claiming it, that is, by laying bare that it is a laying bare of the art it is showing. A modernist painting can only speak for painting as a whole by exposing itself *as painting, as such*: "any painting might teach you what is true of all painting. A modernist painting teaches you this by acknowledgment—which means here that responding to it must itself have the form of accepting it as painting, or rejecting it [as failure or fraud]" (*WV*, 110). Premised on the Hegelian idea that late high modernism reveals the stakes and presuppositions of its earlier avatars,[21] Cavell attempts to think through what is involved here in terms of Fried's pantheon of late-modernist painters: Pollock, Morris Louis, Kenneth Noland, Jules Olitski, Frank Stella. Cavell thinks that what Pollock reveals and Fried's crowd elaborates is the idea of "total thereness"—Cavell's term for presentness: "The quality or condition I wish to emphasize here comes out of my speaking of total thereness as an event of the wholly open, and of the declaration of simultaneity . . . [which] might be expressed as openness achieved through instantaneousness—which is a way of characteriz-

ing the *candid*" (*WV*, 111). It is not too difficult to see how a painting's candidness, so conceived, might be thought to be a mode of acknowledging itself as painting for painting—a kind of way of saying "Here I am, all of me!": "For example, a painting may acknowledge its frontedness, or its finitude, or its specific thereness—that is, its presentness; and your accepting it will accordingly mean acknowledging *your* frontedness, or directionality, or verticality towards its world, or any world—or your presentness, in its aspect of absolute hereness and of nowness" (*WV*, 110).

I confess I find almost all of the paintings being here championed (apart from Pollock's, which can be characterized quite differently) and the critical gesture of acknowledgment being offered for them—total thereness—mawkish and meretricious.[22] That is a worry; what lies behind the worry, however, is the concern that if acceptance is linked to presentness, then it is unclear how acceptance can be connected to the *truth of skepticism*: the continuing discovery that the orders of knowledge and reason are not self-moving or, therefore, self-sufficient. I take the truth of skepticism—think of it as the intimate or personal way in which we experience the lack of a metaphysical absolute (an ultimate fact of the matter) and the finitude of human knowledge—as the place where modernism reveals itself as the self-reflection of modernity. But, then, modernism ought to be what connects the truth of skepticism to acceptance and acknowledgment, and in so doing reveals how the very idea of an expressive empirical order connects to the problem of other minds. What one may feel is the speed or sentimentality of the idea of total thereness—all that candidness and sincerity—derives, I am suggesting, from its failing to connect acceptance to the truth of skepticism.[23] The correct way to make this persuasive is aesthetically.

Rather than directly contesting Fried's canon, let me simply recall my characterization of Caro—a sculptor about whose accomplishment Cavell, Fried, and I agree. I suggested earlier that a singular feature of some of Caro's best work is that it does not presuppose three-dimensional space as a given within which a work appears; rather the works spatialize, create space for themselves, give space dimension and orientation, construct the very space they inhabit, and in so doing they demonstrate how lived space itself is not a given container that we appear in. A Caro is the (fictive) transcendental bracketing (*epoché*) and reconstitution of space. In *Prairie*, for example (Figure 6), suspended just twenty-one inches off the ground is a flat sheet of corrugated metal with four grooves or channels in it (you can

Modernism as Philosophy 103

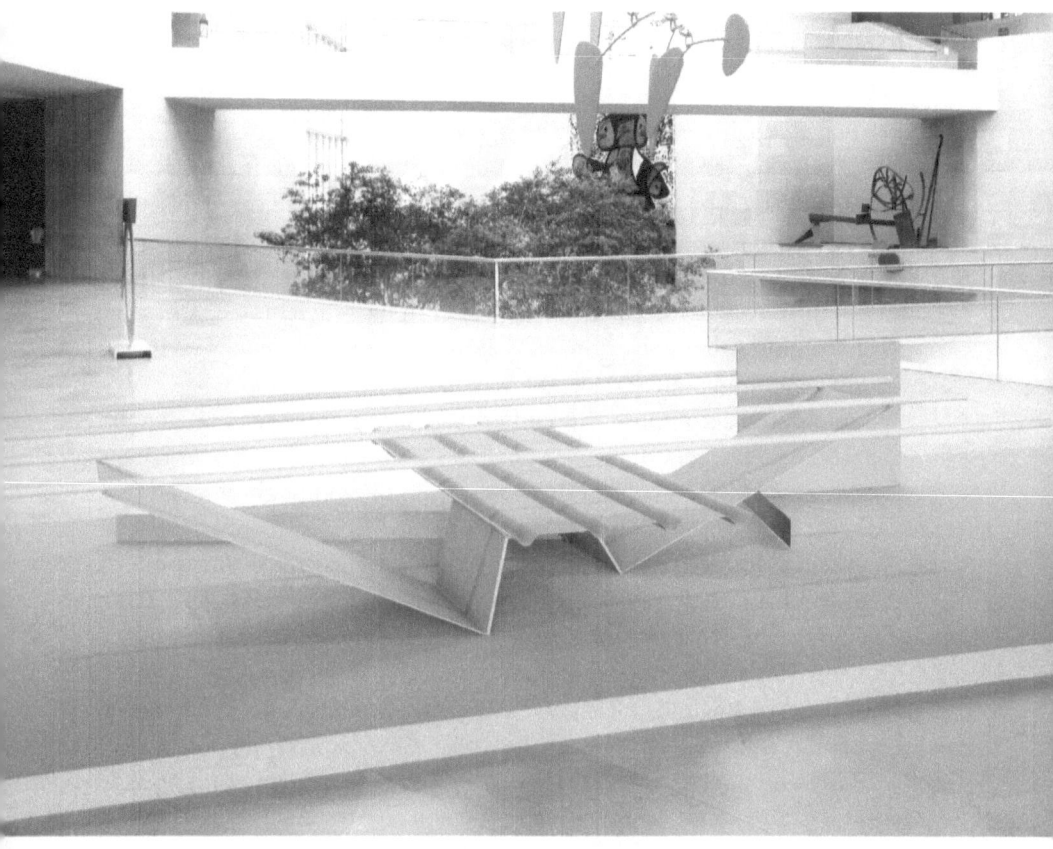

6 Anthony Caro. *Prairie*. Collection of Lois and Georges de Ménil, on loan to National Gallery of Art, Image © 2003 Board of Trustees, National Gallery of Art, Washington, 1967, mild painted steel, .965 x 5.187 x 3.200 m (38 x 229 x 126 in).

imagine water running through them); approaching the work along its north-south axis, the effect of the low suspension and grooving is the feeling that the sheet is running away from you. In fact the sheet is resting, inconspicuously, on two V's, each with a short, nearly vertical leg that does the supporting, and a long wing of sheet metal that rises out from each side of the grooved sheet in something under a forty-five-degree angle. Suspended eleven inches above the grooved sheet and running east-west to its north-south are four long poles of aluminum tubing; the poles are evenly spaced and run parallel to one another. Set aside from the main construc-

tion is a small rectangular wall of sheet metal. All the pieces of the sculpture are painted in a color that is somewhere between a mustard yellow and ripe wheat tan.[24]

In a work like *Prairie* our being upright and forward-looking, which can be taken as given, is revealed as an orientation through its absence. The space projected by *Prairie* both invites us and in the radicality of its horizontal orientation (the sense of its spreading and opening) excludes us, in the same way that the one vertical sheet is disconnected or at least held at a distance from the horizontal, horizon-forming, stretching or stretching-out structures themselves (in the way that prairies invite and exclude us: human and inhuman at once, the way nature is).[25]

In order to accomplish this end of spatializing, space-making, for all its apparent simplicity, Caro's work possesses an (ongoing) *performative* depth and complexity that, beyond particular exclusions of uprightness and frontedness, make it simply unavailable to immediate inspection. *Prairie* first brackets space as a container (say, by its disorienting horizontal orientation), and then determines space as spatiality, giving or having space, spacing or pacing, space as placed here by its three crossed formations of horizonality (the poles, the grooved sheet, and the flanking, inclined "wings"). And, as always with Caro, space is internally related to, an inflection of, the very objects it would contain.

One cannot take in a Caro all at once because one has to find one's way into it (move around it in order to "enter" it, assume it; and some ways are blocked), because what it requires of one in terms of spatial orientation, what is involved in appreciating and sustaining its trumping or dismissing of given space, and of making space all over again, is not itself given but an accomplishment of critical perception (what transpires through or in consequence of one's following, and so acknowledging, the work). If this work of critical perception could be finished, if the work could be finally and simply there, then it would lose its critical relation to given space, its emphatic and typically modernist moment of negation, and hence our experience of it would lose its character of being an experience (a continuous and therefore incomplete aspect-dawning), a transformation of our space, a standing invitation or seduction to inhabit spaces-and-things differently. And only because the work *remains* invitation and critique does it remain a work of art distinct from, an interruption of our ordinary empirical experience of, the world.

Learning this kind of Caro is like learning the gestures of a new tribe: what counts as pointing or bowing or turning away or being relaxed or indifferent or straight or crooked needs interpreting and getting used to, and that work is never done.[26] Of course, these are sculptures and not a new tribe, even if the anthropological analogy is apt. But what makes it apt, I now want to say, is that they frankly and radically avow and display their material conditions of possibility, the fact that they are nothing other than steel rods, beams, and sheets.[27]

Cavell's reasonable thesis about the media of art—that they only count as media once worked—does not, as I think he supposes, obviate the necessity for modernist works to declare their material conditions of possibility, indeed twice over. On the one hand, in declaring their materiality they open the possibility of not being seen as works of art at all, of being just steel rods, beams, and sheets. To *declare* this moment is to declare the truth of skepticism: the sheer facts of the case will not yield meaning, and no telling of the facts will make meaning compelling. It is because authentic works *announce* their less-than-aesthetic facticity that minimalist works, which austerely pose themselves as interesting in their very facticity, can acquire an art-look (minimalist works as, at least, the skeptical moment within authentic works freed from them). On the other hand, the work also means to say that meaning is nothing other than an arrangement of material stuff, such stuff intended in some way. Such radical exposure is the disenchantment of meaning (and natural beauty), of the way art accomplishes the disenchantment of meaning.[28] This is the real candidness or openness of such works; it is not their art that is open to view, there, but that such art is made of nothing other than material stuff ordered *thus*; the yield of such ordering, the work, is both present and absent in the same way that people are present and absent, never fully there.

It is from here that we can understand the necessity and function of acknowledgment in modernism. By virtue of acknowledging their material conditions of possibility, modernist works take up the burden of modernity by declaring the truth of skepticism, as well as by accomplishing the continuing disenchantment of knowing. The material conditions represent both the skeptical denial of meaning (the thought that here there is just stuff) and the achievement once again that from just this stuff art is possible, so meaning is possible, so the world is possible—again. Cavell formulates the situation with respect to painting in this way:

Painting, being art, is revelation: it is revelation because it is acknowledgment; being acknowledgment, it is knowledge, of itself and of its world. Modernism did not invent this situation; it merely lives on nothing else. In reasserting that acknowledgment is the home of knowledge, it recalls what the remainder of culture is at pains to forget. (*WV*, 110)

So my contention is that what Cavell calls the truth of skepticism, what can be healed by acknowledgment and not further knowledge, is itself *necessitated* by modernist works only in their declaration of their material basis and means; this declaration encapsulates the triple hounding of meaning and so the skeptical dilemma that each work confronts: both its loss of traditional authority and the threat to meaning posed by logical reason, determined society, and lawlike nature. In confronting such works we confront our skeptical predicament and pass beyond it by—in the teeth of their strangeness, the *risk* of all previous mediums (which is what calls into play the anthropology analogy), and their unmissable exposure of their simple material being, being just stuff configured—nonetheless letting them make a claim on us, exposing ourselves to their claim, so acknowledging them as, in being art (and not mere things), all but one of us. To say that acknowledgment is the home of knowledge is thus to say, first, that I pass beyond the doubt represented by the self-declared strangeness and materiality of the work by exposing myself to the work, letting it perform its work of bracketing and reconstitution, and so letting it be a work for me, learning what art is from the work; and thus, second, learning that unless I expose myself to the work, let myself and my possibilities of meaning be tested by it, there is nothing to know and so no meaningful knowledge (art reminds us of what the rest of culture is at pains to forget). That there is something to know—how space means, for example—is given through the work's claiming; the necessity configured in the imposingness of its beauty, everything about the work that leads to my wanting to offer my experience of it as objective, demanded of everyone, represents the depth, the human necessity of meaning, that meaning can be deep (necessary), as deep (necessary) as my orientation in space, only in the light of my *letting* it be so. Depth, significance, and necessity are neither metaphysical nor illusory; modernist art reveals how "custom is our nature" (Pascal), how custom can have the authority of nature.

To say that acknowledgment is knowledge of itself and the world is to say that acknowledgment is a mode of self-consciousness, a mode of how,

through the work's taking a stand on itself, declaring itself as art, I am forced to take a stand on myself (as the condition for my perceiving it as a work); only by exposing myself to the other, so only with this acknowledgment, is there a work or a world. If fact and meaning are to be joined, then every look presupposes my looking. My standing on my looking is what makes the look an exposure to meaning and not just a mechanical recording device (as, for example, reliabilist accounts of perception assume).

If modernist works are transcendental sites of meaning, of the joining of fact and meaning in general, of an expressive empirical order as such, that require for themselves and for their observers acknowledgment as a condition of meaningfulness, then there is meaning only if *I* acknowledge it. Acknowledgment is necessary for there to be a jointure of material fact and affective significance. This requires that I take a stand on my meaning in order for it to mean, and this in turn makes the first person noncircumventable in the constitution of meaning. But this is just an inference from the fact of modernism itself: if the possibility of meaning is to be shown through just this work here, and just this work here reveals beyond all previous understanding the possibility of meaningfulness, then there can be meaningfulness at all only if there is some here-and-now. This would make all meaning a matter of conscience: Here I stand and I can do no other; if I do not stand here then there is no standing and no I; all falls down.

Fragments of Philosophical Modernism

My intention thus far has been to explain that the demands on modern art and any philosophy that authentically inhabited the same world as that art would necessarily be the same. One will accept those demands on philosophy only if one accepts the characterization of modernism; and one can accept the characterization of modernism only if one has already found oneself compelled by, for example, Caro's sculpture, accepting it as what sculpture can be and so what art can be. Under the conditions that the authenticity of the modernist work projects, the possibility of meaning in general takes the form of there being a communication between two persons unsupported by tradition or convention, all other possibilities of communication having either dissolved or become frozen, reified. Modernist art promises us "not the re-assembly of community, but personal relationship unsponsored by that community; not the overcoming of our isolation,

but the sharing of that isolation—not to save the world out of love, but to save love for the world, until it is responsive again" (MM, 229). This is what makes the demandingness of modernist works so odd: they want extreme intimacy (say, because the perfect model of communication between just two, unsupported by convention, are the silent exchanges between lovers) and extreme generality (here I am, a work, so here is sculpture and so art and so meaning, again). A philosophy that might bear up to these demands will be as unfamiliar as *Prairie* or *Endgame* or "Sunday Morning" with its unparaphrasable opening in which "she feels the dark/Encroachment of that old catastrophe, / As a calm darkens among water-lights" (see AP, 81). Perhaps it is not, from just these characteristics, obvious how what might characterize a modernist philosophy spells out its becoming literature, or, at least, the sense in which it does so.

The most natural way of thinking about the demand for philosophy to become literature is through the issue of the kind of rational authority that a modernist philosophy can claim for itself. Max Weber claimed that there were three fundamental forms of authority: legal-rational, traditional, and charismatic. These forms should be considered to be distinct only analytically, since when they appear in isolation from one another the result is perspicuous forms of social irrationality: the mechanical bureaucracy, the repressive closed society, the delirium of the cult. Philosophy, almost by definition, has been the attempt to show how traditional and charismatic authority must give way to, indeed be totally dissolved into, legal-rational authority (only legal-rational authority is a valid form of authority). That, we might say, is the hope expressed in the protocols of the ideal-type analytic philosophy. Modernist philosophy means to show that the Enlightenment dilemma of either reason or tradition is a false one. We have already seen how each modernist work is a response to this dilemma: each shows itself to be more than tradition (by dispensing with tradition) while not deducible from reason; each radically *appears* and lodges its claim through the very insistence of its appearing. Call the moment of claiming through appearing the work's charismatic authority.

Perhaps the oddity of artworks is that their authority can seem as if wholly or purely charismatic. But that is not accurate. Hence, the notion of automatism: a generative convention that in its separation from the artist approaches the authority of nature, natural law, itself. A new medium with its automatisms can reveal itself to be such through the series, such as

Monet's haystacks. The fact of the series reveals that the effectiveness of the original, its charismatic authority, is not accidental or arbitrary, that in fact a new medium with its distinct automatisms has been uncovered (*WV*, 115). Now, of course, in the case of the modernist work of art the charismatic character of the individual work is bound to its being a material object that presents itself to the senses, and to the fact that only through sensuous presentation can the work be grasped at all. Beauty is just a clumsy categorial term for (one form of) charismatic authority.[29]

The most direct way in which modernist philosophy reveals its distance from the ideal type of legal-rational authority has been via its fragmentary form. The fragment defies subordination from first premises; but it is just the structure of subordination (from first premises or from an ideal method or procedure) that constitutes the purely rational authority of the ideal-type analytic philosophy. For Cavell, the paradigm cases of fragmentary philosophical writing are Part I of Wittgenstein's *Investigations* and Emerson's essays, in which each sentence feels nearly self-sufficient but for the fact that its thought is continued or echoed or relayed or commented upon by others surrounding it: "I have taken the familiar experience of Emerson's writing as leaving the individual sentences to shuffle for themselves to suggest that each sentence of a paragraph of his can be taken to be its topic sentence. I welcome the consequent suggestion that his essays are collections of equals rather than hierarchies of dependents."[30] A compelling series of fragments is what is meant by an improvising of convention. Part IV of *The Claim of Reason* is a series of fragments: we gain insight into the *problem* of other minds by seeing it in the context of the treatment of (fragments or journal entries [*CR*, xix] relating to) slaves and fetuses, monsters and machines, statues and dolls, horror and tragedy, and so forth. These are not just heuristics, but aspects of the depth and pervasiveness of the problem, its cultural and social actuality ("skepticism concerning other minds is not skepticism [the philosopher's conceit] but tragedy" [*CR*, xix]) as well as its philosophical expression. To recover the fact that the abstract problem is an expression of an actuality, and that actuality itself multi-faceted, is to perceive the existential (psychological, social, and historical) figure in the conceptual carpet. One might say that the totality of fragments form a *constellation* (Adorno's term of art) through which the truth concerning the *problem* of other minds, which is equivalent to the truth of skepticism, and its release—the need, demand, and role of acknowledgment—are disclosed. For Cavell, the notion

of the philosophical fragment is meant to cover a variety of discontinuous forms of philosophical presentation and writing: aphorism, aside, entry, reading, remark, parenthesis, digression, introduction, sentence, etc.[31] What all these have in common is their relative autonomy or independence. So, for example, a sentence may show its independence by making its meaning dependent on its *exact* wording (being almost unparaphrasable); exact wording of this kind underlines the writtenness (*CR*, 5) of the sentence, thus its charismatic authority, which is revealed by its feeling of quotability, hence self-standing, while being, in fact, not easily or directly memorable. Sentences like that approach the status of aphorism.[32] Cavell did not have to await his reading of Emerson to have this ambition for writing; it is there nearly from the beginning.

How, though, does a fragment manage its authority? I take it that Cavell intends a fragment to be the analogue of the modernist work itself, and hence the book the analogue of the series. If so, the puzzle continues, since now we shall want to know what corresponds to the elements of the work (steel beams, rods, sheets)? I think Cavell must say, and does on occasion say, words; it is they that have lost their place, and the work of a modernist philosophy is improvising a sense for them. So Cavell states that Kant's idea that our "understanding of the behavior of the world by understanding the behavior of our concepts of the world, is to be radicalized, so that not just the twelve categories of the understanding are to be deduced, but every word in the language—not as a matter of psychological fact, but as a matter of, say, psychological necessity" (QO, 38). This is a natural enough thought given Cavell's premises, but it cannot be correct as it stands, since there may be different practices that take themselves to be in the business of "deducing" this or that word or concept: perhaps some political actions deduce the meaning of "free" or "equal" (maybe Martin Luther King's actions did this); perhaps a movie or novel might provide for me a deduction of marriage (showing that all marriage is remarriage). If deduction has the sense of showing how a concept is necessary for the possibility of experience, then while the broadening from a few special concepts, the categories, to potentially all follows on the denial of the subordination of many to the one consequent upon the discovery that any word *can* become for me what my life is staked upon, it equally must democratize the locales of deduction. If deduction is the singular event as exemplary, then that event need not occur in a philosophical text (although perhaps we still need philo-

sophical texts to nudge us into recognizing that "there" we witnessed a deduction of freedom or tenderness or love or courage or care or gratitude or cruelty or sorrow—philosophy as a form of "concept criticism" analogous to art criticism). Perhaps, for the health of culture, it should not.

It thus becomes natural to assume that only *some* words are the prerogative of philosophy, even in its modernist dispensation. Unsurprisingly, I think, the words that will be philosophy's to engage are just those that have belonged to it, hence just those in which there exists an overwhelming temptation to believe that they possess an atemporal core meaning that can organize and orient everything that comes under them: know, mean, true, good, free, determined, rational, etc. But this would seem to suggest that a modernist philosophy cannot proceed as quickly as a modernist art, since philosophy is tied to its past not just as a matter of achievement but substantially. Modernist philosophy must be a critique of its traditional past and rationalist present; modernist philosophy must be explicitly critique. If the philosopher is centrally responsible for the critique and transformation of the tradition—the words and concepts that seek to master and dominate what traditionally did fall under them—then will she not centrally be operating in the very terms she means to displace? Philosophy cannot easily depart from abstract conceptuality if it is to sustain its role as critic of abstract conceptuality. If critique, then how is it going to separate itself formally from what it criticizes? Whither its particularity, sensuousness, moment of acknowledgment, charismatic authority?

What if we say that the force of the philosophical fragment derives from the voice or person of the philosopher, where this is understood as the philosopher mastering her subjectivity and making it exemplary? The idea of an exemplary performance certainly responds to the lacunae left by the disappearance of religious charismatic authority. And if there is going to be something corresponding to the sensuousness of the artwork, the singular voice is a plausible candidate. And how better to rebel against the self-righteous impersonality of the analytic ideal type? Let me concede that the idea of an emphatically personal exemplary performance is a modernist one, and that there are locales where it seems unavoidable, the most obvious being ethical action and criticism (of particular works or actions, for example). But the implication is not that philosophy itself should be a matter of exemplary performances in which the person of the philosopher comes to the fore. After all, while in critically responding to an artwork I

aim to objectify my subjective responses in order to incarnate what responding to that work involves, and so enabling you to so respond, the artwork itself is not like that. Works may be infused with subjectivity and affect without, for all that, being a matter of a *personal* voice; there is no hint of that kind of individuality in *Prairie*, for example. In theory and practice, Cavell has at times championed the personal voice—his—as a mode or way of bringing philosophy to its modernist state; but there is nothing compelling about that choice for philosophy, no reason why the philosophical fragment should gain its authority and individuation that way. Nor in Cavell at his best is the singular voice the real bearer of authority.

Here is a complete Cavell paragraph of great power and beauty:

I do not make the world that the thing gathers. I do not systematize the language in which the thing differs from all other things in the world. I testify to both, to acknowledge my need of both.[33]

This paragraph occurs in an essay whose explicit or assigned topic is collecting—the way museums or individuals collect things: books, paintings, butterflies, clocks, locks, medals, coins, stamps, skeletons, toys, dolls, inscriptions. In Cavell's hands the problem of collecting quickly turns into: the problem of memory/history/heritage/tradition (collecting the past), the relation between universals and particulars, the individual painting and the series (as a modernist displacement of the universal-particular relation), a person and her experiences, Hume on the self and the contents of its mind, whole and part, a child's loss of or separation from its first object of love and the desire to find it again (so human connectedness and separateness, love and death), Emerson's visit to the Jardin des Plantes, obsession and collection, Heidegger on the thing, and so on. The essay is made up of eighteen numbered fragments or sections, some quite short, a few sentences, some extended, several paragraphs; for the most part each is dedicated to a separate author or topic, or both. The essay itself is a collection of curiosities, a thing of things; a series of fragments on the meaning and being of fragments.

At nearly the midpoint of the essay (I do not know what else to call the piece), fragment *X*, there is a long, quiet recounting of, primarily, the first hour of Chantal Akerman's film *Jeanne Dielman, 23 quai du Commerce, 1080 Bruxelles* (1975), a film that records a series of the subject's ordinary daily activities—potato peeling for the evening meal, coffee-making, eating

with her son, listening to him read a poem, putting him to bed—methodically done, coolly, distantly observed ("It is hard to know whether everything, or whether nothing, is being judged.")[34] Cavell's cataloguing of moments in the first hour seeks to mimic the patient detachment of Akerman's camera; the film, covering three days, the end of the first two explicitly announced, runs three-and-a-half hours. The discreteness of the woman's activities together with a sense of their real-time duration, make the film appear as a materialization of the idea of the self as a collection, here of actions rather than impressions and ideas. Cavell recounts how the film shows that on the second day the same routine events occur but slightly awry: a button is missing from her son's shirt, she lets the potatoes burn, she can't make her coffee taste right and has to remake it, and so forth.[35] On each day we have seen her enter a room with a man, closing the door behind her, then coming out and being paid. On the third day, we accompany the woman into the room, see her being made love to and, despite her indifference, and against her will, being brought to orgasm. After finishing making love, Cavell reports, she moves about the room to freshen herself, picks up a pair of scissors that we have seen her use earlier to unwrap a present, walks over to the man still lying on her bed, and "stabs him fatally in the throat, and slides the scissors back into the dressing table as she walks out of the room. In the dining room, without turning on the light, she sits on a chair, still, eyes open, we do not know for how long."[36] But we do sit with her for quite a while; I suppose for an eternity. The length of the final shot is extended to yield that conclusion since, initially, we keep expecting an interruption (her son to return home from school with his friend), but it lasts just long enough for us to realize that that is not going to happen, that nothing will interrupt her sitting there, and that this scene could go on forever; given the patience of what has preceded, we wonder if it will until the realization dawns that this is eternity, that Jeanne Dielman's suffering has always been that, that eternity is the name for the suffering of woman. With that the film can end, but now under the condition that its ending is not an end and thus will not, by itself, license our freedom from her torment. In short, neither the murder nor the film's end is, in any way, cathartic. One might think that the film's disabling of the possibility of cathartic release is its artistic point, since such release could only be an illusion and so a betrayal of woman *überhaupt*. Formally, then, the film's movement means to operate as continual suppression of form as the creation of a semblant whole. The continual ef-

fort to turn form into the collapse of form, as the source of filmic betrayal of content, specifies the character of Akerman's modernism.

In the course of his recounting and elaboration of the film, Cavell mentions, first, the idea that in the same way for Kant every object is given with all the conditions for its appearance to us, so every "action that we enter into our world must satisfy all the conditions for its completion, or its disruption."[37] And second, after mentioning how the woman, as she moves from room to room, turns off the light and closes the door, then opens the door and turns on the light in the next room, reflects that this put him in mind of how spaces are kept separate in a cabinet of curiosities, which in turn put him in mind of how collecting in the Renaissance expressed a fear of boredom, leading in turn to a consideration of Walter Benjamin's perception of the era of the Baroque as characterized by melancholy, which, finally, leads to a connecting of tragedy and skepticism. After that strange set of associations (if you lack knowledge of the film, the associations will appear willful and unconvincing, although, even so, we might be glad at the end of it for the reminder about tragedy and skepticism),[38] Cavell concludes the paragraph with the claim that Akerman "has found women to bear undistractibly, however attractively, the marks of supposedly interesting partitions or dissociations.... Call this a new discovery of the violence of the ordinary."[39] The film, which had not been cited before its introduction, is not further discussed or even mentioned for the remainder of the essay.

I am still on the track of the short paragraph, the opening of fragment V, about how I do not make the world's things, gather or systematize the language registering how each thing differs from every other, but rather testify to both, confess my need of both. Here is my hypothesis: the authority of the Cavellian fragment emerges via its exhibition of self-disenfranchisement, its capacity for testimony beyond making and systematizing; which is to say that the Cavellian fragment succeeds when it best approximates the separation of things. This is a delicate operation, since the separation of things from one another is deeply approximate to the violence of separation, as the sublimity of the ordinary is but a hair's breadth from the violence of the ordinary. How are we to distinguish between the patient regard of Akerman's camera, its granting to Jeanne Dielman of every dignity it can (or indignity she suffers?), and Jeanne Dielman's own inability to trust her world, her need for control, order, the careful separating of each activity from every other and the sheer madness of that? How are we to distin-

guish between Cavell's seeking of literary effect, call it the violence of voice, and his capacity for testimony?

Test the power of the short paragraph now: the first sentence states an obvious truism: I cannot make the world because no one can; we are not gods. The second statement inherits its force from the first sentence: If I am not God and so cannot make the world, then if I try to systematize language then I am pretending to be a god, pretending I can make it, and so control and dominate things, make them fully and incontrovertibly "mine," say by putting each in a separate room or cabinet or under a universal or natural law or exchange value designed for the purpose of control. The work of the systematic philosopher is not unlike the madness of Jeanne Dielman, all that separation, all those doors opened and closed, lights turned on and off, the relentlessness of routine actions, their subsidence of doing into mechanism, the unfeeling of it, the horror of feeling when it occurs (by not quite occurring—the violence when it does happen only a minor inflection of the routine preceding it), the final violence.[40] In the first sentence, the word "I" is almost redundant: no human can make a world. In the second sentence, the "I" is more individuated because there is a real action eschewed; but the real action eschewed by the real I is eschewed for logical reasons, at least if one allows the relation of analogical inference connecting the first two sentences—that keeps even the second "I" formal, anyone. In the final sentence, the force of the first person is at once intimate and impersonal. Nothing tells us what to do or what conclusions to draw from our humdrum inability to make the world or from our less humdrum inability to systematize the world (if to systematize means to gather things in a final order, divinely). Cavell could have said, "I *must* offer testimony," but that would displace responsibility, as if the acknowledging of my need of the world were an inference from a rule, or from what is logically demanded by the previous two sentences. Because no inference is given to be drawn, there is no telling what to do; it is up to "I." What we are shown, by the "I" not saying "I (one, we) must" but simply "I testify to both," is that testifying is the recognition of my need, its acknowledgment. To give testimony is to acknowledge need; confessing need is not what must be done; it is just what I do. "I testify to both" is valid if and only if exemplary. Exemplarity is the only kind of validity available to philosophical acts of acknowledgment. Acknowledgment is the exemplary act of self-relinquishment.

How might we be convinced of all this? Everything in Cavell's essay

hangs on his letting Chantal Akerman's film, and so the world of Jeanne Dielman, unfold before us. It matters thus that Akerman's film is itself a work of acknowledgment, a film that approaches the status of the fragment in its refusal of explanatory narrative, which is how Cavell tells the film: "I wish to convey in this selected table of events the sense of how little stands out until the concluding violence, and at the same time that there are so many events taking place that a wholly true account of them could never be completed, and if not in this case, in no case."[41]

The Cavellian fragment, its authority, depends on its being itself a form of acknowledgment. It succeeds as a form of acknowledgment when it can make manifest its dependence and need for things; in Cavell, typically, those separate things are works of art or works of philosophy. This is not any old need or dependence; it occurs in the service of a vision in which things are separate yet capable of gathering a world, an effective jointure of fact and meaning (beyond our power of making or systematizing). The power of the fragment, its authority, is achieved when it releases the thing for that vocation—directly, allegorically, analogically, metaphorically. So philosophy approaches literature only in eschewing the autonomy of reason or concept, their power of gathering through subordination; it does this in Cavell when the individual fragment—sentence, paragraph, aside, parenthetical remark, aphorism—matches the career of the thing in its newly found indigence and beauty.[42] This is not an easy task or one Cavell always manages well, in part because what is demanded is not always clearly in sight. But this is not surprising: philosophy cannot by a force of will alone take on the concreteness, the sensuousness, the dependence on experience that has been the prerogative of art; what created the aesthetic problems of modern philosophy will often leave philosophy beached in abstraction, yearning for a sensuous particularity it cannot quite achieve. And sometimes an odd fragment might manage the difference. After describing Jeanne Dielman's routine of opening and closing doors, Cavell comments: "The spaces are kept as separate as those in a cabinet of curiosities. (What would happen if they touched? A thought would be ignited.)"[43]

4

Aporia of the Sensible—Art, Objecthood, and Anthropomorphism: Michael Fried, Frank Stella, and Minimalism

> Art must find domination a source of shame and seek to overcome the perdurable, the desideratum of the concept of the sublime.
> —T. W. Adorno, *Aesthetic Theory*

I. The Fate of Art

Imagine, if you will, a Second World War bomb shelter: typical concrete construction, cold, damp, the few lights attached to the walls directed at the ceiling. Scattered on the floor are white marble chips, from the sort of marble the great sculptures of the past were made, especially those Greek male bodies. Lying before you as you enter the bunker are four more-or-less coffin-shaped blocks, approximately seven feet long, two feet high, and three feet across. The four blocks are set one behind the other. They are made of Jell-O! Hence the sharp edges of the marble chips dig into them, scoring their flesh: their gross raspberry color vibrant, too vibrant; they are translucent, solids that yet are a medium through which light passes.

This wonderful installation piece, by the Norwegian artist Jeanette Christensen, is almost too successful, almost a piece of conceptual art. Although visually powerful, both amusing and disturbing, it appears to be making statements; or better, we cannot avoid approaching it as if it were making statements: it asks us to connect, on the one hand, the hardness and monumentality of classical sculpture, its implicit celebration of power, its iden-

tification of power and beauty, as now only chips on the floor, with, on the other hand, the need for hardness, the monumentality of the bomb shelter. The bunker and the blasted beauty, the chipped trace of the classical, form a constellation of power, timelessness, and destruction. Further, there is a gendered affinity between the ruined classical sculpture and this bunker, the desire for immortality and the outrages of war, which reduce it to rubble. The work urges the configuration of war and its devastation with the classically beautiful, those artistic perfections of the human Kant celebrated in his ideal of—male—beauty. Christensen accomplishes this constellation through the work's oppositional structure: compare those masculine, atemporal notions of art and worth with the feminine, fleshy, uncanny vulnerability of the always temporally conditioned Jell-O blocks. There is here a call and a claim for transience and embodiedness, an act of mourning and an act of ironic revolt.

In saying that this piece is almost too successful, I mean that it lends itself so fully to statement that its visual spectacle is in danger of being (indeed will be) overwhelmed by what can be said about it.[1] I can, or could, elaborate a whole discourse about this work. Serious reflection about Christensen's work reveals an aporia between the conceptual and the sensuously particular, a token of the type of aporetic relation between truth-only cognition—call it philosophy, call it criticism—and art; above all, I want to claim, it is an aporia that is systematic and categorical in sociocultural practice. This aporia can be, on occasion, mitigated or abbreviated, reflexively acknowledged or evaded, but remains. Its cause is societal rationalization and disenchantment; its fundamental effect is nihilism: the condition in which our highest values lose their value, their ability to be routinely formative in the lives of individuals.

The price Christensen's piece pays for her work's cognitive striving, its allegorical prescience, is that a discourse about it can overwhelm, overreach, and become independent of the piece itself; the work then becomes a mere illustration of a general theory. The reasons for this are overdetermined. In part, one is inclined to say that Christensen's piece so powerfully solicits discursive articulation because it is thetic; but one is also inclined to say that, in being thetic now, the work is ideological, a counter in the debate about gender, history, and art. But to the extent that the work is ideologically potent, it loses its aesthetic compulsion, its power to hold and demand our visual attention simply by virtue of its sensible characteristics

and arrangement. If the work is truly drenched in interests and ideology, then its authenticity is parasitic on our agreeing with the interests and values the work promotes. All this will drum the work itself out of sight and into reflection.

Somewhat differently, one might explicate the work's flirtation with discursivity as a consequence of the art community's immense powers of interpretation and critical elaboration. We have become adepts at reading the visual, decoding it, interpreting, and overinterpreting to the point where the work itself barely registers. Christensen is aware of this danger—what Adorno calls "neutralization"—and its present unavoidability. By making this piece of material that will rot, decay, and dissolve, she is both urging our visual attention against the work's passing and underlining the work's *own* temporality, its status as memory-in-matter, matter's memory, memory mattered, its standing as an event. The event of this work is real: as the days move on a white mold forms on the surface, and then there is a brownish discoloring of the mold. Each day the work is different, its beauty and difficulty something apart from Christensen's control. The fate of this work, its duration, is a condensed history of Western art in six weeks: it dies—putrefies, decays, and passes away—before our eyes. And yet, employing a different temporal matrix, the process of dying is incredibly slow, since unlike a classical sculpture or easel painting it cannot be taken in at a glance. This work—which means to reveal what is true of all works of art but classically denied, dissimulated, and repressed, left unacknowledged—is never present, but *always* passing, dying, dead, always framed in a history it despairs but without which it would lack meaning. And the process of the work's dying is its awkward beauty. Beauty is not other than this work's mortality; only in its decay is its beauty to be found. Finally, gone, the work can live only as a piece of memory and narrative, as the trace of a tradition that is, was, never present, never visible, as, from the beginning, a hostage to the depths of personal memory and the endless words we elaborate around its missing presence.

The work as history, the work as political statement, the work as aesthetics, the work as allegory. In all these ways, Christensen's installation piece eludes and fails visual and perceptual claiming. The subtlety and power of this piece is that these forms of failure are what it is. Christensen relates to the tradition of art through acknowledging its *failure*, and lets that failure be the *visual matter* of her construction. Only by failing monumentality, clas-

sicality, presence, presentness, can the work succeed; and in succeeding it fails; in failing, it succeeds. Without dishonor to Christensen, I want to give the work a name of my own: "The Fate of Art." But other names are possible, each as right and distorting as the next: "Vile Bodies," "The Refuge," "Every Day Is a Miracle," "Lost Love," "His and Hers," "A Chip Off the Old Block," "Kitsch Deferred," "Art Was Here," etc. These names or pseudo-names suspend the work's visual presence, subjecting it to the anxiety of allegorization, its own power of proliferating discourse as what it wants and refuses. Christensen, I am suggesting, locates and identifies the aporia of the sensible for us, and rather than seeking to avoid, evade, or resolve that aporia, places her art in its service, inhabits the aporia, making the aporia, the impossibility of sensuous presentness or instantaneousness, the impossibility of unconditioned perceptual claiming, the matter of her art, its mode and manner of being visually present (absent) to us.

In contrast to Christensen's work, but equally its immediate antecedent, is the last systematically successful project to sustain the claim of sensuous particularity against conceptual claiming: abstract expressionism. Here the price paid for inhabiting the aporia of the sensible was cognitive opacity; those works, from *Excavation* to *Lavender Mist*, appear as indecipherable writing, meaning beyond or without discursive redemption, allegories without referents, meaning always being solicited and refused, so that finally nothing sayable can arise from them. Abstract expressionist works seek to haunt the mind or memory the way trauma might: presence without assimilability. The artistic sublime then is an aestheticization of trauma, its safe reenactment. And these works will fail if they lose their power to disturb, to be traumatically present. The worst thing that could happen to a Rothko or a De Kooning or a Pollock is that it might become beautiful.

Abstract expressionism's singular solicitation and dissolution of discursive meaning can still cause bafflement and outrage: how can an item mean but not discursively mean? Socially and practically, as well as philosophically, Enlightenment rationality stipulates that meaningfulness, discursivity, and communicability without remainder are to be identified. Michael Dummett takes these identifications or equivalences as patent constraints on a theory of meaning.[2] Anything else, he avers, would be a private language, and hence no language at all. What if, however, Dummett's account of language and meaning can be satisfied only by the loss of the material world? And what if what is at stake here is not a theory of language but the

fate of the material world itself, so that the predicament of modern art, the emergence of the aporetic of sensible particularity, is not a narrow problem for art about its possibility of continuing, but the reflective articulation of the aporia of the sensible *überhaupt*, the immanent disappearance of nature from sight, which would be just its disappearance as the acknowledged material medium of human life? What if the extremes of abstract expressionism's cognitive opacity and traumatic unassimilability, and Christensen's richly allegorical presentation, formed the poles of a continuum without a middle: semiotic and symbolic extremes that could touch one another but never infiltrate or mediate one another? And is this broken middle nothing less than our broken modernity? The entwining of the aporia of the sensible as society's fate consequent upon the rationalization processes of modernity and as the dominant constraint on the discontinuous development of modernist art presupposes that art is a reflection of its time in the two-dimensional domain of paint on canvas and the three-dimensional practice of modern sculpture.

These are exorbitant claims. But I know of no better way of processing them than through art, its possibilities and impossibilities, its momentary centrality for culture as a whole between, say, Cézanne and Pollock, and the present waning of that centrality as a consequence of art's loss of its potential to systematically sustain the tension between visual meaning and discursive meaning. A philosophy that argues this thesis is bound to appear suspect since in it conceptual comprehension and sensible claiming will remain divided despite the abstract urging of their belonging together. Thus Jim Elkins has charged *The Fate of Art* fails the radicality it insinuates, betraying the insights it pronounces by remaining so removed from visual works and their claiming.[3] Implicitly, Elkins treats its failures, and those of Derrida and Adorno, the various philosophical attempts to make sense of painting, as if they were flatly failures of will or intellect, failures to find the right mode of filling a space just there to be filled: finding the word that would fit but not be subsumed beneath a welter of historico-philosophical reflection is what particular works solicit or present. Hence, he must assume that Jeanette Christensen, on one side, and say Jackson Pollock on the other, were also failing differently to fill that same space. If there is a difficulty about the tendential impoverishment of the visual in postmodernism (the extreme of this being Danto's end-of-art thesis in which art just becomes philosophy—of art)[4] in relation to the materialistic hermeticism

of high modernism, then this is because there is not yet, or any longer, a space that can, routinely and livably, be filled. Art is bound to the sensuous extreme or gives in too quickly to conceptuality, while philosophy remains bound to a conceptuality it can only conceptually master, and thus fails sensuous particularity. What Michael Kelly has called modernity's iconoclasm, the destruction of sensuous particularity at the hand of the concept (call it reason, capital, technology), which takes distinct and specific forms within art and philosophy, is just a sociohistorical movement that gets played out indefinitely within art as its own private fate. But the problem of art and philosophy is not a problem of art or philosophy; it is about the abstraction of modernity, and hence about the categorical disposition of universal and particular governing everyday life.[5] The difficulties of art and philosophy token and repeat that aporia, they do not make it. Disenchantment is real.

II. Defeating Skepticism

Perhaps the moment when the force of the aporia of the sensible collided with the art world was when the exhaustion of abstract expressionism became palpable. How would art continue? Could it continue? At this precise moment a variety of movements and responses emerged: minimalism, pop art, the austere shaped and striped canvases of Kenneth Noland and Frank Stella, the somewhat different, albeit analogous, colorfield work of Jules Olitski, Larry Poons, and Ad Reinhardt, the sculpture of David Smith and Anthony Caro. I find the all-but-definitive registering of this moment in two essays by Michael Fried: "Art and Objecthood" and "Shape as Form: Frank Stella's New Paintings."[6] These brilliant essays negotiate the relation between criticism, art history, and philosophy in an almost exemplary manner; Fried's response to the works then emerging is as thoughtful and replete as can be imagined. Above all, his critique of minimalism and its fading of art into objecthood seems to me prescient and almost unanswerable. Yet Fried does go wrong in his championing of Stella and Caro because, while half-acknowledging the aporetic condition of art—how else could he stake himself on the claims of such an austere and self-limiting high modernism? —he fails to let the aporia of the sensible and the process of exhaustion and disintegration it tokens inform his judgment. Success, presence, is still the criterion. As Fried famously concludes "Art and Objecthood": "We are all

literalists most or all of our lives. Presentness is grace."⁷ This remark has been disparaged as misplaced theology, which to my mind slides off the difficulty of Fried's assertion. The issue is not, too rapidly expressed, a theological inflation of art, but rather what kind of condition would make us all "literalists," persons who regard the things surrounding them as *mere* things, most or all of our lives? Is the condition of being literalists the human condition, things only or at best ever mere things, without sense or meaning? Are the bodies of human others most or all of the time mere bodies? Is literalism even an intelligible position in regard to everyday things and objects? Is this literalism not too much in thrall to the skepticism about meaning and objecthood that Fried means to be struggling with and against? Fried is too easy about literalism, too accepting of it as the ontology of the ordinary. Conversely, art becomes in his thought too rarified and separate, too disconnected from the formations and deformations of our present mode of inhabiting the world. The absence of the aporia of the sensible in Fried engenders a disengagement of the relation between art and the world; as a consequence his criticism forfeits the existential pathos of art's failures and successes.

Anthropomorphism is the central term around which the meaning and boundaries of art and objecthood are contested. Beginning with Descartes's methodical doubting of appearances, modernity has construed its rationality as a critical overcoming of the endless displays and temptations of anthropomorphic understanding—the projecting of human meaning onto an inhuman or indifferent material world. If, the argument runs, things only have meaning through what we project onto them, then in themselves things are meaningless and thus ought to be understood in the visionless medium of pure mathematics. The same movement of demythologization that fashioned the death of God is carried forward by a rationalism that limits meaning and value to the satisfaction of human desires and interests as processed through a practical reasoning that is instrumental, means-ends rational, through and through. All else is mythology and illusion. No distance at all separates Cartesian skepticism from Hobbesian liberalism.

Without quite comprehending its own skeptical stance, high modernism was equally a movement of demythologization, of overcoming anthropomorphism. If, as a consequence of demythologization outside art, "all the verities involved by religion, authority, tradition, style, are thrown into question,"⁸ then the artist must forsake reliance on the symbols and references

that formed the bond and medium of communication with her audience. These now belong to the domain of desires and interests only, and hence cannot, except in the most narrow sociolect, be relied upon to provide works with their objectivity. In their stead, as Clement Greenberg argued, the medium of art itself becomes the source of discipline and authenticity:

> The history of avant-garde painting is that of a progressive surrender to the resistance of its medium; which resistance consists chiefly in the flat picture plane's denial of efforts to "hole through" it for a realistic perspective. . . . Painting abandons chiaroscuro and shaded modeling. Brush strokes are often defined for their own sake. . . . Line, which is one of the most abstract elements in painting since it is never found in nature as the definition of contour, returns to oil painting as third color between two other color areas. . . . But most important of all, the picture plane itself grows shallower and shallower, flattening out and pressing together the fictive planes of depth until they meet as one upon the real and material plane which is the actual surface of the canvas; where they lie side by side or interlocked or transparently imposed upon each other. Where the painter still tries to indicate real objects their shapes flatten and spread in the dense, two-dimensional atmosphere.[9]

Among other things, Greenberg intends the movement of art into abstraction to be a form of defending anthropomorphism. Indeed, such anthropomorphism is the point of his Kantian construal of abstraction. Kantian, immanent criticism is the mode through which practices justify themselves from the inside: "Each art [must] determine, through the operations peculiar to itself, the effects peculiar and exclusive to itself. By doing this each art would, to be sure, narrow its area of competence, but at the same time it would make its possession of this area all the more secure."[10] While the representational and symbolic contents of traditional painting might be subject to a demythologizing critique, painting itself cannot be:

> But the making of pictures, as against images in the flat, means the deliberate choice and creation of limits. This deliberateness is what Modernism harps on: that is, it spells out the fact that the limiting conditions of art [that is, the flatness of the picture-support] have to be made altogether human limits.[11]

Painting, Greenberg contends, is a fundamental *human* practice which, properly refined, inscribes a domain of the purely optical, a reflective articulation of the world as purely and restrictedly something *seen*, without addition or subtraction. But the *world as seen*, the seen world, is not the world as a thing in itself, but precisely the world as the internal correlate of

the seeing eye. Hence, the optical space that easel painting uncovers transcends whatever images have been historically inscribed within it; the optical space of abstract art performs a limit condition of human interaction with the material world as such.

Greenberg's essentialism is open to obvious complaints. Most directly, his optical account of painting abstracts the human eye from the human body, seeing from touching, the optical from the tactile, and all these from the torsions of desire in seeing: to see or not to see? to look or to stare? to spy or to behold? Even the restrictedly "seen" world as articulated in art must insinuate a phenomenological (sensible) physics and erotics of seeing. Without quite pressing the matter in this direction, Fried is guided by a suspicion concerning Greenberg's essentialism and thus takes a more Hegelian or Wittgensteinian line. In opposition to Greenberg, he denies that it makes sense to search for the timeless conditions of a practice, to even attempt to abstract that practice from the history of which it is so evidently a part. But, he continues:

[T]his is not to say that painting *has no* essence; it *is* to claim that that essence—i.e., that which compels conviction—is largely determined by, and therefore changes continually in response to, the vital work of the recent past. The essence of painting is not something irreducible. Rather, the task of the modernist painter is to discover those conventions that, at a given moment, *alone* are capable of establishing his work's identity as painting.[12]

By placing the emphasis on those "conventions" that can compel conviction, Fried underscores the anthropomorphism of his criticism. The defeat of nihilism is not to be found in an a priori bedrock of opticality as given through the practice of painting, but, under the pressure of changing historical configurations, the essential is that which encounters and defeats skepticism through conventions that defy the suspicion of the arbitrariness of subjectivity to which conventional practices are now subject. In "Shape as Form," Fried compares this notion of essence to Thomas Kuhn's conception of a scientific paradigm.[13] In making this assertion, Fried is not departing absolutely from the Greenbergian vision; Fried too believes that the limits of art are "altogether human limits." His demur is nuanced: altogether human limits are indeed limits, but they are nonetheless a matter of history and convention. The very idea of the historical a priori with which Fried is working takes the difficulty of the human, the difficulty of sus-

taining compelling anthropomorphism, as always a crossing where the apparently merely conventional projects and inscribes a truly limiting condition. Aesthetic judgments, judgments of value and conviction, are articulations of that fragile crossing, finding in the contingent something that is more than contingent, more than mere fact—in truth, an encounter with altogether human limits.

Fried's confidence in the human capacity to defeat skepticism and arrive at compelling conventions cannot be accepted as stated.[14] One may worry that Fried is too conventionalist in his defense of modernist painting, as if the kind or type of historical pressures impinging on art had no intelligible structure or tendencies, as if it were some strange world-historical contingency that the process of purification that Greenberg first traced was not the one that continually found in the conventional as such a threat of arbitrariness that skeptically consumed any hope of objectivity. Which is to say, modernist art has, knowingly or unknowingly, suffered a double pressure: not only uncovering compelling conventions, but in so doing showing that those conventions, and by implication conventions as such, can bear the weight of essentiality. But art need not accept the burden of that double demonstration. The alternative of denying anthropomorphism has been available to modernist art from its inception. Perhaps, unknown to itself, modernism has been *also* a creature of Enlightenment rationalism and skepticism—Seurat, perhaps, would be a case in point where the *also* first becomes palpable and evident; hence, perhaps the best way of construing modernism's progressive demythologization, its skeptical attack on image and representation, is to align it with what that demythologization has been all along in the modern epoch: anti-anthropomorphism. This project possesses an intriguing heroic complexity: to remove from art all traces of (mere) anthropomorphism while yet producing *works*.

"While yet producing works" is the nub of the problem. What locates both Greenberg and Fried as defenders of anthropomorphism is their presumption that *art* matters, that there is art, that there is this human practice that even under the most intense skeptical pressures can discover forms of resistance, forms of authentic sensible appearing. Whether in achieving an a priori bedrock of optical appearing or discovering conventions that hold against the nihilistic onslaught, what both find is a *formation* (transformation or transfiguration) of object that, however minimally or fragilely, silhouettes human intercourse with the material world—with eye or hand or

body, always an inflection of the size of the body, its upright posture, the hand that grasps with its opposing thumb, the forward look, the eye's response to distance, color, shape, and form. These ineliminably belong to an anthropomorphic contouring of the world, to the world as lived by a human body that can engage in practices that transcend the fact of embodiment itself. For both Greenberg and Fried, modern art has had the unique task of inscribing this anthropomorphic minimum (or at least of providing reminders of it), of salvaging the world, including its habitation by emphatically *other* persons, as the forever internal correlate of the material person.

So much, one might have thought, could be taken for granted. But, in the wake of modern science, technology, and bureaucratic rationalization, none of this can be taken for granted; art's apparently constitutive anthropomorphism cannot be taken for granted. If the standard view of modern art is that it is a critical defense of minimal anthropomorphism, at least along its visual axis, there has been and remains a reading of modern art that interprets it as continuous with the critique of all anthropomorphism, and thus aligns art itself with high Enlightenment rationalism. So, for example, while Robert Rosenblum interprets Barnett Newman's *Onement I* as a kabbala-inspired reworking of the romantic sublime in the tradition of Friedrich, Donald Judd describes *Vir Heroicus Sublimis* in these terms:[15]

> *Vir Heroicus Sublimis* was done in 1950 and the color of one stripe was changed in 1951. It's eight feet high and eighteen feet long. Except for five stripes it's a red near cadmium red medium. From the left, a few feet in, there is an inch stripe of a red close in color but different in tone; a few feet further there is an inch of white; across the widest area there is an inch-and-a-half of dark, slightly maroon brown that looks black in the red; a few feet further there is a stripe like the first one on the left; a foot or so before the right edge there is a dark yellow, almost raw sienna stripe, the color that was changed. These stripes are described in sequence but of course are seen at once, and with areas.[16]

In describing Newman's work, Judd eliminates from it not only all psychological associations and connotations, but equally any reference to it as something seen and experienced. Or rather, his phrase "are seen at once" attempts to flatten the seeing, something that Newman must have been aware his painting invited since he insisted that to see it properly the viewer should stand up close to the painting.

I do not wish to deny that Judd intends his account as anti-skeptical, and hence as salvaging objectivity for art; this is what makes his art and

criticism belong to the tradition of Enlightenment rationalism. However, the terminus of art's anti-skeptical strategy on Judd's interpretation is a material item that no longer depends for its holding in the visual field through anthropomorphic assumptions, but appears literally as an object, a mere thing, in the same way that natural objects appear for the natural scientist as constituted through quantities that escape the vagaries of human perceivings and doings. Judd wishes to achieve for artworks an analogue of the perspectiveless appearing that is the telos of absolute knowing: a view from nowhere. Of course, art cannot utterly remove the viewer from the viewed, but it can aspire to neutralize viewing by decentering the viewer and thus disorienting and dehumanizing the visual field.[17] The neutralization of individual orientation on and through a visual field is (one inflection of) artistic anti-anthropomorphism.

Judd and Robert Morris are explicit about their anti-anthropomorphism. For example, in his "Notes on Sculpture, 3," Morris states:

> Surfaces under tension are anthropomorphic: they are under the stresses of work much as the body is in standing. Objects which do not project tensions state most clearly their separateness from the human. They are more clearly objects. It is not the cube itself which exclusively fulfils this role of independent object—it is only the form that most obviously does it well.[18]

Not only does the machinic sheen of minimalist works make (direct) reference to the human hand otiose, but the forms used—cubes, simple rectangles, etc.—by being tensionless, almost material equivalents of Platonic forms, establish a separateness—or is it just a feeling of separateness?—from the human in general.

For Judd, traditional painting is seen as being on the verge of exhaustion; he associates this exhaustion with painting's being bound to anthropomorphic imperatives that have lost their power to compel. Any "part-by-part" complexity in a work, any overtly "relational" character of elements, will sign the presence of the human hand and mind, sign a will to order and arrangement, and thus create a purposiveness without intelligible purpose, whatever that purposiveness may be. Even the most austere post-abstract expressionist painting is still a painting, and thus still at the behest of narrowly subjective human desires and ends. Hence, the minimalist painting as such remains caught in a web of anthropomorphic signification that requires elimination.

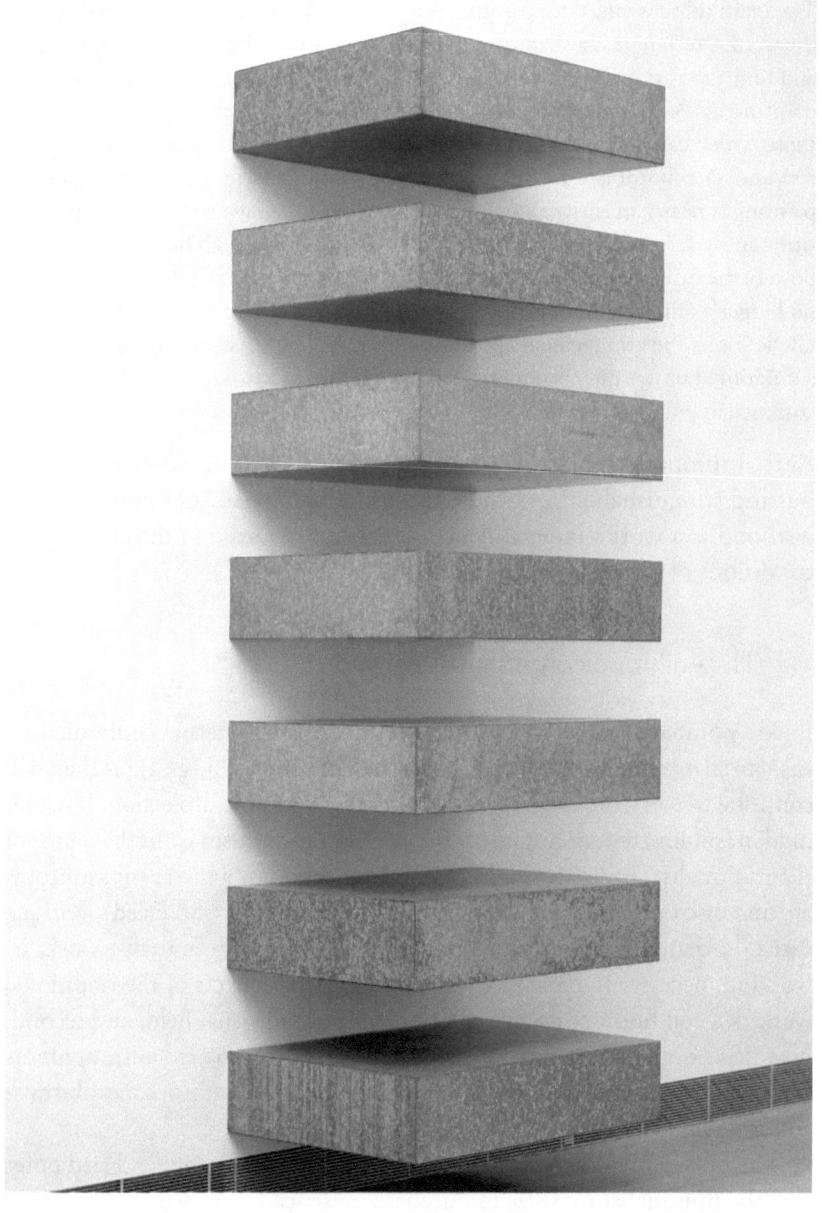

7 Donald Judd. *Untitled* (1965), Moderna Museet C/O. Art © Donald Judd Foundation/Licensed by VAGA, New York, NY. Photo © Estate Rudolph Burckhardt/Licensed by VAGA, New York, NY.

The main thing wrong with painting is that it is a rectangular plane placed against the wall. A rectangle is a shape itself; it is obviously the whole shape; it determines and limits the arrangement of whatever is on or inside of it. . . . [In contemporary painting by Pollock, Rothko, Newman, and co.] the shapes and surface are only those which can occur plausibly within and on a rectangular plane. The parts are few and so subordinate to the unity as not to be parts in an ordinary sense. A painting is *nearly* an entity, one thing, and not the indefinite sum of a group of entities and references [needing to be arranged and ordered]. The one thing overpowers the earlier painting. It also establishes the rectangle as a definite form. It is no longer a fairly neutral limit. . . . The simplicity required to emphasize the rectangle limits the arrangements possible within it. The sense of singleness also has a duration, but it is only beginning and has a better future outside painting. Its occurrence in painting now looks like a beginning.[19]

Anti-anthropomorphism requires the establishment of works that are all but indistinguishable from mere things. What constitutes authentic objecthood is a work's independence, separateness, from anthropomorphic conditions of meaning and appearing.[20]

III. Anthropomorphism Disavowed

Fried's pointed critique of minimalism unearths its internal contradiction. Insofar as minimalist works are works and not mere things, then they will continue to carry the full baggage of anthropomorphic projection, however hidden, sublimated, or disguised this anthropomorphism is. In the hands of the minimalist, Enlightenment rationalism becomes a secret misanthropy, an unconscious misanthropomorphism. The subtlety of Fried's critique turns on demonstrating, first, how the effects of the minimalist work, its working, necessarily *simulate* for the perceiver the effects of the traditional work as a condition of its authentic holding of the visual field; and second, how this simulation, in fact, involves an always dissimulated anthropomorphism. Fried denominates minimalism's dissimulated anthropomorphism as "theatricality."

The first element of simulation is size. Following Greenberg, Fried notes that the minimalist uses size to purchase presence for his work. A large object in any ordinary setting demands our attention; it crowds in on us and asserts itself as something to be looked at, taken in, acknowledged. This deployment of size presupposes the scale and orientation of the human

body; what comes to "feel" like it is crowding or overwhelming depends on both the body's scale and the setting. Even a very large work in the middle of an expansive open field can be diminished by sky and the receding horizon. Only by being placed "here," say in this exhibition space, does the size of the work function as a mechanism of claiming.

Second, the size, or better, the scale of the object can be further inflected through how it structures our relation to the object in terms of distance. Large objects in standard spaces press our bodies away from them as a condition of their being seen at all. This structuring of space, the minimalist contends, creates a "nonpersonal or public mode,"[21] a sense that we are in space *with* things rather than surrounded by them. The nonpersonal or public mode—the neutralization of perspectival viewing—thus intends a certain equiprimordiality of persons and objects that is taken as criterial for anti-anthropomorphism.

These deployments of scale and distance are not, as the minimalists suppose, mechanisms for a public and nonpersonal art. As Fried contends, if something has presence only if we are forced to take it *seriously*, then the appropriate question about minimalist works is, why do we take them seriously (if and when we do)? Fried's answer is that the actual manner of their imposing themselves on us, crowding us, has its precise origin and analogue in our feeling crowded and distanced by "the silent presence of another *person*; the experience of coming upon literalist objects unexpectedly—for example, in somewhat darkened rooms—can be strongly, if momentarily, disquieting in just this way."[22] Such objects are slightly looming presences, portentous, all the more so to the degree that their simple structures but large scale appear as not merely separate from but significantly indifferent to us. In this respect, minimalist works create a situation in which we are subjects by being "subjected" to them, defined in our reach, power, and vulnerability by their indifferent largeness.

Because Fried defends anthropomorphism, his objection to minimalism is not that it is anthropomorphic, or even that it ideologically disputes anthropomorphism and thus must hide or dissimulate its employment. Rather, what is wrong is that "the meaning and, equally, the hiddenness of its anthropomorphism are incurably theatrical."[23] By "theatrical," Fried means a structuring of the work and the situation it creates that *exhausts* itself in its effect on the beholder. This structuring generates as an effect the sense of a human situation—an object demanding to be taken seriously—as the *to-*

tality of its working; minimalist works create what might be termed "the art effect" without anything substantial corresponding to that effectivity. The "theater" is the situation generated, which a fortiori includes the spectator. If the sense of such works *is* the situation they compose, then they are not separate or independent from the viewer, and they *are* relational: poles or elements of a relational situation. Being *only* elements of a situation, deriving their identity from the situation they create, minimalist works lack any "inside," any internal complexity or depth that would token their separateness or autonomy. They exude a sense of hollowness, emptiness. They simulate the manner of an aesthetic encounter without there being anything of significance to encounter. Hence the perplexity and disappointment they generate: the works demand a certain stance and attention, but the demand is empty, the work realized and exhausted in placing the demand.

Another aspect of minimalism's empty theatricality is its endlessness. Traditional works intend an entwinement of the sensible and the conceptual, the semiotic and the symbolic, such that ideally the conceptual cannot be prised off its sensible presentation. Ideally, no verbal recapitulation, paraphrase, or account of an artwork provides what the work itself provides. Only an intransitive understanding of works that permits their sensible features to enter into their full cognitive effectivity can capture what works promise.[24] Abstract works that insinuate meaning without releasing an object-independent thought are designed to effectuate, isolate, and realize intransitive sense. Minimalist works simulate the experience of intransitive meaning through their empty insistence; it is only their insistence and the repeatability of their forms that holds our attention. Their sense is endless, a repetition of the same, not intransitive.[25] Thus Fried comments on Tony Smith's black cube as the exemplary literalist work:

> [It] is *always* of further interest; one never feels that one has come to the end of it; it is inexhaustible. It is inexhaustible, however, not because of any fullness—*that* is the inexhaustibility of art—but because there is nothing there to exhaust. It is endless the way a road might be: if it were circular, for example.[26]

IV. A Haunting Emptiness

Pace Fried, because literalist works do possess and employ an anthropomorphism (albeit disavowed), they can be uncanny, and that uncanniness provides a haunting sense of power. Their very simulation of artistic full-

ness and their insistent emptiness can feel like a particular and horrifying fate of the human, as if all that remained was the wholly empty form of the human, the general idea of anthropomorphism without a content to fill it. The emptiness and theatricality of literalist works, because not apparently overcontrived, can feel "right," can feel like a proper and adequate response to preceding art and its inability to provide a convincing fullness. The endlessness of minimalist works exemplifies and creates an insistent boredom, an ennui that is unnerving by virtue of its insistence, as if art's aesthetic fullness and its emptiness, its power and its impotence, needed to be seen together, as two sides of the same coin. And for this purpose one might reasonably claim that geometric simplicity, simple repetition of the same,[27] and the absence of handedness in the materials represent almost *classical* temptations, the temptations of classicism in a technological age: a materialist Platonism.[28] Hence one can experience the fundamental grammar of minimalism, its classicism and positivism, not as refusing the separateness of the art object, but as attempting to secure it more firmly and radically than traditional modernist art could manage. Minimalism's critique of modernism might then be taken as suggesting that modernist art fails its own terms of authenticity and must do so. But this, then, would be the playing out of a certain kind of Platonism *in* art, *in* the sensible—which I think is one aspect of these works' continuing power. Judd's vertically and horizontally arranged boxes suspended from the wall (see Figure 7) always have something of this appeal for me: an all-too-human, which is to say anthropomorphic, way of disavowing anthropomorphism. Might we not think of such works as *aesthetically* performing (through the *use* of geometric forms, repetition, and machined materials) the claim of Enlightenment rationalism, its demythologizing animus, while in being so emphatically aesthetic, never simply fully rationalized things, mere objects? Fried moralizes the emptiness of minimalism—its possession of an art-look without attaining the status of art—rather than perceiving in his disappointment part of the complex claim lodged by these works.

In contesting Fried's judgment of minimalism, in claiming that its survival is not accidental and that it articulates a certain formation of the modernist sensibility, my aim is to put pressure on the dualistic categories licensing his criticism: art versus objecthood, art versus theatricality. For Fried, for now, "modernist painting has come to find it imperative that it defeat or suspend its own objecthood, and that the crucial factor in this

undertaking is shape, but shape that must belong to *painting*—it must be pictorial, not, or not merely literal; . . . the imperative that modern painting defeat or suspend its objecthood is at bottom the imperative that it *defeat or suspend theatre*."[29] Objecthood is a mode of the theatrical; Fried also criticizes surrealism for its theatricality, but surrealist works are not literalist. Theatrical works take their measure from their effects on the beholder. They are wholly for the beholder, for the other, without any "ownness" proper to themselves. Theatrical works are spectacles, performances designed to please, enchant, or unnerve the spectator. Their lack of reserve or inwardness is their specific kind of emptiness. Lacking autonomous sense or value, they make the entire meaning of the visible a matter of effect. Theatrical works are advertisements for art.

While I would not necessarily want to demur from Fried's Rousseauian critique of theater, his chastisement of the literalist drive toward objecthood (in their minds: toward externalism) as a mode of the theatrical is too simple and direct. However potent the categories "theater" and "objecthood" are as critical tools, they suppress the dynamic, if discontinuous, unfolding of modern art. Fried is of course correct in claiming that it would be a misconstrual of modernist painting to perceive it as consisting in "the progressive revelation of its essential objecthood."[30] But this delusive comprehension of the history of modern painting is not without point. What *forces* have been pressuring art, from within *and* from without, to find its resources within the medium itself? What forces have been skeptically impinging upon the symbolic and representational elements of art, removing them from the repertoire of advanced painting? Why has modern art been forced to become ever more "minimalist" in the broadest sense of that term? While no single answer to these questions is either possible or necessary, it would be unintelligible to suppose that the deracinating anti-anthropomorphism of modernity generally has not, discontinuously, compelled art's inward turn, and that with the achievement and lapse of the opaque cognitivism of abstract expressionism the once external pressure of anti-anthropomorphism could establish itself as a form of *artistic rationality*; does not the notion of shape as form derive from that same anti-anthropomorphic rationality? A pertinent, Wittgensteinian way of making this point would be to say that while, necessarily, anti-anthropomorphism is self-defeating as a general mode of artistic comportment (because art is intrinsically anthropomorphic), there is a biting truth in minimalist skep-

ticism. Minimalism reveals the truth of artistic skepticism: no human fullness is given with anthropomorphism as such. In minimalism's defeat of objecthood (through, again, geometric form, repetition, and the removal of handedness through the deployment of machined or machined-looking forms) aesthetic surplus and emptiness touch. In minimalist works aesthetic form is as opaque as it is in the works of abstract expressionism, only here the affect is one of coldness, coldness as the mood of enlightened reason, that gets expressed.³¹ But this is not nothing: reason's coldness is perhaps the most persistent temptation, because it is the most thoroughly *disillusioned*, of Occidental thought; and what could be more tempting and shocking than to find that from the resources of such a disillusioned, rationalistic stance art can be made? The claim of geometry does not disappear with, say, Renaissance Platonism.

But then the question might naturally be asked, why should this enduring temptation reemerge with such virulence, for art, at this moment? Part of the answer is, of course, the exhaustion of contrived and traditional symbols, the general waning of traditional authority that is an insistent aspect of modernism but rises to prominence, again, with the waning of abstract expressionism. Fried locates eloquently the other part of the answer without appreciating what he pointedly uncovers. It is in his account of Tony Smith's description of a nighttime car ride along the then unfinished New Jersey Turnpike that Smith finds an exuberance in the unframed, open experience of driving along the road; for Smith, this unbounded experience was liberating, putting to shame the closed and framed experiences typical of modern art, as if the experience of the latter indeed belonged to the world of tradition and only the former truly modern. Fried comments:

> [I]f the turnpike, airstrips, and drill ground are not works of art, what are they?—What, indeed if not empty, or "abandoned," *situations*? And what was Smith's experience if not the experience of what I have been calling *theater*? It is as though the turnpike, airstrips, and drill ground reveal the theatrical character of literalist art. . . . In each of the above cases the [art] object is, so to speak, *replaced* by something: for example, on the turnpike by the constant onrush of the road, the simultaneous recession of new reaches of dark pavement illuminated by the onrushing headlights, the sense of the turnpike itself as something enormous, abandoned, derelict.³²

This is a terrific description; it also, and not accidentally, could become, in part at least, a description of Smith's six-foot, black-painted steel cube, *Die*

(1962). What Smith uncovers in the *obsolete* ("derelict," "empty," "abandoned" are Fried's terms) products of rationalized modernity (turnpike, airstrip, drill ground) is an excess that converges, precisely, with the antianthropomorphic impetus of classical rationalism. Smith is hence tapping into the intrinsic ambiguity of rationalized modernity: in its obsolescence it takes on an appeal that is, artistically rendered, the appeal of classical rationalism. *The minimalist object, seen aright, is just the obsolete modern*; in becoming obsolete the promise that actuality deprived it of is returned. This is not to deny what Fried finds alarming—the emptiness and hollowness of the experience (that is, the other side of experience, the source of its ambiguity); nor then do I mean to deny that minimalism, in this form, is a dead-end. But its success and failure are poorly described by the notion of *theater*. Rather, against the background of the fading claim of modernist painting, its exhaustion, its incapacity to figure an experience of separateness and externality, the ambiguity of rationalized modernity, in its obsolescence, becomes artistically available in the rationalized grammar of minimalism. Isn't there something exemplary in the fascination and emptiness of this art, as though, again, the promise of fullness and the disappointment of that promise belonged to the grammar of modern art generally? To modernity generally? And isn't it just the ambiguity of these objects and the consequent ambivalence of our responses to them that Fried seems to be defending himself against (since it is there too in his beloved Stellas and Nolands)? Isn't there in his repudiation of minimalism a defensive reaction? Doth he not protest too much? Isn't there something simply *contrived* in his desire to categorically distinguish Stella from Judd? Isn't there something desperate, and hence unacknowledged, in his championing of Noland and Olitski?

8 (*opposite*) Frank Stella b. 1936. *Die Fahne Hoch!*, 1959. Enamel on canvas, 121 ½ x 73 in (308.61 x 185.42 cm). Whitney Museum of American Art, New York; Gift of Mr. and Mrs. Eugene M. Schwartz and purchase, with funds from the John I. H. Baur Purchase Fund; the Charles and Anita Blatt Fund; Peter M. Brant; B.H. Friedman; the Gilman Foundation, Inc.; Susan Morse Hilles; The Lauder Foundation; Frances and Sydney Lewis; the Albert A. List Fund; Philip Morris Incorporated; Sandra Payson; Mr. and Mrs. Albrecht Saalfield; Mrs. Percy Uris; Warner Communications Inc. and the National Endowment for the Arts 75.22. Photography by Geoffrey Clements.

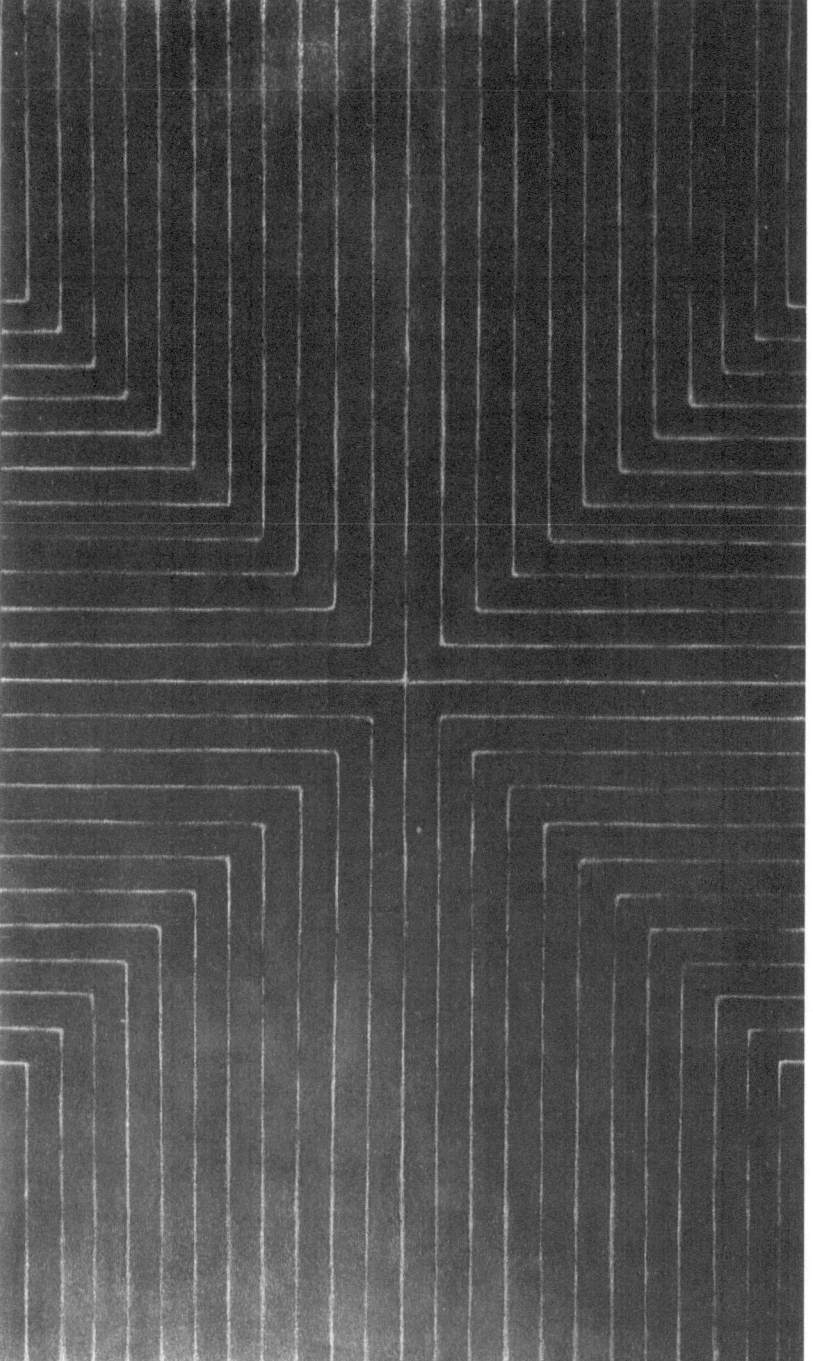

The idea of an emerging aporia of the sensible better captures the complex of forces working on art, from within and without, than do Fried's categories. Unlike his categories, a tendential aporia of the sensible overlaps in an almost one-to-one relation with the problem of anthropomorphism: anti-anthropomorphism is the systematic intention of prising off from the visible any intrinsic human intelligibility. Because anti-anthropomorphism can be connected with either a search for trans-subjective objectivity or anti-subjective technicism, it makes a claim to rationality. Because that claim to rationality found purchase for itself in many forms of social reproduction, its skeptical movement affects all the major subsystems of social life. The disintegration of the visible world as an autonomous source of meaning flows directly into the practices of modern art. Because Fried's categories are so emphatically disjunctive, they must remain insensitive to the incremental exhaustion of artistic materials, to the encroaching sense that art's capacity for visual statement is draining away.

Fried's dualistic categories make objecthood what is to be defeated or suspended. But if the forces of anti-anthropomorphism are real, then victories over objecthood that do not acknowledge it as a potential *threat*, a virus within the visual destroying its capacity to sustain autonomous sense, will themselves feel empty—*merely* aesthetic, further myths and illusions. The formation of artistic failure is, arguably, another type of emptiness and formalism. It is, then, not necessary to dispute Fried's claim that Frank Stella's stripe paintings, especially those executed in metallic paint, "represent the most unequivocal and conflictless acknowledgement of literal shape in the history of Modernism,"[33] since the worry about them is exactly their "conflictless" character.

In Fried's narrative, modernism develops from a concern for acknowledging the flatness or two-dimensional quality of the picture-support, through an exclusively optical illusionism in which the flatness of the surface becomes essentially a creature of its being painted, an effect of pigment on canvas, to the shape of the support becoming a source of ordering and conviction. In making the literal shape of the support a principle or source for the ordering of the canvas, Stella can defeat the distinction between literal and depicted shape. What is depicted in the canvas is its literal shape (see Figure 8). If we are unable to isolate some depicted shape that is sitting inside and being constrained by the enclosing, literal shape of the picture-support, then the efficacy of distinguishing literal from depicted shape

dissolves. The categorical indeterminacy between literal and depicted shape in Stella's shaped paintings, especially the multi-shaped works, amounts to discovering in shape a source of artistic conviction and authenticity, and hence of new conventions through which art can carry on.

The dissolution of the distinction between literal and depicted shape in Stella's paintings was embraced by the literalists. But Fried believes this embrace to be a misunderstanding and thus he seeks to drive a wedge between what the literalists took from Stella and what Stella actually achieved:

> But it ought also to be observed that the literalness isolated and hypostatized in the work of artists like Donald Judd and Larry Bell is by no means the *same* literalness as that acknowledged by advanced painting throughout the past century: it is not the literalness *of the support.* Moreover, hypostatization is not acknowledgement. The continuing problem of *how* to acknowledge the literal character of the support—*of what counts* as that acknowledgement—has been at least as crucial to the development of Modernist painting as the fact of its literalness; and this problem has been eliminated, not solved, by the artists in question. Their pieces cannot be said to acknowledge literalness; they *are literal.* And it is hard to see how literalness as such, divorced from the conventions which, from Manet to Noland, Olitski and Stella, have *given* literalness value and *made* it a bearer of conviction, can be experienced as a *source* of both of these—and what is more, one powerful enough to generate new conventions, a new art.[34]

However eloquent and compelling, the fragility of this argument is overt; it abruptly presupposes that the history of modernism from Manet can be told in wholly endogenous terms, as if the forms of neutralization that *forced* painting to purify and refine itself, that kept making the apparently new just a longing for the new, old before it was new, were *solely* artistic forces. This is implausible. Among the forces that have impinged on art and pressed it toward discovering new sources of conviction and authenticity for itself have been industrialization and mechanization (including the emergence of photography), the growing dominance of the commodity form with its production of novelty as a means of reproducing the same, the rationalization of values making them creatures of subjective desire, and, as a corollary of all these, a tendential movement from the concrete to the abstract.[35] The very idea of art's *having* to establish itself, having to find new resources for conviction, has been a product of art's having to distance and distinguish itself from a diversity of others (photographs, commodities, information) that have been encroaching on its traditional

turf. Once this effort of discrimination is placed in conjunction with progressive demythologization, then the constraints on modern art can come into view. It is this scenario that makes sense of the project of artistic essentialism, art's having to acknowledge the flatness or shape of the picture-support as more than the material condition for its activity. The totality of these forces, internal and external, is just the aporia of the sensible, the fading of the grip of habitable anthropomorphism.

Once the forces disintegrating traditional art are acknowledged, then Fried's separation of an endogenous history of modernism from its exogamous conditioning appears suspect. The endogenous history of modernist art is its ongoing struggle with those exogamous forces against the background of the artistic achievements of the past. This would make the difference between Stella et al., on the one hand, and the literalists, on the other, a matter of *emphasis*. Stella focused on the endogenous history of modernism without adequately acknowledging the forces of disintegration besetting it, and the literalists consumed by the external threat to human conventionality as such under the guiding presumption that there is not enough meaning left in painting (that the moment of painting was always art's most emphatic acknowledgment of its *lack* of worldliness, its withdrawal from the world, and thus its finitude) to make its continuance worth urging, and the turn to sculpture, or at least to three-dimensional objects inevitable. Both sides of the equation are wrong, but only as a matter of emphasis: the endogenous history is illusory on its own terms, while minimalism's assertion or rediscovery of the primacy of sculpture is bound to the desperations of the history of modernist painting, its uncovering of art's finitude again, so that sculpture now becomes a chapter in that history and unintelligible outside it.[36]

Literalism is not a mere or simple "by-product"[37] of the development of modernist painting; the threat of the collapse into objecthood, the collapse of compelling convention (which, again, is what makes the temptation of geometric rationalism reappear as, suddenly, a resource rather than an enemy to be defeated), has been a fate hovering over art almost from the beginning of modernism, whether we identify that sense of threat with Duchamp's ready-mades or Rodchenko's three monochrome panels (1921). What makes Fried even more emphatically wrong is that he conflates literalist ideology and manifesto with the works themselves. The best literalist works are not, in fact, literal, mere things. They are the *artistic pre-*

sentation of objecthood, anthropomorphism at the limit of its power to inform. Whether intentionally or not, they take the aporia of the sensible to a limit of intelligibility: the wholly empty yet anthropomorphically demanding claim of *ideally* constructed material objects. Perhaps one could say of these things that they perform a remembrance of the ordinary, a hope for the now absent uncanny thing.

In their dryness, minimalist works are not so very far from Stella's stripe painting. As Stella himself has argued:

[T]he biggest problem for abstraction is not its flatness, articulated by brittle, dull, bent acrylic edges and exuding a debilitating sense of sameness, unbearably thin and shallow, although this is serious enough. Even more discouraging is the illustrational, easily readable quality of its pictorial effects.[38]

Stella then goes on to instance Noland's offset chevrons and the "inert" space of Olitski's Aqua Gel textures. I take it that what Stella means by easily readable pictorial effects is their availability to critical comprehension—say, the very idea of shape as form, as if the one thing Stella most needed to repudiate about his early work was how brilliantly it could be illuminated by Fried! To the degree to which pictorial effects are easily readable, they no longer possess an autonomous visible demand. The strained, willful, and disappointing character of Stella's later work derives from his urgent desire to defeat the reach of concept domination, to be beyond interpretation—to be outside the grasp of a critic like Fried. That only by *straining* is this now possible underlines the dilemma in a manner independent of Stella's own diagnosis.

What Fried seems not to notice, what he must remain insensitive to, is how the exhaustion of visible meaning affects Stella's work, how its dryness or ready availability to critical comprehension tokens the exhaustion of sensible meaning as emphatically as does the tedium of minimalist works.[39] So while Fried can acknowledge that the modernist requirement that value and quality now can only be located *within* and not between individual arts—the equivalent within the arts of Weberian rationalization as dictating a radical separation of spheres—is "certainly harrowing,"[40] nothing of that harrowing, or the reasons for it, enters into his support for Stella. But if the condition of art is indeed harrowing, what are we to make of a body of work and its critical self-consciousness if nothing of that harrowing is evinced?

In categorically construing the "other" of painting as objecthood, Fried

has carefully located the limit of one fundamental practice in which anthropomorphism is sustained in relation to the material world. His subtle mapping of that categorical space is what gives his criticism its undeniable depth. Because, however, easel painting is so evidently just one conventional way of realizing anthropomorphism, criticism like Fried's is always going to be open to the charge of conservatism. That charge is indigenous to any argument like Fried's, like the one being pursued here, that seeks to raise categorial claims for a conventional practice. No one set of conventions is necessary or ineliminable for securing the anthropomorphic ties articulating the material world as also, and not arbitrarily, a human one, of explicating human nature as an intrinsic part of nature in general. Any adherence of the human to the natural and the material will be conventional, saturated with social and historical contingency. Contingency is not itself a sign of the arbitrary or the privately subjective—but it always can appear so. In the midst of a relentlessly reflective culture like our own, the sensuously particular appears always in danger of being lost, sensible meaning always in danger of splitting into the extremes of an empty linguistic sociality and a blind sensuousness. The thin if salient reminder—call it deconstruction—that linguistic practice is also a material practice, a matter of sound, body, and gesture, forms a desperate philosophical bridge between the collapsing extremes. Or one despairs of the idea of sensible meaning altogether by letting the rampant character of linguistic meaning proliferate until the world becomes nothing but a theater of an uncontrollable symbolic.

What provides evidence that these are indeed extremes, and the aporia of the sensible indeed the bearer of a categorial fate, is the sheer *insistence* of these extremes within the art of the last century.[41] No reckoning with modernism can ignore how visible meaning and the sensible itself have been consistently set upon by a culture without compelling sensuous moorings. The extreme of this tendency is the fine arts as a whole losing their centrality for culture, so that even the question of the sensible becomes in danger of losing its voice. The fine arts, individually and collectively, have been up until now the place within culture in which societies have sought for themselves a manner of securing visible meaning, of acknowledging, implicitly or explicitly, the anthropomorphically articulated sensible world as a source of meaning. We have discovered that sensuous particularity, the material object as intrinsically meaningful, is given only through conventions. Once this is recognized, the skeptical wind of anti-anthropomorphism can enter. There is

no a priori limit that can be used to shield us from this wind. If the forces of anti-anthropomorphism are, in truth, not merely intellectual forces, but the dynamic forces of modern social reproduction itself, then the condition of art, our condition as sensible creatures, will continue to be harrowing.

V. Postscript

After completing the first draft of the essay from which this chapter emerged, I sent it to Jeanette Christensen. She replied:

I am pleased and amused by the use of my work to make your statement. In your memory you have synthesized 3 different installations into 1 piece! I have used World War II bunkers on two different occasions and marble chips on a third occasion. What you probably remember is the first installation in a bomb shelter in Bergen (1990) where I had a 4-meter-long ladder together with 2 mining helmets and a stack of dynamite all moulded in raspberry jell-o, resting on stones covered with a white powder! *Horizontal vertical*, my next installation with raspberry jell-o was in New York (1993): 2 ladders each 4 meters long resting on *marble chips*, but in a gallery space.

There then follows a lovely description of the second bomb shelter installation from a Finnish journal. Christensen goes on to describe a more recent work in New York, *Waiting for Columbus*, in which gelatine and Jell-O are used. The difference between the two is important: "The gelatine grows mold because it has no preservatives but the jell-o doesn't grow mold for the opposite reason, it just dries and wrinkles and finally petrifies."

5

The Death of Sensuous Particulars:
T. J. Clark and Abstract Expressionism

> Hell is the Denial of the Ordinary.
> —John Ciardi, *The Gift*

This chapter engages in three distinct tasks simultaneously. First, it forms a light introduction to the philosophical aesthetics of T. W. Adorno. Second, it reconnoiters a sketch of abstract expressionism in Adornoesque terms. Adorno's aesthetics is usually read as the philosophical counterpart and thinking through of high modernism, of Berg and Schoenberg in music, of Beckett in literature. Adorno's *Aesthetic Theory*, published posthumously, was to be dedicated to Beckett. One, if not the, distinctive feature of Adorno's philosophy is that rather than being an a priori discourse about its objects, it contested the eons-long claim of reason to self-sufficiency, the claim that philosophy could command the world from the height of reason, universality, method; and he did so by explicitly making or letting his philosophy become beholden to its other—art. It is not just that Adorno thinks philosophical concepts are realized or fulfilled or find evidence for themselves in art practices, but rather that such high modernist practices provide, however temporarily, the condition of possibility of there being philosophy at all. To say that these practices are the condition of possibility of philosophy

9 (*opposite*) Newman, Barnett (1905–1970) © ARS, NY. *Onement I*, 1948. Oil on canvas, 27 ¼ x 16 ¼ in. Gift of Annalee Newman. (390.1992). © 2003 Barnett Newman Foundation. Artists Rights Society (ARS), New York. Digital Image © The Museum of Modern Art/Licensed by SCALA/Art Resource, NY.

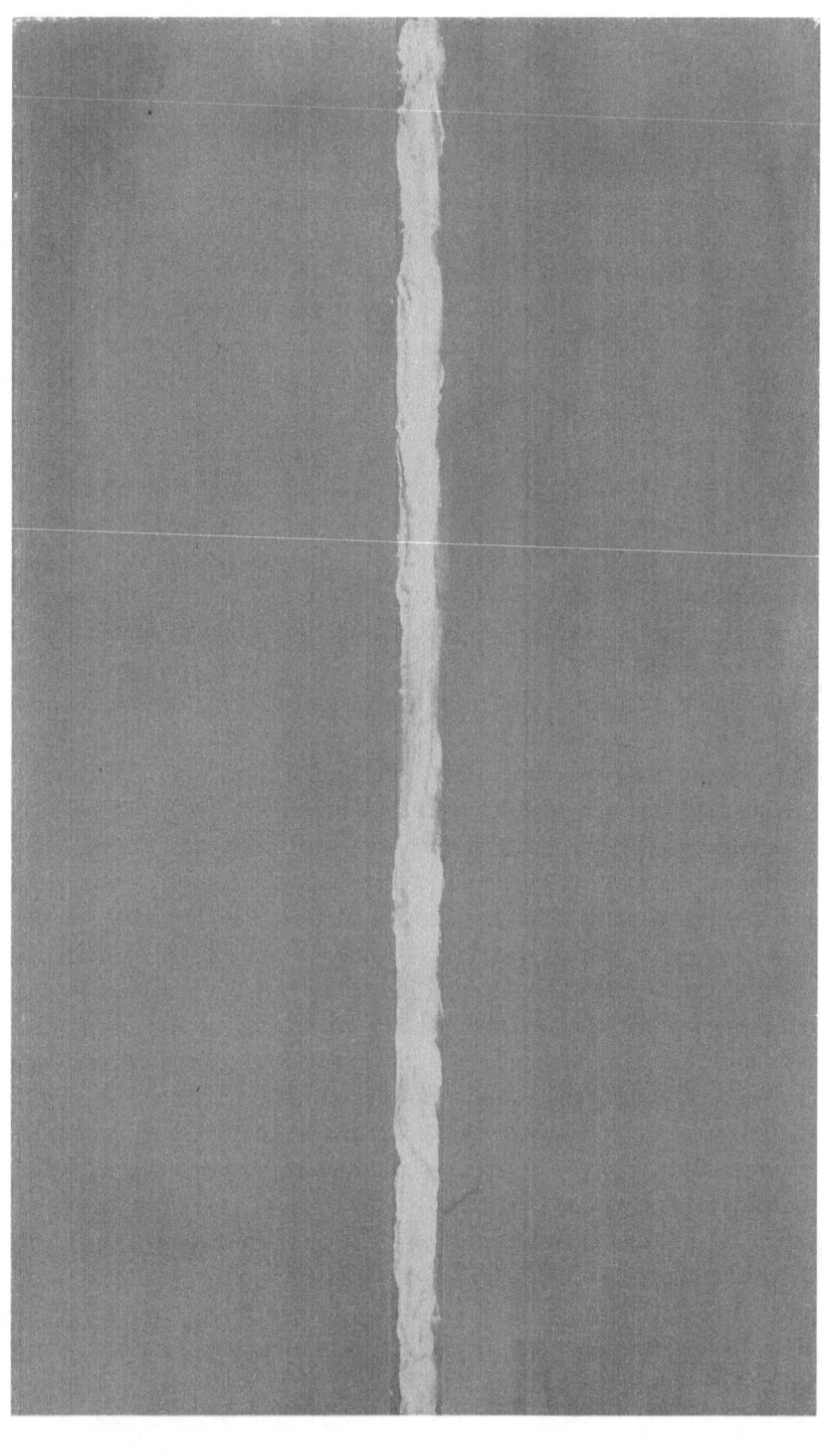

should be taken as equivalent to saying that they provide the condition of possibility for our being or becoming self-conscious about who we are, what the world we inhabit is like, and how those two fit together. If Adorno had turned his attention to art, to painting and sculpture, he would have, could have, only deployed the resources of abstract expressionism for his purposes. His quintessential "Europeanness" did not permit him to recognize in this very American art the same type of claiming that he found in European composers and writers. Finally, these two tasks are choreographed in relation to T. J. Clark's reconstructive essay, "In Defense of Abstract Expressionism."[1]

Presupposed in what follows is the thesis that reflective or second-order practices like art and philosophy operate a closure on the basic terms supportive of meaning in a culture and submit them to "tests" for coherency and consistency that are supplied by the fundamental principles of the practice in question. Philosophy submits the meaning-complexes of everyday practices to the demands of conceptual coherence, while art submits them to the requirements of two-dimensional representation through drawing and painting. Philosophy and art, then, are reflective articulations of first-order, everyday practices of meaning. They operate on first-order meaning complexes through selection, purification and closure—that is, through a decontextualizing of items from their usual place in everyday practices, and a recontextualizing of them in accordance with the rules of a distinct practice that is shielded from the contingencies and demands of the everyday. Philosophical or artistic closure should be considered as doing for domains of meaning what natural science's abstractions, idealizations, and closures do for causal contexts. Philosophical and aesthetic recontextualizations permit the isolation of the inference structures operating invisibly in the open vista of the everyday. So, for example, the most stringent attempts to narrate empirical existence in the modernist novel show everyday life no longer to possess narrative coherence through time, and hence that the modern self is fragmented or decentered in painful and troubling ways. Analogously, that painterly representations of the natural world appear naive or kitsch or sentimental when directly representational and only attain to artistic authenticity when they are abstract (as, for example, Richard Diebenkorn's post–abstract expressionist *Ocean Park* series) says something about the availability or nonavailability of the natural world to us that is hidden in and from everyday life. The transformation of landscape painting reveals that

the natural world is no longer the same kind of empirical expressive order it once was. This is the sense in which art and philosophy are their own time apprehended in representation and thought, respectively (*AT*, 4–8).[2]

There is only one really plausible alternative to this view, namely, that philosophical and artistic practices are, well, just different practices, different language games from the language games of everyday life. Hence while these different language games are certainly *contiguous* with one another, and mutually inform one another through leakage and the grafting of elements form one discourse into and onto another, no regimented relations between the practices exist. One can imagine Wittgenstein or Lyotard or Foucault making such a comment. In one respect this is true: art practices have their own grammar, techniques, and history. Further, they can be about, in the weighty sense of that term, not just perceptual experience, but submit other elements of the everyday experience to artistic treatment; art practices can be used to interrogate the role of the unconscious or memory or history or alienation or gender or ethnicity or religious belief. But what makes art practices matter here is that elements of these phenomena are bound up with "seeing" in its austere and wide sense, with perceiving, representing, and the limits of perceiving and representing, and hence with the way in which these phenomena are articulated in (or for) the domain of the visible. The stakes of art are perceptual experience as a mode of conviction and connection to the world.

But this is equivalent to saying that we are, always already, invested in art, that its tracking of the possibilities of the visible is a tracking of the meaning of the visible world for us. This type of investment in art must, *sotto voce*, be hovering on the borders of Clark's thought since for him the question raised by abstract expressionism is its insistence: that we seem unable to let it go, to make it a thing of the past. At least for now, and no matter how often and how insistently denied, repudiated, in and through that denial and repudiation, that desperation to escape, abstract expressionism appears to have a hegemonic grip over the artistic elaboration of visibility, over what belongs to the visible and what does not, over the proper and improper that belongs to perceiving, its hopes and despairs. For Clark this is troubling to the extent that until abstract expressionism becomes a thing of the past art cannot, meaningfully, confidently, routinely, carry on. Abstract expressionism is the shadow towering over the present that will not let art go forward, but keeps contemporary art stut-

tering, hesitant, failing, sucking everything into its orbit and evacuating its possibility—like a black hole.

Clark, correctly, aligns this anxiety about the shadow of abstract expressionism with Hegel's thesis that art has become for us a thing of the past, with this thought itself articulated in terms of how the progress of art contributes to the disenchantment of the world. Clark's bold thesis is that modernism is "the art of the situation Hegel pointed to, but its job turns out to be to make the endlessness of the ending bearable, by time and again imagining that it has taken place" (DAE, 373). Hence, until abstract expressionism can end, art cannot end (again) and the business of making ending bearable (again) cannot be relaunched. To bring an end to abstract expressionism would be to show that its disenchantment of previous art was still enchanted: imaginary, fictitious, a work of anthropomorphism, a projecting onto the screen of the visible world merely imaginary significations. Insofar as we remain in the grip of abstract expressionism we remain enchanted and the world will appear enchanted, thus regressing from its uniquely modern standpoint. This enchantment of the world, the one accomplished by abstract expressionism, would, he avers, play into the hands of that "general conjuror of depth and desirability back into our world—that is, the commodity form. For the one thing the myth [sic] of the end of art made possible was the maintaining of some kind of distance between art's sensuous immediacy and that of other (stronger) claimants to the same power" (DAE, 374).[3]

While well taken and raising the correct issues (the end of art, the disenchantment of the world, and the relation between aesthetic enchantment and commodity fetishism), Clark's account needs to be contested. Hegel believed that with the coming of modernity art would become, had already become, a thing of the past because modernity arises through the discovery that the world is a human one, that God became man, and that man was but a cipher for community (the descent of the Holy Spirit is the coming-to-be of the religious community as the bearer of the meaning of religion, and, in time, the recognition that there is only community—however fragmented and dispersed). Once this occurs, then the articulation of subject and substance, the individual and her ground, could no longer be representational, a work of picturing, since the ground of human existence is now individuals in relation to one another, in relation to their communities and their essentially open histories. Meaning could be indefatigably

representational—picture thinking—only when the ground of existence was assumed to be outside human history, in God, or what is the same, His history: in a remote (past) origin or a remote (future) telos. Once there are only historical communities without determinate origins or ends, then metaphysical meaning can no longer be represented in pictorial form. Hence the primacy of philosophy and the prose character of the modern world for Hegel. So, in Hegelian terms, the disenchantment of the world meant the process of overcoming the religious enchantment of the world, with this process being accomplished once the relation of self to ground became a forever incomplete reflective process of (communal or collective) self-grounding.

But in ways that Hegel did not foresee, the disenchantment of the world has miscarried precisely by *carrying on*, infringing on and destroying those very relations of community and history that he thought the achievement of modernity had secured. Hence the progress of disenchantment, the work of countering anthropomorphic projections, carried on to the point of undoing the very relations among persons, and among persons and the natural world, that it had in the first instance made possible. Through progressive disenchantment "the destruction of gods and [secondary] qualities is [equally] insisted upon."[4] The loss of the gods is something bearable; the loss of secondary qualities is not.

"Nature in ceasing to be divine, ceases to be human. . . . We must bridge the gap of poetry from science. We must heal the unnatural wound. We must, in the cold reflective way of critical system, justify and organize the truth which poetry, with its quick, naive contacts, has already felt and reported."[5] The author of these sentences is not Adorno, but the young John Dewey, writing in 1891. There is, however, only a sliver's distance between them and, for example, Adorno's "But although art and science became separate in the course of history, the opposition between them should not be hypostatized."[6] What the instrumental rationality exemplified by natural science begets, and what is socially borne into everyday life by industrialization and technology (for Dewey), and by the ever-expanding domination of exchange value over use value, the ever-expanding commodity form (for Adorno), is the disenchantment of the world, the creation of an unnatural wound, a diremption, between human nature and nature. This wound is unnatural, or contrary to nature, because the human animal is part of the natural world. In raising ourselves above it—in (cognitively) making the

world an object of representational knowing, and (practically) making exchange value the measure of all worth—all subjective response to the world, and thus the world as it gains its constitutive sense in its *appearing* to human subjects, is qualified, curtailed, elided to the point of disappearance, to the point where worldly things become mere fungible props for an allegorical system whose truth is number and quantity. The cultural crisis generated by science, technology, and capital is a crisis of subjectivity and meaning; the disenchantment of the world is the proximate and ground cause of the crisis. However inarticulately, this is also the view of the matter taken by the abstract expressionists.

The mechanism of disenchantment is abstraction: "Abstraction, the tool of enlightenment, treats its objects as did fate, the notion of which it rejects: it liquidates them."[7] Abstraction is the negation of a concrete item in its givenness, and its (re-) identification in terms of some more abstract feature or quality, some mark, it shares with other items. Abstraction takes effect through analysis—the fragmentation of the given in order that its multiple features can each be identified by a common mark—and synthesis—the recomposition of the particular through its now fragmented elements. Science abstracts from sensuous givenness, and reidentifies objects through their measurable features. Capital abstracts from use value and labor power, and synthesizes through exchange value and labor time (which prepares labor to be a commodity). The rationalization of society abstracts from intersubjective practices of meaning and synthesizes through function and system. This continuation of disenchantment, the indefinite recruitment of ever more domains into the grasp of an indifferent system of commensuration, reaches down into everyday life and tendentially robs it of subjective qualification.

Heidegger, in considering what it means for the Rhine to become, essentially, a "water power supplier," comments: "In order that we may even remotely consider the monstrousness that reigns here, let us ponder for a moment the contrast that speaks out of the two titles: 'The Rhine' as damned up into the *power* works, and 'The Rhine' as uttered out of the *art* work, in Hölderlin's hymn by that name. But, it will be replied, the Rhine is still there in the landscape, is it not? Perhaps. But how? In no other way than as an object on call for inspection by a tour group ordered there by the vacation industry."[8] The object, the Rhine, and so nature as a whole, but also, *mutatis mutandis*, manufactured things, artifacts, are no longer there

as objects that can be seen: we can have no *experience* of the object perceptually or in a discursivity matching and transmitting perceptual experience since it has been removed from *itself* by the sway of the abstract universal. Enlightenment, progressing through the work of abstraction, is the sacrifice of the sensuous particular to the universal. As Adorno sums up the situation: "The marrow of experience has been sucked out; there is none, not even that apparently set at a remove from commerce, that has not been gnawed away. At the heart of the economy is a process of concentration and centralization that has the power to absorb what is scattered" (*AT*, 31).

For Adorno progressive disenchantment has an ironic structure: the universal—whether scientific, economic, or societal—was to be the means through which the world was appropriated for the sake of human ends: happiness, freedom from fear, equality, and liberty. Now the mechanism, the means, have slipped from the noose of the ends and become universal themselves, vanquishing the ends. The instrument has become the master of the master—we now the slaves. But the instrument is simply a blown-up, articulated, congealed aspect of human subjectivity (means-end rationality in its complex materializations), and hence the stamping of the world by the instrument is making it a mirror of our subjectivity, making the world "for us." In becoming uniquely "for us" the world became no longer "for us" at all, and we no longer for ourselves. To say that the process of abstraction removes the object from itself must include the thought that it removes us from ourselves; it eliminates subjectivity from the subject.

Abstract expressionism combats societal abstraction with artistic abstraction; abstract expressionism combats societal disenchantment through the further disenchantment of art:

This shabby, damaged world of images [in Beckett] is the negative imprint of the administered world. To this extent Beckett is realistic. Even in what passes *vaguement* under the name abstract art, something survives of the tradition it effaced; presumably it corresponds to what one already perceives in traditional painting insofar as one sees images and not copies of something. Art carries out the eclipse of concretion, an eclipse to which expression is refused by a reality in which the concrete continues to exist only as a mask of the abstract and the determinate particular is nothing more than an exemplar of the universal that serves as its camouflage and is fundamentally identical with the ubiquity of monopoly. (*AT*, 31)

One way of taking abstraction might be through understanding representational art as mythologized and anthropomorphic, as a mimesis of the

projection of human needs, interests, and desires onto the object world, and thereby in need of demythologizing. Abstract painting, following in the footsteps of Cézanne and passing beyond the abstractive achievements of analytic and synthetic cubism, would then be understood as operating in precisely the same way as mathematical physics, as its parallel formation, by reducing the visible conditions of visibility—above all color and space. So painting would become an essay on the visibility of the visible without relying on the props of objects locked into the circuit of meaning defined by interest and utility. Such a conception of art would thus construe art's disenchanting as continuous with rather than opposed to the rationalization of experience. I suspect that this is the kind of disenchanting function Clark has in view for art, and why he considers those (like Adorno?) who see art reenchanting as "false friends" (DAE, 374).

But the experience of abstract expressionist works cannot be contained by the scientific view in part because it cannot account for abstract expressionism's long shadow—these works, despite everything, despite their ease of appropriation by the bourgeois world from the beginning, nonetheless continue to matter to art and to life. There is (re)enchantment in them in the sense that they remain obstinately particulars that are not subsumable under any universal. Hence they demonstrate that sensuous particulars can *mean*, can be hypnotic objects of attention, apart from and in defiance of any form of identifying mechanism other than the one their sheer presence insinuates.

The claim of abstract works, at their best, is that of a sensuous particular as indicative of what sensuous particularity could be: having weight and salience, mattering, in itself. This "in itself" opposes the universal "for us" of rationalized society, including all previous art. It tallies with the kind of abstraction such painting enacts: its abstraction from genre, representation, and symbol, but also from "memory, association, nostalgia, legend, myth" —the "devices," as Barnett Newman called them—"of Western European painting."[9] Once universals have become subject to the doubt that they are merely "for us," there for the sake of control and so mirrors of the subject, then any art that participates in the given universal, no matter to what good end, denies the worth of the painting itself. Through abstraction the work is set free (made autonomous) in order to claim for itself. In this respect, in opposition to all the chatter about God, transcendence, and theology in abstract expressionism, Rothko's famous statement about the "in-

timacy" of these artistic mammoths appears just right: "I want to be very intimate and human. To paint a small picture is to place yourself outside your experience, to look upon experience as a steriopticon view or with a reducing glass. . . . However you paint the larger picture, you are in it. It isn't something you command."

It is the achievement of sensuous particularity that distinguishes abstract expressionist works. Our inability to abstract from them, except with respect to what sensuous particularity itself might mean, gives them their specific kind of objectivity. To attend to de Kooning's *Excavation* is to discover resources for meaningfulness exhausted by what appears before the eye. The painting itself is the end; it seeks identity only with itself and is its own "subject." These particularist moves are established through its overall structure, its lack of center, standpoint, or perspective, and through the spontaneity of the painting that appears to escape de Kooning's will only to find a fragmented integration through the canvas as a whole. A heightened freedom and order are here in terse harmony. Part of the continuing enigma of *Excavation*, like *Night Square*, is how little it offers the viewer in sensuous terms, how its scribbles of red, the hints of yellow and blue, tell us, as the paintings of Franz Kline do, how much is to be refused in its "appeal," its claiming, how the painting turns its back on us, on sensuous immediacy and art, and yet commands. Nothing we thought we desired or might desire is here, and yet. . . . So now, if only "this" painting matters, then mattering itself can have its "origin" in something sensuous and particular, in what is ephemeral, finite, transient. Such a view of mattering speaks in favor of the ordinary, of finding the ordinary and the everyday satisfying because they are "uncanny," something for us through their being beyond command. Ironically, in being beyond command perceptual experience is returned to the subject, as if for the first time.

Clark conflates the issue of particularity, and hence the fact that the artist has only "his" art on which to rely (and not tradition), with the equation of art and lyric—"the illusion in an art work of a singular voice or viewpoint, uninterrupted, absolute, laying claim to a world of its own. I mean those metaphors of agency, mastery, and self-centeredness that enforce our acceptance of the work as the expression of a single subject. This impulse is ineradicable" (DAE, 401). Of course, since agency is also a victim of monopoly, there is reason for holding to the equation of art and lyric, for not wishing to surrender it. Nonetheless, the assumption behind

Clark's identification is that particularity and universality, particularity and objective meaning, are incommensurable, and hence so are the claims of the individual subject with respect to the objective world. Hence, "the illusion" and, worse still, the "its own" of the singular viewpoint. Adorno perceives modernist art as contesting that separation:

> The puristic and to this extent rationalistic separation of intuition from the conceptual serves the dichotomy of rationality and sensuousness that society perpetrates and ideologically enjoins. Art would need rather to work in effigy against this dichotomy through the critique that it objectively embodies; through art's restriction to sensuousness this dichotomy is only confirmed. The untruth attacked by [modernist] art is not rationality but rationality's rigid opposition to the particular; if art separates out intuitability and bestows it with the crown of the particular, then art endorses that rigidification, valorizing the detritus of societal rationality and thereby serving to distract from this rationality. (*AT*, 98)

(Art's confirmation of the duality is the confirmation of the diremption outside art. Its confinement to the sensuous extreme is the confinement of its articulation of rationality and particularity to art, to semblance.) If modernist art were lyrical it would be a celebration of the now defunct individual. While artistic modernism achieves its objectivity through extreme individuation, encapsulated in its objectivations is a We, and it is a We that speaks in works, not an I (*AT*, 238, 167). There is not a hint of the tawdry action-painting reading of abstract expressionism in Clark; but he can't let go of the thought of the lyric subject, its deep ludicrousness (DAE, 401), perhaps because with it the achievement and limits of abstract expression can be located in the same place. But the experience of these works is not even remotely akin to the experience of the lyric; in them intensity of expression and an austerity syncopate, as if we had suddenly come upon a ruin, our lost and unacknowledged past. Is there a work less lyrical and more redolent with the unacknowledged suffering of the past, more abysmal than the *First Station* of Newman's *Stations of the Cross*? Isn't Rothko's prescription about largeness and intimacy a formal elaboration of how these works *escape* lyricism and attain automaticism, as Cavell would have it, the sort of objectivation proper to the modernist work? And is not all that just a way of saying that these works shift from I to We? The myth of the artist hero certainly belongs to the environment of abstract expressionism; it is nonetheless ruinous for the appreciation of its works.[10]

Because sensuous givenness and particularity have been the victims of

rationalization, then it is unsurprising that "in important artworks the sensuous illuminated by its art shines forth as spiritual" (*AT*, 15). This spirituality, this transcendence, does not point to anything beyond the material world, although it does point beyond our empirical world. The relation between immanence and transcendence, what counts as immanent and what counts as transcendent, is historical. To endow sensuous immediacy with a "sense" of meaning is to claim for sensuousness a commensurability with meaning and rationality that existing rationality refuses. Pollock's *Lavender Mist Number 1* has twisted fragments of dripped lines of black paint interweaving with, scoring, and cutting the translucent yet opaque surface of blue, pink, and white. The illusion that the surface of the painting does not coincide with the surface of the canvas is everywhere disrupted by the way in which that illusory surface is consistently cut into and etched, like a scalpel randomly slicing through innocent flesh.[11] The vectorial drips provide the otherwise optical field with a tactility that has the effect of embodying the eye of the viewer, of making the experience of seeing the painting an experience of being embodied as a condition of viewing without the painting at any point or moment denying its condition of being a surface. That a sensuous, fragmented *surface*, a surface that robs the viewer of perspective and orientation with respect to it, like the de Kooning, can nonetheless hold the (embodied) eye gives back to sensuous immediacy a potential for statement as such. This, I think, and nothing else is what fascinates us with this canvas, the enigmatic delight that it is not *purely* decorative—although doubtless it soon will be.

To say that sensuous immediacy is capable of holding our attention, of engaging the embodied eye, of so suggesting meaning, is equivalent to saying that meaning does not unconditionally derive from intention, will, or desire—the mental, or, what this is sometimes taken as equivalent to, established conventions—and that it resides in the material/natural too. In tracking this thought we are broaching the way abstract expressionism contests the diremption of nature and human nature. Consider a typical Newman "zip" painting, say, *Vir Heroicus Sublimis*. All we have is the red color field and the five zips, yet everything we need in the way of a semantics (the colors themselves) and a syntax (the work of the zips) is here: the zips, the minima of negativity in a field, "become" syntactical by their division and thus "make" the field a proto-semantics. Of course, Newman offers us a very classical geometric syntax in the central square, only to

contest it with the unbalanced and dissonant zips that break up the two wing fields. The apparently dissonant zips augment the classical syntax, supplying it with a power of articulation that its concern with harmony and balance disallows.

In this accounting the following ratio is assumed: syntax is to semantics as abstraction is to expression. With this ratio in hand, the needed articulation of the meaning of the terms "abstract" and "expressionism" begins to come into view. In abstract expressionism (we must hear this concatenation of terms as oxymoronic) the dual dimensions of meaning are folded into the material medium. Because even those Newman works that do not explicitly employ classical geometric syntax insinuate it, remind us of it through its abridgment, the apparent risk of his canvases, and hence their power, can feel limited. We are never absolutely sure if we are responding to a novel sensuous syntactical/semantic formation or being reminded of the classical one, if we are spectating on the purely sensuous appearing of the minima for an intelligible world or seeing an illustration of the conception of how such a world is possible. Newman can appear as almost a conceptual artist—although he never is.[12]

Nonetheless, beginning from Newman it is not difficult to understand why Adorno operates with a dual-axis conception of language. Adorno labels the two axes: sign and image, concept and object, rationality and truth, and, most tellingly for us, communication and expression. These two axes condition each other and hence require each other. They are ineliminable and irreducible. However, while they can be coordinated, they naturally pull in opposite directions and hence must forever remain in a state of constant tension that permits of no ideal resolution.

In the "communication and expression" version of Adorno's analysis the term "expression" condenses the formula "expressing oneself . . . about something" into a single complex dimension. That matters, since for Adorno the "aboutness" of language cannot be detached from the subject's *embodied response* to the object world. The moment of response features in more standard accounts as the "resistance of the world" in inner-worldly experiences. In accordance with Enlightenment ideology, this resistance is usually rationalized as "the Given" or "empirical significance" or, say, the moment of falsification in testing procedures—the theory of fallibilism.[13] Fallibilism is the instrumental reduction of subjective response to the limit case of falsifying expectations, the reduction of experience (*Erfahrung*) to

experiment. There is reason in this reduction, but it is the reasoning of instrumentality itself. Inner-worldly experiences resist language not merely negatively but essentially in that they resist *full or unconditioned discursivity*, the linguistic exchange of meaning without remainder.[14] And they exceed full discursivity because our bodily response to things, our seeing, feeling, and hearing them, is forever *dependent* upon, forever beholden to, and forever in debt to things, in just the way Adorno conceives his philosophy as indebted to and beholden to art. The moment of dependence in language, which instrumental discourse attempts to surmount, master, and leave behind, is recorded as, among other items, sensation, image, feeling, and expression, the somatic moment Adorno entitles "mimesis" or "affinity." This dimension of meaning can be presented (for response) but never represented (exchanged), and hence from the perspective of full discursivity is a moment of silence. Full discursivity does not hear the silence; the language of abstract expressionism makes somatic silence articulate and unavoidable. It is, in Adorno's phrase, a language without signification, a "nonconceptual, nonrigidified significative language" (*AT*, 67).

Because abstract expressionism aims to reveal its material medium as "unowned," not subjective, but as the point of affinity between subject and object it urges color not as a "secondary property" of things but as primary, as objective as measurable properties. Because the color elements of nature are themselves articulate in these canvases, they portend a renewed *language* of nature, a language without signification and without speech: "A language remote from all meaning is not a speaking language and this is its affinity to muteness. Perhaps all expression, which is most akin to transcendence, is as close to falling mute as in great new music nothing is so full of expression as what flickers out" (*AT*, 79). It is, thus, not an accident that Gottlieb's late "bursts" should have developed out of his earlier pictographs, or that we should associate the calligraphic biomorphs of Motherwell's *Elegy to the Spanish Republic* series with the central accomplishments of the color-field painters. In all, however differently, the presentation of a nonsignifying language of nature—"writing," as Adorno sometimes calls it—is pivotal (see *AT*, 95, 124). The routine construal of Pollocks as presenting a "baroque scrawl" (DAE, 441n9; Greenberg's phrase) simply underlines this point. For us and for now, Adorno believes, "the more strictly artworks abstain from rank natural growth and the replication of nature, the more the successful ones approach nature. Aesthetic objectivity, the reflection of the being-in-

itself of nature, realizes the subjective teleological element of unity; exclusively thereby do artworks become comparable to nature" (*AT*, 77). To say that this capture is reflective and reflexive is equally to say that such images of nature are critical and negative, not sheer (re-)presentations. Hence Adorno's qualification: "Artworks say that something exists in itself, without predicating anything about it" (*AT*, 77). Isn't this kind of frisson and intrigue released by the best Pollocks, de Koonings, Newmans—the reason why, despite everything, and implausibly, they keep mattering?

We should distinguish two ways in which we can detect the will and intentions of a painter in a canvas: the first in the effort of composition, in integrating "these" materials in just "this" way; the second in our sense of contrivance, an awareness that a gesture is there in order to produce a certain effect on us. We can align these two artistic wills with Fried's categories of "absorption" and "theatricality."[15] Clyfford Still's paintings strike me as almost always theatrical and lacking absorption: all those highly contrived jagged edges—suggesting leaf, bark, and fire—breaking and fragmenting the color plane. It is a technique for producing the effect of sublimity on the viewer, for theatrically preserving aura, for providing his works with consummate "exhibition value" (*AT*, 45).

If we configure the three themes so far sketched—the element of further aesthetic abstraction to counter both empirical and artistic abstraction, the connection between abstraction and sensuous particularity, and the idea of an enigmatic, nonsignifying language of nature—we have the raw materials to engage with the central worry and claim of Clark's paper. He hopes, by coming up with a new term to describe and evaluate the specificity of abstract expressionism, that the historical blockage it represents for contemporary art can be loosened. The concept he thinks best captures abstract expressionism is "vulgar." It is, he thinks, an advantage of this term that it points in two directions: "to the object itself, to some abjectness or absurdity in its very makeup, some telltale blemish, some atrociously visual quality that the object will never stop betraying however hard it tries; and to the object's existence in a particular social world, for a set of tastes and styles of individuality that have still to be defined, but are somehow *there*, in the word even before it is deployed" (DAE, 376). Clark appropriates for himself the idea that the abject object side of vulgarity reveals it as "one of the forms of death," of "death mingled with life," and hence with abjectness itself (DAE, 384–85). He associates the "existence of the object in a

particular social world of tastes and styles" side of vulgarity with abstract expressionism being an expression of petty bourgeois taste, of the bourgeoisie deploying petty bourgeois taste as the guilty façade for the failure of bourgeois ideals to be realized (DAE, 383–84): "Abstract Expressionism . . . is the style of a certain petty bourgeoisie's aspiration to aristocracy. . . . It is the art of that moment when the petty bourgeoisie thinks it can speak . . . the aristocrat's claim to individuality" (DAE, 389).

Clark hopes that calling a work vulgar will be found more transgressive than calling it low or *informe* (DAE, 375). But if those terms are to key our appreciation of how Clark means to distance us from these works, then it seems reasonable to assume that the vulgar is a replacement term, the successor concept of the sublime. Sublimity was always a negativity in relation to a standing measure. The idea of the "modernist sublime" tokened the moment of dissonance in autonomous art, the moment of negativity through which such art declared its departure from the canon of the harmonious, the beautiful, the tasteful.[16] Vulgarity's contented transgression of good taste makes it a plausible successor to sublimity; it also makes Clark's innovation less startling or radical than it sounds at first blush—which is not to deny that feeling uplifted by the sublime and feeling uplifted by something vulgar are not the same thing! That is the critical edge Clark wants from his innovation.

Because the vulgar in Clark's usage is a late progeny of the sublime, it is not necessary to contest its credentials; on the contrary, the term's inner relation to sublimity makes it eminently usable in *explaining*, and to that extent *vindicating*, our inability to make abstract expressionism a thing of the past. Its long, vulgar shadow is an accomplishment of nearly as high an order as its proponents wished and claimed. So I am claiming that Clark's argument must trade on the exchange between sublime and vulgar; otherwise there is nothing to redescribe.

In building his case for the abject vulgarity of abstract expressionism, Clark approvingly cites a description of Rothko's work by Clyfford Still:

When they are hung in tight phalanx, as he would have them hung, and flooded with the light he demands that they receive, the tyranny of his ambition to suffocate or crush all who stand in his way becomes fully manifest. . . . It is not without significance, therefore, that the surfaces of these paintings reveal the gesture of negation, and that their means are the devices of seduction and assault. Not I, but himself, has made it clear that his work is of frustration, resentment and aggres-

sion. And that it is the brightness of death that veils their bloodless febrility and clinical evacuations. (DAE, 387–88)

The "death" in question here refers not to the explicit references to it that Rothko, but not he alone, was wont to summon into his art for the sake of profundity, but to the precise "death" that belongs to the execution of the paintings themselves, their cheap colors ("a vulgar fulsomeness of reds, pinks, purples, oranges, lemons, lime greens, powder-puff whites"), their abstraction.

As a hint about where Still's prescient passage might lead, let me instance a corresponding passage from Adorno:

If in modern artworks cruelty raises its head undisguised, it confirms the truth that in the face of the overwhelming force of reality art can no longer rely on its a priori ability to transform the dreadful into form. Cruelty is an element of art's critical reflection on itself; art despairs over the claim to power it fulfills in being reconciled. Cruelty steps forward unadorned from the artworks as soon as their own spell is broken. The mythical terror of beauty extends into artworks as their irresistibility. (*AT*, 50)

I note, parenthetically, that this cruelty, this moment of anti-art, which is just the moment of abstraction itself, is the key to the connection between de Kooning's pure abstractions and the assault on art and spectator alike in his *Woman* paintings.[17] A constant temptation and fate for abstract expressionist works is that they might lose their moment of cruelty and anti-art, that they might lose their abstraction, their negativity, and become either dull and familiar ("neutralized" is Adorno's term) or sweetly beautiful (as *Lavender Mist* has probably already become). Scrap the bravura: de Kooning knows the danger and finds resources even more disturbing than Soutine's carcasses to enact the moment of abstraction itself. That these moments are themselves "representational" focuses the anti-art moment of abstraction, the fact that its negativity is poised against both society's and art's own abstract universality. However misogynist, de Kooning's *Woman* paintings are properly death masks, abstract expressionism's painterly *memento mori*.

As Still correctly notes, and Clark fails to pursue, it is the "gestures of negation" that belong to the paintings that determine their vulgarity.[18] At issue in these "gestures of negation" is the meaning of abstraction itself, and hence of the cost involved in overcoming the disenchantment of art and

world through its continuation—that is, through a further work of disenchanting, further negations. Art cannot avoid the progressive disenchantment of the world that has occurred outside art; if it sought to obtain authenticity and authority for itself by summoning dead gods and dead meanings into its precincts, it would rightly be accused of naivete or anachronism. But almost all mentionable constructions of meaning are subject to this stricture, including both previous aesthetic forms and the sorts of archaic or primitive images from the collective unconscious to which abstract expressionists themselves liked to refer. One now can be charmed by Klee's or Gottlieb's pictographs, but their conventionality, mythicality, is unavoidable. Authenticity without cruelty is no longer possible. De Kooning's parodic *Woman* is the cut of the scalpel applied with a—ghastly—smile.

If there are no positive meanings outside art that can be cited, then art will be forced to cite itself, the fact of its continuing, without anything to support that self-citation other than works. What such works allow us is *the experience of the absence of experience*. But that experience is one of semblance, illusion. It refers to nothing in the world. To be so locked in semblance—"the new as a longing for the new" so necessarily not new, but always already old—in itself makes modernist art abject. It equally yields, by the time abstract expressionism arrives, to a certain posturing about "art," a self-aggrandizing gesturing, which becomes internal and intrinsic to a practice that intends or promises more than art. For the promise of meaning, the promise of *human* happiness, to be lodged in the space of aesthetic illusion, in messing about with bits of paint on canvas, is outrageous and ludicrous. Abstract expressionism invites and shoulders the burden of this promising, becoming heroic, self-serving, self-important, fatuous, and kitsch all at the same time. The constellation of these concepts —vulgarity itself, perhaps—configures the meaning of the present, not of art alone. Clark thinks there is an appropriate irony to the overemphatic moments of Asger Jorn, hence a refinement against which the Americans look naive (DAE, 389-91). But irony always withdraws affect; vulgarity is the price of sublimity at its limit.

"It is outside the purview of aesthetics today," Adorno states, "whether it is to become art's necrology" (*AT*, 4). This conception of the death of art is quite other than Clark's "making the endlessness of ending bearable" since the latter takes the disenchantment of the world to be emphatic, that is, to be a situation in which our "inability to go on giving Idea and World sensu-

ous immediacy, of a kind that opened both to the play of practice—would itself prove a persistent, maybe sufficient, subject" (DAE, 372). For Clark our "inability" to provide an articulation of Idea and World is enough, an intrigue of its own. What speaks against this intrigue is that the fit between Idea and World that is wanting is that between human subjects and everyday objects—including other subjects. Hence the question, the problem of sensuous immediacy, what is proper to art, is invested with a significance that art's first disenchantment, specifically, its becoming autonomous from the demand of re-presenting the religious absolute, can hardly have prepared it for. As Adorno notes, "what appears in the artwork as its own lawfulness is the late product of an inner-technical evolution as well as art's position within progressive secularization" (*AT*, 3). This inner logic of development is nothing other than a "dialectic of enlightenment," that is, progressive demythologization through the sacrifice of the particular to the universal. Art becomes the polar opposite of the abstract universal by continuing this process inversely: it sacrifices the universal to the particular through the universal (technique). If this is the process of which abstract expressionism is a potential concluding moment, it is that moment because even sensuous immediacy itself must, in time, come before the court of negation. Yet to give up on sensuous immediacy would be, for all intents and purposes, to give up on art, what made works compelling *as* works of art. Hence abstract expressionism's long shadow: *we* cannot give up on sensuous immediacy without giving up on the claims of sensuous particulars *überhaupt*, and yet if post–abstract expressionism is to avoid regression, then it can only go forward by canceling the medium of art itself, art as medium-bound, which to a certain extent is exactly what has happened. It is this happening itself, the happening of happenings, of minimalism and conceptual art, that has, in fact, *kept* abstract expressionism alive despite the cultural neutralizations it has undergone. The inner artistic necessity of "carrying on" suffers the counter-thrust of the claim of sensuous particularity, a claim raised strictly by virtue of its painful or playful absence; this makes the "carrying on" itself belated, a work of belatedness. "The promise that the content is real—which makes it truth content—is bound up with the sensual. Here art is as materialistic as is all metaphysical truth. That today this element is proscribed probably involves the true crisis of art. Without recollection of this element, however, there would no longer be art, any more than if art abandoned itself entirely to the sensual" (*AT*, 277).

Adorno's brief way with this thought about the dialectic of abstraction is to claim that its transitoriness and hence mortality could be art's content (*AT*, 3). His longer way is this:

> If art were to free itself from the once perceived illusion of duration, were to internalize its own transience in sympathy with ephemeral life, it would approximate an idea of truth conceived not as something abstractly enduring but in consciousness of its temporal essence. If all art is the secularization of transcendence, it participates in the dialectic of enlightenment. Art has confronted this dialectic with the aesthetic conception of antiart; indeed, without this element art is no longer thinkable. This implies nothing less than that art must go beyond its own concept in order to remain faithful to that concept. The idea of its abolition does it homage by honoring its truth claim. (*AT*, 28–29)

The cruelty of abstraction, its cutting into the flesh of sensuousness in order to enact such sensuousness, engages us on the ground of our bodily mortality, which the reigning universals eclipse as a condition for meaning. The disturbance, distress, suffering of the material surface—just that—that these canvases perform (on and to us) are a way of calling back and voicing sensuous reality in its mortal coils, of recalling or inventing an experience of depth or transcendence that hangs on nothing more than our bodily habitation of a material world in which all things pass away.[19] That all this might (must) transpire within the frame of petty bourgeois vulgarity, through canvases unable to rid themselves of the "telltale blemish" of tackiness and kitsch, is the minor materialist miracle that engraves the moment of abstract expressionism as still our own. The long shadow of abstract expressionism is the persistence of the need for art; what such art promises, but is impotent to realize, is that the need for art—the *precise* need to which abstract expressionism is a response—can disappear because its promise was realized. That abstract expressionism, despite everything, *answers* that need is what Clark's panicky comments about the lyric rush to cover over, as if that thought will lead us to forget the real source of our allegiance.

That there is a need for art here and now is how art becomes entangled with commodity fetishism. Clark would like a situation in which the enchantment of art and the enchantment of the commodity could be firmly distinguished. For Adorno, insofar as commodity fetishism continues to reign, then no such separation is possible. On the contrary, works of art are "in fact absolute commodities in that they are a social product that has rejected every semblance of existing for society, a semblance to which com-

modities otherwise cling" (*AT*, 336). That abstract expressionism's commodity character should adhere to the vulgarity of the petty bourgeois has everything to do with this art's unique self-importance and impotence. The progress of capital has made even the bourgeoisie petty bourgeois. Vulgarity is the death's head of self-deceived bourgeois optimism.

In survey: the above account of abstract expressionism features the significance of how its abstractions, overallness, and largeness fed particularism, how its connecting of color and writing fed a relation to nature, and how the linking of particularity and nature fed an objectivity and transcendence. This characterization of abstract expressionism enjoins both the thought that disenchantment has become diremption and that under existing conditions abstract expressionism appears to be a definitive response to our social impasse in painting. Or, if that seems too grandiose, then at least: abstract expression continues to *model* what can count as a revelation of our need for art, and in that sense remains exemplary.

6

Social Signs, Natural Bodies:
T. J. Clark and Jackson Pollock

Modernism and Melancholy Culture

"But clearly something of socialism and modernism has died, in both cases deservedly."[1] Modernism is no longer the dominant and leading edge of high culture; so there is no contesting that something of modernism has died, but deservedly? As if it merited that death and passing, like someone deserving the death penalty?

T. J. Clark's judgment here, the judgment that his book *Farewell to an Idea* aims to bring to pass, is somewhat wishful and vengeful, as if the death of modernism might become more bearable—and to his credit, modernism's death is finally not quite bearable for Clark—if we could find it not just intelligible, in the sense of, retrospectively, predictable and inevitable (the way someone's death from a fatal genetic disease is), but, in the light of cold judgment, the black robe and white wig kind of judgment, deserved. Of course, there could not be the fierceness, the will or desire for separation, except against a background of bewildered attachment, erotic obsession. If these are somewhat histrionic terms for framing a cultural history of modernism, they are ones that Clark does more than invite; they represent a level or stratum without which cultural history, art history, would cease to matter. As the attachment to and the drive for separation from modernism, they also represent some of the modernist rhythm of Clark's modernist history of modernism, its fervent dialectic of destruction and narration.[2] The

book's subtitle is *Episodes from a History of Modernism*; "episodes" could just as well be read as "fragments."

Farewell to an Idea is a book torn between a lived cultural melancholy, the melancholy of our inability to put modernism in general and abstract expressionism in particular behind us, and a maddened desire to mourn, a fantasy of mourning in which, finally, we could be done with it (them), put it in the past in a way that would enable art to happen again: "Not being able to make a previous moment of high achievement part of the past—not to lose it and mourn it and, if necessary, revile it—is, for art in modernist circumstances, more or less synonymous with not being able to make art at all" (371), that is, to make an art that, speaking loosely, might command general assent. If art might happen again, then (so the subtext of *Farewell* desperately hopes) so might socialism. Of course, a possible future for art is not a necessary condition for a renewal of socialism, but it might be thought indicative since the two great wishes of modernism—to lead its audience toward a recognition of the social reality of the sign, and conversely, of turning the sign "back to a bedrock of World/Nature/Sensation/Subjectivity which the to and fro of Capitalism has all but destroyed" (9–10)—are, in fact, two irrepressible aspects of modernity. Hence an art that might make sense of our autonomy, our secular powers for world-making, on the one hand, and an art that simultaneously could make sense of us as wholly natural creatures inhabiting a material world, would be an art that could found a collective sense of purpose and focus, or at least the possibility of such, on the far side of the negations through which secular modernity was formed. The social reality of the sign and the bedrock of world, nature, sensation, etc., are, we can now see, the actualities of what I described in the Introduction in the narrow epistemic language of Kantian idealism as the diremption of concept and intuition, or what Schiller describes as the clash between the form-drive and the sense-drive. Although not immediately obvious from his manner of approach, Clark's structuring of his analysis converges fully with the terms governing our analysis thus far.

It is worth noting that the entirety of Clark's argument flies under what is almost certainly a false counterfactual, namely, that "there could have been (there ought to have been) an imagining otherwise which had more of the stuff of the world to it" (9). Clark believes that since "socialism occupied the real ground on which modernity could be described and opposed" (9), then ideally modernist art (as the art that has pitched itself

against capitalist modernity and commodity culture) ought to have flowed from socialism. But, of course, the socialism we actually had was "compromised—complicit with what it claimed to hate" (9), and thus unusable by modernism. So Clark's fantasy speculative history has the thought that modernism (in its weightlessness and extremism, its occupation of an unreal ground) and socialism in its extremism, were two halves of integral freedom that did not add up—but they could have, should have. I mean this is a fantasy only in the sense that I doubt the absence of socialism, as opposed to the presence of capitalism, is necessary for the explanation of the failure of modernism—a thesis that will become pivotal in my critique of Clark. Still, this is not to deny that the success of modernism, what it would be to realize its potential, requires socialism.

So the project of *Farewell* is to transform melancholy into a possible mourning, a mourning that would be accomplished if, at least, a new representational art, one possessing "more stuff of the world," might emerge; but such an art is only likely to emerge with or in anticipation of socialism, making socialism the glue or the standpoint of the historical narration, and hence what must arrive for its vindication. If you agree with the premise, the melancholy of the present, then formally at least the strategy is impeccable.

Since I do agree with Clark's premise, and further agree that somewhere in the entanglement between the parallel but different destinies of socialism and modernism is the source of the melancholic structure of the present—both suffer the diremption of social sign and natural world as the deracinating force subverting their claim to rationality—then, I will want to distinguish myself from him by, finally, explaining differently how they are to be related. Standing on the ground of a future socialism, the unsurprising means Clark adopts in order to carry out his project, provides the orientation and means of redescription that will generate his fragmentary and partial canon of modernism—Jacques-Louis David's *Death of Marat*, Pissarro's *Two Young Peasant Women* (Figure 10), Cézanne's various Bathers, the great period of Picasso's cubism, 1910–12, El Lissitzky (or is it Kasimir Malevich?) in 1920, Pollock between 1947 and 1950, and abstract expressionism (especially, finally, Hans Hofmann)[3]—such that, in each case, the achievement the works in question exemplify becomes utterly saturated by and hence nondetachable from its historical moment, in either its sociopolitical fullness (David, Pissarro, Malevich) or the imaginary escape from it into fantasized immediacy or new beginning (Cézanne, Picasso, Pollock).

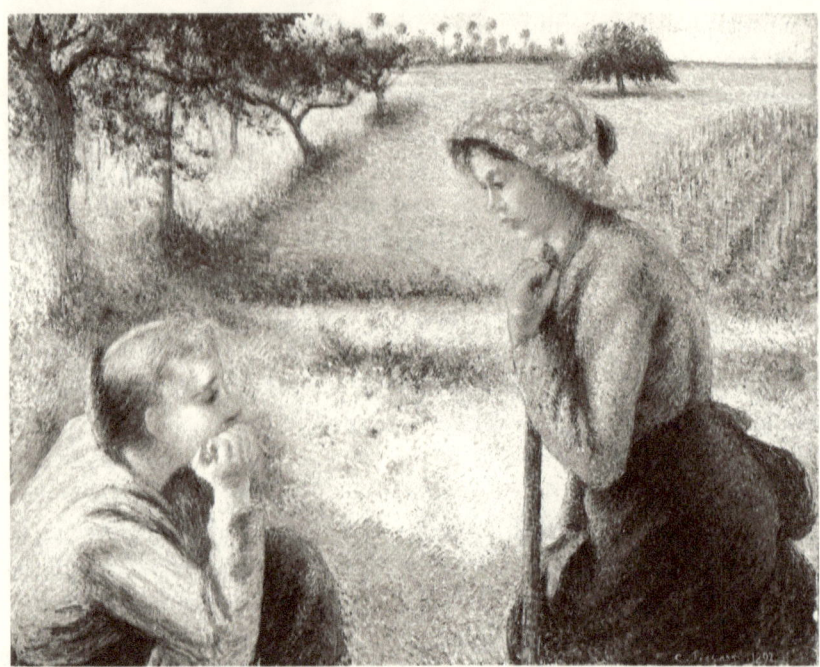

10 Pissarro, Camille (1830–1903). *Two Young Peasant Women*. Oil on canvas. H. 35-¼, W. 45-⅞ in. (89.5 x 116.5 cm). The Metropolitan Museum of Art, Gift of Mr. and Mrs. Charles Wrightsman, 1973 (1973.311.5). All rights reserved, The Metropolitan Museum of Art

So just that moment—in its social *and* art-historical thickness—is necessary for that work to have the *aesthetic* force it does (or lacks), and hence the work belongs to that moment in its greatness and pathos, and hence can and must be left there, in that past, if we are to inherit it at all. Lacking that placement, the works, in being narratively untethered and thus historically untethered, are thereby untellable—which is to say they will continue to circulate like traumatic memories, representations (of art and the meaning of art) that do not represent but are the sign of an event that culture cannot get on level terms with but can only suffer. And, of course, on Clark's own accounting there has been such a vast and awful event of wounding: capitalist modernity. This is the "holocaust" (3) that makes modernism in fact appear as a series of unintelligible, "unreadable" (2) fragments: "because the 'modernity' which modernism prophesied has finally arrived . . .

the forms it originally gave rise to are now unreadable. . . . Modernism is unintelligible now because it had truck with a modernity not yet fully in place. . . . Modernism is our antiquity" (2–3).

But you can also now begin to see how Clark's project might misfire generally: by standing on the ground of an as yet groundless socialism (Clark's notion of historical writing is, I think, for him the occupation of that ground, the one we remain capable of), Clark wants to generate a fragmented narrative of modernism that, despite its fragmentary character albeit through it, will open up the possibility of rendering the past past and history thus usable (inheritable rather than haunting). The social history of art can be therapeutic because, at least at the level of the sign, its *placing* of artworks through the recovery of the scene making them aesthetically possible enables separation from them; and to be free of modernism in this setting, in which it is the marker for secularizing modernity's self-understanding or a certain crazed resistance to that self-understanding, is to be free of at least some of modernity's self-defeating logic. Said differently: Clark thinks that political/class history operates as a third term mediating the possibilities of relating social sign to natural bodies at each moment, so that the proximity of overcoming their separation operates more or less in proportion to their nearness to and distance from the real ground that would bind them together: socialism. Diagnosis and critical practice are in perfect alignment; it is a brilliant strategy.[4] But this, I am suggesting, is just a fantasy because if culture really is traumatically wounded, and the depth of the wound figured precisely in an art bound to its own impossibility, then it cannot be put in the past but will haunt, traumatically. For the moment an art bound to its own impossibility can be read as simply an art that is incapable of providing representations that would offer a *substantive* binding collective orientation (hence an art that is always already past, too late, something belated, an art inhabiting art's demise). Clark thinks the haunting power of modernism derives from our misdescription or misunderstanding of it; if we could see through it, see it as internally, intrinsically, and hopelessly flawed (when it is) —caught in nothing less than a self-contradiction (365)—then putting it behind us would become possible.

I see the obviously flawed but nonetheless haunting power of modernism as a consequence of its being trapped and blocked by what (traumatically) places it. Clark thinks modernism died because it was somehow intrinsically false; I think it died because it was trapped in a social forma-

tion that blocked its progressive forms from realization. Our differences, I now think, are, in the first instance, explanatory: Clark thinks the mediating third term between social sign and natural body (holding them apart or allowing their unification) is political and class history, while I think the mediating third term increasingly becomes societal rationalization generally, hence a diversity of forces operating from a distance and always indirectly holding the terms of our life apart. So explanatorily the issue between us is in a sense sociological: to what extent and to what degree does Clark's traditionally Marxist account of modernity need to acknowledge the emphases of the Weberian account of societal rationalization, the incremental displacement of class history by general processes of societal rationalization? Answering that question does not, however, provide recourse to the competing sociologies of modernity, which anyway would remain inconclusive, since the *measure* of our sociological difference will congeal in the telling of works because, necessarily, sociological difference opens out into larger differences about *how* to tell the narrative of modernism and what is going to appear as an achievement and what a failure.[5] Because I think the forces of dispersion operating on art and against which it strives are more diverse and indirect, I equally think that modernism accomplishes more—but only epistemically and rationally, not politically. This, in a sense, was the point of beginning my account with the contrast between Descartes and de Hooch.[6] For both of us it is true to say that modernism will continue to haunt art until socialism arrives (or the world fully becomes a place past caring). Clark deplores this fact; for me it is the best hope we have.

There is a mismatch between the detail of Clark's readings, the hermeneutics of modernism that generates, and the overall diagnostic project, betwixt trees and forest. In a manner that is unfair to the subtlety and fineness of the particular analyses, I here at least want to suggest the actuality and significance of the mismatch.

It is possible, I think, to demonstrate how each chapter, apart from the one on David, is open to criticism—the places of criticism obvious because they derive from the overkill of the method—that is, again, making the conjunctural, politically informed redescription the necessary underpinning for sustaining the judgment of the works' aesthetic force and achievement, or failure. By "obvious" I mean two things: first, that the criticism does not depend on specialist knowledge because, second, it responds to junctures where interpretation suddenly appears forced or extreme or un-

necessary. This could be just misreading or insensitivity on my part, not fully taking in all the detail, but for the fact that I shall argue that the forcing is a consequence of an untoward theoretical belief about the nature or structure of modernism. Fact and theory, of course, swing together. My account will fall into two parts: a brief critical summary of the Pissarro, Cézanne, and Picasso chapters, and then a somewhat fuller survey of Clark's account of Pollock, which I understand to be the linchpin of the argument of the book as a whole.[7] Of course, I am saying here in a few short paragraphs what would take at least a handful of essays to defend properly.

Before commencing, however, a brief word about David's *Death of Marat*. It is daring and outrageous to claim that modernism begins in Year 2 with this painting and not, say, with Manet or impressionism. I have not digested Clark's argument sufficiently to know quite what I think about it; but the structure of his argument is instantly plausible. Modernism in art emerges emphatically only when traditional authority is no longer formative for determining what counts as painting. At this moment in 1793 "contingency rules. Contingency enters the process of picturing. It invades it. There is no other substance out of which paintings can now be made—no givens, no matters and subject-matters, no forms, no usable pasts" (18). What then must be shown about the *Death of Marat* is that contingency rules with it by demonstrating how utterly the painting is a response to the political events surrounding it, where politics "is the form of the contingency that makes modernism what it is" (21). This last thought is essential.[8] If I have understood Clark aright, he can say that contingency rules because the form of politics that David's painting articulates (expresses, furthers, is a moment in) is, affirmatively, a politics of radical freedom, and/or, more dubiously, a politics of revolutionary purity. Either way, the authority of the people, the new authority opposing traditional authority that was to be represented in the painting and be its authority, in its Jacobin dress, was understood negatively (in opposition to the *riches* and the *aristocrates*), and thereby, finally, as without determinate content. This opens traditional authority to the full force of negativity that makes contingency constitutive; Jacobinism is, in political fact, the skeptical doubt that opens modernity to its self-grounding secular fate as well as skeptical negativity.

In constructing his argument Clark makes an extraordinary claim, namely, that the placeholder for the emptiness of "the People" in this painting is the empty background of, in particular, the right-hand corner of the

painting (47). To see not only a politics, but a crucible for modernity's groundlessness and openness to contingency entering into painting in this bit of scumbling (45) is, well, gripping. And there is more, since the evacuation of eternity entailed by the rule of contingency equally entails that the medium through which contingency emerges suddenly comes to possess a weight or authority of its own. So the empty background of the painting is "something more like a representation of painting, of painting as pure activity. Painting as material, therefore. Aimless. In the end detached from any one representational task. Bodily. Generating (monotonous) orders out of itself, or maybe out of ingrained habit. A kind of automatic writing" (45). Not only do we here have an adumbration of modernism right through to Pollock and abstract expressionism, but with it, right from the get-go, the need for another politics as the content that might redeem modernism's negativity and subsignifying materialism. But, again, all that hangs on the claim that David's background is quite other to any previous blank background in the history of painting.

It is impossible not to mention how closely this account of David presents an art-historical account of the French Revolution that parallels the form of consciousness analysis found in Hegel's *Phenomenology of Spirit*. One might think this to be a coincidence or contingent vindication of Hegel but for the fact that Clark entitles and organizes his account of Pollock on Hegel's depiction of "The Unhappy Consciousness"; further, his final chapter on abstract expressionism is self-consciously a meditation on Hegel's end-of-art doctrine. If three chapters of the text are explicitly Hegelian in inspiration, what of the rest? And if Clark's text is itself modernist, the irony in his critique of modernism, is he suggesting that a usable modernism is Hegelian? Or that a usable Marxism must be Hegelian?

Three Fragments of Modernism

Pissarro's *Two Young Peasant Women*: Her back pressed against the left edge of the canvas, the bottom of the canvas cutting her off at the waist, we have a woman sitting, her knees raised, her hand beneath her chin: the pose of the thinker, someone lost in thought. Her companion, center right, is kneeling, upright, resting on the handle of what is perhaps her hoe (we see the handle but not the bottom), staring directly down and across at the meditating figure as if in expectation. It feels as if both women have been pressed

to the front of the canvas. Behind them is a field, and a line of trees along the left-hand side behind the contemplating woman. The women are in dark blue skirts; the figure on the left is wearing a white shirt shaded green and pink, the companion a blue shirt, but a blue lighter than her skirt. They have paused from their work. In the pause, their quietness, their nonwork, is their dignity. Clark contends that the new characteristics in Pissarro's painting that come to an exquisite realization in *Two Young Peasant Women* of 1892—the ones that speak of his overcoming the sentimentality of Millet and his distancing of himself from the mechanism of pointillism—are, so to speak, nudged into place, or what is the same, impossible to explain without Pissarro's commitment to anarchism: "[H]is [Pissarro's] mood counts. It is the anarchist temper—vengeful, self-doubting, and serene—out of which *Two Young Peasant Women* comes" (104). More explicitly:

> The moment of anarchist politics in late 1891 was specific, I think, and had effects on Pissarro's *Two Young Peasant Women*. Not dramatically. Not in terms of particular imagery or even firmly identifiable tone. . . . I see no outright socialist politics in it. There is a slight shifting of boundaries—in a modernist practice where even the slightest shift in conception endangers the economy of the whole—between expressiveness and surface integrity, or drawing and color, or pastoral and monumentality. A willingness to risk stiffness and solemnity. To bring the figures closer. To try to overhear them. (99)

Clark shows convincingly that there is an elective affinity between anarchism, considered as a theory of the compatibility of freedom and order, and Pissarro's kind of painting. But the detail account is not compelling. In order for it to be compelling we would have to find ourselves necessitated by a new redescription of the painting that made the old ways of telling the painting's achievement inadequate and only made adequate by the pressure of 1891's politics. But Clark never quite mounts that argument; nor can he.

Surely well before 1891 Pissarro's commitments to the pastoral (say our essential belonging to the natural world no matter how disenchanted) and the peasant as the Wordsworthian figure (combining "passion, maturity, plainness, emphasis, unrestraint" [71]) of the working class are well in place. The formal, technical problems those two commitments engender are everywhere severe for Pissarro. But once that is conceded, then the game is up. To be sure, the 1892 painting is unique, and quite different from Pissarro's other peasant pictures. Nonetheless, the features that best describe *Two Young Peasant Women* (and I am persuaded by Clark's description) all seem to me

to follow *directly* from asking how one might carry on pastoral/peasant painting without falling into sentimentality and naivete and the too-much-beauty sweetness of Monet; that is, asking how the constellation of theme and painterly practice can be united into an authentic work—full stop. Perhaps without his anarchism we could not explain why he would want, as a modernist, to continue with the pastoral-peasant genre; and the wanting to continue with that genre is, rightly, his mode of resistance to other visions of modernism, and hence the signature of the possibility of depth, ethical depth, in his painting. But that really is at the wrong level of explanatory significance. Does anarchism, even as motive, help in appreciating the dignity afforded by placing the two women in a moment of interrupted conversation (they cannot be talking, since the figure on the left is clearly lost in contemplation, far away, in the pose of a thinker/contemplator), or in appreciating the necessity of introducing incompleteness (the cropping of the thinking woman), not to bring us in too close (86–87), but I think, in order that the *weight* of head and shoulder in the left-hand figure can become palpable, dominating, so it is the figure of "woman-pensiveness" we see rather than simply woman-sitting-on-the-ground-thinking? And that decision requires the extra size of the canvas: her absorptive (68) weightiness would be ludicrous if miniaturized. Indeed, I would go further than Clark and say that incompleteness coupled with an increase in dimension is what enables the left-hand figure to possess the kind of absorptive weightiness that allows her to be the formal and emotional center of the picture despite her corner position, and it is this that is the painting's dissonant structuring, its strange monumentality, this raising what is low (by withdrawing it from the picture) without sentimentality or cheap pathos.[9] And all that is echoed by the gaze of the kneeling woman; she is as rapt by her thinking companion as we are, and her gaze forces us back to the meditating figure.

The problems resolved by the painting are those of a genre in the context of previous and contemporary painting. Showing the context certainly helps focus the achievement. But none of any of this requires the mention of anarchism. No new description of the achievement emerges; on the contrary, the best account remains the internal, painterly practice, problem-solving approach: again, given a certain set of thematic and painterly commitments, how is it possible to make an authentic work, one that avoids a range of aesthetic dangers lurking in the vicinity (sentimentality, sweetness, mechanism for Pissarro)?

I have a quicker and more defiant way with Cézanne and Picasso. Certainly, I will never see *The Large Bathers* (1895–1906; Barnes Foundation) the same again: the right-hand figure leaning on the tree has become androgynous: head unclear, maybe/maybe not breasts; the dark shadow rising up to the belly button, well the male organ is not an impossible conjecture; while the head of the figure on the far left of the painting now does look more like a penis than a head should! And with Clark's guidance, I can only see the figure on the right of the Philadelphia Museum's *The Large Bathers* (1904–06) as a head atop buttocks and legs. Although there are some truths about modernism that Clark infers here—I like best and agree most with the thesis that "modernism . . . would not anger its opponents in the way it seems to if it did not so flagrantly assert the beautiful as its ultimate commitment. And if it did not repeatedly discover the beautiful as nothing but mechanism, nothing but matter dictating (dead) form" (167). I am not sure they come from, or rather, come best from these paintings. But, and here is the rub, the "Bathers" paintings have always seemed to me anomalous in the context of Cézanne's oeuvre, to have been driven by some fantasy that sprints free of *The Mt. Sainte-Victoire* pictures and the still lifes, those paintings upon which both his achievement and his influence rest. But this is to say that those paintings that have always been difficult to place in Cézanne's oeuvre here become, through Clark's accounting, even more outlandish, fantastic (literally), and unplaceable. The claim that these are limit cases through which we understand the rest is not implausible in principle, just here stranded on the extremism of these pictures, an extremism that Clark neither tames (he wouldn't want to) nor places.[10]

There is a further possibility about the Cézanne, namely, that the payoff for the analysis of the emergence of sexual material relates not to the remainder of Cézanne's oeuvre at all, but rather is designed to adumbrate a crucial moment in the Pollock chapter. It will be a surprise to some that Clark accepts, rightly, the central element of Michael Fried's analysis, namely, that Pollock's achievement turns on freeing the line "at last from the job of describing contours and bounding shapes"; and that by virtue of this freeing of the line, the pictorial field tilts away from the tactile to become almost wholly "optical."[11] The rightness of this claim entails the exclusions (of painterly materialism) that Fried assumed. But the rub I am interested in here is Clark's contention, as part of a broader analysis of the role of sex and gender in Pollock (355–63), that the transformation of line,

the undoing of it as border or boundary or limit, which may be the central plank of Pollock's abstractness, "was rooted in a previous (maybe continuing) dream of gender writing itself to death" (362); you cannot undo the line without undoing gender division—a particularly male fantasy of incorporation. Hence, what is adumbrated by Cézanne's libidinous, unconscious transfiguration of the body is Pollock's disembodying line. So the significance of Cézanne is his adumbration of modernism sinking into the writing of the unconscious? Something is half-done here.

I found the interpretive claims concerning Picasso the most compelling in *Farewell* and the most forced, a place where Clark's insight is indisputable and yet what he takes himself to have shown is troubling, forced. Crudely, Clark's claim is, negatively, that the cubism of 1911–12 is not the discovery of a new language of representation, and hence a new quasi-scientific analytic that would be painting's own, the object-world offering itself "in the form of juxtaposition, not silhouette" and hence admitting fully to the picture being flat (205). What Picasso suffers, at Cadaqués, is the "disenchantment of painting—the revealing of more and more, and deeper and deeper, structures of depiction as purely contingent, nothing but devices" and emerging out of this a new project, painting continuing by "counterfeiting necessity" (220). This is the moment of hyper-conventionalism that is the twin of Cézanne's positivism and scientism for Clark. The detailed description of the works is telling; but their framing, the extremism of the discovery of the true language of painting, on the one hand, collapsing into a counterfeiting of necessity on the other, seems wildly forced and extreme since neither account captures what *in fact* appears to be the achievement of these paintings. The extremism of the two possibilities floats free of whatever force or achievement we might now find in the paintings themselves.

What does either "true language of painting" talk or "counterfeiting necessity" talk have to do with those works as experienced? Rather than explaining the works, the account makes their aesthetic achievement unintelligible. To put it another way: did anyone—outside the classroom—ever suppose that the intrinsic demand of a cubist painting was its epistemological uncovering of deceit, its new representational integrity, as opposed, more plausibly I believe, to the continuing acknowledgment that commanding visual attention is not dependent on representational success, but on autonomous/just-paint-on-canvas rendering? And while this latter raises questions, indeed all the questions about how paintings compel (to

which cubism in 1911–12 offers a subtle and complex answer that draws heavily on foregrounding flatness and devices), those are questions that hug the shore of visual comprehension, of the actual cognitive achievement of these paintings.

If Clark is not then destroying our illusion about the language of cubism, then is it being rendered past in the way he intends, or does its pastness remain of the familiar kind, namely another necessary failure?[12] The notion of necessary failure is mine, not Clark's. And I will return to it momentarily.

Representation, or the Return of the Repressed

There will be other occasions for weighing and evaluating the detail of Clark's history. For the purposes at hand we need to cut to the chase: his presumption of a single, pervasive, underlying fault in modernism, one that comes to a head and is evacuated with abstract expressionism. Clark contends, again, that modernism "had two great wishes. It wanted its audience to be led toward a recognition of the social reality of the sign (away from the comforts of narrative and illusionism, was the claim); but equally it dreamed of turning the sign back to a bedrock of World/Nature/Sensation/Subjectivity which the to and fro of capitalism had all but destroyed" (9–10). Let us say that these two wishes are equivalent to the claim that, on the one hand there is no surpassing of conventionality, of what "we," however this "we" is figured, think and believe in the light of our needs and history, and hence, to rephrase the claim, that there is no surpassing of the wholly fragmentary and exemplary character of "our" social rationality. On the other hand, in opposition to the denaturing and disembodying effects of capital, all social rationality would be that of mortal embodied selves, selves forever bidding farewell to a nature from which no final farewell is possible. It is difficult to state this second claim perspicuously (which is why it keeps shifting in the course of modernist practice, taking wild and exorbitant forms—all modernism's sensationalism and positivism), although Hegel's version of it in his account of Greek tragedy seems most promising: that we are in the position of continually rehearsing the loss of nature as ground—what is figured in the images of matricide, patricide, and incest —as the condition for becoming political beings; that rehearsal of the loss of nature *is* our continuing relation to it.[13]

The continuing loss of nature as ground has a nice fit with modernism's progress, its desperation. I want to put the matter thus because these ideals seem to me good ones—they state, when joined together, what I think the notion of "contingency" comes to.[14] And hence they are very different in kind from the extremes of modernism—"crude voluntarism and an equally crude positivity (in the nature of materials and so on)" (10), and the more deracinating features of contingency upon which Clark focuses: "the turning from past to future, the acceptance of risk, the omnipresence of change, the malleability of time and space . . . an absolute, quantitative increase in uncontrolled and unpredictable events" (10). Clark contends that modernism failed because it "lacked the basis, social and epistemological, on which its two wishes might be reconciled" (10). I would prefer to say that modernism lacked the social basis not for reconciling its two halves (that is just what it does do at its best), but for letting those reconciliations, at least the kind of reconciliations available (namely, unreal ones), possess the kind of content that would enable them to become socially efficacious. *Lack of perspicuous affirmative social content is the price modernism pays for its continuing power of reconciliation.* Hence, I dispute Clark's epistemological claim. The last thing we need is a new epistemology (or a new foundation for one); but it is just that which Clark surreptitiously does want, and what he thinks is implied by the commitment to socialism.

Although Clark at one point describes himself as a "modernist cynic" (397), he is not. Indeed, against the flow of his rhetoric, despite the almost hallucinatory effect of his voice throughout *Farewell*, a voice whose often stunningly acute judgment, and whose historical and cultural knowingness can be overwhelming and irresistible, Clark's is not the voice of a modernist, that is, the voice of someone who accepts that the two halves of the modernist project are reconcilable without modification and hence accepts what might be called, to be overly literal for a moment, fragmented material rationality. On the contrary, Clark thinks that some as yet unstated socialism would provide the *representational* resources necessary to provide collective focus and purpose (11), and it is only through those representational resources that the two sides of modernism, as he conceives them, could be reconciled.

In putting the matter this way, it becomes evident that what Clark resists about modernism is its embrace of the fragmentary and the contingent, hence the idea of a local rationality. Because Clark thinks socialism

and some form of totalizing representation go together, and that going together is incompatible with the fragmentary, his critique of modernism is a kind of overkill: the baby (fragmentary material rationality) and the bathwater (abstraction as modernist negativity, modernism's belonging to *capitalist* modernity) get thrown out together. Part of this story—Clark's reduction of abstract expressionism to the lyric, and his consequent denial that these work to project a "we" (a "we" that arises in and through the binding of an event)—I tried to at least forestall in the previous chapter. Other matters are at stake here.

The whole range of issues now circulating becomes vocal in his concluding remarks on Pollock. The brunt of his argument seems at one level compelling: namely, since 1850 "no work of real concentration was possible without it being fired—superintended—by . . . some form of intransigence or difficulty in the object produced, some action against the codes and procedures by which the world was lent its usual likeness" (364), hence some way of negating, resisting, and exceeding our normal representational understanding of the world. Clark rightly urges that this work of abstraction/negation is not self-sufficient, not an element in a process whose telos would be the uncovering of the essence of painting in flatness and the delimitation of flatness, for example (although hardly merely for example). On the contrary, Clark urges:

> [A] work of art will only strike the receiver as difficult . . . if it succeeds in showing (or intimating) what its work against likeness is for or about: on what other basis in shared experience it might be seen to rest, how it could alter our attitudes to objects and processes we recognize as held in common: in a word, what the meaning of abstraction is, as applied to these materials (this "world"), at this particular moment. (364)

Stated so benignly, one can find this thesis impossible to resist; must not the movement of abstraction be the experience of the sensuous particularity of things in their unavailability to us, hence, as I have been wont to state it, a concrete material experience of the absence of such experience—at least? Only that, or something more? Of course, either way, the concreteness of the experience is illusory, just art, but that is the contradictory appeal of modernist art: when sensuous material meaning compellingly or authentically appears, it does so *only* as art—which casts an intolerable shadow over art and world. From this standpoint all the tensions in Clark's

account flow: he too is compelled by modernist works, but wants to displace that compulsion (explain it away?) by showing that it is either fully consonant with our representational commitments (the significance of Pissarro and Malevich), or utterly empty, pure pretense, imaginary (Cézanne, Picasso, Pollock). At no point does he allow that the power of compulsion, our assent to it, derives from the placement, the peculiarity, the puzzling fact of *art* itself in the modern world—modernist art figuring, each time again, our continuing commitment to the materiality of the social sign.[15] Clark cannot allow that at a certain moment the achievement of visual authority, of a concrete sensuous particular being demanding and having a claim, is itself a critical achievement, a defeat of skepticism, conventionalism, nihilism, and the patent forces ruining the perceived world. This does make the achievement of some modernist works, the more abstract ones, second order, "general," indeed abstract, of the kind "here again is material meaning," or, as Cavell would state it, the surprise that we can intend the world at all, and hence, indeed, lacking thick social content.[16] But this is to say one needs some more general account of "art" in order to tap the significance of modernism; and there is no "aesthetic theory" in Clark; so, despite the fineness of the aesthetic judgments subtending each moment of it, and despite his insistence that aesthetic depth means cognitive content, his work of narration is accomplished "without aesthetics," apart, to be sure, from the particular aesthetics of the painters themselves.

Some framing is in order before turning to Clark's final indictment of Pollock, the "contradiction" in Pollock that explains why abstraction stopped, why the paintings, and so modernism, come to nothing, ended. To make the whole story finally turn on the uncovering of a contradiction is, at least for me, brave and right, even if I disagree. The overt frame for the chapter is the least convincing: the Cecil Beaton fashion photographs, each model in front of a different Pollock, from the March 1951 *Vogue*; and what goes along with that easy assimilation of Pollock, the bad dream, the nightmare of modernism: that it either falsely celebrated what was, in fact, a feature of capitalist rationalization, or, in its exploration of an other to bourgeois experience, it did no more than prepare the way for the further expansion of capital (306).[17]

Obviously the second bit of the nightmare is one that thinks about how Beaton and Pollock are brought together, and how the Beaton photographs represent the sad tail-end of the public use of modernist art that began

with David's *Death of Marat* being marched through the streets of Paris, the painting and the event a marker for the entry of "the people" onto the stage of power that Clark believes is the "deepest cause of modernism" (46). Clark's history charts how modernism, in the very midst of its continuing path of negation, inhabited ever narrower, less political, less collective, less resisting cultural spaces in which the final step, after Pollock being "Beaton," is Hans Hofmann's painting fitting so neatly on Marcia Weisman's sitting-room wall—indicating, it is claimed, a profound community of interest between artist and client: "He could not have painted their interiors if they were not his interior too" (397).

This discontinuous historical trajectory of the public use of modernism makes the nightmare/Beaton frame apt. But I do not find it fruit-bearing here because nothing Clark says convinces me that the "crass" answers to this conundrum are not sufficient: that abstraction emerges as necessary to modernism when representations can no longer be the bearer of our conviction and connectedness with the world (344); that the same process that undermines representation as the bearer of conviction and connection with the world equally corrodes the achievement of abstract art; that there is an *aspect* of abstraction's power that is or can be seen as "decorative" (that the symbolic in the semiotic, rhythm, can appear as indistinguishable from what is merely decorative), an aspect that Beaton could and did exploit (the photographs of Pollock's paintings eliminate the force of their monumentality);[18] that less extreme versions of abstraction had prepared the way for Pollock. None of which is to deny that the pairing of Pollock, his risky, daring, transgressive, gothic, difficult paintings, with fashion models in *Vogue* is chilling—I am conceding that the bad dream of modernism is true, too true, which is my point. The *Vogue* photographs are a worthy reminder, but not a frame, and not one that Clark can do much with.

The other frame for Clark's analysis, which is the formal version of the nightmare/Beaton frame, is "why abstraction stops at its moment of triumph" (343). I think there is an *obvious* answer to this question implied by Clark's magnificent account, even if it is not the one that satisfies him. Abstraction ended at the moment of its triumph because the very means Pollock found necessary to make painting after Picasso and after his surreal (representational) forms were found insufficient, all the de-skilling, the negations, the magnifying and shrinking of the canvas, all the refusals that make *Number 1, 1948* possible, equally *exhaust* painting's resources (every-

thing that could be negated and transformed was); and any further step would not be or be a continuation of easel painting, but its displacement and transformation—which Pollock himself half believed and wanted.[19] The detail of Clark's account, his fineness in showing just what was involved in making those paintings—what Pollock does to line and color, to handling, to size—makes the exhaustion story, the aporia of the sensible account, irresistible. I would underline two features: (1) Pollock's production of a molecular anatomy of paint-stuff: in the line family there are threads, ropes, skeins, and webs; there are dots, spots, points; fuller areas can be splodges, pools, puddles, stains; together with the multiplication of these by the method of application: drip, pour, splash, throw, etc.; (2) a notion that the largeness involved in the very idea of all-overness "is made out of an unregenerate, unsublated smallness."[20] To think of these two features of Pollock together is, by itself, to begin thinking of easel painting being brought to its limit and so its end. But it is not Clark's story (even if all its elements are presented by him). With it we would not be able to put Pollock or modernism behind us. As anticipated above, the heft of Clark's account depends on foregrounding the world departed from; but this is to say that exhaustion is not the focal issue for Clark; instead it is the distance from representation, the limits of anti-representation. It is inevitable that Clark should come to conclude his chapter with an analysis of the (quasi-)representational works that Pollock continued to produce, including the magnificent and overly commented upon *Out of the Web: Number 7, 1949*. The matter needs delicate handling because, although I want to acknowledge that there is a deep issue of representation *in* modernism, representation is not the problem *of* modernism. Hence Clark's treatment of representation as the return of the repressed misfires.

The focus of Clark's argument is Pollock's *The Wooden Horse*, from 1948 (Figure 11); or better, Clark uses this work in order to allegorize the poles of Pollock's endeavor.[21] This is perhaps a strange work on which to base an indictment of modernism as a whole—for that is essentially what Clark is about here; however, for the sake of argument, let me concede that the interplay of "abstract" and "figurative" in this painting/collage is in some sense exemplary, allegorical, for their interplay generally in Pollock, hence part of the trajectory of his painting even when nothing figurative is present. A real, somewhat elongated wooden horse's head sits in the left-center of the brown cotton canvas; the brown ground dominates the painting. The horse's head

is of the kind that would fit atop a pole in the simplest version of children's hobbyhorses. Pollock continues the head with a crude outlined yellow neck with the hint of some black reins that trail out into the middle of the canvas to become just a wandering, emphatically abstract, poured line of black paint. Facing the horse on the right-hand side of the painting, as if in dialogue with the horse's head, is an almost self-contained painting on its own (an abstract painting facing the representational figure): a broken circle or head shape in white has within it drips and pours of white and black, with smudges of red and orange. There is a solid tube of orange protruding from a smaller white circle below the broken circle.[22] Between the two portions of the painting are thin skeins of black, red, white, not many, with an orange banana shape in the top center. Clark initially presents the painting/collage in terms of a personified dialogical agon in which first the wooden horse's head, as the voice of representation, and then the oil and duco, as the voice of abstraction, speak. After the horse's head affirms that likeness is both easy and unavoidable, avoiding it just bravura, the oil and duco reply: "[A]imlessness is the heart of matter. Painting now stands or falls exactly by its ability to show what gets in the way of likeness. . . . These thrown lines, this wretched meandering—the scratches of blue, red, and yellow that (almost) fill them out and give them body—they are ways of circling *around* likeness, looking for likeness in those movements where you would least expect it" (354–55). That is very odd, the horse's head arguing with the oil and duco. But, of course, it opens on to the thought that there are *sides* here in conflict, an "agon" (355); maybe even an unresolvable contradiction.

Clark's indictment occurs in two stages. Here is stage one: "*What is hardest to take about The Wooden Horse . . . is that the work against resemblance is still going on, and looks like it will go on forever*" (364; emphasis mine). He follows that indictment with the sober representational reminder: "Nothing will finally put paid to making and matching. The banal simulacrum of horse will always win. A painter can seize on infantile certainty about reference and parrot it to the point of disintegration. . . . But the "horse" is still there. Reference is imperturbable. Abstraction is parasitic on likeness, however much the achievement in abstraction may depend on fighting that conclusion to the death" (364). So what Clark despairs of here is that nothing of the abstraction indicates its lack of worldly stuff, its failed ambition to worldliness, so it strands abstraction permanently outside the representational contents that alone, finally, would make it meaningful.

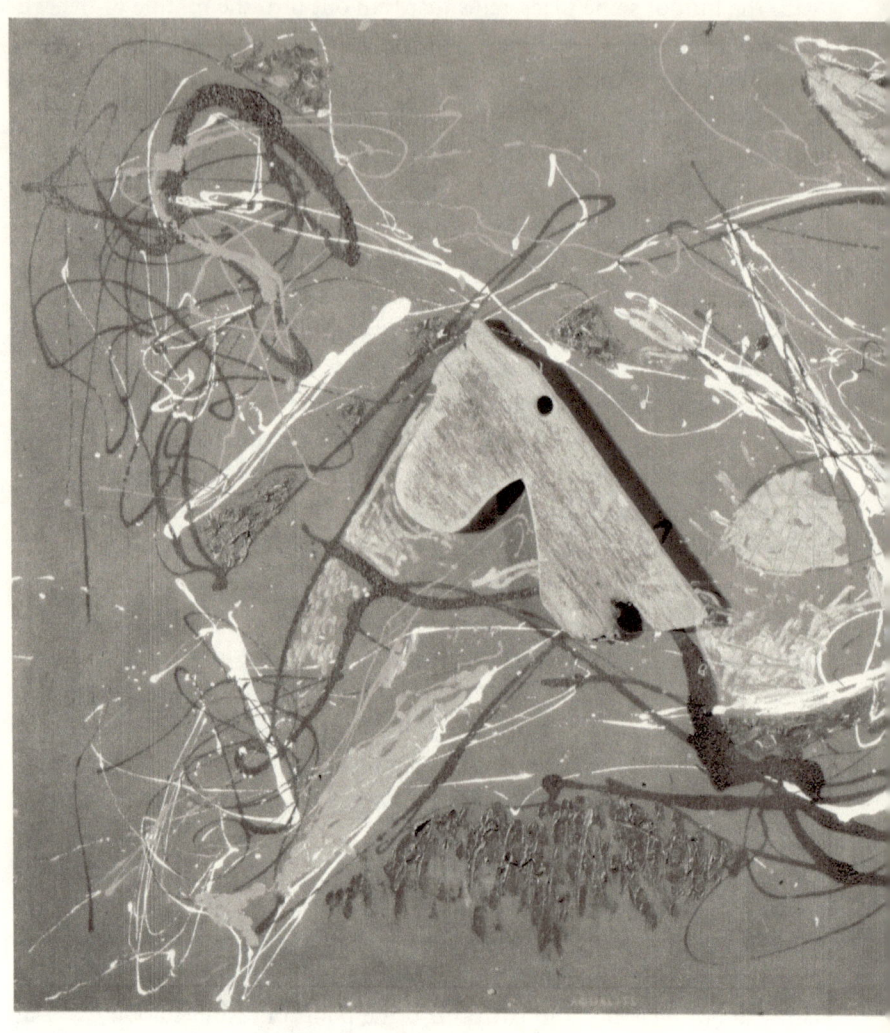

11 Jackson Pollock. *The Wooden Horse (Number 10)*. © 2003 Pollock-Krasner Foundation/Artists Rights Society (ARS) New York. Moderna Museet C/O.

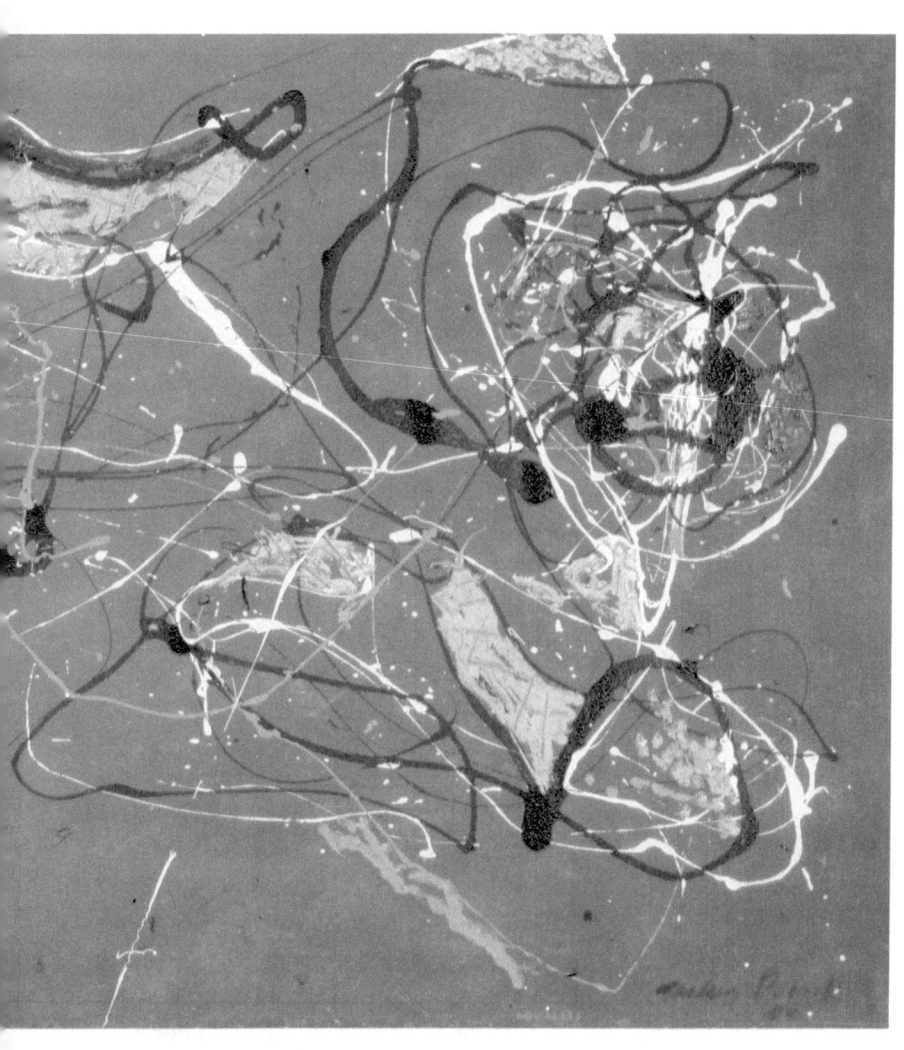

The contest between abstraction and figuration itself becomes aporetic, final, so leaving modernism as a whole (since it is inconceivable without the moment of abstraction) stranded and lost, forever.

This claim depends on what I take to be a willful inflating of the claim of painting, of Pollock's and modernism's claim, for the sake of disposing of that claim. I read *The Wooden Horse* as pointing in exactly the opposite direction: the wooden horse itself points to both the idea of pretend and deception, hence to the idea of painting being like a child's hobbyhorse, a simulacrum of the real thing, and with it the childhood investment in corporeal fantasy. Art, painting, then would be something like a hobbyhorse for grown-ups, which is to say, a fantasized experience of somatic exhilaration in a world bereft of such. Hence the exhilaration of painting is pretense; such painting may be thought mournful or melancholic, depending on the possibilities of somatic exhilaration outside art, but nothing in the painting/collage signals that the work against resemblance will go on forever, or at any rate that that is the stakes of this art: it is not representation as such that aimlessness, purposelessness, calls into question, but rather the kind of purposefulness that instrumentalizes each sensuously particular thing and submerges it. The hobbyhorse is not any old worldly object, but a figure of play, maybe the play-drive itself. This is the minimal aesthetic theory, call it Kantian if you wish, necessary for thinking about how formalism slides into abstraction, and hence how representation gets caught in the eddy of the aesthetic critique of instrumental rationality.

Is not the correct way then to take the wooden horse's head as a dissonant moment of excess that in ruining the self-sufficient abstract whole (showing how much more "real" even a pretend horse is) reminds us what that whole, or those like it, are for and about? And does not the horse's head in its dissonant excess, its whistle-blowing, circumscribe and thereby avoid the regressive investment that a blind attachment to the painting would install? Hence is not the horse's head a moment of nonironic reflexivity, precisely the avoidance of infantile posturing? Further, do not painting, the material act, and the horse's head refer to each other: blasted and illusory fragments? Is it the work against representation that is going on forever, or is it the dialogue between representation and abstraction—that is, between the instrumental reason and its curtailment?[23] And if the latter, how might we place or explain the forever?

At the very least, then, the horse's head is deeply ambiguous, and this

ambiguity is precisely what the painting wishes for itself and is unwilling to forfeit. In so doing the horse's head must be ambiguous between, again, a representational object that would be the opposite of the abstraction, *and* a representational echo of the abstraction, a vision of purposelessness outside painting that would be its stakes. Put it this way: what must appear as an abstract dualism, figurative versus nonfigurative employment of line, cannot be the duality it is posed to be and "this" still be a painting. Clark's indictment will not tolerate the ambiguity.[24]

Stage two. There is a stage two because, I think, Clark is aware that somehow the indictment of *The Wooden Horse* overshoots. So he corrects himself and launches in again—against Pollock and modernism as a whole. I need to quote Clark at length here since this is his big claim:

> What I want to say, finally, is that *Pollock's painting in its best period, from 1947 to 1950, is contradictory: it lives on its contradictions, thrives on them, and comes to nothing because of them. Its contradictions are the ones that any abstract painting will encounter as long as it is done within bourgeois society*, in a culture that cannot grasp—for all its wish to do so—the social reality of the sign. That is to say: on the one hand, abstract painting must set itself the task of canceling nature, and ending painting's relation to the world of things. It will make a new order to experience: it will put its faith in the sign, in the medium: it will have painting be a kind of writing at last, and therefore write a script none of us has read before. But on the other hand, painting discovers that none of this is achievable with the means it has. Nature simply will not go away. It reasserts its right over the new handwriting, and writes a familiar script with it—in the script of *One*-ness, *Autumn Rhythm, Lavender Mist*. So that painting always reneges on its dream of anti-*phusis*, and comes back to the body—that thing of things, that figure of figures. It cuts the body out of the sign, out of the field of writing. (365; emphasis mine)

When Clark says the paintings come to nothing, he must mean they come to be backdrops in Cecil Beaton's photographs. I presume that the dialectic here described matches my account of the tragic cancellation and displacement of nature (patricide) becoming a mourning of that loss as our relation to nature. Or at least the cancellation and acknowledgment of nature in Pollock is radical in both directions; it gives the paintings their presumption, fierceness, and sense of loss. That thought needs to be owned in terms of painting.

I suppose in order to answer Clark's critique in full I would need to say something about Pollock's best paintings. But that is not necessary in or-

der to catch where he goes wrong. Let's return to the instance of *The Wooden Horse* since it is the reemergence of the figurative and representational there that fuels Clark's critique—although I could just as easily, and even better perhaps, make use of *Full Fathom Five*. I casually described *The Wooden Horse* as a painting/collage; I want to defend that slash. To say of *The Wooden Horse* that it is a painting/collage is to say that it means to equivocate between painting and collage: that painting is just, only, collage absent the fragmentary things collages are made of, so they are collages made of paint (this was in part Soutine's thought). The modernist collage is the taking of the detritus of experience, the fragments of material reality that are broken, fragmented, because the thing has been devoured by capital, and creating from those bits and pieces a second-order life, call it a fragmentary script, that is a way of not mourning but, let's say, *preserving them as fragments of a lost reality*, as if the canvas were an embalming fluid or a glass-windowed mausoleum.[25]

Every abstract painting is, or so Pollock is insisting, a dissolved collage—the fragments dissolved into paint-stuff (which literally is what happens perceptually in *Full Fathom Five* with its inventory of button, matches, key, pennies, etc., physically embedded in the paint but dissolved, utterly, in the abstract perceptual swirl).[26] And every collage is an abstract painting in the making since the fragmentation of the world to which the collage points will continue leaving fragments and even less than fragments, perhaps just "stuff," like paint itself.[27] And both on this account are forms or modes of melancholia, melancholia become form, become art. *And this would make sense just in case our only access to material meaning, the materiality of the sign, were art, the art we call modernist.*

In saying that what is preserved in art are always fragments or ruins of the (material) representational world, I am agreeing with Clark that abstraction always refers back to the object. But we read that fact differently: for me the power of art to accomplish that work of preservation speaks to a defused potential that hibernates in aesthetic form: aesthetic form is, finally, in modernist art a stand-in for the social reality of the sign, a compensation for a lost social "we" and hence an anticipation of another one. Aesthetic form is thus the social reality of the material sign in its displacement—its excision from the world and lapse into, alas, art.[28] Even an arbitrarily grounded practice is capable, through the efficacy of singular works, of sustaining moments of material meaningfulness. Hence, particular

works, fragments, can be meaningful in opposition to the totality of which they are a part. The power of works to preserve is the power of the fragment. I am not of course suggesting that modernists have always meant this; but it is what modernism comes to.

In contrast, Clark's argument rests on nothing more than an ambiguity in the notion of "representation": he construes the abstraction/figuration relation, what I claimed is best conceived in terms of the relation between abstract painting and collage, as implicitly projecting (in the moment of representation: the horse's head, Pollock's occasional hand prints, etc.) a representational whole: call it socialist society and its narrative telling. This is bizarre and unearned—the whole edifice turning on an ambiguity in the concept of "representation": as if one cannot say of a human body that it has been brutalized without summoning up a whole nonbrutal social formation. For Clark the nonbrutal social formation is the ultimate source of the intelligibility of there being whole human bodies; for me, the lesson of modernism is that matters are the other way around: our glimpse of a nonbrutalized body occurs through the preservation of its broken parts in a work, which is in turn the source of intelligibility of there being nonbrutalizing social practices. It comes to that.

It is not hard to figure Clark's response to me, namely, that in neither mood nor ambition are Pollock's best works compatible with my notion of melancholic form (although the idea of a self-consciousness of art as melancholic form is, is it not, a less pejorative way of speaking of Pollock as an "unhappy consciousness"?). About the ambition, Clark contends, "[I]f Pollock had a dream of exceeding the normal terms of painting's reference—and I am sure he had—the fantasy was more of endlessness and transparency than of physical grounding" (332). Clark presses this idea with respect to *Number 1, 1948* and *Number 32, 1950* in which, as he powerfully describes what occurs, Pollock's ambition is to provide literally a Hegelian sublation of handling ("traces of making, demonstrations of the artist's touch"):

[H]andling here seems not to be the sign of unity, whether the picture's or the picturemaker's. The marks in these paintings . . . are not meant to be read as consistent trace of a making subject, but rather as a texture of interruptions, gaps, zigzags, a-rhythms and incorrectnesses: all of which signify a making, no doubt, but at the same time the absence of a singular maker—if by that we mean a central, continuous psyche persisting from start to finish. (331–32)[29]

After this, Clark goes on to make his central point about abstract painting's ambition to be rid of resemblance, and thus to make the first painting, again. Four points in response to this. First, and most important, it is a demand of painting that it demonstrate an objectivity, a being something more than an individual willing, for which nature is a continuing model, while nonetheless acknowledging itself as something made. If you grant that these are general demands on modernist painting, then Pollock may have been brought to an extreme in order to accomplish them—that is, the repudiation of handling in its traditional guise and the opening up of the canvas to the full force of its material substratum as material—but *formally* he is doing no more or less than what any modernist painter must do.

Second, even if we concede to Clark (in his running critique of Rosalind Krauss) the idea that Pollock sought transparency, that he meant his paintings to be optical, to appeal to the eye against the tactility of previous modernist art (330), and so on, all this is a project of *painting*, hence, as Clark well knows, deeply immured with the color and the materiality of the paint (331, 336–37). He can set off one aspect of Pollock (endlessness) against the other (materiality) only because he smuggles into the idea of materiality that of embodiment and thus resemblance. But why not say that in painting what materiality and embodiment come to is *sensuous particularity*, and that the embrace of sensuous particularity in abstraction from full embodiment is precisely the price that is paid for art being art and not world?

Third, a tired point but one necessary in the light of how Clark operates his historical method: even if he is right about Pollock's ambition, it does not follow that he is right about the meaning of the paintings—what the paintings accomplish and what they were meant to accomplish are different things. In fact, Clark powerfully spells out the materialist/dissonant, Adornoian aspect of Pollock (337) and argues for a dialectic of dissonance and totality in which the process of blocking connotation by multiplying it should nonetheless yield a dense totality (338–39). This, again, seems fine, which makes the trailing criticism seem forced.

Fourth, Clark would be right to complain that my description of what is accomplished is incompatible with the actual ambition of the big canvases, their monumentality and wild hubris. But nothing I have said is meant to deny that over-ambition, literally attempting the impossible, cannot be a *necessary condition* for art to accomplish what it does. The whole

point about what I think of as the a priori deadness of art is that a successful work is impossible—it cannot really accomplish a reconciliation of matter and sign, universal and particular—just because it is art, and so any modernist painter must attempt to provide utterly self-contained or autonomous forms of meaningfulness from within the terms, paint on canvas, afforded. And this will fail because objects imply worldly practice, and that is the one thing that capitalist culture will not permit its art to be.

So, what goes wrong in Clark's big critique is what went wrong in its anticipation: a transforming of ambiguity, contingency, and aporia into contradiction. Art can only accomplish its task of affirmative melancholy by contriving something like a putative new set of conventions, conventions made possible by the fact of art itself. These conventions will collapse because the autonomy of art is premised on nothing but its excision from everyday, intersubjective, social utilitarian practice, on the one hand, and on what is *in the last instance* a wholly arbitrary conventional frame (easel painting itself as the stand-in for the material aspect of the social sign) on the other. But again what is so outlandishly and intolerably exiled there, in painting, is nothing other than the very two elements that Clark claims are in contradiction: the sociality and materiality of the sign. I am not denying that in modernism, sometimes, the extremes of sociality (the arbitrariness of the sign) and materiality (the scrawl of the unconscious) get asserted; and I am certainly not denying that the sociality and materiality of the sign routinely and necessarily fall apart (or connect only "imaginatively")—this is just what modernist works lament when they achieve that mood. But those episodes, I am suggesting, are a consequence of modernism, as the fundamental effort to establish the materiality of the social sign, being under siege, of its attempt to secure the materiality of the social sign against the grain of the dominant practices surrounding it. So I am committed to the thought that a different history of modernism would show that each of its moments of achievement are ones in which there is an uprising of meaning from materiality (or a sinking of meaning back into its material conditions of possibility), where the very fact of the uprising (or sinking), its achievement, is what solders sign to material. (Which, again, makes the whole enterprise more abstractly cognitive than is standard; each moment presents and defeats a particular kind of skeptical challenge. Modernist negativity is then a use of skepticism to defeat skepticism. Clark perceives the cognitive achievement of his politically informed artists, but not their dissociated brethren.)

The further recuperation of the original moment of uprising (or sinking) will, inevitably, recover more sociality (in the Bakhtinian sense in which the material for sense-making is "already bespoken") in it than it appeared to have at the moment of emergence (even if the moment of emergence is thought as only logically prior to the moment of reception). Is what happens in Clark, then, a matter of his attempt to push the moment of recuperation back into the moment of uprising? And since that is doable, how can I resist his knowingness? But is not this knowingness one that, finally, defeats art as such? This is why I used the word "vengeful" in my opening paragraph.

I said at the outset that I agreed with Clark that modernism fails, and I am claiming that modernism's failure, its a priori deadness, is intrinsic to it: it is what is bizarrely most alive about it (so, in a sense, we agree that modernist art "lives on its contradictions"—that is, the impossibility of its doing the work of reconciliation here and now), but that it fails like this, being only a public mausoleum, because of the lack of an adequate social basis, but not as a consequence of its epistemological failure. I can now make this claim a little more precise: modernist art provides us with all the evidence we possess that the sociality and materiality of the sign are reconcilable; but that form of reconciliation would be *both representational and fragmentary*. Socialism, the one that failed and deserved to, was premised on a more totalizing representational account of the world as its condition for providing collective focus and purpose.[30]

Like Clark, I am willing to bet that human lives require focus and purpose; unlike Clark, I do not think socialism in its traditional guise can provide those things without running aground in all the horrific ways it did in the past century. What I find deeply puzzling about Clark is that his critique of modernism leaves him without resources for resurrecting socialism. This is the ambiguity in the title of the book: the farewell may be not only to modernism and bad, old socialism, but to socialism itself; although, again, it is only on the ground of an absent socialism—perhaps now a forever absent socialism?—that he can construct his narration at all (so socialism becomes a Kantian regulative idea). Perhaps he is indeed more cynical than I am imagining. Or romantic, since for him the critique of modernism points to an absent epistemology, one that would reconcile the two halves of modernism—the sociality of the sign and the materiality of the body—in a "whole."

However delicate and indirect his approach, if I am reading him aright this does sound awfully like the romantic utopianism of the early Marx. It is not too wild, I think, to see the modernist cynic and the utopian romantic Marxist as two sides of the same coin: fantastical hopefulness and cynical despair locked into their familiar two-step. Be that as it may, to await the revolution while awaiting a saving epistemology seems just wrongheaded. Surely it is modernist practice itself that projects, if anything does, the form of a collective practice adequate to a wholly secular world. Only with the emergence of such a practice, which is to say, only through the practical continuation of modernism into everyday life, could modernist art's melancholy be mourned.

7

Readymades, Monochromes, Etc.: Nominalism and the Paradox of Modernism (Thierry de Duve and Marcel Duchamp)

> If Schopenhauer's thesis of art as an image of the world once
> over bears a kernel of truth, then it does so only insofar as
> this second world is composed out of elements that have been
> transposed out of the empirical world in accord with Jewish
> descriptions of the messianic order as an order just like
> the habitual order but changed in the slightest degree.
>
> —T. W. Adorno, *Aesthetic Theory*[1]

Adorno's philosophy as a whole, and his aesthetic theory in particular, are irrevocably bound to the tradition and achievements of high modernism. Although Adorno himself did not recognize American abstract expression as the apotheosis of high modernism in painting, that judgment now seems hardly contentious. And that raises a problem: it is the problem of R. Mutt again, the problem of the porcelain urinal called *Fountain* that was refused admittance to the Society of Independent Artists' Exhibition in April 1917 in spite of the society's implicit commitment to the democratic slogan "No jury, no prizes." It is the work whose life or after-life begins with the beautiful photograph of it by Alfred Stieglitz set against the background of Marsden Hartley's *The Warriors* that appeared shortly thereafter in the new avant-garde journal *The Blind Man*.

Whatever the immediate repercussions of *Fountain*, there can be little doubt that much of what was most vital in art in the second half of the twentieth century, art after abstract expressionism, was unthinkable with-

out it; Marcel Duchamp's readymade offers an exemplary alternative to the tradition of high-modernist painting that has continued to be generative. For a modernist like Adorno for whom authentic art is that which best rises to the demands and necessities of artistic materials, for whom internal consistency and rigor would appear to be everything, for whom, finally, aesthetic form is the "objective organization within each artwork of what appears as *bindingly eloquent*" (*AT*, 143; emphasis mine), Duchamp's gesture of simply naming or claiming artistic status for an ordinary bathroom fixture must be anathema. In this respect, Adorno's aesthetic theory would seem to be in the same predicament as Clement Greenberg's modernism: inextricably bound to a tradition that history has left behind. And while the option of refuting the claim of *Fountain* is certainly possible, and should not be too quickly suppressed (there is something in the claim that will forever be skeptically self-defeating), nonetheless there appears to be an exemplariness to *Fountain* that exceeds the narrow provocation of Duchamp's nominalist gesture; something in the readymade, in fact, seems (art historically? aesthetically? conceptually?) irresistible. If so, then modernist formalism must either find a way of accommodating the readymade without departing from its internal logic or find its claim to our attention forfeited.

After laying out the bold outlines of Adorno's formalism, the remainder of this essay seeks to uncover an account of the readymade in the context of what I call "the paradox of modernism" in order to locate in what way the claim of the readymade can be accommodated to a defense of Adorno's late modernism. For the purposes of this argument, I will assume that the best overall defense of Duchamp's gesture, which makes it foundational for the understanding of modern art, is that offered by Thierry de Duve in his *Kant after Duchamp*.[2] My elaboration of Adorno's late modernism proceeds, in part, through a charting of some of the fault lines in de Duve's Duchamp. My contention is that the generativity of *Fountain* as readymade, *suitably modified*, not only belongs within modernism, but is only intelligible within a wholly modernist and formalist frame of reference.

Adorno's Formalism and the Material Motive

Adorno opens the section of *Aesthetic Theory* entitled "Coherence and Meaning" with the drastic sounding thesis that "Although artworks are neither conceptual nor judgmental, they are logical" (*AT*, 136). He continues:

In them nothing would be enigmatic if their immanent logicality did not accommodate discursive thought, which criteria they nevertheless regularly disappoint. They most resemble the form of a syllogism and its prototype in empirical thought. That in the temporal arts one moment is said to follow from another is hardly metaphorical; that one event is said to be caused by another at the very least allows the empirical causal relation to shimmer through. It is not only in the temporal arts that one moment is to issue from another; the visual arts have no less a need of logical consistency. (*AT*, 136)

Artworks "gain objectivation" for themselves by virtue of the way in which their components are bound together. In the temporal arts this binding occurs when we feel that a second moment had to follow from a previous moment, that the movement from *a* to *b* was somehow right or necessary or inevitable, albeit oftentimes only retrospectively. And this sense of rigor can have the character of being *like* an inference drawn from a premise, or like one event causally necessitating a later one. In the visual arts the demand for logical consistency is channeled through the traditional requirement that works be "self-alike," that is, that component parts of a whole belong intrinsically and not accidentally to the whole of which they are parts. But it is just this self-alikeness that underwrites a work's objectivity, since it entails that works lodge their claims on the spectator only indirectly; it is the internal relation of parts to whole, a work's immanent necessity, which makes it "an interior" (*AT*, 136) that is its claim to attention. What would directly appeal to the spectator, by being immediately affecting, for example, would make a work a machine for producing effects that would thereby be worthless—the machine either works or does not, and no judgment beyond that is possible. Good machines and good artworks are different animals.

All this is correct, but for the hyperbole. Art's logicality is not that of the syllogism since it is made without concept or judgment; and whatever causal nexus links events in a temporal artwork, it is not a matter of lawlike necessity. Further, although everything appears in an artwork as if "it must be as it is and could not be otherwise" (*AT*, 136), this is not literally true. As in dreams, a feeling of coercive consistency is bound up with an equal sense of contingency. There is a sense, then, in which authentic artworks must be capable of sustaining the judgment that their parts do logically hang together while acknowledging that different choices would have produced a different but equally binding work—an outcome that is not un-

usual, at least in painting, where the series is employed to establish a new logicality. But for Adorno this fact is meant to be expressive of a feature unique to art: in artworks the logical (quasi-conceptual) and the causal are not finally distinguishable: "in art the archaic undifferentiatedness of logic and causality hibernates" (*AT*, 137).

For Adorno it is the historical separation of logic and causality that underpins the disenchantment and rationalization of modern social formations. Logic apart from causality is rationalized reason that exists apart from and independent of its objects and material presuppositions; autonomous logic is the logic of exchange value apart from use value, bureaucratic rationalization apart from local practices, the laws of natural science as explanatory of the items falling under them, the laws of inference apart from the statements connected. It is the totality of these separations that generates what Adorno entitles, somewhat misleadingly, instrumental reason. In the naive celebration of this, it is said that autonomous logic is the "space of reasons" in which human conceptuality operates without causal or material constraint; hence the space of reasons is the space of freedom. Conversely, then, once experience is systematically deprived of its own "logicality," all that is left are raw causal episodes, meaningless in themselves.

In proposing that artworks are logical, consistent, internally coherent, and simultaneously causal, Adorno is contending that central to what makes artworks worthy of attention is that they transform the very forms of empirical experience, the reified duality of logic and cause, in a direction that deprives those forms of their external coerciveness. If art had nothing to do with causality and logicality—the very bonds connecting things in a disenchanted world—then, by that very fact, it would lose contact with empirical experience; alternatively, if in art causality and logicality were unchanged, then art would succumb to the "spell" of disenchantment: "The autonomous law of form of artworks protests against logicality even though logicality defines form as a principle. . . . [O]nly by its double character, which provokes permanent conflict, does art succeed at escaping the spell by even the slightest degree" (*AT*, 138).

Adorno's commitment to formalism is rooted in his understanding of art's logicality. Art's connection to the routine objects of knowledge is a result of "implicit critique of nature-dominating *ratio*, whose rigid determinations art sets in movement by modifying them" (*AT*, 139). In art empirical form—space, time, and causality—and logical form are given a "refracted

appearance" (*AT*, 137) that enables them to relate to their material constituents otherwise. The consequence of refraction is that in works linkages are not conclusions or distinct events; rather, what aesthetic consistency generates is a "communication between objects" that preserves "the affinity of elements that remain unidentified" (*AT*, 138). "Communication" and "affinity" are among the terms Adorno employs in order to insinuate a potentiality for objects unidentified by standard, reified concepts to mean something other than their empirical meaning. They reveal this meaning otherwise by standing in relation to one another in works in ways that are both compelling and not capable of being captured by conceptual or causal means. Above all, then, affinity and communication insinuate the idea of material form, of form as emergent from or implicit in art's material substratum (*AT*, 142). Artworks are illusory acts of an anthropomorphic hylomorphism. Adorno will go so far as to say that artworks "move toward the idea of a language of things . . . through the organization of their disparate elements" (*AT*, 140).

In his elaboration of art's logicality, Adorno approaches the problem of aesthetic form sideways on. The reason for his indirect approach is evident: Adorno is in no doubt that art simply is "identical with form" (*AT*, 140); but form traditionally is what orders a content or a material. In order to break from this notion of form while remaining formalist, Adorno locates the domain of form apart from traditional forms themselves in the transformation that empirical logicality and causality undergo when they operate within works. Form is the bearer of the different and manifold modes in which logicality and causality are intermeshed in works as their principle of order:

[A]esthetic form is the objective organization within each artwork of what appears as bindingly eloquent. It is the nonviolent synthesis of the diffuse that nevertheless preserves it as what it is in its divergences and contradictions, and for this reason form is actually an unfolding of truth. A posited unity, it constantly suspends itself as such. Essential to it is that it interrupts itself through its other just as the essence of its coherence is that it does not cohere. In its relation to its other—whose foreignness it mollifies and yet maintains—form is what is anti-barbaric in art; through form art participates in the civilization that it criticizes by its very existence. (*AT*, 143)

The full ramifications of this dense passage cannot be unpacked all at once; nor, it is worth adding, are its lines of argument accessible as here pre-

sented. Its full exposition is all but synonymous with what I want to say in this chapter as a whole. But a small beginning needs to be made. Binding eloquence is the aesthetic corollary of (the unity of) valid inference and causal connection. Whatever in a work—proportions of space and surface or color contrast—that provides compelling order is thereby form. Form in modernist works need not be, and at its most rigorous is not, different from what is so ordered: a field of color divided by a vertical line of a different color, one of whose edges is slightly blurred, generates form. But the form so generated is nothing but the organization of the content (color field and contrast, vertical line). And if, as in this case, the form is minimal, then acknowledgment of the form is had at the same time as acknowledgment of the "foreignness" of what is formed—the colors themselves and the vertical tearing.

For Adorno, for reasons that will become clearer, modernist works display their inherence in their materials by letting those materials—colors, paint-on-canvas, the rough brush stroke, the drip of paint—appear in their own right. To put it another way, the kind of form modernist works possess is in part dictated by what I will call art's "material motive." Traditional works of art are for the sake of ideas and ideals that were presumed to exist independently of the material formed. Modernist works, Adorno contends, enact a reversal in which form is for the sake of what is formed; or better, the intelligibility of modernist works, the development of abstraction and negation, the role of dissonance in them, etc., all only makes sense if, apart from all intentions, modernism is dragged or pushed forward by a material motive that subtends all contesting ideal motives. It is because of this reversal that modernist works must interrupt themselves: although artworks appear to demonstrate, through their forms, a binding eloquence of their material substratum, this appearance of consistency is just that—appearance and semblance, something that can occur only within the refuge of art with its dispensation from practical purposiveness. Because the binding eloquence is semblance, and yet for the sake of what is being made eloquent, then artworks can carry out their task of critically opposing empirical logic and causality only by suspending their own accomplishment. To suspend their own accomplishment is thus both to acknowledge the relative autonomy of the materials and, by the very fact, enact the reversal whereby form operates for their sake.

Adorno's insistent formalism is utterly bound to the material motive.

The material motive, like the formal motive of entrenching painting in its own area of competence, is not to be thought of as what this or that artist intended, but as a tendency or tropism in modernist practice that is visible only in its waning.[3] Or better, only now in the case of painting is the material motive being appropriately recognized in relation to the otherwise impeccable formalist analysis of modernist practice. So, for example, in reviewing the Museum of Modern Art's large Jackson Pollock exhibition (1998), Thomas Crow felt compelled to urge against both the museum's own conception of Pollock, and by extension the optical interpretation promoted by Greenberg and Michael Fried, an account that underlined the "literal concreteness, the obdurate materiality" of the canvases:

> The dissonant disabling of a represented nature made Pollock's canvases function themselves as the equivalent of nature, where the powers of the artist to impose form are strictly limited, where final effects are instead a matter of inducement and invitation, with the brute fact of the painting having the last word.[4]

Crow's nuanced statement of the "dissonant disabling" of represented nature on the one hand, and on the other the restriction of Pollock's power to impose form, hence "inducement and invitation," recapitulates Adorno's notion of a coherence that does not cohere as the release of the material motive. Gaining clarity about the material motive in Pollock's work remains urgent since, in the setting of abstract expressionism, his and their work increasingly looks like an apotheosis, *a last emphatic exploration of the systematic possibilities of modernist painting.* After Pollock and Rothko and de Kooning and Newman, after abstract expressionism if painting continues, as it does, say, in the works of Gerhard Richter and Robert Ryman, for reasons we shall come to, it no longer does so as part of a larger systematic undertaking. The latter's works can appear almost memorial, an ascetic exercise in remembrance of painting rather than the thing itself.[5] It is the *exhaustion* of painting that after a thirty-year or more delay made the exemplar of *Fountain* appear, once again, promising.

Abnormal Painting

De Duve contends that Duchamp's self-understanding invites the idea that the readymade "is a sort of abnormal painting" (*KD*, 162).[6] What is at issue in this claim is the idea that we must consider the readymade as a

certain, paradoxical, *continuation* of modernist painting, as a response to the exhaustion of painting, and hence as a way of sustaining the stakes of painting in the absence of painting. This thought is not too shocking if we keep in mind that the minimalist works of Donald Judd, Robert Morris, Carl Andre, and Dan Flavin were explicitly, if inconsistently, intended as responses to the impasse of painting and a continuation of trends in it (explicitly, in the paintings of Frank Stella and Barnett Newman).[7] What should be puzzling, in the first instance, is not that certain three-dimensional works, readymades and minimalist ones, are conceived in relation to painting, but that painting should be so *privileged* in this story that the *legitimacy and meaning* of readymades and minimalist works remain parasitic on it.[8]

Summarizing horribly, de Duve offers a three-stage account of the unfolding of modern art (*KD*, 377–81). In stage one, in both premodern times and even in modern autonomous art up to the middle of the nineteenth century, "practitioners of a given discipline . . . *knew* beforehand what technical and aesthetic constraints their productions had to meet in order to be conceptually identified as paintings" (*KD*, 378). There were technical and aesthetic rules of the trade that constituted what it was for something to be a painting and even what made something a good painting (although both technique and standards developed and changed); these rules were an implicit contract with the public. With the onset of modernism (stage two), de Duve argues, things changed. Painters began to challenge the taken-for-granted character of the previous rules. What conventions can a painting dispense with and still be a painting? What conventions can a painting dispense with and still be aesthetically worthy? Once painting becomes reflexive, an interrogation of what painting is, the unitary set that had integrally harmonized something being a painting and something being beautiful, fell apart. Once painting is no longer founded on traditional authority, painting stops being a (complex) unified concept and becomes "a word void of a priori knowledge about the minimum rules and conventions its practice must obey; it is no longer a concept; instead it has become a proper name with which I baptize the things that I judge deserved to be so called" (*KD*, 378–79).

Stage three. What is the best way to articulate what happens when artists break the old rules and propose new ones for something to be a painting? At one level, the correct answer must be of the kind: they renegotiate

their social contract with the public. But if this is correct, then it follows that all modernist artistic practice is best construed as presenting works of art so that they can be judged as such, that is, modernist art is shown to the public for "no other purpose than begging approval and/or provoking disapproval" (*KD*, 380). In exhibiting *Fountain*, a work from which all trace of craft and "every conventional alibi" that might allow one to identify it as a painting or a sculpture has been withdrawn, Duchamp insisted that it be "appreciated for its quality as a work of art, period," that the judgment as to the quality of the work "bear on the very fact of having to judge whether *status* [as art] equals *quality*" (*KD*, 379). De Duve's double gesture here is intriguing: on the one hand he sees Duchamp as opening the nominalist floodgates (that de Duve confusedly conceptualizes under the idea of art being a proper name)[9] whereby since no conventions are essential to something being a work of art anything can be; on the other hand, he tries to half-close the gates again (against the institutional theory of art and Joseph Kosuth's idea of conceptual art) by insisting on the role of the spectator and thereby the ineliminability of judgment. The aporia in this double gesture is evident: once anything can be proposed as a work of art, on what basis are we supposed to judge? How is judgment to gain a foothold? What could conceivably guide or govern our judging? A comparison with the works of the past won't do since, by the example of modernist painting itself, we know some past judgments were premised on fully disposable conventions. And to say that time will decide whether artist and public were right or wrong is to move in an empty circle. If no sources of judgment can be located, how can the role of judgment be sanctioned? Saying that works of art are for the sake of judgment and must be judged leaves mysterious why judgment should be so pivotal.

On de Duve's account, the role of painting is fundamental only in that the dynamic of modernism whereby new works transgressively attempt to inherit the mantle of "painting" is generalized by Duchamp from painting to art, hence dissociating art from the conventions that might be instituted in or by a particular practice (painting, sculpture, etc.). But this, although it is a valid inductive inference, atrociously flattens painting since the key idea that emerges from the inductive inference is that of a practice developing through transgression; and *any* such practice would of course require a moment of judgment because the new rule is won, if it is, through appeal to the new radical case. This is an important and worthy idea;[10] but how

does it relate to art? to the model of painting? Is there some special reason why the notion of transgression and judgment appears in painting? Is there some reason to think it belongs to painting?

In fact, there are a number of stories kicking around here, none of which adds to up to the actual generalization from painting to art that de Duve operates. One story concerns Duchamp's own dawning perception that painting was no longer possible. Duchamp's feeling that painting is impossible is the subjective accompaniment to the "awareness of its objective uselessness in a society where the production of images has been mechanized and from which painting has withdrawn, like a relic from an obsolete artisanal past" (*KD*, 171). One response to this dilemma would be to opt for photography or film, as Walter Benjamin urged in "The Work of Art in the Age of Its Technical Reproducibility." But de Duve contends that Duchamp's gesture is for the sake of painting; Duchamp stops painting in order that painting can survive as an unactualized possibility (*KD*, 171–72). This is not implausible; on the contrary, I suppose that modernist painting is like this: it paints the impossibility of painting in order to hold open the possibility of painting. Nothing to here, however, enables me to say that. And even if it could be said, it leaves wholly undetermined why Duchamp, or anyone, might be nonetheless invested in painting in a manner that was not blatantly nostalgic for the artisanal past.

The next story is owed to Greenberg. As late as 1958, Greenberg could open his essay "'American-Type' Painting" full of optimism about its future. Of all the arts, only painting was still a viable avant-garde project. In all the arts the movement of modernism is to isolate and expend those conventions not essential to it. Modernist practice advances by distinguishing the merely conventional from the intrinsically conventional; the latter being just those conventions beyond which a practice cannot go and still be recognizable as a continuation of its negated past. Conventions are overhauled "not for revolutionary effect, but in order to maintain the irreplaceability and renew the vitality of art in the face of a society bent in principle on rationalizing everything." Literature and music, Greenberg avers, have either already located those conventions essential to them or have nearly done so. Things are otherwise in painting; it has "turned out to have a greater number of *expendable* conventions" embedded in it, and hence "has a relatively long way to go before being reduced to its viable essence."[11] In "Modernist Painting," Greenberg goes so far as to suggest that modernism's

"limiting conditions," emphatically for him a painting's flatness, "can be pushed back *indefinitely* before a picture stops being a picture and turns into an arbitrary object."[12]

It is worth noting that Greenberg fully endorses the thought that the *vitality* of an avant-garde practice depends on its remaining progressive, transforming itself by more fully exploring its conventional constitution, risking more in reducing itself to its essential features, which conversely have to be more explicitly observed, more rigorously adhered to, the further the limits are pushed back. Literature and music have passed the point of dynamic progress. They are exhausted as forms of resistance to rationalized society. That painting could suffer the same fate is conceded by analogy with the cases of literature and music. As de Duve narrates the tale, correctly I think, the progressive analysis of art unraveled rather rapidly in the face of the 1959 exhibition of Frank Stella's black stripe paintings (see Figure 8). These paintings in their adherence to the picture plane look as if they were designed to illustrate Greenberg's conception of flatness; yet Greenberg did not care for them. I imagine him thinking the same of these that he did of Mondrian, that they were "almost too disciplined," too traditional in their "subservience to the frame."[13]

It is as if, with these paintings of Stella, painting had suddenly broached its limiting conditions, that it no longer had conventions it could expend, that the energy of negation had been depleted at one go. What is surprising in this is Greenberg's surprise, his denial and beleaguered resistance. Imagine a room with three large canvases: a late Clyfford Still all black with just a few bark-like crevices of red; a Newman; and a Rothko. Seeing these together, one's astonishment would have the form of near disbelief that these painters had avoided the monochrome; thought of together and in retrospect, their art appears to be an abandonment to the claims of the monochrome while nonetheless avoiding it, just the slightest inflection—ragged crevice, zip, contrasting colors of paint soaked into the canvas—separating their pictures from the zero point of the monochrome (with the blank canvas forever lurking behind the monochrome).[14] But painting did not have to wait till this point to appreciate that somewhere in the history of negations that comprise the advance of modernist painting in its abstract phase there stood the iron gate of the monochrome, since almost simultaneous with the birth of abstract painting we have the examples of Malevich's *Black Square* and Rodchenko's red, yellow, and blue triptych. Is

there anything in music or literature like the monochrome in being so identifiable an *end* (it is, after all, the telos of the process of negations) and exhausted *limit* (no further negation is left but the blank canvas)?

Certainly it is not implausible to regard minimalism as a continuation of Newman's and Stella's asceticism punched through "from the fictive depths . . . through the surface of the canvas to emerge on the other side"[15] in the form of a three-dimensional object as a way of continuing. Nor is it implausible to believe that Duchamp spied this fate early on and employed the readymade as his way of escaping the threatening sterility of the monochrome. While this narrative has the correct shape, a central element is still missing. On this account, painting is pivotal de facto only; the privilege of painting is only that it was an art practice whose modernist dynamic sustained the avant-garde till the moment it became exhausted in the monochrome, at which point there was no way to go on other than by crashing through into the three-dimensionality of the minimalist work and/or readymade. And to be sure, once the breakthrough occurs there is a shift from painting (specific practice) to art in the generic. And this is what leads de Duve to exclaim that what was at stake in these struggles "was the name art" (*KD*, 81). But by itself that sounds remarkably hollow and tautological. What one wants to say is that minimalism and the readymade inherit the *stakes of art*, not its name but what is at stake in the name.[16] What is missing in all this, I want to urge, is, again, the material motive.

Non-Art and Anti-Art

Adorno imagines that once upon a time, in the age of myth, sign and image were one. With the "clean separation of science and poetry" there developed a division of intellectual labor that extended into the heart of language: "For science the word is a sign: as sound, image, and word proper it is distributed among the different arts, and is not permitted to reconstitute itself by their addition."[17] The arts, in the plural (music, painting and sculpture, literature), are for Adorno a repository of the elements of *particular, sensuous, embodied* experience that were found expendable for cognition once the abstract sign—first the Platonic universal, later the mathematical sign and the logical connective—became legislative for empirical knowledge and practical reasoning. Thus when the arts finally become autonomous (from magic, religion, metaphysics, politics), when they began

self-consciously articulating their conventions and limiting conditions, the logicality unique to them, as their mode of progressive self-formation, they are to be understood, in their blasted fragmentariness, as articulating the binding rationality of what belongs uniquely to what was found expendable in the advance of reason: particular, sensuous, embodied experience. Almost. Very nearly. Not quite. If one understands the arts as having developed under the pressure of a rationality that wished to dispose of what was intrinsically particular, sensuous, and embodied, then *the arts owe their very existence to a historical calamity*, the diremption of the symbol into sign and image or concept and intuition (*AT*, 96) or, returning to our starting point, the rupture of material inference into logic and cause, or: "the untruth attacked by art is not rationality but rationality's rigid opposition to the particular" (*AT*, 98).

The arts for Adorno are a broken-off limb of rational experience that is broken, fragmented, in itself, each art inheriting the restricted experience of an amputated organ—eye or ear or linguistic sensorium—to preserve it in a space apart, as if in a bottle or box or glass jar or metal cage. Hence the condition of the arts developing their austere late logics is their excision from everyday life and practice, their being sequestered in a domain without point or purpose apart from rehearsing, to death, these claims of sensuous particularity that have no place in practical experience. But this is to admit that their logicality has about it something riven and abject, not yet logical at all but a quivering—Adorno will say "suffering"—in its absence.

Said all at once and so directly, this is not, I concede, an obvious way to consider the arts, although the deep peculiarity of pure painting directed to the eye (no matter how embodied that eye) and pure music directed to the ear is too little commented upon. Yet, if we hold it in place as a background hypothesis, a theoretical heuristic, some of the difficulties in the preceding analysis might be resolved. To be more precise, if we disentangle the various strands of the argument to here, we are left with a singular feature of the story that neither de Duve nor Greenberg explains, namely, *why the very dynamic process of progress through negation that underwrites the vitality, rationality, and social significance of modernist art is progress toward art's extinction*. Isn't this the enigma of the monochrome, that it is simultaneously both end as goal and end as death? If anything deserves to be called the paradox of modernism it is this. And is not this paradox, which is simply more patent and striking in painting than elsewhere, what must be dis-

entangled or resolved if what comes after painting is to comment on painting, inherit it? Although there are diverse routes through this issue, I am going to follow one that runs through the middle of *Aesthetic Theory*.

It is the issue of non-art and anti-art. On Greenberg's analysis, and de Duve follows him in this, non-art belongs to the dialectic of modernism in being that moment in the appearing of a work in which, by virtue of its particular disposal of heretofore assumed conventions, the question of whether what is confronting us really is a painting is demanded. If modernist works intend to claim on the basis of their own internal logic alone, to progressively renegotiate their contract with the spectator by subverting agreed convention, then they can assert their claim only by emerging transgressively, appearing as transgressive, new. Non-art is, in the first instance, the *look* of the new (art), and hence a continuing sign, for as long as it lasts, of avantgarde vitality; but this look must give way to an art-look, a look of familiarity, if a work's claim is to be acknowledged.

For Adorno four elements, at least, are absent from this analysis. First is the issue of particularity. If the stakes of art are sensuous particularity as such, then conventional understanding itself, of whatever sort, threatens the integrity of artworks. Once we can fully comprehend a work of art apart from sensuous engagement with it, once our understanding is capable of exhausting the work, or at least finding nothing more or demanding in the experience of engaging with it that remains resistant to us, excessive and yet demanding, then the situation is no different than rational experience outside art. The particular disappears in its understanding or sheer familiarity. But this is equivalent to saying that in order for artworks to stand as unique sensuous particulars they must assert themselves as unique and particular, each an emphatic "this," as if, for all the world, each could stand all by itself. Without sensuous particularity belonging to the stakes of art, there would be no need for judgment to be a permanent feature of art. Sensuous particularization is what explains and secures the role of judgment in art and explains why the non-art look of newness relates to art's very form of claiming rather than being either an accidental aspect of its development or its immurement in fashion.

Second, artworks are not unique particulars. They are images or semblances of unique particulars, sensuous particulars whose viability depends on their being framed, jarred, boxed, caged. Modernist works signal this ambiguity in themselves through containing a moment or mode of ap-

pearing that is intended to collide with their formal appearing. Drawing on his musical background, Adorno conceives of this as dissonance. Dissonance is the crumbling of form, its dissolution; it is that moment in which the elements composed in a work return to their elementality, their abject separateness. Arguably, dissonance is consubstantial with abstraction in painting: the undoing of representation necessarily will foreground some feature of a painting's material presuppositions.

So far as I can see, neither Greenberg nor de Duve acknowledges the centrality of inner disintegration for modernist works, their insistent undoing of themselves as a condition of their appearing, their foregrounding of their material presuppositions to break through their illusory appearing. Dissonance's crumbling of form, forming through de-forming, underwrites works' sensuous particularity. The moment of dissonance is thus the moment in which the ideal motive is revoked in favor of the material motive, in favor of the color, the paint-stuff, the paint-on-canvas of the modernist work. Dissonance, Adorno states,

> is the truth about harmony. If the ideal of harmony is taken strictly, it proves to be unreachable according to its own concept. Its desiderata are satisfied only when such unreachableness appears as essence, which is how it appears in the late style of important artists. . . . The rebellion against semblance, art's dissatisfaction with itself, has been an intermittent element of its claim to truth from time immemorial. Art, whatever its material, has always desired dissonance. (*AT*, 110)

Harmony is unreachable because if the sensuous, material elements composing a work could be truly integrated without remainder the work would be not semblance, but real, a worldly thing. Harmony is only ever the illusion of wholeness. Dissonance, say the clotted brush stroke of Van Gogh, the sudden isolation of sheer paint-color in a Matisse, the obdurate materiality of a Pollock, dissolves the illusion in its very appearing. Hence the momentary non-art appearing of a new work, its transgressive appearing, is underwritten, as it were, by a non-art moment *in* the work, the work "interrupting" itself through its "other." To be sure, even dissonance can be "neutralized" through habituation and familiarity, and hence can stop feeling like a disruption or collapse of the work—all too easily if dissonance is conflated with the original non-art appearance of an avant-garde work.

Third, this intrinsic non-art moment in modernist works is meant to signal "art's dissatisfaction with itself." To state the thought directly: the claim of sensuous particularity will always be betrayed so long as it can

only be registered in a consistent and systematic way in art. If art is the refuge of sensuous particularity, it is equally its prison cell; art's being autonomous, having a logic of its own, and its being a prison are two sides of the same coin. This inflects art's dissonant moment into something more radical: anti-art. The idea of anti-art "implies nothing less than that art must go beyond its own concept in order to remain faithful to that concept. The idea of its abolition does it homage by honoring its claim to truth" (*AT*, 29). Adorno hears, sees, in dissonance a rebellion against autonomous art as such, a rebellion that, with great optimism and naivete, various avant-garde movements have attempted to put into practice. But this is to concede that such avant-garde movements did understand something about modernism that goes missing altogether when the anti-art accent of the dissonant moment in high modernist works is suppressed. As things turn out, it is the aesthetic rigor of dissonant modernism that alone is competent to honor art's anti-art moment rather than its praxis. Vindication of high modernism over the radical avant-garde, however, is not a cause for cheer.

Fourth, then, given all of the previous points, however dynamic the unfolding of modernist art appears to be, there is something static and immobile overhanging the whole process. If art desires non-art, call it concretion, call it everydayness or the ordinary, then each new thing in art, each new painting or composition or sculpture or poem, is only a placeholder for that absent thing, the sensuous particular itself: "The new is the longing for the new, not the new itself. That is what everything new suffers from. What takes itself to be utopia remains the negation of what exists and is obedient to it" (*AT*, 32). By "new" Adorno means something categorial, namely, an item that is not reducible to antecedent conceptual elaborations since, a fortiori, if an item were graspable by an existing conceptuality it would be something "old," already known, hence not new. In this respect, the new in Adorno is synonymous with sensuous particularity. The new in art is never quite truly new because it is a semblance, an *appearing*, of newness. Art is critique; its novelty is the process through which one placeholder for the *absent new* is replaced with another placeholder. In this respect, the non-art look of the new and its becoming an art-look spells out a continuing form of failure, of failing to be truly new as the form of success available to modernist works. In continuation of this claim, Adorno states:

Art is no more able than theory to concretize utopia, not even negatively. A cryptogram of the new is the image of collapse; only by virtue of the absolute negativity of collapse does art enunciate the unspeakable: utopia. In this image of collapse all the stigmata of the repulsive and loathsome in modern art gather. Through the irreconcilable renunciation of the semblance of reconciliation, art holds fast to the promise of reconciliation in the midst of the unreconciled. (*AT*, 32–33)

Utopia is the condition in which the new could be new, hence the condition in which there could be actual sensuous particulars known as such. Art does not enable this condition to be imaged, even negatively. It can signal its absence by an exacerbation of dissonance: an imaging of what is broken in its utter destitution.

Nothing I have yet said explains the paradox of modernism (or makes much headway on the readymade). But the whole progress, completion, exhaustion nexus must now look very different. Adorno's thought that there is nothing actually new in art is equivalent to saying that art's exhaustion or immobility is there from the outset, there as soon as sensuous particularity is placed into a practice apart from empirical, worldly, purposive practices. To put the same thought more exorbitantly, the elements upon which art works, its materials, are the remnants and ruins of empirical experience, elements of empirical experience that have been radically expelled from it. But this entails there being a terrible caesura in modernist art: the material motive of modernism, its essential *for the sake of which*, is just that on the precise condition that it cannot be satisfied. The material medium and presuppositions of art belong uniquely to *art* only on the condition that they be without the possibility of life outside art, that their art-being be the sign of expulsion, excision, dismemberment, ruination elsewhere. Art does not save or redeem or enliven its material conditions of possibility or what those conditions refer to; that is exactly what art cannot do, what it remains impotent before. Rather, at best, art preserves and transmits its material in its destitute state.[18]

Consider Jackson Pollock's *Full Fathom Five*. Seen close up it contains "nails of various sizes, a disintegrating cigarette, tops off paint tubes, a button, thumbtacks, matches, a key, pushpins, pennies. The debris of everyday life."[19] Now step back to normal viewing distance and all that disappears "into the slow swirl of water and weed."[20] These two views are the two views of the modernist work: image and material, form and dissonance, illusion and disillusion. This is thought through in *Full Fathom Five*. The obdurate materiality of the paint, Pollock is exclaiming, is the translation of

the button, cigarette, thumbtacks, key, and pennies; or more exactly, paint-stuff is the generalized equivalent of those things, what they are transmuted into in being reduced to the two-dimensional world of the canvas. Paint-on-canvas is the exchange value that renders buttons and thumbtacks two-dimensional. But unlike money, it is also *like* the key or the pennies, material stuff—which is why, finally, painting can rid itself of representation and remain painting: the paint-stuff can stand in for objects by being one of them; the forming of the paint-stuff into intensive patterns does for it what representation did for the objects represented. This makes unmysterious how abstraction can come to form a mode of connection and conviction in place of representation but continuous with it.

Reading the equivalence in the other direction, however, reveals that the fashioning of the paint material into the watery swirl of that familiar painting is not the triumph we might have hoped. Does the step back enliven, redeem, save the cigarette or the button? Are they truly *transfigured* by the forming action of the painting? In a profound sense they remain the debris they always were, still with us in their destitution despite their having becoming invisible in the painting's fullness. The watery swirl is not transfiguration but transmission, the transmission of what has lost its worldly claim. The achievement of transmission, of satisfactorily bearing the weight of the debris, is immense: nothing less than painting itself; without the watery swirl all would be just left behind, lost forever. If, however, paint-stuff is at this level the equivalent of the debris, then its fashioning does not enliven it or salvage it either—that is why obdurate materiality matters. Paint-stuff participates in the very destitution of the sensuous particulars for which it stands in, which is why revealing it reveals the material motive of painting as such—its utopic drive toward non-art.

We should not be disconcerted by this since it is a condition of possibility of there being anything like painting that visual experience, its depth and demandingness, be excised, removed, hollowed out of everyday experience and become something almost purely optical. The draining of visual experience of its habitation in a three-dimensional world into the refined precincts, finally, of easel painting is the price paid for having a domain in which the material logic of perception is preserved. Autonomous art enlivens its materials the way embalming fluid enlivens a corpse. And this, I want to insist, is art's glory. When I said earlier that modernist painting is always about the impossibility of painting, that the progress of painting

sustains or keeps alive the idea of painting, its actuality, by rehearsing or discovering over and over again its impossibility, I had in mind this idea of art's material motive conjoined with its a priori deadness.

Nominalism and Destitute Things

Modernist painting is not quite the exploration of the logic of sensuous particularity because in art there are no real sensuous particulars. Nor is modernist painting quite an exploration of visual experience, since ordinary visual experience occurs in three dimensions. Rather, modernist painting is the sustaining of the idea and claim of such a logic through the wholly conventional medium of *easel painting*.

As de Duve rightly underlines, easel painting is a concrete social and historical product: "Not until the Renaissance, when a painting began to be seen as an illusionistic window, did it detach itself from the wall, distinguish itself from the mural, gain mobility and autonomy from architecture and become 'a plane one or two inches in front of another plane, the wall, and parallel to it,' as Judd said" (*KD*, 251). Easel painting, with its load of historical specificity, including the idea of producing visual works that, by virtue of their detached mobility, can be bought, sold, and heaved about from one place to another like other commodities, is the bearer of the claims of visual experience. What enables easel painting to accomplish that end is precisely what modernist painting reveals. *The austere logicality of modernist works is the logic of visual experience that the conventions of easel painting permit.* Full stop. We can only explore the possibility, in principle, of a material logic of vision within the constraints set by the nonetheless conventional stretched canvas to which pigment is applied.

Because from the outset this visual experience has been reduced to the possibilities of paint-on-canvas, denatured, then from the outset it is not visual experience itself but its after-image, echo, disembodied-and-partially-reembodied idea that we are engaging. And since that engaging has no constraints or conditions other than those provided by stretched canvas and the placement of pigment on it, then from the outset the project is haunted by its doom. Progress through negation was potent because it step-by-step revealed a disillusioned rigor within painting's visuality that stayed one step ahead of the exhaustion that lay in wait for it. But because painting could neither break through and enliven its materials nor rid itself of the con-

ventionality of its easel-bound, two-dimensional world, it could not avoid eventually meeting its unique and wholly conventional condition head-on: monochrome and blank canvas. And what radiates from that condition is necessarily art's a priori deadness.[21] This, I presume, explains the paradox of modernism.

Nominalism is a condition for modernism and a threat. The nominalist bent of all modernist art is its railing against existing universals, the old conventions that attempt to constitute the meaning of works independent of the works themselves. Modernist works live off their power to negate existing meaning, the old universals, while nonetheless claiming meaning for themselves. In this respect nominalism is but another expression for modernism's idea of progress through negativity. But nominalism could not be that without at the same time possessing an integral idea of its own: that we be done with detached universals forever.

Under the idea of "musical nominalism" Adorno urges this thesis in "*Vers une musique informelle.*" A work conceived under the flag of nominalism must be "completely free of anything irreducibly alien to itself" or "superimposed"; nevertheless, it should "constitute itself in an objectively compelling way."[22] If such music is to constitute itself in an objectively compelling way, then it will require universals, conventions. If informal music dispenses with "the musically bad universal forms of internal compositional categories—then these universal forms will surface again in the innermost recesses of the particular event and set them alight."[23] Adorno instances the music of Webern and contends that there was a missed opportunity for an extension of this radicalism around 1910.

Whatever the case in music, the premise of my argument to here is that the project of a *painterly nominalism* was in fact achieved in abstract expressionism, and that its enduring and doleful weight over art in the past half-century is due to that fact. More precisely, the dual requirements of satisfying the demand for objectivity while enabling the universal forms intrinsic to the practice to surface in the innermost recesses of the work turns out to be an exhausting demand: either the universal forms become external again through their exemplification in nominalist works or, in the search for purity and in opposition to arbitrariness, the limit of the monochrome looms.[24]

Integral nominalism, which is co-extensive with the moment of particularization itself, is nothing but the idea of rationally compelling sensuous

particularity without external conceptuality. And this, I now want to claim, is the *generative* idea in the readymade, an idea implied but not satisfied by *Fountain*. Part of the permanent difficulty in dealing with *Fountain* is that it is truly an indeterminate case, instantiating with equal insistence a skeptical and an integral nominalist conception of art, and doing so because both forms of nominalism emphatically operate in the art history that produces it. The reason why *Fountain* can be indeterminate between skeptical and integral nominalism is because Duchamp's original insight is indifferent to the two possibilities. That insight is one I have broached more than once, above all in my account of *Full Fathom Five*—namely, that painting is the wholly conventional and in principle exhaustible reduction and preservation of the claim of sensuous particularity to the two-dimensional world of the stretched canvas to which pigment is applied. Modernist painting thus embeds three inescapable ideas: (1) painting is a complex exploration and preservation of visual rationality (= painting's logicality); (2) painting is pursued for the sake of de re sensuous particularity (= painting's material motive); (3) painting rests on a, finally, arbitrary, hence illogical, premise: the convention of stretched canvas to which pigment (or its equivalent) is applied (= painting's a priori deadness, its formation through calamity). *Fountain* actualizes all three ideas. The complex arthistorical gesture called *Fountain* is exactly the same gesture as the thumbtacks and pennies and cigarette *without paint or canvas*, but still, the very same gesture and thought. The readymade is truly abnormal painting.[25]

Fountain is able to release (1) and (2) only by underlining (3). And while (3) is perfectly true, when underlined, made emphatic, it tendentially collapses integral nominalism into its skeptical shadow, since on its own the premise is illogical, arbitrary. Instead of the "slow swirl of water and weed" Duchamp through the name of R. Mutt simply issues the claim of art. What that claim signals, I am suggesting, is that although the logic of art is austere and indeed a logic, the historical calamity that fragmented the claims of the sensuous particular object into the differentiated practices of painting, sculpture, music, et al., entails that each practice has at its base an irrational premise, an arbitrary convention that permits its logicality to occur. Duchamp's gesture is the recalling and repetition otherwise of that arbitrariness. But art will appear to be wholly or only a matter of arbitrary conventions only if (3) is cut off from (1) and (2); without them, that which the conventional is for the sake of will be lost. So, more precisely now,

Duchamp's gesture is the revelation of (2) by means of (3). But without (2) or *an analogue* of (2), we have the claim of art without anything that might support it.[26] Or rather, Duchamp offers only a minimum of conventionality to signal "art": the urinal's being turned 90 degrees onto its back and placed on a black pedestal. But that level of conventionality invites exactly the wrong thought, namely, that any object can be perceived "aesthetically," as if the difference between art and utility were just a matter of perceptual attitude.[27] Part of the point of modernist art is to insist that access to a nonrationalized or noninstrumental take on things is only *rationally* available through the *practice* of the arts capable of exploiting conventions intrinsic to their mediums.

The wrong thought that anything can be art through nominal insistence or attitude, however, sequesters the better one, which appears as the epigraph to this chapter: art is a second world "composed out of elements that have been transposed out of the empirical world in accord with Jewish descriptions of the messianic order as an order just like the habitual order but changed in the slightest degree" (*AT*, 138).

In the readymade the obdurate materiality out of which artworks are composed reappears as the lost sensuous particular itself—thumbtacks, keys, pushpins, urinal, snow shovel, bottle rack, bicycle wheel, comb. All the difficulty and the claim of the readymade hence turns on how they are "changed in the slightest degree." Duchamp's lesson, beyond his insight into painting's for-the-sake-of-which and its a priori deadness, is certainly that the "slightest degree" is an arbitrary convention that recapitulates the historical calamity that makes art necessary. Adorno's addition to that thought, which remains equivocal in *Fountain*,[28] is that the *inaugurating convention must be generative; that is, it must be capable of supplying conditions and limits that enable an alternative material logic to appear*. But what I here want to designate through the idea of an inaugurating convention that releases an alternative material logic is what Cavell taught us to think of as art's producing a *new medium* (with its specific automatisms), a medium that must be invented out of itself. For the purposes of *producing* a new medium, I can think of nothing more meretricious than the readymade. Conversely, will not, say, a box with a glass front or a cell of wire mesh do?

The boxes of Joseph Cornell and the *Cells* Louise Bourgeois produced in the 1990s I would count as among the uncontestable works in which the *promise* of Duchamp's readymade is realized (see Figures 12 and 13). That

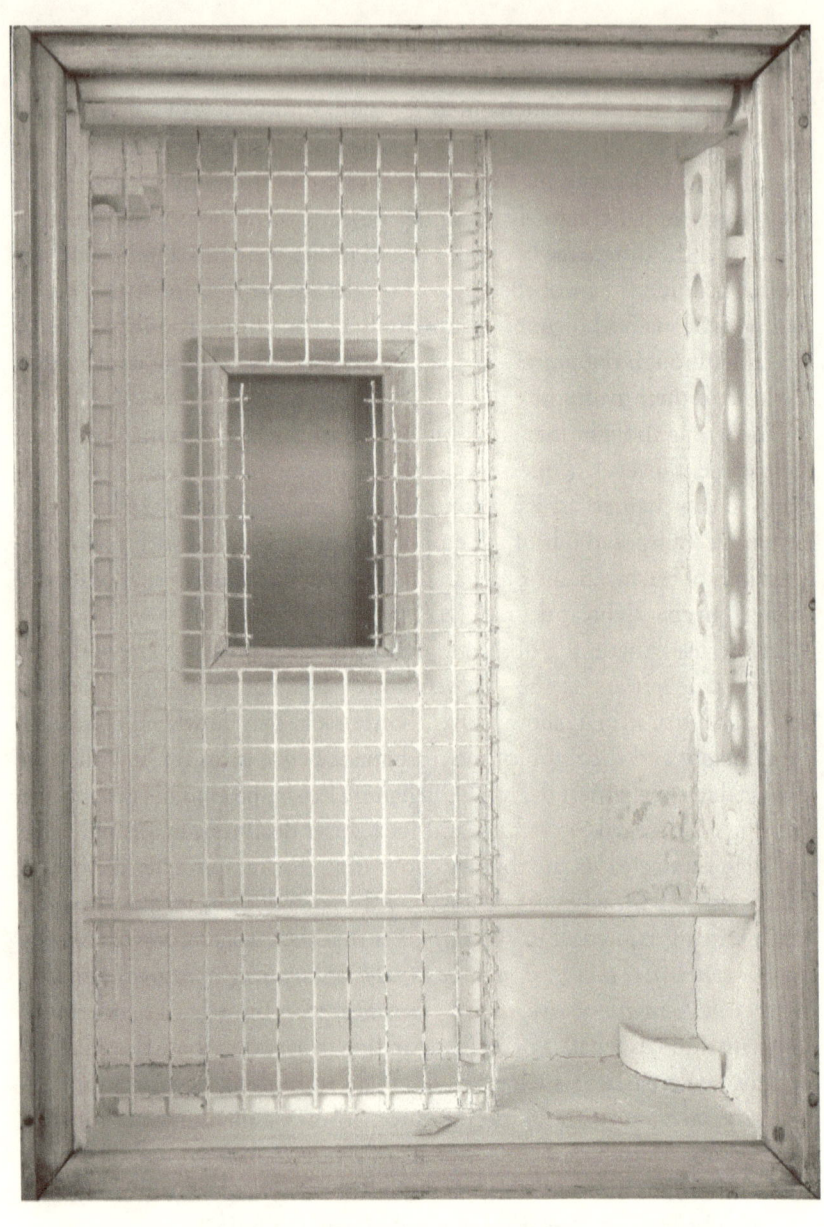

12 Joseph Cornell. *Toward the "Blue Peninsula" (for Emily Dickinson)*. Courtesy of the Robert Lehrman Art Trust. Licensed by VAGA, New York, NY.

13 Louise Bourgeois. *Cell 1*. Photography: Peter Bellemy. From the Daros Collection, Switzerland. Courtesy Cheim & Read, New York. Art © Louise Bourgeois/Licensed by VAGA, New York, NY.

these works are not readymades but assemblages, installations, constructions, says everything about what I take the equivocalness of the readymade to be, its nominalist skepticism and its projection of an integral nominalism. Even a minimal account of either Cornell or Bourgeois would be immensely complex. In the case of Cornell's boxes it would have to include his relation to French poetry, his aestheticism, his attachment to theater and dance, the ambivalence between nostalgic symbolism and modernism in his early works, the recurrence of images related to childhood.[29] In the case of Bourgeois the big interpretative issue would be the relation of the *Cells* to her sculpture. Nonetheless, I want to suggest that both artists carry through the promise of the readymade without concession to either Dada or surrealism.[30] In both cases a *frame*, a box or cell, offers an inaugurating convention, the sign of "art," that *explicitly* makes art a refuge and a trap: boxing preserves and kills, just as cells are prisons and the lowest level of life. The duality suppressed in the tradition of the stretched canvas thus becomes overt here. Further, in both cases what is chosen to appear in the frame are remnants and ruins, debris, thus reflexively appropriating painting's material motive. For Cornell the ruins are, for the most part, those of culture itself.[31] For Bourgeois the accumulation of objects is more complex; sometimes the objects are themselves made, as in *Cell (Three White Marble Spheres)*, sometimes they are routine objects like beds, chairs, chains, perfume bottles, and mirrors.[32] In either case the scene is one of past violence, sometimes an anonymous one in the lives of women, sometimes explicitly of dismemberment. In short the ruins of a Bourgeois *Cell* are those of the female body. But, and this is what I want to insist upon, whatever the symbolic load a box or a *Cell* contains, symbolic (or narrative)[33] articulation is always curtailed and then reignited by the forms of adjacency, contiguity, and juxtaposition, which the inaugurating condition generates among the objects presented. Box and cell give on to adjacency, contiguity, and juxtaposition, which while operating differently for each, are the forms that enable a material logic of the fragment to appear. Perhaps I can put the thought this way: through their handling, Cornell and Bourgeois reveal how the inaugurating conventions of box and cell invite or solicit certain types of objects while excluding others by the way in which those objects are set into relation via their frame.

Boxes and *Cells* provide each artist in turn with sets of conventional constraints that make the objects in those environments communicate with one

another in accordance with a logic specific to that environment; so box and cell are explicitly inheritors of the square or quadrangular stretched canvas. At one level, Cornell's boxes *are* representational easel paintings in which the implied third dimension has been made literal. But that forging of continuity with painting, which simultaneously connects painting with theater (a fact underlined by the number of boxes that have images pasted to their back wall, like a stage set), is at the wrong level, being too symbolic to capture the power of the boxes as forms. Once the third dimension is literal, then size becomes literal rather than proportional. By the nature of their relatively small size each box recalls the childlike fascination with the miniature: smallness as a chance for controlling what in reality one cannot control at all: the miniature as the wish for meaning in the face of the overwhelmingly terrifying, protecting the helpless or what one cannot be protected from.

Because these boxes are not those of a child, they recall rather than instantiate that wishfulness; their work of preservation is memorial rather than imaginary. This comes through as well in how routinely the boxes are themselves composed of smaller boxes—compartments, drawers, shelves, holes. In a collection, as in a cabinet of curiosities, or cataloguing, they become both presentational devices and contents, as well as devices thus connecting adult obsession with its childhood avatars (the shoebox of treasured possessions). So a Cornell box is the artistic presentational device that itself connects art to childhood, on the one hand, and childhood to adult obsessions of collecting and cataloguing on the other. Size generates one constraint; having a glass (or wire) front generates another. Whatever is to be preserved must conform to the requirements of a scene in which two- and three-dimensional objects are perceived from just one direct line of sight; so boxes are storage places, displays (of cultural history as natural history), and small theaters. A condition of a destitute thing or image being preserved is that it "perform" in a drama whose script is nothing other than its relation to other objects in the box. In the case of Cornell's more austere boxes in particular, in which more mundane objects (glass, ball, pipe, ring) are used, adjacency, contiguity, and juxtaposition generate a script or bond, an affinity among the objects that perspicuously exceeds their literal and symbolic significance.[34] Indeed, it is the very point of a Cornell box that it possesses this form of excess, that it sets off a communication of its objects that invites interpretation while making any fully

discursive accounting impossible. Life in the box, so to speak, is the lost life of each object on its own. Life in the box, illusory life, holds open the unspeakable promise of each object as what is forever broken—which is why "modernist," rather than "surrealist," seems to me a more accurate mode for expounding on the continuing claim of Cornell's boxes.

The way in which the different kinds of objects communicate in the different *Cells* is even more remarkable, since by means of adjacency, contiguity, and juxtaposition each *Cell* speaks of a different region of human pain, a strange history of pain almost.[35] The large size and construction of the *Cells*, of wire mesh and/or glass, sometimes with doors (each of which invokes a permeable limit, an autonomous domain whose autonomy is necessarily broached and broachable), immediately bespeak rooms and homes; their contents routinely make the association with home turn into or recall the human body (hence a third framing idea: violated interiors). I think of the cells as working in a direction almost exactly opposite to a Cornell box: instead of each object recalling a chance missed, Bourgeois gives to each object its precise weight as sedimenting a past, actual or psychological, so recalling, sometimes, lost pleasure, but more commonly a history of violence, violence committed or suffered or witnessed. And of course there is an internal connection between pain remembered, sedimented, and the pain of the prison cell (as the bearer of art's autonomy)—that is, the pain of art's obsession with form. Alex Potts pointedly states the link: "Art . . . is an obsession that functions to distance psychic pain, but can only be redeemed by pain from the self-enclosing obsession with form that produces this distance."[36] What is implicit in painting becomes explicit in the cells, namely, how the autonomy that makes modern art possible is paid for with what art does to its materials.

Presenting ordinary objects as witnesses to violence is perhaps the most enduring and haunting accomplishment of these works; like an Atget photograph depicting a suspiciously empty street, cells are often fragmented scenes of an unspeakable ancient crime. And like the Atget photograph again, they may be scenes whose emptiness invites speculation on the crime committed, a work of detection and empathic identification—each object a site, a sign, and a clue: fragments. But this is equally to underline how the kind of three-dimensional inaugurating convention that the cells represent gains an advantage over the easel painting: they enable the implicit fragmentariness, the dissonance of the modernist work, to become

explicit. Bourgeois's cells neither invite nor permit the totalizing wholeness, the finishedness and completeness that can haunt modernist painting, to arise. Hence the fragmentation of body and memory that the cells depict is equally their fragmentary logic, a logic that defeats the nostalgic insinuation of wholeness that the fragmentary contents themselves provoke.[37]

Fragmentation as a logic of violence and pain does not stop with contents or form, but invades the encounter with the work as well. What is worst, as we walk around and investigate the Bourgeois scene, as we must with the cells, as we become immersed in it, is that our complicity in enjoyment and fascination with this violence is announced; our scopic pleasure and empathic identification is here inevitably tinged with an alternating sadistic delight and masochistic pleasure in submission.[38] Indeed both boxes and *Cells*, by positioning the spectator with glass panes and wire mesh (cells of another kind) as outside looking in, transform art-looking into voyeurism, in an impeccable rebuttal of the belief that art enables us to take up an aesthetic attitude. In our implicated gazing, the interest of aesthetic disinterest is registered and measured. In placing us as voyeurs, boxes and *Cells* as the inheritance of the stretched canvas underline the detachment of art from life, art's being a priori dead, and hence the precise cost (pain) of that detachment. Yet by virtue of box and cell, their character as inaugurating conventions, what appears in them becomes bindingly eloquent: logics of loss, pathos, and pain. I said earlier, and provocatively, that autonomous art enlivens its materials the way embalming fluid enlivens a corpse. Well, does not that description fit the abnormal painting of a Cornell box or a Bourgeois *Cell*?

Neither Cornell boxes nor Bourgeois cells *look* like the paradigm works of high modernism, from Manet to Pollock. But looks can be deceiving. By equating the claims of artistic modernism with the claims of modernist painting, the securing of flatness and the delimitation of flatness, Greenberg issued a red herring that disoriented critics and artists alike. And by failing to distinguish with the readymade the difference between integral and skeptical nominalism, Duchamp unintentionally suppressed the stakes and motives of modernism, generating a red herring of his own. Greenberg's essentialism and Duchamp's skeptical nominalism are the precise antithetical ideas of modernism, the logical extremes, which need to be avoided if the logic and paradox of modernism are to be understood.

If we think of *Full Fathom Five* as allegorically recapitulating the deep

logic of modernism, then easel painting, box, and cell can be gathered together as exemplary inaugurating conventions that enable that logic to be performed. And, what the exemplarity of box and cell accomplish is to point to the calamity, the disaster, the ruination that calls art of a modernist kind into existence. The contingency of these frames, these inaugurating conventions, is at one with the loss represented.

Doubtless neither boxes nor *Cells* are as fecund or constraining as the stretched canvas to which pigment is applied.[39] And perhaps it does follow from this that the eloquence they enable is less binding. But that is only to concede that we are here in the vicinity of abnormal painting whose inaugurating conventions are somehow more arbitrary than those of modern painting. It is the increment of arbitrariness, the lack of the routinely exploitable conventions of easel painting, the consequent loss of routine or systematically available conventions, and hence the fragility or contingency in the binding power of contemporary art, the art of the past forty-five years, that makes it "late." But my suggestion has been that this lateness also makes explicit what remained merely implicit in high modernist art, above all abstract expressionism. In this logical or conceptual sense, temporally late modernism is no later than its moments of highest achievement.

Adorno's aesthetic theory is about this logical lateness, about the calamity through which art is forged, about art's a priori deadness, and its strange form of hope. Above all, Adorno's aesthetic theory is about the reason of art, its material logic, and the claim of that material logic, all the complexity and pathos of the medium, art's being medium-bound. While certainly a good deal of recent art is pitched against the material logic of modernism, Adorno gives us good reason to think that even the intelligibility and claim of the readymade depends on what the most ardent supporters of it would love to dismiss: art's inescapable formalism.

8

Freedom from Nature? Reflections on the End(s) of Art: Arthur Danto, Yves-Alain Bois, and Robert Ryman

> Hegel's thesis that art is consciousness of plight has been confirmed beyond anything he could have envisioned. Thus his thesis was transformed into a protest against his own verdict on art.... The darkening of the world makes the irrational of art rational: radically darkened art.
>
> —T. W. Adorno

There is an intense elective affinity between Hegel's announcement of the end of art and the situation of twentieth-century art, especially modernist art, as if the fate that Hegel had proclaimed was finally realized, or perhaps just realized again, with the social eclipse of the project of modernist painting that occurred sometime in the middle part of the twentieth century. So much might be gathered from the titles of important recent works: *After the End of Art* by Arthur Danto (1997); *Farewell to an Idea* by T. J. Clark (1999); "Painting: The Task of Mourning" by Yves-Alain Bois (1993); or, somewhat less portentously, *The Originality of the Avant-Garde and Other Modernist Myths* by Rosalind Krauss (1986). That the two most demanding works of twentieth-century aesthetics—Martin Heidegger's "The Origin of the Work of Art" and T. W. Adorno's *Aesthetic Theory*—explicitly locate their reflections in the context of Hegel's end-of-art doctrine makes the thought irresistible.

Something of art has ended. The debate is not about the fact, but about

its significance: What does it mean to say art has ended? How does that end manifest itself in art? Above all, is that end something we might welcome, as Hegel welcomed it, or is it something whose eventuality is a cause for concern, even distress, a sign of an intolerable defeat?

What is uncanny about Hegel's end-of-art doctrine is how perspicuously it projects the terms of the twentieth-century debate. As is well known, when Hegel states that "art is, and remains for us, on the side of its highest vocation, a thing of the past" (*ILA*, 13), by "highest vocation" he means it no longer "satisfies our supreme need" to represent the divine (*ILA*, 12);[1] that is, it no longer *can* represent the truth about human beings. And this is because the truth about human beings is that our spiritual life is self-authorizing, free and self-determining. So the determining fact of modern life, anticipated in Descartes and Kant, but made intersubjective, social, and historical in Hegel, is the discovery of our utterly secular but nonetheless emphatic *freedom from the authority of nature*.[2] That is why, for Hegel, art beauty supplants natural beauty, and the truth of art beauty is its utter mindedness, spirit in the alien form of sensuousness, spirit infusing dead matter with its own vitality.[3] Of course, so saying is already to view art from the perspective of its overcoming: in art, spirit is illegitimately bound to its sensuous representation and therefore falsely presented. A full-throated version of this claim occurs in a context where Hegel is fending off the anxious thought that works of art are concoctions of dead matter, and we, generally, "are wont to prize the living more than the dead" (*ILA*, 33); if this is so, and it is, then would we not be bound to nature's authority, its gift of life (at least), in opposition to dead matter? How can we care about art above nature?

> We must admit, of course, that the work of art has not in itself movement and life. An animated being in nature is within and without an organization appropriately elaborated down to its minutest parts, while the work of art attains the semblance of animation on its surface only, but within is common stone, or wood and canvas, or as in the case of poetry, is idea, uttering itself in speech and letters. But this aspect, viz., its external existence, is not what makes a work into a production of fine art; it is a work of art only in as far as, being the offspring of mind, it continues to belong to the realm of mind, has received the baptism of the spiritual, and only represents that which has been moulded in harmony with the mind. (*ILA*, 33)

There is something presumptuous, ominous, and ambiguous in Hegel's confident statement. What is presumptuous is the claim that *all* the animation of the work of art derives from its being an offspring of the mind,

as if art's sensuous immediacy were not a factor in its animation.[4] Is not sensuous immediacy precisely the way in which abstract thought achieves feeling vitality? And does that not mean that abstract thought on its own lacks something, say incarnation?

What is ominous in Hegel's statement is the idea that it is a *condition* for nature to become a pure vehicle of mindedness that it be dead (stone, wood, canvas, sounds and words), as if spirit could only assure itself of its ultimate and unsurpassable authority through the slaughter of nature. What is eerie here is the way in which the metaphorical murder of nature as authority converges with the mediums of art being dead nature. Only if nature is really dead, so to speak, can the material basis of art that founds its sensuous character be an empty husk, a corpse, leaving only the mindedness of works as demanding attention, so that in works, finally, it is an issue of the mind knowing itself, and with that recognition the claim of art to be divine is forever surpassed. But all that assumes a negative response to claims about the role of sensuousness in providing animation for ideas. Hegel cannot think both that art receives its animation from spirit *alone* and that art is surpassed thereby, since the "thereby" would be otiose if spirit "alone" were the source of vitality. Even for Hegel, despite himself and against the grain of his explicit claim, medium-bound sensuousness must play a role in how spirit manifests itself in art (because, say, medium-specificity is what makes artworks symbols rather than signs);[5] but since sensuousness in art is provided by dead nature, then dead nature must play a role in art's animation. Further, if the authority of spirit reveals itself only in relation to that which it departs *from*, then the authority of spirit will depend on the presentation of the site of slaughter. In this double way, then, might dead nature belong to art's animation? Might not the role of dead nature in art strike us, on a second reading, as not only ominous but also riven with ambiguity?

The twentieth-century replays of Hegel's end-of-art doctrine reiterate the doubleness of this passage, its calm confidence that art belongs to mind, and the anxious insistence that the cost of such belonging is murderous and thus intolerable. My ambition in this chapter is to document this thesis—that is, to demonstrate how in facing the end of art a line is drawn between those who find in it the reassurance that art belongs to the mind alone (the position of Arthur Danto and Yves-Alain Bois), and those who find in art's extinction, actual or anticipated, the extinction of the worth of sensuous particulars, so the worth of the everyday and the ordinary of which moder-

nity was to be a celebration (Adorno). In documenting this ambivalence, I mean to raise the possibility, at least, that the *absolute need* for art concerns not its role in aiding the mind to know itself, but its function as a form of resistance, a reminder, a placeholder, for the claim of sensuous particularity, and so nature, against the claim of self-authorizing mindedness. But this claim would be feeble if something of what I claim is the doubleness of the end of art did not recur even in those proclaiming its rightness. Where then does dead nature hibernate, find refuge for itself, in contemporary art theory? Surely nowhere else than in art's opacity, its "enigmaticalness," its resistance to the claims for transparency and discursive legitimation. The opacity of the work of art, that in it which makes direct engagement, actual perception, a necessary condition for encountering at all, stands for our standing need for the forever lost authority of nature.

Danto's Philosophical Displacement

Arthur Danto opens *The Transfiguration of the Commonplace* with a delightful account of a series of qualitatively identical, hence perceptually indiscernible, red monochromes. He starts with Kierkegaard's account of a work, "The Red Sea," which depicts the moment after the Israelites have already crossed over and the Egyptians were drowned. Naming some of the other works in the series will give you Danto's idea: "Kierkegaard's Mood"; "Red Square" (a bit of Moscow landscape); "Red Square" (a work of geometric art); "Nirvana"; "The Red Table Cloth" (by an embittered student of Matisse).[6] The point of this story is minimally the same as the point of Warhol's *Brillo Boxes*, minimalist cubes and tubes, slabs and planks that are identical with their industrial counterparts, or indeed Marcel Duchamp's readymades—*Fountain*, but equally the comb, the bottle rack, snow shovel, and others. If the monochromes are sensibly indistinguishable from one another, and from a prepared canvas that is not an artwork, not to speak of a non-art red square (say one I put on my wall for decoration), then what makes something a work of art, a painting, as distinguished from an object in the world, is not something evident to the eye: it is nothing visual. As Danto states, "once that was acknowledged [which is what pop and minimalism achieved, that acknowledgment in general], the visual arts became detached from the act of vision, and the way was open to fusion with the

other arts" (*W*, 59). This is what might be called the "deretinalization thesis" in a nutshell.⁷

So, in a certain respect, Danto claims, pop and minimalism bring about the end of art—not of course the end of art-making; on the contrary, art-making is now free to do whatever it likes, and pluralism becomes the order of the day. So it is the end of art in some different sense. To clarify this, a little contextualization is necessary.

Danto plausibly tracks the unfolding of modern art as possessing four stages: (1) Cubism, which was narrower than abstractionism in that it assumed that painting was representational, while asking, at least, why it must remain attached to our optical experience of the visible world, above all perspective. Cubism, we might say, aimed to connect representation to the specific characteristics of painting, namely, the reduction of three dimensions to two, acknowledging thereby the flatness of the canvas. (2) Abstractionism—think Kandinsky—denied representation altogether, but assumed all the conventions of pictorial space, hence the nonrepresentational use of color, line, form, etc. (3) Abstract expressionism "broke the identification between painting and pictorialism by making the act of painting central, with the work itself but a record of the fierce interaction between artist and pigment" (*W*, 57). The final stage, of course, is (4) the advent of pop and minimalism.

Even if this is overly simple, the shape of the story is plausible: keeping representation but dropping the illusion of likeness to ordinary perception of things in space; the dropping of representation but holding to the construction of spaces, depths, movement, and the use of line to enclose a space, and so pictorial illusion without representation; abstract expressionism's dropping of both pictorial illusion and representation—which is the "action painting" interpretation of abstract expressionism. Finally, there is pop, in which all modernism's severity and asceticism is reversed, wherein all the items, whose systematic taboo had constituted the dynamic history of modernism, come flooding back in. What kind of story is this? What is happening here?

Danto understands this unfolding or history as a *quest*, a quest to discover in art what art is, to discover in painting what is essential to painting, what makes painting painting. To ask this is to ask: from what does painting derive its authority, what is the source or ground of its authority, hence the source or ground of its goodness, what in truly appreciating a

painting are we responding to? What about painting is the source of our concern or caring for it? One might say then that the history of modernist painting was philosophical since its ambition was to discover what emphatically distinguished painting from nonpainting (painting from the other arts and from reality). And, by any usual account, the business of drawing boundaries around activities, distinguishing the real world from illusion, has been from the get-go, since Plato, the business of philosophy.

Modernist art is determined by a theoretical, philosophical quest: to discover the meaning or essence of art. Now as this short history makes evident, modernist art aimed at producing novelties—not novelties for their own sake, but novelties that would be revolutionary: each taboo engendering another idea of painting, another concept of what painting is and means. The combination of novelty and revolutionary ambition is what made the modernist art scene such a hot and contested cultural space. In this view:

[T]he innovations of modernist art are means, not ends, toward the crafting of self-conscious responses to the place of that art or movement in the tradition or traditions of art. As such, a modernist movement is not simply *typified by*, but further, *defines* itself through the stance it adopts toward its own history; whether implicitly . . . or explicitly, any given modernist movement depicts the movements out of which it arose as having posed questions they did not, or more strongly, could not resolve, questions the nature of which is made visible only through the achievements of this, the later, movement. The very identity of a modernist movement is thus essentially historical. (*W*, 9)[8]

It is this history that Danto has in view in his accounting of the emergence of pop and minimalism; for him this mini-history stands for the *entire* self-revolutionizing history of modern art. Now pop and minimalism break from this history, and in the manner of their breaking from it, end it. Pop was an assault on the very idea of delimitation and policing, taboomaking; it seems to assert that there are no proper boundaries, no borders; but if there are no significant borders then it puts to an end the sequence of revolutionizing movements, since in its overturning of the delimitations it inherits it would leave no future revolutionary boundary crossing for art to accomplish.

In a sense, this is where we came in. But it is a fraught and complex moment. Evidently, Danto is treating pop and minimalism as symbolic of something; and indeed, for Danto artworks *are* symbols or metaphors (this

is what he thinks is the core philosophical notion of art). Metaphors, he says, are minor works of art.[9]

In ordinary judgments we claim that an object possesses a specific property of a kind that objects of that sort typically possess; in metaphorical attribution, we link to the object properties or qualities that are literally false but invoke a series of indeterminate ideas and associations: 'Her hair fell like night in the jungle.' For Danto, judgments using signs are normally and ideally transparent in their meaning, while in symbolic and metaphorical discourse (symbols are metaphors for Danto) qualification is rich in associations, so rich that meaning remains indeterminate and therefore opaque. Danto's way of getting to this opacity is by considering how what is originally transparent (a sign) can become opaque (a metaphor or symbol); the transparent meaning of a sign is its "extensional" sense, while the opacity of a symbol is its "intensional" meaning. To say of metaphors or symbols that they are intensional rather than extensional is to say that there can be no full discursive elaboration or precisification of them, or, more technically, that they generate contexts in which substitution and quantification are blocked in the same way that intensional contexts typically block substitution and quantification. For example, if Jones is a spy, and if I *believe* I saw Jones in the park this morning, then it does not follow that I believe that I saw a spy this morning. My "believing" ties my seeing Jones back to the body of my beliefs; in this *closed context*, the sense of "Jones" is determined by my beliefs irrespective of what is in fact, "extensionally," true. If I believe I saw Jones, and further believe Jones to be a patriot, then I will believe I saw a patriot. Belief, and similar mental attitudes, generate a closed, "intensional," context. On Danto's view, intensional contexts are best conceived as quotational, the quoting of something that is itself a (transparent) representation.

When we say, or quote, what another said, we automatically bracket the truth claim of the original saying: "She said: 'The cookie is in the cookie jar.'" The quoting of the original statement places its original claim in suspense, no longer a straightforward truth claim: my saying what she said does not commit me to the truth of her statement. On the contrary, in quoting her I am taking her statement as a whole and preparing it for another purpose, for example, as evidence of her pathological interest in cookies. Quoting is the model of doing things with ordinarily transparent signs that brackets or holds in suspense their usual transparent meaning.[10]

Roughly, then, apart from their representational use, literary signs are chosen for other purposes, to do other things, and these other purposes, expressive or formal, are *equivalent to* placing a sentence in quotation marks. The idea of intensionality, on which Danto spends the bulk of the last chapter of *Transfiguration*, is an analytic way of getting at what Heidegger says about concealment and its vehicle, earth.[11]

More simply, for a sign a meaning is external to it, while for a symbol its meaning is internal to it (like the reference to my beliefs in the case of Jones or the revelation of cookie mania in the statement about the current location of a cookie); symbols give presence to their content: "The concept of the symbol I am advancing is almost entirely Hegelian, in that it consists of giving sensuous or material embodiment to what Hegel would certainly have called Idea: it is Idea made flesh" (*W*, 105). But if a symbol makes something present, it can do so only if what is made present, incarnated, is originally absent. But a symbol cannot make fully present what is absent; if it could, the original absence would be contingent, insignificant. So a symbol both incarnates something absent and points to that absence; in pointing to that absence it necessarily points to its own constitutive inadequacy. Full incarnation—blood becoming wine—is not symbolic but magical. Symbols are disillusioned magical signs.

So initially, pop looks like a symbol of the history of art leading up to it and a refusal and delegitimation of that history. But it is more than this. For Danto the significance of pop and minimalism is philosophical, and the philosophical point is, by virtue of being deretinalizing, anti-symbolic; that is, the symbolic significance of pop is that it overcomes the constitutive inadequacy of the artistic symbol by *fully* lending itself to the philosophical purpose of revealing the meaning of art, which meaning again is nothing retinal.[12] Art liberates itself from philosophy, from seeking transcendence outside itself, by becoming philosophy, by becoming the idea of itself. Or more precisely, pop fully acknowledges the indiscernibility thesis, insists on it; in so doing it realizes its essence is not visual. At that moment, Danto avers, once art realizes that its sensible art-making cannot uncover the essence, because the essence is nothing visual, then art is freed to hand over the matter to philosophy and itself becomes free from philosophy.[13] With pop, art became one with its own philosophy in that it sensuously realized the limits of sensuous, symbolic presentation for elaborating the meaning of art.

Said another way, art symbolically announced the limits of symbolic presentation for stating the meaning of art—the very meaning that the dynamic history of art had been questing after—and hence inscribed within itself the end of its quest, the end of its dynamic history: the meaning of art now belongs to the discursive elaboration of philosophy itself. Even in art and for art, the meaning of art detaches itself from material embodiment (the deretinalization thesis) and becomes a matter of rational mindedness. This is Danto's Hegelian thesis. Once art becomes one with its own philosophy, then, after pop, art has no more historical or philosophical secrets to protect. After pop, after the end of art, art can become posthistorical, wholly absorbed in its moment and innocence, each work defining itself.

While there are deep Hegelian inflections in this story, with the antiopticality, deretinalization aspect of it converging with Hegel's sense of art being discovered to be really a vehicle of mind, it equally is very anti-Hegelian. For Hegel, art's ending meant, above all, that art was no longer an adequate vehicle for expressing the truth about human existence; art, that is, stopped being *formative* for culture because the meaning of culture as a whole could no longer be adequately expressed in sensuous terms— the truth was discursive and not sensuous. But this is something quite different from Danto's claim that *art* becomes posthistorical because *its* meaning, what art is, cannot be presented symbolically—even if being symbolic and opaque is the nature of art. For Hegel the issue of the end of art concerns its adequacy as a vehicle for expressing the truth about human existence at a time and place; for Danto the end of art is art's own inadequacy for specifying its character as art as opposed to other forms of meaning. By making the stakes of the history of art wholly and simply the question of what distinguishes art-meanings from other kinds of meanings, Danto suppresses the cultural role of art, art as a form of absolute spirit—a mode in which a culture comes to self-consciousness about itself with respect to its fundamental aspirations and their current nonsatisfaction.

What is puzzling, then, about Danto's account is that the *need for art* plays no role in his account of what art *is* (it is as if the heat of modernism's revolutionary questing had no cultural motivations but was solely an artifact of its cognitive quest—the stakes only ever philosophical). Yet despite its aversion to the problem of need, there is space for detecting ambivalence: his theory seems torn between a denial that there could be such a thing as a culture-wide and so constitutive need for art—which is implied by his

posthistorical conception of each work of art autonomously determining its own meaning and significance—and its conception of the work of art as symbol. Art as symbol implies that the transparency of the mind to itself somehow misses out on or represses some feature or aspect of human existence that can only be had, if at all, in forms or expressions that are inherently inadequate, in contexts that include some irremediable opacity.[14]

The philosophical transparency of the definition of art appears to stand in direct opposition to what that definition specifies, namely, that art addresses some absence that cannot be made present, and hence cannot be represented (in the manner in which a sign represents). Hence *Danto's gesture of revealing what art truly is simultaneously makes art's purpose(s) utterly inscrutable: why art*? But is not this just art's complaint about transparent representation, about philosophy, that it makes the yearnings, the suffering and the enjoyment, of the concrete and particular as if nothing in relation to the sweep of universal truth?

Bois's Semiotic Turn

> All artworks are writing, not just those that are obviously such; they are hieroglyphs for which the code has been lost.
> —T. W. Adorno

One obvious way in which Danto's account of the unfolding of modernism is inadequate is that it makes the defining purpose of art's quest the purely cognitive one of discovering what art truly is. This seems factually, historically, wrong; if Danto is refining and sublating Clement Greenberg's history of modernism, he seems to have forgotten a singular feature of Greenberg's story, namely that the arts were "*hunted back* to their mediums, and there they have been isolated, concentrated and defined. To restore the identity of an art the opacity of its medium must be emphasized."[15] That the arts were "hunted back" to their mediums, painting as painting and nothing else, signals that there was an operation of brutal harassment in relation to which recourse to the medium, delimiting the boundaries of painting by hugging to the shoreline of the medium itself, was to be a form of defense; and securing that defense meant securing an opacity against the depredations of rational mindedness; for this quest for resistance to terminate in conceding all to the philosophical concept would thus be the sign of defeat.

In the nineteenth century the most immediate threat to painting came from photography: "From today painting is dead," Paul Delaroche is reported to have said on seeing the results of Daguerre's invention (*P*, 231). What modernist art sought was some way of revealing what gave artworks their *authority* in a context in which photography had already made evident that such authority could not be located in rendering a true likeness to the world. For that purpose photography will always be found superior to art. In seeking some delimitation of what distinguished it from photography, there was simultaneously an extravagant awareness that what was at stake was locating for itself a mode of claiming that would be *resistant* to engulfment by the advance of technology and, to bring in art's second predator, the allure of the market where things were suddenly to be prized not for their use value (or moral worth, for that matter) but, well, for their allure itself—which in brief is what Marx had in mind with the notion that commodities are fetishes. If the notion of artistic medium was to function as a moment of opacity against rational transparency, what was needed in order to prevent artworks from becoming commodities purely exchangeable against other commodities was a mechanism for putting comparison (and so exchange) out of play. For this purpose—that is, to ensure that works were utterly unique—each modern work of art had to be *new*. Arguably, it was this search for the new that motored the revolutionary questing of modernism that Danto supposes was primarily a philosophical quest. Walter Benjamin parses Baudelaire's conception of the new in these words: "This vilification which things suffer by their ability to be taxed as commodities is counterbalanced in Baudelaire's conception by the inestimable value of novelty. Novelty represents an absolute which can neither be interpreted [as allegory] nor compared [as commodity]. It becomes the ultimate entrenchment of art."[16]

If photography in this scenario is a stand-in for technology in general, and one supposes that the advance of technology, on the one hand, and the reduction of all items to exchangeable commodities, on the other hand, were threats not just to art, but to the integrity of bourgeois life, its promise of freedom and happiness (its promise to set life within a self-authorizing whole), then art's seeking resistance to them was not merely for the sake of saving its own skin, *but for the sake of modernity itself.* Unless the claim of sensuous particulars themselves could be salvaged from the advance of technology and its rationality, and from the usurpations of the market (where

even human labor is a commodity to be sold and bought subject to market mechanisms of supply and demand), then the project of modernity would itself be defeated.

Because the claim of art always had been bound up with its sensuous nature, then, by a twist of historical fate, art, in taking a stand on its difference from everything that was not art, was simultaneously attempting to critique rational modernity for the sake of (another) modernity. This is the culture-wide *need* for art, "the consciousness of plight," which modernism, inconstantly but continuously, had in its sights, the precise absence that the modernist art symbol, to use Danto's notion, incarnates. What art aims to incarnate is the necessity of, the unsublatable need for incarnation itself.[17] If artworks are incarnations of ideas, and the aim of art is to incarnate incarnation, to make itself a symbol of the need for symbolic, irreducible material meaning, then art's becoming reflexive in relation to its medium, its constitutive opacity, is the institutional way in which *we* self-consciously authorize that need and necessity.[18] This makes art philosophical all right, but its claim can succeed only if it resists translation into discursive rationality.

I am here already encroaching on the territory of Yves-Alain Bois's "Painting: The Task of Mourning," which presents an elegant historical account of three modes—imaginary, real, and symbolic[19]—in which modernist art inhabits or projects its end as the reverse side of the mechanisms through which it attempted to avoid delegitimation from without. What Danto sees as the posthistorical flourishing of art, its born-again innocence, Bois perceives as surrender to the market, a surrender that involves art losing its power to be formative for culture as a whole. What Danto celebrates, Bois sees as the repression of the need for art. Pop and its progeny brought about the de facto end of art (as expressing culture's highest need), but have left the de jure question hanging.[20] Yet that de facto end could not have occurred unless it was prepared for by the very ways in which it was resisted. If I have understood him aright, Bois thinks that modernist art resisted its cultural extinction by internalizing the threats to it, say, by inhabiting that end, even longing for it, but longing for its death in a manner through which it might be finally realized, the symbol incarnated historically and socially. But this way of holding on, of resisting, is intrinsically melancholic: in internalizing the threat to it, art survives, lives off, a constant self-beratement (of its status as art). In telling his story, Bois wants to teach art to mourn,

to let go of its melancholic past so that it might live again. Mourning, I shall suggest, looks terribly like the renunciation of sensuous particularity, its specific form of opacity.

The most obvious way in which art attempted to defeat photography, the mechanization of beauty, was through a foregrounding of touch, texture, and gesture. By bringing these features of painting to the fore, art could reveal the absence of the hand, as the metonymic symbol of the human body and so of subjectivity, from industrial products, where the absence of the hand from industrial products was understood to be a consequence of the tendential displacement and repression of the subject, and so subjectivity itself, in the industrial process. The handedness of modernist representations of the world, in Cézanne, say, means to reinsert the subject back into the world represented. Bois contends that the attempt to resurrect the claim of subjectivity in this way turns out to be without authority because it is, finally, just an empty flaunting of subjectivity, as if the very fact of handedness could by itself authorize embodied subjectivity by its mere appearance. Handedness on its own cannot but beg the question it is meant to answer—it will always look to be an irrational protest against enlightened rationality.

In opposition to the cult of the touch, Bois witnesses the paintings of Robert Ryman, whose painterly effort is to dissect the touch, stroke, and gesture along with the insistence of pictorial raw material, every aspect of it, down to their most minimal units. In so doing, Ryman dissolves the relationship between the trace on the canvas and its "organic referent. The body of the artist moves toward the condition of photography: the division of labor is interiorized" (*P*, 231–32). This is not intended as a criticism of Ryman; he is the hero of Bois's book, "the last modernist painter" (*P*, 225), and "the guardian of the tomb of modernist painting" (*P*, 232). Ryman's project is through an "excess of reflexivity, to outflank the tautological reflexiveness [painting about painting] in which modernism has been locked" (*P*, 224).[21] What Bois admires is not that Ryman actually succeeds in overcoming reflexivity through reflexivity, giving back to painting its lost objectivity and worldliness, but that his *failures* themselves "produce objects that are increasingly enigmatic and interminable" (*P*, 224–25), where being enigmatic and interminable are construed as the perfected forms of that opacity Greenberg wished for modernism and Danto claims is constitutive of the art symbol. In this context, being enigmatic and interminable are, precisely,

symbols of (incarnate) objectivity.²² I shall return to the question of the enigmatic below.

Let Ryman stand for the claim of modernism, its achieved state; the strategy of internalizing industrial rationality in order to defeat it,²³ which became self-conscious with Seurat, reaches its culmination—after a long history of avoidance, "analytic decomposition" (*P*, 233), with Pollock as its foremost representative—with Ryman.²⁴ This is a dark scenario, since Bois's defense of art includes its processual capitulation to industrial rationality, which is what his championing of Ryman against Pollock amounts to. On the face of it, this sounds perverse. It is that perversity I am interested in. What brings Bois to this pitch is the view that all the nonindustrial (nonmimetic) strategies of resistance fail, and they are shown to fail by artists themselves: Duchamp, Rodchenko, and Mondrian. What Bois thus wants to explain is the historical trajectory through which modernism achieved its exemplary state, became nothing but Ryman's endlessly deferred collapse into photography: no touch, no hand, just traces of the body asymptotically approaching the state of the machine, with only its failures to do so providing a space of hope.

Let us return first to the hopes for resistance lodged in the medium, paint-on-canvas, and the pleadings of novelty, the shock of the new. Neither will do, neither will give to art an authenticity outside the imprecations of industrial rationality or the market. First, paint itself is not some ur-raw material, some stand-in for repressed nature, beyond the reach of technology. On the contrary, modern painting was made possible by oil paint becoming available in tubes. In this respect, the return to the medium as a source of sensuous opacity was in reality already an internalization of the mass-produced, the recognition of which "led to Duchamp's disgust for paintings and his invention of the readymade" (*P*, 233). Readymade here connotes the idea that there is nothing original, nothing given, nothing not already mediated and prepared.

Second, the new cannot bear the weight of uniqueness because it is always harassed by interpretation and comparison; as soon as interpretation and comparison get their tentacles into a work, which is all but simultaneous with its being consumed, it becomes old, a part of the history it was meant to escape. Hence, the quest for the absolutely new can never stop; novelty is itself perishable.²⁵ Adorno will state this as the idea that the new in art is nothing but a longing for the new (because in the world there is

nothing new, and art is not world but semblance). Moreover, and worse, novelty belongs to the intrinsic logic of commodity production, since it is "the very guise that the commodity adopts to fulfill its fetishistic transfiguration" (*P*, 235). Because artworks do not even pretend to have a use, in the context of capital they become absolute commodities, absolute fetishes, their emptiness being the condition of fulfilling "the collector's fantasy of a purely symbolic or ideal value, a supplement to his soul" (*P*, 237). According to Bois, all these deconstructions of art's *imaginary* claim to authenticity are carried out by Duchamp's recourse to the readymade, with the refinement of the reminder that the so-called autonomy of the art object was produced by a "nominalist institution (the museum or art gallery)" (*P*, 236), which constantly buried the perspective of artistic production beneath the point of view of consumption.

A second line of defense and conceit of modernism was that in departing from perspective and pictorial illusionism, it could escape, finally, from its Platonically decried liability, the liability which, beyond its sensuousness, has always made artworks abject, deserving of the philistine disdain for the disappointment they cannot avoid eliciting, namely, their being forms of mere semblance, hopelessly cut off from the domain of the real. During the Russian Revolution this escape seemed both possible and necessary, as if the revolutionary situation could engender new relations of production and consumption that would enable works to have a *real* political use value.[26]

This was the message and hope lodged in Rodchenko's exhibition of three monochrome panels in 1921. Bois cites these sentences of Rodchenko: "I reduced painting to its logical conclusion and exhibited three canvases: red, blue, and yellow. I affirmed: It's all over. Basic colors. Every plane is a plane, and there is to be no more representation" (*P*, 238). Rodchenko's work defeats itself: the monochromes might wish for the death of art as the condition under which it might finally join the real—but a true joining would be its realized death, not its achievement. That is why the monochrome, rather than being the quintessential renunciation of art's semblance character, topples over into a space of uncontrolled symbolic investment. If we had not already seen this with Danto's red monochromes, this passage from T. J. Clark, on Kasimir Malevich's *Black Square*, would close the matter: "Among its many other undecidables—is it figure? is it ground? is it matter? is it spirit? is it fullness? is it emptiness? is it end? is it beginning? is

it nothing? is it everything? is it manic assertion? or absolute letting go?—is the question of whether it laughs itself to scorn. (And even if it does, laughter and scorn could as well be Nietzschean positives as Duchampian naysaying. They might lead the way to the Nothing that is.)"[27]

Finally, to Mondrian, whose project was to deconstruct painting's entire *symbolic* order: the laws embodied in the tradition of Western painting that provided the conditions for its internal developmental order, its history, namely, form, color, figure/ground opposition, even the frame (to the extent that placing a picture *in* a frame immediately produces the window effect, and so the figure/background relation). The project was socialist and Hegelian at once, a curious fusion of socialist ambition—in which art could return to life with the advent of a non-reified, classless society (where classlessness includes the lapse of the distinction between artists and non-artists)—and Hegelian dialectical working through. What needed working through, and so dissolving, was of course nothing other than sensuous particularity, so that even the domain of sensuousness could become saturated with the forms of dialectical opposition, determination through opposition, that constitute the Hegelian concrete universal.

Mondrian's "general principle of plastic equivalence" supposes the operation of a "dialectic whose action is to dissolve any particularity, any center, any hierarchy. Anything which is not determined by its contrary is vague, particular, individual, tragic: it is a cipher of authoritarianism" (*P*, 240).[28] Hegelianism *in* painting would extirpate from itself the trace of sensuous particularity and contingency that Hegel thought made art a remnant of nature, its surpassed authority. Mondrian's project was to demonstrate how the authority of painting itself could belong fully to self-determining spirit. According to Bois, Mondrian saw the task of the painter as destroying all the elements on which the particularity of his art is based: the destruction of colored planes by lines; of lines by repetition; and of the optical illusion of depth by the sculptural weave of the painterly surface: "Each destructive act follows the previous one and amounts to the abolition of the figure/ground opposition which is the perceptual limitation at the base of our emprisoned vision, and of the whole enterprise of painting" (*P*, 240). While art does not replace politics for Mondrian, it does possess an indefatigable normative component: to provide a demonstration that real freedom requires mutual equivalence. The dissolution of all the particular elements composing works in a manner that would lead them to take their signifi-

cance only from their relation to other elements, which is as far as the principle of plastic equivalence can go, is meant thence to be the plastic version of mutual recognition.[29]

Mondrian intended the practice of dialectical analysis to be an indefinite, interminable holding action that would prevent painting from being absorbed by the market until such time as the world in the form of a socialist society was logically ready for it: so art must rehearse its death, the *telos* of being joined with life, as its particular form of living. It is a terrible irony that perhaps no art has been so thoroughly embraced by the market as Mondrian's: plastic equivalence just the thing for this season's line of dresses.

Against the delicacy of his analyses, Bois's conclusion, when it arrives, appears sudden and willful. Despite the fact that Duchamp, Rodchenko, and Mondrian wish for an end of painting that would be its truth and so overcoming, that end has failed to arrive, at least in the form they wished for. Instead of ending painting, by unmasking the deceptions of painting without being able to realize another paradigm of it these painters effectively exhausted it, leaving it nowhere to go.

In response to this dilemma, Bois contends that what his troika of artists ended is not the *game* of painting as such, but merely a particular *play* within the game, and thus there is space for painting to begin again even in the context of the changed situation of the society of the simulacrum. But this claim is in a way the very opposite of the standpoint of mourning and working through that is Bois's declared position. All the game/play thesis says is: painting is a conventional practice, and because really it is only that, then with an unbroken desire to paint, with sufficient self-awareness, and with a good will new generative conventions may yet emerge, which because purely conventional cannot be predicted or foretold. As tautology this is harmless; as therapeutic diagnosis, it is whistling in the dark.

Formally, at its limit, and against the grain of his own delicate analyses, Bois's position converges with Danto's, only Bois is still holding on to the need for art against its engulfment, while Danto, who is officially indifferent to the "need for art" doctrine, thinks the reality of art as the proliferation of new conventional practices is already here. This makes Bois, *theoretically*, one of the "manic mourners" whose unsupported belief—that we can just return to painting because, since it is all over with painting, we can "rejoice at the killing of the dead" (*P*, 243)—he rightly decries.[30] The only thing really separating Bois from Danto is the enigmatic and interminable

character of Ryman's best canvases: their opacity rivets him; it is the source of all his resistance, of all his claim for the necessity of mourning, of all the willingness to work through the history of modern painting as though it belonged intrinsically to our self-consciousness, as if it afforded a dark self-recognition in absolute otherness.

But Bois's allegiance to Ryman, his binding of himself to Ryman's achievement, is something that he cannot rationally ground because, finally, for Bois, Ryman's achievement really is groundless and *merely* conventional. At the conclusion of his essay on Ryman, Bois says just this: "Ryman also realizes that when the norms of painting are put to the test, *what is arbitrary will have the last word*" (*P*, 226; emphasis mine). By "arbitrary" Bois means the arbitrariness of the sign, where the arbitrariness of the sign is to be understood as the discovery that no signs, including the resemblances on which representational painting relied, have natural referents, that signs only have meaning in the context of other signs, and that the system of signs as a whole is groundless. The advent of the discovery of the arbitrariness of the sign in painting, which oddly plays no role in "Painting: The Task of Mourning," and which Bois nonetheless affirms as "*the principal rupture in this century's art*" (*P*, 79; emphasis mine), occurs with Picasso's acquisition of a Grebo mask and his making of the *papier collé Guitar*. What Picasso is claimed to have recognized in the African mask, put to work in his *papiers collés*, and then elaborated in the transformations that mark the movement from analytic to synthetic cubism, is that the sculptural sign is syntactically, semantically, and materially arbitrary.

The mask is syntactically arbitrary in that the arrangement of parts, their articulation of one with another, does not, and need not, track the articulations of the human body itself: knowledge of anatomical order does not determine sculptural order. And semantically, the parts need not themselves resemble what they stand for: "A cowry can represent an eye, but a nail can fill the same function. From this second type of arbitrariness unfolds the third (that of materials), as well as the complete range of poetic methods that we might now call metaphoric displacements. A cowry can represent an eye but also a navel or a mouth; therefore, an eye is also a mouth or a navel" (*P*, 84–85). If the syntactic, semantic, and material terms of an art are all, through and through, arbitrary, then art will have no forms of necessity it can call its own, and hence no authority. All empty.[31] I always sense that while Bois needs Duchamp's readymade for his semiologi-

cal unmasking, nominalism being the perfect metaphysical adumbration of the arbitrariness of the sign, he secretly despises Duchamp's cynicism and nay-saying (his "disgust" with painting), resistance to which appears in his championing of Ryman, Mondrian, and Barnett Newman.[32] Affirming, recounting, Picasso's discovery in the way he does, leaves Bois without any resources for making any sense of either his despising or his allegiances.

You might think of Picasso's discovery this way: the revealing that the sculptural sign is syntactically, semantically, and materially arbitrary is equivalent to the utter deauthorization of nature, and *thus the making* of nature into a dead thing, a corpse, a husk—a mere vehicle for the play of the sign; but that utter deauthorization of nature, because it comes through or entails the conventionality (arbitrariness, contingency) of the sign in general, simultaneously deauthorizes linguistic practice with it. So the disenchantment of art entails the disenchantment of nature, which disenchantments jointly entail the disenchantment of society.[33] But that is not the true order of things, merely the order of discovery; in truth, it is the arbitrariness of the social sign that manages the slaughter all by itself: *the threefold arbitrariness of the sign is meant to reveal precisely its detachment from material determination and even the memory of nature's authority.* The Hegelian temptation is to here urge a halt to arbitrariness on the grounds that, after all, if Hegel is right (if Mondrian is right), then the circulation of the social sign must, ought to be, governed by the norms of equivalence and reciprocity that are the actuality of the demand for recognition. But how will that help? How will those norms fill the need for art against technology and the market with which this telling began? More to the point, since mutual recognition in a sense *begins* from insight into the triple arbitrariness of the sign—that the authority of the sign is nothing representational and that its having meaning and authority is somehow up to us[34]—how is it going to cope with the claim that (knowledge of) the anatomy of the human body is without intrinsic authority? So is it the case that in representing ourselves to ourselves we are simply going to freely, rationally *agree* that my eyes belong in their sockets and my head atop my neck and shoulders?

If that counterclaim sounds hopelessly wild, too fast, even desperate, and above all crude, it is.[35] But the crudeness of the flat-footed counter is surely just the flip-side of the crudeness of the claim for the arbitrariness of the sign, as if its mention might take us anywhere other than to a dead-end. What gets left behind in such theoretical unmasking are the particu-

lars themselves, their being there before us and somehow managing a claim.[36] Since half of what is at stake here is the status of convention—the haunting anxiety that all conventions are mere conventions (which I take to be the upshot of the claim that the arbitrariness of the sign has the last word), let me return to Ryman.

I will need to simplify greatly (I mean simplify the complexity of Ryman's painting, the relation between the product and the process through which it is produced). When Bois claims that Ryman's analytic procedure is to approach the condition of the machine, what he actually has in mind is that within many works whatever element of painting is being interrogated (brush stroke, texture), his procedure is to set that element in motion through repetition.[37] (See Figure 14.) Ryman does sometimes surmount the subjectivity of the touch, gesture, and brush stroke, through a procedure of indefinite repetition. And while on one level that makes the element subject to mechanical determination (repeating "mechanically," without variation or interference, as the fundamental logic of the machine), on another level it sets in place a structure through which subjective expression can take on objective form: iteration.

A conventional sign cannot be a sign unless it is in principle repeatable; so actual repeating is a way of demonstrating that something is (potentially) a sign. Repetition (or seriality) thus transforms the apparently subjective/organic gesture into a *conventional* potentiality for meaning.[38] This is the real reason why, in the pictures where repetition is used, the bodily expressive moment is never fully overcome in Ryman (and why the elements of a Ryman can so confidently flag their subjective look). It is not an asymptotic approach to photography that occurs; rather it is a mobilizing of what I want to call painting's "visionemic" syntax—instead of linguistic phonemes, we have the minimum material units of the tradition of painting and drawing—visual/material phonemes, so to speak, so visionemes, with repetition taking the place of difference in providing for the minimum condition of identity.[39] By never leaving the visionemic level, but pressing forward with the repetition, what emerges is a potentiality for meaning that is never allowed to unequivocally semantically mean. Unlike with Newman, where a minimal syntactic gesture, the zip, generates a proto-semantic field, with Ryman we get a writing or sounding that is without a master code: an undecipherable writing. Ryman paints painting as "this" material-constituted condition of worldliness; Ryman paints the whole of the material-bound

14 Robert Ryman. *Untitled.* 1962. Oil on canvas. 9-¾ x 9-¾ in (24.8 x 24.8 cm). Photograph by: Ellen Page Wilson. Courtesy Pace Wildenstein, New York 2003 © Robert Ryman.

and conventional practice of painting without addition or subtraction.[40] Ryman paints the material practice of painting, and nothing else.

Hence something further occurs with Ryman. If iterability is a necessary condition for the possibility of meaning, by continuing to repeat Ryman produces an opaque context where the full force of the minimum unit as potentiality for meaning unaccountably but emphatically appears. Because repetition does no more than work up the original subjective or unmotivated gesture, then we are bound to say that the *appearance* of (proto-)meaning—the "brilliant, hovering, vibrating, and materially dense" white of *Empire* (*P*, 216), for example—is not fully or utterly arbitrary, not a mere convention.[41] How so? What within Ryman's practice emphatically prohibits arbitrariness from having a determining first word? Stating the question another way: what in Ryman's practice shows that the arbitrariness of the sign having the last word does not entail the emptying of the force of convention as such, as if that final arbitrary word would make naught all that preceded it?[42] What does Ryman's practice do for the restitution of conventional meaning? My answer is that his procedures *exhibit* and thereby make *actual* the limits of meaning as its condition of possibility. If limits really are both limits and conditions of possibility, then limitation must be necessary and actual in the emergence of meaning. The opacity of artworks thus contributes to rather than detracts from the manner of works' modes of claiming, and in so doing they transcendentally inform what meaning means.

While an element of painting would be utterly meaningless on its own, bald repetition is not something *other* than the element; it is just the element itself, again (and again and again). Although it adds nothing to the element, repetition gives back to the first a potentiality it lacked in its bare state. In that way, the giving back is giving to the element a potentiality that, from another angle, must be borrowed from the element itself since nothing extra is being added.[43]

Repetition is form; it is the minimum of form; *repetition is form bound to the material's own insistence.* Repetition is mimesis, so repetition is the minimum of mimetic form, of mimesis as form. In saying this, I am not exactly denying that Ryman's strategy is one of a mimetic adaptation to death.[44] What I am urging is that we construe his achievement from the opposing angle of vision: his performance of repeating, and repeating mechanically, when he does, reclaims repetition for conventional meaning against mechanism. And in reclaiming repetition, he authorizes the meaning-potential

of the element, certainly the painterly brush stroke, but for Ryman all the wholly conventional material aspects of a painting possess this potential: the materials affixing paintings to the wall (tape and screws), their shape, their visible or invisible edges, their standing off the wall *facing* us, etc. Repetition transforms fact into form. (If one were to speak of this psychoanalytically, a perspective all but demanded by Ryman's strategy of a mimetic adaptation to death, one could say: if repetition is nothing but the death drive itself, then what Ryman uncovers is how the death drive operates in the service of life. This is the crux of the ambiguity between repetition as mechanism (the death drive pure and simple) and as convention (the death drive in the service of life). In Ryman, the performance of repetition—which is halfway between subjective doing and mechanical procedure—becomes a metaphor for rational form still bound to the materiality of the medium. By deploying nothing but indeterminate element and empty repetition, the opacity of its medium restores the identity of painting as Greenberg urged. Hence the notion of medium comes to stand for materiality—read: embodied subjectivity—as the necessary opaque condition for meaning.

Again, repetition mobilizes but does not add anything to the indigent element. Analogously, by painting nothing but white canvases, Ryman does not negate Duchamp's disgust that even color is industrial and readymade; white, its neutrality, its cool indifference, neutralizes and deflates Duchamp's negation. Often, therefore, in Ryman white's neutrality is its most significant feature since what then becomes salient is its viscosity or density or texture, where these material qualities of the paint-stuff itself become an echo or articulation of the material qualities of the canvas (linen, paper, steel) support below. Here I want to say, the paint-stuff mimetically repeats the support.[45] But Ryman's white can also stand for the urgency of color, color as a lost language of nature, through its (chromatic) absence. Ryman's insight is to recognize the indeterminacy or undecidability of repetition between convention and mechanism. Repeating repetition empties it of its mechanical character so that it can take on that indeterminacy, figure it. Making his paintings white does the same for color: white is indeterminate between color as husk, color emptied of all intrinsic (natural) potential for meaning, and an amorphous indeterminacy that projects color as such as a potential for meaning.[46] Ryman performs the conditions of painting in the absence of painting, which is to say *he performs painting*

as medium and nothing else. That the performance sometimes issues in those enigmatic wholes, as Bois avers, is the force of the claim, its standing as claim.

The moment of indeterminacy, the indigent elements, the all but mechanical repetition, the neutralizing whiteness, collectively ensure opacity, and in ensuring opacity shield convention from transparency, and hence block comparison and allegory, and thus block the conventions of painting from becoming mere conventions. (How painting means is not up to us, not a pure work of freedom or mutuality or equivalence.) The *force of convention* is derived not from rational mindedness—that is what renders a convention "mere"—but its unknown-ness, its nontransparency, its being shielded from the depredations of rational mindedness. This is to say that the force of convention, what halts its utter arbitrariness, is the opacity it borrows from dead nature.

Ryman's paintings are thus symbols of (or metaphors for) materiality: matter as nothing and everything. The authority of nature, material meaning writ direct, is gone; but that does not mean that we can finally detach ourselves from that loss, since to do so would be to effectively usurp the claims of embodiment as a condition of mindedness. That each element is *indeterminate* between a potential for meaning and non-meaning—gesture is indeterminate between subjective expression and private language; repetition is indeterminate between principle of iterability and mechanism; white is indeterminate between all colors and the absence of color; above all, paint-stuff is indeterminate between mere inorganic stuff and body—entails that each whole Ryman painting inherits that indeterminacy. The negative (private language, mechanism, absence of color, paint-stuff) is the placeholder for dead nature, and hence for the vanquished authority of nature. Because of this opacity and negativity, we cannot ascribe the potentiality of meaning to nature itself. But equally, when visual meaning occurs, it is *utterly bound to this deadness*, so that the emphatic limit of meaning here becomes effective as its condition of possibility. Thus, *pace* Hegel, the "baptism of the spiritual" achieved through repetition is not the sole source of the animation of a work; that animation, and hence authority, is indefinitely and indeterminately borrowed from dead nature.[47] What we experience in Ryman's paintings is that mechanism has not yet swamped subjectivity, and that the claim of subjectivity can remain just so long as freedom's long good-bye to nature remains unfinished.[48]

Adorno's Blindness

> If the artwork assumes the expression of incomprehensibility and in its name destroys its own internal comprehensibility, the traditional hierarchy of comprehension collapses. Its place is taken by reflection on art's enigmatic character.
> —T. W. Adorno[49]

Nothing I have said in defense of Ryman exactly answers Bois's final salvo and lament: what is arbitrary will have the last word. Nor has anything I have said fully answered Duchamp's disgust that even paint is readymade. I have not answered Rodchenko's Platonic lament that art is semblance and not real. Nor have I answered my own lament that Mondrian's novel practice has been reduced to fashion. I assume that all of these lamentations, when read straight, are melancholic and thus components of art's self-beratement: its internalizing of freedom's despite of art, and thus art's impotent raging against freedom for killing it, being turned against itself. What art cannot finally bear, what it finds intolerable, and what we find intolerable about it, is that it is just art and not world.

Adorno does not so much deny art's melancholic predicament as reveal it as the constitutive condition of modern art. Melancholia cannot be made into mourning since we are not in a position to mourn the passing of art; its passing has not yet passed away (and short of utopia, which may mean never, cannot pass away—unless of course the world becomes a place beyond caring).[50] But recognizing this, a recognition Adorno ascribes to the works of high modernism themselves, transforms self-beratement into a dialectical tension within modernist works: modernist works include a moment within themselves of anti-art. The anti-art moment of modernist works, the moment that Duchamp and Rodchenko attempt to make complete, enacts art's desire to be world and not art; but only *as art*, as semblance, can art evince that desire, perform it.[51] Semblance in Adorno is the appearing of artworks to be wholes, and so to be things in themselves. Since artworks are not things in themselves, not worldly items, and thus not really wholes, this appearing is illusory. Semblance belongs to the substance of the modernist work: harmony and unity, theme and variation, foreground and background, the binding of beginning and end, completeness and self-sufficiency are all formal mechanisms for making works whole; the finer the mechanism, the deeper the illusion. Advanced works signal their despair

at this fact in a moment of non-semblance, in a moment of sublime dissonance, in a moment of formlessness, in a moment in which the material (sound, color, line, paint, word, space, movement) breaks free from the forming impulse and displays its incomprehensible deadness.[52] The corpse in the ghost.[53] Nothing is more world than dead nature, the eloquent matter of art suddenly returned to its bald, formless, causally saturated state. This much of Hegel's reminder—"but within is common stone, or wood and canvas ... idea, uttering itself in speech and letters"—has been absorbed by art itself as a moment within its unfolding. Although not every work we are wont to identify as modernist fully exemplifies this movement of formation and deformation, of being beautiful and sublime at once, this dialectic of form and opacity, Adorno does consider it constitutive of modernist art. Modernist art embraces its incapacity.

If modernist art is the sort of art that "seeks refuge in its own negation, hoping to survive through its death" (*AT*, 338; something that might stand as the motto for Ryman's art), it is, nonetheless, the processual and structural character of that negation, the exhibition of dead nature in the midst of eloquence, hence the binding of meaning to non-meaning as the condition of meaning, that distinguishes modernist art from what has sought to succeed it. Or rather, we will only begin to comprehend modernism's embrace of incapacity if the acknowledgment of the corpse within the ghost is logically and causally related to the powers of the ghosting, art's spirit, itself. The dialectical movement between form and formlessness, spirit and matter, must be more than a modest acknowledgment of insufficiency; it must be transcendental: the non-meaning of dead nature is the bearer of art-meaning, where art-meaning is itself the bearer of the meaning of meaning. To be sure, the arbitrariness of the sign in the last instance is also a form of non-meaning, but it is, finally, the non-meaning of the will, of freedom itself, the non-meaning that is transmitted to the sign from the will's power of negation, or, perhaps, the non-meaning that reverberates onto freedom from the sign's detachment from its object.

While the postmodernist would explicate the freedom of the will through the arbitrariness of the sign, the Hegelian would adopt the opposite direction of explanation; since will and sign give arbitrariness to each other, they can be conceived as mutually conditioning each other. It is this that explains the direct echo of Hegel's dispatching of art in the postmodern slaughter: both the arbitrariness of the sign and the negativity of the will

first impugn then extinguish the lost authority of nature as a condition of meaning.

The non-meaning of arbitrariness makes meaning possible in that the contextual conditions of meaning cannot themselves determine meaning fully; if a meaning were not in principle detachable from its realization "here," there could be no realization of it ("this" meaning "here") at all. Generality and iterability (jointly: the same again) depend on this thought. Once disenchanted, the claim of universality can be seen to depend on the detachability of a contextualized meaning from the context in which it is to be found; but what makes detachment possible is the non-meaning of the (final) arbitrariness of the sign and the negativity of the freedom of the will.[54] Hence the terrible discovery of self-defeating modernity: the universality of technical rationality and commodity production, the epitomes of detached meaning, is simultaneously the extirpation of meaning and rationality, the modern rational irrational in itself.[55] Modernism responds to this discovery and the crisis it generated by insisting on an opposing principle: no meaning without context, no context without particulars, no particulars without matter. Inevitably, the notion of matter required here is fraught, but in the same way in which disenchanted universality is fraught (entwining meaning within non-meaning). If matter were utterly raw, without any form or determinacy of its own, it is unclear how rational meaning might *depend* on it; conversely, if the matter necessary for meaning, as the force enabling context to oppose the decontextualizing force of universality, possessed its own form, it would be a natural meaning. Hence, the matter necessary to halt the ascendance of modern universality into arbitrariness can be neither raw nor formed—*it is lost.*

Bearing the weight of this predicament orients Adorno's analytic of modernism and critique of Hegel's aesthetics. So, for example, in the course of his defense of the role of natural beauty in art beauty, Adorno contends that nowhere is the "devastation that idealism sowed" more glaringly evident than in its victims, instancing Johann Peter Hebel. Adorno continues:

Perhaps nowhere else is the desiccation of everything not totally ruled by the subject more apparent, nowhere else is the dark shadow of idealism more obvious, than in aesthetics. If the case of natural beauty were pending, dignity would be found culpable for having raised the human animal above the animal. In the experience of nature, dignity reveals itself as subjective usurpation that degrades what is not subordinate to the subject—the qualities—to mere material and ex-

pulses it from art as a totally indeterminate potential, even though art requires it according to its own concept. (*AT*, 62)

If the dignity of the subject is idealistically construed as its distance from animal nature, then natural beauty will be found wanting; and this wanting will be transmitted into art—if freedom is going to discover only itself in works—through the reduction of its material conditions to "indeterminate potentials." This is contrary to art's own concept, its being bound to sensuousness. (Which is to concede that there is a compelling necessity in Hegel's declamation of the end of art.) If color, say, were "mere material," then the limit case of the monochrome with its explosion of possible meanings would be the norm for art. It is just this that the great modern colorists seek to refute: the claim of Matisse's *The Red Studio* is precisely that, unlike the other elements in the painting, its red is not reducible to artistic intention; and hence the claim of the red, as the normative substance of the painting, instigates an objectivity that is incommensurable with the objectivity enjoined through the practices of drawing, forming, composing. Finding a painterly objectivity that might defeat the will as an arbitrary (subjective) source of meaning by producing *intentionless* appearances, images that are not images of anything, is a constant of modernism, where that intentionlessness is secured through what cannot be intended, say "this" color as such.

If Rodchenko overstated the case for his monochromes, he nonetheless captured an impulse belonging to the deepest stratum of modernism, the extinguishing of the will in the object, a gesture whose realization has routinely been sought through the binding of work to the shoreline of the medium.[56] (Mondrian's constructivism should be regarded as an opposing technique for achieving the same end.)[57] The materiality of the medium is, of course, not the materiality of first nature direct: the red of *The Red Studio* does not, could not, mount its claim anywhere else but in the painting. But that is in part Adorno's point: the nature that finds its way into painting, on which painting depends, and which is what is glimpsed in natural beauty ("nature can in a sense only be seen blindly"—*AT*, 69), is a nature that is no longer an object of scientific knowledge or practical labor, which prima facie may be assumed to exhaust what nature may be. What else of nature there is, art alone systematically interrogates. If art depends on this impossible nature for it objectivity, it is equally true that *only in the context of art is nature as appearance salvaged.*

Not too far down this path lies Adorno's most replete linking of art beauty and natural beauty, art beauty as the enlightened and so disenchanted version of natural beauty: "Only what had escaped nature as fate would help nature to its restitution. The more that art is thoroughly organized as object by the subject and divested of the subject's intentions, the more articulately does it speak according to the model of a nonconceptual, nonrigidified significative language; this would perhaps be the same language that is inscribed in what the sentimental age gave the beautiful if threadbare name, 'The Book of Nature'" (*AT*, 67).

If context is to contribute to meaning and reason, then perhaps it is necessary that some portion of cognition be nondiscursive; and perhaps it is necessary for the possibility of nondiscursive cognition that meaning adhere to things, have a moment of nondetachability; and perhaps it is necessary in order to think nondetachability that we have in mind the idea of a "nonconceptual, nonrigidified significative language." Still, all this pushes a step further than is capable of vindication here. But a weaker thought is available, and one that follows directly from the claim that the nature of natural beauty in modernist art is a nature divested of the attributes it possesses as object of knowledge and subject of technological forming. As we learned on Kant's knee, the nature that is made to appear once abstraction from epistemic, utilitarian, and practical ends is carried out is, ideally, one that is purposeful but without purpose, where that characterization carries over into the very idea of what it is to ascribe form to artworks. Although the initial cut of "without purpose" is directed against the anthropomorphism of idealism itself, that matters because those purposes have become ultimate: they succeed the collapse of natural teleology. Hence the moment of "without purpose" is the relay of the collapse of the authority of nature into idealism as its finitude; but this is to concede that the finitude of human knowing and acting is conditioned by the death of nature's authority.

The apparently modest "without purpose" thus reverberates with the death of natural teleology and, with it, the authority of nature. *Only artworks elaborate the loss of the authority of nature as their condition of possibility; they signal their ultimate "without purpose" through their constitutive incomprehensibility.* Now I suggested at the outset that we would find the place of dead nature in art in a constitutive moment of opacity, of being enigmatic; the "without purpose" through which nature becomes appearance and artworks autonomous is exactly what makes them opaque and enigmatic.

It is not accidental that amidst the usual-sounding chapter titles ("Natural Beauty," "Art Beauty," "Semblance and Expression") Adorno should have "Enigmaticalness, Truth Content, Metaphysics." In attempting to elicit the constitutive enigmatic quality of art, Adorno is not, Nietzsche-like, espousing art as the irrational, Dionysian other to formal reason, or withdrawing from his hyper-cognitive orientation to aesthetics generally: "The enigmaticalness of artworks is less their irrationality than their rationality; the more methodically they are ruled, the more sharply their enigmaticalness is thrown into relief. Through form, artworks gain their resemblance to language, seeming at every point to be just this and only this, and at the same time whatever it is slips away" (*AT*, 120).[58] Ryman's mimesis, Mondrian's dialectical formality, Newman's sublime austerity—each one disillusions traditional practice so that nothing may be hidden; yet the distinctly formal and revealed language of each is precisely what renders their best works compelling and enigmatic at once. The expressly enigmatic character of such hermetic, modernist works (which is the plausible source of the philistine's finding them ridiculous, absurd) amounts to the admission of the enigmaticalness of all art (*AT*, 122). Enigmaticalness attaches both to works and hence to art itself; as a consequence, what is required is that enigmaticalness be understood in itself, not dissolved: "The solution to the enigma amounts to giving the reason for its insolubility, which is the gaze artworks direct at the viewer" (*AT*, 122).

It is that gaze which Ryman's works direct at the viewer. In the case of the best Rymans, as with Newman's finest canvases, the incandescent appearing of the work drags with it as its shadow its enigmaticalness. That the work that appears to hide nothing, to almost throw off the will to appearance, and to exhibit without modesty or restraint the materials making it possible, dead nature, should be so emphatically enigmatic speaks to what art is and can do, our need for it. In such works spirit "throws itself away" and "ignites on what is opposed to it, on materiality.... The rationality of artworks becomes spirit only when it is immersed in its polar opposite" (*AT*, 118).

9

The Horror of Nonidentity: Cindy Sherman's Tragic Modernism

Within contemporary art, Cindy Sherman's works are the most emphatically cognitive of which I am aware. Picking up an undercurrent from the *Untitled Film Stills*, the works produced from the mid-1980s on transpose us into another scene of knowing, another scene of both what needs knowing or acknowledging and what is involved in such knowing. What needs showing is something about our embodiment, our placement in the natural world, what has happened to nature, inner nature but also in a sense outer nature, as a consequence of the systematic and, for her, cultural ways in which its suppression and repudiation has taken place. The need for another knowing derives from a history of denial and repression. In her later works she employs various genres—fantasy, horror, pornography—as mechanisms of abstraction, ones appropriate to photography (so enabling the inventing or reinventing of photography as an *artistic* medium), that release such embodiment for encounter.[1] The consequence of the abstraction and reformation of the material is to reveal what might be called an overlooked syntactic quality of its objects, say, their aliveness or deadness, their injurability or vulnerability, their brokenness or jouissance—in all, their being forms of meaning beyond representational meaning. If this latter claim is correct, then Sherman is a modernist.

At one level, to claim Sherman for modernism must seem perverse: the ambience of her oeuvre is the postmodern image universe, and, without question, she could not have found the space she required to produce her body of work without the permissions provided by the postmodern repudi-

ation of modernist formalism, above all its repudiation of the modernist image ban with its constant work against likeness. From the standpoint of a certain, severe formalist modernism the very idea of photographic modernism must seem a contradiction. But if it is correct to consider the genres of the grotesque that Sherman uses as *already* forms of negation, as already a work against likeness for the sake of revealing what representational likeness misrepresents, suppresses and denies (which I take to be the initial attraction of these genres to Sherman), then both the scope and meaning of abstraction, and the significance of likeness will need to be reevaluated. Sherman's work, her work on those genres, forces that reevaluation on us. In so doing, however, it simultaneously forces us to consider or reconsider the kind of claim that, with remarkable insistence and consistency, runs throughout her pictures. If modernism is the essentially anti-skeptical cognitive practice I have been claiming it is, and if, further, it operates by demonstrating how meaning can and indeed must adhere in what modernity has forced us to regard as its meaningless material substratum, if modernism is the place in which we recover the promise of our perceptional habitation in a material world as orientational for human practices, then Sherman's works of the 1980s and 1990s should be taken as exemplary for modernist art, as a form of painting in the absence of painting, as late modernism itself.

This chapter begins with a broad reconnoitering of what now seems to me the relevant conceptual frame needed in order to adequately encounter Sherman's pictures. In particular, I want to reinvigorate the concept of aura, that strange notion of the peculiar power of claiming that artworks possess, their way of placing us, of soliciting us to respond to them as though they were more than mere things, as if they were like persons. Sherman's *Untitled Film Stills* are best encountered in the context of Horkheimer and Adorno's genealogy of aura, from its primitive beginnings through the transformation that occurs with discovery of photography, to its culture industry appropriation by Hollywood. Part of this story concerns how photography mechanizes, makes automatic, the kind of disinterestedness appropriate to aesthetic reflective judging, and how it thus enables the manufacture of aura. The other side of this story concerns the power of the culture industry cliché to manufacture identities, to recruit us to those identities. Sherman's *Untitled Film Stills*, their aura, is their work against the illusory aura that emanates from the clichéd identity that is the content of each picture.

Two things occur with the so-called fashion pictures of the mid-1980s.

On the one hand, Sherman becomes interested in what has been repudiated, repressed, and excluded by the homogeneity-producing mechanisms of modern culture, interested in the remnants and ruins of modernity rather than the auratic power of its surface sheen. On the other hand, she becomes interested in the operation of aesthetic categories, in, more precisely, the violence of beauty (nowhere more evident than in the fashion image), and hence the claim of the ugly against beauty. These interests self-evidently overlap. The question that then faced Sherman on this accounting was how to exploit and interrogate that overlap, to mobilize it for picture-making, picture-making that is both representational and modernist, a modernist picture-making that is appropriate to the powers of photography, negatively and positively. It is here that she discovers the untapped resources of a series of heretofore marginal genres: fairy tales, horror movies, pornography, and others. These genres, I contend, already operate in the space where repression and the ugly converge, where the ugly—distortion and fragmentation—operates as a disruptive counterforce to the compulsive stilling of the beautiful. More precisely, I argue that we can locate the force of Sherman's deployment of the horror genre, which I will take as paradigmatic for the operation of the various series at stake here, in a tradition that begins with ancient tragedy, then turns into the idea of the sublime in the eighteenth-century, finally reaching a kind of apotheosis in realist horror.

Horror is a late, always too late, version of the modernist sublime. For me, the various strands of Sherman's practice achieve perspicuity, a clarity of meaning and claiming, with the disturbing high comedy and high tragedy of the sex pictures she produced in 1992. These pictures not only lodge a powerful anti-skeptical claim, but do so by bringing us to a pitch of self-recognition in the otherness of dismemberment that, in retrospect, appears as a radical gathering of what modernist art has been about all along, the truth about the auratic power of modernist painting, painting in the absence of painting.

I. Abstraction, the Extirpation of Animism, and Aura

In what is one of the best essays on Sherman's art, Norman Bryson sets up his excavation by asking a series of pertinent questions: "What is the nature of the transition, in the postmodern image universe, that seems to go in one move from everything-is-representation to the body-as-horror?

From the proposition that what is real is the simulacrum to the collapse of the simulacrum in a Sadeian meltdown? From *Untitled Film Stills* to Cindy Sherman's present take on the body as house of horrors and house of wax?"[2] While pertinent, these questions operate with two assumptions that need to be contested.

First, what makes Bryson so sure that we are here witnessing a transition rather than a continuation, a probing of the same space from different angles? Bryson is doing no more at this juncture than echoing the standard critical line on Sherman, but which on the face of it seems obvious, above all to the eye; who could question that the *Untitled Film Stills* and those of, for example, dirt, vomit, excrement, waste, and formless matter were different, the latter coming from a space quite other than the space enclosing the first? Part of what controls Bryson's presumption that there is a transition and reversal here is that he believes, and this is his second assumption, that the transition occurs in "the postmodern image universe." But what if there never was, really—that is with normative authority and not just empirical sweep—a postmodern image universe, one that has permanently and rightly put aside modernism as modernity's conscience in order to simply inhabit a forever shifting and changing image world without beginning or end? What if the idea of such a universe insulates contemporary art from the deep structures of the culture of which it is a part, and thereby deforms the consistent and overarching problematic that Sherman's art engages? What if the claim of a "transition" is a way of defusing the awkwardness of the *Untitled Film Stills* and, conversely, falsely dramatizes, makes histrionic, the *informe* and sex pictures? Even before we can look on Sherman's works, or for that matter say something about what a philosophical criticism of them should aspire to, there is the question of the appropriate frame of reference. By shifting the frame of reference in which we look at Sherman's photographs, the hope is that we might be able to see them.

In *Dialectic of Enlightenment*, Adorno and Horkheimer provide their now well-known and all too familiar account of the emergence and structure of modernity as a closed and reified totality. That totality is a consequence of a processual demythologization and disenchantment of the world caused by the domination of enlightened, instrumental rationality as the explicit logic of reflective thought and the implicit operator structuring societal rationalization. Coiled within their account, however, and controlling it, is a metaphorics and/or conceptualization that is too little commented upon or

discussed (one that only became apparent to me as I attempted to make sense of Sherman's works, their manner of insisting). "The disenchantment of the world," they claim, "means the extirpation of animism."[3] Picking up this thought a little later in the first "Excursus," they elaborate: "The reason that represses mimesis is not merely its opposite. It is itself mimesis: of death. The subjective mind which disintegrates the spiritualization [*Beseelung*] of nature masters spiritless [*entseelte*] nature only by imitating its rigidity, disintegrating itself as animistic" (*DoE*, 44– 45). Something that the language of reification, alienation, rationalization, ideology, and domination suppresses is the extent to which *Dialectic of Enlightenment* is organized around the distinctions living/non-living and living/dead.

Distancing itself from sensuous particularity through reflective abstraction, that is, by subsuming particulars under ever more universalistic concepts, enlightened conceptualization brackets, then bypasses, the most salient feature of the perceptual object, that the very thing before our eyes is paradigmatically a living being. Instrumental reason in treating every object as in principle subject to mean-ends ratiocination and hence as indefinitely manipulable, as quantifiable and subject to causal analysis, extirpates life from the world, or, perhaps, first rationally brackets and then rationally excludes the cognitive experience of our perceiving living beings like ourselves *as living*; or perhaps, finally, as our experience of the living becomes both more remote (hidden from view) and more ambiguous, more contoured across the extremes of armored or mechanized or sculptured or coded bodies (fashion bodies, sport bodies, uniformed bodies, bodies tattooed or pierced) and sentimentalized animalism inflated (vegetarian despair), simultaneously the rational authority of experiences of the living, what counts as experiencing the living as living is delegitimated, emptied, left without distinct meaning or authority.

It is certainly worth noting how ruthlessly dry and dead are the objects of perception with which philosophy has classically dealt: impressions and ideas, qualia and sense data, synthesizing perceptual manifolds, seeing versus seeing as, interpreting visual information, and so on. Even G. E. Moore's "This hand I see before me" is more ghost hand than living one, a vivid hand-image occupying the forefront of a visual field. Nothing within these accounts gives a hint that their objects could be living beings subject to not mere breaking apart or destruction, but tearing and flaying, violation and invasion, that unlike mere things where what is outside and what inside re-

mains spatial and contingent, the outside of a living being is the outside *of* an inside, a skin or flesh protecting and mediating a (heated, palpitating, fluid, viscous, stringy, dense) inside with what is external to it. The constitutive vulnerability and injurability of the perceptual subject and object is voided as irrelevant to epistemology; *epistemology is constituted by this elision and suppression, its deadliness.* While from the get-go Sherman's subjects are exposed and vulnerable, in the late genre pictures that vulnerability becomes emphatically that of a living being, the being whose very *life* has been unknown to epistemology and most traditional art. Something gets *seen* in Sherman that has not, or has only rarely, been seen before, or if seen then not acknowledged, something constitutive of our perceptual engagement with the world. Sherman's pictures mean to wring that acknowledgment from us. Hence my contention that what is at stake in Sherman is the scene of human knowing *überhaupt*, a scene that might displace Moore's common-sense hand or Descartes's comfortable sitting beside his fireplace in his winter cloak.

Mimetic cognition—Adorno's term for what became, after centuries of evisceration and then the rise of modern science, Kantian intuition—was originally that form of cognitive experience that took up the "multitudinous *affinities* between existing things," say, life knowing life; this is "supplanted by the single relationship between the subject who bestows meaning and the meaningless object, between rational significance [concept] and its accidental bearer [intuition]" (*DoE*, 7). The "affinity" between subjects and objects functions as almost a dummy term, a surrogate concept that stands for all the vital similarities of subjects and objects, all those affective responses and empathetic identifications, that are passed over when likeness becomes mirroring or correspondence.[4] The bestowal of meaning, the giving of meaning *to* the object, is what denies it, empties it, thereby making it meaningless, a mere bearer of meaning. But there cannot be cognition without mimesis, perception without affection; hence the rational subject in deploying the abstract conceptuality of enlightened reason is mimetically adapting himself to the world already disenchanted into dead matter; in what he presumes is his effort of mastering the brute thing, the rational subject is mimetically adapting himself to it: introjecting death.

To his credit, Bryson recognizes and underlines the disappearance of the living body as a fundamental event within the modern world without,

however, perceiving that this is what modernity is or connecting it systematically to societal rationalization. Or better, Bryson records the disappearance of the body without quite connecting it to the fundamental process of the extirpation of animism (although he implies their connection by, in a wholly "critical theory" gesture, counterpointing the eclipse of the body with the resistance of pain as a nonfungible and hence nonrationally conceptualizable matter).[5] Here is his mini-history:

> From the eighteenth century on, practices in which the body possessed any kind of insistence are designated barbarous and hidden from view: . . . animals are not to be killed in courtyards by local butchers but in abattoirs on the outskirts of the city where no one goes; the display of meat as something frankly carved up from an actual beast . . . with a head, with internal organs, with a recognizable cadaverous form, is rethought so that meat can cease to appear as recently living flesh and becomes instead a hygienic, quasi-industrial product obtained who knows where or how; . . . the dying no longer spend their last days and hours at home with their families and friends, their death continuous with the rest of their life and their surroundings, but instead are sequestered behind white walls and hospital screens.[6]

What is odd is that in so perspicuously seeing modernity as, at least from the eighteenth century, extirpating the emphatically living self, our animal self from its precincts and transforming the experience of life into a series of abstract, hygienic signifiers, Bryson should think of this linguistified space as synonymous with the postmodern image universe. Or perhaps there is an intended irony in his account, for if modernity is the processual extirpation of animism, and that extirpation is realized in a linguistic idealism that accords all meaning to language operating on dead matter, matter so dead it disappears behind the endless movement of reason and signification, then postmodernism is nothing other than the ideology of a modernity oblivious to itself. Bryson's mistake, if mistake it is, is easy to comprehend: the postmodern critique of modernity is primarily a critique of high, enlightened rationalism (variously identified as foundationalism, presence, teleology, progress, grand narratives) in the name of the complex, local, relative, contextual, etc. And there is certainly a difference worth noting between these two. However, that difference slides into insignificance before what they share: the belief that reason or language is self-sufficient, wholly independent from and wildly underdetermined by—to the point of irrelevance—its object. It is the movement toward the self-

sufficiency of reason and language (the whole tawdry business of the arbitrariness of the sign again) that, according to Adorno and Horkheimer, is the fundamental gesture of enlightenment; the self-preserving drive to self-sufficiency and independence opposes subject to object, culture to nature, enabling thereby the equally skeptical formations of reductive scientism and relativistic culturalism.[7] Postmodernism and enlightened rationalism, Vico(/Joyce) and Descartes, converge in refusing affinity and dependence. Enlightened rationalism was always but one-half of cultural modernity; every rationalistic terror has had its critical, and equally modern Burke; for every claim of a new rationalized beginning, there has been a consciousness of historical belatedness, of history without a meaning beyond its own groundless movements, the endless play of the sign. Postmodernism has thus always been *an*, if not *the*, ideology of modernity; and modernism has always come after postmodernism, being nothing but the critique of postmodernism.[8]

Animistic and mimetic thought cognized its object as fully other. Following Hubert and Mauss, Horkheimer and Adorno contend that *mana*, "the moving spirit," is not to be regarded anthropomorphically as a subjective projection of the human onto the inhuman, but rather as an *acknowledgment* of the preponderance of living nature over the weak psyches of primitive people. Hence "if the tree is addressed no longer as simply a tree but as evidence of something else, a location of *mana*, language expresses the contradiction that it is at the same time itself and something other than itself, identical and not identical. Through the deity, speech is transformed from tautology into language" (*DoE*, 11). Speech escapes tautology (a tree is whatever we call a tree; and a tree is a tree is a tree) when it cannot appropriate the object to itself, when it is beholden to the object, when the object exceeds it. *Mana* is the animistic mode in which language's incapacity is acknowledged.

This matters to art. For Horkheimer and Adorno, it is the primitive notion of *mana* that forms the remote origin and semantic core of auratic art: "The work of art constantly re-enacts the duplication by which the thing appeared as something spiritual, a manifestation of *mana*. This constitutes its aura" (*DoE*, 14). It is not the presumptive genealogy of aura from *mana* that is significant, as much as what that genealogy expresses about their conception of auratic art. In a manner from which Adorno never deviates, aura belongs intrinsically to the art object, it is that moment in the art ob-

ject that suspends its objecthood: "Aura is not only . . . the here and now of the artwork, it is whatever goes beyond its factual givenness, its content: one cannot abolish it [aura] and still want art."[9] Horkheimer and Adorno's genealogy of aura, as the artwork's intrinsic capacity to defeat mere objecthood, gives back to works a somewhat uncanny aspect: aura is the appearing of a thing to be an *animate* other; hence aesthetic semblance is always the *semblance* of life, an illusory infusion of life, spirit, into dead matter. In the discussions of Soutine, and Hegel's warranting of the artwork's appearing to possess something beyond the dead matter from which it is made, we have seen that there is something uneasily mortifying about artworks, their liveliness or animation seemingly more vital than the lives of the subjects regarding them. The genealogy of aura reveals this moment of mortification, or more precisely, what *we* experience as mortification is intrinsic to the very idea of art; the negativity of the modernist work, abstraction, is the mechanism through which the preponderance of the work, its aura, is released, and in being released mortifies us. In our mortification we *feel* the life that has been lost. Every modern artwork is, in this respect, antique in that it preserves an *experience* of the preponderance of nature, the excess of the living being, that has disappeared from everyday life. If that disappearance is just the rationality of the ordinary in modernity, then in experiencing the object's preponderance we cannot but be experiencing our mortification.

This should not be so surprising since what Adorno and Horkheimer's genealogy suggests is that animism is, when stripped of its naive spiritualism, an acknowledgment of a thing's meaning in excess of our meaning it, and that *paradigmatic* of this excess is a thing's being alive, its having a life that is its own, as if animation were itself the real essence of animism. It is sometimes said that the human body is the thing of all things. Horkheimer and Adorno take this thought to be equivalent to the thesis that our perception of (primarily) human bodies is orientational for human perceptual experience generally, as if perception were always already geared to and awaiting the emergence of the living, animate other to provide perception with a focus, target, or purpose, and that the perception of the merely organic and the inorganic is always parasitic on the perception of that thing of all things, the body.[10] Now, as a theoretical claim, a claim from within philosophy, that thought must idle. This is why Horkheimer and Adorno do not utter it directly; rather they offer it, sideways on so to speak, from

the perspective of the genealogy of the aura of the artwork. The aura of the modernist work, genealogically understood, is the afterimage of that orientational outlook, of the orientation given to perception by the experience of the living thing's preponderance.

The uncanniness of aesthetic perception is thus not only the experience of meaning in what otherwise lacks meaning—brute sounds, paint-on-canvas; in order for something to be meaningful it must equally be the bearer of life. Artistic materialism, in theory and practice, is a form of (illusory) animism. The production of auratic works is the production of a semblance of a living thing, the animation of the undead. Or perhaps, more precisely, the wedding of materiality and meaning in modernist works is sublinguistic, recalling or invoking the kind of proto-meaning, meaning before meaning, the anticipation of meaning borne by bare life. I am unsure exactly how to phrase this without it spinning utterly out of control. What I am nonetheless certain of is that Sherman's pictures interrogate aura in this exorbitant sense, her work bringing back into play the suppressed binding of aura to animism that its genealogy reveals, a suppression that Soutine's elision from the canon of modernism has only furthered.

Let me fill out Horkheimer and Adorno's genealogy with one additional idea. In the eventual rationalization of language its components, those aspects of it that made it both identical and nonidentical with itself, were separated out: the rationalized concept became the sign, and the mimetic remnant became image. The image is the refuge of mimetic cognition, the cognition of life. Of course sign and image are never quite separated from each other, especially in ordinary language; however they are rationalized into the distinct spheres of practice of science and art respectively, and the process of societal rationalization is the process by means of which it becomes a function of the pure sign. (Insofar as the arbitrariness of the relationship of signifier to signified composes the center of the postmodern analysis of the sign, then what is thereby analyzed is what Horkheimer and Adorno conceive of as the pure sign. It is thus unsurprising that the movement whereby the world is conceived of as an endless signifying chain should so perfectly replicate rationalism's extirpation of animism. It is the same extirpation.)

Artistic modernism's claim was always the appearing animation of what is indefatigably inanimate, the purely material appearing meaningful in it-

self. This is why abstract expression is so readily taken to be the last moment in the process of modernist claiming: it belongs to that moment when the symbolic order has been thrown into doubt because it is increasingly both meaningless in itself (call it nihilism) and a betrayal of the perceptual world (symbolic codings of sensuous experience appearing merely conventional). Eschewing all elements that could be thought to belong to the domain of the pure sign, through the mere arrangement of dead matter, paint-on-canvas, abstract expressionism sought to invoke a claim to meaning. High modernism is indeed opposed to the postmodern image world, opposing auratic individuality to the play of the sign. The play of the sign is the play of form; auratic art always sought to break through form in a moment of dissonance. "Dissonance," Adorno states, "is effectively expression. . . . If expression is scarcely to be conceived except as the expression of suffering . . . expression is the element immanent to art through which, as one of its constituents, art defends itself against immanence that it develops by its law of form. Artistic expression comports itself mimetically, just as the expression of living creatures is that of pain" (*AT*, 110). The notions of suffering and pain that Adorno notes here are stand-ins for the whole range of the psychical articulations of injury and hurt: "sadness, energy, or longing. Expression is the suffering countenance of artworks" (*AT*, 111). The aura of a Pollock is nothing but anxious energy (as the record of its application) of the paint; the aura of a Rothko the countenance of somber depression. Our eye in responding to drips, blobs, webs of lines of paint, fields of color sees (a nervous, gestural) energy beyond any code or symbol, in Rothko's febrile color fields a depression beyond any linguistic articulation of it. *These works visually mean the way a body in pain means. That is their aura.*[11]

But this is a liminal moment since the auratic quality of the modernist work soon became neutralized, all too often not uncanny or terrifying but beautiful, decorative, desirable, and appropriable by all; worse, it began to signify art rather than life, to be seen as just the pure commodity fetish it always in part was. This moment of the withering of the claim of high modernism created a vacuum. Many artists and art practices attempted to fill that vacuum—through either emulation (Frank Stella, Cy Twombley, and others) or rejection (minimalism, conceptual art, installation art, happening art, whatever). Cindy Sherman's photographs are the fullest, most consistent and sustained response to this situation yet devised.

II. The Claims of Art, the Claims of Philosophy

Abstract expressionism retrospectively defines modernism not as a desire for presence or aesthetic purity or beauty or even sublimity, but as a quest for auratic individuality, for an illusion of otherness in the animistic/undead sense. To be sure, each of the items that I am contending modernism does not quest after has been thought to be its object by either artists or critics, and thus has been quested after. But in each case the meaning of that comprehension of its telos was meant to define a space beyond immanence as the principle of cognizability through repeatability (*DoE*, 12). The principle of immanence, identity thinking, is indeed akin to what Michel Foucault recognizes as "discipline" and Georges Bataille interrogates under the labels of "homogeneity" and "assimilation." The privilege of Adornoian immanence, in the first instance, is its tight linking to the emergence of modernity through processes of rationalization, and the power of that conception of rationalization to explain the modernity of both intellectual and societal practices, what Weber calls "intellectualism" and bureaucratization.[12]

From within the purview of rationalized thought, it seems logically appropriate to hold out difference or otherness against the claims of identity and the same; and it is the search for what constitutes irreducible otherness that drives the various conceptions of modern art in their attempt to salvage sensible uniqueness. Beauty, harmony (a closed totality), presentness, sublimity, the purely painterly, each differently stakes a claim to what constitutes this uniqueness. To affirm this series is not to underwrite its accomplishments as such, but to conceive of the past as seeking through art a nonconceptual form of synthesis that will oppose conceptual synthesis, rationalized identity, securing thereby an affinity between nature and human nature, a grounding of intellectual operations in a like-minded affinity with appearing nature as folded into the medium of painting. However it is figured, the Kantian moment of aesthetic reflective judgment as a *sensus communis* must form the core of any conception of modern art and aesthetics since it represents the moment at which art and the aesthetic receive their first rationalized articulation: the autonomy of art from knowledge and morality in a sphere of practice that must hold its own against these others. Beneath its surface, as it were, both parts of *The Critique of Judgment*, in the dual characterization of reflective judgment as aesthetic and teleological, as taste and as the judgment of the living, represent rational-

izations of the cognition of animism; mimesis of the living hibernates in those rational forms.

To place past modern art wholly on the side of homogeneity, say, overly simplifies the structures at stake—sameness versus otherness, operations of homogenizing versus operations of deforming without end—until the manner of connection between societal rationalization and artistic rationalization is severed. Aura as illusory animism closes the series of artistic modernisms, and does so persuasively because it can be tied to the ur-development of rationalized thought—the extirpation of animism. Part of my confidence that Sherman's work belongs to this tradition is that she emphatically defines it; while the thesis of the extirpation of animism is indeed a dominant leitmotif of Adorno's work (and of Horkheimer's), I doubt I could have seen its connection to Adorno's defense of modernism, and thus could not have read abstract expressionism in quite the way I have, without the exemplar of Sherman's work, itself comprehended cumulatively and through retrospection.

In saying this I mean to approach a model of what philosophical criticism of the arts does and how it relates to its objects. From the commencement of modernity, art criticism and theory as *intellectual* practices find themselves cut off from their object; their mode of working is henceforth incommensurable with art's own. In Horkheimer and Adorno's lexicon, the division of labor between sign and image is for the present unsurpassable; as a consequence, philosophy must restrict itself to work on the diremption between sign and image from the standpoint of the lifeless sign. Philosophy can *state* its own mimesis unto death, can talk *about* animism, can *rehearse* its participation in the extirpation of animism, but cannot itself make a truth-claim, cannot, that is, disclose an animate particular or even the illusion of one. Animism hibernates in image. But if image in this sense is but the fragmented material portion of the concept, then the artistic image, which is to say, art in its various manifestations (sound images, word images, movement images, line and color images, etc.) is a mimetic cognition; or more precisely, since mimetic cognition is what is excluded by rationalization, artworks are enigmatic things: in calling for explication and interpretation, they are more than things; but in denying that what they say can be discursively rendered, they are less than assertions.

Philosophical criticism thus becomes the effort of disentangling conceptual space in order to release the truth-claim, which only the work itself

can make. Works make claims, and hence our experience of works is a cognitive experience; but works cannot themselves say that is what they are doing; that task is left to philosophy. But the sort of claiming that works do is not wholly exterior to philosophy; the truth-claim of every (authentic/modernist) work of art includes the claim of auratic animism against the claims of the abstract concept and pure sign. Artworks make categorial claims, claims about sign and image in the language of image, by *being* sensuous particulars. Because artworks are privileged in making particular types of categorial claims, the traditional province of philosophy, philosophy needs art, depends upon it, in order to tell the truth about the concept. Philosophical criticism thus depends on art, and must hence abrogate its claim to self-sufficiency in order to retail the claim it must but cannot make about itself. Conversely, art needs philosophy, although remaining independent of it (in being irreducible to the abstract concept or pure sign), in order to discriminate and legitimate its claiming.

III. *Untitled Film Stills*: The Anxiety of Narcissism

Death is the *eidos* of [the] Photograph
—Roland Barthes

If abstract expressionism's success in producing auratic works overshadowed alternative art practices, the fate of aura itself throughout the 1950s and early 1960s was not so unequivocally triumphant. The production of illusory and so empty aura, most perspicuously in the Hollywood film and star system, and the continual disintegration of artistic aura in (and through) photography and pop art (among other places), troubled the meaning and being of auratic animism. However, the movement of the withering of auratic animism and the corresponding production of empty auras are not distinct processes, but dialectically linked extremes of a single process. Adorno and Horkheimer call that process "the culture industry." The complex trajectory of photography and the photographic image writes in miniature the development of the culture industry as a whole.

Like aesthetic reflective judgment itself, the camera enacts a work of passive synthesis: on the one hand, the photographic image is a consequence of a causal interaction between object and film by means of light; on the other hand, the camera through lens, focus, length of exposure, and, non-

mechanically, spatial positioning, cropping, etc., is a synthesis. Nonetheless, and disturbingly, the camera does not have to take up a disinterested stance or bracket the work of conceptualization; the mechanical (optical-chemical or automatic) process by means of which images are recorded, the registering of light waves reflected by objects, *ensures a disinterested gaze*, ensures that the photographic image itself is at least a causal index of, and thus causally bound to, the object producing it. Photographic images are mimetic in Adorno's sense in that in them there is an affinity between image (copy) and object: "Such images are indeed able to usurp reality because first of all a photograph is not only an image (as a painting is an image), an interpretation of the real; it is also a trace, something directly stenciled off the real, like a footprint or a death mask."[13] That moment in which an image is recorded by means of exposing a film to light waves is both a moment of affinity between image and object, and the mechanization and so rationalization of aesthetic disinterest. The emphatic causal indexing of the photographic image is a *mark* of disinterestedness and thereby a symbol for it; the internal connection between mark and symbol is the mechanism through which the photographic image secures its *authority*. This is what makes *every* photograph perfect: photography is the automatization of the disinterested stance that constitutes aesthetic reflective judgment.

From the moment Kant issued his doctrine of disinterested reflection, which is to say reflection that is neither explicitly cognitive (conceptualizing) nor governed by moral interest, the question arose of what the interest of such a disinterest may be. By mechanizing disinterest, the camera deflates the question: the complications of what it might be for an object to resist cognitive control or moralization can be evacuated if there are in principle no constraints on the scope of disinterested looking, if there is nothing needed in order to achieve it: click. In locating the possibility of every time discovering an affinity between subject (camera) and object, of every time securing the fitness of nature for cognition or the fitness of nature for enabling moral life, in making that fitness automatic, mechanical, then by the very fact of automating the problem, the question is dissolved, with any notion of fitness, amenability, consequently emptied. If the problem of aesthetics is the problem of how the aesthetic image connects to cognitive and moral interests, and that raises, again, the question of the interest of disinterest, where a disinterested stance is meant to be an achievement of some kind, then in making that achievement mechanical, the

question can no longer be asked. If the question can no longer be asked, then auratic animism must fade.

But the mechanization of aesthetic reflection equally inflates the scope and availability of aesthetic looking; because the eye of the camera can be trained anywhere, because any object or fragment of any object can be *the* object of the camera's indiscriminate gaze, then any object can be aestheticized, seen for itself, seen as worth seeing for itself, become an object of (aesthetic) interest: "But notwithstanding the declared aims of indiscreet, unposed, often harsh photography to reveal truth, not beauty, photography still beautifies. Indeed, the most enduring triumph of photography has been its aptitude for discovering beauty in the humble, the inane, the decrepit. At the very least, the real has a pathos. And that pathos is—beauty. (The beauty of the poor, for example.)"[14]

There is no disentangling the two sides of this process: the rationalization of aesthetic reflection through the technology of the camera withers aura by reducing disinterest to a mechanical process, which simultaneously can produce an aesthetic aura around everything. And, again, that process of de-auraticization in and through rationalized re-auraticization is, in miniature, how the culture industry, the so-called postmodern image universe, operates, continually decreasing the gap between image and object while transferring authority to the image produced. So, in miniature, is the society of the spectacle produced and reproduced.

Throughout its history photography has had to struggle against its rationalization and so liquidation of the aura of image and object. In "A Small History of Photography," Walter Benjamin condenses that eventual fate of the photographic image into the chilling curiosity of a portrait of the young Franz Kafka. The wide-eyed stare of little Franz, abandoned in the artificial setting of plants in a mock conservatory, sitting (standing) in his tight-fitting suit, hands holding an enormous hat, captures what was "deadly" in daguerreotypy, "the prolonged looking into the camera, since the camera records our likeness without returning our gaze," thus defeating the expectation that "our look will be returned by the object of our gaze."[15] The haunted eyes of little Franz are a mimesis of the dead gaze of the camera—an abbreviated vision of how the decay of auratic animism in object (subject) and image are entangled: in mimetically adapting himself to the dead-eyed stare of the lens, little Franz anticipates the fate awaiting the modern subject and conveys that back into the image of him. Every-

thing is right about this story except its starting point: little Franz's haunted eyes are incomparably beautiful.

Adorno's writing on the culture industry is governed not by a concern for its meaning or thereby a concern for its relation to high art, although these are indeed aspects of the analysis. Rather, its dominating thesis concerns the disappearance of the difference between culture and practical life. Culture now has the task of producing for everyone together the fit between the categories of the intellect and the objects of everyday experience, which formally was accomplished by what Kant entitled the schematizing work of the individual imagination. The space of schematism, imagination, and judgment all referred to capacities in the individual for relating the abstract universal (what belonged to the activity of the intellect) and concrete particulars known through the passivity of the senses; the space of reflective mediation was the space of individuality itself. Without that space, without the intellectual effort through which individuals found sense in particular circumstances by finding the universal most suitable to them, and conversely, finding ways of relating the categories of mind to experience, there would be nothing that belonged properly to the individual, nothing individuating them from others except the accident of birth and their specific spatio-temporal path through the world. In claiming that mass culture increasingly provides the schema for relating universal and particular, the difficult gap between them, between mental activity and sensuous experience, is crossed automatically. With the space of individuation thus preformed, individuals are given the identity handed out to them. "Real life," Adorno and Horkheimer state, "is becoming indistinguishable from the movies" (*DoE*, 126):

> The dream industry does not so much fabricate the dreams of the customers as introduce the dreams of the suppliers among the people. . . . As far as mass culture is concerned reification is no metaphor: it makes the human beings that it reproduces resemble things even where their teeth do not represent toothpaste and their careworn wrinkles do not evoke laxative. Whoever goes to a film is only waiting for the day when this spell will be broken, and perhaps ultimately it is only that well concealed hope which draws people to the cinema. But once there they obey. They assimilate themselves to what is dead. And that is how they become disposable. Mimesis explains the enigmatically empty ecstasy of the fans in mass culture.[16]

The mimesis unto death that is the culmination of the extirpation of animism was being carried out in American culture in the middle part of the

twentieth century through film. It schematized identity by producing clichés that represented both a hope and a trap. Whatever her intentions, Sherman's *Untitled Film Stills* circulate around and thematize this moment of crisis within the bourgeois self: individuality without individuation. And the works that come after only enlarge the diagnosis of the crisis and its scope.

Sherman states that she stopped making the *Untitled Film Stills* when she ran out of clichés. The pathos and energy of this claim will become apparent. Clichés here are schemata of the self—not simply trite ideas about the self, easy or ready-to-hand representations of ideas of selfhood, but commandments about who the self must be:

> When a film presents us with a strikingly beautiful young woman it may officially approve or disapprove of her, she may be glorified as a successful heroine or punished as a vamp. Yet as a written character she announces something quite different from the psychological banners draped around her grinning mouth, namely the injunction to be like her. The new context into which these pre-prepared images enter as so many letters is always that of command. The viewer is required constantly to translate the images back into writing. The exercise in obedience inheres in the fact of translation itself as soon as it takes place automatically.[17]

The command structure of the film cliché is the mechanism through which individuals are subjected to the schemata on offer. This, however, makes problematic the object of the *Film Still* series. It is tempting both because of the title of the untitled series and because so many of the photographs appear to explicitly refer to either particular film styles (*film noir*, Hitchcock) or actresses (Marilyn Monroe [or is it Kim Novak?], Lana Turner, Gina Lollobrigida) to think that the series is about the "fabrication of dreams," a poking fun at Hollywood's constant work of mythologizing character types or individual stars—which is done in the series and does represent their initial accessibility and charm—rather than being about culture industry clichés. While many of the clichés quoted in the *Film Still* series do appear to refer to identifiable moments of film, others simply belong to the more anonymous clichés that belong to the same period, clichés that may or may not belong to identifiable types of films—although perhaps they should have. I certainly dated the characters in #10 and #61, #9 is a friend of my sister's, and #15, well, everybody knew her (or pretended they had). These, and others like them, have the hallucinatory familiarity of film stills, but their banality points to a wider domain of cultural production, to an even more anonymous and invisible schematizing operation.

However, that even these more banal photographs can summon the kind of familiarity and identification that belongs to "film stills" themselves, underlines the stakes of the series: the power of the cultural cliché. Film stills, we might say, are thus both paradigms of the operation of the cultural cliché and thereby model the operation of such clichés inside and outside the filmic world.

It has not gone unnoticed that the *Film Stills* are clichés, copies without originals;[18] but the point needs extending. Even if someone could identity the very scene from the very film on which a *Film Still* is based, it would not help, because that scene too would be a copy without an original, a cliché, a stereotyped command to be a self of this or that kind. Sherman has continued to leave her works untitled; this being untitled has come to signify in the later works the gap between sign and image, how the authority of the sign can infringe upon the meaning of the image so totally that we feel disbarred from countermanding the lesson of the sign, to encounter the image. In the later works, then, being untitled is at least part of a strategy of giving back to the "unsigned" image its autonomous authority. This is not the case in the first series, where being "untitled" carries a different sense: there, I think, her assumption is that it would be contradictory to give a proper name to the representation of the depersonalized and anonymous yet auratic clichés of the culture industry that, through their very anonymity and familiarity, close the gap between culture industry and everyday life.

The remainder of the title of these untitled works is equally significant. Many, if not most, of the *Film Stills* catch a character in mid-action, so that we imaginatively project onto the scene a narrative structure, the very narrative, so to speak, from which the still has been culled. For example, in #40 (Figure 15), an innocent is perched on a crumbling wall expectantly, if not a little too self-consciously. She is lower middle class and with an effort is dressed to look proper and decent. She is sitting outside her own family's apartment block and is waiting to be picked up by her date, who we imagine, although from the same class as she, is less constrained by lower-middle-class proprieties. The narrative speaks to the fragility of her self-identity, the crossings of desire, fear, expectation, anxiety. But, of course, there is no narrative here, no story; everything is already decided. The narrative, the film we mentally screen, is a "still," stilled and frozen; hence the unfolding temporality that is meant to be the prerogative of the film over the photo-

15 Cindy Sherman. *Untitled Film Still, #40.* Courtesy of the Artist and Metro Pictures Gallery.

graph is a deceit. From the perspective of the function of identity production and recruitment, the truth of filmic temporality is the still.[19] And that reduction is meant to be telling against both film and photography. In being captured by a cliché, a still, each character portrayed is enacting a mimesis unto death; they are the vehicle and the victim of the cliché they exemplify. Yet each still is more than this, more than the cliché it quotes; the more is the aura each still emanates. That aura is complex, at least double: the empty aura of the cliché itself, which is co-extensive with its power as cliché, and then the aura of Sherman's picture. Inauthentic and authentic auras are interwoven in uncomfortable, because not easily discriminable, ways.

The way in which each quoted cliché is both an object of desire and a command is the original cliché's aura (an aura that is uncannily quoted by Sherman).[20] Sometimes, Sherman subjects the auratic quality of the original cliché to ironic treatment by placing a halo around the head of the character (#13, #21, #22, #47, #50, #53). Unless each quoted cliché pos-

sessed its own aura it would not have the power to make its ready identification simultaneously an act of recruitment. Our identification of each cliché, our ability to name it and identify it "as" this or that stereotype, is the mechanism by which it slips into our consciousness, generating our identification "with" the character. We see through the cliché, seeing it as a cliché, and nonetheless "obey." Adorno contends that this movement whereby we both see through (translating the image/hieroglyphic back into writing) and obey (identify "with") is the fundamental mechanism of the culture industry; the time and effort of translating the image is the means through which under the guise of letting itself be objectified under a concept (letting itself be conceptually mastered) it secretes itself into consciousness.[21] Even more emphatically than the cliché being an object of desire (and these clichés would be nothing if they did not model a temptation and thereby become one), seeing through enables desire to operate behind the back of the knowing viewer. The culture-industry effect thus operates in a manner that circumvents our insightful guarding against it; rather than our identifying with and seeing through being something that destroys the illusion and credibility of the image ("how very Hitchcockian"), that work of mastery is the means through which we are in turn mastered.

Sherman too insists upon the auratic quality of the quoted cliché; even before she has quoted them and worked upon them they are identifiable as clichés, and their being so identifiable is a part of their allure rather than anything that undermines it. One way of underlining this point would be to notice that in some of the darker *Film Stills* the obvious artifice of quotation—framing, pose, angle of vision, etc.—is dropped, and we are tempted, almost, to forget that these are quotations, and thus are almost, not quite, exposed directly to the cliché itself. Compare the artificiality of, say, #13 with the directness of #27; quote, unquote, but both clichés.

The Untitled Film Stills are a mimesis of the mimesis unto death of the quoted cliché. The second mimesis is the distancing work of Sherman's art. Here most especially, but elsewhere throughout Sherman's work as well, there is an interrogation and critique of photography—because if the overall disposition of photography is its production of illusory auras, an aesthetic form of death, then any authentic photograph must mount a certain work against the medium. Each Sherman picture to a greater or lesser extent flags and calls attention to what I shall call, simply, "the setup." Every element of every picture is carefully and explicitly placed in a way that makes

it impossible not to be aware that they are so placed. The pose, the frame, the lighting, camera angle, cropping, fore-shortening, background, whatever—all are presented and presented as artifice. There are no natural objects or disinterested observings of given scenes. Both sides of the dialectic of the photograph, its disinterest and its interest, are bracketed, made into second-order constructs detached from the camera's mechanized and automatic judgment. By so explicitly producing the scene to be photographed, and so explicitly deploying and displaying the options that she as photographer has under her control, Sherman undermines the natural authority of the photographic image. Neither the causal indexing of the image nor the beautifying effect of the camera's disinterested, aestheticizing gaze is permitted to operate. However, both are quoted.

If Sherman's setups intrude upon and undermine the source of the photographic image's authority, then how can we account for the authority of the *Film Stills*? Her ability to so accurately capture, recapture, or convey a cliché, however seductive and intriguing, cannot be the source of authority since, at that level alone, the power of the stills would be no better than, say, a comedian doing an impersonation; nor, I have suggested, can the fact that she enables us, by flagging the setup, to see through the illusion be the source of authority since enabling in that way is a function of the culture industry. In this respect my referring to the *Film Stills* as quotations of clichés has been misleading because quotation tends to imply ironic distancing, an easy movement from being caught in a deception to emancipatory insight. Not only does the culture industry's strategy of permitting us to see through and obey anyway itself turn ironic distancing against the ironic observer, but the engine of the *Film Still* series, the endless proliferation of clichés, filmed and banal, calls into question the privilege of ironic distancing, hence the very idea of the privileged bourgeois subject who can oversee and stand apart from the identities on offer. Consider: if there had been just one *Film Still*, then its power would be ambiguous, perhaps not much better than a photographed impersonation, a parlor game. It matters that this is a large series, sixty-nine pictures in all, and every one of its images a cliché of selfhood. The cumulative effect of the series, especially when seen altogether, is thus to throw into radical doubt the conceit of the autonomous—individuated, ironic—subject, and to pinpoint the blame for this disappearance on the culture industry's employment of the technology of image production.

Sherman cannot plausibly be seen as questioning the idea of the autonomous subject, but only its existence. She cannot plausibly be seen as stating or claiming or wanting to claim that the truth of the subject is that it is, in idea and reality, nothing but a tissue of clichés—although this would be the natural postmodern reading of her. For all their nostalgic glances at a recent past, all their easy charm, cleverness, and knowingness, the *Film Stills* convey something disconcerting, dark. And it is in the territory of their darkness that their authority as works resides. It is a widely noted feature of the *Film Stills* that the characters portrayed are routinely caught in moments of unguardedness, transition, preparation, exposure, of being somehow inside and outside the very clichés they embody. Even the most assured characters (such as #37, #50) are a little too assured, as if needing to attain or appropriate their secure identities. As Laura Mulvey states: "Sherman accentuates the uneasiness by inscribing vulnerability into both the *mise en scène* of the photographs and the women's poses and expressions."[22] Can the scope of vulnerability, the anxiety of identities that prohibit individuation and hence do not permit their inhabitants the possibility of attaining a relation of subjectivity *to* the world, be restricted and localized to the characters portrayed? The presumption of this restriction is unequivocal in the literature. For example, Verena Lueken states:

> Cindy Sherman's *Film Stills*, despite the fact that the artist features in all of them, are not self-portraits. She is her own model and, as is the case with all models, this does not make her the subject of her art . . . she does not surrender to the voyeuristic lust she provokes. She is the object of the beholder's regard but controls it too, because as photographer she directs it. It is thus the beholder, not the artist, who forfeits his status as universal subject. . . . As an artist she is in complete command of her means. As her own model she is a host of intensified clichés. And as a person she admits to being just as confused as anybody else.[23]

All of this seems to me exactly wrong.

As already stated, if Sherman had made just one *Film Still*, its effect would not be the one delivered by these photographs. Part of the unease and fascination of the *Film Stills* is that we are intensely aware that in each and every one, besides the character portrayed, we are witnessing Cindy Sherman. Hence, what begins as a marveling at her ability of impersonation and disguise—the apparent mobility and indeterminacy of her features that permit her to take on so diverse a cast of characters—becomes increasingly a site of anxiety. And here it begins to matter terribly that these

are photographs, and that as such there is going to remain the causal indexing of the image to the original—the "death mask" of the original object, as Sontag has it. The indexing of image to original is what transforms the sense of what being a "model" means between painting and photography. The camera's disinterested gaze pierces the artifice of the setup, the elaborate paraphernalia of scene, pose, and construction, and by the very reiteration of images imposes a wholly indeterminate singularity as the anxious object of each picture: this is Cindy Sherman. The more of each photograph, its auratic power and animism, turns precisely on the excess of each beyond artifice and explicit content that is a consequence of the combination of the camera's mechanic looking and the proliferation of images, each being part of an indefinitely long series.

What is finally most disturbing about the series is that it can be nothing else but self-portraits. *The story they tell is, finally, of the unbearable tension between anxious singularity and clichéd identity.* The narcissistic self is both fascinated by its self and has no self with which to be fascinated (something queasily evident in pictures #2, #13, #39, and #81, for example, that have narcissism as their topic); hence, Sherman's proliferation of self-images achieve their haunting power by exemplifying the desire for self in each of the inadequate forms that denies it.[24]

Notice how desperately Lueken has to parcel out Sherman's various identities in order to sustain her position as being in "complete command" and remaining a "universal subject": Sherman as model, as artist, as person "just as confused as anybody else." Model, artist, confused modern person (who is different from the model who is different from the artist, who alone is a universal subject in command): are we not here being offered intensified clichés of the very kind that Sherman is interrogating? The space of command, direction, control, of being a universal subject who has the codes of culture at her command, would seem to be the very thing Sherman is denying us.

One of the conceits of the late-high modernism of abstract expressionism is that, despite its skeptical denial of the conventions sustaining bourgeois culture and its insistence on a domain of material meaning that remained other to and the other of hollow cultural codes, there still remained the myth of the artist-as-hero who was able, through the sustaining individuality of artistic genius, to uncover, recover, or create a domain of material meaning that lay beyond the social banalities; try as we might, it is ex-

tremely difficult to extirpate from our experience of a Pollock the crude and misdirected thought of each as a record of *his* actions in producing them (which I take to be part of what Barnett Newman thought he had to resist in Pollock's idea of painting). Whatever the space of creation afforded those painters, it was emphatically less than the reassuring individualism of the stereotype of artist-as-hero. In describing the *Film Stills* as a mimesis of the mimesis unto death, I am implying how minimal that space is, how minimal, marginal, difficult Sherman shows us that space to be. Adorno comments: "But since as subjects men themselves still represent the ultimate limit of reification, mass culture must try and take hold of them again and again: the bad infinity involved in this hopeless effort of repetition is the only trace of hope that this repetition might be in vain, that men cannot wholly be grasped after all."[25] The culture industry's bad infinity of subjection is rehearsed and represented in the *Film Stills* series in order to reveal both the bad infinity itself and, by virtue of the repetition of the cultural repetition, that Sherman herself is that ultimate limit, the excess that breaks through the camera's aestheticizing gaze, the allure, seduction, and aura of each cliché. Unless these photographs were self-portraits, there would not, could not, be a breakthrough.

IV. Searching for the Limit

In contending that the auratic power of the *Untitled Film Stills* is an animism, and this animism the moment of excess or breakthrough beyond the image, there is implied a pathos that is, finally, incommensurable with the image itself, where this pathos must be regarded as a consequence of the causal indexing of the image to, let's call it, the fact of Sherman herself. Her interiority is distinguishable from the interiority of the characters portrayed as the effect of her reiterated appearance with each portrayal, and hence, because it is bound to the excess within the repetitions, can appear only as responsive affect and not as image. The pathos of singularity is the photographic equivalent or recapitulation of the first defiant moments of the exhibition of paint-on-canvas of early modernism—in Manet or Van Gogh, for instance. The analogy is more exact than it appears once the time lag between the two moments, with all its restricting consequences, is taken into account. In both cases, the stakes are the authenticity of works themselves rather than, or in opposition to, the illusion of the represented object. Un-

less the representing could bear the weight of being an object of unconditioned attention, then neither could what was represented. Van Gogh's displaying of paint-on-canvas does not substitute the painting for the represented object, but sets up an inner affinity between the arrangement of matter as the condition of representing and the material object represented in order that the worth or dignity or authenticity of each is revealed.

Sherman's sphere of operation is far more severely restricted because illusionism is no longer contrastive between art and reality; it has become pervasive. This is part of the reason the display of the setup is not sufficient to engender a moment of materiality. The artifice of the setup, to be sure, signals the mediation, the fiction-making or creating of what is portrayed against photographic realism; but because empty artifice, mere convention, is pervasive, simple display cannot provide escape from it. Only Sherman's self-same presence, by its repeated insistence, reveals itself as more than the collocation of codes inscribing it. Each photograph then is a sublimation and expression of the anxious singularity that is the remainder and limit of the culture industry's relentless production of clichés. To run out of clichés to repeat is thus an intensification of the crisis of subjectivity that is the incipient cause and meaning of the series.

The illusion of command and control that the *Untitled Film Stills* emanate is a consequence, I think, of their retrospective character: these *were* the clichés of identity in which Sherman grew up. The temporal distance between the clichés' time of appearance and her re-presenting them is what enables their ready identification, and provides the patina of datedness that allows them to evoke a nostalgic mood. Because, as Sherman clearly knows, if what is portrayed is nonetheless the culture industry's relentless work of subjection, then the distancing enabled by the retrospective setting of the series is itself an illusion. Without the balm of distance enabling identification, the operation of subjection becomes truly anonymous and therefore ever more threatening. The *Film Stills* portend this exacerbation of the crisis.

The indeterminacy and ambiguity of Sherman's first forays into color in the early 1980s are a consequence of the running out of identifiable clichés from her formative past. The lifting of the veil of nostalgia separating past and present is marked by a movement from the comforting black-and-white format of the *Film Stills* into an insistent brightness; the employment of color functions as a tense operator enveloping the new images (while this may be thought to be ambiguous in the rear-screen projections, it is

perspicuous in the centerfolds and pink robe series). The explanation of why these photographs are not as uniformly successful as their predecessors is that Sherman is unable in them to insinuate the complex exchange between cliché and self that was the pivot of the earlier series. Without that complex exchange with the eventual surfacing of herself in each image as its sublime effect, the immediate aura of each of these pictures is often as much the aura of the cliché as its representation. And the reasons for that are clear: the clichés being worked are not as readily identifiable as in the first series; there are not as many of them—so the cumulative effect of repeating a repetition cannot get started; and in their (mostly) very presentness, the access to a space of separation between the model and what is being modeled becomes radically abbreviated.

While accurate, this explanation is too quick in one respect. Implicitly, Sherman must be aware of these difficulties since these pictures hesitantly begin to search for and dramatize new ways of figuring the limit of cliché, of figuring a significant materiality of meaning that will animistically exceed the image and imply a material or somatic reality that the clichéd image cannot capture. Neither light nor color (#74), nor contrast between character and back projection (#66), nor the use of close-up (#76), nor dissolving the image into the background (#69), nor setting off the colored image of self against a black background (#112, #116), nor the implicit continuity of self and pink robe (#97–#99), is adequate to this task. But the diversity of strategies does make evident that they are strategies, and it underlines the consistency of Sherman's desire: to find or uncover a limit to the images of self overwhelming her that give her only herself as a possible subject (object) of reflection. And while these photographs do figure materiality as that limit, they nowhere consistently insinuate that materiality as animate and dislocated by the insistence of clichéd images perspicuously lacking interiority. Or perhaps more accurately, all the problem of interiority in these pictures is condensed into the eyes: do they look back?

To my eye, the centerfolds are exemplary of the problems here. In them it is above all not the look but the interior of the characters that is clichéd: erotic reverie, adolescent desire, neediness. Singularity cannot break through in these pictures because the characters themselves are already isolated, abandoned, through their desiring; thus the implied excess of self over image is crowded out. And while Rosalind Krauss is correct in pointing to the shift from the vertical to the horizontal axis as a presentational strategy, that shift

cannot carry the burden of a critique of the cultural and above all art-historical fetishization of the vertical axis, which has become the terminal point in the sublimation of animal desire into beauty. Unlike with Pollock and his successors, there is no hint of the pull of gravity or the return to materiality in Sherman's pictures. On the contrary, some of these photographs (such as #87) come dangerously close to becoming vehicles for what they mean to resist.

This is not surprising since, on the one hand, the cultural coding of vertical and horizontal is heavily conventional (horizontality in the context of the world of centerfolds is anything but critical); on the other hand, there is nothing in the photographing of the horizontal human figure to halt its becoming another fetish. Like some other early colored works, the technical transformations that Sherman employs in these photographs lack the full force of negativity. Their technical maneuvers are unable to sufficiently abstract from the clichés they mediate; and given the hegemony of the cliché for purposes of identity formation, there is no reason to think that simple technical rationalization of the image could accomplish this end. If the culture industry hasn't in each case arrived there first, it will have. This begins to suggest the kind of achievement the *Untitled Film Stills* is. In the *Film Stills* temporal lag not only permits a certain distancing, but together with the repetitions of the series, it functions as a force of negativity and abstraction. As Sherman evidently came to recognize, in order to generate the negativity necessary to reanimate the dead image, to locate the limit of the cliché through the image, she would have to get behind the cliché, to image and express what it excluded.

Or perhaps a better way to express this thesis would be to say that in the *Film Stills* Sherman accidentally discovered how repetition could be deployed as a force of negativity that enabled her to invent or reinvent photography as an artistic medium; but this invention or reinvention did not transpire through repetition alone: it depended on the *precise* relation between repetition and the *genre* of the "original" (film stills). It was the nature of the genre of the film still (its generation of stereotypes of modern female identity) that allowed repetition to take on the force of the negative —from which it follows that repetition could not be counted on to bear the burden of negativity, which is, nonetheless, the necessary condition for the institution/invention of a photographic medium against photography as mechanism. The future of her art would hence come to rely on the

crossing of three formal constraints: the *stilling* of a narrative/temporal movement into an image from a *genre* whose temporal or horizontal unfolding could be discovered to be completed, in the service of the stilled image, which, internally, displayed the *disintegration* or *rematerialization* of the object imaged. It is this last that bears the burden of negativity, call it abstraction, in her later works. And if each genre so transfigured can hence be thought to be the invention of a new photographic medium, it is nonetheless the discovery of the equivalent of photographic abstraction that makes those inventions possible. And that discovery, I now want to argue, depended on Sherman's coming to see something very specific about the relation between abstraction and negativity, on the one hand, and the categories of traditional art and aesthetics on the other.

V. The Ugly and the Beautiful

With the "fashion" photographs of 1983–84, Sherman begins to include in her pictures what the clichéd image itself excludes, deforms in excluding, leaves behind as remnant, or, perhaps, coming at it from the inside out, how the subject conceives of herself in relation to an image she must fail. The fashion cliché prolongs through the mediation of the image of what used to be accomplished through binding, corseting, painting, piercing, and now continues through the efficacy of the surgeon's knife or the poison sting of a botox injection. But the cruelty of the disciplinary practices necessary to create female beauty have always been mediated by and depended on the *image* of beauty, and could not have operated in its absence.

Categorially, beauty has always contained a moment of cruelty through which the recalcitrant and threatening materiality of nature and the human body were formed, tamed, idealized: "[A]rt's own gesture is cruel. In aesthetic forms, cruelty becomes imagination: something is excised from the living, from the body of language, from tones, from visual experience. The purer the form and the higher the autonomy of the works, the more cruel they are" (*AT*, 50). Long after the canons of modern art had recognized the cruelty of beauty and dispensed with it (a point I shall return to), and in a sense were forced to do so through the interruption of their unfolding caused by the discovery of photography, the demands and claims of beauty did not simply live on, but grew and intensified through the medium of photography. The fashion image testifies to the radical failure of artistic

modernism in its attempt to expose the cruelty of beauty by surgically removing from the picture surface the illusion of natural form or the innocence of rational harmony, and leaving behind the scars of its own unnatural forming process. In the fashion image the cruelty and irresistibility of the beautiful reach a deadly perfection before which the endeavors of painting and sculpture are powerless. If the camera is the mechanical realization of the human power to take up an aesthetic stance that can transform the ugly into the beautiful, then finally only through the photograph can the violence of image-making be exposed. The continuation of the dialectic of artistic modernism in photography is no accident, but a categorial necessity. Perhaps we could say that in her fashion pictures Sherman avenges modernism for the absorption it suffered in the Cecil Beaton photographs that used Pollock as their background accessory. But does not the Beaton/Pollock episode demonstrate why only photography could exact this vengeance? And that it would need to do so if modernism were to continue?

While the cruelty of the fashion image is not a new thought with Sherman, her handling of it in relation to her general concern for the culture industry's rationalization of subjectivity brings to the surface, quite literally, both the implicit negativity of her earlier works and the claims of the animate body, now forcibly appearing as the ruined other of the painful abstractions and subsumptions of the ever-changing, always-the-same cultural cliché. What gives these photographs their eerie power is that in them both the fashion image and the ruin it creates and masquerades inhabit the same image space, thereby reversing the camera's aestheticizing gaze. In this reversal there is equally a reversal of a historical dialectic: traditionally, art's spiritualization of nature demonstrated its unlimited reach by making the ugly beautiful; this, we have seen, the camera's disinterested gaze accomplishes almost automatically. Sherman's making the beautiful ugly signals for the first time in her work, sometimes comically, sometimes horrifically, the claims of nature against its wholesale submersion in a process of aestheticization without limit.

Earlier, I suggested that the power of the *Untitled Film Stills* depended on a moment of dissonance rather than simple ironic distancing. "Dissonance," Adorno states, "is the technical term for the reception through art of what aesthetics as well as naïveté calls ugly" (*AT*, 46). Throughout the history of art, the ugly has dynamically represented the counter-image to art's law of form, its beautifying: "The ambiguousness of the ugly results

from the fact that the subject subsumes under the abstract and formal category of ugliness everything condemned by art: polymorphous sexuality as well as the violently mutilated and lethal" (*AT*, 47). At this level, however, beauty and ugliness are simply mutually defining categories: ugliness is the negation of beauty through which beauty tests its strength. Because the canons of beauty change, so do ideas of ugliness. The contrastive use of beauty and ugliness leaves beauty innocent. Only when the cruelty of beauty becomes apparent can the ugliness of the beautiful itself be detected.

> Just as during the Olympian age the amorphous power of myth was concentrated in a single deity who subordinated the all and the many and retained its destructiveness, great artworks, as destructive works, have also retained the power to destroy in the authority of their success. Their radiance is dark; the beautiful permeates negativity, which appears to have mastered it. As if they feared that immortality would draw out their life blood, even the most seemingly neutral objects that art has sought to eternalize as beautiful radiate—entirely out of their materials—hardness, unassimilability, indeed ugliness. (*AT*, 50)

Adorno's retrospective deciphering of the ugliness of great art is intended as one exemplification of Walter Benjamin's thesis that there is no document of civilization that is not at the same time a document of barbarism. Fashion images take over and unashamedly employ the destructive element of beauty: blatant stylizing, sculpting, and distorting are its routine mechanisms of beautification. What the traditional artist sought to hide, the fashion photographer triumphantly exploits.

From the vantage point of the fashion pictures, one is tempted to say that the negativity and dissonance of the *Untitled Film Stills* was as much a function of their subject matter as a thought through intention. Confronting the fashion image, however, Sherman could not avoid engaging with the inner identity of the culture industry cliché, its aestheticizing function, and the deformation and exclusion of the animate body involved in that process—its inclusion through exclusion, its de-animation. In so doing she reignites a central dialectic of artistic modernism. The fashion image is not only one tentacle of the culture industry's withering of aura and displacing it with an empty aura; for Sherman that empty aura marks out the fate of the artistically beautiful, spelling out the ugliness, the cruelty, and the violence it always contained anyway. Because a reified conception of beauty is so fundamental to the operation of the fashion image, Sherman could not negate it without simultaneously calling into question the artistically beau-

tiful itself. Without the inflected interrogation of artistic beauty, Sherman's photographs would have been social critique, while remaining outside and irrelevant to the major lines of development of modern art. Hence, at their most obvious level, the work of the fashion images is to make visible the cruelty of beauty, contrasting fashion image with its violent offspring, what it excludes and thereby reproduces through expulsion. In *Untitled #132* (Figure 16), the neat red-and-white-striped dress is set off by the model's ravaged face, past cosmetic repair, and her dissoluteness: cigarette, beer, dirty fingernails—the trademarks of the working-class male and, simultaneously, the debris of hygienic culture. The whole of this photograph operates as a genealogy of what fashion simultaneously repudiates and produces: the grim dialectical entanglement of beauty and ugliness. The come-hither "woo" of the model in the—comical—*Untitled #131* is mocked by the swirling cloth breasts of her golden fashion-bodice top; fashion here thus becoming a prosthetic that displaces into sheer materiality (as is echoed in the flowered wallpaper backdrop) the sexual desire it is meant to express and thereby engender. With her hands both covering and, apparently, stimulating her sex, we are left in do doubt as to the narcissistic target of her erotic look. If the logic of beauty and ugliness sets the terms for Sherman's later works, it is those swirling, prosthetic breasts that best hint at their material content.

I imagine Sherman's discovery here to be driven by the insight that, given that the mediations proper to photography—the setup—are fully in league with the photographic gaze, then there are left, logically or structurally, only two fundamental ways to overcome the automatism of the camera's aestheticizing work of mortification, to ruin its unfailing perfection: either to introduce *into the photographic image* itself the purposelessness proper to art meaning, something Gerhard Richter achieves through the painterly mechanisms of blurring and grisaille; or, allowing the camera its immediacy, indeed to depend on its realism effect, to somehow "abstract" the photographic *object* (which of course is ambiguous between the object photographed and the image of that object). Those prosthetic breasts hint at how this is to occur. Sherman's work on the photographic object transpires through the production of what might be called material allegories. She allegorizes the mortification produced by the photographic regard by artificially anticipating its result in the object, offering to the camera's disinterested gaze just and exactly what its looking creates through

16 Cindy Sherman. *Untitled, #132*. Courtesy of the Artist and Metro Pictures Gallery.

exclusion. So we can come to see the ravaged face of the model as what is produced and excluded through the beautifying work of the fashion image; and the swirling breasts are both the reified result of reducing sexual appearance to immediacy and a too real, exorbitant excess overtaking the model's demure self-desiring.[26]

By finding objective correlatives for the camera's work of mortification, its making each immediacy into a frozen past, Sherman anticipates the photographic violence and gets there first. But this anticipation is, of course, just the logical extension of what posing for the camera involves. It is because to pose for the camera is already to make ourselves into the objects we become in its gaze that the apparent and obvious artificiality of Sherman's constructions (of self and objects) in fact is not so; on the contrary, the constructions elaborate both our anticipations of being photographed and the inevitable consequence of being photographed (which is why we pose: resistance is useless since even not posing will in the end appear to be a posing); hence they make visible the intrinsic structural dialectic of camera and object, the exchange between camera and subject that occurs with each click of the photographic button. It is this logical backdrop of her practice that makes her constructed scenes anything but artificial, mere constructs; a significant component of the authority of her works depends on this.

Another component involves the deployment of photographic realism against itself: because the camera cannot look away, so to speak, from these prepared analogues of its work of mortification, then what it *compulsively* pictures is the very thing that its automatism meant to overcome: what cannot be beautified. Perfected, hypnotic ugliness is the ever-again surprising consequence of its transformed looking. It is sometimes said that Sherman is not a photographer but an artist, who happens to create pictures through photographic means. I am arguing the converse thesis: that the authority of Sherman's pictures is their consistent work against the structural logic of photography, its automatism of the disinterested look.[27]

One additional thought is necessary at this juncture. I have urged that a central mechanism of Sherman's later works is the provision of objective correlatives of the camera's reifying gaze; and I have further suggested that one of the ways in which fashion photography is useful in this regard is that it so overtly operates in an analogous way: the posing of the model is the work of abstracting from reality in order to create a second-order image that

is independent from its living original, leaving behind, ideally forever, what does not fit the ideality of the fashion image itself. And again, Sherman's effort is to place its excluded other together with the fashion image. Sherman's dawning recognition at this juncture is that there already exist artistic *genres* whose task it has always been to make visible the excluded other; and hence, rather than one-by-one finding objective correlatives, she could tap the logic of existing artistic genres by transforming them into photographic genres. The genres—fairy tale, horror, pornography—are forms of abstraction, but forms of abstraction that nonetheless remain within the ambit of representation. That says something about both what abstraction is and what representation is, and how conceiving of them as direct opposites falsifies both. Understanding the normative authority of Sherman's later works thus necessitates understanding the logic of these genres, their underlying truth content, and explicating how that truth content can be turned toward the ends of photographic modernism. This bundle of discoveries is what makes Sherman's work on the fashion image a turning point: it foreshadows the fairy tale, *informe*, disaster, horror, and sex pictures and directly relates to the art history and mask photographs.[28]

As we shall see, with the art history and mask photographs it becomes plausible to regard Sherman as going beyond the problem of contemporary art and society and consciously raising the stakes of her photographic interrogation to include the categorial constitution of both modern representational art and art in its most primitive and archaic forms. This is to say that eventually her art comes to encompass the role of art itself in the formation of subjectivity, and hence its complex historical complicity in the contemporary decomposition that is tracked from the *Untitled Film Stills* on.

VI. Tragedy, Sublimity, Horror

> The legacy of the sublime is unassuaged negativity, as stark and illusionless as was once promised by the semblance of the sublime. This is at the same time the legacy of the comic.
>
> —T. W. Adorno, *Aesthetic Theory*

Much of the difficulty in understanding and placing Sherman's work derives from its nonchronological relationship to artistic modernism: it appears simply to come after the collapse of high modernism. As is generally acknowledged, the reign of photography was both an incipient cause and

a cultural pressure that forced painting into abstraction, thereby leaving photography and film free to explore the human figure in representational terms. However, what that reasonable story leaves out is that the departure of painting from the field of representation and the freedom of photography simultaneously produce the *insistence* within photography of art's laws of form and hence the categories of aesthetics that artistic modernism had been busying itself transforming. It is because those laws of form and categories have remained insistent within photography, and because the culture industry has so fully appropriated and exploited them to its own ends, brutally fulfilling them in the fashion image, that the critical efforts of modernism need to be reworked, done again, in photography.

In saying this I do not wish to deny the appropriateness or usefulness of the categories of either feminist aesthetics or psychoanalysis for understanding Sherman's oeuvre; but if those frames of reference are permitted to saturate our understanding of her work, then we will end up repeating the dislocation of photography from the art practices that perhaps too quickly surrendered the human subject to the manipulations of the camera's disinterested gaze in the first instance. My offhand remark that Sherman's *Untitled Film Stills* recapitulated a moment of early modernism needs to be extended. Her work, chronologically coming after modernism, *begins* at the moment of cleavage between painting and photography and recapitulates the dialectic of modernism, the dialectic of negativity and negation that was its dynamic principle, *in photography* but under a dual constraint: she must engage the subject that has emerged as a consequence of that cleavage, while resisting the temptation of regarding abstraction and negation as leading to a focus on medium and form, as an exploration of the potentialities of photography itself. Photography cannot follow the path of literature, painting, music, or sculpture because, quite simply, photography is not an art but a *general* medium, a technology, a language, requiring thus that the invention or reinvention of photographic mediums as artistic mediums must be explicitly mediated by something other than the material presuppositions of the practice—something that I have argued, following Cavell and *pace* Greenberg, is equally true of painting but is only now being appropriately acknowledged as the return of modernism, its lateness, becomes an explicit issue for art. Sherman's photographic modernism will not transparently look like modernism in the other arts, but that look was always a red herring.

Although Sherman's photography provides a critique of the harmonistically beautiful, and elaborates on an analogue of the modernist sublime, photography as a general medium and not an art medium does not appear to have material presuppositions for its practice that would allow it to retreat to them for sublime effects. I would guess that it was in part the uselessness of the standard vocabulary of aesthetics—harmony, beauty, sublimity, taste, dissonance—for the purposes of comprehending her work that led critics to less traditional hermeneutical frameworks. The mistake in this desertion derives from an overly aestheticized conception of the sublime as the contrary of the beautiful. While the tradition and history of the beautiful has been continuous, the sublime would appear to be a uniquely modern category, and hence not as tightly conceptually bound to the discourse of beauty as it first appears. The sublime, I want to suggest, is the modern analogue and successor to tragedy; and one dominant line of photographic modernism involves, almost, a synthesis of tragedy and sublimity. We call that twisting together of tragedy and sublimity "horror."

Near the center of his analysis of the culture industry, Adorno notes that its reigning over society is synonymous with elision of tragedy. In making this suggestion, Adorno is not claiming that tragic phenomena are absent from mass culture; on the contrary, "the culture industry stakes its company pride in looking [suffering] manfully in the eye, and acknowledging it with unflinching composure. The posture of steadfast endurance justifies the world which the posture makes necessary" (*DoE*, 122). If the culture industry eliminated all suffering from its precincts, it would descend into sheer escapism and amusement, forfeiting its photographically inspired principle of the exact reproduction of phenomena. Rather than remove tragic material, the culture industry adopts and administers it: "Tragedy, included in society's calculations and affirmed as a moment of the world, becomes a blessing. It deflects the charge that truth is glossed over, whereas in fact it is appropriated with cynical regret" (*DoE*, 122). The culture industry's strategy for handling tragic subject matter is various, but it tends in one of two dominant directions: either tragic fate is turned into just punishment for not cooperating with society's ways, or by a miracle of integration the outsider finds refuge, surviving his or her ruin and thus again confirming the defenselessness and weakness of the individual in comparison to society: "Today tragedy has been dissipated in the void of the false identity of society and subject, the horror of which is still just fleetingly vis-

ible in the vacuous semblance of the tragic. But the miracle of integration, the permanent benevolence of those in command [monopoly], who admit the unresisting subject while he chokes down his unruliness—all this signifies fascism" (*DoE*, 124).[29] The hegemony of the cultural cliché and the eclipse of tragedy are two sides of the same phenomenon: "This liquidation of tragedy confirms the abolition of the individual" (*DoE*, 154). The liquidation of tragedy, I want to contend, explains in part the prestige and importance of abstract art throughout most of this century since it is through the latter that the claims of auratic animism have been sustained.

More precisely, my thought is that the "pity, fear, and catharsis" structure of tragic experience lives on, after the collapse of narrative as the conveyor of individual fate, in the "pain/pleasure" structure of the modernist sublime. And, to rush ahead quickly, while the genre of horror was originally bound, in novel and film, to the plot demands of tragedy, it is noteworthy that what might be called "realist horror," in which spectacle triumphs over plot, began coming into dominance around the same time that the centrality of abstract art began to fade.[30] Realist horror movies are moving film stills. Much of Cindy Sherman's late work is to be understood as high art appropriations of realist horror.[31] What makes sense of that appropriation, its claim, is the discontinuous philosophy of history that has tragedy being transformed into the sublime, and the sublime into realist horror. What these transformations map are the forms of availability of auratic animism, that is, the decreasing availability of the animistic person for representation and the art-historical forms in which the claims of animism, broadly speaking, the preponderance of nature and the focal, orienting significance of the human body, continue to be made. Reductively, the series operates in accordance with rules of inverse proportion: the more reified individual life becomes, the less narrative can be its organizing frame of reference; the less narrative is the organizing frame of reference, the more abstract, disorganized, and formless the object of "tragic" representation becomes; the more formless the object of "tragic" representation becomes, the smaller the boundary there is between culture and nature; the smaller the boundary between culture and nature, the more life becomes a mimesis unto death; the more life becomes a mimesis unto death—a direct proportionality now—the more difficult, painful, and horrible the recognition and experience of animism becomes.

Tragedy, sublimity, and horror are immensely complex art-historical

genres, whose complexity is well beyond the scope of this essay. In placing them in a series, however, their complexity can be narrowed down to their collective stake as forms of experience. In his important essay "Katharsis," Jonathan Lear begins with the suggestion that "normal educated people in normal circumstances and outside of the theatre seem to have certain beliefs that they do not feel,"[32] and that when such people experience a good tragedy, they are able to unify their beliefs with the emotions appropriate to them. I take it that this thought extends beyond tragedy to much of art (music, fiction, dance, poetry, painting). A condition of ordinary life, of surviving and functioning in it, is that we split off or shield from ourselves the affective depth of some of our most troubling and significant beliefs. In the case of tragedy, Lear thinks the beliefs at issue relate to eventualities that are remote, and that like the skeptic the tragedian brings those remote possibilities closer to home in an environment that is "safe." Being able to experience those emotions is important to us because although the possibilities are remote, unlike skeptical possibilities, they are real: "Even if tragedy does not befall us, it goes to the root of the human condition that it is a possibility we must live with" (K, 334).

The fundamental structure of the Aristotelian conception of tragedy is familiar. The conception is normative to the extent that Aristotle evaluates tragic plots in terms of their potential effects on the audience. Only those plots that cause pity and fear are properly tragic. The universality of tragic plots derives from their consideration of events that *might* happen; because these are events that might happen, they concern everyone. In tragedies, the terrible events and fall of the central character occur as a consequence of some error or mistake. The mistake rationalizes and explains the fall; the feeling of pity, Aristotle states, "is occasioned by undeserved misfortune"; a fall that is totally irrational "is not fear-inspiring or piteous, but simply disgusting" (*Poetics* 13, 1454). We shall need to come back to what is disgusting. We feel pity, then, for others when they suffer undeserved pain; however, not every undeserved suffering of another is an object of pity: "We must also believe that the terrible event which has befallen them might befall us or our loved ones and, moreover, might befall us soon. Thus in order for us to feel pity for others, we must believe that the others' situation is significantly similar to our own" (K, 330–31). Aristotelian pity is thus structurally not that remote from *pitié*; it is an other-regarding emotion that involves a significant element of identification; pity is empathic. "Fear," says

Aristotle, "is caused by whatever we feel has great power of destroying us, or of harming us in ways that tend to cause great pain" (*Rhetoric*, II.5). Aristotle believes that things that are too remote or too minor or that we believe cannot really happen to us cannot cause fear.

The restrictions Aristotle places on the occasions of feeling fear and pity simultaneously circumscribe the kind of plot that can cause them. As Lear points out, Aristotle uses the same word, "*pathos*," to signify emotion and to signify "a terrible event, a catastrophe or serious misfortune" (K, 330). Only an objective *pathos*, a destructive event, can be the appropriate cause of subjective *pathos*, pity and fear.

Catharsis occurs when we feel we have experienced the worst, in reality or in imagination, and survived. Our survival, which is guaranteed when we have experienced the worst only imaginatively, is what permits the release of our pent-up emotions. Having survived, appreciating our survival, we have nothing further to fear. "There is consolation in realizing that one has experienced the worst, there is nothing further to fear, and yet the world remains a rational, meaningful place in which a person can conduct himself with dignity. Even in tragedy, perhaps especially in tragedy, the fundamental goodness of man and world are reaffirmed" (K, 335).[33]

What makes the Aristotelian conception of tragedy so telling is how it relates the internal structures of the play, plot and objective *pathos*, to the response that structure arouses in the onlooker, the subjective *pathos* of pity and fear. The transformation of tragedy into sublimity and of sublimity into horror will hence involve the emergence of new values satisfying the variables of objective and subjective *pathos* that can make their normative interdependence continue to hold. In its first sighting, the occasion of sublime fear (pain or awe) was the might or extent of raw nature beyond what the imagination (as the placeholder of human sensibility) could unify or grasp. Like tragedy, sublimity is understood as, precisely, a relation between an objective *pathos*, a greatness in size or intensity threatening our sensible being (from the measure of the body), and a subjective *pathos*, fear and anxiety. The scene, although dramatic in itself, is no longer a drama, a series of actions. It is not characters we observe, but ourselves, who are both audience and hero in one. This is why pity drops out of the formula; there is no one's downfall to empathize with. Hence the movement is directly from a safely observed threat to the recognition of rational safety and the catharsis of pleasure. What sense can be made of the short-circuiting of ac-

tion? Why is the terrifying event now a direct confrontation with so-called raw nature?

The fascination of the sublime, its probability as a real fear, is ambiguous. On the one hand, as in tragedy, what is sought in the sublime is reassurance that the world is a rational place through contrast with threatening nature, which has been mastered and left behind in the emergence of bourgeois society. But this is equivalent to saying that the kind of downfall depicted by tragedy, the loss of what is most valuable through erroneous action, no longer appears as a probable event in society; society now supports and protects the individual in ways that dull action. The more rational and orderly society is, the less individual action is required to bear the burden of our standing in the world. Significant action as now conceived is intimate, tactful, a question of manners or strategy, novelistic. On the other hand, then, this orderly and rational world is already beginning to feel flat, small, incapable of presenting in its own terms anything that might be said to go to "the root of the human condition" (K, 334); as Adorno pursues this idea, "the subject's powerlessness in a society petrified into a second nature becomes the motor of the flight into a purportedly first nature" (AT, 65). *In this case, the sublime reaches past the complaisant narcissism of the everyday in order to allow us to measure and sense society as whole, and us in it, as composed still of mortal and vulnerable beings triumphing over a hostile nature.* In this respect, however, the emergence of the sublime marks a significant alteration in the kind of split or shielding of belief from emotion that the event of the sublime is meant to unify. As early as the eighteenth century the situation being addressed was the dissociation of beliefs about the human condition from emotions as such. People's background beliefs and worry did not concern a remote threat (although there was that too), *but that there was nothing to fear*; in losing the sense of fear and threat as even remote possibilities of action, individuals were losing a sense of themselves as the sensible, vulnerable beings they knew themselves still to be. The *fascination* of the sublime, of raw, untamed nature, of the wild, presupposes a loss of affect in relation to nonetheless unavoidable beliefs. The original sublime was culture's first attempt, and the first need to make an attempt, to find the limit of rational order that would reanimate the subject. We *desire* the sublime that might destroy us as the reminder of natural mortality, of our mortal fate, since only in relation to that fate does our *living* become pertinent.

VII. Disgust and Horror

Both tragedy and sublimity were fundamentally concerned with human vulnerability, with what could destroy us as individual agents or simply as embodied subjects. Both depict what an older philosophy might have called "limit situations," situations in which we come to self-consciousness as the limit of social power and order is reached. One might even say that each limit situation depicts the limits of culture with respect to an unmasterable nature that can only appear at and through the moment of cultural (rational) collapse.

In the aesthetic forms of tragedy and the sublime, the exchange between nature and culture is rehearsed as a moment of culture, a moment in which culture comes to self-consciousness about its limits and conditions of possibility. Although the thought that coming to self-consciousness only occurs through the acknowledgment of a violent disorder has become a trope of modern philosophy, from Hobbes's state of nature through Descartes's evil demon and Hegel's battle for recognition, my contention is that this mode of self-comprehension has most consistently been the province of art and aesthetics. In noting the internal connection between tragedy and the sublime, we can perceive a necessity in the operation of these forms of aesthetic experience that is perhaps not visible when each is considered separately; conversely, we can see the extent to which modern philosophy has staked itself on overcoming the threat, making it a past forever dislocated from our cultural present. Philosophy, in its opposition to art, is the a priori suppression of tragic belief. To Cavell's question as to whether philosophy could find space within its precincts for tragedy and still recognize itself, no easy affirmative answer is possible. Philosophy would need to transform itself, utterly. Call that transformation, again, the arrival of modernism.

When sublimity reappears in the twentieth century as a category of art proper, as the kind of art that refuses the aesthetically beautiful, direct reference to human vulnerability lapses. But this does not mean that the fundamental structure has altered. Rather, nature reappears in modernist works as the material substratum of the practice, as what working within a medium signifies. And, rather than seeking a limit in which human vulnerability appears in relation to nature, in modernist works the relation between nature and embodiment becomes internal to the logic of the work itself in the relation between harmony and its dissonant shattering, between ideal

and spleen. But if it is correct to think of the modernist sublime as a formal internalizing of the natural sublime, then it follows automatically that we should construe the dissonant moment as an expression of suffering. And once all this is conceded, there should be no a priori objection to the modernist sublime's being compatible with representation and iconicity so long as a locus for sublime negativity can be found.

Tragedy and sublimity both sought out the boundaries and limits of rational order. In the early sublime this limit was raw nature. But the category of raw nature is already a *reflective production of reason*; in determining the meaning of nature as (dynamic) might beyond our power or as a number beyond what can be finitely counted, as indefinitely powerful and infinitely large, rugged, mountainous, lightning-blasted landscapes and the starry heavens are being transformed in order that they can function as *figures* of nature as the other of culture. Nature has thus already become unseen and unseeable, no longer truly an object of perception but rather the constitutive other of the visible world of society and culture.[34] Nature has become the nonidentical, the sensuously particular excess beyond and conditioning the identifications of our saturating social symbolic. The modulation involved in the movement from the natural to the artistic sublime is a modulation within the meaning of repressed nature; the ambiguity of the natural sublime as figuring both the desire for nature in response to a rigidifying social order and the threat of unmasterable nature as an external limit to the comforts of that order has now shifted (almost) wholly to the first limb of the ambiguity. If nature is what is wholly repressed and repudiated as a condition for rational society, then the limit is no longer an external or exterior other, but the suffering of our mortified lives with respect to what might animate them. Modernism is the tragic art of modernity; it is tragedy without action or event. The responsibility of the modern artist is still to unify belief and emotion; only now the disastrous event, the objective *pathos*, is not a remote possibility, *but has always already occurred.* What needs to be made visible now, brought to expression, is the violence that has already been done to the subject, that has already murdered the autonomous subject and left in her place the walking dead, the zombie, the monster. The monstrous here has a narrow and precise signification: it represents the dead *in* the apparently living, the living in what is deathly, the gross vitality of what is apparently dead, the boundary between the living and the dead as becoming indeterminate. But if the boundary between

what is living and what is dead is indeterminate, then so is the boundary between what is subject and what is object.

Aristotle said that to perceive a good man falling from good fortune to bad without reason could not inspire fear or pity but only disgust; but what if that fall is both rationalized, because it is not a remote possibility but a necessity, and still irrational, a contingency beyond the powers of the subject himself? Does not that condition deserve to become the objective *pathos* of the highest possible drama about the destiny of the subject? And if so, must not disgust become the proper subjective *pathos* of such a falling? If, analogously, the beautiful is no longer beautiful but cruel and ugly, if art is going to refuse utterly the forms of the beautiful, then must not its objective *pathos* be the ugly and its subjective *pathos* disgust, as Kant, following directly in the line of Aristotle's thought, already determined? Kant contends that fine art can render beautiful what we dislike or find ugly: "furies, diseases, devastations of war." However, there is one ugliness that cannot be presented in conformity with nature without obliterating all aesthetic liking and hence artistic beauty: "that ugliness which arouses *disgust*. For in that strange sensation, which rests on nothing but the imagination, the object is presented as if it insisted, as it were, on our enjoying it even though that is just what we are forcefully resisting; and hence the artistic presentation of the object is no longer distinguished in our sensation from the nature of this object itself, so that it cannot possibly be considered beautiful."[35]

In Aristotle what aroused disgust was morally repugnant; in Kant the object of disgust is what resists transformation, idealization, beautifying as such. In the shift from Aristotle to Kant disgust has already lost its status as a fully ethical category and become merely contemplative, a limit of the reach of reason as such, but still of a reason that could be affirmed. Once that affirmation disintegrates, then disgust slips into the space vacated by ethical and rational fear as the ugly becomes the objective *pathos* that brings us to ethical and rational self-consciousness. This is the ugly that insists on our liking it, desiring it, wanting it (as previously we secretly desired the violence of the abyss and the overwhelming infinity of the stars). What is an ugliness that insists on our enjoying it? Perhaps just this: this is now what is left of me, myself; this is my better self, my alter whom I must love and cannot love. Adorno calls this the nonidentical.

Horror is a form of the ugly: the illusory appearing of the monstrous sensuous particularity that is the violated and brutalized remnant of the corpo-

real subject. Horror is an ugliness that connects or modulates the difference between the fearful and the disgusting. It connects with the fearful because it is the site of a disastrous event, a violation of the self that has already been perpetrated. Horror recognizes the violation of the animate body and underlines it. In horror, psychic violence and physical violence are both violations of embodied subjectivity. Violence and vile transgression, as the successors of sublime natural might, shatter rational form as the inaugural condition permitting the reunification of belief and emotion. Horror connects with disgust because the consequence of that violence is the systematic and active ruination of the embodied subject. Death in horror is always active, a verb. Corpsed. *In horror, all that is left of nature is the inversion of natural form: the continuous dismemberment of the—normative—unity of the animate organism.* But if this inversion is all that is left, then the normative authority of natural form is transferred into its opposite: what ought never to be seen, the endless work of dismemberment, is what must be seen if nature is to be seen at all. Hence disgust, which is the limit of aesthetic representation in Aristotle and Kant, now becomes the site of aesthetic vision. *Horror is the means through which the disgusting is provided with aesthetic form.* Our desire and fascinated repulsion at the horrible thus replays in the mode of disgust the duplicity of the original sublime, only now the moment of pleasure is dispatched into awareness of our mortification: the too much animation of active dismemberment, the "verbed" form of suffering, has become the unique point of access to the limit of rational form. Horror, then, addresses an anxiety that life does not live, in relation to an inarticulate and unfelt belief concerning the normative authority of life, of memberment as the impulse of the living. Horror's narrative, actual or stilled, gives scope to the anxiety in relation to the belief; hence the fascination with horror, of seeing it, is giving negative expression, and hence "satisfaction" with respect to the anxiety and the belief: the authority of memberment, the claim of the animated, unified living body, continues, survives, in the compelling disgust at dismemberment.[36] One might think of this as a precise materialist inversion of normative idealism: suffering all the way down.

The materialism of abstract expressionism, however much it obliquely referred to embodiment, abstracted from the figure of the human body itself as a condition for its locating the material substratum of its practice. However dissonant it was, for the most part its products were sublime but not ugly, expressive of suffering but not objects of disgust; as we learned to

find our way around it, its dissonances became almost beautiful. Horror emphatically reappropriates the measure of the body from the eighteenth-century sublime, now figured not in its upright posture, but as violated sensuousness through and through—the vulnerable and already violated body, hence the body of flesh and bone, blood and guts. This moment had been anticipated in the emergence of abstract expressionism in the works of Chaim Soutine, whose paintings of ox carcasses and landscapes should be recognized as the proximate origins of de Kooning's woman paintings. While it is evident that Soutine's carcass paintings are intended as homages to Rembrandt that make the anatomical body organic again, thus returning to it its status as dead *flesh*, the sort of flesh that can rot (and did rot in his studio), and be the home for lower life-forms (flies, worms, maggots), his landscapes of Céret are if anything more uncanny, more disturbing. Robert Hughes's description of them is apt:

> For sheer pictorial violence, the Céret landscapes had no precedents in art. The sense of *matière* in his still-lives, where the paint that depicts the ox acquires its own fatty carnality, reaches an extreme in them, utterly distorting the descriptive content of the landscape. The houses lean as if in a gale, hills rear up, the horizon is dragged on a furious slant, and the whole scene becomes a mass of tumbling paint, like chicken-guts.[37]

The final "chicken-guts" is particularly pointed: it is as if the landscape could only reveal itself as part of the natural world if it is imaged in terms of the inner body parts—fatty carnality and chicken-guts. Soutine's anthropomorphic gesture, his projection onto the landscape of his subjectivity, searches out an affinity between it, paint-on-canvas, and inner body parts. Soutine's artistic materialism focuses or refocuses the trajectory of artistic modernism by inflecting nonskeptical anthropomorphism as animism in Rembrandt, Van Gogh, Cézanne, and thus anticipating modernist horror.

Soutine's paintings can remain within the domain of painterly illusionism because they depend on the uncovering and instituting of material affinities. That is a power of painting that photography cannot directly emulate. Conversely, while painting can generate mild revulsion, it is never really horrible—although Francis Bacon tried to make it so.[38] The horrible, being closer to both tragedy and the early sublime, depends upon something *there*, on the body that ought not to be seen, whose sight is the antithesis of the practical aims of seeing, on the body that eludes direct perception but is materially present. Photographic illusionism, as generated by

Sherman's work on the object of photography, combines the insistently real with its invisibility, the causal indexing of the real with fantasy, which is thus an ideal medium for encountering the repressed dismembered body. If one thinks of the problem of horror as the balancing of bodily insistence and the normally/normative unseen (but not unseeable), causality and fantasy, then Sherman's shifting of the ratio of these elements in the fairy-tale pictures and the disaster and *informe* pictures becomes intelligible. But what remains consistently at stake is the identification and location of the ugly, what living and what dead.

Untitled #153 (Figure 17) strikes me as just another film still—a typical murdered beauty—with just the contrast of the face of death and the perfect green of grass, moss, and dirt suggesting that something is terribly awry here—all the life is in the green (as if the organic had become just this color), and the death in the human (apart, of course, from what appears to be not a bruise but a nasty red boil on her right cheek—the boil's irreal liveliness scoring her deadness). The white-blond beauty is like a long echo or afterimage of the white marbled statues of the past. What thus makes this photograph uncanny is the absence of horror, the absence of the devastating event that has brought about this quiet, still, composed completion. The composed quiet of the scene echoes the camera's cool, beautifying regard; the tinge or anticipation of horror is in seeing the stillness of the corpse as composed, as if it were the fulfillment of what posing for the camera has necessitated all along. Consider that necessity rational life. To the question that would be the film's title, "Who Killed the Beautiful Blond?," we know the answer: the camera did it.

Contrast this with *Untitled #177*. Enveloping it too is a narrative, perhaps a realist horror movie, a slasher film. The murder, the rape, the violation, the terror of it about to happen and happening, none of these are there, perhaps because in seeing them we would not see what needs to be seen, or we have seen them too often and wrongly. To image the slasher as simply one of us would be an illusory anthropomorphism. Instead we have the face in the right-hand corner, staring out at us—or is she looking on the scene of devastation itself? The face is shadowed in bluish purple, somewhat out of focus; it is unclear whether this is the face of someone living or dead, whether it is Sherman's signature (the artist as horrified witness), the ghostly apparition of the violated body or, given its and the buttocks' equally frontal position, a severed head. (This same sort of ambiguity is present in

17 Cindy Sherman. *Untitled, #153*. Courtesy of the Artist and Metro Pictures Gallery.

#167, where we have both the face buried in dirt, its fingers distributed in a manner suggesting they are no longer connected to the body as a whole, and another face—whose?—in the small makeup mirror.) What is unambiguous is that the most vital, living things in this picture are the livid pimples de-aestheticizing and thereby de-eroticizing the buttocks, and the ants wandering freely over its surface, about to enter and make it their home. Those livid pimples are (the) unforgettable; suffering life.

The exposure of the anus in *Untitled #177* draws on a strategy of Sherman's that requires separate accounting. One constant source of the disgust in her pictures, whether horrified or comic, is that in them skin is only rarely a simple container (although sometimes it is a rigidified container: armor). Rather, skin is depicted as a highly porous, almost always failing membrane in which inside and outside become indeterminate, reversible and exchangeable (the inside already outside): flesh rather than skin. *Untitled #244* is a picture of a magnified portion of anonymous flesh that is *leaking* blood, the leakage appearing less the consequence of a wound or piercing than as if the blood had first pressed its way to the surface, as figured by a variety of unidentifiable dark red, black-red spots and splodges, and then finally seeped through, making it appear as if the skin were just surface, not so much containing the blood but rather a briefly congealed moment of a liquid or fluid body. But the leaking fluid is, in its uncontrollable seepage, still our lifeblood. This disquieting, queasy-making image in which outside and inside fluidly exchange positions should key us to Sherman's insistent depiction of orifices—mouths, anuses, vaginas—as operating similarly, that is, as revealing the extent to which skin is not, cannot be, a container, that the sense of containment, and hence the sense of a reassuring distinction between inside and outside, is illusory. This exposure of the inside, turning it out (by turning the flesh in), is not for the sake of destroying the integrity of the skin, but rather of reanimating it by folding it back into the viscous fluid life inside, against the pretense skin has become. If normally for visible bodies the skin separates what is visible from what *ought* to be hidden, Sherman's practice interrogates the functioning of that ought, and hence the dualism of inside and outside it generates as a force of repression and self-repudiation, as deathly. The categorical imperative making the skin a container is as repressive of life as Kant's moral sublimation of it. Again, what leaks and seeps in *Untitled #244* is our *life*.[39]

Within the logic of turning the inside out, the tongue will naturally have a special place since while having the characteristics of an internal organ—a sticky, wet, textured surface—it can extend outside the mouth and lips, which normally mark a limit. This thought is deployed to significant effect in *Untitled #150*. Sherman's picture is a fantasy of cannibalism that makes the monster enormous in comparison with her victims. But it is, of course, her tongue, enormous, fleshy, with the taste of flesh still on it, that rivets our attention. Almost affectless—as confirmed by the smallness of her victims—without disgust, she tastes flesh, tastes herself (her finger); her tongue, impossibly real, is the figure not just of the inside truth of the subject coming out, but equally of a desire that remains ambiguous between the sexual and the cannibalistically culinary, the sort of culinary tasting that aesthetic tasting has too often collapsed into. So it is a complex weaving of an allegory of beauty as cannibalism, and an elaborating of the cold cannibals we have become, eating and being eaten. And yet the entire fantasy exists for the sake of releasing the image of the tongue—a tongue that has lost the power of disgust, lost the sense of limits—and through that very fact arousing it.

Each of these photographs is a compelling object of visual attention, a culinary spectacle of color, fantasy, anxiety; in their gross, hallucinatory moment of sensuous excess they conjure and institute an auratic animism, but one quite remote from the human face or the human figure: it is misplaced life, boil, livid pimples, leaking flesh, and fleshy tongue that now bear the full burden of the claim that life lives, lives on in its organic animation, its pulsating decomposition, its disgusting remnants. At the extreme of this series are those of decay, and those that press the question of life to the limit of the indeterminacy between the organic and inorganic. The first feature of *Untitled #190* (Figure 18) one notices is its lustrous, gleaming, dark mucous surface, with glints of intense blue like gems shining in the darkness; these are the visual trinkets and baubles, which, like the surface sheen of the color photograph in general, catch our naive eye; how easily we can be tricked into looking, how casually we buy the visual spectacle. But this is all surface, and the surface is shit. If we look any longer it is the stained white teeth and reddish tongue covered in excrement, what we think must be excrement, that become the focus of our attention. Is that face, with its blue eyes like the indeterminate glints of blueness, buried in colonic slime, or is it emerging out of it? Maybe one wants to say about this

18 Cindy Sherman. *Untitled, #190.* Courtesy of the Artist and Metro Pictures Gallery.

picture that its ugliness is too much, too close to the cliché of the horrible to be truly revolting (although if you are really revolted by it, I would not argue the point), and that it is, finally, almost comic, kitsch horror. Even if that is true, it is unlike the comic horribleness of classic horror movies, for whether we view it as truly or only comically disgusting we are left with an imprint: the excremental scene is the natural habitat of the human face.

In suggesting that the excremental scene is the natural habitat of the human face, I want to intrigue the claim that this is a stratum of meaning, not a real beyond meaning, but a locus of meaning, where meaning begins, the glint of light becoming the glint of the eye, life emerging from and merging back into slime, in the cry of terror or agony or disgust through which revolting nature becomes an object, becomes something that stands over or opposed or is different from us but us: phantasmagoric affinity. Adorno would perhaps speak here of nonidentity, Kristeva perhaps of the symbolic *in* the semiotic. In either case, horror is emphatically the *form* of disgust: our repulsion converted or doubled in the fascination that leaves us turning away and turning toward the scene compulsively—forever hiding our eyes

behind our hands with the fingers pried open by a force that is as driven as it is normative. Because there is form here, because the object of disgust is capable of receiving form, even as it is figured in the course of its undoing and so the undoing of all form, it belongs within the ambit of meaning as limit and condition of possibility. Contrast this way of thinking about and responding to Sherman with Norman Bryson's:

> The body is everything that cannot be turned into representation, and for this reason is never directly recognizable: if, in our minds, we were to picture this body-outside-discourse, it would not *resemble* a body at all, since the body-as-resemblance is precisely that into which it may not be converted. . . . Like language, visual representation can only find analogues and comparants for this body: it is *like* this or that. . . . At the edges of representation or behind it hovers a body that you will know about only because these inadequate stand-ins, which are there simply to mark a limit or boundary to representation, are able to conjure up a penumbra or something lying beyond representability. The penumbra indicates that discourse-as-sight cannot quite detect this region or bring it into focus.[40]

This is confused, and worse, its mistake repeats the very assumptions about meaning that are the root cause of the violence of discourse that Sherman's pictures are criticizing. The contrast between representation and the real assumes that we—subjectivity, language, discursive practices, call it what you may—are the locus or origin or self-sufficient source of all meaning and sense, that our capacities to speak and mean are perhaps conditioned by a material substratum but are not dependent on it or parasitic. At a certain level, there is something theoretically silly in the way the real is posited as excessive; so when Bryson comments that "the medical-student mannequins and body parts and Halloween masks and prostheses cannot live up to, cannot *match*, the affect they induce,"[41] we may well ask what kind of failure this is. What is it to provide a representation, a mimesis of pain or terror or violation? Does language ever "match" the affects it induces? What sort of matching is being assembled here?

What Sherman presents is beyond the culture industry's rationalized regime of representation, beyond what is established as formations of meaning and significance. As Bryson rightly says: "What reemerges from that very disappearance [of Sherman's own body as subject/object] is everything about the body that the image stream throws out in order to maintain the ideas of the body as socialised, clean, representable: the body's material density, its internal drives and pulsions, the convulsiveness of its pain and plea-

sure, the thickness of its enjoyment."⁴² However, while livid pimples, gross tongue, and colonic slime are surrogates for this real, and images of it, in the context of Sherman's work they are not the beyond of representation but its very origin. By origin, I do not of course mean that these forms of material excess and excrescence are themselves the foundations of meaning or a source of law—they are too negative for that. Rather they are the other side of bound or bordered subjects, hence that in relation to which every integral difference, every difference capable of providing identity and individuation, must depart and acknowledge as having been departed from. If what the *Untitled Film Stills* depict is identity without individuation, then what it forebodes is the self as corpse, the living self and the dead self becoming indistinct. But if identity can only arise through marking that distinction, acknowledging the indeterminate substratum as the condition of determinacy, what *must be* included as the excluded limit, then the horror pictures provide, precisely, the symbolic forming of those borderline situations, the border as border, as the fate of the self and as what it must be capable of separating itself from. The duplicity *within* the horror pictures establishes the duality of presenting the loss of boundaries and the incompleteness of that loss that the *Untitled Film Stills* achieved through repetition. If the affect of the *Film Stills* was anxiety, in these pictures disgust at the other is the form of pain through which life is affirmed.

The horror pictures both break through rationalized cognition (whose purity demands the suppression and nonacknowledgment of what cannot be formed or bound, beautified), and with horrific or comic insistence force upon us another scene of knowing, a primal scene of knowing beyond the reification of the ordinary: *what we cannot swallow, ingest, taste, is equally what we cannot doubt.* The illusion of rational mastery is undermined in an instance of binding cognitive revulsion. Call this the *bodily cogito*. This is unmistakably the pain of the sublime, but a pain that cannot be recovered by rational reassurance since the reason that would reassure us is the cause of the pain, the cause of the decomposition. Sublime pain hence becomes reassurance itself (that life lives, that I am not yet dead although more dead than I realized). Horror is one of the art forms that Sherman employs in order to permit these others to speak; if one were Kantian, one might say that these works are sites of transcendental affinity. But the affinities are not transcendental in Kant's sense: they are empirically indexed and bound.

To be sure, we are operating in the domain of art and illusion—the

colonic slime is, thankfully, odorless and tasteless—and in ordinary life these natural yet anthropomorphic (if de-anthropomorphicized) sources of meaning have been excised in all the ways we earlier saw Bryson helpfully track. But that is what raises the stakes for this other scene of meaning. Is there any other public way in which our beliefs and emotions could be unified? Is there any other shared and social space in which our beliefs about our bodies and embodiment could be so radically transfigured in order to lodge an anti-skeptical claim? What do we know, know in the full sense of believing and feeling, about our embodiment that is a better knowledge, a better cognition, than what Sherman's horror pictures supply? Outside what Sherman *says*, do we know fully what a theoretical term like "abjection" means? If we do not, then what does that say about what knowing has become? In tragedy itself the business of relating affect and belief was not anti-skeptical because there was no skeptical belief that the affect had to engage. Beginning with the eighteenth-century sublime, I have suggested, the significance of limit situations that tragedy presents has altered: in ordered and rational society we presume that we possess everything that would comprise a life but for a lingering doubt: we do not feel alive. And with that doubt comes the suspicion that maybe, somehow, indescribably, we are not fully alive. Sherman's pictures order these sets of doubts and beliefs, they perform the anxiety that we have become something other than a living being, namely, a *cliché*; and then, turning us inside out, they locate the life beyond the cliché: life out of place, pulsating, slimy, leaking and seeping life. Mine own true self.

Sherman's art is the most insistently and unashamedly cognitive I know; each work tests, criticizes, and reconfigures its materials into a scene of knowing, or even more radically, the scene of knowledge itself—the last left to us. To call this the scene of knowledge in general is to suggest that the image universe of modernity as figured in miniature by the photographic image must come to be seen as illusory: its image of beautiful life our death, beautiful suffering revealed, finally, as the repudiation of life and suffering. The camera is a last evil demon. To overcome photographic mortification from within requires making visible something that cannot be aestheticized or beautified: the object of disgust. If we do not taste our mortification here, then there is nothing to know. To give disgust form thus becomes the condition for self-consciousness in general. In this respect, Sherman's insistent deployment of horror in relation to what preceded it appears as a self-

conscious comprehension of the dilemma and what is required to surmount it. It is the consistency of Sherman's epistemic performance that distinguishes her work from the apparently similar.

VIII. Sex Pictures and History

The history and sex pictures work in an analogous two-step manner in which there is a moment of a radical de-aestheticizing of the original scene accomplished by the substitution of a medical prosthesis or mannequin or mannequin part for a body part or whole person; in the disconcerting second moment we experience this displacement or dismemberment as active, and hence as a reanimation of the original scene. Through making the dismemberment active, accomplished, the plastic substitute comes to strike us as *more* material, *more* living and vital than that which it replaces; that these wholly inanimate objects appear more vital than what they displace is their primary effect; they make literal the Hegelian worry that what is mere matter appears more alive than life in a manner that seems incapable of being reclaimed by spirit—any more, of course, than any of the other modernists I have discussed. That we turn to Sherman's modernist works and find in them a vitality we lack is their terrible knowledge. The history pictures are genealogical: they trace the subtle, almost invisible dematerialization of the human body in the very art that was, we can now see, not just celebrating but idealizing it in ways that have *become* suspect: idealization has become reification. Without their uncanny moments of reanimation (for example, the uneasy moment in *Untitled #223* in which the babe suckles the plastic breast; or the thin stream of milk shooting from the prosthetic breast in *Untitled #225*), these pictures could not accomplish all their other exchanges with the history of art;[43] without the moment of reanimation these works would become theoretical toys for critical reflection. Only the moment of dissonant reanimation makes these emphatically *works*.

Reanimation not only desublimates the original, but simultaneously gives back to it its auratic power by revealing the *dependency* of the ideally beautiful on what it sublimates, although the work of giving back is, again, carried through by replacing the image of human flesh with a plastic prosthesis. But if that is correct, then these works are ambiguous and ambivalent in a way that, for example, Rosalind Krauss misses: "It is as though Sherman's own earlier work with the /horizontal/ had now led her back to

the vertical, sublimated image, but only to disbelieve it. Greeting the vertical axis with total skepticism, the *History Portraits* work to dis-corroborate it, to deflate it, to stand in the way of its interpellant effect."[44] While it might be right to say, for example, that in Barnett Newman's zip paintings the vertical axis has an interpellant effect, I am not sure what it would be for the vertical axis of historical portraits to have an interpellant effect; I cannot be *recruited* to verticality: I am vertical, at least most of the time. Nor is it clear why one would go to the history of painting in order to douse the claim of verticality. Perhaps what Krauss has in mind is the thought that a component of the reanimating materialism (which is equally a de-animating of traditional painting's insistent ideality) occurs through having the materiality of the rubber prostheses insinuate the sheer pull of gravity, the dumb weight of materiality against the ideality of what is portrayed. This seems pertinent with respect to, say, the nose and echoing cloth hat and hanging pearls of *Untitled #211*, and the enormous breasts of *Untitled #222*. But in the latter there is an *ongoing* downward motion that moves from the woman's eyes through the lace hanging from her shoulders to, finally, the outsized and improbable breasts. The comic potential of the breasts is undercut by the downward movement, so that those breasts become expressive of the same haunted sadness of the eyes. More than skepticism about verticality is at issue here.

The history portraits mean to capture something of the "film stills" of the past, the interpellant clichés of the time before photography and film. The stakes of these pictures are akin to the *Untitled Film Stills*, only now the issue is not the culture industry cliché but the ideality of painterly forms, the art history cliché.[45] Hence it matters that, again, this is Cindy Sherman interrogating, experiencing for herself, for us, a dead past, but still one whose decisive moments were turning points in the construction of the modern subject; and if these moments were turning points, then they are sedimented in what subjectivity has become. Their ideality anticipates the culture industry cliché and so belongs to art's own dialectic of enlightenment: ideality mortifies the subject in idealizing it, or so we must now come to see. But there is historical contingency in this operation. Each moment of idealization was not only a destructive sublimation of materiality, but an opportunity missed, a slim chance of identity, including gender identity, that might have been otherwise; what else are we to make of her impersonation of male characters? They enable us to detect aspects of both contingency

and noncontingency in the historical formation of gender identities. But in giving to works of the past, or rather giving to their idealizing grammar an ambivalence, making them into scenes in which the work of rigidifying idealization occurs before our very eyes by virtue of its material correction, Sherman equally returns to these works their *historical* effectivity, a historical depth that is anything but purely formal. Her reanimations tear these works out of the museum as if out of a sepulcher, and turn them into elements of historically effective consciousness.

There is a stratum of Sherman's sex pictures that must be construed as an elaboration or continuation of the feminist critique of pornography. If, in standard pornography, male desire, the male gaze, anatomizes the female body, reducing it to just its sexual body parts, then this desiring and gazing can be turned against itself by offering to it precisely what it wishes: the female body as just and only organs for arousal and penetration. *Untitled #258* has at its center an impossibly large, fully exposed anal cavity, a receptacle that cannot be for the sake of anything other than being filled and penetrated, and yet so large that it utterly defies that possibility. And while that would be sufficient to freeze (wither?) the desire that had wanted this compliant self-exposure, in the soiled soles of the puppet/mannequin's feet that press out to the front of the picture plane, and the grimy hands with dirty fingernails that hold the buttocks in preparation, there is a pathos and a melancholic disappointment that need accounting for. The soiling operates as both a de-aestheticizing/de-eroticizing marker (revealing that the original scene without those reminders was aestheticized, purified), and simultaneously as a reminder of the vertical, upright person; but uprightness here can manifest itself only as blemish. It would not be impossible to interpret what I am calling pathos and melancholic disappointment simply as resignation, submissiveness, thus construing the whole in a directly critical manner. But in the context of a series of pictures in which male heads are placed atop female anatomy, male and female organs joined in one truncated mannequin body (*Untitled #263*), and even male sexual melancholy given mannequin/doll form (*Untitled #256*), one is tempted to say that the comical exaggeration that operates as a spoof of pornography contains an excess beyond what would fit with the idea of these pictures as merely or only critique. Something about sex itself, and about the relation between sex and pictures, seems to be at stake. Calling these pictures spoofs or parodies or ironic depictions leaves untouched their evident and willful polit-

ical incorrectness. On a page of one of her notebooks, Sherman states: "Shouldn't be merely about sex per se as shock element. The shock (or terror) should come from what the sexual elements are really standing for—death, power, aggression, beauty, sadness, etc.... But I also want to explore the abstract use of the body parts—a more formal (art—traditional) approach."[46] Consider these sentences as providing constraints that an adequate interpretation of these pictures should satisfy.

I claimed earlier that Sherman's modernist appropriation of the genre of horror releases its cognitive and critical potentials; the sex pictures do something analogous for pornography. In making this claim I am suggesting that pornography itself contains cognitive and critical potentials that its social circulation aestheticizes and mystifies. This should not be news. In its culture industry use, pornography operates as an objectification of, dominantly, the female body as a space in which fantasies of sexual gratification through subjugation are played out as stimulants for the male gaze. In order for the predominantly female body to function in this way it must be aestheticized, sex and violence idealized: this aestheticization and idealization are what is involved in constituting the female body through the male gaze. However, that work of aestheticizing, cleansing, and purifying of sex and sexuality is continuous with culture's more routine denaturalization of sex (the joyless *Joy of Sex*). Culture does to sex what it does to beauty, and it did it to sex first. However, pornography in modernity has always been, *also*, a reminder of a set of uncomfortable grammatical facts; these grammatical facts, as I wish to call them, are needed if we are to make sense of why human beings so utterly and uncontrollably care about sex, invest in it, make its often predictable, routine, even boring pleasures and pains something for which all else (marriages, careers, reputations, security) might be sacrificed. Something about sex feels deeply important, but important in ways that do not get accounted for, made intelligible, through the accounting of desires and pleasures; nor is it, quite, accounted for through the dubious satisfactions that standard pornography provides. Or, more accurately, the ultimate stakes of pornography are misdescribed when they are paced out in terms of the interests in domination as defined by the male gaze.

At least part of what makes sex matter, something we invest in well beyond hormonal and chemical imperatives, beyond the pleasures and enjoyments it confers, is that all human sexual practices worthy of the name are

transgressive, broaching or breaking the boundaries of culture and performatively revealing the interchange between nature and culture, between animal embodiment and its thoroughgoing cultural articulation; all human sexual practices worthy of the name contain moments of objectification, aggression, dismemberment, and animal solitariness, and it is via those moments alone that our animal bodies receive an emphatic moment of independence from cultural norms, or, what is the same, it is only through those moments, through dismemberment, that embodiment can be nontransitively experienced as the source of a claim. But to be in the position of experiencing embodiment, the emotions proper to our suppressed beliefs about it, only through its fracture, fragmentation, and ruin is to claim that what we experience there is a certain absence of experience, namely, of our normatively whole bodies.[47] Sexual practices then enact the very same broaching of the limit of culture in relation to unmasterable nature that I have argued has been the cultural work of tragedy, the sublime, and horror.

Placing sex and its pornographic elaboration in this series (as if sex were to pornography as sublimity is to horror) enables a clearer comprehension of the claim of sex. Sexual acts, hence sexual practices, are the routine and everyday ways in which human beings have experienced nature as condition and limit, as animating and violating,[48] and in that doubleness is a condition for culture in general.

Grant for the sake of argument that at a certain moment, perhaps with the Jewish invocation of an invisible god and the consequent ban on images, perhaps with the emergence of the self-authorizing polity depicted in Greek tragedy,[49] that cultural belonging came to authenticate itself through repudiation of the authority of nature and what is natural.[50] Arguably, from this moment, sex becomes the original site of our self-comprehension of ourselves as cultural creatures for whom cultural belonging can always become a threat to our natural or vital or animal bodies that are (normally, normatively) to be realized *through* culture. Call that cultural norm, its promise and bindingness, the pursuit of happiness. The functional and normative role of sex as happiness and as the promise of happiness is to bind culture to natural embodiment, self-realization to vitality.[51] But the depth of that vitality is inseparable from our vital bodies being emphatically mortal bodies, suffering bodies, bodies whose pains *and* pleasures are *both* things suffered, undergone. But this is to say that the affirmative moment of sex is integrally bound to its dissolving moment, memberment bound to dis-

memberment, memberment and dismemberment in their mutuality the *work* of sex.

The repudiation of the living-and-dying body, a repudiation that is always lurking so long as culture authenticates itself through the depredation of animal nature, is the repudiation of our being natural creatures in general, hence the repudiation of the pursuit of happiness, *which promise culture cannot forfeit without dissolving its own claim to authority*. But, if it is right to argue that acknowledgment of nature/embodiment/sex *requires* acknowledgment of the moment of dismemberment, then there really is in sex something that is difficult, awkward, uncomfortable; and there is too, inevitably, a persistent reminder of the terrifying nature we thought we had left behind permanently in the attainment of autonomous culture. But because that terrifying moment is just the inverse of the animating one, then sex becomes a scene of urgent desire and equally urgent revulsion, fascination, and disgust. And it is this duplicity in relation to sex that became socially coded, was symbolically worked through, in traditional notions of gender identity: the male/masculine negation and disavowal of corporeality, the becoming of the disembodied, universal subject, achieved by displacing onto woman, the idea of her, all the complex attributes of normative nature: the construction of female identity as standing for creative-and-destructive nature.[52]

In claiming that the domination of women has been the cultural vehicle through which society enacts the depth and complexity of the claim of the pursuit of happiness, I do not wish to minimize the awfulness of that domination, but to underline how the stakes of that domination transcend the problem of gender. I take this de Beauvoirian overlap between gender domination and the rationalization of nature to be the recognition that enabled Sherman's art from the time of the fashion pictures. It is in this categorial, trans-gender way that her feminism operates.

The one place in which natural embodiment must press its claim to be constitutive of our being in general, to be essential to our pleasures and pains (the normative character of the pursuit of happiness), and thus where our ontologically suffering body becomes manifest, is in sex. The more culture denies the body this standing, the more it claims autonomy for itself and the more successful the extirpation of animism is felt to be (the desire animating, again, the emergence of the sublime), the more emphatically are the claims of happiness made to devolve onto sex until they can emerge

only through the radicalization of the transgressive moment that pornography pronounces. I take this narrative to be a continuation of Bryson's narrative concerning the suppression of death recounted above. Typically, the transgressive elements of the grammar of sex are displaced, repudiated, and repressed, and our fascination or obsession with sex made a cause of shame—this shame being but a screen for what truly fascinates and repulses us. The dialectic of fascination and repulsion is reproduced as a fully cultural artifact in our relation to pornography and the pornographic. Even in its most hygienic forms, pornography isolates the transgressive, revelatory moment of sex. As Judith Butler comments in contesting the attempt to think of sex as wholly within the bounds of human autonomy and consent: "If . . . questions of consent and action are suspended through the pornographic text, then the text does not override consent, but produces *a visual field of sexuality that is in some sense prior to consent and, indeed, prior to the constitution of the willing subject itself.* As a cultural reserve of a sexually overdetermined visual field, the pornographic is precisely what circulates without our consent, but not for that reason against it."[53] *The pornographic is the visual or optical counterpart of the transgressive element of the grammar of sex; it is the form of sexual excess.*

If art, in general, is the generation of a visual field that is independent of consent, its authority heteronomous with respect to the claims of self-determination, then there is an elective affinity between the claims of art and the pornographic. The role of the nude in art history is in part the repressed version of this thought. What, then, is particularly disconcerting about the uncomfortable grammatical facts of sex is that public acknowledgment of them, if there is any, occurs in pornography. It is as if we can only properly inhabit or experience our embodiment when it receives a moment of independence from culture, not because of what sex or embodiment intrinsically are—not, that is, because sex and embodiment are intrinsically antithetical to cultural habitation—but because of what they have *become* in the light of what culture has become.

But as sex and pornography become subject to the same aestheticizing force that drove sublimity into horror, above all through photography, which effectively recruits pornography to the male gaze (making late-modern pornography an inflection of the automatization of the disinterested look; or is it the other way around?), pornography, like sex, loses its role as a limit situation and hence its power to be a site of acknowledgment.[54]

Pornography without obscenity is sex without transgression: standard pornography is the mortification of sex itself, something that Sherman makes baldly, comically?, literal in the drooping stone penis of *Untitled #252*, frozen hard and withered at once: an anti-phallus.

Sherman's sex pictures aim to restore to the pornographic its grammatical insistence, its space as one of insight, self-consciousness, and loss; or better, the pictures aim to restore to pornography its ambiguity by revealing *in* pornographic objectification an excess that is not reducible to male desire or the male gaze as such, its interest in domination (which, of course, requires the defeat of that desire, the demonstration of its aestheticizing stakes in order to liberate the suppressed grammatical excess). (Because, again, there is an ontological interest subtending and motivating the social one.) Hence the comedy of the sex pictures, like the charm and nostalgia of the *Untitled Film Stills*, contains a darkening subtext, something that stifles the laughter they nonetheless provoke. In order for this to occur, some of the obscenity of pornography must be reactivated. The pornographic obscene is, formally, the horror of sex, as if all that is left to us of sex as the exchange between culture and nature is its dismembering moment, the moment of repulsion—so, again, a making visible of what ought not to be seen, only now in the very context in which that seeing and not seeing have been routinely elaborated. In this respect, *Untitled #179*, which belongs awkwardly to the disaster or fairy-tale series, anticipates what comes later. In it the insistent images of discarded implements for vaginal penetration leave no space for the aestheticizing imagination to take a grip. The one thing we are not reminded of is sexual gratification; but that does not mean we forget sex. Presented is a sense of sexuality that makes female sexuality invisible, derivative, a faceless, imageless corollary of indifferent tools and instruments. Those tools and instruments are *real*, not painted, not fantasized. Brute, phallic things brutally observed—as painted, as mediated, they would contain none of the flat indifference to human desire that they emanate. From the fact that all these phallic things appear as so much debris, we can infer their utter uselessness, but equally both the female subject's dissatisfaction and her obsessive search for satisfaction. Something of sex has died, say, its pleasures. Does that put sex out of mind? Does that mean that all of sex has died? Something remains, and what remains is precisely what the moment of idealization in the objectifying gaze excludes.

19 Cindy Sherman. *Untitled, #250.* Courtesy of the Artist and Metro Pictures Gallery.

Hal Foster asks, "Can there be an evocation of the obscene that is *not* pornographic?"[55] This seems a misdirected question, both because of what obscenity is (the objective pathos that triggers sexual disgust) and because of what pornography is. If the pornographic is ambiguous, and part of that ambiguity is its implication of transgression, of searching for the limit against culture's aesthetics of sex, then while there can be obscene things that do not come within the ambit of pornography or the pornographic, the thought that art should avoid slipping into the pornographic demands, bizarrely, a properly ethical obscene that can be detached from what pornography and the pornographic reveals. Even the most irreal of Sherman's sex pictures, like *Untitled #250* (Figure 19), by dint of their materialist desublimation of sexuality, and hence in order to give back to the fantasized body its materiality, generate a reanimation and animistic surplus that cannot be critically controlled or contained: only through these prostheses that provide for an activation of dismemberment, can sexual dismemberment, the pain of sex, which is a claim for the life of the body, be made visible.

The pornographic as objectifying gaze is thematic in *Untitled #250* since

the scene is one not of sexual activity or preparation for it, but just the display of the body as visual scene: a string of sausages hanging from the vagina of a legless, anatomized, youthful torso, lying atop a bed of human hair; the vulva appears painfully red. Our looking at this bottom left-center side of the picture, our implicated gaze, is at each moment interrupted, lifted up to the head at the top right-center of the picture. It is not the head of a young girl that we see, but a wizened, ancient face, all age and loss. From its features, one might conjecture that it is the face of a man, but for the fact of the long blond hair that trails from it as if from a different head or the same head at a different time. The mouth is closed, its expression hard to read: long-suffering? inured to suffering? past it? But then the corners of the mouth are slightly up-turned, certainly not in a smile or in pleasure, but at least in a way that halts the simple ascription of suffering and pain. Perhaps we should say that the expression of the mouth is enigmatic, a late-modern *Mona Lisa*. The eyes, wide open and somehow younger appearing than the face, are looking directly at us, returning our gaze. Their expression is neither sad, like the figure in *Untitled #222*, nor resigned, quite, but still somehow expressive, poignant and enigmatic.

In his essay "The Image of Proust," Walter Benjamin comments that the "wrinkles and creases on our faces are the registration of the great passions, vices, insights that called on us; but we, the masters, were not home."[56] I take the aged face to be expressive in just this way: this sex is my aging, my dying, my undoing. The face activates the dismemberment, but does so, disturbingly, by giving it an interiority that dislocates the utter exteriority of the original pornographic gaze. If the gazing back defines the object body, reconstitutes it, as a subject body, its agedness makes that subject body itself a site of irremediable loss. The loss is not something other than the body of the pornographic gaze; it is that body seen aright.

So the condition of our inhabiting our bodies as such, of locating ourselves as subjects through our embodiment, which is the originary promise of sex itself and then its pornographic elaboration, when it is finally achieved, at least reflectively through art, impels the thought that the body reclaimed, the one on which I must take a stand if I am to stand at all, is the suffering, dismembered body of the pornographic gaze. Consider the matter this way: as the pornographic gaze of the spectator and the returning gaze of the ancient face cross (and continue crossing), the whole picture achieves an auratic surplus, so that the very thing which must be excluded from sight nor-

matively saturates it as what must be seen. Because the claim of the work occurs through the crossing of the implicated gaze of the spectator and the gaze back of the ancient face, then acknowledgment of the work as a whole, our aesthetic attention, is necessarily implicated in the crossing of the first two gazes. This implication makes aesthetic assent something other than aesthetic. Call this auratic appearing the pornographic sublime: self-recognition in absolute otherness. The claim of embodiment, of the whole body, the normative charge in the pursuit of happiness, emerges, *as claim*, only in the light of and through the acknowledgment of the dismembered remnant, that doll or mannequin or prosthesis as the proper bearer of our petrified self. Aura, the kind that art alone can now generate, remains, but what looks back is not the subject but its dismembered remnant. Sublimity was always, however displaced, an acknowledgment of this; the history of the present is how this acknowledgment has been transmitted from the raging abyss to the strident dissonances of the modernist sublime to, finally, the photographic image of the mortified remnant.

Said all at once: If the claim of embodiment necessary for the pursuit of happiness is itself necessary for culture in general, and that claim is now only available through its negated remnant, the dismembered body, and that body only capable of securing a claim, possessing aura, when provided with symbolic form, and pornography that form, then modernist pornography is the site in which the "transcendental" conditions providing for the possibility of a culture in general now occurs. Horror and pornography are modalities of the same claim. Each brings us to a normally blinded scene of knowing, of what our knowing incessantly repudiates, and in so doing empties itself of significance. The emptiness of knowing is knowing without significant exteriority, knowing that absorbs the object, allowing it to be nothing but a dull reflection of the subject's striving for independence and autonomy. Since significant exteriority must be of a kind before which the claims of freedom (consent) and reason (freedom in thought) collapse, then a visual field irreducible to its discursive elaboration is the only place in which such a claim can authentically and intrinsically emerge. Art forms are symbolic forms through which intentionless nature is acknowledged; and the pornographic sublime is simply the most recent of such forms. Sherman's modernist pornography is the history of our time in image.

That it is in the violated and degraded body, the body carved into parts, anatomized and sexually dissected, that this auratic surplus occurs says more

about the context that produces pornography than it does about pornography. It should be no odder that the usually hidden, material, and obscene side of the pornographic image can be the site of insight than that tragic insight, in its broadest sense, should occur through scenes of murder or patricide. Materialist pornography, which is and is not pornographic, pornography without titillation, is another inflection of the ugly.

IX. Coda: Masks

My aim in these paragraphs has not been to deny what I concede is undeniable: that Sherman's oeuvre could not have arisen other than through a sensibility saturated in feminist thought and experience, and an art world environment in which feminist thought and experience was becoming formally productive; that some of her works operate exclusively in this ambience, especially those directly following the *Untitled Film Stills*—the rear-projections, centerfolds, and pink robe series; that for a range of her works and as a stratum in many is a social-critical impulse operating through the deployment of parodic repetition. My aim, rather, has been to urge that explicitly from the time of the first fashion pictures, but still continuous with the impulse of the *Film Stills*, Sherman discovered that the photographic gaze that was pivotal in the production and reproduction of the reified identities of the *Film Stills* was, on its social side, a component of wider processes of reification and rationalization, which, from an art-historical, aesthetic perspective, could be seen as an automatization of disinterested aesthetic perception.

This dual discovery entailed that the effort of the artistic critique of reified feminine identities could only proceed through a simultaneous critique of the photographic gaze and of the constitutive categories of the aesthetic—centrally those of beauty and ugliness—implied by it; and that her performative work on the object of the photographic gaze used in the *Film Stills* could be turned to socially wider and aesthetically more systematic ends. But it is precisely the pursuit of these wider and more systematic ends that places her work in the mainstream of artistic modernism, a continuation of the project of modernist painting in photography.

In maintaining this claim my evidence is not Sherman's stated artistic intentions, but the continuous operation of her artistic judgments: her courting of the politically incorrect; her choice to employ the genres of fan-

tasy, horror, and pornography; and her particular handling of those genres. Above all, my claim turns on there being, from the outset, a seeking out and the foregrounding of a darker, more uncomfortable, and more disturbing thought than what a reading of her as a fundamentally parodic and ironic artist could reasonably license. From the time of the fashion pictures, the object of Sherman's pictures became the ugly, not the idealizing surface and its cruelty, but what that idealizing left behind: all that was incompatible with, substantively, rationalized modernity, and aesthetically, the beauty of the automatized, disinterested gaze of the camera.

In this context, the mask pictures of the mid-1990s are particularly instructive. It is tempting to think of the mask as a metaphor for the performative, self-implicating element of Sherman's art. Each transformation of the photographic object can thus be regarded as Sherman donning another mask, literally when she herself is the model, metaphorically in her use of mannequins, mannequin parts, and medical prostheses—her grotesque doll's house. Hence the turn to actual masks becomes a reflective interrogation of the origin and meaning of her art in general, a way of making explicit the stakes of her art, how art and masking might be thought of as determining the meaning of each other. Against the background of such a thought, a reductive, anti-modernist sensibility might suggest that the mask is the clue to the meaning of human identity, that it is "masks all the way down," that there is nothing behind masks, that all identities are nothing but masks, hence that the parodic deployment of masks reveals the empty truth of human identity, and once this emptiness, this groundlessness of human existence is accepted we become free (to the extent society allows) to compose our lives in an appropriately artistic way, making and remaking ourselves as just so many efforts of donning one mask and then replacing it with another, swapping one self-legislated, self-created table of laws for another.

Although grotesque and exorbitant, there is nothing of the parodic or comic in Sherman's mask pictures. They speak, again and again, of terror and fear, of being petrified, of being trapped behind a mask, of the mask as the image of the disfigurement that it was intended to be a protection from. The masks perform ugliness, insist upon it; they are a cipher for the ugly.

It is noteworthy that Adorno takes up the question of masks in the middle of his account of the genealogy of the ugly. Having the full thesis before us will prove helpful:

> What appears ugly is in the first place what is historically older, what art rejected on its path toward autonomy, and what is therefore mediated in itself. The concept of the ugly may well have originated in the separation of art from its archaic phase: It marks the permanent return of the archaic, intertwined with the dialectic of enlightenment in which art participates. Archaic ugliness, the cannibalistically threatening cult masks and grimaces, was the substantive imitation of fear, which it disseminated around itself in expiation. As mythical fear diminished with the awakening of subjectivity, the traits of this fear fell subject to the taboo whose organon they were; they first became ugly vis-à-vis the idea of reconciliation, which comes into the world with the subject and his nascent freedom. (*AT*, 47)

As is typical in Adorno, this is a bit of reflective anthropology. Although integral to the genealogy of the ugly, masks do not in the first instance denote it. Rather, masks initially were imitations of fear—that is, material formations of the fearful expression or of the object of fear.

The cause of primitive fear was overpowering and threatening nature. Even today, Halloween masks function in an analogous way: providing form for the child's fear or its presumed object, some monster standing for all that is beyond the child's comprehension and powers of ordering. The transform between subject and object here is systematic: the look of fear authenticates its expression of fear by inspiring it, entailing that the donning of the fear-inspiring look is a way of expressing (and so mastering) the fear it arouses. In masking, we are both subject and object, which is in part how masking functionally succeeds. By expressing the subject or object of primitive fear, masks were adaptive mechanisms that operated through mimesis. In this respect, masks belong to the prehistory of artistic mimesis in being materially mimetic forms within a still practical setting.

The archaic mask becomes the ugly, stands for it, when its traits—which is to say, its imprecation of fear and the fearful, overpowering nature—become incompatible with the understanding of the subject as not intrinsically fearful but autonomous, and nature as no longer a permanent threat but a human habitat. At this moment the traits of fear expressed by the mask become taboo; they are what mimetic art must either exclude or make beautiful. But, Adorno's dialectic-of-enlightenment thesis contends, the taboo turns out to be equally a form of repression and denial: within the taboo hibernates the ban on graven images, the *Bilderverbot*, which is the repudiation of normative nature.[57] Masks are the ur-ugly: they are the ugly before it is normatively legislated as ugly, and what becomes ugly through

being normatively excluded. The moment of transition from masks as substantive imitations of fear to the taboo that makes such expressions ugly is, essentially, the precipitate of the extirpation of animism. The precipitate is not itself the extirpation, but it sets in place the mechanism of taboo, which will repress and then forget the fear and the fearful, thus inaugurating the idealization of subject and nature that is the reification of both. That masks, puppets, and dolls contain this ambiguity, of fear expressed and repressed, is the source of their uncanniness: the puppet becoming animated is the return of the repressed—the return of the repressed being precisely the return of the archaic mask. The mask then is the exemplary model of repressed animating and de-animating corporeality. Since it is both the archetype of mimetic art and the very thing tabooed by art in its becoming autonomous, just and only art, then the mask is the pivot connecting the history of art to the history of subjectivity.

In *Untitled #316* (Figure 20), which is a doll face in close-up, turning the whole doll thereby into a mask, Sherman potently captures this duality within the mask by providing a layering of masks, revealing below a smooth outer surface (mask) another mask, scarred, pitted, ravaged—the inner mask the truth of the outer mask, the layers of masking replicating the history of the mask. The ravaged mask animates the smooth surface mask, making the latter the repudiation of the former. And, of course, the eyes of this doll are human eyes, no longer frightened or terrified—it is too late for that—but unutterably sad. Kafka eyes. In almost all of the mask pictures, the eyes are not mechanical but human, the site of the subject who is masked, every mask a terrible masking. In pictures like *Untitled #321* and *#323*, extreme close-ups of faces bathed in lurid, dark tones, the inner identity of mask and photograph is asserted: what makes these faces into masks is nothing other than distance, angle, light and shadow, color: photography. These faces, however, which have the feel of—expressionist—film stills, are neither frightened nor sad; they are menacing, almost malignant: the animation of the undead.

If the doleful fate of modern art is its being bound to the material nature that is excluded in the triumphal progress of rational civilization, then art will be bound to the expression of the ugly, which is to say, if this art, our art, is to express the excluded, and to elicit our connectedness with and conviction concerning visual experience, elaborating the fate of our standing in relation to the bodily material world, then it must become the art of the

20 Cindy Sherman. *Untitled, #316*. Courtesy of the Artist and Metro Pictures Gallery.

mask, the archaic mask, its displacements and repetitions become art. The thought compressed in the mask is what every child who watches horror movies or dons a Halloween mask intuitively knows. And this intuitive knowledge is what underlies the art we call modernist. As I said at the beginning, the mutual implication of high modernism and horror, just the most recent avatar of the mask, is the truth content of Cindy Sherman's art.

Reference Matter

Notes

INTRODUCTION

1. The idea of "orientation" is owed to Kant, "What Is Orientation in Thinking?" trans. H. B. Nisbet, in *Kant: Political Writings*, ed. Hans Reiss (Cambridge: Cambridge University Press, 1970).

2. In J. M. Bernstein, *Adorno: Disenchantment and Ethics* (Cambridge: Cambridge University Press, 2001), Chaps. 2 and 6, I seek to provide an account of the notion of experience at stake here.

3. This double way of thinking about the meaning of sensory encounter in Kant's thought follows Schiller's example.

4. For this breakdown, slightly modified, and its problems, see Robert Brandom, *Making It Explicit: Reasoning, Representing, and Discursive Commitment* (Cambridge, Mass.: Harvard University Press, 1994), pp. 616ff. What, of course, drives Kant's dualistic construction is the disenchantment of nature; so the right-hand, second term of each dualism depicts nature as deauthorized and delegitimated, without a language of its own—blinded. That is the ultimate significance of Kant's Copernican turn. I take up the full scope of the deauthorization of nature in Chapter 8. Brandom's own account, by removing even a hint of material worldliness from perceptual experience, deepens rather than resolves the problem.

5. The best statement of the puzzle is to be found in Robert B. Pippin, *Kant's Theory of Form: An Essay on The Critique of Pure Reason* (New Haven, Conn.: Yale University Press, 1982), Chap. 2. To my ear, the orthodox solution to the puzzle simply side-steps it: "a Kantian sensible intuition is only 'proleptically' the awareness of a particular. . . . Although intuitions do not in fact represent or refer to objects apart from being 'brought under concepts' in a judgment, they *can* be brought under concepts, and when they are they *do* represent particular objects." Henry E. Allison, *Kant's Transcendental Idealism: An Interpretation and Defense* (New Haven, Conn.: Yale University Press, 1983), pp. 67–68. Whatever else one might say about this solution, it says nothing to the problems of guidance, triggering, and resistance, not to speak of sensory awareness itself. Its optimistic construal would be that nothing needs saying (concepts refer to other concepts, with

exteriority being only epistemic entrances or exits, spurs or refutations). A more restrained way to go here would be to say that the surface grammar of determinative judgments hides their material commitments. So Tom Huhn, *Imitation and Society: The Persistence of Mimesis in the Aesthetics of Edmund Burke, William Hogarth, and Immanuel Kant* (State College, Penn.: Pennsylvania State University Press, 2004), states that representations are curious in that "they are profoundly deceptive insofar as they simultaneously assert and deny their relation to reference. That is, representations at once both refer themselves to some source *and* deny that they are products of this gesture of referencing." Huhn goes on to argue that the reason for this deception is that in determinative judgments the fit between material and concept, their mutual determination, "is so snug that the history of a judgment having been made, of a schema imposing an order between concept and material, is effaced. In short, determinative judgement is overdetermined judgment." With Huhn's notion of "the history of a judgement" in mind, we can restate the objection to the orthodox version of Kant's theory this way: what the claim that intuitions can only be experienced after concepts have been applied ignores is that, at some point, we have to learn concepts, that we go on learning new concepts routinely, and that equally routinely we must extend existing concepts to new phenomena that stand squarely outside the previous history of application. In short, *concept acquisition and extension* demand that there be occasions in which we do encounter things prior to having the concepts they will later fall under. Kant's standard doctrine represses the learning, history, and novelty of conceptual life, aspects of conceptual life that require sensory encounter. With this thought in mind, one could justifiably contend that only in what Kant calls "reflective judgments of taste," his account of aesthetic judgment, *is the history of judgment displayed, and the role of the material in judgment given its proper due.* While I am not unsympathetic to this gesture, as Schiller complains, it only forestalls or defers the problem, which now arises as a contest between the claims of the surface grammar of determinative judgment, entailing, finally, that all empirical judgments be translatable into science, and the grammar of reflective judgment, demanding that sensible material order be irreducible. On the line I am pursuing, the snugness of fit is the manner in which sensuous particulars become disenchanted, entailing that not reflective judgment, but its historical successor, modernist art itself, becomes the bearer of the repudiated history of determination. To treat modernist art as the bearer of the repudiated history of determination is to take up Kantian aesthetics in a Hegelian manner. For Allison's change of mind on the role of sensory encounter in Kant, see his *Kant's Theory of Taste: A Reading of the Critique of Aesthetic Judgment* (New York: Cambridge University Press, 2001), esp. Chap. 1.

6. There is nothing untoward in science as such; science is an issue only when it claims and achieves hegemony over knowing, that is, only when all (ordinary) knowledge requires translation into scientific knowing for its validity. This was, it is worth noting, Kant's own view of how things should go. So the apparently hum-

drum contention that requires the establishment of the claim of modernism for its vindication is: *valid knowledge not translatable into or explicable by scientific knowledge is possible.*

7. The precise character and vehicles of the hounding are bound to be complex and overdetermined: mass art, kitsch, photography, commodity goods, the evaporation of traditional authority, the crisis of bourgeois values after 1848 and the Great War. The notion of "hounding" I realized, after writing it, echoes Greenberg's statement that the arts have been "*hunted back* to their mediums, and there they have been isolated, concentrated and defined. To restore the identity of an art the opacity of its medium must be emphasized." Clement Greenberg, "Towards a Newer Laocoon," in *Pollock and After: The Critical Debate*, edited by Francis Frascina (London: Harper and Row, 1985), p. 42 (emphasis mine). If Greenberg had taken more seriously the issue of the "opacity" of mediums, his account would have dovetailed more emphatically with Adorno's.

8. For a detailing of this claim, see Bernstein, *Adorno: Disenchantment and Ethics*, Chap. 2, §5. Chapter 9, §4, provides a general account of fugitive experience.

9. One version of this thesis appears in the writings of Arthur Danto. For a collection of relevant essays, including a trenchant critical introduction by Gregg Horowitz and Tom Huhn, see Arthur C. Danto, *The Wake of Art: Criticism, Philosophy, and the Ends of Taste* (Amsterdam: G & B Arts International, 1998). For my construal of Danto's thesis, see Chapter 8 in this volume.

10. In Gregg Horowitz, *Sustaining Loss: Art and Mournful Life* (Stanford, Calif.: Stanford University Press, 2001), a work in which Adorno's name is not used but his spirit pervasive, Horowitz forcefully defends a modernist interpretation of the presumptively paradigmatic postmodern works of Ilya Kabakov and Gerhard Richter. Of course, my notion of lateness is a variation on the notion of late style that Adorno develops, most radically, in his musicology, above all in his essay "Beethoven's Late Style." For an appreciation of lateness as the potential key to Adorno's thought as a whole, see Edward Said, "Adorno as Lateness Itself," in *Adorno: A Critical Reader*, edited by Nigel Gibson and Andrew Rubin (Oxford: Blackwell, 2002), pp. 193–208.

11. This is not quite accurate as stated, since de Duve and Bois, finally, consider their positions modernist; however the former's position is inspired by Marcel Duchamp, the key figure in the explosion of postmodern art, and the latter surveys the ruins of modernism in order to pass beyond it, so for the sake of a not yet postmodern art.

12. I should alert the reader that she will not find in these essays a full, critical elaboration of the theories concerned. My intention, rather, is to bring these theories, and the works they thematize, into critical conversation with some aspect or stretch of Adorno's thought. Hence my aim is only to provide a sufficient profile of the theory concerned so as to allow a worthwhile encounter to occur.

13. It is I think worth confessing that Sherman's pictures also led me to recon-

struct my defense of Adorno's ethics and epistemology. The record of that transformation is perspicuous in Chapter 4 of *Adorno: Disenchantment and Ethics*. That works of art can and should have this kind of salience for philosophical reflection is necessary if philosophy is truly to *depend* on art, rather than, say, find in art evidence for what is thought already. One of the embarrassments of the Sherman essay is that there is so much of *Dialectic of Enlightenment* in it; the reader should not assume that I find in Sherman evidence for my reading of Adorno and Horkheimer's book. The effort was the other way round: her pictures forced me to acknowledge aspects of their thought that my previous readings had flatly suppressed.

14. See J. M. Bernstein, "Introduction" to *Classic and Romantic German Aesthetics* (Cambridge: Cambridge University Press, 2003), and for an extended critique of Jena Romanticism's deployment of the arbitrariness of the sign as an acid dissolving the medium-bound authority of nonlinguistic arts, J. M. Bernstein, "Poesy and the Arbitrariness of the Sign: Notes for a Critique of Jena Romanticism," in *Philosophy and Romanticism*, edited by Nikolas Kompridis (London: Routledge, 2005).

15. Michael Newman, "Medium and Event in the Work of Tacita Dean," in the catalogue for the exhibition of her work at Tate Britain, *Tacita Dean: Recent Films and Other Works* (London: Tate Gallery, 2001), p. 24.

16. Ibid.

17. Ibid.

18. Friedrich Kettler, *Gramophone, Film, Typewriter* (Stanford: Stanford University Press, 1999).

19. In the past few years, I have heard both Hal Foster and T. J. Clark argue to the same conclusion with the same anxiety. Digitalization makes older debates and differences look like small change.

20. The title of this book is taken from an earlier published essay, J. M. Bernstein, "Against Voluptuous Bodies: Of Satiation without Happiness," *New Left Review* 225 (Sept./Oct. 1997), and now reprinted in *The Philistine Controversy*, edited by Dave Beech and John Roberts (London: Verso, 2002), which I originally planned to have as this book's opening chapter. While I think its critique of the aesthetics of contemporary British art is right, it did not, on reflection, seem strong enough to include. The phrase, in all its ambiguity, nonetheless seems to capture much of the stakes of this work, so it seemed appropriate to retain it as the book's title.

CHAPTER I

1. All references in the text are to *The Philosophical Works of Descartes*, Vol. 1, trans. Elizabeth S. Haldane and G. R. T. Ross (Cambridge: Cambridge University Press, 1969).

2. For what I take to be the correct reading of this passage, see Bernard Wil-

liams, *Descartes: the Project of Pure Enquiry* (Harmondsworth, Eng.: Penguin Books, 1978), Chap. 8.

3. A major de Hooch exhibition ran from December 1998 through March 1999 at the Wadworth Atheneum in Hartford, Connecticut. The exhibition had also appeared in the autumn of 1998 in the Dulwich Picture Gallery in London. The beautiful and useful catalogue for the exhibition is available: Peter C. Sutton, *Pieter de Hooch, 1629–1684* (New Haven, Conn.: Yale University Press, 1998).

4. Francisco de Hollanda, *Four Dialogues on Painting*, trans. Aubrey F. G. Bell (London: Oxford University Press, 1928), pp. 15–16; quoted in Svetlana Alpers, *The Art of Describing: Dutch Art in the Seventeenth Century* (Chicago: University of Chicago Press, 1983), p. xxiii.

5. E. H. Gombrich, "Norm and Form: The Stylistic Categories of Art History and Their Origins in Renaissance Ideals," in Gombrich, *Norm and Form: Studies in the Art of the Renaissance* (London: Phaidon, 1966), p. 96.

6. I take it as given that some of the power of Gombrich's analysis turns on the match between his claims for the internal dynamic between order and fidelity to nature with Kant's contention that concepts (order) without intuitions (fidelity to nature) are empty, and intuitions without concepts blind. Hence the "classic solution" becomes an anticipation of the ideal of cognitive synthesis, and deviation from the ideal thus a failure in the sense of accomplishing no synthesis at all; to depart radically from the ideal is thus tantamount to not *painting* at all. And this will sound potent, indeed unimpeachable, until we recall that Descartes's fiery dissolution of the piece of wax into its wholly intelligible counterpart entails the radical *blinding* of intuitions as such to the point that there is no sensible or sensuously particular nature for painterly order to be faithful to. This I understand to be the suppressed dilemma of modern painting, the pressure that generates abstract painting as simultaneously resistance and defeat. Thus I am locating in de Hooch the anticipation of that dialectic of resistance and defeat that I take to be the project and fate of modern painting.

7. Ibid., p. 95. For Gombrich the axes are both descriptive and normative. He takes it as obvious, for example, that an "increase in naturalism" can only mean or accomplish "a decrease in order" (p. 94), where it is assumed that the decrease in order is a technical failure that a fortiori entails an aesthetic failure. If order necessarily has the sense of fit with an *ideal* of unity, hence fit with demands that are necessarily extrinsic to their material objects, then the ambition of Dutch art and what succeeded it are necessarily empty: painterly modernism is in principle impossible and without authority. I am thus construing the adventure of Dutch realism as providing the genealogical conditions of possibility for modernist painting, as instituting the idea of painting as a response to a wholly secular world set free from ideals that forever transcend it. Said another way, I am ascribing to de Hooch, above all his brick walls, a conception of material signification that can

dispense with reliance on signifiers that are in principle detachable from their material embodiment.

8. For the core example of this approach, see Eddy de Jongh, "Realism and Seeming Realism in Seventeenth-Century Dutch Painting," trans. Kist Kilian Communications in Wayne Franits, ed., *Looking at Seventeenth-Century Dutch Art: Realism Reconsidered* (Cambridge: Cambridge University Press, 1997), pp. 21–56. See pp. 258–59 for a bibliography of de Jongh's writings; "Realism and Seeming Realism" was originally published in 1971.

9. Peter C. Sutton, *Pieter de Hooch, 1629–1684* (Dulwich Picture Gallery and Wadworth Atheneum in association with New Haven, Conn.: Yale University Press, 1998), p. 70.

10. I am grateful to Gregg Horowitz for pointing out to me how Alpers's work responds to Gombrich.

11. Erwin Panofsky, *Early Netherlandish Painting*, 2 vols. (Cambridge, Mass.: Harvard University Press, 1953), Vol. I, p. 182, quoted in Alpers, *The Art of Describing*, p. xxi.

12. Alpers, *The Art of Describing*, p. xxiv.

13. Ibid., p. 78.

14. Ibid., p. 102.

15. This is to concede that some of the "elements" that appear in the canvases of 1658 were anticipated elsewhere. Perhaps the most interesting developments in the use of perspective are found in the paintings of church interiors by Gerard Houckgeest, Pieter Saenredam, and Emmanuel de Witte. With respect to the possibilities of cityscapes, de Hooch was anticipated by Carel Fabritius and Daniel Vosmaer. With respect to interiors, it is customary to mention Nicolaes Maes, Samuel van Hoogstraten, and Isaack Koedijck. In the case of the latter three, the connection to de Hooch remains speculative.

16. More precisely, the white garments of the woman and the standing man are clearly being lit by sunlight that is coming through the just barely visible windows on the far left, which makes the glare on the door more difficult to understand.

17. On the significance of smoking, see Ivan Gaskell, "Tobacco, Social Deviance, and Dutch Art in the Seventeenth Century," in Franits, *Looking at Seventeenth-Century Dutch Art*, pp. 69–77. By 1658, smoking was losing its association with social deviancy and the lower classes and becoming an acceptable middle-class recreation—but "becoming" is the operative word here. De Hooch, I think, employs the ambiguity, heightening the interplay between low pleasure and sunlit innocence. In putting the matter this way, I do mean to imply that de Hooch's gesture here should be regarded as one of securalizing: sunlit sociality becoming perceptible as a good in itself.

18. Elizabeth Alice Honig, "The Space of Gender in Seventeenth-Century Dutch Painting," in Franits, *Looking at Seventeenth-Century Dutch Art*, pp. 186–201.

19. Ibid., p. 193.

20. Ibid., p. 194.

21. Gombrich, "Norm and Form," p. 97.

22. This is analogous to the way the inside and outside of the body cross and exchange places in Cindy Sherman's pictures (see Chapter 9 in this volume). But this is perhaps to suggest that de Hooch's exchange of inside and outside, their reversibility, is modeled on the reversibility of human embodiment, its vulnerable flesh. Let's say then that the reversible inside/outside structure is a way of blocking a metaphysical duality of foreground and background. In so doing, the powers of painting and what is painted attain a fitness for each other.

23. In saying this I do not mean to deny the obvious fact that these paintings possess an obvious, too obvious in my judgment, compositional order, only that is not the order that gives them their power of claiming.

24. See Michael Fried, *Courbet's Realism* (Chicago: University of Chicago Press, 1990). For a quick philosophical view of this argument, see Stephen Melville's review of Fried's book, "Compelling Acts, Haunting Convictions," in Melville, *Seams: Art as a Philosophical Context* (New York: G+B Arts, 1996). In this account opacity is located simply in the performative excess of the act of painting in relation to the thing painted, hence in the excess of representing to any representation. This would make the shift from Courbet to Manet something like an extended, incremental Copernican turn in painting (despite Melville's Heideggerian rhetoric). And although I think there is this kind of excess, it seems too broad and philosophical to make what is puzzling and compelling about realism and its withdrawal too assured, as if the surrender of realism had nothing to do with the withdrawal of the world.

25. For Kant and the amenability problem, see Chapter 2. In that chapter I propose something more on the idea of painting's performing transcendental inductions about the possibility of experience in the paintings of Chaim Soutine.

26. After writing this, it slowly dawned on me that my fitness argument is, finally, extremely proximate to, and hence a confirmation of those lovely passages on Dutch painting in Hegel's *Aesthetics: Lectures on Fine Art*, trans. T. M. Knox (Oxford: Clarendon, 1975), in which he thinks of it as celebrating "the Sunday of life" (p. 887), as possessing a sure-footed location "in the prose of life" (p. 598). So, on the side of content, Hegel underlines how these paintings find "satisfaction in present-day life, even in the commonest and smallest things," especially those most transitory: "the luster of metal, the shimmer of a bunch of grapes by candlelight. . . . a smile, the expression of a swiftly passing emotion" (pp. 597, 599). This art gives to the transitory the depth of substance, that is, as being "appearance for its own sake"; while there is triumph of art over the transitory, it is "a triumph in which the substantial is as it were cheated of its power over the contingent and fleeting." Hegel's concession that in these paintings the substantial is cheated of its power over the contingent is to concede the glory of these paintings against his own adherence to the substantial. For me this makes his concession both more moving and more telling. His explanation for the possibility of this "love for what is evi-

dently momentary and trifling" (p. 886), this self-sufficiency of the prose of the world, is that the Dutch, uniquely, have *produced* the world they inhabit through their fierce industry: it is truly a world of their own making. Turning now to the powers of painting that are internally related to the world painted, Hegel states: "[T]he chief thing now—independently of the topic itself—is the subjective recreation of the external world in the visible element of colours and lighting. This is as it were an objective music, a peal in colour" (pp. 599–600), "the magic and enchantment of light, illumination, and color" (p. 886). There is, as it were, a transcendental affinity between the powers of painting, *its* world of light and color, and the evanescent things that compose the ordinary, the world of everyday life. The painterly celebration of the contingent is thus "the greatest truth of which art is capable" (p. 886). To be sure, the idea of a fitness between the kind of art a people have and the life of that people is one of the driving principles of Hegel's aesthetics; what distinguishes his appreciation of Dutch art is his revelation of the self-consciousness of the congruence between the powers of painting, colors and light, and the celebration of the prose of the world. Hegel's treatment of Terborch's painting of satin (p. 600) is hence not very far from my analysis of de Hooch's brick walls. Against the background of Hegel's reading, it might be complained that I have made too little of the explosion and intensity of the colors in de Hooch's paintings of 1658 as compared with what preceded them. It would also follow that de Hooch is not quite as unique as I am claiming, although I would observe that de Hooch's practice makes what is otherwise *implicit* in Dutch painting *explicit*, that he finds the terms, above all in his subject matter, through which that claim can become explicit.

27. And indeed, should we not construe Bacon's critique of the idols that stand in the way of our apprehending the world as a claim about the *fitness* of the world for being gathered through empirical observation? Fitness in Bacon is bluntly metaphysical, while in de Hooch it unites the metaphysical with the historical. So my complaint against Alpers might be that, in order for her argument to have force, she must accept Bacon's naive fitness argument. But this brings us back to my original complaint about her reliance on bad scientific theory, and the equal worry that it robs realist painting of its specificity.

28. That the relation between realism and modernism is both political and epistemological is the splinter in the eye of T. J. Clark's reconstruction of modernism. Further, I agree with Clark's analysis of Jacques-Louis David's *Death of Marat* in locating the opacity of modern painting in the domain of a constitutive contingency, including, but not restricted to, the relations between painter and beholders. The role of women as subjects of painting and beholders of it, the blindness or unseeing of the paternal gaze, are not mere accessories in this story: they stake out the form of a certain contingency that is both weakly political (with respect to the kind of community formed by painter and audience) and ontological (what woman means in relation to our conception of nature). On Clark, see Chapter 6.

29. My point here is that the distance from the street and the oddness of the angle of vision give to the painting the sort of link between spontaneity and realism that we associate with photography. And this feeling holds whatever the means of the painting's production. Vermeer's visual brilliance, like de Hooch's, is both technical and semantic; because their painterly semantics are so different, we have all the reason in the world to suppose that their visual brilliance is not exhausted by whatever technical means of production Vermeer (and de Hooch?) had at hand. For the claim that Vermeer employed a camera obscura to create some of his images, see Philip Steadman, *Vermeer's Camera: Uncovering the Truth behind the Masterpieces* (Oxford: Oxford University Press, 2001).

30. Edward Snow, *A Study of Vermeer*, revised and enlarged edition (Berkeley: University of California Press, 1994), p. 109.

31. Here is Lawrence Gowing: "In the *Maidservant* light collects into pearly globules. The surface of the bread is lost under *a separate crust of incandescence*. On the skirt, where it is gathered at the waist, the points of paint lie like jewels, lending the cloth *an independent and immaterial luster*"; in *Vermeer* (Berkeley: University of California Press, 1997), pp. 111–12 (emphasis mine). Gowing's classic study was originally published in 1952. All that "incandescence" and "immaterial luster" push in exactly the direction of the difference I want to draw, the distance separating Vermeer's bread from de Hooch's lime-leached brick.

32. Snow, *A Study of Vermeer*, p. 12.

33. Even the more traditional reading of Vermeer by Gowing must concede something of what I am urging here. So, for example, after articulating the standard idea that Vermeer conceives of the world as something that has the intrinsic capacity to be seen, and it is that capacity which the seeing of painting sees, he continues: "He was engaged in unfolding the deepest fantasy, the fantasy, as it seems, that visible things in their integrity were capable of coming together in the community of a perfect plane, were capable there of meeting him and of conferring on him all the enrichment of outward things, the fantasy that on a flat surface the world in essence could become his." Gowing, *Vermeer*, p. 46. The role of "fantasy" and the world (as woman?) becoming "his" in Gowing's account exactly captures the distance from de Hooch that I am interested in, the distance of the female from the male gaze. What Gowing I think misses, and Snow senses (although perhaps in a too Heideggerian register), is that the iridescent surface of Vermeer is always bound up with concealment, inwardness, mystery. I always suppose that for Vermeer the mystery of woman and the mystery of the world are the same mystery, with painting being the revelation of the mystery; so, for example, the inwardness of *A Woman in Blue Reading a Letter* is not, even for a moment, Protestant. The mystery thus remains even when, as in *Head of a Girl*, the subject is not depicted as "absorbed" in some task.

34. Julia Kristeva, *Black Sun: Depression and Melancholia*, trans. Leon S. Roudiez (New York: Columbia University Press, 1989), p. 137.

35. Ibid., p. 117.

36. On the difference between knowing and acknowledging, and the role of art as acknowledgment, see Chapter 3.

37. The quickness with which de Hooch succumbs makes one suspicious that in the Delft paintings de Hooch was attempting to flatter female patrons by making, well, paintings from a feminine point of view. Such a cynical reading of the great Delft paintings should not be dismissed. But that cynicism, I think, will not infringe upon the logic of my fitness argument since everything still turns on de Hooch's matching the powers of painting to the proprieties of that feminine point of view; there is still a fit between the syntax of his kind of realism and the semantics of the world represented. When the semantics shift, becoming a "guy thing" in the Amsterdam paintings, the paintings lose the power to claim, or at least to claim in the same way. That shift and loss is all that is necessary for my argument, however cynically subtended.

38. The major task required to substantiate my interpretation of Delft materialism would be to show how, in painting ordinary objects, de Hooch and Vermeer rendered visible how such objects are not merely useful but also good in themselves—their utility and intrinsic goodness are one, materially. But this is just a vision of how ordinary life, visionary domesticity, is intrinsically good.

39. On the still life, see Norman Bryson's compelling *Looking at the Overlooked: Four Essays on Still-Life Painting* (Cambridge, Mass.: Harvard University Press, 1989). For the fate of the still life in modernism, see Meyer Schapiro, "The Apples of Cézanne: An Essay on the Meaning of Still-life," in Schapiro, *Modern Art: 19th and 20th Centuries* (New York: George Braziller, 1979), pp. 1–38.

CHAPTER 2

1. Immanuel Kant, *Critique of Judgment, Including the First Introduction*, trans. Werner S. Pluhar (Indianapolis: Hackett, 1987). All references in the body of the text are to this edition, *CJ* referring to the published body of Kant's text, *FI* to the first introduction, which was originally unpublished.

2. This and the previous phrase are from Robert Hughes, *The Shock of the New: Art and the Century of Change* (London: Thames and Hudson, 1991), p. 292.

3. This is equivalent to the dematerialization of nature because, in explaining the appearances, mathematical physics was taken as showing that there was nothing *in the world* corresponding to how the world appeared in our pretheoretical experience of it. Hence the way the world appeared lacked irreducible meaningfulness.

4. This is why, as Alice Kuzniar pointed out to me, from the Jena romantics through Nietzsche, animals are posited as emblems of the rationality of human embodiment. *Animality is the reason that Enlightenment reason disavowed.* What I have called in the first sentence of this paragraph "circumambient nature" is, in the first instance and minimally, the environment that is the internal correlate of the animal body.

5. Philippe Lacoue-Labarthe and Jean-Luc Nancy, *The Literary Absolute: The Theory of Literature in German Romanticism*, trans. Philip Barnard and Cheryl Lester (Albany: State University of New York Press, 1988), 30–31, get right the crisis of the subject, its loss of substance, but conspicuously fail to mention the crisis of nature.

6. Immanuel Kant, *Critique of Pure Reason*, trans. Norman Kemp Smith (New York: St. Martin's, 1965), A653–54/B 681–82. Just before this, at A 651/B 679, Kant stated similarly: "The law of reason which requires us to seek for this unity [of natural powers and hence of nature as a system of laws], is a necessary law, since without it we should have no reason at all, and without reason no coherent employment of the understanding, and in the absence of this no sufficient criterion of empirical truth."

7. It should be noted, though, that the sense of "mechanical" in the first *Critique* is narrower than in the third. See Henry Allison, "Kant's Antinomy of Teleological Judgment," *Southern Journal of Philosophy* 30, Supplement (1991): 26–28. In its expanded sense, the mechanical is opposed to the purposive, where the former, but not the latter, is extensionally equivalent to what is *discursively* intelligible. For an interesting account of the amenability problem in the final *Critique* from the perspective of Kant's moral philosophy, see Véronique Zanetti, "Teleology and the Freedom of the Self," in Karl Ameriks and Dieter Sturma, eds., *The Modern Subject: Conceptions of the Self in Classical German Philosophy* (Albany: State University of New York Press, 1995), pp. 47–63.

8. Christel Fricke, "Explaining the Inexplicable. The Hypotheses of the Faculty of Reflective Judgment in Kant's Third Critique," *Noûs* 24 (1990): 56.

9. Of course, processes of composition and decomposition can alter what kind of stuff something is; but since those processes are themselves mechanical, they do not alter the fundamental point. On the contrary. That is precisely Kant's point about the mechanical operation of mere nature.

10. Hannah Gingsborg, "Reflective Judgment and Taste," *Noûs* 24 (1990): 65. Ginsborg must be correct in extending the problem of heterogeneity down to the level of the individual concept, since Kant goes on to say, in the very next section, that "the principle by which we reflect on given objects of nature is this: that for all natural things *concepts* can be found that are determined empirically" (*FI*, p. 211).

11. Ludwig Wittgenstein, *Philosophical Investigations*, trans. G. E. M. Anscombe (London: Macmillan, 1969), §284.

12. I presume that "smooth" in Wittgenstein is wholly metaphorical, designating everything about the stone, even if it is a very rough and ragged one, that makes it a mere thing, not living, not dead, just a thing. For the purposes of the argument, I have shifted "smooth" so that its use parallels that of "wriggling." I consider this run of argument in Wittgenstein, from §283 to §286, atypical because it is the problem of "other bodies," not other minds, and because that prob-

lem is at least partially detachable from questions of behavior and the use of various terms to refer to mental experiences. It does not harm my claims here that this particular run of interrogations includes an explicit moment of nondiscursive—mimetic—cognition: "Think of the recognition of *facial expressions*. Or of the description of facial expressions—which does not consist in giving the measurements of the face! Think, too, how one can imitate a man's face without seeing one's own in the mirror" (§285). For a helpful consideration of these passages in the context of the private language argument, see Marie McGinn, *Wittgenstein and the Philosophical Investigations* (London: Routledge, 1997), pp. 150–57.

13. For a defense of the thought that the *Critique of Judgment* concerns a sense of "orientation" that cannot be "the result of any inference or application of, or even obedience to, a rule," see Robert Pippin, "Avoiding German Idealism: Kant, Hegel, and the Reflective Judgment Problem," in Pippin, *Idealism as Modernism: Hegelian Variations* (New York: Cambridge University Press, 1997), pp. 147–48. This way of reading the third *Critique* first came to my notice in Howard Caygill's *The Art of Judgment* (Oxford: Basil Blackwell, 1989), whose argument has been quietly working away at me for over a decade.

14. For a good discussion of the relation between apprehension and presentation in aesthetic reflective judgments as reflective specification, see Rudolf A. Makkreel, *Imagination and Interpretation in Kant: The Hermeneutical Import of the Critique of Judgment* (Chicago: Chicago University Press, 1990), pp. 51–58.

15. David Bell, in "The Art of Judgement," *Mind* 96, no. 2 (1987): 221–44, elaborates or extends Kant's account of reflective judgment through a consideration of Wittgenstein, introducing in his analysis the notion of "intransitive understanding," a notion that I take to parallel my conception of nondiscursive cognition. Wittgenstein's examples of intransitive understanding—understanding a face, piece of music, posture, poem, etc.—are initially quite aesthetic. However, as Bell points out (p. 243), in §527 Wittgenstein extends the intransitive/aesthetic to linguistic understanding itself: "Understanding a sentence of language is much more akin to understanding a theme in music than one might think. What I mean is that understanding a sentence lies nearer than one thinks to what is ordinarily called understanding a musical theme. Why is just *this* the pattern of variation in loudness and tempo? One would like to say 'Because I know what it's all about.' But 'what is it all about' I should not be able to say." Should we not say here that discursive and nondiscursive, transitive and intransitive are touching? And what is touching here? Certainly nothing I want to call merely, pejoratively, "aesthetic."

16. For an elaboration of this historical formation of nature, see Theodor W. Adorno, *Aesthetic Theory*, trans. Robert Hullot-Kentor (Minneapolis: University of Minnesota Press, 1997), pp. 61–77. Behind the reflections in this paragraph are Adorno's sentences: "For in every particular aesthetic experience of nature the social whole is lodged. Society not only provides the schemata of perception but

peremptorily determines what nature means through contrast and similarity. . . . Natural beauty is ideology where it serves to disguise mediateness as immediacy" (p. 68).

17. I am not here flatly asserting that there are now no valid aesthetic judgments of nature. Rather, the point of putting the thesis in the interrogative is to signal that the issue relates in the first instance to our rational confidence in the worth or goodness of such judgments. We now possess powerful and discomforting reasons to feel deep anxieties about this range of aesthetic judgments, an anxiety that was directly paralleled by the fate of representational art—explicitly still lifes and landscapes—throughout the twentieth century. The same set of pressures that, for example, force Richard Diebenkorn to turn the scene outside his window into abstract colorfields—his painful manner of continuing the tradition of landscape—in order to avoid having that represented scene fall into cliché or sentimentality or kitsch, forces each of us to feel hesitant about the authenticity or validity of our aesthetic appreciation of natural beauties. Inevitably our judgments come with question marks attached. The somber shadow of the interrogative is all that is required for the purposes of the argument, for the transition from natural beauty to art beauty. This transition does not, however, utterly drive out the experience of natural beauty, although it should drive out the thought that in appreciating natural beauty we are in touch with *nature*. In *Aesthetic Theory* (p. 69), Adorno puts the thought this way: "Natural beauty remains the allegory of this beyond [of bourgeois society, its labor, and its commodities] in spite of its mediation through social immanence [that is, being turned into landscape]." We can put Adorno's point as a question: Could an emphatic conception of beauty exist without a conception of natural beauty? A negative response to this question would immediately secure the place of Kant's reflections in the *Critique of Judgment* in relation to modernist art. Here, of course, I am broaching the same conclusion from the perspective of Kant.

18. The inclusion of the experience of the negation of known sense as a condition for appreciating aesthetic sense entails a lapsing of Kant's distinction between sublimity and beauty.

19. My interpretation, placing, and championing of Soutine are not altogether novel, however unusual they may be in the critical present in which he has become a forgotten figure. Norman L. Kleeblatt and Kenneth Silver's *An Expressionist in Paris: The Paintings of Chaim Soutine* (New York: Prestel, 1998), the catalogue to the Soutine exhibition in New York, Los Angeles, and Cincinnati in 1998–99, is excellent in documenting Soutine's reception and directing readers to the surprisingly fine critical literature on Soutine. The section title here, "Soutine's Hemorrhage," is drawn from Waldemar George, quoted by Silver (p. 30): "His work looks to me like a hemorrhage."

20. Clement Greenberg, "Soutine" in Greenberg, *Art and Culture* (London: Thames and Hudson, 1973), p. 115.

21. Soutine was an ardent admirer of traditional art, of Rembrandt, Tintoretto, El Greco, Courbet, and Corot; and many of his later works drew on traditional models, Rembrandt in particular.

22. Greenberg, *Art and Culture*, p. 216.

23. For a reading of Van Gogh along these lines, see J. M. Bernstein, *The Fate of Art: Aesthetic Alienation from Kant to Derrida and Adorno* (University Park, Penn.: Pennsylvania State University Press, 1992), pp. 213–15.

24. For more in the way of appreciation and criticism of the Greenberg/Michael Fried story, see Chapter 4 in this volume.

25. The third paragraph of Greenberg's essay on Soutine, pp. 115–16, eloquently lauds him for his feeling for paint matter, comparing him to Rembrandt and Van Gogh. However, even in this praise Greenberg's purification of the visual is operative: "Soutine used impasto for the sake of color alone, never sculpturally or to enrich the surface. His paint matter is kneaded and mauled, thinned or thickened, in order to render it chromatic, altogether retinal."

26. That works of art may appear more alive than living things, which is their power of mortification, is central to Hegel's end-of-art doctrine. I take up this issue, of dead nature in Hegel, in Chapter 8.

27. Elie Faure, *Soutine* (Paris: Editions Crès, 1929), p. 14, quoted by Kenneth Silver, "Where Soutine Belongs: His Art and Critical Reception in Paris between the Wars," in *An Expressionist in Paris*, p. 31. Faure is certainly Soutine's most eloquent interpreter. His monograph was republished in 1956 by La Maison de la Pensée Française. As Silver and others in the same volume point out, Faure's interpretation of Soutine is nonorthodoxly religious. What nonetheless sustains the integrity of his interpretation, what he gets emphatically right (and writes beautifully about) is the way Soutine locates "spirit" in the lowest forms of matter. Whether Faure's thought is original is another issue.

In 1912 we find the critic La Fresnaye writing of Cézanne: "Each object, in one of the late canvases, has ceased to exist only in itself, and become little by little a cell with the whole organism of the painting. This is the really fruitful aspect of Cézanne's painting and the reason for which it is at the root of all the modern tendencies." Quoted in John Golding, *Cubism: A History and an Analysis, 1907–1914* (London: Faber and Faber, 1971), p. 79. Of course, the rhetoric of organic wholeness is traditional. I am assuming that its reappearance to describe Cézanne's *planes*, Braque's facets, and Soutine's deformations indicates that it is being reconfigured in the light of or under the pressure of these novel forms of decomposition. It is composing through decomposing, where the weight of decomposition indicates minimal units that are, rhetorically speaking, more *vital* than the elements of a geometric figure or an inorganic object, say, in that they possess an intrinsic potential for mutation, transformation, integration, and thus are both more and less indigent than conceptions of a "part" of some whole. More indigent because the part is (experienced as) severed or cut rather than merely isolated; less indigent be-

cause it possesses more individual integrity as a part and yields more in its moment of composition.

28. Silver, "Where Soutine Belongs," 23.

29. Ibid., pp. 29–37.

30. Greenberg, "Soutine," p. 117.

31. Ibid. In "Soutine's Shudder: Jewish Naiveté?" in Kleeblatt and Silver, *An Expressionist in Paris*, Donald Kuspit pointedly associates what I am calling the "writhing" or "twitching" character of these canvases with Adorno's notion of "shudder." For Adorno a shudder is the precise reverse of the death rattle: the bare rattle of life escaping mortification (reification). Shudder then is not a bad theoretical translation for "embryonic organism." And while Adorno thinks of shudder as the experience afforded by modernist art, Kuspit's contention that Soutine's paintings are "nothing but shudder" (p. 78) would be prescient if considered formally.

32. Throughout this paragraph I mean to suggest that Greenberg's vision of modernism, even when it motions in the direction of negativity and the sublime, cannot really capture those features of works.

33. As Kant's argument for judgments of taste half implies but refuses to confess: beauty is nothing but the acknowledgment of living nature beyond brute mechanical nature. Nature's amenability is, paradigmatically, nature's being alive.

34. Although I can imagine works in which this criticism seems appropriate, in this setting it is merely a way of asking that any showing of painterliness be resolved back into quiet unity. Greenberg's ardent defense of beauty over sublimity is probably the crucial form in which his resistance to artistic materialism is enacted.

35. As Gregg Horowitz has urged on me, the correct way of expressing the "Jewish" character of Soutine's art that connects with his materialism would be to say that these paintings *are* "jews," unassimilable in the exorbitancy of their suffering (which is the same as their exteriority); hence "jews" in the way in which the suffering Christ is one. Elie Faure was wont to consider Soutine's still lifes of dead animals as transformations of Rembrandt's crucifixions. And it is precisely Soutine's insistent naturalism—nothing but painted dead animals—that thus performs a final vindication of religious art (drawing out Rembrandt's claim, so to speak): its heights were never anything but the quiver of a brush stroke.

36. For criticisms of Greenberg's and Michael Fried's interpretation of abstract expression, above all of Pollock, that anticipate the one implied here, see Rosalind Krauss, *The Optical Unconscious* (Cambridge, Mass.: MIT Press, 1993), Chap. 6; and Briony Fer, *On Abstract Art* (New Haven, Conn.: Yale University Press, 1997), Chap. 5. The gain in reading Pollock and abstract expressionism through the lens of Soutine is that it permits Krauss's and Fer's materialist emphases to take on a precise semantic content and lineage, while, above all, making Pollock's materialism an apotheosis, say, rather than a break from what preceded it.

CHAPTER 3

1. Abbreviations used in this chapter are as follows:

MD = Stanley Cavell, "Music Discomposed," in Cavell, *Must We Mean What We Say?* (Cambridge: Cambridge University Press, 1976).

CR = Stanley Cavell, *The Claim of Reason: Wittgenstein, Skepticism, Morality, and Tragedy* (Oxford: Clarendon Press, 1979).

AP = Stanley Cavell, "Aesthetic Problems of Modern Philosophy," in Cavell, *Must We Mean What We Say?*

WV = Stanley Cavell, *The World Viewed: Reflections on the Ontology of Film* (Cambridge, Mass.: Harvard University Press, 1979).

MM = Stanley Cavell, "A Matter of Meaning It," in Cavell, *Must We Mean What We Say?*

QO = Stanley Cavell, *In Quest of the Ordinary: Lines of Skepticism and Romanticism* (Chicago: University of Chicago Press, 1988).

CJ = Immanuel Kant, *Critique of Judgment*, trans. Werner S. Pluhar (Indianapolis: Hackett, 1987).

2. It is the failure of acknowledgment—of trust, not of knowledge—that makes Othello's jealous quest death-dealing, making skepticism, its truth, a function of our disappointment in knowledge—from which no knowledge can save us.

3. That for Cavell what I am calling transcendental cannot be pure in Kant's sense—that is, a pure form knowable a priori—is entailed immediately by the locale of the claim, the domain of the aesthetic. And that means that the notion of the transcendental will need to undergo a sea change. Still, the risk or cost of not using it here to fix the correct level of argument seems to be greater than the risk of using it. In fact, my anxiety goes the other way around. Because Cavell thinks that skepticism depends upon a certain fantasy of knowing, and that it is only through this fantasy that the skeptic is led to displace all the contextual conditions that make knowledge possible, then it becomes tempting to think that there are certain standing transcendental conditions that make knowledge possible. For more on this thought, see note 8 below.

4. There is a pathos in the question because it is a plea for recognition there and then, since there and then the bodies of Othello and Desdemona are lying together before us, an emblem of the truth of skepticism. The becoming has already taken place; so Cavell is asking whether his philosophy, *The Claim of Reason* in its full modernist self-presentation, including its inclusion of Othello and Desdemona, will be recognized as a continuation, fulfillment, and transformation of the debates over skepticism, presented almost decorously in the first three parts of the text.

5. That this occurs at the moment when modernism as the leading edge of high culture is in rapid retreat, leading to its presumed disappearance and replacement by postmodernism, is not without significance. As Cavell was turning to Romanticism, Michael Fried, who was his partner in modernist crime, was eschew-

ing art criticism for art history. Dark times for modernism. The premise of this essay is that the cultural eclipse of modernism has not yet made it a thing of the past with which we could be over and done.

6. For a helpful fleshing out of this claim, see Richard Eldridge's Introduction to *The Persistence of Romanticism* (New York: Cambridge University Press, 2001).

7. This claim is not original with me. For fine and lucid accounts of the topics of this essay to which I am much indebted, see Stephen Mulhall, *Stanley Cavell: Philosophy's Recounting of the Ordinary* (Oxford: Clarendon, 1994), pp. vii–xvii, 23–33, 69–74; and Mulhall, "On Refusing to Begin," in *Common Knowledge* (1996): 25–41. Anyone concerned with these topics in Cavell should start with Mulhall's essay (which paces out the compressed argument of his book's Foreword); it provides a commentary on the opening five paragraphs of *The Claim of Reason*, leading to a modernist framing of the work as a whole.

8. All of this is indiscriminate because it ignores the type of claim at issue. This lack of discrimination echoes an oddity of Cavell's philosophy, namely, his manner of slipping past the exact locale or level of his claims. By speaking about knowledge and skepticism generally, and how these have their human and logical origins in skepticism concerning other minds, and saying that skepticism relates to, baldly, the transcendental facts of human separateness (and so our mortality and isolation) and connectedness, Cavell keeps his interrogations of meaning and knowledge perfectly general, that is, indifferent to the domains of morals or politics or perception or science or. . . . He will alight on each of these at particular moments for particular reasons, but he thinks that his domain of questioning (running from thing to other person skepticism, and from thence to minimal conditions of intersubjectivity) logically precedes and hence bears on all the traditional areas of philosophy.

9. While I think the antagonism is nearly as grand as I am portraying it, there always have been strains within modern philosophy of an empiricist and pragmatic kind—not to speak of the desire to couple the ideal type with various forms of moral and political individualism—that significantly soften the contrast. In light of the contrast, Cavell's decision to hold firmly to the line of philosophical reflection that starts from the problem of skepticism becomes comprehensible: the aim of overcoming subjectivity as the path to knowledge is intelligible only as a response to skepticism. Hence the *problem* of skepticism is the precise place where the antagonists are joined.

10. It may be a terrible thing that I find something pleasant, but that is a different matter entirely. Any claim about "false" pleasures will thus need to contain some account about what is wrong with finding such-and-such pleasant (for example, that it is morally corrupting or corrupt; or it blocks off the formation of nobler pleasures) without thereby gainsaying what is felt. I leave aside the marginal case in which I say that I find something pleasant because I know that I should find it so, even though I do not, which is awkward because, my self-deception being what it

is, I may not know or realize that I do not find pleasurable what I say I do. And if I do not know, or will never know, then where is the self-deception located, where is the pleasure's falsity?

11. If you do not hear this as a retreat, or find laughable, as Kant remarks, the idea that someone might claim flatly, "This is beautiful *for me*," then we shall not be able even to get started. The premise of the argument is the oddness of aesthetic claiming, that we find ourselves irresistibly posing certain types of judgments of taste in curiously objective terms. The philosophical burden is doing something with the grammatical curiosity.

12. Mulhall, *Stanley Cavell*, p. 28. In "Aesthetic Problems of Modern Philosophy," the idea of mastering one's subjectivity and making it exemplary for others, so quickly stated, has to carry a large burden, since it stands in for Kant's deduction of the judgment of taste. But this is just to say that Cavell is shifting the burden of Kant's analysis from our relation to nature as a whole to our relations to one another as a whole. I am here ignoring this lacuna in the argument. But the fact of this shift is my reason for including my account of Cavell in this setting: it attempts to detach the rational kernel of Kant's aesthetics from the particulars (such as the harmony of the faculties, or the relation of imagination to understanding) of Kant's transcendental philosophy. Indeed, one could say that Cavell tells Kant's aesthetic doctrine in a purely Hegelian, intersubjective, recognitive way. That thought, at any rate, is the mainspring of my reconstruction.

13. For Cavell's own account of the role of "fishiness" in the meaning of actions, see "Must We Mean What We Say?," pp. 12–19.

14. Cavell can sometimes present his position as if this is what is being urged; see, for example, *CR*, p. 29.

15. For essays informing Cavell's and my account of Caro, see Michael Fried, "New Work by Anthony Caro," "Two Sculptures by Anthony Caro," "Caro's Abstractness," and "Anthony Caro," all collected in Fried, *Art and Objecthood* (Chicago: University of Chicago Press, 1998); and Clement Greenberg, "The New Sculpture" and "Modernist Sculpture, Its Pictorial Past," both in Greenberg, *Art and Culture* (Boston: Beacon, 1961).

16. In the next chapter I attempt to defend minimalism against Fried's construction of it.

17. In posing skepticism in this way, I am agreeing with Steven Affeldt, "The Ground of Mutuality: Criteria, Judgment and Intelligibility in Stephen Mulhall and Stanley Cavell," *European Journal of Philosophy* (April 1998): 21, that for Cavell skepticism depends "upon a fantasy of our language as a framework of rule which itself governs the use and determines the meaning of words and which itself functions to align him with others." Unless it were this fantasy (and the facts of "determined society" that make it something more than a fantasy) that supported skepticism, it would be unclear why Cavell employed an aesthetic logic as its other.

18. I presume this sentence is intended as an interpretation and thus a defense of Clement Greenberg's "Avant-Garde and Kitsch," in Greenberg, *Art and Culture*.

19. "Now I might define the problem of modernism as one in which the question of value comes first as well as last: to classify a modern work as art is already to have staked value, more starkly than the (later) decision concerning its goodness or badness" (MM, p. 216). "Value" has here the sense that it places a claim upon me, deserves attention, calls for response, and does so intrinsically, as a matter of its configured materials.

20. Fried, *Art and Objecthood*, p. 187.

21. In fact, it is not Hegelian art history informing Fried's theory but Maurice Merleau-Ponty's rendering of Georg Lukács's concept of dialectic in *History and Class Consciousness*.

22. For Cavell's continued allegiance to this idea, see "The World as Things: Collecting Thoughts on Collecting," in the exhibition catalogue *Rendezvous: Masterpieces from the Centre Georges Pompidou and the Guggenheim Museums* (New York: Guggenheim Museum Publications, 1998), p. 81. Fried now admits that his reading of Pollock downplayed his paint-on-canvas materialism: "Optical Allusions," *Artforum* (April 1999): 97–101, 143, 146. In making this acknowledgment he acknowledges a certain limit to his reading of Pollock as instantiating the aesthetics of presentness; but all indications are that, despite this, the broad view remains intact.

23. Cavell intends the notion of candidness, finally, to connect two separate thoughts: that a work must be done, finished, closed (and thus I have finished with it), and, thereby, that the work can stand apart from me, be an automatism. While these characteristics seem, criterially, fine—they jointly announce my responsibility for the work *and* its separateness from me, where responsibility and separateness are what require acknowledgment—I am not convinced that even they are best thought through the notion of thereness or candidness. For all that, it should be noticed that Cavell's attempt in these pages is to flesh out the antitheatrical ideal implied by Fried in a manner that would demonstrate how the kind of art that avoids theater is equally the kind of art that requires acceptance and acknowledgment. Because some of the art here being championed eschews the sign of hand, wrist, and muscle, then explaining how it nonetheless sustains an ideal of art opposed to the interestingness of minimalism is no easy critical task.

24. For an account of *Prairie*, see Fried, "Two Sculptures by Anthony Caro," in *Art and Objecthood*, pp. 181–83 (and figure 43 and plate 14).

25. I am here implying that Fried's account of *Prairie*, *Art and Objecthood*, pp. 182–83, goes beyond the critical terms in which it is framed. The "openness," radical horizontality, the "frankly avowed . . . physicality" of it, etc., all press toward a sublimity that defeats, and was meant to defeat, presentness. I am claiming that what we experience in "seeing" *Prairie* is ambiguous between its physical

presence and its horizontal orientation, insisting on ambiguity that Fried tries to resolve in one direction: "*Prairie* compels us to believe what we see rather than what we know, to accept the witness of the senses against the constructions of the mind" (p. 183). For me, the experience of the piece is the experience of the "against." For ease, brevity, and dialectical advantage I am here accepting Rosalind Krauss's thesis that, with Pollock, horizontality becomes a new medium of advanced art, as a way of characterizing at least one feature of Caro's achievement. For a brief restatement of Krauss's position germane to this discussion (there is a footnote on Cavell), see Krauss, "The Crisis of the Easel Picture," in Kirk Varnedoe and Pepe Karmel, eds., *Jackson Pollock: New Approaches* (New York: Museum of Modern Art, 1999), esp. pp. 168–70. We are not, I think, going to be able to easily separate *Prairie* from Richard Serra's *Cutting Device: Base, Plate, Measure*, pictured on page 176 of Krauss's essay; the latter is like a scattered version of the former, the vertical now forgotten altogether.

26. Caro's earliest interesting if unsuccessful work involves the attempt to depict from the outside what human action or gesture feels like from the inside. My suggestion here is that the project remained but its means changed from the quasi-representational to the fully abstract. In their capacity to make the space they inhabit, some of Caro's most abstract works have the sense of being new or unknown gestures or postures that we must grasp as both participants (dialogically, so to speak) and observers (objective field observers excluded from participation). These works, I would claim, are the height of his achievement, what is most unavoidable in his oeuvre. I am using the anthropology analogy not only as a vehicle for the "other minds" aspect of engaging with the work, but also to suggest that the analogy works via a kind of sublimity or interruption.

27. A point Fried acknowledges, *Art and Objecthood*, p. 183.

28. In these comments I mean to elaborate the following sentences from Adorno's *Aesthetic Theory*, trans. Robert Hullot-Kentor (Minneapolis: University of Minnesota Press, 1997), 78, that open the chapter "Art Beauty": "Nature is beautiful in that it appears to say more that it is. To wrest this more from that more's contingency, to gain control of its semblance, to determine it as semblance as well as to negate it as unreal: This is the idea of art."

29. For an attempt to demonstrate the centrality of Weber's theory of authority for a contemporary analysis of human conceptuality in general, see J. M. Bernstein, *Adorno: Disenchantment and Ethics* (New York: Cambridge University Press, 2001), Chap. 2, §6, and Chap. 6, §7.

30. Cavell, "The World as Things," 69. This, of course, is just Adorno's notion of parataxis; see ibid., pp. 356–58.

31. A point that Richard Eldridge urged on me—all too rightly.

32. Everything said here about Cavell's theory and practice could equally be said about Adorno's—and I do so say throughout *Adorno: Disenchantment and Ethics*; see, in particular, Chaps. 1 and 6.

33. Cavell, "The World as Things," p. 69.

34. Ibid., p. 73.

35. The coffee episode, all in real time, is epic in its presentation; I mean it possesses the same coolly distanced external presentation, and the same fullness or completeness we think of as belonging to epic literature as opposed to novelistic realism: the on-going not-rightness of the taste of the coffee a velleity of human dissatisfaction. In the end this minor epic of dissatisfaction turns out to have been epical in actuality: the display of a world in which a subjectivity worth having has been erased. The combination of an epical presentation of a mere velleity yields, or creates, for the viewer a need to immerse herself utterly in the externality of this world, hence an absorptive participation in the masochism of repetition that is at one with Jeanne Dielman's own. In context, the coffee tasting is one of the most disturbing scenes in modern cinema. Akerman's staring camera might tempt one to suppose that her film is monotone; in fact, remarkably, despite what at first appears to be a wholly neutral presentation, the film modulates among genres and forms: one moment (of Jeanne Dielman in a chair) is a photograph, another (of her sitting in a café) becomes an exquisite realist painting. It is as if Jeanne Dielman's life was composed of uncoordinated genres, which the epic genre of film displays or presents. What I am calling the epical character of Akerman's film-making might naturally be described as a certain commitment to cinematic realism. So what Cavell is trying to capture in his account, I think, is how realism and modernism (the weight of the fragment) hang together in Akerman's movie.

36. Ibid., p. 74.

37. Ibid. This is why each tiny displacement of the completion of one of Jeanne Dielman's actions—dropping a spoon, leaving a window open, skipping a button as she does up her bathrobe—feels like a whole world shattering, fragmenting, separating, beyond repair. And terribly enough, this is what is occurring, except for the fact that the shattering has already happened, and the order of the day is a desperate veneer. On my second viewing of Akerman's film, I was aware of this sense of desperation within the first couple of minutes of it, making the whole seem infinitely longer than my first viewing: the three-plus hours a small, hellish eternity.

38. I mean by this complaint that Cavell does not attempt to directly tie the associations back to the movie, not that they are in any way inappropriate in themselves. On the contrary, each association is, in fact, *exactly* appropriate, unpacking at the discursive level the unfolding logic of Jeanne Dielman's melancholic and tragic universe.

39. Ibid., p. 75.

40. It is almost impossible not to perceive *Jeanne Dielman* as the reversed image of Doris Lessing's *The Golden Notebook*.

41. Cavell, "The World as Things," pp. 74–75.

42. For more on the status of the philosophical fragment, see Bernstein, *Adorno: Disenchantment and Ethics*, Chaps. 6 and 7.

43. Cavell, "The World as Things," p. 75. The tense of the first part of this is not quite right since, distractedly, on the second and third days doors are occasionally left open, lights on; but these are certainly never things that Jeanne Dielman *lets* happen.

CHAPTER 4

1. For my misremembering of the slides Christensen showed me, see the Postscript to this essay. Since writing this essay, Mieke Bal has interrogated Christensen's work in a manner nicely convergent with the emphases of my opening paragraphs: Mieke Bal, *Quoting Caravaggio: Contemporary Art, Preposterous History* (Chicago: University of Chicago Press, 1999), pp. 31–36, 165–75. The problem of misremembering is present in the sentence from Francis Bacon that Bal uses as the epigraph for her account: "And the moment the story is elaborated, the boredom sets in; the story talks louder than the paint."

2. M. A. E. Dummett, "Frege's Distinction between Sense and Reference," in *Truth and Other Enigmas* (London: Duckworth, 1978), pp. 116–17.

3. At the November 1995 meeting of the American Society for Aesthetics in St. Louis there occurred a session devoted to my *The Fate of Art: Aesthetic Alienation from Kant to Derrida and Adorno* (Cambridge: Polity Press, 1992). The present chapter grew directly out of my reply to just one of my critics, Jim Elkins. In part, Elkins was concerned about the lack of concrete discussions of artworks in a text that argued that philosophical discourse about art could not be self-sufficient. But more emphatically, he believed that my thesis that artworks had lost the capacity to be bearers of truth claims was inflated; and, in consequence, that however visually impoverished aesthetics now is, there is no necessity in this impoverishment. It is merely the consequence of bad aesthetic theorizing. The notion of a historically induced aporia of the sensible is an attempt to reveal how the duality between concept and image infects the history of modern art.

4. Arthur Danto, "After the End of Art," *Artforum* (April 1993): 62–69.

5. The full diagnosis of this predicament of conceptuality, image, and anthropomorphism is the subject of my *Adorno: Ethics and Disenchantment* (New York: Cambridge University Press, 2001).

6. "Art and Objecthood" originally appeared in *Artforum* (June 1967). "Shape as Form: Frank Stella's New Paintings" appears in Henry Geldzahler, *New York Painting and Sculpture: 1940–1970* (London: Pall Mall Press, 1969), pp. 403–25. Both are now reprinted in Michael Fried, *Art and Objecthood: Essays and Reviews* (Chicago: University of Chicago Press, 1998). All references to Fried, *AO*, are to this volume.

7. *AO*, p. 168. While Fried's assertion of presentness—the instantaneousness of aesthetic perception—is central to his philosophy, as my instancing of Christensen's work here, and my account of Caro in Chapter 3 argued, the claim is sim-

ply implausible. And while it may, perhaps, be possible to get what goes wrong in Fried's account from his repudiation of temporality, in what follows I want to follow a different leading idea, one that attempts to get at the peculiar difficulty of the art-historical moment under examination.

8. Clement Greenberg, "Avant-Garde and Kitsch," in Greenberg, *Art and Culture* (London: Thames and Hudson, 1973), p. 4. This essay was originally published in 1939.

9. Clement Greenberg, "Towards a Newer Laocoön," in Francis Frascina, ed., *Pollock and After* (London: Harper & Row, 1985), p. 43. This essay originally appeared in the *Partisan Review* in 1940.

10. Clement Greenberg, "Modernist Painting," in Francis Frascina and Charles Harrison, eds., *Modern Art and Modernism* (London: Harper & Row, 1982), p. 5. This relatively late essay of Greenberg's appeared first in *Art and Literature* in 1965.

11. Ibid., p. 9.

12. *AO*, p. 169.

13. *AO*, p. 99n.

14. "Confidence" is perhaps the wrong word since perhaps the most resilient puzzle about Fried's position is how he connects his shifts away from Greenberg, away from the narrowly cognitivist story of art's arriving at its ahistorical essence, and toward a more fully historical accounting with his sense that, nonetheless, with Stella and Noland and Olitski, modernism comes mysteriously to a halt. His Hegelian historicism and his sense of crisis, or at least stasis, do not add up, at least if one thinks that the unfolding of modern art since the mid-1960s cannot be simply written off by the accusation that contemporary artists have one and all fallen victim to the temptations of theatricality, hence making the failure of art to further unfold a moral rather than a historico-categorial matter. Theater is not a sufficient term of criticism for the dilemmas faced by contemporary art, given Fried's own historicist assumption, even if it does point to a temptation and danger. For prosecution of a similar thought that attempts to work within Fried's insights, see note 36 in this chapter.

15. Robert Rosenblum, *Modern Painting and the Northern Romantic Tradition: Friedrich to Rothko* (London: Thames and Hudson, 1975), p. 210. I am borrowing this reference from Richard Hooker, "Sublimity as Process," *Art and Design*, no. 40 (1995): 49.

16. Donald Judd, "Barnett Newman," in Frascina and Harrison, *Modern Art and Modernism*, p. 130.

17. Obviously, although it is not part of my argument here, the disorientation of the visual field could be interpreted as *recovering* the materiality of the object from out of the illusory constituting powers of the subjective, first-person point of view, and thus as insinuating a wider or more generous anthropomorphism. This is the emphasis that would naturally appear if I were discussing Robert Smithson,

Richard Serra, and Eva Hesse. Judd's description of Newman does not allow such a reading, and hence, perhaps despite itself, licenses the reductive reading of minimalism that fires Fried's account.

18. Robert Morris, in Charles Harrison and Paul Wood, eds., *Art in Theory: 1900–1990* (Oxford: Blackwell, 1992), p. 821.

19. Ibid.

20. Of course, minimalism, especially in Morris's accounting, also possessed a phenomenological aspiration: minimalism's ideal forms presenting best-case scenarios for the interrogation of the excess of perceptual *experience* beyond the objects given to it; so the more ideally structured the object (geometric forms in repetitive patterns), the more the difference between the object given and its visual appearing might register. This is evidently the point of Morris's large white plywood L shapes differentially positioned (*Untitled*, 1965). I shall return to this side of minimalism, which stands in clear contradiction to its critique of anthropomorphism, below. For a delicate tracing both of the different elements composing the emergence of minimalism and of how those elements played out in its reception, see Hal Foster, *The Return of the Real: The Avant-Garde at the End of the Century* (Cambridge, Mass.: MIT Press, 1996), Chap. 2.

21. Morris, in Gregory Battock, ed., *Minimal Art: A Critical Anthology* (New York: E. P. Dutton, 1968).

22. *AO*, p. 155.

23. Ibid., p. 157.

24. "Intransitive understanding or sense" is the kind of sense appropriate to Kantian aesthetic reflective judgments. For a fleshing out of this sense of intransitivity see my *Adorno: Disenchantment and Ethics*, pp. 306–19.

25. *AO*, p. 159.

26. Ibid., p. 166.

27. For a defense of the claim that repetition of the same can be regarded as an utterly "minimal" notion of *form*, see Chapter 8. Rosalind Krauss, *Passages in Modern Sculpture* (Cambridge, Mass.: MIT Press, 1977), Chap. 7, rightly underlines the use of repetition as form in minimalism. But she misjudges the continuing claim of these works by, apparently, accepting Judd's—perverse—judgment that it was the previous art that was "rationalistic" and premised on "a priori systems," and that the new grammar minimalism was in search of would thereby need to be, somehow, more truly external. What Judd, I think, was opposing was not rationalism, at least not in the ordinary meaning of that concept, but form as something imposed on the material from without in accordance with a preconceived idea in the mind of the artist—which is not rationalism but subjectivism. Judd was hence apparently oblivious to the rationalism implied by geometric forms, repetition, and unhanded (readymade) material. Thus at the theoretical level, so it seems, minimalism developed out of a misunderstanding of abstract expressionism (as a rationalism premised on the idea of composition), and a misunderstanding of its own fundamental

gestures. The claim of these works (Judd, Morris, Andre, Le Wit) as suspending objecthood aesthetically and so in relation to an utterly minimal, exhausted anthropomorphism, I am contending, can be detached from the series of reflections that drew them into existence.

28. Notoriously, the minimalists themselves and Fried contrast modernism's insistence on *conviction* with minimalism's turn toward *interest* (*AO*, p. 165) as the crux between, say, a modernist humanism and a Duchamp-inspired antihumanism. My strategy here is to evade this duality by recruiting minimalism for modernism, albeit a modernism at its limit, a limit whose intelligibility requires the acknowledgment of the aporia of the sensible as a categorical fact about modernist works.

29. *AO*, pp. 151, 160.

30. Ibid.

31. On coldness as the mood or *Stimmung* of enlightened reason, see my *Adorno: Disenchantment and Ethics*, Chap. 8, §4, "Coldness: The Fundamental Principle of Bourgeois Subjectivity."

32. *AO*, p. 159.

33. Ibid., p. 88.

34. Ibid.

35. One interesting version of the story of the relation between social forces and art is found in Yves-Alain Bois, "Painting: The Task of Mourning," in Bois, *Endgame: Reference and Simulation in Recent Painting and Sculpture* (Boston: Institute of Contemporary Art, 1986), 29–49; now reprinted in Bois, *Painting as Model* (Cambridge, Mass.: MIT Press, 1990), pp. 229–44. Although it is a topic for another occasion (see Chapter 8), I would want to defend the nuance of Bois's closing paragraph, where the task of painting for us is to escape the melancholic repetitions of late modernity in order to achieve a standpoint of mourning. Yet we should not be too quick to embrace these categories since, at first glance, the distinction between mourning and melancholy appears to overlap, considerably, with the distinction between art and objecthood. How else might we understand the repetitions of minimalism than as melancholic? And would not the blurring of literal and depicted shape be a sublimation of fixity, an achievement of mourning? What if the *possibility* of drawing a firm, categorical line between mourning and melancholia were dependent upon the *social conditions* of painting being nonpathological? While I would want to agree with Bois that painting can evade subsumption by the market in unpredictable ways, the meaning of that evasion is equivocal. If mourning is the best possible fate of art in late modernity is it still mourning? Can there be an identifiable state of mourning when, for art, that state is endless, melancholic? For an analogous, equivocal take on art, mourning, and melancholy, see Julia Kristeva, *Black Sun*, trans. Leon S. Roudiez (New York: Columbia University Press, 1989).

36. For a riveting and compelling version of an analogous thesis, see Stephen Melville, "What Was Postminimalism?" in Dana Arnold and Margaret Iversen,

eds., *Art and Thought* (Oxford: Blackwell, 2003), pp. 156–73. Melville's subtle elaboration of Fried's thought depends on pushing the whole account in a more explicitly Hegelian direction, with determinate negation and the system of the arts playing the leading roles. In so doing, Melville intends to demonstrate how the best art that emerges in the wake of minimalism can be construed as continuous with an appropriately expanded conception of modernism. While I eagerly await the whole of which this essay is evidently a fragment, I shall simply flag here that, like Fried, Melville makes nothing of the wider social history of which the history of art is a part. So while he provides (a sketch for) a more capacious and pointed history of art after painting, seeing depth where Fried could only find theater, at least here the question of medium, which still and rightly drives the whole endeavor, is taken for granted rather than elaborated. This is just a little shocking since the pivot of the essay is the works of Robert Smithson, who, surely, is thinking all the time about the relation between medium and nature.

37. *AO*, p. 88.

38. Frank Stella, *Working Space* (Cambridge, Mass.: Harvard University Press, 1986), p. 43.

39. And, conversely, how impossible it is to take the measure of Stella's uncovering of shape as form without also noting its deployment of classical rationalism.

40. *AO*, p. 98n.

41. In this essay, while I am attempting to exemplify the aporia of the sensible, I have not quite managed to locate the operation of its logic inside modernist art. I attempt to do so in Chapter 7 with respect to what I there call "the paradox of modernism."

CHAPTER 5

1. "In Defense of Abstract Expressionism" (here abbreviated DAE) was originally published in *October* 69 (1994): 23–44. The essay now appears as Chapter 7 of Clark's *Farewell to an Idea: Episodes from a History of Modernism* (New Haven, Conn.: Yale University Press, 1999). References in the body of the essay are to Clark's book. References to Adorno's *Aesthetic Theory*, hereafter *AT*, are to the translation by Robert Hullot-Kentor (Minneapolis: University of Minnesota Press, 1997). This chapter was originally presented as a lecture at the Slade School of Art in February 1995.

2. See Lambert Zuidervaart, *Adorno's Aesthetic Theory: The Redemption of Illusion* (Cambridge, Mass.: MIT Press, 1991), pp. 152–54.

3. Clark finds abstract expressionism still too enchanted, hence still too bound to its moment and petty bourgeois class position, and thus inadequate for resisting the world of which it is a part. Indeed its *ease* of fit into that world is what he wants to unearth since that would open up that right kind of critical distance. I do not intend to deny the fit, but only to redescribe the nature of the accomplish-

ment in a manner that will make that fitness matter less. For Adorno (and Benjamin) there is no avoiding deep complicity and thoroughgoing culpability, no pure-hearted outside to the guilt context of the living.

4. Max Horkheimer and T. W. Adorno, *Dialectic of Enlightenment*, trans. John Cummings (New York: Seabury, 1972), p. 8.

5. John Dewey, "Wondering between Two Worlds," quoted in John Patrick Diggins, *The Promise of Pragmatism* (Chicago: University of Chicago Press, 1994), p. 4.

6. *Notes to Literature*, Vol. 1, trans. Shierry Weber Nicholsen (New York: Columbia University Press, 1991), p. 7.

7. Horkheimer and Adorno, *Dialectic of Enlightenment*, p. 13.

8. Martin Heidegger, *The Question Concerning Technology and Other Essays*, trans. William Lovitt (New York: Harper & Row,, 1977), p. 16.

9. Barnett Newman, "The Sublime Is Now," in Charles Harrison and Paul Weed, eds., *Art in Theory: 1900–1990* (Oxford: Basil Blackwell, 1992), p. 574. The essay was originally published in 1948.

10. There is a methodological issue here separating Clark and me: he thinks an effective or authentic We requires very precise types of sociohistorical conditions and ideological presumptions, ones perhaps available to Jean-Jacques David, Camille Pissarro, the early Pablo Picasso (when he and Georges Braque worked together), and El Lissitzky; I consider the standpoint of the We as a formal achievement, a matter of extinguishing the will of the artist in the image, and hence the production of imageless images, images that are not *of* anything. This formalism requires adherence to the demands of the medium in the sense laid down by Cavell. My account of Caro's "Prairie" exemplifies the thesis. Hence at issue between me and Clark are the variable roles of context and form. My formalism gives to these works more authenticity than his contextualism allows, without, I hope, denying the role of context. If Fried ignores the role of context, Clark gives it too commanding a role. I continue this discussion in the following chapter.

11. Some of what I think about *Lavender Mist* is influenced by Rosalind Krauss, *The Optical Unconscious* (Cambridge, Mass.: MIT Press, 1993), esp. p. 307. Her central concerns in her discussion of Pollock, the shift from the vertical to the horizontal and the play of gravity, were originally broached by Leo Steinberg in *Other Criteria* (London: Oxford University Press, 1972). Throughout, however, I have been more than influenced by Adorno's thesis that in modernist art meaning and causality are (still or re-)combined. This thesis is at the heart, I would argue, of any adequately materialist epistemology or account of meaning. Finally, it is worth recalling here what remains the best starting place for reflection on modernist painting and the surface, Richard Wollheim's "The Work of Art as Object," in Wollheim, *On Art and the Mind* (Cambridge, Mass.: Harvard University Press, 1973).

12. This angle on Newman was already suggested by Clement Greenberg, "After Abstract Expressionism," *Art International* (October 1962): 24–32. I like noth-

ing better on Newman than Yves-Alain Bois's "Perceiving Newman," in Bois, *Painting as Model* (Cambridge, Mass.: MIT Press, 1990). As Bois rightly remarks, the employment of bilateral symmetry in Newman, the apparently geometric subtext, in fact serves the purpose of insinuating "the erect human being" (pp. 194–95) the vertical axis our body, its frontal orientation, hence the body's habitation of a prepersonal or prehistorical spatial orientation. I find Newman exemplary—he looks better to me all the time; Clark thinks, like Greenberg, that Newman "was never vulgar enough" (DAE, p. 387). How different would Clark's position have to become if he could be convinced that Newman was Rothko's equal?

13. For a renewed critique of the myth of the given, which still serves to prop up the duality of meaning and materialism, see John McDowell's lucid *Mind and World* (Cambridge, Mass.: Harvard University Press, 1994). McDowell, naturally enough, is primarily concerned with demonstrating that the space of reason must reach out all the way to the object. Adorno works the other side of the same fence: if there is meaning all the way out (or down), equally there is object and materiality all the way in (and up). Adorno's materialism is not anti-idealist, but a nuanced inflection of idealism. Bald naturalism or coherency theories like those of Quine and Davidson are, from an Adornoesque perspective, equally forms of "identity thinking."

14. For a useful critique of the ideal pure discursivity, pure communication without remainder, see David Bell, "The Art of Judgement," *Mind* 96, no. 2 (1987): 221–44.

15. Michael Fried, *Absorption and Theatricality: Painting and the Beholder in the Age of Diderot* (Berkeley: University of California Press, 1980).

16. This modernist reading of the meaning of the sublime is a leitmotif throughout my *The Fate of Art: Aesthetic Alienation from Kant to Derrida and Adorno* (Cambridge: Polity Press, 1992).

17. This is a rapid shorthand for an immense historico-philosophical problem. From the beginning of modernity the themes of sensuousness, and so sexuality, and mortality have been relayed through a fragmentation and splitting of the female body, and thus through cruelty and negativity. This begins, at least, with Andrew Marvell's *To His Coy Mistress*. For these beginnings see Francis Barker's *The Tremulous Private Body* (London: Methuen, 1984). I presume that the relatively immediate precedent for de Kooning's *Woman* series should be traced to some of Picasso's women, certainly the viciously ironic *Ma Jolie*.

18. That Clark of all people should not pursue the issue of negativity here is puzzling since no critic of modernism has been as relentless as Clark in upholding the movement and dynamics of negation that are central both to the syntax of modernist works themselves and, simultaneously, to modernism's historical dynamic.

19. It is the lack of this in Asger Jorn that I find dispiriting. When Clark momentarily gestures at Jorn, is he not making the same sort of critical qualification that Greenberg uses when he damns Soutine in Matisse's name? If my defense of

Soutine is right—and not denying that Matisse is the greater artist—then perhaps there is a more genial space for abstract expressionism than Clark credits.

CHAPTER 6

1. All references in the body of the text are to T. J. Clark, *Farewell to an Idea: Episodes from a History of Modernism* (New Haven, Conn.: Yale University Press, 1999); here, the quote is from page 8. This chapter is an expanded version of a talk given at the Radical Philosophy conference in May 2000.

2. The chapter on Pollock, for example, is carved into one- and two-page sections, some with overweening metaphorical titles such as "Vortex," "Moby-Dick," "The Magic Mirror," and "Sleeping Effort"; some with titles that are the name of the work being discussed in the section. And we are offered three endings to the chapter, or Clark finds himself forced into ending and then doing so again and again. Although some chapters are more emphatically narrated than others, and the Picasso chapter I shall suggest overly so, often Clark wants the totalizing figure, his narrative, to emerge from the fragments of history, biography, intentional analysis, fine-grained pictorial analysis, etc.: "[T]he book's basic form—its brokenness and arbitrariness, and the accompanying effort at completeness of knowledge . . . in a few test cases . . . [are] core samples, or preliminary totalizations. . . . They [the cases] are chapters from a modernist dig" (pp. 6–7). Certainly some chapters, including the one on Pollock, and the book as a whole, are, I am suggesting, something of a Pollock.

3. Hofmann left a goodly number of works to Clark's home university, the University of California, Berkeley. So there is an intimacy involved in Clark's positioning of Hofmann.

4. Methodologically, Clark is taking his own originally explanatory model of the social history of art and giving it a suitable therapeutic twist.

5. Simply put, as I attempted to argue in the two previous chapters, I want to accept something like the traditional endogenous history of modernism but explain its failing through the remote but insistent operations of an aporia of the sensible, which is the hounding of art by societal rationalization experienced internally. This is not to necessarily discount the political and class factors that Clark wants to center, but it is to displace them, making their appearance less constitutive of any present and less central to the unfolding of the narrative. At another level, one could say that my and Clark's stories converge since we both think, indeed everybody thinks, that capitalist modernity has swept away competing orientations and weakened almost to the point of disappearance the hubs of resistance, including modernism as formative for culture as a whole.

6. Another way of explicating the difference would be to say that my account is, finally, transcendental: it concerns the necessary conditions for the possibility of orientation, the possibility of our conviction and connection to the world of the

everyday. Clark supposes the matter is more empirical, a question of how modernist art at any given time expresses class orientation. That there is a transcendental/empirical divide methodologically is, however, only possible because modernity is just the unhinging of the relation between transcendental orientation and actual experience; and that fact is revealed by art's autonomy; it is what art's autonomy comes to, its pathos.

7. I have yet to grasp exactly how Clark intends his account of El Lissitzky to bear on our evaluation of Malevich, which is to say I am missing that chapter's hook.

8. It is essential not only to the analysis of Jacques-Louis David, but to his history generally: by claiming that politics is the form of the contingency that makes modernism what it is, he can continue to gear his account to politics. Even if I were willing to concede the thesis for the *Death of Marat*, I am not convinced that it can be generalized. I think that painting becomes abandoned to history and contingency by becoming autonomous, and that autonomy incrementally forced itself on art initially through the disenchantment of nature, and the consequent separation of value spheres in modernity—that is, through truth becoming the property of science and the good the property of reason: in sum, Kantian idealism as a theory of modernity. This is how reason itself becomes rationalized in modernity. For a detailing of this claim, see the Introduction to J. M. Bernstein, *The Fate of Art: Aesthetic Alienation from Kant to Derrrida and Adorno* (University Park, Penn.: Pennsylvania State University Press, 1992).

9. Clark, I should say, wants the dissonance to be less representational, more truly modernist by virtue of the kneeling woman coming forward and spreading across the picture plane (p. 68). But isn't the pushing her up and across the picture plane simply a consequence of her corner position, her habitation of it? Position rather than flatness is the crux. For a convergent judgment of Clark's treatment of Pissarro, see Malcolm Bull, "Between the Cultures of Capital," *New Left Review* 11 (September/October 2001): 105–8. Bull helpfully points out, on the one hand, that anarchists close to Pissarro were associated with a variety of modernist painterly practices (neo-impressionism, naturalism, and symbolism); and, on the other hand, that when Pissarro himself explicitly takes up his anarchism in the pen-and-ink drawings of 1889 entitled *Les Turpitudes sociales*, the results look nothing like the painting.

10. Clark makes one quick stab at inclusive significance: "Flatness in general in Cézanne had always been at root a metaphor for materiality—for the painter's conviction that in a world made up of matter the being-in-the-eye of an object is also its being-out-there-at-a-distance, known to us only by acquaintance. This is the truth to which the Philadelphia picture naively returns" (p. 159). This seems to me just right; but does not the "naively returns" amount to a surrender, pointing to the places where Cézanne works this idea more austerely? The starting place for such an inquiry would be Meyer Schapiro's still breathtaking "The Apples of

Cézanne: An Essay on the Meaning of Still-life," in Schapiro, *Modern Art: 19th and 20th Centuries: Selected Papers* (New York: George Braziller, 1979).

11. Michael Fried, *Three American Painters: Noland, Olitski, Stella* (1965), now reprinted in Fried's *Art and Objecthood: Essays and Reviews* (Chicago: University of Chicago Press, 1998), p. 224. On page 227 Fried provides some of the terms that come to fruition in Clark when he states that the problems faced by Pollock in *The Wooden Horse* and related pictures seem to have been "how to achieve figuration within the context of a style that entailed the denial of figuration, or . . . with the problem of how to restore to line some measure of its traditional figurative capability, within the context of a style that entailed the renunciation of that capability."

12. In Chapter 8 I contrast Bois's handling of Picasso's moment of disillusionment with a little more detail concerning Clark's.

13. Gregg Horowitz has convinced me that this Hegelian thesis is what Freud's doctrine comes to, and that it holds up better than competitors as a general account of our relation to nature. Put it this way: in the light of our secularity, we cannot forgo a fundamental acknowledgment of our belonging to the material/natural world; in the light of our conventionality, that belonging has no positive normative content. But we cannot acknowledge our naturalness without acknowledging that naturalness is unnatural, that we are displaced from the natural world of which we are nonetheless a part. Acknowledging our *displacement* from nature thus becomes our mode of acknowledging how it is we are placed in it. This last sentence adumbrates what I think is at least *a* if not *the* fundamental gesture of modernism.

14. In J. M. Bernstein, *Adorno: Disenchantment and Ethics* (New York: Cambridge University Press, 2001), Chap. 5, I argue that idealism, naturalism, and particularism represent three irreducible categorial orientations that are jointly constitutive of modernity. That Clark sees the first two so powerfully and does not appear to have space for the third outside its political impress is striking, since it is there, one might suppose, that modernist painting belongs. I mean the thought that it is an always fragmented sensuous particularity that modernist works give us, and that holding of the moment, this way of settling the desperate difference between social sign and materiality just "here" is the new formation of rationality they project. I guess that is the gravamen of this chapter.

15. Again, one might think this is the difference between perceiving the stakes of modernism as somehow transcendental, and Clark's pressuring of it to possess more representational content, more empirical power of orientation.

16. Throughout my accounts of Cavell and minimalism I have been at pains to underline how modernism's fullness *and* emptiness go hand-in-hand because I think it involves, each time, the demonstration that social sign and natural bedrock are not essentially incompatible.

17. Bull, "Between the Cultures of Capital," argues that the despairing view is also the true one, modernism "just a late stage in the history of fetishism as it pro-

gressed from religion to fashion" (p. 113). While his argument fits well with and explains some of the logic of the moment in which each modernist work is neutralized and appropriated, it says nothing about the other moment, the one of resistance, as if modernism's power of negation were *only* the frame through which the idea of fashion as such might come into being. This seems deeply implausible.

18. No one has better grasped the role of monumentality, size, in Pollock than Clark, "Pollock's Smallness," in Kirk Varnedoe and Pepe Karmel, eds., *Jackson Pollock: New Approaches* (New York: Museum of Modern Art, 1999), pp. 15–31.

19. More important than what Pollock anticipated is what happened to painting after him and abstract expressionism. I think of early Frank Stella, Kenneth Noland, Morris Louis, Jules Olitski, to mention Michael Fried's post-Pollock pantheon, and the like as revealing just how exhausted painting had become, and hence the uprising of an art that turns against easel painting being necessary, inevitable, and regressive at once. Again, the exhaustion story is one in which there is a dialectic of modernism that is simultaneously progressive and regressive; its regression involves the drying up of the force of negation till there is no further progressive negation possible. I elaborate what I call the paradox of modernism, why a dialectical progress should entail a path of exhaustion, which is the expanded and generalized version of Clark's question (why does Pollock's painting cease at its moment of highest achievement?), in the following chapter, "Readymades, Monochromes, Etc.—Nominalism and the Paradox of Modernism."

20. T. J. Clark, "Pollock's Smallness," p. 23. I think this essay demonstrates the exhaustion thesis superbly (see page 30 for this point). I even think that Clark's historicism in this essay—we could not think this logic of smallness and cosmic largeness, the atomic and the cosmic, without the time's awareness of atomic fusion and fission, "of the small and large as instantly convertible, as terrible immediate transforms of each other" (p. 29)—helps explicate the exhaustion, tying together endogenous and exogamous history.

21. I am grateful to a member of the audience at the Radical Philosophy conference for the thought that Clark interprets *The Wooden Horse* as itself an allegory of modernist art.

22. I am leaving ambiguous whether the right-hand figure is meant to suggest, despite itself, a figure: head, body, protruding organ.

23. This might be the crux of my difference from Clark: he comprehends artistic aimlessness, with abstraction—from David's scumbling to Pollock's pourings—as its leading edge, as instigating the groundlessness and contingency of the social sign, while I, following Kant and Adorno, conceive of art's purposelessness, which is the condition of its autonomy, as the necessary condition for its critique of formal reason (be it that of instrumental rationality or capitalist exchange), and hence as the condition for proposing an alternative form of rationality in which sociality and materiality might somehow collaborate.

24. That there are successful canvases containing emphatically figurative and

nonfigurative elements is not so much, I think, a matter of Pollock's flatly wanting to combine figuration with his nonfigurative overall style as much as interrogating what they could mean to one another. Which is to say, I detect a more exploratory, interrogative, and puzzled mien in these paintings than does Clark (or Fried). If Clark is right that tone matters in modernist painting, then that matters.

25. This idea is pursued in my "Readymades, Monochromes, Etc."

26. I presume that inventory has its analogue in what I called Pollock's molecular anatomy of paint-stuff.

27. Between the two extremes might be the skins of congealed paint from open paint cans used in *Autumn Rhythm*. Are the skins paint or fragments of reality?

28. That, in a nutshell, is the aesthetic theory I think *Farewell* lacks.

29. Having said this of Pollock, one wonders how Clark comes to think of abstract expressionism's modernist sublime, aka vulgarity, as, finally the tone of the lyric subject.

30. My only hesitancy in ascribing this view to Clark is the degree to which one might find Pissarro the hero of this book, and so think that if it contains an express politics it is one that might give anarchist socialism a second hearing (p. 9). Or is this different from the position I am ascribing to him? I would hope, at any rate, that my response here not read as a "prearranged sneer" (p. 9).

CHAPTER 7

1. T. W. Adorno, *Aesthetic Theory*, trans. Robert Hullot-Kentor (Minneapolis: University of Minnesota Press, 1997), p. 138. All further references to this work are designated *AT*, referring to pages in this edition.

2. Thierry de Duve, *Kant after Duchamp* (Cambridge, Mass.: MIT Press, 1996). All further references to this work are designated *KD*.

3. The case may be different in music. Adorno attributes to both Schoenberg and Berg a clarity about the material motive that would be hard to cash out for paintings done during the same period.

4. Thomas Crow, "Moving Pictures," *Artforum* (April 1999): 95. In the same issue, there is also a review by Michael Fried, "Optical Allusions," which concedes that his own optical analysis was somewhat overstated in relation to the resilient and unavoidable materiality of the canvases.

5. This is perhaps not the best way to state the achievement of these artists. In arguing for Ryman as the last modernist painter, Yves-Alain Bois states his practice as the attempt "to paint that he paints that he paints; that he has always wanted, by means of an excess of reflexivity, to outflank the tautological reflexiveness [painting about painting] in which modernism has been locked. Further, his success is due . . . to the fact that every failure of his audacious attempt removes him further from his object, driving him to produce objects that are increasingly enigmatic and indeterminable." Yves-Alain Bois, "Ryman's Tact," in Bois, *Painting as Model*

(Cambridge, Mass.: MIT Press, 1990), pp. 224–25; and Chapter 8 below for a detailed accounting.

6. De Duve's exact reasoning at this juncture is unpersuasive, depending on two thoughts: "choice is the main thing, even in normal painting" (*KD*, p. 163, quoting Duchamp), and the tube of paint, as opposed to making colors oneself, is a readymade. Since even de Duve conceives of the notion of choice here as equivocal (in fact becoming necessity!), and, however significant the tube of paint is in re-forming the practice of painting, it does not by that fact either make paintings aided readymades or have the same impact on painting that photography does (*KD*, p. 176), then a looser way of making the connection, also available in de Duve, is required. Whatever my disagreements with de Duve, the idea of locating the significance of the readymade so directly in relation to painting, the readymade as abnormal painting, rather than as a distinct alternative to the tradition of modernist painting is, I would argue, the real achievement of his book, and the one off of which this essay lives.

7. See "Aporia of the Sensible: Art, Objecthood and Anthropomorphism," Chapter 4 in this volume.

8. Needless to say, not everyone would agree to this conjoining of modernist painting and the readymade; indeed, most historians treat Duchamp as the author of a tradition that becomes postmodernism and is thus in direct competition with (a completed? exhausted?) modernism. De Duve recruits Duchamp for modernism; or rather, makes *Fountain* something like the apotheosis of modernism, what reveals its true idea.

9. As several reviewers have pointed out, de Duve confuses the plausible Kantian idea that art, like a judgment of beauty, does not possess a set of defining conceptual characteristics with the idea of a logically proper name that is rigidly tied to the *single* object named (for example, Aristotle) apart from any defining descriptive characterization. Even extending this idea to nouns will not help since there the thesis is everything that is the *same* as "this" item is, say, gold or water. But sameness is the last thing one wants for art. For a lucid discussion, see Jason Gaiger's review, "Art after Beauty: Retrieving Aesthetic Judgement," *Art History* (December 1997).

10. It is perhaps even the key idea for a critical ethics.

11. Clement Greenberg, "'American-Type' Painting," in Greenberg, *Art and Culture* (London: Thames and Hudson, 1973), pp. 208 and 209.

12. Clement Greenberg, "Modernist Painting," in Francis Frassina and Charles Harrison, eds., *Modern Art and Modernism: A Critical Anthology* (New York: Harper & Row, 1982), p. 8 (emphasis mine).

13. Ibid.

14. This is somewhat hyperbolic, since perhaps the most compelling and intriguing feature of Newman's work when seen en masse is that one never, even for a moment, supposes that he felt a need to resist the tug of the monochrome; rather,

the generativity of the zip feels indefinite in his handling, as if he could go on interrogating its possibilities without halt. Certainly. But is not that thought itself, the negative thesis that Newman's paintings are untouched by the claim of the monochrome, part of his achievement?

15. Clement Greenberg, "Towards a Newer Laocoon," in Francis Frascina, ed., *Pollock and After: The Critical Debate* (New York: Harper & Row, 1985), p. 44.

16. Of course, de Duve does think that struggles for the name of art are struggles for its stakes, but his theory of art as a proper name forces him to keep the issue of what those stakes might be indeterminate and open; or rather, there is a tension in his thought between how openly he thinks he can or must specify art and how concretely he is, despite himself, tempted to go. Even more strangely, the final chapter of *KD* can be read as a working out of the stakes; but now these appear as a radicalized version of Kant's moral philosophy—and hence very far from painting. Or rather, de Duve does not show how the ideas of freedom and equality are implicated in the stressed physiognomy of modernist painting. For de Duve's continuation of his argument, and his exploration of the stakes of modernism, see Thierry de Duve, *Look, 100 Years of Contemporary Art*, trans. Simon Pleasance and Fronza Woods (Ghent-Amsterdam: Luidon, 2001); the book is an enlarged and revised edition of the book published to go with the exhibition "Voici, 100 ans d'art contemporain" held in Brussels, November 23, 2000–January 28, 2001.

17. Max Horkheimer and Theodor W. Adorno, *Dialectic of Enlightenment*, trans. John Cumming (London: Allen Lane, 1972), p. 17.

18. I have learned this thought, in full, from Gregg Horowitz. For its elaboration and defense, see Gregg Horowitz, *Sustaining Loss: Art and Mournful Life* (Stanford, Calif.: Stanford University Press, 2001).

19. T. J. Clark, *Farewell to an Idea: Episodes from a History of Modernism* (New Haven, Conn.: Yale University Press, 1999), p. 300. What astounded me in Clark's treatment of *Full Fathom Five* is how little he made of it.

20. Ibid.

21. This is not to suggest that any or every monochrome radiates only a priori deadness; on the contrary, perhaps the must austere success of modernism is the discovery that this is not the case, that even the monochrome can, just about, sustain art's "more," its surplus beyond being an arbitrary thing.

22. T. W. Adorno, "*Vers un musique informelle*," in Adorno, *Quasi una Fantasia: Essays on Modern Music*, trans. Rodney Livingstone (New York: Verso, 1992), p. 272.

23. Ibid., p. 273.

24. For an evaluation of the proposal for a musical nominalism, see Raymond Geuss, "Form and 'the New' in Adorno's '*Vers une musique informelle*,'" in Geuss, *Morality, Culture, and History: Essays on German Philosophy* (New York: Cambridge University Press, 1999), pp. 140–66. Geuss is severely critical of Adorno's account of artistic progress without, however, taking adequate account of the dialectic of new-

ness and exhaustion. Painting's being exhausted does not entail that there is no more painting; rather, the painting that compellingly arises now does so in the light of exhaustion, through and because of it. So I would want to construe the achievements of Ryman and Richter; conversely, I think Frank Stella's late works fail because they so blatantly work in defiance if not outright denial of the desert landscape that surrounds them.

25. I am here claiming that we should (a) interpret *Full Fathom Five* as a complex reflection on the meaning of painting in relation to the ideas of the readymade and the (cubist) collage; and (b) acknowledge that Pollock's own painting is itself the (achieved) exploration and articulation of the relation between painting and abnormal painting, painting and readymade.

26. In *Look*, de Duve provides a threefold account of the "for the sake of which" of modernism, keying his account to Manet: (1) resurrection of art's raw materials; (2) art's address, as an other, to you (through facingness) in your freedom (pp. 165–67); (3) the recruitment to an egalitarian community, to "we," through the renegotiation of its compact with its audience. It is over the proper interpretation of (1) that, I suspect, my account and de Duve's would most emphatically part company. He states, for example, "The artist's task is to turn a thing into a living being so that it can be mortal. Only then can it 'really' be called living, and deserve the esteem due to living beings. Aesthetic creation only gives birth to a work of art if it first of all resurrects its raw materials" (p. 51). I am arguing, and I am simply unsure how this differs from de Duve, that austerely "resurrection" must be comprehended as transmission. For more on this, see J. M. Bernstein, "Melancholy as Form: Towards an Archaeology of Modernism," in John J. Joughin and Simon Malpas, eds., *The New Aestheticism* (Manchester: Manchester University Press, 2003), pp. 167–89.

27. For a strong aesthetic reading of *Fountain*, see William A. Camfield, "Marcel Duchamp's *Fountain*: Its History and Aesthetics in the Context of 1917," in Rudolph E. Kuenzli and Francis M. Naumann, eds., *Marcel Duchamp: Artist of the Century* (Cambridge, Mass.: MIT Press, 1990), pp. 64–94.

28. I am here ignoring whether this extra thought is equivocal in Duchamp's work as a whole. Depending on how one locates *Fountain* within his output, one will come up with different answers to the question. However, it is just the lack of a clear forging of the connection between materiality and articulate convention in *Fountain* that is its permanent exposure to a skeptical nihilism. And if that is all *Fountain* did, it would someday be dismissible. Because it raises such deep questions about art and everyday things, its power of interrogation will continue.

29. For a useful survey of Cornell's work, see Diane Waldman, *Joseph Cornell: Master of Dreams* (New York: Harry N. Abrams, 2002). Deborah Solomon's *Utopia Parkway: The Life and Works of Joseph Cornell* (New York: Farrar, Straus and Giroux, 1997) is invaluable on the life.

30. Although Cornell counted Dada and surrealism among the inspirations he

transformed, Bourgeois always had a more suspicious relationship to each (especially Dada, especially Duchamp's coolness and irony). What I am interested in locating here is an asceticism and austerity, a fundamental *formalism* in both artists that places their work, if only in part, within the shadow of painting's exhaustion. I am painfully aware that the unsupported claims that follow are to a certain degree at odds with the critical literature on both artists. My intention, however, is not to flatten the complexity of their works, but rather to suggest, at admittedly a very high level of abstraction, what kind of complexity it is. And again, crucially at stake is the role of the generativity of the inaugurating conventions deployed in relation to their conventionality itself, on the one hand, and the inaugurating conventions of easel painting on the other.

31. Although there are also the stuffed and pictured birds, the animals, the grasses, and the consistent fascination with the heavens, real and imaginary.

32. Because I interpret the readymade as inheriting art's material motive as being for the sake of ruined sensuous particularity, hence composed of the sensuous particular debris of society, then it is not untoward that some works that belong to the heritage of the readymade include made things. So long as what emerges is "an immanent logic of destitute things," then the insight of the readymade is being honored.

33. For a systematic critique of narrative readings of Bourgeois, see Mieke Bal, *Louise Bourgeois' Spider: The Architecture of Art-Writing* (Chicago: University of Chicago Press, 2001). All the terrific essays in the special issue of *Oxford Art Journal* 22, no. 2 (1999) dedicated to Bourgeois seek to displace the narrative, biographical reading of her work. Anne M. Wagner's "Bourgeois Prehistory, or the Ransom of Fantasies," provides a more convincing reading of the sculptures than any of which I am aware, while the emphases of Alex Potts's "Louise Bourgeois—Sculptural Confrontations" converge with the ideas I am most interested in underlining.

34. For a nice statement of this, see Dawn Ades, "The Transcendental Surrealism of Joseph Cornell," in Kynaston McShine, ed., *Joseph Cornell* (New York: Museum of Modern Art, 1980), p. 16. Often in the more austere boxes, for example, *An Image for 2 Emilies* and *Toward the Blue Peninsula (for Emily Dickinson)*, the four edges of the front of the box are explicitly frames.

35. Bourgeois has stated: "The *Cells* represent different types of pain: the physical, the emotional and the psychological.... Each *Cell* deals with fear. Fear is pain.... Each *Cell* deals with the pleasure of the voyeur, the thrill of looking and being looked at." Quoted in Marie-Laure Bernadac, *Louise Bourgeois* (New York: Flammarion, 1996), p. 121.

36. Potts, "Louise Bourgeois—Sculptural Confrontations," p. 37. Because I think that his consistent use of echoes of the box within a box (drawers, holes, shelves, etc., again) and his occasional use of wire mesh in place of glass all point to the relation between obsession and form, then I suppose that Potts's summary of the logic of pain in *Cell I* (1991) fits Cornell as well. But this is to suggest that

the preciousness of Cornell boxes, which Bourgeois herself despised, is misunderstood if detached from the way in which the pain of art's formalism relates to the pain of loss. These connections point to another area of overlap between boxes and cells: the deployment of childhood and so *regression* as an artistic resource.

37. See Bal, *Louise Bourgeois' Spider*, pp. 77–85.

38. For an insightful handling of the scopic drive in Bourgeois's sculptures, see Briony Fer, "Objects beyond Objecthood," in *Oxford Art Journal* 22, no. 2 (1999): 25–36.

39. And the reason for that fact is simple, namely: easel painting is a formation of the capacity to *draw* likenesses, to make two-dimensional likenesses of things. My framing of modernism in the context of de Hooch's realism is meant as a dull acknowledgment of that significance.

CHAPTER 8

1. Abbreviations used in this essay are as follows:

ILA = G. W. F. Hegel, *Introductory Lectures on Aesthetics*, trans. Bernard Bosanquet (Harmondsworth, Eng.: Penguin Books, 1993).

W = Arthur C. Danto, *The Wake of Art: Criticism: Criticism, Philosophy, and the Ends of Taste* (Amsterdam: G&B Arts International, 1998).

P = Yves-Alain Bois, *Painting as Model* (Cambridge, Mass.: MIT Press, 1993).

AT = T. W. Adorno, *Aesthetic Theory*, trans. Robert Hullot-Kentor (Minneapolis: University of Minnesota Press, 1997).

2. The two pieces I know of that best capture this thesis are: Gregg M. Horowitz, *Sustaining Loss: Art and Mournful Life* (Stanford, Calif.: Stanford University Press, 2001), Chap. 3, "Art as the Tomb of the Past: The Afterlife of Normativity in Hegel"; and Robert B. Pippin, "What Was Abstract Art? (From the Point of View of Hegel)," *Critical Inquiry* (Autumn 2002): 1–24. Pippin's essay is essentially a reply to the treatment of Hegel as a figure in the great tradition of religious iconoclasm put forward by Alain Besançon, *The Forbidden Image: An Intellectual History of Iconoclasm*, trans. Jane Marie Todd (Chicago: University of Chicago Press, 2000). While both Horowitz and Pippin focus on the freedom-from-nature thesis, Horowitz reads Hegel against the grain by underlining art's *remaining* a thing of the past, that is, as standing for an authority of nature whose being past we can never quite get over. Something of that emphasis reverberates in this essay. For a defense of Hegel against the claims of, in particular, Clement Greenberg's conception of modernist painting, see Stephen Houlgate, "Hegel and the Art of Painting," in William Maker, ed., *Hegel and Aesthetics* (Albany: State University of New York Press, 2000), pp. 61–82.

3. In my Introduction to J. M. Bernstein, ed., *Classic and Romantic German Aesthetics* (Cambridge: Cambridge University Press, 2003), I argued that this is the governing and revolutionary thesis of Lessing's *Laocoön*. When Hegel discusses

how flesh color should appear in painting, he sounds almost as if he is paraphrasing Lessing's notion of the pregnant moment: "For this inwardness and the subjective side of life should not appear on a surface as laid on, as material colour in strokes and points, etc., but as itself a living whole—transparent, profound, like the blue sky which would not be in our eyes a resistant surface, but something in which we must be able to immerse ourselves." G. W. F. Hegel, *Aesthetics: Lectures on Fine Art*, trans. T. M. Knox (Oxford: Clarendon Press, 1975), Vol. 2, p. 847. The end-of-art doctrine and a passage like this fit awkwardly with the undeniable fact that Hegel's entire system of the arts depends upon the comprehension of the structuring role of medium specificity. For present purposes, I am going to simply leave the tension between Hegel's richly contoured discussion of medium specificity and his primacy-of-spirit doctrine unresolved.

4. And, again, Lessing's one hesitation over seeing art as an expression of freedom turns on precisely the issue of animation.

5. For this see Kathleen Dow Magnus, *Hegel and the Symbolic Mediation of Spirit* (Albany: State University of New York Press, 2001).

6. Arthur C. Danto, *The Transfiguration of the Commonplace: A Philosophy of Art* (Cambridge, Mass.: Harvard University Press, 1981), pp. 1–3.

7. Danto mentions that other philosophical innovations depend on separating perceptually indiscernible items: Descartes: there are no qualitative marks separating waking from dreaming; Kant: there are no perceptual marks for distinguishing between acting in accord with law and acting from the law; Heidegger: authentic and inauthentic actions look the same.

8. This is not Danto, but Gregg Horowitz and Tom Huhn in their superb Introduction to *The Wake of Art*. Their account is the best overall appreciation of Danto available. My account here is indebted to their patient reconstruction and critique.

9. Danto, *The Transfiguration of the Commonplace*, p. 189.

10. "Transparency" here is a relative term, not an absolute one; the crux is the contrast between the unquoted, referential use of terms, and their quoted, nonreferential use.

11. Lack of space has made it impossible for me to include an account of Heidegger's "The Origin of the Work of Art" in these pages. Heidegger mobilizes the problem of freedom and nature, their conflicting claims to authority, in terms of the battle, agon, of world and earth, where earth is a principle of opacity and a figure of nature as a potentiality for meaningfulness. The claim of earth contests rational transparency. If I were to mobilize Heidegger's thought in this context, it is that thesis to which I would turn. My worry about Heidegger's handling of it is that he presumes access to the earth-world structure independently of the achievements of modernist art in which, I am claiming, the whole issue of freedom breaking from nature is given its most elaborated articulation. For a useful, if finally somewhat mystifying, account of Heidegger's essay, including a clear statement of

his appropriation of Hegel's end-of-art doctrine, see Julian Young, *Heidegger's Philosophy of Art* (Cambridge: Cambridge University Press, 2001). My own take on Heidegger's essay is in J. M. Bernstein, *The Fate of Art: Aesthetic Alienation from Kant to Derrida and Adorno* (Cambridge: Polity Press, 1992), Chap. 2.

12. Danto's own art criticism shows that he does not truly believe that the pop symbol *fully* lends itself to philosophical purposes—consider Warhol's disaster pictures; this is the wedge that Horowitz and Huhn deploy against the theory. Hence, there is a lingering absence and opacity even in the pop symbol.

13. Arthur Danto, *After the End of Art: Contemporary Art and the Pale of History* (Princeton, N.J.: Princeton University Press, 1997), p. 36.

14. For Danto, again, opacity is said to derive from the sign in art having uses other than representation. But the thought is left just there, with no sense given as to what those other uses may be, and why what they gain can only be accomplished through opaque contexts. Which is to say, the fundamental interests of art as art are dropped from Danto's account. If he had homed in on his own claim that every metaphor is a minor work of art, things might have looked different. In their Introduction to *The Wake of Art*, Horowitz and Huhn deftly and tellingly use Danto's own art criticism to counter his claim that we have achieved a situation of posthistorical freedom. They reveal a set of determining investments in his art criticism that his theory cannot account for or indeed in principle license the possibility of.

15. Greenberg, "Towards a Newer Laocoon," in Francis Frascina, ed., *Pollock and After: The Critical Debate* (London: Harper & Row, 1985), p. 42 (emphasis mine).

16. Walter Benjamin, *The Arcades Project*, trans. Howard Eiland and Kevin McLaughlin (Cambridge, Mass.: Harvard University Press, 1999). The interpolations in the passage are Bois's (*P*, p. 235).

17. I am not here claiming that the rational mindedness of Hegelian spirit and the rational mindedness of technology and commodification are the same. For Hegel, the rational mindedness of technology and commodification belong to the reign of the understanding, *Verstand*, scientific reason, which he always regarded as necessarily falling short of the demands for rational self-determination. However, it is in the light of technology and commodification that *the emphatic need for incarnation becomes salient*—which, of course, was just Marx's original critique of Hegel's political doctrine. Hence, in supposing that the need for art can be sublated, Hegelian thought, ambiguously still, converges with the reductive forms of rational mindedness it meant to displace. Said another way, Hegelianism cannot sustain its critique of the mechanical, reductive rationality of *Verstand* without withdrawing from its end-of-art thesis. This would be one reason why someone like Adorno could consider his defense of art authentically Hegelian, true to the demands of Hegelian thought while critical of the letter of Hegel's writing. This necessity for a post-Hegelian Hegelian defense of art is what I was pointing to as the "ambiguity"

of Hegel's own doctrine; this thought will govern the concluding argument of this chapter, where I take up Adorno's account of the role of natural beauty (which is primary for Kant) in its sublation by art beauty (the Hegelian thesis). Stephen Houlgate is to be thanked for pressing on me the need for clarification here.

18. One might suppose that the most contestable aspect of this thesis is the way it connects the manner in which artworks secure authority for themselves with the culture-wide need for art. How might one vindicate the thesis that art's plight is society's plight? Does not modernism's excessive questing *overdramatize* the plight of modernity? Certainly that objection is the one heard most often in response to the line of argument being pursued here. The direct answer to this objection is that modernism's obsessive questing, the precise manner of that questing, must be considered to be directly proportional to the force deauthorizing the claims of sensuous particularity as such. Hence, it is the manner in which artworks are hunted back to their medium that reveals both the need for sensuous particularity as such and the opposing force evacuating the authority of that need. In this way, the drama of modernism *is* a normative (transcendental?) sociology of modernity. But, as Gillian Rose, *Hegel Contra Sociology* (London: Athlone Press, 1981), forcefully pointed out, this is Hegel's way of thinking about art and society: "Hegel inquires into the possibility of art-forms. He asks which forms of art and which individual arts are possible under specific historical and social preconditions. This enquiry is transcendental because it assumes actual art-forms and individual arts as given and examines their possibility. The enquiry is sociological because it connects social structure (precondition) to art-forms (the conditioned)" (p. 122). The difference with modernism is, lacking the comfort of a stable retrospective point of view, that we must (can only?) illuminate the precondition in the way that the conditioned historically attempts to secure an art-form appropriate to its context. In this light, the drama of modernism implicates the sociology of modernity that seeks its displacement. If something like the aporia of the sensible (Chapter 4) or the paradox of modernism (Chapter 7) does effectively capture the drama, then that is the best possible reason for buying into the critical sociology of modernity subtending it.

19. Bois here metaphorically borrows Jacques Lacan's terminology of imaginary, real, and symbolic, without, I think, taking on the full body of commitments that would make the analysis truly Lacanian (*P*, p. 237). The metaphoric borrowing is meant to allow Bois to diagnose the different *dimensions* in which artworks secure their specific character: authenticity and uniqueness; thinghood; internal logic. It is an interesting question as to how different the analysis might have been if he had, for instance, metaphorically borrowed Charles Sanders Peirce's triad of icon, index, and symbol instead.

20. In stating the point this way, I take myself not so much to be introducing a normative/transcendental dimension into art's history, but rather tracking the way in which that dimension is raised in art, hence how modernist works raise transcendental claims about the authority of art-claiming in general through the

manner in which their aesthetic claiming arises. So, for example, in Danto's reading, pop's explicit claiming is an effort to repudiate the need or necessity for a work to raise a transcendental claim in order to lay claim to aesthetic attention.

21. Bois construes reflexiveness as what makes early modernism logically question-begging.

22. Ryman means to mourn modernism, but knows that such mourning requires an endless working through; because the working through is endless, asymptotically approaching the condition of the photograph without arriving there (*P*, p. 232), it has the form of melancholia. Should we say that with his practice melancholy becomes form? Would not that thesis appropriately connect up with the role of the internalizing of the dead object, the mimetic adaptation to death, and the role of repetition in his art? For a pressing of the claim that with modernism melancholy becomes form, see J. M. Bernstein, "Melancholy as Form: Towards an Archaeology of Modernism," in John J. Joughin and Simon Malpas, eds., *The New Aestheticism* (Manchester: Manchester University Press, 2003).

23. "New art is as abstract as social relations have in truth become. In like manner, the concepts of the realistic and the symbolic are put out of service. Because the spell of external reality over its subjects and their reactions has become absolute, the artwork can only oppose this spell by assimilating itself to it" (*AT*, p. 31).

24. For convenience, I am here simply conceding this claim to Bois, but it is far from obvious. He thinks the authority of touch, handedness, dissolved because as it reached its limit in Pollock it finally, fatefully, converged with the analytic of touch, the interiorization of the machine, enacted by Ryman. But since Ryman never fully achieves the interiorization, then the original claim against touch cannot be a contesting of its authority—the authority of the paintings licensed through it—but must rather be something like its weakness as a defense. But that seems to burden the claim of touch with its impotence, as if it is its fault that capital and technology were stronger. Sometimes I hear Bois as being unwilling to forgive the modernism of touch for not being sufficient, as if it were its own fault that its promise was broken. It is that, I think, which leads him to prize Ryman in the way he does: his method of failure, however delicate and balanced, can go on indefinitely, his mimesis of the dead the perfect answer to it. I shall contest this reading of Ryman later.

25. This is why for Benjamin it is obsolescence rather than novelty that becomes the site of utopian hope. At least from one angle, it might be claimed that Joseph Cornell is the master of the art of obsolescence.

26. I do not mean to deny here that a revolutionary situation would generate new relations of artistic production and consumption. The point is rather that we comprehend the artforms produced—Rodchenko's monochromes, for example—and hence the monochrome as a modernist form in general, in relation to the *hope* for surmounting artistic semblance in it, and the failure of that hope. The monochrome is almost symbolic of modernism's hopefulness as a yearning for art's death, and so its self-beratement.

27. T. J. Clark, *Farewell to an Idea: Episodes from a History of Modernism* (New Haven, Conn.: Yale University Press, 1999), p. 254.

28. While, to be sure, Mondrian's actual method was more akin to analytic decomposition, and his dialectic does not function through dialectical reversal, his conception of universality/transparency possesses an evident Hegelian inspiration. A kind evaluation of his Hegelianism would say that he sought to unite left Hegelian radicalism with right Hegelian logicism. Maybe this is what Hegelianism in painting looks like.

29. This is brutal in its speed. For Bois's nuanced appreciation, see "Piet Mondrian, *New York City*" (*P*, pp. 157–83).

30. And if Bois, finally, is a manic mourner, then so is Danto—but we might have guessed that since he doth protest too much.

31. Although his genealogy is not the same as Bois's, T. J. Clark understands the emergence of synthetic cubism in an analogous way: "At Cadaqués Picasso had come face to face with the disenchantment of the world. Which meant, in Picasso's case, the disenchantment of painting—the revealing of more and more, and deeper and deeper, structures of depiction as purely contingent, nothing but devices. . . . The way painting continues, it turns out, is by counterfeiting necessity (on the surface) but having one's metaphors of matter reinstate (on the surface) pure contingency at every point. Laughing at contingency, but not from anywhere outside it. This is Cubism's (modernism's) 'base kind of materialism'" (Clark, *Farewell to an Idea*, pp. 220–21). I let Clark get in his claim about materialism here because in the very next paragraph he attempts to lever it up against the competing semiological analysis of the phenomenon that I am here rehearsing. While I prefer Clark's materialism to Bois's semiology, his defense amounts to no more than the judgment that the force of Cubism's metaphorical reframings is left in abeyance by semiotic unmasking. Which seems right, but locating how Clark thinks he has succeeded in making sense of that force is not easy. The sentence that is supposed to bear the weight states: "The limited particulars [to which Cubism's metaphors do apply] are the means of illusionism; and these the Cubist language does represent with genuine vividness, and manage to make strange: it effects a point-by-point reframing and rearticulation of painting's pursuit of likeness, which reveals this pursuit and its procedures as the unlikely things they always were" (ibid., p. 221). Everything hangs on that "genuine vividness," the "strange" and the successful (how so?) reframing. I suppose the idea is that *metaphors of matter* by yielding an opaque context can take on the burden of a lost language of material meaning. In the context of painting, then, metaphors of matter revert into the materiality of metaphor, metaphor as (improbable representational) meaning still bound to its (lost) material conditions of possibility. Since, on the face of it, this looks like a compelling conclusion, perhaps the best painting can achieve under the circumstances and the one I am fumbling after, it is odd that Clark downplays it. It is the "contingency at every point" that ruins the achievement for him; he sees it as a form of irony, and

so as retracting the force of what the painterly metaphors instantiate. Might not there be a non-ironic way of reading contingency here? Might not contingency connote lostness? Might not contingency be a way of doubling the constitutive absential dimension of the painterly symbol?

32. I guess I think he *logically* must despise Duchamp since the readymade is, literally, the readymade, that is, the unworked bringing of art to its end; hence Duchamp is a manic mourner, a melancholic. Nothing so signifies the melancholic self-beratement of art, the internalizing of the dead thing, as the readymade. I take this to be a definition of the readymade. If this is Bois's judgment, I share it: Duchamp might have intended more, but I don't see how the readymade can avoid this collapse. As I suggested in the previous chapter, the readymade is the great red herring of contemporary art, leading it astray at nearly—but thankfully not every—juncture.

33. So art becomes a vehicle for the disenchantment of society rather than a resource for a resistance to that disenchantment.

34. The critique of representational meaning, of epistemology as first philosophy, is the determining gesture of the transition from "Consciousness" (sense-certainty, perception, and understanding) to self-consciousness (the master-slave dialectic) in the *Phenomenology of Spirit.*

35. The long route would begin with an account of the emergence of the body ego (of the original ego as necessarily a bodily ego), underlining the role of kinesthetic self-awareness and proprioception in the formation of our body image. This would at least hold in place the claim that there is for folk "like us" a core body image that is the correlate of embodied action that is not arbitrary or merely conventional. Another step would involve the attempt to demonstrate the normative force of that *whole* body image through an account of how its negation is a condition for the aesthetic force of the wide range of artistic grotesques, all those monsters and horrors and masks and prostheses and mannequins and puppets. I do want to say, then, that against his own disenchanted understanding, the force of much of Picasso's work depends on tapping the force of such a negation. For a more sustained tracking of the relation between the historical attempt to transcend embodiment and the way it, as the repressed, returns for contemporary art, see Chapter 9.

36. I am not suggesting that the only possible source of critical resistance to the doctrine of the arbitrariness of the sign are exemplary aesthetic particulars, only that, at least here, that exemplarity is already at issue and has been left unaccounted for. For openers, a strong semiotic theory like Bois's abstracts from context, including the life content, the form of life, in which signs are used. A Hegelian and/or Wittgensteinian inflection will always find semiology too abstract, already a skepticism rather than acknowledging the truth of skepticism and finding a role for acknowledgment. As I evidence below, I think that Bois would now operate with something closer to the kind of modernism of acknowledgment I am proposing.

37. From the use of seriality in early modernism (say, Monet) through to mini-

malism, repetition has been a continual resource for modernism. The following remarks attempt to tap the rationality of that employment. In so doing, I am presuming throughout that we have another word for repetition, one intrinsic to the history of art, namely, mimesis. Hence, in attempting to uncover the role of repetition in modernism, I am also interrogating Adorno's continued and puzzling claim that works of art employ a mimetic language, and that the purpose of art is to restore the mimetic moment of meaning to rational discourse. Eliciting the inner connection between mimesis and materiality is the overall purpose of my remarks.

38. One reason why I speak of potentiality for meaning here is that repeatability is a necessary but not sufficient condition for sign-meaning. The second reason will follow forthwith.

39. If an element can be repeated, then it is at least different from itself; so repetition is a mechanism of displaying identity through difference. Because, in fact, Ryman's elements are those of the tradition of painting and drawing, the austere conditions of phonemic differentiation are not necessary for his visionemes. The point of the repetition is to show *that* the elements are visionemes. I am using the notion of visioneme, on analogy with phoneme, rather than syntax or grammar for the evident reason that the former but not the latter presupposes the kind of *material* (material/visual, aural) articulated.

40. If one thinks of the elements of painting as composing what Julia Kristeva calls "the semiotic," namely, those presymbolic material pulsions that are indeterminate between sheer material things and psychological events, then painterly repetition confers on its semiotic elements (the semiotic material of visual perception) a symbolic form, a chance for becoming meaning or a chance for meaning to arise through them, that everyday life has withdrawn from them or defaulted on providing for them. For this way of construing Kristeva's theory I am indebted to Sara Beardsworth's study, *Kristeva: Psychoanalysis and Modernity* (Albany: State University of New York Press, 2004).

41. Stephen Houlgate, "Hegel and the Art of Painting," pp. 74–75, is thus quite wrong to think that modernism, for Greenberg or anyone else, repudiates appearing and illusion; that move, when and if it occurs, is a limit notion, postmodern. Appearance and illusion in modernist painting is, however, routinely optical rather than perspectival (a window). But this is to say that meaning or inwardness or facing are, remain, components of modernist painting; the ambition, again, is to bind such inwardness to the material expressing it, so nature too might appear as facing us, again.

42. This much, we might agree, is the force of Kant's Copernican turn—that the limits of knowledge are its conditions of possibility—that Hegel's idealism finally actualizes. Crudely, because Hegel thinks that conditionedness derives from the *ongoing* social determination of meaning, then the ultimate conditioning of knowing and meaning is history. But this way of conceiving of the absolute conditionedness of knowing turns out to be a limitless limit, the condition unable to

make limitation visible and thereby socially actual. Despite itself, the only real limit Hegelian sociality encounters is the ultimate, final, arbitrariness of the sign. This is the complaint that painting, acting in the name of embodied subjectivity, raises against Hegelian history and the claim of rational mindedness. In this setting, painting's opacity stands for the limits of knowledge, hence for the conditionedness of the human in general. On my reading, modernist painting aims to salvage the Hegelian infinite, the internalizing of the limits of knowing as proper to knowing, against Hegel's own construal.

My claim that the arbitrariness of the sign can always have the last word is meant to acknowledge that there is no "certain" or "foundational" answer to the force of arbitrariness and skeptical negativity. The problem with the semiotic analysis of Picasso, which may or may not echo Picasso's own skeptical doubts about art, his disenchantment with painting, is that it perceives that skeptical force as infecting the body of meaning from the outset, always already, so to speak, so that there never is meaning but only the illusion of meaning—which must be false. Logically, the problem arises, again, because nothing is going to show that a conventional structure of meaning is not arbitrary (there is no getting around contingency); and that damages rational confidence since once we actually discover a rational practice to be, finally, groundless, our capacity to operate with it collapses. Rationality cannot bear too much brightness. But this whole syndrome of arbitrariness and skepticism derives from a repudiation of the finitude of meaning (reason and knowing). The fact that meaning cannot bear up under indefinite critical scrutiny does not entail that it was all along naught, but rather that it was all along finite, transient, vulnerable, mortal, and that those features of meaning are what make it possible. It is this, in part, that the modernist works exhibit—and why such works are so antithetical to the ideals of classicism and rationalism, antithetical to, to return to the very beginning of my story, the Italian model.

43. Perhaps it could be said: Ryman's procedure is the material exhibition of the operation of the reproductive imagination (as Kant conceived it); or, it is the material exhibition of the principle of iterability (as Derrida conceives it). I see the same materialization of the reproductive imagination as the operative principle of Giacometti's practice of painting.

44. I do not need this denial if it is conceded that the death drive—mimetic adaptation—works, can work, in the service of life. But that surely is something that Freud, in his way, was attempting to urge without denying the obvious. Perhaps this reminder about the ambivalence of the death drive (which I am positing should be understood in terms of mimetic adaptation) is all I need as a counter to Bois.

45. This is as good a place as any to confess that I do not think that mechanical repetition in Bois's sense is the *dominant* way in which dead nature figures in Ryman's paintings. That role surely belongs to the materials—paint-stuff, canvas, paper, steel, tape, support, etc.—from which paintings are made. Nor is mechanical repetition his most usual or salient means of defeating thinghood: the *mimetic* in-

teraction of paint-stuff with the surface it adheres to (clings to, lies on, slips or washes over, is brushed across, etc.) plays that role. On the whole, in my judgment, repetition narrowly construed operates emphatically really only in the serial works in which a variation in the support (for example, notched or unnotched sides) or the mechanism of affixing the work to the wall (tape, different kinds of screws or bolts) have even their objecthood suspended through repetition and variation. In single-canvas works (on steel, linen, or paper, for example), it is the interplay between the material quality of the surface and the way the paint (including the mode of its application) echoes and resists, or reverses foreground and background, that is at play: Ryman can make a steel support look and feel liquid, as if it is in need of licking rather than looking, the looking kinesthetically becoming an oral act, through the thinness and brushiness of the application of the paint. (Watching Ellen Levy resist the temptation taught me more about how to respond to some Rymans than most articles I have read.) So the mimetic language of Ryman's single works lies in the responsiveness of the application of the paint stuff to the supporting surface; and while certainly touch matters here, the uncanniness of this depends on the mimetic relation between paint and surface itself—two brute material things—becoming the form through which the potential for meaning of each is revealed. The serial works, when they fail, do so through didacticism. The single works are the more gorgeous and painterly, and when they fail they do so because the conversation between painting and support does not yield a new possibility of painting.

I have focused on the role of repetition here not, then, in order to give a complete account of Ryman's achievement, but to take on Bois at the place where he pitches his argument. And this is appropriate to the extent that repetition and seriality in Ryman can be seen as paradigmatic for their operation in minimalism generally: repetition belongs to the syntax of minimalist art (it is, for example, the guiding thread in Dia: Beacon's summation of minimalism), even if it is not the whole of it. Repetition is the most primitive version of mimesis since even the mimetic adaptation to death is a mechanism of defense, and thus a matter of form. Minimalism, unbeknownst to itself, activates this thought; that is its power. Because minimalist art did not comprehend aright that repetition is the minimum of mimesis, as a practice it became an artistic dead-end.

Hence, I strongly dissent from Bois's framing thesis about the mechanizing of painting in order to approach the condition of photography. Conversely the problem of the "deadness" of painting's medium as everywhere and always becoming a source of meaning is pervasive: Ryman's thing. So I agree with Bois that in some significant sense Ryman is, formally, "the last modernist painter." Understanding Ryman's brushwork requires focusing on the mimetic responsiveness of the painterly touch (or lack of it when the paintbrush is itself the "subject" of application) to the physical/tactile properties of the support, and the way whiteness either neutrally enables its revelation or qualifies *that* responsiveness in light of the support's optical (color) qualities.

46. Adorno has anticipated this argument: "But the artwork must absorb even its most fatal enemy—fungibility; rather than fleeing into concretion, the artwork must present through its own concretion the total nexus of abstraction and thereby resist it. Repetition in authentic new artworks is not always an accommodation to the archaic compulsion toward repetition. Many artworks indite this compulsion and thereby take the part of what . . . has been called the unrepeatable; Beckett's *Play*, with the spurious infinity of its reprise, presents the most accomplished example. The black and grey of recent art, its asceticism against color, is the negative apotheosis of color" (*AT*, p. 135).

47. My pacing out of the logic of Ryman's practice in this paragraph should ideally collapse the distance between his achievement and Pollock's.

48. All this seems to me emphatic with Ryman's most recent paintings, shown at Pacewildenstein, October 11–November 9, 2002: en masse, as beautiful and intoxicating Rymans as I have seen. As Bois (who else?!) states in his introduction to the catalogue, *Robert Ryman: New Paintings*, these paintings radicalize the analytic or chemical elements that impressionism, above all Signac, had already distinguished and highlighted: heightened colors, conspicuous brush strokes, revealed support. In these canvases, an often vibrant or rich color (midnight blue, dark grass green) has been applied to cotton or sized linen (usually, but not always, primed). As it turns out, this underpainting has apparently been applied quickly and roughly, and most of the time not reaching out to the edge of the canvas, leaving an irregular surround. On top of the underpainting, Ryman has applied an "overlay of nervous, wormy, white brushstrokes" (Bois, p. 7), sometimes, apparently, done in braids or cross-hatchings, which do not fully cover the underpainting, but nearly. One might suppose that these paintings were done by a Nietzschean ascetic priest since the effort of analytic decomposition and isolation should have ideally stranded each element, heaving it back into the state of being just dead matter, so fully acknowledging the (Kantian, formalist) taboo on sensuous delight. In fact, the result is almost the exact opposite: the irregular expanses of underpainting and white overlay take on a totemic quality against the square support; the minute specks of remaining underpainting at just those points where, fortuitously, two sets of braiding have crossed but not overlapped, yield an iridescent world of lost color that is both literal and figural at the same time; and, finally, the white brush strokes, while heavy-handed close up ("pasty" is Bois's term), become both expressive and, despite themselves, delicate prisms both for the refused color beneath and for light itself (the overall effect of these canvases wildly different in different lighting conditions). The analytic decomposition makes these moments separate and coalesce in irregular rhythms in attending, so that the tension between the reduction and the coalescence becomes a kind of dance. Call this dance the authority of painting, the claim of dead nature as a limiting condition of meaning and so a source of it. If anything like this is correct, then what distinguishes my interpretation from Bois's is that he, at least in the major essay on Ry-

man, illegitimately and implausibly narrows the scope of Ryman's ascetic practice to the mimesis of the machine. Far more plausibly, one might say that Ryman has self-consciously adopted, generally and systematically, the dialectic of the Hegelian "unhappy consciousness" whose every effort to banish the enjoyment of the body, whose every fast and self-flagellation intensifies the claim of the lacerated, subjectivity-starved matter. The title of Clark's chapter on Pollock in *Farewell to an Idea*, I should note, is "The Unhappy Consciousness." As a stand-in for a general survey of Ryman's most experimental dealings with the medium of painting, see Jeffrey Weiss's lucid "Radiant Dispersion: Robert Ryman, *Philadelphia Prototype, 2002*," *Artforum* (September 2002): 187–91, 224.

49. *AT*, p. 347. I presume the "hierarchy of comprehension" is meant to refer to Plato's divided line and its successors: ascent from sensuous particulars to intelligible-only universals.

50. I am not denying here that the world can become a place beyond caring, or that such a world is tendentially operating in the society of the simulacrum.

51. The model for this breaking free of semblance in the midst of semblance in Adorno is derived from the "late" works of traditional bourgeois artists, above all Beethoven.

52. In Ryman, dissonance is transmitted from part to whole: the interlacing of empty element and dumb repetition together being formless (opaque) form.

53. I take Pollock to provide the best instances of this logic. Because his work so remarkably performs and inhabits the dialectical tension between semblance (the optical beauty of Pollock) and dissonance (the display of raw materiality), without, in his best works, trying to resolve it, there is reason to resist Bois's championing of Ryman and Mondrian over Pollock. If I were to attempt to draw Ryman and Mondrian into this circle, then I would need to claim that what they mean to achieve is a state in which *a whole work* in its very appearing to the eyes is both semblance and dissonance, the appearing to the eye never settling into a comforting completeness but vibrating, formless in its nonetheless purified and dry formality. This captures something of what Bois wants to say about *Empire* and, however differently, *New York City*. It should be conceded, however, that the dual optic only works with Ryman from certain distances; often from an ideal viewing distance the works are simply and directly ravishing.

54. This way of explicating universality is Hegelian. It turns on the idea that the minimum necessary condition for non-natural meaning is the negation of the immediate. If every form of universality commences with the negation of the given in its immediacy, then universality stems from negation and arbitrariness: detachability. Rational universality is not reducible to detachability, but it is conditioned by it; otherwise all universality (reason and judgment) would be reducible to an algorithm. Said naturalistically, the thought is that universality refers to the capacity of the human to engage a context in terms that potentially transcend that context. Coming to see the role of arbitrariness and negation *in* universality is the

disenchanting of it, removing it from its Platonic heaven or a priori shelter and bringing it into natural history.

55. Technical rationality and commodity production are irrational because they repudiate their own conditions of possibility; but that repudiation only matters because the universality of formal reason is not intrinsically rational.

56. This is why I think the correct way to read Ryman's brushwork is not in terms of touch but through mimetic responsiveness; or better, in Ryman touch becomes the mimetic responsiveness of paint-stuff to surface. This is why touch in Ryman is never *directly* expressive of his subjective act. In an almost quintessentially Adornoesque manner, painterly touch for Ryman is his way of mimetically responding to and echoing the claims of the "other," the surface. But the claims of the other, its having the potential to claim and mean, are there only by virtue of the forming action of painting.

57. It is also to concede that there is something authentic in minimalism; what is inauthentic is the disavowal of semblance.

58. What Hullot-Kentor translates as enigmaticalness is *Rätselcharakter*, riddle-character. Adorno, who wants to underline the darkness and incomprehensibility of works, wants also to avoid, at all costs, any association with mysteriousness, anything smacking of the mystical or transcendent. A riddle does not have those associations. On the other hand, he does want that riddling to relate to the purpose(s) of art in general, and above all the loss of transcendent purpose. Enigmaticalness perhaps captures those ideas better than would "riddle-character."

CHAPTER 9

1. For a straightforward documenting of the phases of Sherman's career, see Amada Cruz, "Movies, Monstrosities, and Masks: Twenty Years of Cindy Sherman," in *Cindy Sherman: Retrospective* (Chicago: Museum of Contemporary Art, 1997), pp. 1–17. My own thinking about Sherman began when I heard a version of what became the title essay of Hal Foster's *Return of the Real* (Cambridge, Mass.: MIT Press, 1996) and read Rosalind Krauss's *Cindy Sherman* (New York: Rizzoli, 1993).

2. Norman Bryson, "House of Wax," in *Cindy Sherman 1975–1993*, text by Rosalind Krauss (New York: Rizzoli, 1993), p. 217.

3. Max Horkheimer and Theodor W. Adorno, *Dialectic of Enlightenment: Philosophical Fragments*, trans. Edmund Jephcott (Stanford, Calif.: Stanford University Press, 2002), p. 2. Hereafter references in the text to this work are abbreviated *DoE*.

4. Maurice Merleau-Ponty reconfigures affinity as *flesh*. For a go at using Merleau-Pontean phenomenology to analyze Sherman, see Amelia Jones, "Tracing the Subject with Cindy Sherman," in *Cindy Sherman: Retrospective*, pp. 33–49.

5. Bryson, "House of Wax," p. 219.

6. Ibid., pp. 218–19.

7. Or, as Giorgio Agamben states the thesis: "In the society of the spectacle . . . language not only constitutes itself as an autonomous sphere, but no longer reveals anything at all." Giorgio Agamben, "Marginal Notes on *Commentaries on the Society of the Spectacle*," in Agamben, *Means without End: Notes on Politics*, trans. Vincenzo Binetti and Cesare Casarino (Minneapolis: University of Minnesota Press, 2000), p. 84. Of course, it is the very fact of this autonomy that lends itself to the postmodern presumption of universal linguisticality; but the experience of such linguisticality is equally, but not obviously, the experience of language's emptiness—always on holiday.

8. If Clark and I are right in seeing the grand duality of modernity as the clash between social sign and the bedrock of nature and body, then postmodernism in almost all of its guises looks very much like the cultural version of the earlier rationalistic conceding of all to the social sign without resistance. Perhaps one could even say that the ceding of all to the social sign and coming to regard resistance as hopeless, or naive, is what the postmodern critique of modernism comes to.

9. Theodor W. Adorno, *Aesthetic Theory*, trans. Robert Hullot-Kentor (Minneapolis: University of Minnesota Press, 1997), p. 45. Hereafter references to this work in the text are abbreviated *AT*.

10. In his attempt to provide a general philosophical analysis of the depicted body, James Elkins in *Pictures of the Body: Pain and Metamorphosis* (Stanford: Stanford University Press, 1999), pursues an analogous parasitism argument in distinguishing between the calm of our perception of animate bodies, what he calls "first seeing," with the restlessness of our perception of ambient things without a living focus, "second seeing" (pp. 5–12). Elkins sums up his core thesis (p. 289n2) by saying that "bodies are both the primary objects of seeing and the principal conditions for the possibility of seeing." I take the notion of bodies as being the primary objects of seeing to be equivalent to the claim that the perception of the living body is orientational for a world of significances. Elkins's book begins startlingly with the claim: "Every picture is a picture of the body. Every work of visual art is a representation of the body" (p. 1). I don't know if his claims are true, but they are utterly congenial to the project of this and related chapters: it is the emergent claim of painterly modernism, of the idea of painting.

11. This is not a novel claim. Most obviously, Rosalind Krauss's *The Optical Unconscious* (Cambridge, Mass.: MIT Press, 1993) is nothing but a staging of the role of the somatic and bodily at central junctures in the development of modernism against Greenberg's resistance to that thought.

In *Pictures of Bodies*, Elkins bracingly denominates all somatic feeling that slips past cognitive control, *pain*; pain, he states, "is the *general condition of being alive*" (p. 23). For me (for everyone?) that thought, or at least some version of it, has been kicking around since Elaine Scarry's *The Body in Pain: The Making and Unmaking of the World* (New York: Oxford University Press, 1985).

12. For a detailing of this claim see J. M. Bernstein, *Adorno: Disenchantment and Ethics* (New York: Cambridge University Press, 2001), Chaps. 2 and 4.

13. Susan Sontag, *On Photography* (Harmondsworth, Eng.: Penguin Books, 1979), p. 154. On pp. 153–80 ("The Image-World"), Sontag elegantly rehearses the dual nature of the photographic image I am here sketching, including both the thesis that photography returns us to a primitive affinity between image and object (pp. 155–56), and the thesis that it is a form of disinterested interest (p. 176). I presume that behind Sontag's framing lies André Bazin's "The Ontology of the Photographic Image," in Bazin, *What Is Cinema?* Vol. I, trans. Hugh Gray (Berkeley: University of California Press, 1967). So, for example, Bazin states (p. 15): "The aesthetic qualities of photography are to be sought in its power to lay bare the realities. It is not for me to separate off, in the complex fabric of the objective world, here a reflection on a damp sidewalk, there the gesture of a child. Only the impassive lens, stripping its object of all those ways of seeing it, those piled-up preconceptions, that spiritual dust and grime with which my eyes have covered it, is able to present it in all its virginal purity to my attention and consequently to my love." Even if one despairs of the impulse lying behind Bazin's rhetoric, as I do in most moods, he touches on what I take to be the deepest and most troubling normative reflex of the logic of the photographic image.

14. Sontag, *On Photography*, p. 102. This claim has a family resemblance to that rehearsed by Stephen Melville, "Painting Put Asunder: Moments Lucid and Opaque Like Turner's Sun and Cindy Sherman's Face," in the volume of his essays edited by Jeremy Gilbert-Rolfe, *Seams: Art as a Philosophical Context* (New York: G+B Arts, 1996) when he claims that the essential "problem of photography has been that it has not known what to do with its absoluteness.... *[It] seems essentially unable to fail, and so is itself evidently incapable of modernity.* Its only real decision is about what it will look like—like a painting or like life? Like life when it fails in resemblance to painting?" (p. 205, emphasis mine). What Melville does not say is that this likeness is not factual, or merely factual, blindly mimetic (whatever that means—I think nothing), but aesthetic, that for us its automaticity inevitably has the look of a disinterested looking.

15. Walter Benjamin, *Illuminations*, trans. Harry Zohn (London: Collins/Fontana Books, 1973), p. 190. In *Camera Lucida: Reflections on Photography*, trans. Richard Howard (New York: Hill and Wang, 1981), Roland Barthes records how one prepares oneself for being photographed: "I constitute myself in the process of 'posing,' I instantaneously make another body for myself, I transform myself in advance into an image. This transformation is an active one: I feel that the Photograph creates my body or mortifies it, according to its caprice" (pp. 10–11). For Barthes too this process anticipates the truth of photography generally, its strange power of auratic de-animation. It is what leads him to claim, "Death is the *eidos* of [the] Photograph" (p. 15). I will return to the issue of posing below.

16. T. W. Adorno, "The Schema of Mass Culture," trans. Nicholas Walker, in

Adorno, *The Culture Industry: Selected Essays on Mass Culture*, ed. J. M. Bernstein (London: Routledge, 1991), pp. 80, 82. Failing to see Adorno's meaning, I permitted *Laxativ* to be translated as "cosmetics." Miriam Hansen corrected me. See note 17 below.

17. Ibid., p. 81. On writing, script, etc., in this essay see Miriam Bratu Hansen's important "Mass Culture as Hieroglyphic Writing: Adorno, Derrida, Kracauer," reprinted in Max Pensky, ed., *The Actuality of Adorno: Critical Essays on Adorno and the Postmodern* (Albany: State University of New York Press, 1997), pp. 83–111, especially the opening ten pages of the article.

18. Krauss, *Cindy Sherman*, p. 17.

19. For a different version of the claim that the photographic still is the truth of the filmic image, see Roland Barthes, "The Third Meaning: Research Notes on Some Eisenstein Stills," in the collection of his essays edited and translated by Stephen Heath, *Image-Music-Text* (London: Fontana/Collins, 1977).

20. If one were to translate this thought into the language of Barthes's *Camera Lucida*, we could say that in production of the anonymous cliché Sherman is revealing how the photographic "studium" is produced. Each Sherman *Film Still* turns on a dialectic of *studium* and *punctum*, Barthes's version of general and particular in the domain of photography: *studium* the force of typicality or generality, and *punctum* the telling detail that pulls the photograph out of the realm of generality. The deep problem for comprehending Sherman's *Untitled Film Stills* is locating their *punctum*.

21. Adorno, "The Schema of Mass Culture," pp. 81–92; and my introduction, pp. 10–14; see also Hansen, "Mass Culture as Hieroglyphic Writing."

22. Laura Mulvey, "A Phantasmagoria of the Female Body: The Work of Cindy Sherman," *New Left Review* (July/August 1991): 140. For all my disagreements with this essay, it remains the best single account of Sherman's work as a whole.

23. Verena Lueken, "Cindy Sherman and Her *Film Stills*—Frozen Performances," in the catalogue *Cindy Sherman*, Staatliche Kunsthalle, Baden-Baden (1997), p. 25.

24. Of course, in saying they are self-portraits I do not mean that they are in any substantive sense empirically autobiographical. I am claiming, rather, that they are *formally* self-portraits, *formally* autobiographical in that their effect depends, finally, on the space between the clichéd identity and the self inhabiting that identification. It might have been logically possible to achieve this separation by using separate models for each picture; but for that to work the choice of model would have had to become *internally* related to the cliché pictured, hence destroying what I am claiming is the source of authority. Clichéd identifications are in a sense masks, implying thereby a self behind the mask. The space between the two becomes the frisson for the series as a whole, their form of mattering. They would not have come to matter in this way unless Sherman, or some *one* other model, was the model throughout. By virtue of this series, the very idea of model is given

an existential twist, a twist belonging to the logic of photography. Hence the effect of the series becomes that *each* of us in our singularity is subject to the same multiplication of identities that refuse us as selves, as Sherman, formally, is refused. Hence, it is constitutive of the operation of the series that we experience *both* the inauthentic and authentic aura of the pictures. That, again, is the darkness and unease that the series projects.

25. Adorno, "The Schema of Mass Culture," p. 80. I take the repetitive, serial character of Sherman's works to be acknowledgment of this mode of hope: the repetition of the culture industry's repetitions yields the difference in repetition. In this light, Sherman's ritual of performing each clichéd identity, the revelation of identity as ritual performance, converges with Judith Butler's conception of gender performativity in *Gender Trouble: Feminism and the Subversion of Identity* (New York: Routledge, 1990).

26. While this picture belongs to the anyway gentler critique of the "Dianne B" series (the tougher ones done for *Vogue* for the designer Dorothée Bis), it would nonetheless need to be a comic critique since Madonna's use of the idea was already a wild crossing of sexual provocation, sexual aggression, and self-parody.

27. I think it is because so many theorists are unwilling to take seriously photographic automatism, because it seems to fly in the face of the massive manipulation possible in the production of the photographic image (the anti-realism argument) and would negate the presumptions of so many earlier practices of art photography (forgetting that modernism always operates through negations), that leads the underlying logic of Sherman's practice to be overlooked. Because the current generation of art theorists have grown up with a skepticism about images, the claims about photographic realism are now out of favor; and, to be sure, digitization might truly make the normative logic of photographic realism unintelligible in the future. But none of those concerns touches on the original logic of photographic claiming, the nature of the authority of the photographic image both in its emergence and throughout the past century. Conversely, one final source of resistance to this analysis amounts to a sentimental Kantianism: could aesthetic reflective judgment, the disinterested judgment of taste, really become automaticized, mechanized? A proper account of the logic of photographic realism demands an affirmative answer to this question.

28. The names of the various series of pictures, apart from the first, come from critics, not Sherman. They are shorthand labels; in fact, the relationship between the various series is not precise; there is overlap and indeterminacy. I retitle some stretches of production; for example, some of the disaster pictures I think of as belonging to the logic of the *informe* (such as #234–#238), and what I am calling the "mask" series typically is regarded as belonging to the horror and surrealist pictures of 1994–96.

29. "Monopoly" was the original term; "those in command" is a variant marking the shift from an economic to political understanding of the present. On the

textual variants that occurred between the original 1944 mimeographed version of the text and its 1947 publication, see *DoE*, pp. 248–52.

30. For an Aristotelian analysis of classical horror as a late form of tragedy, see Noël Carroll, *The Philosophy of Horror, or Paradoxes of the Heart* (London: Routledge, 1990). For an account of realist horror's divergence from the tragic paradigm and an ideological critique of realist horror, see Cynthia A. Freeland, "Realist Horror," in Cynthia A. Freeland and Thomas E. Wartenberg, eds., *Philosophy and Film* (London: Routledge, 1995), pp. 126–42.

31. For a more direct version of this claim, see Peter Schjeldahl, "Delirious Watching: Cindy Sherman and Horror Movies," in the Staatliche Kunsthalle catalogue, *Cindy Sherman*, pp. 142–46.

32. Jonathan Lear, "Katharsis," in Amélie Oksenberg Rorty, ed., *Essays on Aristotle's Poetics* (Princeton, N.J.: Princeton University Press, 1992), p. 332. Hereafter reference in the text to this essay is given as K, followed by the page number.

33. Schjeldahl, "Delirious Watching," p. 142, reports Sherman as stating: "Horror movies are cathartic for me. They are like rehearsals or preparations for the worst that can happen."

34. Idealism might be metaphysically false, but it is historically true: the world has become saturated with "rational" meaning, even in the apparently nonrational moment of the sublime, which is why Adorno's entire project can be an immanent critique of philosophical idealism.

35. Immanuel Kant, *Critique of Judgment*, trans. Werner S. Pluhar (Indianapolis: Hackett, 1987), pp. 312, 326.

36. In his telling critique of Noël Carroll's *The Philosophy of Horror*, which offers a pure cognitive account of horror's satisfactions, Mark Vorobej, "Monsters and the Paradox of Horror," *Dialogue* XXXVI (1997), pp. 219–46, rightly contends that the true object of fascination in horror is ourselves "and the human condition in general" (p. 239); but he leaves open the question why self-knowledge must be gained in horror though violence aimed at the destruction of life (p. 240). Placing horror in relation to tragedy and sublimity as a natural, philosophical history of limit situations and focusing on the anxiety that life does not live is meant to serve as a response to that query.

37. Robert Hughes, *The Shock of the New: Art and the Century of Change* (London: Thames and Hudson, 1991), p. 292.

38. I do not have an easy answer as to why I find Bacon unpersuasive. I suppose the answer would lie in the thought that the drama of skin, the drama of its failures of containment, becomes histrionic rather than compelling in Bacon's distortions; his distortions are the wrong sort of objective correlative of the phenomenon he is seeking to express. For the opposing view see Gilles Deleuze, *Francis Bacon: The Logic of Sensation*, trans. Daniel W. Smith (New York: Continuum, 2003). Nonetheless, as the argument of Chapter 4, "Body, Meat and Spirit, Becoming Animal," makes evident, especially the argument concerning the zone of

indiscernibility between man and animal, and his ideas concerning flesh and meat, Deleuze's concerns are not completely remote from those of this chapter. More interesting to me would be the cases of Lucien Freud and Jenny Saville (certainly the best painter in the new British art scene). On Freud, see Jennifer Stone's *Freud's Body Ego or Memorabilia of Grief: Lucien Freud and William Kentridge* (New York: jarvaribook.com, 2003). This is a Web publication.

39. On the logic of inside and outside with respect to skin and flesh, see Elkins, *Pictures of the Body*, Chap. 1.

40. Bryson, "House of Wax," p. 220.

41. Ibid.

42. Ibid., p. 222.

43. What is plain in these pictures is that the substitutions can perform their task of reanimation only via photography. Neither as painted nor real would they be compelling.

44. Krauss, *Cindy Sherman*, p. 174.

45. It is not irrelevant that, like the *Film Stills*, the bulk of the history portraits are not actually "after" particular historical works, but work on anonymous types that have the force of familiarity even though there are no particular paintings they repeat.

46. *Cindy Sherman: Retrospective* (Chicago: Museum of Contemporary Art, 1997), p. 164.

47. This explains the hysterical role of sport in contemporary culture.

48. In putting the matter this way I mean to signal something of how in sex, desire and the death drive are entwined. The litmus test for my account, however, is to reveal the nature of this entwinement without explicitly relying on psychoanalytic theory, since my aim is to demonstrate how Sherman manages to illuminate the relation between sex and picturing, that is, pornography, through artistic means.

49. As Henry Harris elegantly states this thesis: "[P]arricide and incest are poetic metaphors for what human nature does to itself (logically) when it becomes *political.*" *Hegel's Ladder II: The Odyssey of Spirit* (Indianapolis: Hackett, 1997), p. 217. The repudiation of the *authority* of nature is a necessary condition for the possibility of rational society. My argument is not meant to dispute this necessity, but only to reveal why it must remain aporetic. There is aporia here because, although we cannot forgo the cultural effort of self-authorization without self-defeat, without making our commitments in principle unintelligible and things for which we are not accountable and responsible, that effort of pure self-authorization cannot be completed. To be sure, it will always be logically incomplete because it is subject to historical contingency; but, or so I am claiming, it will always be ontologically and so rationally incomplete because there is a *claim of nature*—say, the authority of suffering—that cannot be *exhausted* by its social acknowledgment: to suppose that suffering matters because we say so sounds for all the world like a denial, as if it really could be up to us to decide the matter. More directly, then, the authority of the

claim of the pursuit of happiness is not there solely or only because we grant it authority, because we self-legislate its significance, although it would be as nothing (except a causal source of a self-defeating performance yielding misery, as in Hegel's depiction of Christian asceticism) if we turned our social back on it. One way of stating this might be to say that nature is a *forever lost source of authority*. What might it mean to place ourselves in permanent relation to a lost, past source of authority? Perhaps this: such authority only ever appears as semblance.

50. In collapsing the difference between the Jewish ban on images and the emergence of the Greek polity, I am of course treating both in a Hegelian frame of reference as components in the discontinuous emergence of human autonomy against the authority of nature, as if the Jewish *Bilderverbot* were best construed as an anticipation of Protestant secularization. But this is to say that for me the history of iconoclasm is best understood as a struggle with the standing of the authority of nature with respect to culture, where there is a constant pressure for culture to authorize itself in opposition to nature. On this reading, there is no autonomous history of religion; rather religion is one of the irreducible modes in which the demands of culture in relation to nature are worked through—which is the genius of the Hegelian narrative. For a detailed and intriguing opposing story, see Alain Besançon, *The Forbidden Image: An Intellectual History of Iconoclasm*, trans. Jane Marie Todd (Chicago: University of Chicago Press, 2000).

51. The converse of this thesis is explanatorily important since it reveals why the pursuit of happiness inevitably models itself after sexual happiness, something that the sheer intensity of sexual pleasure, *jouissance*, leaves mystifying—as if the quantitative intensity of a pleasure might all by itself be sufficient to invoke and project the meaning of a form of life.

52. Judith Butler encapsulates this conception of the meaning of gender identity that was first elaborated in Simone de Beauvoir's *Second Sex* this way: "By defining women as "Other," men are able through the shortcut of definition to dispose of their bodies, to make themselves other than their bodies—a symbol potentially of human decay and transience, of limitation generally—and to make their bodies other than themselves." Judith Butler, "Variations on Sex and Gender: Beauvoir, Wittig and Foucault," in Seyla Benhabib and Drucilla Cornell, eds., *Feminism as Critique* (Cambridge: Polity Press, 1987), p. 133. Transience and decay are the passive forms of dismemberment.

53. Judith Butler, *Excitable Speech: A Politics of the Performative* (New York: Routledge, 1997), p. 95 (emphasis mine).

54. For a persuasive critical account of the satisfactions of late modern pornography, see Linda Williams, *Hard Core: Power, Pleasure, and the "Frenzy of the Visible"* (Berkeley: University of California Press, 1989).

55. Hal Foster, *The Return of the Real: The Avant-Garde at the End of the Century* (Cambridge, Mass.: MIT Press, 1996), p. 156.

56. In *Illuminations*, trans. Harry Zohn (London: Collins, 1970), pp. 213–14.

57. Which is why, of course, beauty finally becomes antagonistic to sensuousness in general and the ugly its only possible site. This is the place to acknowledge Adorno's own allegiance to the image ban. His iconophobia, as I read it, derived from his inability to imagine how iconic images could bear the weight of negativity necessary for a modernist art. It was this inability that motored his antipathy to photography and film. From the perspective of Adornoian aesthetics, the gravamen of this essay has been to demonstrate how Sherman's artistic practice has managed to unite iconic imaging with modernist negativity.

Index

abjectness, 9, 158, 161, 206, 237, 306
abnormal painting, 200, 214, 221–22, 360n6, 362n25
absorption, 158
abstract expressionism: abstraction and, 160; Adorno and, 144, 146, 194; artistic genius and, 276; aura and, 264–66; Clark and, 166–67, 172, 177, 179; cognitive opacity of, 120–21, 134; Danto and, 227; disenchantment and, 148, 150–52; hegemony of, 147; as last moment of modernism, 2, 122, 135, 200, 222, 263; lyric and, 154; materialism of, 297; material meaning and, 156–57; need for art and, 163–64; nominalism and, 213; sensuous particularity and, 153, 155, 162; Soutine and, 73, 298; vulgarity of, 158–59, 161
abstraction: abstract expressionism and, 160, 163–64; art and, 2, 124, 152, 199, 227; aura and, 261; disenchantment and, 150–51; disinterestedness and, 57, 62, 251; dissonance and, 208; genres as, 253–54, 287; modernity and, 44, 122; in Newman, 156; photography and, 280–81, 288; Pollock and, 179–81, 183, 186–90, 211; science and, 146; sensuous particularity and, 23, 66, 116, 158, 257
abstract painting, 2, 152, 188–90, 204, 331n6
acknowledgment: Cavell and, 78, 95, 109, 115–16, 345n23; in de Hooch, 42; experience and, 5; of living nature, 260–61;

312, 341n33; modernism and, 14, 100–102, 105–7, 248; of paint matter, 65; philosophy and, 111; in Pollock, 187; pornography and, 313, 317; in Sherman, 258; in Soutine, 67, 73
action, 51, 87–91, 100, 111, 293
action-painting, 154, 227
Ades, Dawn, 363n34
Adorno, T. W., 109, 119; abstract expressionism and, 146, 160, 194; animism and, 265; art's logicality and, 197–98, 205–6, 222, 353n11; on aura, 254, 260–62; convention and, 215; on culture industry, 266, 269, 273, 277, 289; disenchantment and, 149, 151–52, 161–63, 256; on dissonance, 208, 263, 282; end of art and, 223, 226; enigmaticalness and, 252, 376n58; image ban and, 384n57; language and, 156–58; late modernism of, 195; material motive and, 199–200; mimesis and, 258, 267; on modernism, 11, 17, 154, 247–48; natural beauty and, 249–51, 339n17; the new and, 236; nominalism and, 213; nonidentity and, 303; philosophy of, 12–13, 121, 144, 354n13, 381n34; repetition and, 374n46; sensuous particularity and, 207, 209–10; shudder and, 341n31; the sublime and, 293; on ugliness, 283, 296, 319–20
aesthetic claim. *See* claim
aesthetic culture, 61
aesthetic form. *See* form
aestheticism, 218

aesthetic judgment. *See* reflective judgment
aesthetic perception, 61, 82, 262, 318, 348*n*7
aesthetics: of Adorno, 144, 194–95, 222, 252, 384*n*57; Christensen and, 119; Clark and, 180; end of art and, 223; of Hegel, 249, 334*n*26; Italian, 26, 29; Kantian, 14, 186, 264, 328*n*5, 344*n*12; materialism and, 46–47; medium and, 15–17; minimalism and, 101; modernism and, 1, 11–12, 63, 78, 80; photography and, 267, 281, 288–89; psychology and, 82–83
affective significance, 90–91, 107
Affeldt, Steven, 344*n*17
affinity: abstract expressionism and, 157; Adorno and, 198, 258, 260; art and, 264; Cornell and, 219; Dutch realism and, 334*n*26; Merleau-Ponty and, 376*n*4; photography and, 267, 378*n*13; Sherman and, 303, 305; Soutine and, 66–67, 70, 74, 298; Van Gogh and, 278
Agamben, Giorgio, 377*n*7
aimlessness, 186, 358*n*23
Akerman, Chantal, 112–14, 116, 347*n*35, 347*n*37
alienation, 6, 88, 257
allegory, 118–21, 246, 284, 302
Allison, Henry, 327*n*5, 337*n*7
Alpers, Svetlana, 14, 26–29, 35–38, 44, 334*n*27
amenability problem, 48–49, 52, 57–58, 60–62, 337*n*7. *See also* fitness; purposiveness
analytic philosophy, 80, 98, 108–9, 111
anarchism, 173–74, 356*n*9
Andre, Carl, 201
Anglo-American philosophy, 80–81
animation: Hegel and, 224–25, 246; Sherman and, 261–62, 297, 302, 321. *See also* reanimation
animism: culture industry and, 266, 269; epistemology and, 6; horror and, 290, 302; living body and, 259, 261–62, 312; masks and, 321; mimetic cognition and, 265; photography and, 14, 268, 276–77; Soutine and, 298

anthropomorphism: abstract expressionism and, 148; Fried and, 125–26, 138, 140, 142; Greenberg and, 124; of idealism, 251; minimalism and, 128, 130–35, 141; modernism and, 123, 127, 143; in Soutine, 298
anti-anthropomorphism. *See* anthropomorphism
anti-art, 160, 207, 209, 247
aphorism, 110, 116
aporia of the sensible, 120–23, 138, 140–42, 182, 348*n*3, 351*n*28, 355*n*5
a priori deadness, 191–92, 212–15, 221–22, 361*n*21
Arendt, Hannah, 90
Aristotle, 291–92, 296–97
art beauty, 48, 224, 249, 251, 339*n*7. *See also* beauty; natural beauty
art criticism, 14–15, 85–87, 100, 111, 118, 122, 265–66, 343*n*5
art history, 24, 122, 165, 214, 287, 308, 313, 343*n*5
asceticism, 205, 227
Atget, (Jean-)Eugène(-Auguste), 220
aura: abstract expressionism and, 158, 264; Adorno and Horkheimer on, 260–62; culture industry and, 266, 271; of dismembered subject, 317; modernism and, 263, 265; photography and, 254, 268; Sherman and, 272–73, 276–277, 279, 283
Austin, J. L., 90
authenticity: Greenberg and, 124; ideology and, 119; against illusion, 277–78; of material world, 23; meaning and, 161; of modernism, 63, 78, 92, 107, 133, 236–37; natural world and, 146; Soutine and, 70, 73; Stella and, 139
authority: of art, 1, 9, 14, 161, 180, 227, 233, 238, 240, 313, 367*n*18, 367*n*20; of Cavellian fragment, 114, 116; of culture, 73, 312; of experience, 7, 9, 257; of genres, 287; of life, 297; of medium, 172; of nature, 10–11, 35, 49–51, 224–26, 246, 249, 251, 311, 382*n*49, 383*n*50; philosophy and, 108–12; photography and, 267–68,

380*n*27; of sensory awareness, 20, 22–23, 29, 45; of Sherman's works, 271, 274–75, 286–87; of sign, 241; traditional, 92, 98, 106, 135, 171, 201

automatism: Cavell and, 95–96, 99, 108–9, 215; of photography, 284, 286, 380*n*27

autonomy: of art, 3, 43–44, 191, 205, 209, 220, 264, 356*n*6, 358*n*23; of artistic materials, 199; of the concept, 116; of culture, 312; human, 75, 166, 313, 383*n*50; of painting, 1, 15, 356*n*8; of the subject, 317; of the work of art, 96, 132, 237

avant-garde, 203–5, 207–9

awareness: of human finitude, 81; of mortification, 297; sensory, 5–6, 20, 327*n*5

Bacon, Francis (painter), 68, 298
Bacon, Sir Francis (philosopher), 334*n*27
Baconianism, 27–28
Bal, Mieke, 348*m*, 363*n*33
Barker, Francis, 354*m*7
Baroque, 114
Barthes, Roland, 378*m*5, 379*nn*19–20
Bataille, Georges, 264
Baudelaire, Charles, 233
Bazin, André, 378*m*13
Beardsworth, Sara, 371*n*40
Beaton, Cecil, 180–81, 187, 282
beauty: acknowledgment and, 106; Cavell and, 116; as charismatic authority, 109; Christensen and, 118–19; culture and, 310; de Hooch and, 26, 42; freedom and, 75; judgment of, 57, 61, 83; photography and, 235, 319; Soutine and, 72; sublimation and, 280; the sublime and, 289; ugliness and, 283, 296, 318, 384*n*57; violence of, 255, 281–82, 284, 302. *See also* art beauty; natural beauty
Beckett, Samuel, 144
Beethoven, Ludwig, van, 375*n*51
Bell, David, 338*m*5, 354*m*4
Benjamin, Walter, 16, 114, 203, 233, 268, 283, 316, 353*m*3, 368*n*25
Berg, Alban, 144
Besançon, Alain, 364*m*2, 383*n*50

body, the: animism and, 290; anthropomorphism and, 125, 127, 131, 142; artistic materialism and, 47, 50, 72–73; aura and, 263; Bois and, 235–36, 240–41, 246; Bourgeois and, 218, 220–21; Clark and, 170, 176, 189, 192; disappearance of, 258–59, 312; Elkins and, 377*m*10; female, 354*m*7; horror and, 290, 297–99, 301; image of, 370n35; perception and, 261; Sherman and, 281–83, 307, 309–10, 315–17

Bois, Yves-Alain, 12–13, 223, 225, 234–42, 246–47, 367*n*19, 368*n*24, 370*n*36, 372*n*45, 374*n*48

Bourgeois, Louise, 10, 15, 215, 218, 220–21, 363*n*30

boxes, 215, 218–22, 363*n*36

bracketing, 57–58, 61–62, 66, 73, 102, 104, 106

Brandom, Robert, 327*n*4
Braque, Georges, 340*n*27
Bryson, Norman, 255–56, 258–59, 304, 306, 313
Bull, Malcolm, 356*n*9; 357*m*7
bureaucracy, 52, 108
Burke, Edmund, 260
Butler, Judith, 313, 380*n*25, 383*n*52

Cadaqués, 176
Camfield, William, 362*m*27
candidness, 102, 105, 345*n*23
capital, 32, 52, 61, 122, 150, 164, 177, 180, 188, 237
Caro, Anthony, 14–15, 94, 98, 105, 107, 122; *Bennington*, 93; *Deep Body Blue*, 93; *Prairie*, 102, 104, 108, 112
Carroll, Noël, 381*n*30
categories: aesthetic, 133–34, 138, 158, 255, 281, 283, 288, 318; Kantian, 110, 269
Cats, Jacob, 26
causality, 197–99, 299
Cavell, Stanley, 98–99, 180; acknowledgment and, 100–102, 105–6; aesthetic judgments and, 83–87, 344*m*2; aesthetics and, 11–12, 14, 78; Akerman and, 113;

artistic mediums and, 288; automatism and, 95–97, 154, 215; Caro and, 93–94; the fragment and, 109–110, 112, 114–16; philosophy and, 79–81, 92; skepticism and, 342*nn*3–4, 343*nn*8–9; on tragedy, 294

Caygill, Howard, 338*n*13

centerfold, 279–80, 318

Céret landscapes. *See* landscapes

Cézanne, Paul, 2, 43, 65, 121, 152, 167, 171, 176, 180, 235, 298, 340*n*27; *The Large Bathers*, 175; *The Mt. Sainte-Victoire*, 175

chance, 97

Chardin, Jean-Baptiste-Siméon: *Kitchen Still Life*, 44; *Saying Grace*, 44

charismatic authority. *See* authority

childhood, 26, 186, 218–19, 364*n*36

Christensen, Jeanette, 117–21; *Waiting for Columbus*, 143

Christianity, 40

Clark, T. J., 12–13, 15, 223; abstract expressionism and, 146–48, 152–54, 158–63, 352*n*3; Cézanne and, 175; David and, 171–72; Malevich and, 237; modernism and, 165–70, 177–78, 191–92, 355*n*5; Picasso and, 176, 369*n*31; Pissarro and, 173–74; Pollock and, 179–83, 187–190

classicism, 133

classic solution, 25, 35

cliché: art history, 308; culture industry, 270–76, 278–83, 290, 306

closure, 70, 146

cognition: Adorno and, 205; art and, 8–9, 47, 82–83; in Kant, 4; mechanization of disinterest and, 267; mimesis and, 258, 262, 265; nondiscursivity and, 251; reflective judgment and, 54–58, 60–62; Sherman and, 305–6; truth-only, 118. *See also* encounter; experience

cognitivism, 134

collage, 182–83, 186, 188–89

collecting, 112, 114, 219

collective unconscious, 161

commodity fetishism, 139, 148–49, 163, 233, 263

communication, 107–8, 156, 198, 219

community, 90, 148–49

composition, 2, 35, 97, 100, 158

concept: Adorno and, 156, 273; art and, 14–15, 62, 196, 232, 265–66; critique of, 111, 116; deduction of, 110; intuition and, 12, 17, 166, 206; judgment and, 52–54, 56–57, 60, 83, 85–86, 90; Kantian, 4–8, 328*n*5; modernity and, 122; nature and, 10, 50; sensuous particularity and, 257; sign and, 262; Stella and, 141

conceptual art, 117, 156, 162, 202, 263

constellation, 109, 118

constructivism, 250

contingency: art and, 196; Clark and, 171–72, 178, 191, 334*n*8, 356*n*8, 369*n*31; convention and, 142, 222; modernism and, 12; Mondrian and, 238; Picasso and, 241; realism and, 38

convention, 206; abstract expressionism and, 155, 276; automatism as, 108; Cavell and, 93–94, 96, 109; de Duve and, 201–2; Duchamp and, 215; easel painting as, 212; end of art and, 239; Fried and, 125–26, 139–40, 142; Greenberg and, 66, 70, 203–4; inaugurating, 218, 220–22; modernism and, 107–8, 191; modernity and, 98–99; nominalism and, 213–14; non–art and, 207; photography and, 278; Ryman and, 240, 242, 244–46.

conviction: convention and, 125–26, 138–39; painting as form of, 3, 64–65, 67, 73; experience and, 11, 147, 321; representation and, 181, 211

Cornell, Joseph, 15, 215, 218–21, 362*n*30, 363*n*36, 368*n*25

Corot, Jean-Baptiste-Camille, 340*n*21

Courbet, Gustave, 37, 333*n*24, 340*n*21

courtyard paintings, 30, 33–34, 36–38, 45

crisis: of authority, 92; of bourgeois self, 270; disenchantment as, 49–52, 74, 150, 249; of subjectivity, 278

Critical Theory, 13, 259

criticism. *See* art criticism

critique: art as, 3, 29, 104, 186, 209, 234;

philosophy as, 111; postmodernism as, 259; Romanticism as, 80; in Sherman's photography, 284, 289, 309, 318
Crow, Thomas, 200
cruelty, 160–61, 163, 281–84, 319
Cruz, Amanda, 376*n*1
cubism, 2, 152, 167, 176–77, 227, 240, 369*n*31
culturalism, 260
culture: Adorno and, 269; art and, 106, 121, 142, 146, 168–69, 191, 231, 234, 256; in Cornell, 218; the claim of embodiment and, 317; in de Hooch, 35–36, 38, 45; nature and, 260, 290, 294–95, 383*n*50; philosophy and, 92, 99, 111; Romanticism and, 80; sex and, 310–15; Sherman and, 276, 284; Soutine and, 66–67, 73; the sublime and, 293. *See also* culture industry
culture industry, 61; Adorno and, 269; aura and, 254, 266, 268; cliché and, 270–71, 273–74, 277–78, 280, 283; fashion and, 288; pornography and, 310; rationalization and, 282, 304; tragedy and, 289. *See also* culture
custom, 106

Dada, 218, 362*n*30
Danto, Arthur, 12–13, 121, 223, 225–35, 237, 239, 329*n*9, 366*n*14
David, Jacques-Louis, 170–72; *Death of Marat*, 167, 171, 181, 334*n*28
dead nature, 10, 50, 60, 62, 225–26, 246, 248, 251–52. *See also* nature
Dean, Tacita, 16–17
death drive, 245, 372*n*44
de Beauvoir, Simone, 383*n*52
debris, 211, 218, 284, 314
decay, 35–36, 70, 72, 75, 119, 302
decomposition, 2, 70, 72–73, 236, 287, 302, 305, 340*n*27, 374*n*48
deconstruction, 142
decorativeness, 64, 70, 155, 181, 263
deduction of taste, 60–61

de Duve, Thierry, 12–13, 195, 200–208, 212, 360*n*6, 361*n*16, 362*n*26
de Hooch, Pieter, 12, 14–15, 23–26, 29, 35–40, 42–45, 170, 331*nn*6–7, 334*n*26, 336*n*37; *The Bedroom*, 33; *Card Players*, 30; *A Courtyard in Delft with a Woman and Child*, 34; *Figures Drinking in a Courtyard*, 34; *A Mother and Child with Its Head in Her Lap*, 33; *Portrait of a Family Making Music*, 43; *Two Women and a Child in a Courtyard*, 33; *Two Women in a Courtyard*, 36; *A Woman and Child in a Bleaching Ground*, 34; *A Woman Nursing an Infant with a Child and a Dog*, 33; *A Woman with a Baby in Her Lap, and a Small Child*, 32
de Jongh, Eddy, 332*n*8
de Kooning, Willem, 15, 44, 65, 73–74, 155, 200; *Excavation*, 120; *Night Square*, 153; *Woman* paintings, 160–61, 298
Delaroche, Paul, 233
delegitimation: of art, 230, 234; of experience, 7–8, 257; of nature, 49–52, 74–75; of sensory awareness, 20, 22. *See also* dematerialization
Deleuze, Gilles, 381*n*38
dematerialization, 49–52, 74–75, 307. *See also* delegitimation
demythologization, 123–24, 126, 133, 140, 152, 162, 256
deretinalization, 227, 230–31
Derrida, Jacques, 121
Descartes, René, 12, 19–23, 28, 43–45, 49, 123, 170, 224, 258, 260, 294
determinate meaning. *See* empirical meaning
determinant judgment, 48, 53, 58–60, 328*n*5. *See also* reflective judgment
determined society, 98, 100, 106
determinism, 88–91
Dewey, John, 149
de Witte, Emmanuel, 332*n*15
dialectical analysis, 239
Diebenkorn, Richard, 339*n*17; *Ocean Park*, 146

digitalization, 16–17, 330n19
diremption, 45, 149, 154–55, 164, 166–67, 206, 265
discursivity, 6, 47–48, 54, 56, 60–63, 119–21, 151, 157. *See also* cognition; nondiscursivity
disenchantment: abstract expressionism and, 150–52, 160–62, 164; Adorno and, 197, 256; arbitrariness of the sign and, 241, 249; art and, 95, 105, 122; Christensen and, 118; Hegel and, 148–49; Kant and, 48–50, 52
disgust, 296–97, 301–4, 306, 312, 315
disinterestedness, 57–58, 62, 267
dismemberment, 255, 297, 307, 311–12, 315–16
dissonance, 248, 263; in abstract expressionism, 190, 298; Adorno on, 199, 208–10; Bourgeois and, 220; in Sherman's photography, 282–83; sublimity as, 159, 317
distortion, 68, 70, 72, 255, 340n27
domesticity, 33–34, 336n38
Dou, Gerard, 26
dualism, 5, 83, 95, 133, 138, 187
Duchamp, Marcel, 140, 203, 205, 236–37, 239–41, 245, 247, 370n32; *Fountain*, 194–95, 200, 202, 214–15, 221, 226, 360n8, 362n28
Dummett, Michael, 120
Dutch realism, 12, 24–29, 32, 36–38, 42, 44, 331n7. *See also* realism

easel painting, 119, 125, 142, 182, 191, 211–12, 219–20, 222, 364n39
Eddington, Sir Arthur Stanley, 22
Eldridge, Richard, 343n6, 346n31
El Greco, 340n21
Elkins, Jim, 121, 348n3, 377n10
El Lissitzky, 167
eloquence, 199, 222, 248
embodiment: abstract expressionism and, 155, 190, 297; anthropomorphism and, 127; Christensen and, 118; Danto and, 231; modernism and, 95, 205–6; nature and, 48, 294; Ryman and, 245–46; sex and, 311–13, 316–17; Sherman and, 253, 306; Soutine and, 47, 66, 74–75, 77
embryonic organism, 68, 72–73
Emerson, Ralph Waldo, 81, 98, 109–10, 112
empirical structure, 90–91
encounter, 3–7, 17, 28–29, 43, 55, 58, 62, 132, 226, 327n5. *See also* cognition; experience
endlessness, 132–33, 190
end-of-art thesis, 121, 148, 172, 223–27, 231, 234, 250
enigmaticalness, 226, 252, 376n58
enlightenment, 156, 320; abstraction of, 151, 162; Adorno and Horkheimer on, 260; anthropomorphism and, 126–28, 130, 133; art and, 308; Descartes and, 22–24, 29; as historical moment, 19; modernist philosophy and, 108; rationality of, 120
epistemology, 4–6, 49, 178, 192–93, 258
essentialism, 125, 140, 221
everyday life, 146–47; art's excision from, 3, 206; culture industry and, 271; disenchantment and, 6, 122, 149–50, 261; Dutch realism and, 24, 45; modernism and, 193. *See also* secular world
everyday practices, 146, 206
exemplary object, 86
exemplary performance, 111
exhaustion: of abstract expressionism, 122; of painting, 128, 135–36, 138, 141, 182, 200–201, 210, 212
existential emptiness, 9
experience, 110, 156–57; abstract expressionism and, 155, 161, 163, 179, 188; Adorno and, 197, 205–7, 269; aesthetic, 14; aesthetic judgment and, 58; art and, 8–10, 17, 77, 83, 147, 152, 210, 266; Caro and, 104; de Hooch and, 23, 45; of embodiment, 311, 313; Kant's conception of, 4–6, 50, 53; of living nature, 47, 55–56, 60, 257, 259, 261–62; mimetic, 258; minimalism and, 136; perceptual, 11, 151, 153; sensory, 3, 7, 15, 47, 263; Soutine and, 73, 75; tragedy as form of, 291, 294; visual, 211–12, 227, 321. *See also* cognition; encounter

expression, 156–57, 242, 246, 321
expressionism, 68
expressive empirical order, 98–99, 102, 107, 147
externalism, 134

Fabritius, Carel, 332*n*15
facticity, 105
fallibilism, 156
fashion image. *See* image
Faure, Elie, 68, 341*n*35
fear, 291–92, 296, 319–21
Fer, Briony, 341*n*36, 364*n*38
female gaze, 32, 40
figuration, 186, 189
figure painting, 67–68
film, 203, 270–72, 288, 290, 308
fine arts, 142
finitude, 42, 81, 102, 140, 251
fitness, 13, 37–38, 48, 58, 60, 267, 334*n*27. *See also* amenability problem; purposiveness
flatness, 2, 17, 65, 138, 140, 177, 179, 204, 221, 227
Flavin, Dan, 201
form, 249, 251, 263; Adorno and, 195, 197–99, 208, 248; aesthetic judgment and, 57; Akerman and, 113–14; beauty and, 282; Bourgeois and, 220–21; Cartesian enlightenment and, 22; horror and, 297, 304, 306; in Kant, 5; of living beings, 54–55, 60, 62; melancholy and, 11, 188–89; minimalism and, 134–35, 141; photography and, 288; Ryman and, 244–45
formalism, 12, 138, 186, 195, 197, 199, 222, 254, 363n30
formal reason, 77, 252
Foster, Hal, 13, 315, 330*m*19, 350*n*20, 376*m*
Foucault, Michel, 147, 264
fragment, 81, 109–12, 114, 116, 166, 188–89, 218, 220
fragmentary material rationality, 178–79
frame, 218, 222
fraudulence, 96–101

freedom, 197; art and, 75, 77, 247, 250; Clark and, 167, 171, 173; exteriority and, 317; Hegel and, 224; Kant and, 51–52; nature and, 10; non-meaning and, 248–49; Mondrian and, 238; ordinary-language philosophy and, 88–91; Ryman and, 246
Freeland, Cynthia, 381*n*30
French Revolution, 52, 172
Freud, Lucien, 382*n*38
Freud, Sigmund, 82, 357*m*3
Fricke, Christel, 53
Fried, Michael, 12–15, 122–23, 158, 175, 345*n*22, 348*n*7, 349*m*4; on artistic fraudulence, 97–98; Cavell and, 101–2; convention and, 142; dualism of, 138–41; Greenberg and, 125–27, 200; on minimalism, 130–36
Friedrich, Caspar David, 127

Gaiger, Jason, 360*n*9
Galileo, 22
gap, 86–87, 89–90
Gaskell, Ivan, 332*m*17
gender, 175–76, 308–9, 312
genre, 67, 95, 152, 280–81, 287, 291, 318–19
geometric forms, 133, 135
George, Waldemar, 339*m*9
gesture, 235, 242–43, 246
Geuss, Raymond, 361*n*24
Giacometti, Alberto, 372*n*43
God, 40
Golding, John, 340n27
Gombrich, E. H., 25–26, 35, 331*nn*5–7
Gorky, Arshile, 73
Gottlieb, Adolph, 157, 161
Gowing, Lawrence, 335*m*31, 335*m*33
grammar: of art practices, 147; of de Hooch, 36; as material a priori, 56; of minimalism, 133, 136; of sex, 313; in Sherman, 309; of Soutine, 68, 72
Greek tragedy. *See* tragedy
Greenberg, Clement, 12–15, 157, 195, 329*n*7, 341*n*34; anthropomorphism and, 124–27, 130; artistic mediums and, 232,

288; flatness and, 221; modernist painting and, 203–4, 206–8; opacity and, 235, 245; Pollock and, 200; Soutine and, 63–68, 70, 72–73
Grunwald, Matthias, 42

handedness, 133, 135, 235, 368*n*24
Hansen, Miriam Bratu, 379*n*17
happenings, 162, 263
harmony, 72, 156, 208, 247, 264, 282, 294
Harris, Henry, 382*n*49
Hartley, Marsden, 194
heatedness, 70, 72
Hebel, Johann Peter, 249
Hegel, G. W. F., 246, 248, 261, 294, 364*n*3, 367*m*8, 371*n*42; aesthetics of, 249; arbitrariness of the sign and, 241; Clark and, 172; Dutch realism and, 333*n*26; end of art and, 148–49, 223–25, 231, 238, 250; loss of nature and, 177
Hegelianism, 238, 369*n*28
Heidegger, Martin, 112, 150, 223, 230, 365*m*1
high modernism, 221–22; of abstract expressionism, 276; Adorno on, 11, 144, 194, 209, 247; Cavell and, 101; Fried and, 123; hermeticism of, 122; melancholia and, 247; postmodernism and, 263; Romanticism and, 81; Sherman and, 287, 323. *See also* late modernism
Hobbes, Thomas, 294
Hofmann, Hans, 167, 181
Holbein, Hans, 40, 42–43
Hollanda, Francisco de, 24
Hollywood, 266, 270
Honig, Elizabeth Alice, 30, 32
Horkheimer, Max, 254, 256–57, 260–62, 265–66, 268, 330*m*3
Horowitz, Gregg, 329*nn*9–10, 341*n*35, 357*m*3, 361*m*8, 364*n*2
horror, 255, 287, 289–90, 296–99, 303, 305, 310, 314, 317, 319, 323
Houckgeest, Gerard, 332*m*5
Houlgate, Stephen, 364*n*2, 371*n*41
hounding, 7–9, 12, 15–16, 98–99, 106, 329*n*7, 355*n*5

Hubert, Henri, 260
Hughes, Robert, 298
Huhn, Tom, 328*n*5, 329*n*9
Hume, David, 24, 112
hyper-conventionalism, 176

idealism, 166, 249, 251, 297; linguistic, 259
idea of painting, 9–10, 186, 212
ideology, 119, 259–60
images: Adorno and, 156–58, 205–7, 262, 265–66, 273; ban on, 254, 311, 320; fashion, 255, 282–84, 286–88; objectivity and, 250; photography and, 267–68, 271, 274, 276–77, 279–81, 306, 317; Pollock and, 210; pornographic, 318; postmodernism and, 253, 256, 259, 263; skepticism and, 126; in Soutine, 68, 70, 72–73
impressionism, 66, 171, 374*n*48
improvisation, 97
incarnation, 225, 230, 234, 366*m*7
indeterminacy, 245–46
induction. *See* transcendental induction
industrialism, 80, 139, 149, 236
informal music, 213
installation, 117, 119, 143, 218, 263
instrumental reason, 23, 77, 123, 149, 157, 186, 197, 256–57
integral nominalism. *See* nominalism
intensional contexts, 229
intentional objects, 67, 94
interpretation, 15, 85, 119, 141, 236
intersubjectivity, 23, 58, 83, 86, 150, 191, 224
intransitive understanding, 132
intuition: Caro and, 93; concept and, 12, 14–15, 17, 206; Kantian, 4–8, 53, 166, 258, 327*n*5, 331*n*6
Italian model, 14, 25–29, 35, 44

Jacobinism, 171
Jena romanticism, 330*m*4, 336*n*4
Jesus, 40
jointure, 91, 98, 100, 107, 116
Jones, Amelia, 376*n*4
Jorn, Asger, 161, 354*m*9

Joyce, James, 260
Judd, Donald, 127–28, 133, 136, 201, 350*n*27
judgment of taste. *See* reflective judgment

Kabakov, Ilya, 329*n*10
kabbala, 127
Kafka, Franz, 268, 321
Kandinsky, Wassily, 2, 227
Kant, Immanuel, 11–12, 46–47, 118, 224, 305; aesthetics and, 82; categorical imperative of, 301; Cavell and, 96, 110, 114; conception of experience in, 4–6, 327*n*5; disenchantment of nature and, 49–52; disinterestedness and, 267; on disgust, 296–97; enlightenment and, 24; on imagination, 269; judgment of life and, 53, 55; nature and, 251; reflective judgment and, 37, 48, 54, 56–61, 67, 83, 87
Kelly, Michael, 122
Kettler, Friedrich, 16–17
Kierkegaard, S<sla>oren, 226
King, Martin Luther, Jr., 110
kitsch, 67, 146, 161, 163, 303
Klee, Paul, 161
Kleeblatt, Norman, 339*n*19
Kline, Franz, 153
Koedijck, Isaack, 332*n*15
Kosuth, Joseph, 202
Kristeva, Julia, 40, 303, 351*n*35, 371*n*40
Krauss, Rosalind, 13, 190, 223, 279, 307–8, 341*n*36, 346*n*25, 350*n*27, 353*n*11
Krenek, Ernst, 96–97
Kuhn, Thomas, 125
Kuspit, Donald, 341*n*31
Kuzniar, Alice, 336*n*4

Lacan, Jacques, 367*n*19
Lacoue-Labarthe, Philippe, 337*n*5
La Fresnaye, 340*n*27
landscapes, 61, 146, 295; of Céret, 49, 67, 70, 72, 298
language, 56, 120, 156, 205, 259–60, 262, 304; of nature, 50, 59, 157–58, 245
language games, 147

late modernism, 8, 10, 195, 222, 254. *See also* high modernism
lateness, 1, 8–10, 16, 169, 222, 288, 329*n*10
lawfulness, 59
Lear, Jonathan, 291–92
legal-rational authority. *See* authority
Lessing, Doris, 347*n*40
Lessing, Gotthold, 16, 364*n*3
liberalism, 123
linguistic practice, 142, 241
literalism, 72, 97, 123, 132–34, 139–40
literature, 79–80, 82, 108, 116, 203–5
lived space, 102
living beings, 53–55, 62, 68, 72, 257–58, 261, 306
Locke, John, 24
logic: Adorno and, 197, 199, 206; aesthetics and, 82–83, 85–86; of art, 207, 209, 211–12, 214–15; Cavell and, 78–79, 87; of commodity production, 237; of the fragment, 218, 221; of genres, 287; of instrumental reason, 256; Kant and, 48, 51; of modernism, 222, 294; of photography, 286
longing, 43, 45, 139, 161, 209, 234, 236
Louis, Morris, 96, 101
Lueken, Verena, 275–76
Lukács, Georg, 46, 345*n*21
Lyotard, Jean-François, 147
lyric, 153–54, 163, 179

Maes, Nicolaes, 332*n*15
Magnus, Kathleen Dow, 365*n*5
Makkreel, Rudolf, 338*n*14
male gaze, 32–33, 40, 309–10, 313–14
Malevich, Kasimir, 167, 180; Black Square, 204, 237
mana, 260
Manet, Édouard, 2, 16, 65, 139, 171, 221, 277, 333*n*24, 362*n*26
manifold, 57, 59–60, 62
mannerism, 42, 72
Marvell, Andrew, 354*n*17
Marx, Karl, 193, 233
Marxism, 172

masks, 240. *See also* Sherman, Cindy
mass culture, 80, 269, 289
material a priori, 56, 67, 75
material conditions of possibility, 73–75, 83, 95, 105, 191, 210
materialism: of abstract expressionism, 297; of de Hooch, 23, 36–39; minimalism and, 133; of modernism, 12, 121, 172, 262; of science, 82; in Sherman, 308, 315, 318; Soutine and, 46–47, 73, 298
materialist realism. *See* materialism
material logic. *See* logic
material meaning: abstract expressionism and, 276; aesthetics and, 47–48, 83; modernism and, 179–80, 188, 234; Ryman and, 246; Soutine and, 75
material motive, 199–200, 205, 208, 210–12, 214, 218
material substratum, 75, 77, 190, 198–99, 254, 294, 297, 304
material world, 166; abstract expressionism and, 120–21, 155, 163; anthropomorphism and, 123, 125–26, 142; de Hooch and, 42, 45; Descartes and, 22–23, 29; mechanization of, 48; Sherman and, 254, 321; Soutine and, 73
mathematical physics, 21, 49, 82, 152, 336n3. *See also* natural science
Matisse, Henri, 68, 208, 226; *The Red Studio*, 250
matter, 14, 191; in art, 248–49, 261, 263; Cavell and, 95; Christensen and, 119; in de Hooch, 36, 44; in Descartes, 21; Hegel and, 224; in Kant, 5–6; meaning and, 258–59; Ryman and, 246; Sherman and, 307; in Soutine, 66, 73, 75, 77. *See also* paint-stuff
Mauss, Marcel, 260
McDowell, John, 354n13
McGinn, Marie, 338n12
meaning-complexes, 146
mechanism: as hegemony of discursive thinking, 61, 63; in Kant, 47; photography and, 280; Ryman and, 244–46
mechanization, 48, 139, 235, 267–68

medium, 210; abstract expressionism and, 156–57, 162; Adorno and, 222; Cavell and, 95–96, 99, 101, 106; digitalization and, 17; Greenberg and, 124, 232; Hegel and, 225; modernism and, 215, 233–34, 236, 250, 294; photography and, 253, 273, 280–81, 288–89; Ryman and, 245–46; Soutine and, 65, 74–75, 77; as stand-in for nature, 11, 15–16
melancholic form, 189
melancholy: Adorno and, 247; Benjamin and, 114; Bois and, 351n35; Clark and, 166–67, 191; Holbein and, 42; of modern painting, 9, 11, 14, 193; sexual, 309
Melville, Stephen, 333n24, 351n36, 378m14
memory, 39, 112, 119–20, 221
Merleau-Ponty, Maurice, 345n21, 376m4
metaphor, 229, 246, 369n31
Michelangelo, 24
Millet, Jean-François, 173
mimesis: Adorno and, 157, 258, 371n37; art and, 265; death and, 269; masks as, 320; photography and, 268; representational art as, 151; Ryman and, 244, 252, 373n45; Sherman and, 272–73, 277, 290, 304
mindedness, 224–26, 231–32, 246, 366m7, 372n42
minimalism, 263, 350n20, 350n27, 351n28; anthropomorphism and, 128; Danto and, 226–28, 230; Fried and, 97–98, 122, 130–36, 140–41; of Holbein, 42; painting and, 162, 201, 205; Ryman and, 373n45; skepticism and, 100, 105
modernist novel, 146
modernist painting: abstract expressionism and, 200; Alpers and, 14, 44; Bourgeois and, 221; Cavell and, 101; Clark and, 190; Danto and, 228; Duchamp and, 195, 201–3, 214; emptiness of, 9; ending of, 7, 223; Fried and, 126, 134, 136, 140; Greenberg and, 64, 66, 204; impossibility of, 211; Kant and, 47; modernism and, 11, 13; postmodernism and, 10; Sherman and, 255, 318; Soutine and, 72,

77; standard story of, 1; visual experience and, 212
modernist philosophy, 1, 8, 11, 13, 81, 99, 108–11. *See also* philosophy
modernity: Adorno and Horkheimer on, 256; art and, 3, 12, 15, 92, 102, 105, 134, 166, 225, 233–34, 254; Clark and, 167–72, 179; Dutch realism and, 29, 40, 45; experience in, 4, 6, 8; Hegel and, 148–49; mathematical knowing and, 22, 43–44; philosophy and, 99, 265; pornography in, 310; rationality and, 74, 98, 121–23, 136, 249, 259–61, 264; Sherman and, 255, 306, 319; tragedy and, 295
Mondrian, Piet, 204, 236–39, 241, 247, 250, 252, 369 n28
Monet, Claude, 109, 174
monochrome, 140, 204–6, 213, 226, 237, 250, 361 n21, 368 n26
monumentality, 117–19, 174, 181, 190
Moore, G. E., 257–58
Morris, Robert, 128, 201, 350 n20
mortification, 3, 14, 67, 72, 261, 284, 286, 297, 306, 314
Motherwell, Robert, 157
mourning, 42, 118, 166–67, 188, 235, 239–40, 247, 351 n35, 368 n22
Mulhall, Stephen, 87, 343 n7
Mulvey, Laura, 275
music, 96, 144, 203–6, 213–14

Nancy, Jean-Luc, 337 n5
natural beauty, 48, 60–61, 67, 105, 224, 249–51, 339 n17. *See also* art beauty; beauty
naturalism, 23, 63–64, 67, 82, 98
natural science, 6, 21, 61, 81–82, 98, 146, 149, 197, 328 n6. *See also* mathematical physics
natural world. *See* nature
nature: abstract expressionism and, 155, 157–58, 164, 200; Adorno and Horkheimer on, 260–61; animism and, 290, 321; art and, 7, 10, 121, 146–47, 226, 250–51, 264; automatism and, 108;

beauty and, 281; Caro and, 94, 104; Clark and, 166, 177–78, 187, 190; convention and, 142, 357 n13; in de Hooch, 33, 35–38, 42–43; Descartes and, 17, 21; disenchantment of, 49–51, 149–50, 241; Hegel and, 224–25, 238; horror and, 297, 303; as indifferent, 98, 100, 106; Italian model and, 25; Kant and, 12, 47–48, 52–63; masks and, 320–21; medium and, 11, 15, 74–75, 77, 236; photography and, 267; postmodernism and, 249; Ryman and, 246; sex and, 311–12, 314; Sherman and, 253, 282, 317; Soutine and, 65–67, 73; sublimity and, 292–95. *See also* dead nature
negation: abstract expressionism and, 160–62, 179; abstraction and, 150; Caro and, 104; disinterestedness and, 57, 62; Duchamp and, 245; modernism as, 63, 181, 199, 204–6, 212, 248, 288; modernity and, 166; Sherman and, 254; Soutine and, 68, 72
neutralization, 119, 139, 160, 162
new, the: 139, 161, 207, 209–10, 233, 236
Newman, Barnett, 152, 156, 200–201, 204–5, 241–42, 252, 277, 308, 353 n12, 360 n14; *Onement I*, 127; *Stations of the Cross*, 154; *Vir Heroicus Sublimis*, 155
Newman, Michael, 16–17
Newtonian physics, 88–90. *See also* mathematical physics
Nietzsche, Friedrich, 82, 336 n4
nihilism, 118, 125–26, 180, 263
Noland, Kenneth, 101, 122, 136, 141
nominalism, 12, 96, 98, 202, 213–14, 218, 221, 241
non-art, 207–9, 211
nondiscursivity, 47, 54–56, 58–60, 251. *See also* cognition; discursivity
normative commitment, 51
novelty, 139, 209, 228, 233, 236–37
nuclear family, 26

objecthood, 130, 133–35, 138, 140–41, 261. *See also* thinghood

objectivity: abstract expressionism and, 153, 164, 190, 213; of modernism, 154, 250; reflective judgment and, 83, 85, 87; Ryman and, 235–36; of works of art, 124, 126–27, 138, 196

obsolescence, 16, 136, 368*n*25

Olitski, Jules, 101, 122, 136, 141

opacity: of abstract expressionism, 120–21; of art, 226, 248, 251; convention and, 246; Danto and, 229, 232, 366*n*14; of medium, 233–36; of realist painting, 37–38, 42; Ryman and, 240, 244–46

opticality, 125

ordinary language philosophy, 78, 88–91, 98

organic unity, 72

orientational significance, 3, 6, 11, 56, 60–61. *See also* transcendental significance

overallness, 164

pain: abstract expressionism and, 263; Bourgeois and, 220–21; Bryson and, 259, 304; judgment of life and, 56; in Soutine, 68, 73; sublimity and, 290–92; Sherman and, 305, 315

painterliness, 63–65

paint matter. *See* paint-stuff

paint-stuff: dissonance and, 208; Pollock and, 182, 188, 211; Ryman and, 245–46; Soutine and, 12, 64–68, 70, 72–74

Panofsky, Erwin, 26

papiers collés, 240

paradox of modernism, 195, 206, 210, 213, 221

particulars. *See* sensuous particulars

Pascal, Blaise, 106

pastoral painting, 173–74

pathos: Adorno and, 222; in Aristotle, 292; of art, 123; disgust and, 296, 315; in Sherman, 277, 309; in Soutine, 64, 67; tragedy and, 295

Peirce, Charles Sanders, 367*n*19

perfectionism, 87

perspective, 37, 64–65, 72, 153, 155, 227, 237

petty bourgeoisie, 159, 164

philosophy: Adorno and, 144; art and, 8–9, 12, 107, 118, 121–22, 228, 230–32; Cavell and, 78–81, 87, 92, 99–100, 108, 112, 116; criticism and, 265–66; everyday practices and, 146–47; Hegel and, 149; ideal type of, 82–83, 98; perception and, 257; personal performance and, 111; tragedy and, 294. *See also* modernist philosophy

photography: art and, 139, 233, 235–36; aura and, 266, 272; beauty and, 281–82; Benjamin and, 203; horror and, 299; male gaze and, 313; masks and, 321; modernist painting and, 287–88, 298; mortification and, 284; rationalization and, 268; Ryman and, 242; Sherman and, 253–55, 273, 276, 280, 286; the sublime and, 289

physics. *See* mathematical physics

Picasso, Pablo, 167, 171, 175–76, 180–81, 241; *Girl with a Mandolin*, 2; *Guitar*, 240; *Ma Jolie*, 354*n*17; *Man with Mandolin*, 2; *Portrait of Ambroise Vollard*, 2

pictographs, 161

pictorial effects, 141

pictorial illusionism, 237

pictorialism, 2

picture plane, 2, 65, 72, 204

Pippin, Robert, 327*n*5, 338*m*13, 364*n*2

Pissarro, Camille, 171–74, 180; *Two Young Peasant Women*, 167, 172–73

pity, 291–92, 296

plastic equivalence, 239

Plato, 78, 228, 375*n*49

Platonism, 133, 135

poetry, 218

pointillism, 173

political history, 169–70

politics, 99, 171–72, 238

Pollock, Jackson, 15, 44, 73, 121, 167; aura and, 263; *Autumn Rhythm*, 359*n*27; Beaton photographs and, 282; Bois and, 236, 375*n*53; Cavell and, 101–2; chance and, 97; Clark and, 171–72, 175–76, 179–83, 187–90; *Full Fathom Five*, 188, 210, 214, 221, 362*n*25; individualism and, 277; *Lavender Mist*, 120, 155, 160;

materiality and, 65, 200, 208, 280, 341*n*36; *Number 1, 1948*, 181, 189; *Number 32, 1950*, 189; *Out of the Web: Number 7, 1949*, 182; *The Wooden Horse*, 182, 186–88
Poons, Larry, 122
pop art, 122, 226–28, 230–31, 234, 266
pornography, 287, 309–11, 313–15, 317–19
positivism, 133, 176–77
postmodernism: aesthetics and, 12, 16; arbitrariness of the sign and, 248, 262–63; chance and, 97; culture industry and, 268; modernist painting and, 10, 29, 121, 342*n*5, 360n8; rationalism and, 259–60; Sherman and, 253, 256, 275
potentiality for meaning, 242–43, 245–46
Potts, Alex, 220, 363*n*33, 363*n*36
presentness, 101–102, 123, 348*n*7
problem-solving, 82
psychoanalysis, 288
psychology, 82
public mode, 131
pure painting, 64–65, 67, 73, 206
purposiveness, 48, 52–54, 57–60, 77, 128, 199. *See also* amenability problem; fitness
pursuit of happiness, 311–12, 317

rational authority. *See* authority
rational freedom. *See* freedom
rationalism: anthropomorphism and, 123, 126–28, 130, 133, 136; as hermeneutics of painting, 37; literalism and, 140, 350*n*27; postmodernism and, 259–60, 262
rationality potential, 4, 7, 12, 74, 77
rationalization: Adorno and, 197; anthropomorphism and, 127; art and, 139, 141, 152, 180, 355*n*5; disenchantment and, 118, 150; of everyday life, 3, 6; of experience, 73; of language, 262; modernity and, 23, 121, 256–57, 264; nature and, 61, 312; photography and, 267–68, 280, 318; sensuous particularity and, 155; Sherman and, 282; societal, 170, 259, 265
readymade, 210; as abnormal painting, 200, 360*n*6; Adorno and, 222; arbitrary convention and, 214–15; Bois and, 237, 240, 370*n*32; Bourgeois and Cornell and, 218; color as, 245, 247; Danto and, 226; material motive and, 363*n*32; medium and, 236; modernism and, 140, 195; nominalism and, 221; painting and, 201, 205, 362*n*25
realism, 12–13, 43; photographic, 278, 284, 286, 380*n*27. *See also* Dutch realism
reanimation, 307, 309, 315. *See also* animation
recognition, 80, 115, 239, 241, 290, 294
reduction of meaning, 73
reflective judgment: aesthetic, 56–61; anthropomorphism and, 126; Cavell and, 83–85, 87; judging life and, 55; Kant and, 48, 54, 328*n*5; modernism and, 62, 98; of natural beauty, 339n17; ordinary language philosophy and, 90; photography and, 266–67; realism and, 37; as *sensus communis*, 264; Soutine and, 67. *See also* determinant judgment
reflective practices, 146
reflexivity, 186, 235
reification, 3, 47, 257, 305, 307, 318, 321
Reinhardt, Ad, 122
religion, 148
Rembrandt, 298, 340*n*21, 340*n*25, 341*n*35
Renaissance, 114
repetition: as mimesis, 371n37; minimalism and, 132–33, 135, 350*n*27; Mondrian and, 238; Ryman and, 242, 244–46, 371*n*39, 372*n*45; Sherman and, 277, 279–80, 305, 318, 380*n*25
representation: abstraction and, 151–52, 160, 208, 211, 287; arbitrariness of the sign and, 240–41; Clark and, 167–69, 176, 178–83, 186–89, 192; Danto and, 227, 229–30, 232; disenchantment and, 150; disgust and, 297; Hegel and, 148–49, 224; intuition as, 4, 7; in painting, 1–3, 64, 77, 124, 126, 134, 146, 183, 339*n*17; Sherman and, 253–55, 270–71, 287–88, 304–5; in Soutine, 68; the sublime and, 295; tragic, 290

representational content. *See* representation
Rhine, 150
Richter, Gerhard, 73, 200, 284, 329*n*10
Rodchenko, Aleksandr Mikhailovich, 140, 204, 236–37, 239, 247, 250
Romanticism, 80–81, 342*n*5
Rose, Gillian, 367*m*8
Rosenblum, Robert, 127
Rothko, Mark, 73, 120, 152, 154, 159–60, 200, 204, 263
Rousseau, Jean-Jacques, 24
ruins, 188, 210, 218, 255, 282
Russian Revolution, 237
Ryman, Robert, 12, 15, 200, 235–36, 240–48, 252, 359*n*5, 368*n*22, 368*n*24; *Empire*, 244

Saenredam, Pieter, 332*m*15
Said, Edward, 329*m*10
Saville, Jenny, 382*n*38
scale, 130–31
Scarry, Elaine, 377*n*11
Schapiro, Meyer, 356*m*10
Schiller, Friedrich, 5, 16, 75, 166, 327*n*3, 328*n*5
Schjeldahl, Peter, 381*n*31
Schlegel, Friedrich, 16
Schoenberg, Arnold, 144
scientism, 80, 176, 260
sculpture: beauty and, 282; of Bourgeois, 218; Caro and, 93–94, 98, 104–5, 107–8; classical, 117–19; Duchamp and, 202, 214; as medium, 74; minimalism and, 97, 140; as reflection of its time, 121
secondary qualities, 149, 157
secular world, 23, 29, 34, 37, 39–40, 43–44, 193. *See also* everyday life
self-consciousness: acknowledgment and, 106; disenchantment and, 52; disgust and, 296, 306; modernism and, 3, 73, 77, 146, 189, 231, 240; of modernity, 11; pornography and, 314; tragedy and, 294
semantics, 38, 155–56
semblance: Adorno and, 199, 207–9; art as, 9, 77, 154, 161, 237, 247–48; of life, 261–62; in Soutine, 67, 72–73

sensationalism, 177
sense-making, 74–75, 77
sensible meaning, 47, 63, 141–42
sensible world, 12, 23, 43, 45, 142
sensory experience. *See* experience
sensuous immediacy, 148, 153, 155, 162, 225
sensuous meaning, 47, 63, 141–42
sensuousness, 237, 250; abstraction and, 163; Dutch realism and, 39; Hegel and, 224–25; horror and, 298; life and, 47; meaning and, 155; Mondrian and, 238; philosophy and, 111, 116; in reflective culture, 142
sensuous particulars: abstract expressionism and, 120, 152–54, 158, 162, 186, 211; Adorno and, 206–10; anthropomorphism and, 142; art and, 9–10, 47, 121, 212–14, 233–35, 367*m*8; artworks as, 8, 241, 266; Christensen and, 118; Clark and, 180, 190; end of art and, 225–26; enlightenment and, 257; experience of, 5, 7, 151, 179; Greenberg and, 66; horror and, 296; meaning and, 249; Mondrian and, 238; nature and, 295; philosophy and, 116, 122; readymade as, 215, 363*n*32
seriality, 242, 373*n*45
series, 108–10, 112, 197, 274, 280
Serra, Richard, 346*n*25
Seurat, Georges, 126, 236
severance, 40, 42
sexual desire, 40, 42, 61, 284, 302, 309, 314
sexual practices, 310–11
Shakespeare, William, 81
Sherman, Cindy, 13, 15, 73, 257–58; aura and, 262–63, 265, 272–73, 277; centerfolds, 280; cliché and, 271, 279; fashion photographs, 281–82, 284, 286–87; gender and, 312; history pictures, 307; horror and, 290, 299, 301–2, 304–6; individuality and, 270, 275–76, 278, 308; mask pictures, 319, 321, 323; modernism and, 10, 12, 288, 318; photography and, 274, 317; sex pictures, 309–10, 314–15; the sublime and, 289; *Untitled Film Stills*, 253–54, 256, 270–71, 273–75,

277–78, 280, 282–83, 287–88, 305, 308, 314, 318
sign: abstract expressionism and, 263; arbitrariness of, 12, 98, 191, 240–42, 244, 248–49, 260, 370*n*36, 372*n*42; Clark and, 166–67, 169–70, 180, 188, 191–92; concept as, 262, 265–66; Danto and, 229–30, 232; de Hooch and, 44; image and, 156, 205–6, 271; materiality of, 9
Signac, Paul, 374*n*48
Silver, Kenneth, 339*m*9
singularity, 276–79
skepticism: Cavell and, 78, 95, 99, 102, 105–6, 109, 114, 342*n*3, 343*nn*8–9, 344*m*7; Clark and, 180, 191; Fried and, 123, 125–26; minimalism and, 135; of readymade, 218
Smith, David, 122
Smith, Tony, 98, 132, 135–36
Smithson, Robert, 352*m*36
Snow, Edward, 39–40, 335*n*33
socialism, 166–67, 169–70, 178, 192
social reproduction, 7, 23, 138, 143
society of the simulacrum, 239
Solomon, Deborah, 362*n*29
Sontag, Susan, 276, 378*m*13
Soutine, Chaim, 12–13, 15, 47, 49, 63–67, 70, 73–74, 160, 188, 261–62, 298, 340*n*27, 341*n*35; *The Beef*, 72; *Carcass of Beef*, 75; *Self-Portrait*, 68
spatialization, 93–94, 102, 104
spirit, 9, 224–25, 231, 238, 248, 252, 261, 307
Steadman, Philip, 335*n*29
Steinberg, Leo, 353*m*11
Stella, Frank, 15, 101, 122, 136, 138–41, 201, 204–5, 263
Stieglitz, Alfred, 194
Still, Clyfford, 73, 158–60
still life, 67, 72–73, 175
Stone, Jennifer, 382*m*38
Strawson, P. F., 90
subjectivity: abstraction and, 151; art and, 3, 7, 75; of art conventions, 125; Cavell and, 86, 90, 100, 111–12; crisis of, 50, 74, 150; handedness and, 235; horror and, 297; Kant and, 51; masks and, 321; minimalism and, 98; reflective judgment and, 84; Ryman and, 242, 245–46; Sherman and, 275, 278, 282, 287, 304, 308; of Soutine, 298
sublime. *See* sublimity
sublimity, 14, 114, 264, 311, 313; in abstract expressionism, 120; Clark and, 159, 161; in de Hooch, 24; fascination of, 293; horror and, 255, 297–98, 305; nature and, 294–95, 312; Newman and, 127, 252; pornographic, 317; semblance and, 248; Sherman and, 279; in Soutine, 66, 70; Still and, 158; tragedy and, 289–90, 292, 306
subsumption: abstract expressionism and, 152; of cultural cliché, 282; enlightenment and, 257; in Kant, 4–5, 52–53, 57–58, 83; modernism and, 62–63; of use value, 23
surplus of form, 55, 62
surrealism, 134, 218, 362*m*30
Sutton, Peter, 26
symbolism, 25, 28, 218
symbol: abstract expressionism and, 263; abstraction from, 152; Adorno and, 206; in Chardin, 44–45; in Christensen, 121; Danto and, 228–32, 234–35; medium-bound sensuousness and, 225; in painting, 132, 134–35; Ryman and, 246; in Vermeer, 39
syntax, 38, 155–56, 242

taboo, 227–28, 320–21
technicism, 138
technology, 52, 122, 127, 149–50, 233, 236, 241, 366*n*17
teleological explanation, 54–55
temporality, 119, 271–72
theater, 218–19
theatricality, 98, 130–34, 136, 158
theology, 152
thinghood, 94–95, 98, 372*n*45. *See also* objecthood
Thoreau, Henry David, 81

Tintoretto, 340n21
total composition, 97–98, 100
tragedy, 114, 255, 289–95, 298, 306; Greek, 177, 311
transcendence, 37, 40, 42, 155, 163–64, 230
transcendental claim, 79, 83, 94, 100, 367n20
transcendental induction, 38, 49, 67
transcendental significance, 61–62, 80. *See also* orientational significance
transgression, 159, 202–3, 297, 314–15
transmission, 211
transparency, 190, 226, 229, 232–33, 246
Twombly, Cy, 263

ugliness, 283–84, 286, 296–97, 303, 318–19
uncanniness, 132, 262, 321
unhappy consciousness, 172, 189, 375n48
unique object, 7, 75
unity, 70, 72–73, 247, 297
universals, 83, 92, 96, 112, 122, 151–52, 162–63, 205, 213, 269
universal voice, 85, 87, 90, 98
uprightness, 104, 127, 309
utopia, 19, 23, 43–44, 210, 247

van Eyck, Jan, 26
Van Gogh, Vincent, 43, 65, 208, 277–78, 298, 340n25
van Hoogstraten, Samuel, 332n15
Vermeer, Jan, 15, 24, 40, 42, 335n29, 335n31, 336n38; *Head of a Girl*, 335n33; *The Little Street*, 38; *The Milkmaid*, 39; *A Woman in Blue Reading a Letter*, 335n33
Vico, Giambattista, 260
violence: Bourgeois and, 218, 220–21; Cavell and, 114–15; horror and, 297; in Sherman, 255, 282–83, 286, 304, 310; in Soutine, 73; tragedy and, 295
visionemic syntax, 242
visual field, 128, 130, 313, 317
visual meaning, 66, 68, 73, 121, 141–42, 246
vitality, 224–25, 295, 307, 311
Vogue, 180–81
Vorobej, Mark, 381n36

Vosmaer, Daniel, 332n15
voyeurism, 221
vulgarity, 158–61, 163–64

Wagner, Anne, 363n33
Waldman, Diane, 362n29
Warhol, Andy, 10, 226; *Brillo Boxes*, 10, 226
Weber, Max, 108, 264
Webern, Anton von, 213
Weiss, Jeffrey, 375n48
wholeness, 208, 221
Williams, Bernard, 330n2
Williams, Linda, 383n54
Wittgenstein, Ludwig, 14, 55–56, 78, 81, 109, 147, 337n12, 338n15
Wollheim, Richard, 353n11
working through, 239
writhing, 70
writing, 242

Young, Julian, 366n11

Zanetti, Véronique, 337n7
zip, 155–56, 204, 242, 361n14
Zuidervaart, Lambert, 352n2

The authorized representative in the EU for product safety and compliance is:
Mare Nostrum Group
B.V Doelen 72
4831 GR Breda
The Netherlands

www.ingramcontent.com/pod-product-compliance
Lightning Source LLC
Chambersburg PA
CBHW020721180526
45163CB00001B/63